Caught in the Act

an anthology of **performance art** by Canadian women

Caught in the Act

an anthology of **performance art** by Canadian women

edited by **Tanya Mars** & **Johanna Householder**

YYZ Books | Toronto

MANAGING EDITORS
Sally McKay
Kerri Embrey

COPY EDITOR
Bridget Indelicato

PUBLISHING INTERNS
Iga Janik
Jennifer Matotek
Anne Merrill
Ron Nurwisah
Aubrey Reeves

LIBRARY AND ARCHIVES CANADA
CATALOGUING IN PUBLICATION

Caught in the Act : an anthology of performance
art by Canadian women / edited by Tanya
Mars and Johanna Householder.

Includes bibliographical references.
ISBN 0-920397-84-0

1. Performance art--Canada. 2. Women
artists--Canada.
3. Performance artists--Canada. 4.
Performance art--Canada--History.
I. Mars, Tanya, 1948- II. Householder,
Johanna, 1949-

NX456.5.P38C39 2004 700'.82'0971
C2004-905479-1

GRAPHIC DESIGN Zab Design & Typography

Printed in Canada by Kromar Printing Limited

Distributed by ABC Art Books Canada
www.ABCartbookscanada.com

YYZ Books is an alternative press dedicated to
publishing critical writings on Canadian art
and culture. YYZ Books is associated with YYZ
Artists' Outlet, an artist-run centre that pres-
ents challenging programs of visual art, film,
video, performance, lectures and publications.

YYZ Artists' Outlet is supported by its mem-
bers, The Canada Council for the Arts, the
Ontario Arts Council and the city of Toronto
through the Toronto Arts Council.

YYZ Artists' Outlet gratefully acknowledges
the support of The Canada Council for the Arts
for our publishing program.

401 Richmond Street West, Suite 140
Toronto, ON M5V 3A8
T: 416-598-4546
F: 416-598-2282
www.yyzartistsoutlet.org

The authors and publisher have done their
utmost to credit photographers, however, there
are instances where the photographer is unknown.
We apologize to any photographer who has not
been properly acknowledged. If you see your
image in this book, please send information to
YYZ Books at publish@yyzartistsoutlet.org and
we will make the correction in the next edition.

YYZ BOOKS CURRENT TITLES

Peter MacCallum: Material World
Photographs: Interiors 1986-2004
Concrete Industries 1998-2004
Edited by Rebecca Diederichs

Aural Cultures
Edited by Jim Drobnick

Susan Kealey: Ordinary Marvel
Edited by Jennifer Rudder

Why Stoics Box and Other Essays
on Art and Society
By Jeanne Randolph, edited by Bruce Grenville

Crime and Ornament: The Arts and Popular
Culture in the Shadow of Adolf Loos
Edited by Melony Ward and Bernie Miller

Money Value Art: State Funding, Free Markets,
Big Pictures
Edited by Sally McKay and Andrew J. Paterson

LUX: A Decade of Artists' Film and Video
Edited by Steve Reinke and Tom Taylor
[SOLD OUT]

Practice Practise Praxis: Serial Repetition
Organizational Behaviour and Strategic
Action in Architecture
Edited by Scott Sorli

Foodculture: Tasting Identities and
Geographies in Art
Edited by Barbara Fischer

Material Matters: The Art and Culture of
Contemporary Textiles
Edited by Ingrid Bachmann and Ruth Scheuing

Plague Years: A Life in Underground Movies
By Mike Hoolboom, edited by Steve Reinke

By the Skin of their Tongues: Artist Video Scripts
Edited by Steve Reinke and Nelson Henricks

Symbolization and its Discontents
By Jeanne Randolph

Theory Rules
Edited by Jody Berland, Will Straw, and
David Thomas
[SOLD OUT]

Mirror Machine: Video and Identity
Edited by Janine Marchessault

Decalog: YYZ 1979-1989
By Barbara Fischer

Psychoanalysis and Synchronized Swimming
By Jeanne Randolph
[SOLD OUT]

Struggles With The Image:
Essays in Art Criticism
By Philip Monk

THE CANADA COUNCIL | LE CONSEIL DES ARTS
FOR THE ARTS | DU CANADA
SINCE 1957 | DEPUIS 1957

Dedicated to our daughters Lara and Carmen & all of our performance art daughters

Contents

Acknowledgements

First we must thank the artists and writers who contributed so generously to this undertaking. Their support, encouragement, images and words, perceptions, and responses were a great source of inspiration to us throughout the course of the production of this book. Every image, every article is a testament to the rich and fascinating history of performance art in Canada.

There are of course many artists, women and men, who are not profiled here but who contributed to the zeitgeist from which the artists in this book were able to work. We hope that they will recognize themselves within.

Thank you to Clive Robertson for believing in us and encouraging us to take on this daunting task. The initial support for this book came from The Canada Council, Intermedia Officer, Yasmin Karim, who recognized the need for it. The proposal found a receptive ear in Melony Ward, then at YYZ. The YYZ board members, publishing committee, and managing editors, Dionne McAffee, Kerri Embrey, Sally McKay, and now Rob Labossière never wavered during the long gestation period. It is Sally McKay who must be credited with the fruition of this project which grew under her guidance. She worked with graceful diligence, heart, and panache. Iga Janik patiently combed the snarls out of the bibliography, and Bridget Indelicato oversaw the text. Several people generously provided help with images: Paul Petro, Suzy Lake,

Kim Tomczak, Tom Graff, Pari Nadimi, Rick Simon, and especially Richard Hill.

Thank you to Ron Shuebrook, President of the Ontario College of Art and Design and to Elizabeth Cowper, Chair of Humanities, University of Toronto at Scarborough for their institutions' support.

Special thanks also go to Zab (Elizabeth Hobart) for her splendid design.

We would also like to thank our pals in 7a*11d, past and present, for their belief in performance art, and George Manupelli for opening a door which we both walked through.

Most importantly we would like to thank all Canadian women performance artists who have laboured for so long in relative obscurity: we wrote this book to honour you.

JOHANNA HOUSEHOLDER: This anthology would never have come into being without Tanya Mars, and I am grateful to her for inviting me to join her in this project. She is remarkable in every way.

I would like to thank my art collaborators Frances Leeming, George Manupelli, John Oswald, Louise Garfield and Janice Hladki, Brenda Nielson, and b.h. Yael for their creative inspiration. I thank my friends Lisa Steele, Clive Robertson, Dot Tuer, and Ian Carr-Harris, for being role models. Thank you to my dear family of Householders, Pedaris, Warner, Hinmans, Stevens, and now a Carlson, for observing my performances from a gracious distance. I will always miss the steady support of my father, Sam. And to Angelo Pedari for his continued and continuous strength and good humour and Carmen Householder-Pedari, exploited though she may be, thank you from the bottom of my heart.

TANYA MARS: Johanna, thank you for being the left (or was it the right?) side of my brain; you were ever tenacious and perceptive. This book would not have been possible without you. I would like to thank my friend and art angel, Colin Campbell, for seeing me through the beginning stages and assuaging my doubt.

As always, I wish to thank the members of my family: my daughter, Lara, for being a constant source of sanity and stability, James for his calm resolve, and my grandsons Jacob, Joshua, and Jonathan who give me endless joy. I thank my friend Jan Peacock for her belief in the viability of this project, and my colleague Janis Hoogstraten for picking up the slack at the college when my focus wandered. I would also like to thank my friends and fellow travellers Paul Ledoux, Rina Fraticelli, Bob White, Ann Dean, Susan Hoover, and Odette Oliver for a lifetime of unconditional love and creative support. Lastly, thanks to Ray Avendt for showing me that the glass can be half full and for bearing the brunt of my angst.

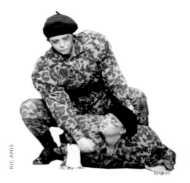

JOHANNA HOUSEHOLDER and **TANYA MARS** in *Nine Lives* by Tanya Mars and Odette Oliver, DanceWorks 30, The Brigantine Room, Toronto, April 1983

RIC AMIS

The idea for this book came nearly a decade ago. One night at Jan Peacock's house, after a long day teaching at the Nova Scotia College of Art and Design in Halifax, she and I were bemoaning the lack of Canadian representation in the NSCAD slide library. I was particularly distressed at how few slides there were on Canadian performance artists and how even fewer were on the work of Canadian women artists. There were only three Canadian books. Inevitably, this dearth of resources biased the teaching of performance art. It occurred to me that I was teaching myself right out of history, which was ironic given that I had been actively engaged in both the feminist and artist-run movements of the 70s and 80s, doing my utmost to ensure that women artists were not omitted from that history. As artists women were addressing the lack of representation, but as teachers it was clear that we had been lax.

I asked myself, why, despite Canada's very rich contemporary art activity, were our images absent from the existing literature? We were prolific, our work was strong, we were vocal. Where were we?

I decided that it was time to fill the void. The concept of self-determination that had fueled my resolve to be a woman artist in a male-dominated arena, would now fuel my passion to give Canadian women artists the attention and profile they deserve.

It became clear that others shared my frustration with the lack of resources on Canadian artists. It became clear that writing a book would be an enormous undertaking, and that I did not want to do it alone.

My performance art doppleganger, Johanna Householder, enthusiastically embraced the idea of putting together an anthology about Canadian women performance artists. Together we spent the next few years interviewing artists, doing research and shaping the book.

We had to make difficult choices. We could not effectively tell the entire history in one book. Given that this would be the first book of its kind in Canada, we decided to focus on the 70s and 80s; that time when women made a significant impact on the contemporary art scene. We also wanted to place Canadian performance by women within a broader art historical context, and to address the fact that feminism and women's work had profoundly affected the art discourse that emerged in the alternative scene.

In order to establish a solid critical position for the work, the book begins with several articles that provide context, looking at performance art from different perspectives. The articles are followed by a series of thirty-four profiles that focus attention on each individual artist and her unique body of work. We invited writers (some of whom are also performance artists) who already had a keen interest in and an intimate knowledge of performance.

What has been assembled is a dense pastiche of performance activity that spans 30 years representing many artists from across Canada. Diverse aesthetics, politics, and motivations are reflected here; work that covers the gamut from the exquisite to the extreme. We have focused on artists who had established practices prior to 1990 and tried to select those who have had a sustained practice in, or left an indelible mark upon, the discipline. Nevertheless, regrettably, there are omissions.

This book is timely. Pioneering women performance artists are not getting any younger, and the history of the medium lives predominantly as memory. Because of its ephemeral nature and the fragility of its documentation, not to mention the fragility of memory and the tendency to revise history, we felt it was imperative that the history be recorded before it is lost.

I see this as the first of many books, as women artists continue to make remarkable contributions to the ever-burgeoning field of performance art.

TANYA MARS

Johanna Householder

ap·o·lo·gi·a

n, a formal, usually written, defense or justification of a belief, theory, or policy.[1]

Thirty years ago, ravening women roamed the Canadian wilderness, singly and in packs, searching for new means of expression. They were starving and naïve, willing to try anything to satiate the unnatural desire which had taken hold within them; they wanted to be represented on their own terms. They longed to find the images, sounds, and actions which would explode across the cities and prairies, scorching the eyeballs of all who beheld them; they sought the secret subtle art that would seep like a purifying gas through social structures and ways of being, to transform vision entirely.

Disguised in the innocent guile of dance or play they trained to kick their legs high enough to knock off the heads of those who weren't paying attention. Sometimes collectives were formed. They conducted grueling six-hour "meetings" in which every aspect of newness was ruthlessly examined for residue of the old ways. They fanned out across the provinces dressed in wild robes, wigs, aprons and bustiers; suspended from ropes, breathing fire, and chewing up the scenery.

By June 1979, Peggy Gale was able to write in the Introduction to *Performance by Artists*:

In both Europe and America there seemed to be significant numbers of performances by women, original in form, varied in content, and addressing

a broad range of issues. It seemed important to consider works by women in this context as offering a possible insight into the development of performance activity and rationale overall.[2]

Performance work by women had laid claim to the territory in a ten-year span that American performance art historian Moira Roth called *The Amazing Decade.*[3]

Performance art seeks to investigate existing conditions, includes human presence, and questions the purposes, processes, apprehension, and experience of art; while making it. So though it is a vanguard practice, in the sense of exploring the necessary conditions of its own existence, it is simultaneously fundamental in its devotion to process. Without performance there would be no painting, no video, no Cindy Sherman, no looking. It is my argument that performance art is not only an essential practice but that it is *the* essential practice of late 20th / early 21st century art; an art form from which, today, all other arts subtend. This belief may draw heat from all sides, especially from those for whom live performance is a "creative anachronism"[4] made quaint by our increasingly televisual existences. However, it's my observation that the body is not *quite* obsolete and performance art presses this point home. As Dot Tuer observed in 1987, performance "renders visible the politics of representation as a struggle over the control of real bodies in time and space."[5]

The importance of performance and the performance art action has been gradually but steadily increasing throughout this century, in retrospect almost inexorably. Even ten years ago, no one within the contemporary art world or without it would have predicted the ascendancy of this/these practice(s), in alternative venues and in the eye of the mainstream, now it would appear that the signs have been there all along.

I do not want to fall into a trap of tracing historical antecedents — from Cthonic rites to Bauhaus pageants — of which practitioners at the time were completely unaware, or if aware saw no link to their own investigations. I take the anti-historical position that I believe most of my contemporary female counterparts took: that performance art was an expedient, almost involuntary, political positioning for artists who had little interest in creating work within the confines of pre-existing genres, media, or mechanisms for production and distribution. I understand that *political* is a heavily freighted term. A certain amount of joy was also involved.

po·lit·i·cal *adj*

1. relating to politics, especially party politics
2. relating to civil administration or government
3. arising from somebody's voiced opposition to a government or from voiced support for policies and principles regarded by authorities as unacceptable
4. carried out for reasons that best serve a desired outcome rather than for reasons that are, for example, morally justifiable.[6]

Reasons that best serve a desired outcome rather than morally justifiable reasons. And what was that desired outcome of performance art by women, if not a simple desire for attention? Of course attention, like all simple

1 *Encarta® World English Dictionary* (Microsoft Corporation, 1999). Developed for Microsoft by Bloomsbury Publishing Plc.

2 A A Bronson and Peggy Gale, eds., *Performance by Artists* (Toronto: Art Metropole, 1979).

3 Moira Roth, *The Amazing Decade: Women and Performance Art in America, 1970-1980* (Los Angeles: AstroArtz, 1983).

4 Philip Auslander, *Liveness: performance in a mediatized culture* (New York and London: Routledge, 1999).

5 Dot Tuer, "Gestures in the Looking Glass" *C Magazine* (1986).

6 *Encarta® World English Dictionary.*

desires, is complicated. Attention itself is highly problematic and uncontrollable, something that we now know well, but that wasn't necessarily a consideration for the early performance practitioners we are celebrating with this book. In one respect these were short-sighted women. Women who had no idea that they were jeopardizing any hope they might have of an art career for the morally unjustifiable reason that it was more important to be seen and heard, than to be "serious." In the 1970s and 80s, when performance art was more likely to be defined by what it was not, than what it was, they claimed authenticity *and* the limelight; the attention they sought to exploit was personal and collective; not collectible.

Women and Canada are also defined by what they are not

An argument for a women's history as qualitatively and quantitatively distinct from a history of art in general (and which might include more than two genders) stands in opposition to the assertion that binary gendering occludes interesting work being done by both men and women.[7] The different history for women is that performance art (and to some extent the equally uncharted territories of video art and postmodern dance) were fields that women artists occupied unbeholden to entrenched history. There was a sense in which the door was opened at the moment she walked through it. Most importantly, women artists were obliged at that moment to make work with the consciousness of being women. Sometimes the framework for that consciousness was feminism but sometimes it was not. Women excelled in these vague arts in a way that they had not excelled "differently" since home crafts like quilting and needlework were excluded from consideration as fine art. As Martha Wilson wrote in 1979:

> People can express themselves now in ways they never thought were possible. So women are good at that if that's what good means. The reason they're good is that they've been released from the format. They can go into territories now like impersonating other people … a territory that painting couldn't go into because it wasn't within the limits of those two-dimensional issues. But when you get into performance and you have a set of social issues, there's all this other stuff that becomes a part of the piece.[8]

While the performance works by Oppenheim, Acconci, and Burden did not receive *more* than their fair share of recognition and analysis; the work by women that paralleled theirs never achieved the same kind of acceptance and tip of the tongue recognition. Hannah Wilke can never catch up to her contemporaries on the fame scale. Ana Mendieta may never fetch the prices that Carl Andre does. And Carolee Schneemann will be justifiably bitter about it all. Without a doubt, even the earliest performance work was reported, received, catalogued, and historicized by gender. And our own, our Canadian women performance artists? Well, read on …

Canada is not coherent

In Canada, spaces of performance were local phenomena which were sometimes internationally aware but had the occasional national blind spot. Similar

7 Barbara Fischer, *Love Gasoline* (Toronto: Mercer Union, 1996).

8 *Performance by Artists*, p.240

9 Alvin Balkind, "Body-Snatching: Performance Art in Vancouver A View of Its History," *Living Art Vancouver* (Vancouver: Western Front/Pumps/Video Inn, 1980).

ROBIN COLLYER

threads taken up in different cities, played out differently. The importance of Tangente in Montreal and the developments by movement-trained artists were paralleled by 15 Dance Lab in Toronto. Tangente the space, and Dena Davida, its founder, supported the performance edge of dance with interdisciplinary programming like *Choréographies d'artistes visuels* (1982) in which performance artists were able to find venues for work that was not supported in the gallery context. Conversely, performance art offered an audience for "independent choreographers" who were not interested in pursuing the dance company hierarchy. The artists of Tangente however, remained firmly within the dance idiom.

The experiments in interdisciplinarity and pushing out the borders sometimes had a greater impact on the theatre or new music of a locale. While in Québec the first discipline specific performance festival was in 1974; in Toronto the first international festival was not until 1997. In Halifax, Popular Projects operated a visible politic, in Vancouver the visible lampooned the political:

History doesn't begin or end anywhere, genesis and the Apocalypse notwithstanding. If we choose to examine a microdot of it, we must dangle our toes where the water seems warmest.[9]

LISA STEELE as Mrs. Pauly, at The Body Politic rally, Toronto, 1979

Alvin Balkind chose to dangle his toe in 1959, the year that Marshall McLuhan visited Vancouver and turned the tap on for a sequence of events, people and phenomena which carried the stream of ideas around intermedia to coalesce in Performance Art in 1979.

Writing 25 years later, I choose to direct attention to the pool of events around 1979, as a source from which this anthology of personal histories flows. One such event was the *Living Art Performance Festival* in Vancouver in September 1979. In Toronto there was the *Tele-Performance Festival* in 1978. *Hors Jeux* at the Musée d'art contemporain in Montréal was preceded by the *Festival de Performance au MBAM* (1978), and followed by the conference, *Multidisciplinary Aspects of Performance: Postmodernism* in 1980, which produced a key document of its proceedings.[10]

It was a time when there was a density of reflection upon the subject of performance and related attempts to corral and define the disparate, anarchic and, dare I say narcissistic actions of dozens of artists in order to bestow disciplinary status upon them/it/us. What the above list also says to me is that though performance art is predominantly local, messy and argumentative its histories have been formed in an attempt to link the locals with big theory. The attempt to summarize, however seems to have been short-lived and perhaps premature.

Absence as history

When I began teaching Intermedia Performance at the Ontario College of Art ten years later, performance art had almost fallen off the screen in terms of its newsworthiness, or the record of its production in the books, magazines and conference proceedings published during the mid to late 80s. In Canada, it seemed that performance art had been wrapped up and defined by the small handful of books such as *Performance by Artists* (1979) and *Performance Text(e)s & Documents*, (1981) both of which were intent upon setting Canadian practices within an international context. Though this book owes a great debt to both of these, it is clear that attention had shifted to American, and in Québec to European, artists and that the Canadian women whose practices had been identified at that moment as fulfilling the criteria of Performance Artist were few (Gathie Falk, Lisa Steele and Elizabeth Chitty were featured in both.) In his essay, *The Function of Performance in Postmodern Culture: A Critique*, in *Performance Text(e)s & Documents*, Bruce Barber diagnosed performance as, if not dead, dysfunctional. I believe he identified this period as dysfunctional because performance did not appear to be fulfilling its earlier promise to liberate artistic expression from social controls. It seemed to have retreated to a secure distance from its audience, straying into the theoretically unforgivable territory of "spectacle."

Nevertheless, throughout the 80s women did not retreat, they continued to exhibit themselves. Why they did this remains to be uncovered in the writings in this book. Their motives were as varied as their actions. And the function of their actions remains an open question. As artists, they shouldered the burden of blame for their "dysfunction" with panache, and carried

10 Alain Martin-Richard, "Action Art in Québec: Private Body and Public Body." in R. Martel ed., *Art Action 1958—1998* (Québec: Éditions Interventions, 2001), p. 320

11 Chantal Pontbriand, *Three in Performance* (Saskatoon: Mendel Art Gallery, 1983).

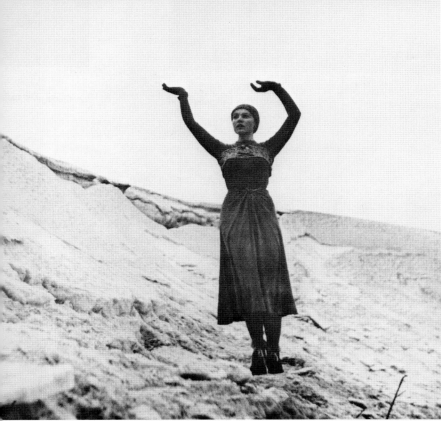

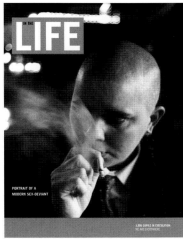

on. It was a critical struggle for content, and for experiment, versus theory. With apologies to Barthes, it was a lacuna of the "now that the author is a woman, it turns out the author is dead" variety. And so it falls to this book to promote the ideas in performance art as practiced by some women in Canada, and to defend its functionlessness, while justifying my belief in the importance of performance as a lens through which all contemporary art might be examined. Or as Chantal Pontbriand described it, "an attitude present at the core of contemporary art."[11]

FRANÇOISE SULLIVAN *Danse dans la neige*, 1948. Collection Musée d'art contemporain, Montréal

SHAWNA DEMPSEY & LORRI MILLAN *In the Life* cover, 1995

Evil genies

Performance criticism has long suffered from the inadequacy of definition or its undecidability; as Johanne Lamoureux worried in 1981:

How can we explain this sudden "authority" of the performer on performance, compared to that of the painter on painting? ... Do critics tend to quote performers about performance because they naively believe performance to be about performers?

There is some evidence that the performer-critics are engaged in a process of creating an illusion of authenticity. They often mingle autobiographical fragments and public information with fiction or "borrowed"

confidences as though they are creating imaginary archives. The viewer almost becomes like the exorcist, trying to name, to identify the "evil" genie speaking through someone possessed. Performers have blurred the frontier between truth and falsehood. They have become sophisticated manipulators of documents, seduced by their distorting effect and value more than by their veracity or testimonial value.[12]

To define a field is a conservative and exclusionary undertaking. Though it is now possible for us to look back and say "oh yes, she was doing the same thing there" in a way that wasn't possible in 1981; many of the women included in this book were initially (perhaps still are) uncertain if they desired the designation of performance artist. And so we have invited "performer-critics" to contribute their own embodied knowledge of the blurry frontier. This book does not attempt to exorcize the demon of performance art nor does it seek to give a comprehensive history. Instead we wish to supply the actions and images in the individual ways in which they first emerged.

There were/are women who are not represented or are under-represented in this book, who were engaged in all kinds of what we now can call *performative practices*. There were women in many contexts and communities, devising ways to make more meaning, and they brought the performed self into theatre, and poetry, and music, and stand-up comedy. They were performing the body and asserting the other self in clubs, church halls and community centres. Women who were acting out, especially a longing for home or a sense of dislocation. Of these many women, in this book we have focused on those who were engaging with the art idea. There were countless other forms of expression — painting a wall, choreographing a demo, making a skit, costuming a street action — by which women physicalized themselves and embodied their concerns.

We took up this project because this book showed no signs of coming into existence on its own. Its faults are apparent. Sections overlap and intersect as people do; ideas criss-cross the country. The importance of collaborative practices is evident here too. This impulse toward collaboration among artists or with audiences may be a distinguishing characteristic of performance, but it also brings forward the collaboration disguised in all art practices, in teaching, and in writing about each other's work. The legacy of the women in this book is very much in evidence on the streets and in the art venues of the country. There is a next generation of performance artists who are completely convinced that their medium is alive and well, that their bodily incursions into public space or technological space or intimate space are important, relevant and critically respectable. The audiences of each performance may be small, but combined, the women in this book have made themselves and the performance project visible for thousands of people.

In 1970, Françoise Sullivan performed a walk between the Musée d'art contemporain and the Musée des beaux-arts de Montréal documenting her progress by taking a photograph at every intersection — until she was stopped by the police for trespassing on a public thoroughfare.[13]

Thirty-five years later the texts and photographs in this book document a history of women performance artists who were (and continue to be) unstoppable.

KATE CRAIG and **HANK BULL** *World Shadows.* Photo taken at Grenada Gazelle's house, Toronto, 1981

LILLIAN ALLEN in *Bronco's Kiss* by Tanya Mars, A Space, Trinity Bellwoods Park, Toronto, 1996

REBECCA BELMORE *Ayum ee-aawach Oomama-mowan (Speaking to their Mother)* PM's rez on Sussex, Ottawa, ON, 1996. The event took place on June 21, which is officially First Nations Day

12 Johanne Lamoureux, "On coverage: performance, seduction, flatness" *artscanada* (March/April, 1981).

13 Conversation with Françoise Sullivan, Johanna Householder and Tanya Mars (July, 2004).

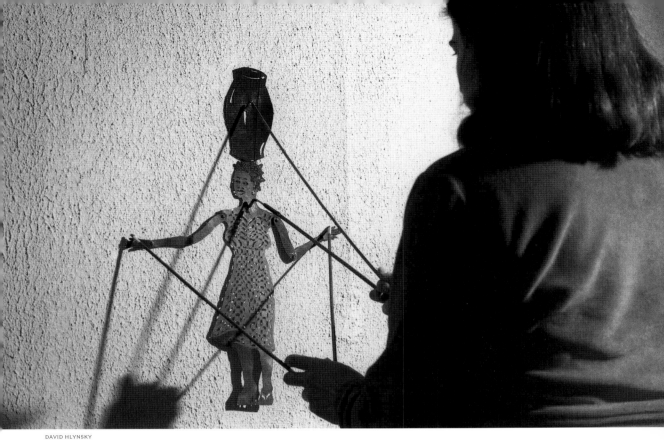

DAVID HLYNSKY

DAVID HLYNSKY

MICHAEL BEYNON

Tanya Mars

Not Just for Laughs

WOMEN, PERFORMANCE, AND HUMOUR

Life is too important to be taken seriously.
— OSCAR WILDE

Women who use humor are women who use power.[1]

 After a close examination of the existing literature on performance art, it is remarkable to see how much emphasis has been placed on the grim, the intense, and the masochistic. Indeed, performance audiences have come to expect to be shocked, to witness artists being covered with bodily fluids, pierced, hung, confined, and/or mutilated. Transgressive, taboo expression gets the lion's share of attention from both the press and the academy, and fuels both the curiosity and outrage of the public.

 The media loves to report incidents of outrageous behaviour, whether reality or myth, in an attempt to create controversy while capitalizing on the public's fascination with the extreme. Extreme performance art that has reached the public consciousness, from Chris Burden's *Shoot Piece* onward, is what has come to be known as performance art.[2]

 Transgressive performance art has a deeply rooted place in the canon of body art and performance art history, as exemplified by the work of such artists as Gina Pane, Marina Abramović, Istvan Kantor, Vito Acconci, Hermann Nitsch, and others. These artists have chosen to address political and social issues from what Kathy O'Dell describes as a masochistic position; a somewhat controlled masochism that uses the willingness to harm one's

own body as a vehicle for artistic metaphor or symbolism.[3] Performance artists of the 70s felt it was important to eschew formulaic and established performer/audience relationships and to push the limits of the body to extremes. Further, performance art and body art of the time was against entertainment, against the theatrical, and against the narrative. It was without humour.

The images of women's performances from the 70s, in particular, which have received the most attention in art history are those of women stuffed, bound, and naked. One cannot deny the power of these images. Ana Mendieta's raped and bloodied body, Adrian Piper's stuffed mouth, Angelika Festa's bound body, or Gina Pane's scarred body are images that still have the potential to provoke strong reactions. O'Dell states that:

The concerns of typical masochistic performance include the mechanics of alienation in art and everyday life; the psychological influences of the domestic site on art and everyday life; the sensation of being both human subject and an object; the function of metaphor in art; and especially, the relationship between artist and audience.[4]

In addition, I would argue that these alienating representations are reminders of the consistently low status of women in society. What extreme body art performance emphasizes is detachment and alienation, creating a distance between performer and spectator; there is both fascination with and resistance to an unpleasant image. Audiences avert their gaze from the image before them of women's subjugation; dismissing the image as a grotesque spectacle or kitschy horror-movie cliché. There are those who contend that masochistic body-based performance work is a true test of our human capacity to withstand and express physical and emotional extremes; that it is the only true performance art; and that anything else is mere representation, and therefore, just theatre, which is despised. Is the representation of the violent or the tragic the only serious territory for performance art? Is this kind of work effective at resolving feminist issues or is it a reinforcement of victimization?

There is the belief in theories of trauma that to "name" something (to express it or act it out) is to know it, to claim it; and only then can one begin to "heal" it or change it. This is borne out through feminist art from the 70s and 80s in which artists actively incorporated the feminist motto that the "personal was political." Frequently in early feminist work, personal testaments to various kinds of social and sexual trauma were played out publicly in a variety of ways. In the context of a public politics, this work was important. However, I think that the danger inherent in the proliferation of masochistic images is that they proffer a culture of victimization. I wonder if they are implicitly more conservative despite their "extreme" look, relying on a reactionary response from the viewer, rather than a contemplative one. These images play into sensationalism and tabloid sensibility — relying on graphic representations of the disturbing, or the troubling, which reinforce the idea that the rightful position of women in society/culture is as victim. While I do believe that naming was a useful step to address feminist issues, I see it as

1 Regina Barreca, *They Used to Call Me Snow White … but I Drifted: Women's Strategic Use of Humor* (New York: Penguin Books, 1991).

2 I find it fascinating that these sensationalist performances have received scorn from the public (and some art historians). I think they are uncannily prescient as we see the advent of popular reality television shows like *Fear Factor* and *Extreme Sports* that depend on the public's willingness to dance with danger in order to attain money and/or fame.

3 Kathy O'Dell, *Contract with the Skin: Masochism, Performance Art and the 1970s* (Minneapolis/London: University of Minnesota Press, 1998), 4.

4 Ibid., 2.

just that, a first step. I would argue that the ability to laugh at something allows you to finally demonstrate your control over it.[5]

Is the legacy of performance art as austere body art — a medium that canonizes self-inflicted pain — so all encompassing that there is no room for other strategies? Where are the strong, positive, celebratory images of women in performance art history?[6] I do not intend to disavow the extreme work wholesale; rather, I hope to demonstrate how humour is as serious a performance strategy, and that those artists who employed it in the 70s and early 80s were not held in as high esteem as those who performed trauma.

Tragedy holds a lofty position in art. It is the accepted form for the expression and resolution of the plight of humanity. Comedy, on the other hand, is considered a lesser form of art; it is entertainment: easy, light, and escapist. Comedy is felt to deal with less serious issues, or to deal with important issues less seriously. In fact, Freud proposes that: "Humor is not resigned; it is rebellious. It signifies not only the triumph of the ego but also of the pleasure principle ..."[7] and Barecca supports this position by asserting that, "The witty person in a group is among the most powerful members of the group; that the strategic use of humor is one of the identifying factors of the so-called natural leaders."[8]

The central question to me is: Why is humour diminished in artistic circles, when in "... most societies, the humorist adopts a position of superiority ... of truth telling"?[9] And why are women performance artists who use humour in their work perceived to be entertainers rather than artists, while the women who engage in alienating or masochistic work are considered serious artists? I would argue that this attitude toward women using humour in their work is not significantly different from how women are generally perceived, that is, that what women think and do and produce is frivolous, and ultimately unimportant. Not only are women considered to be poor comics, but they, particularly feminists, are often accused of not being able to take a joke.

Q: How many feminists does it take to screw in a light bulb?

A: One. And it's not funny.

Woman's inferior status as humorist was given credence by Freud's notion that women produce fewer and less effective jokes than men because they have a less complex superego structure.[10] Walker, however, argues against Freud's position, that male comics are considered funnier by both men and women, and that this argument is based on differences in culturally determined gender roles rather than the relative strength of the superego.[11]

While most women performance artists in the US and Europe were engaged in humourless works, many Canadian women performance artists were doing something different. In Canada, there is a strong legacy of the comic in both popular culture (Mary Walsh and Cathy Jones) and the avant-garde (Sheila Gostick, Diane Flacks, Marcia Canon, Gwendolyn) perhaps because Canadians find themselves culturally positioned (squeezed) between American and European culture. In the performance art arena, artists such as The Clichettes, Colette Urban, Anna Banana, Tanya Mars,

5 Barrecca, 169.

6 While I would say that the predominance of 70s work in the US by women fell into either the mashochistic body art category or the praising of the goddess category, there were a few who embraced humour: Lynda Benglis' 1974 *Art Forum Ad* will go down in the annals of art as one of the most outrageous images to be created by a woman artist. Pat Olesko's costumes created a wide range of personae that were both funny and ironic, Hannah Wilke's *SuperTart* series was a strong parody, and Linda Montano's *Chicken Woman* and *Disband* also provided laughs.

7 Sigmund Freud, *Jokes and their Relation to the Unconscious* (London: Penguin Books, 1991. First published in English 1916).

8 Barrecca, 113.

9 Nancy A. Walker, *A Very Serious Thing: Women's Humor and American Culture* (Minneapolis: University of Minnesota Press, 1988), 25.

10 Barrecca, 89.

11 Walker, 84.

12 Susanne K. Langer, *Feeling and Form* (New York: Charles Scribner's Sons, 1953), 338.

13 Barrecca, 142.

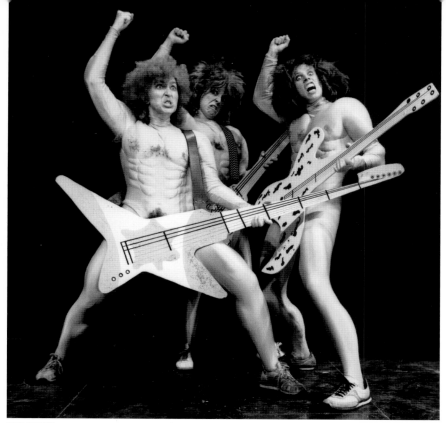

DAVID HLYNSKY

Frances Leeming, Shawna Dempsey, Lorri Millan, Margaret Dragu, and The Hummer Sisters have consistently used humour in their practices: irony, political satire, or parody, in both text-driven narratives and complex imagistic performances.

In defense of humour, Suzanne Langer outlines for us how comedy effectively uses basic human feelings that allow us to deal with alienation, danger, and the unexpected in a comic rather than a tragic light. According to Langer, "Humor has its place in all the arts … comedy may be frivolous, farcical, ribald, ludicrous to any degree, and still be true art. Laughter springs from its very structure."[12] It is well-accepted common knowledge that laughter plays a significant role with regard to coping with stress. "Sociologists have found that laughing together creates and reinforces a sense of solidarity and intimacy within a group."[13]

Shawna Dempsey and Lorri Millan use humour precisely in this way. Feminist, outrageous, and outspoken, *We're Talking Vulva* epitomizes biting, raucous humour that fuels a feminist crowd to unbridled laughter. Backed by a band, Dempsey, dressed in a bigger than life-sized vulva costume, raps out a wacky set of dos and don'ts when it comes to pleasuring that place "down there." *We're Talking Vulva* was enormously popular with women's

THE CLICHETTES Louise Garfield, Johanna Householder, Janice Hladki perform "Go to Hell" by Motorhead, 1985

audiences, garnering solidarity between gay and straight women. Some humour does not translate from one group to another; however, Dempsey & Millan make it easy for all women, straight or gay, to laugh together, to identify their common ground, and to bond:

Is a woman without a body still a woman? Without a body does a woman in fact exist? I know from experience that without a body, it's difficult to get around ... without a body you're at the mercy of some guy with a sack. Frightening thought isn't it? Not very 90s.[14]

In *Mary Medusa* and *The Thin Skin of Normal*, Dempsey & Millan at once attack the status quo and the patriarchy. Their highly crafted scripts use a self-deprecatory strategy to attack the establishment. This self-deprecation is ingratiating rather than aggressive, it allows the speaker to participate in the process without alienating the members of the majority:[15]

I manage one of the country's fastest growing defense firms. Sometimes by the end of the day international trade deals, the end of the cold war, and pesky peaceniks can leave me with a real headache. So when I get home, the last thing I need to worry about is why my whites aren't whiter. It's always something, isn't it? You get your MBA, and you claw your way to the top. You can put up with the sexual harassment, the lower salary, having to do your job twice as well as your fellow man, so what really burns your butt is that no one can invent a hairspray that really holds. I mean where is the control that they promised me? I guess you get what you pay for.[16]

Cheerleaders for the disenfranchised, Dempsey & Millan create solidarity by bringing the enemy down to size:

2000 years of patriarchy haven't dampened my sense of style. When I get dressed in the morning, I'm doing more than covering a little original sin. I'm making a statement, I'm getting to the point about fashion and philosophy, feminism, and form and how they intersect or cross my body. How layers and layers of theory and criticism contrast beautifully to the sharp reality of personal and collective experience. Oh, I know it is a difficult look to pull off. It is considered so unfashionable these days. But it is, if I may say, so me. It's got moxie, it's got bite. It could be described as aggressively feminine.[17]

Dempsey & Millan write narratives about the trials and tribulations of real life: the growing pains, the epiphanies, the disappointments. Their quick-witted stories vividly describe female experiences that make us weep with laughter. They epitomize what Langer refers to as human life-feeling:

This human life-feeling is the essence of comedy. It is at once religious and ribald, knowing and defiant, social and freakishly individual. The illusion of life which the comic poet creates is the oncoming future fraught with dangers and opportunities, that is, with physical or social events occurring by chance and building up the coincidences with which individuals cope according to their lives. This ineluctable future — ineluctable because its countless factors are beyond human knowledge and control — is Fortune. Destiny in the guise of Fortune is the fabric of comedy; it is developed by comic action, which is the upset and recovery of the protagonist's equilibrium, his contest with the world and his triumph by wit, luck, personal power, or even

14 Shawna Dempsey & Lorri Millan, *Mary Medusa*, script excerpt.

15 Barreca, 24.

16 Shawna Dempsey & Lorri Millan, *Mary Medusa*, script excerpt.

17 Shawna Dempsey & Lorri Millan, *The Thin Skin of Normal*, script excerpt.

18 Langer, 331.

19 Shawna Dempsey & Lorri Millan, *The Thin Skin of Normal*, script excerpt.

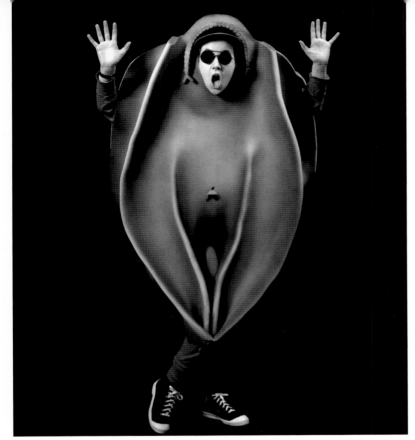

SHEILA SPENCE

humorous, or ironical, or philosophical acceptance of mischance.[18]

Dempsey & Millan elaborate upon this comic destiny:

We have this gender tyranny, in language and in thought, this blinding binary that divides the world into this or that, his or hers, that now we are being asked to reclaim. Find the balance. Embrace the male and the female. Let them come together in perfect harmony, let them stand holding hands as equals in your soul. What is this retro-hetero mumbo-jumbo? It's like having boy-girl foreplay in your psyche. And since when do men and women stand together as equals anywhere, why should my soul be any different? If we really wanted to talk about masculine and feminine characteristics, then dollars to donuts my masculine side would be telling my feminine side to lose ten pounds. Who needs that? To be populated by one's masculine self, one's feminine self, one's child within — it becomes conceptually crowded.[19]

But Dempsey & Millan's humour goes far beyond the typical stereotyping of male/female dichotomies. Their piercing look at women as the object/ subject of desire for women offers audiences a sexy, yet candid, take on the inevitable pitfalls and intricacies of love in the fast lesbian lane:

I want you to want me. I want you to want me even though I don't really want you. I don't want you at all. But I want everyone else to. I want everyone

SHAWNA DEMPSEY & LORRI MILLAN
We're Talking Vulva. First performed by Shawna Dempsey, 1986

else to want you. But I don't want you to want anyone else but me. All I want is your want. I want you to need me and to cry for me and to suffer for me. I want to be your chocolate cake, your hot water bottle, your saviour, as long as it doesn't take too much of my time. As long as I can say thanks, but no thanks. And you'll still love me and want me forever. And I will be beautiful forever. And will live forever and ever in your broken heart. While I remain perfectly intact, wanted.[20]

Two beats, fade to black. As the lights come up, we hear this hot, graphic barrage:

I want to fuck you. I want to fuck you until you can't come anymore. I want to run my hands down your body, squeezing your nipples between my fingers as I bite your neck, my tongue in your ear, your mouth, going down, down, down your belly, your thigh. I want you. My face parting your lips, biting clit as my fingers curl inside of you turning, scratching, reaching, then behind you, your legs beneath me, my tongue in and out yes I want you. On my face, dripping into my mouth, hair tickling up and down, I'm fucking you on the floor, on the bed, kneeling, with my face, my fists, my hands, my feet, again and again until you can't come anymore. I want to fuck you. I want you.[21]

The ability of the performer to laugh at herself, extends outwardly into the community at large, giving female audiences a chance to identify openly with the performer — she is up there pouring out her deepest, darkest secrets, unafraid. Audiences can in turn laugh with the performer and each other, and take comfort in the knowledge that they are not alone. Dempsey & Millan give savage voice to women and women's sexuality. Fearless and unabashed, they tackle big identity issues, and none more poignantly than the self-realization of a young girl's sexual orientation in *Growing Up Suite*. Here Dempsey & Millan deliver the real goods:

... In 1968 in Scarborough, it was all I had. In 1968 in Scarborough I was five. I hadn't heard of erotica or porn. I didn't know those words, and though I know them now, I don't know the difference between the meaning of the two. I just know what turns me on. Girls. Though what turned me on then, in 1968 in Scarborough was the Eaton's catalogue, ten pages of ladies wearing lingerie that resembled architecture, covered in buckles and zippers and snaps. Industrial strength underwear concealing body parts that I didn't have. Body parts so powerful they needed hardware to keep them in place. I didn't know the word lesbian. Lesbianism wasn't very fashionable in Scarborough, *lezzy* was a dirty word. And though my thoughts were dirty, they were not without love. The first love of my life being winter, page 117. I didn't know if I wanted to be her staring off into middle distance so beautiful and calm or if I wanted to be her undoing. The one to take the straps down from her shoulders, the row of hooks from their eyes, the teeth of the zipper unfurling. I just knew that I wanted her, winter, page 117, in 1968 in Scarborough, my small chubby hands touching the pages of the Eaton's catalogue. Not knowing what I would do with her, but knowing that she so undressed would have an idea or two. And eventually in another fifteen years or so maybe we would figure it out.[22]

20 Shawna Dempsey & Lorri Millan, *Object/Subject of Desire*, script excerpt.

21 Ibid.

22 Shawna Dempsey & Lorri Millan, *Growing Up Suite*, script excerpt.

23 Barreca, 46.

24 Ibid., 4.

25 The term "mock-male" was originated by The Clichettes and Marni Jackson in *She-Devils of Niagara* (1985).

26 Clive Robertson, "The Compleat Clichettes," *Fuse* Magazine (Dec./Jan., 1986), 13.

27 Ibid., 14.

28 Barreca, 28.

29 Ibid., 112.

30 Robertson, 14.

Whether using tragic or comic approaches to their material, women performance artists are unilaterally the Bad Girls of the art scene because Bad Girls say what they think. They not only make fun of themselves, but also send up the self-important, precious attitude of the community at large. They challenge the status quo. While Good Girls don't "swear, sweat, succumb, or satirize,"[23] Bad Girls are ever ready to tell it like it is. According to Barreca:

The image of the Good Girl was a product developed in conspiracy among parents, the media, and advertising with support from the church, educational, and economic institutions. Good Girls didn't make trouble for anybody. They did what they were told ... Good Girls did not draw attention to themselves or their ideas.[24]

Drawing attention to themselves with panache, The Clichettes were the quintessential Bad Girls of Canadian performance of the 70s. The trio, Louise Garfield, Johanna Householder, and Janice Hladki, deemed "dangerously and aggressively funny" by *Fuse* magazine's Clive Robertson, successfully straddled the line between pointed political commentary and entertainment. More than a nostalgia act, The Clichettes wowed audiences with their unparalleled wit, parodying the clichéd emotions of girl groups of the 60s and 70s. The Clichettes blended choreography, pop music iconography, and elaborate costume into scathing and accessible feminist satire. At their most mischievous, they did a series of lip-sync versions of male songs, assuming "mock-male"[25] personae. With bravado and machismo, The Clichettes "hit hard at patriarchal puffery, jock swaggering, and the god-given rights of heterosexual males."[26] Their version of Paul Anka's "Having My Baby," which segued into the Four Season's "Walk Like a Man," created images that brilliantly undermined patriarchy.

In "Having My Baby," the trio, dressed in cheap suits and male wigs, leaves the stage to cruise the audience. As women dressed as men, they look at the male members of the audience with knowing nods and winks, and an irony that beats you over the head. Pinned into the lining of their jackets are the chorus lyrics that they reveal on cue: "I'm a woman in love and I love what it's doing to me."[27] This kind of funny, direct confrontation disarmed both male and female audience members all the while subversively attacking the patriarchy and the lunacy of the prescribed roles outlined for women. As Barreca points out: "Women's humor has a particular interest in challenging the most formidable structures, because they keep them from positions of power."[28] The Clichettes irreverently eschew the powers that be, challenging the men in the audience to laugh at themselves, providing a bonding experience for the women, who recognize that "laughter implies a community of shared values."[29]

In The Clichettes's version of Motorhead's "Go To Hell," the three mock-males bound onstage wearing anatomically correct male body suits, brandishing cardboard guitars, and exhibiting all sorts of male-bonding physicality: tongue wagging, pelvic thrusting, butt rubbing in "true feigned heavy metal rock n' roll ecstasy."[30] With gritted teeth, heads banging, at the

grand finale, all three gleefully rip their private parts from their groins and hold them up as trophies for all to see. The audience goes wild.

In *Out for Blood*, a full-length theatrical production, The Clichettes portray a cast of female characters who are out for revenge. Some mythical, some real, these women come together to avenge themselves of patriarchal wrongdoings. In the prologue to the performance, Bernardine Dohrn of the Weatherman Underground interrogates a reporter:

> Did you get all of that? Did you get all the stuff about the Days of Rage and about urban guerrilla warfare and what has to be done now — by any means necessary? Are you listening to me?! Don't look at my legs, asshole, or I'll wrap them around your neck and twist your head off! You take my story, my history, and you write it up good. Honky Amerika is going to have to wake up to a nightmare. To ... me. [31]

Goddesses, political activists, and failed Hollywood actresses all ultimately become enraged and resort to feminism. Girl actress Patty McCormack, the Baddest of the Bad Girls, best known for her definitive performance as Rhoda, the young murderess, in the movie *The Bad Seed*, sums up their position nicely:

> I'm a feminist. I think that women are smarter, stronger, and more beautiful than men and that they should rule the world and have all the men be their slaves. I would have all the boys at school be my slaves and bring me presents. I love nice things. You know, if you were really powerful you could have all the nice things you wanted. You could just take them... Or people would give them to you because they liked you. Do you like me? I like you. Could I have your watch? [32]

And finally, Medusa and Athene go head-to-head over fraternizing with the enemy:

> Medusa and Athene stand, holding the spear.
>
> ATHENE: You have betrayed me.
>
> MEDUSA: I had no idea you and Poseidon were lovers.
>
> ATHENE: Sex is not the issue here, Medusa. Power is the issue, and you've just given it all away. [33]

According to Barreca:

> "Bad" can refer to more than toughness, smartness, or even sexual awareness ... [it] can mean anything unfeminine: messy, clumsy, loud, opinionated, physically strong, physically fit, angry, or frustrated. Anything, in other words, human as opposed to feminine. [34]

In *Out for Blood*, The Clichettes not only examine the complexity of these issues, but also make us aware of how history has been shaped to the detriment of women, how history and Hollywood and headlines make strong women out to be bad girls.

Other notable Canadian performance art Bad Girls Gwendolyn and Sheila Gostick, honed a brand of standup comedy that openly talked about sexuality, the sex trade, poverty, and other taboo subjects. Audiences were thrilled with Gwendolyn's outrageous safe sex routine in which she demonstrated how to put on a condom on an appropriately phallic vegetable without using your hands.

31 Johanna Householder, Janice Hladki, and Louise Garfield, "Out for Blood," in *Canadian Theatre Review 86* (spring 1996), 35-48.

32 Ibid.

33 Ibid.

34 Barreca, 47.

35 Deanne Taylor, Janet Burke, Bobbe Besold, and Marien Lewis were the original Hummer Sisters. After Marien Lewis and Bobbe Besold left, Jenny Dean joined the group. It was Taylor, Burke, and Dean who ran the *Hummer for Mayor* campaign.

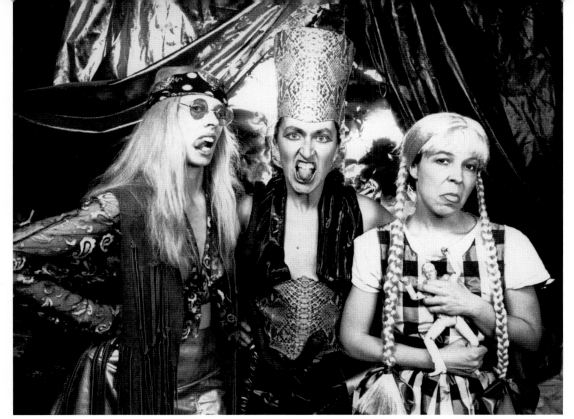

DAVID HLYNSKY

By 1972, women artists begin to take up video and performance with a vengeance. In contrast to other forms of art where there were already established rules and canons, these media provided a safe haven for women to explore their bodies, their politics, and their humour. In Toronto, it was The Hummer Sisters[35] who most successfully explored and exploited the use of video in performance.

Straddling the line between performance and experimental theatre, The Hummer Sisters created extravagant, multimedia political satires that addressed timely feminist issues, but also looked to more specific political subjects, particularly local civic politics. Smart, savvy characters were played by the four, who were backed by a live band (The Government, in the 1970s) and banks of TV monitors which provided them with a rich cast of onscreen characters. Technically complex, and intellectually rigorous, the Hummers were harsh political critics, and no politician, at home or abroad, could escape the scrutiny of their scathing wit:

Born in the crossfire of rock and TV
Suckled by the CBS news
Studied history and ethics and Disneyland
Served under General Foods

THE CLICHETTES *Out for Blood* publicity shot with Janice Hladki as Bernardine Dohrn, Louise Garfield as Medusa, and Johanna Householder as The Bad Seed, Toronto, 1990

Went AWOL with Janis and Jimi
Got fat on imported dues
Paid in Alabama and Vietnam
By cats in blue suede shoes [36]

In an interview with Deanne Taylor and Janet Burke, Taylor describes the main themes of the Hummers' works:

There are two types of content in the scripts. One is about girls and boys and sex and bodies, very much about bodies. From the beginning, part of being post-feminist was being post-birth control pills, post-invasive body changing, hormone changing. Big science versus the body is one of my favourite subjects because it's sort of like big media versus the mind. It's all about the media invading and dumbing down and treating us all as consumers and widgets in the great industrial machine, that all problems are fixable by science and mechanics. All those things offended me deeply. Whether they are doing it to the hamburger or to my ovaries. So the early plays were a big mix of current events ... [37]

As self-proclaimed "post-feminist, urban guerrilla, girl-next-door rock-stars," the Hummers tackled subjects that loomed large in the media and the public consciousness. In *Nympho Warrior* (1972), The Hummer Sisters guide us through the female cycle of reproduction vs. desire. "Lunar tick, lunar tock, whatcha got? Got the hots!" [38] They offer female audience members valuable birth control information, as well as insights into the ever-complex world of male/female relationships. In addition, as archeologists for the Ministry of Nymphomania, the women go on a quest for enlightenment to the Lost Continent of the Male Vagina:

You lucky people ... Here in these hallowed halls. Here in the glow of mutual surveillance. The great themes, the great questions pose themselves in attitudes of stern reproach. Begging an answer ... What's the matter? What IS the matter? (I don't know.) [39]

The structure of *Nympho Warrior* included a live band, singing, live video feed, smart lyrics and dialogue, and drawing — a true multimedia extravaganza. The content of *Nympho Warrior* is full of puns and innuendo, revealing a kind of tough-broad, uppity feminist humour.

Q: You know what happened to the woman who stopped struggling?
A: She ended up with a mink coat. [40]

Later in the 1970s, they looked to international news stories as the inspiration for their elaborate narratives. *The Bible As Told To Karen Ann Quinland* and *The Patty Rehearst Story*, were two of the early works that questioned the sanity of authority:

Cleaning up the mess. Sisters
Your bodies are occupied
territory, bristling with
IUD installations, humming
with chemical sterility,
invaded by vacuums and
knives. Sisters wipe those

36 Deanne Taylor, lyrics from the song, "Born in the Crossfire," in *The Bible As Told To Karen Ann Quinland* (1977-79).

37 Deanne Taylor, interview with Tanya Mars (May 2003).

38 The Hummer Sisters, lyrics from *Nympho Warrior* (1972).

39 Ibid.

40 Deanne Taylor, excerpt from *The Patty Rehearst Story* (1976-79).

41 Deanne Taylor, excerpt from *The Bible As Told To Karen Ann Quinland* (1977-79).

42 Barreca, 57.

43 Deanne Taylor, excerpt from *The Patty Rehearst Story* (1976-79).

smiles off your faces and
chew a big wad of garlic
at all times. Find someone to
marry, don't fuck under the
full moon, less is more, have a nice baby, habdullah, allah y'allah.
No one wants to confess in the closet anymore.
New chroniclers. New contenders. Not one of them wants
to play Jesus. They all want to play God.
The corridors of power are lit up like a catwalk. [41]

Humour is indeed a very serious business, and in the hands of women who create feminist humour it is a very seriously subversive business. As Barreca notes, "… humor is often directed at any institutional body of regulations… Any set of rules needs needling, needs the perspective humor can offer… [42] The Hummer Sisters, exemplary feminist needlers, belted out lyrics with a lusty, raunchy gusto that got right to the core of the issues:

PATTY: … we must learn to speak in headlines.
DRUMS/SYMBIONESE LIBERATION ALL-STARS: No sex without work
No work without sex
A woman's business office
Is a Moonlit Deck. Yeah!
ROCKY: What did we ever do before dialectical Infantilism?
PATTY: I was a successful princess.
CRYSTAL: I was a vivisectionist.
ROCKY: I slept all the time. [43]

Blunt and pushy, The Hummer Sisters let you know exactly what to expect when you mess with Bad Girls, just in case you thought you could get away with something:

She'll cut you dead. Fast or slow. She'll stick it in
She'll stick it on you.
And suck the life from you.
She'll cut your lumps off and
Put them in a yogurt thing and
Save them in the fridge.
She'll cut your toenails off
And put them in a little Kleenex in her pocket.
She hands you things that explode in your mouth.
She'll smear blood on your bed and whisper your name
To the other zombies.
She listens to your breathing and presses on your heart
To make it stop.
She fits herself to you
As close as a skin.
Then she peels you down to the jelly. She'll fuck you silly and
While you're sleeping
She'll clean up your floor
She'll clean up your table and

Your ashtray and your donuts and
Your papers and your matters and your mood and
Your manners and your memory and when you wake up
And you won't know who you are or
What you did and I'll tell you.
You're a dead man. Amnesiac castrati. [44]

And they remind you that:
You can have my body
Just stay out of my mind
Out of my mind.
Out of my mind.
Screwing you is Our business. [45]

In 1980, The Hummer Sisters ran for mayor of Toronto against Art Eggleton, a conservative politician who was openly unsupportive of the arts. Running on the campaign slogan ART vs. Art, Janet Burke, Deanne Taylor, and Jenny Dean gripped the imagination of the public. According to Burke, "We ran basically because Art Eggleton was running uncontested. It was a shoe-in for him. ... We thought, this is our moment and off we went." The Cameron House[46] was campaign headquarters for the Hummers. Deanne Taylor and Janet Burke describe how the whole idea came about:

D: I was doing the usual griping about local politics when everyone else was more concerned about Nicaragua. That was what I found with most of the progressive, thoughtful, educated, passionate people in the city with very good hearts — they focused internationally on all kinds of problems in other countries ... But you could not get anyone the slightest bit interested in local politics ... I was sort of interested in all the boring details. How policy happens or doesn't happen. I thought people would be interested if they knew about it. That if they could see that grand theft was going on at the waterfront, for example, then they would care as much as they cared about the Sandinistas. It hit me to run for mayor. I wasn't thinking about Mr. Peanut and our friends who had done it. Of course that was part of our experience and it was in there and it was a wonderful example. But I didn't think about that at first, I just thought, wow what about this. I immediately phoned you guys [the other Hummers] and you came over. That was an idea that never stopped getting yeses as soon as you heard about it. Then we called a hundred friends, got them all in a room together, and said would you all help? Absolutely and they all did.

J: The whole community got behind us from every medium — musicians, actors, and visual artists. It was like a giant, fabulous parade. It was phenomenal.

D: It was.

J: A month here at The Cameron and the month leading up to it. It was an extremely brilliant thing. [47]

At its best, humour, like art, has many functions. "Besides serving as entertainment, an escape mechanism, and an expression of subversive intent, it is also used to establish cohesion, solidarity, and group identity within

44 Deanne Taylor, excerpt from *The Bible As Told To Karen Ann Quinland* (1977-79).

45 Ibid.

46 In the late 1970s and 1980s, The Cameron House was a popular Queen Street West bar and hotel that was frequented by artists and musicians. Owners Herb Tookey, Paul Sanella, and Anne-Marie Sannella were very supportive of all kinds of artists and their projects, among them The Hummer Sisters and VideoCabaret. The Cameron was campaign headquarters for the *Hummer for Mayor* campaign. Artists continue to live at The Cameron House.

47 Janet Burke and Deanne Taylor, interview with Tanya Mars (May 2003).

This is no job for politicians . . .

HUMMER
FOR MAYOR

specific communities."[48] This is exactly what the *Hummer for Mayor* campaign accomplished. And despite being Bad Girls, The Hummer Sisters got ten percent of the vote. While they did not get elected, they did demonstrate to politicians that the "art" vote did count. At the same time, they showed the art community that it could have a significant impact on local politics.

If the quality associated with Good Girls is control, then the quality most explicitly associated with Bad Girls is excess.[49] There is no one who could characterize excess more than Anna Banana, who has excessively and successfully exploited the banana and manifested it in every conceivable representation throughout her thirty-year career as an artist. In 1971, after being teased "Anna Banana" by her friends, one night at a boisterous party in Big Sur, CA, she was accidentally pushed into a big pile of bananas. Anna took this as a sign from the big banana in the sky and embraced her moniker. In Vancouver in the 70s, it was common for artists to assume alter-egos and to play out new identities in their art practice as well as in their daily lives. There was a fascination with the fine line between art and life, evidenced most profoundly in the artists who were involved with Intermedia and the Western Front. This "art as life" sensibility seems to have been popular all along the west coast of both Canada and the US and many artists moved frequently and easily across the border. The proximity of Hollywood and the propensity for actors to change their names, as well as the quest for fame were strong influences. Yet, while these artists were sending up the rich and famous, at the same time they took their personifications very seriously. "... personas were elaborated and animated into a performance burlesque, a form of public art which emulated media hype and celebrated character."[50]

With the common banana as her medium, Anna Banana has evolved a densely rich art practice in both performance and mail art. Through mail art, she acquired a huge collection of banana paraphernalia that she has used throughout her career; they are the foundation of all her work. Initially, she manifested the banana persona literally, by wearing a banana costume; however, in more recent works, the banana has become the subject of the performances. There is no separation between Anna Banana the artist and Anna Banana the person. Her life and her work are inextricably intertwined, as evidenced in her extensive Banana Archive, *The Encyclopedia Bananica*, which is being used as the basis for her life's work.

The remarkable thing about Anna and her banana fetish, is how perfect the banana is as a device to facilitate her aesthetic and her philosophy of art. Anna Banana's performances focus on interactivity and parody. Her main preoccupation is to break the audience/spectator barrier and to engage the passive viewer in the creative process. The banana is silly, it is difficult to be intimidated by the banana; indeed, the banana is the antithesis of other more aggressive performance art images, such as bondage or bodily fluids. Because the banana is so unthreatening, Anna Banana has been able to facilitate her performance activities in communities around the world with relative ease. These events are celebratory, inclusive, humorous,

48 Marcia Tucker, *Bad Girls* (New York: The New Museum of Contemporary Art, Cambridge: MIT Press, 1994), 46.

49 Barreca, 46.

50 Karen Henry, *Parachute* 59.

51 Anna Banana, written correspondence with Tanya Mars (June 2002).

TIM PORTER UPI

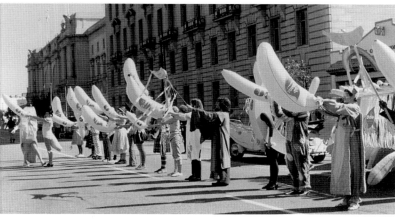

CHARLES CHICKADEL

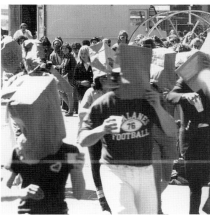

WM. WHITNEY

and fun. They are a vehicle for people to experience themselves as performers and creators; to experience the interface between art and life as a creative process. Anna Banana states:

> I believe that as a society we have given up authority over our lives, and too often, opt to "let the experts" do it, whatever "it" may be — sing, dance, race, swim (entertain ourselves), think, conclude, etc. However, with my humorous approach, I am able to engage people, to move them (if only for an event) from a consumer role to a participant role; to exercise their own abilities rather than relying on experts to fill in the gaps, the blanks.[51]

A parody of the Olympic Games, *The 1975 Banana Olympics* in San Franscisco, was a major event which drew over 100 contestants who ran a variety of bizarre races invented by Anna Banana: the 100-yard dash backwards, the bureaucrat's marathon, the overhanded banana throw, and team races such as the back-to-belly-banana race. The grand finale in the Banana Olympics was the Lap Sit Event in which over 330 people assembled, sitting on one another's knees around a downtown Plaza, all eating bananas. In this work, Anna critiques society's elitist value system so that winning is based not on who crosses the finish line first, but on who performs the race with the most "a-peel."

ANNA BANANA The "Hand" team of contestants in the *1975 Banana Olympics*, Embarcadero Plaza, San Francisco, CA

ANNA BANANA *Columbus Day Parade* entry, San Francisco, CA, 1974. Banana leads the team in the banana salute

ANNA BANANA *1975 Banana Olympics*, at the finish line, Embarcadero Plaza, San Francisco, CA

As an artist who works with humour, I feel the serious intentions behind my work are often overlooked. I use humour as a device to make my work more accessible, less threatening than more confrontational approaches to critique societal values. I parody existing forms/institutions, as a way of questioning their values and approaches. For example, with the Banana Olympics, I present alternatives to a value system that dictates that only the best, the fastest, are allowed to compete, are worthy of our attention, while in fact, I believe each individual's efforts are and should be valued and encouraged. To that end, I create events in which the non-artist is asked to participate in a creative way, and the humour/banana theme makes accepting that invitation more possible. [52]

I think Anna Banana's work is a good example of how celebratory work is sometimes devalued. After all, who can take seriously an adult woman who willingly calls herself Anna Banana? Do we mistrust the comic because it gives us pleasure? If something gives us pleasure, can it be valuable? Deep? Thought-provoking? Important? I believe that there is a unique quality in this work that celebrates playfulness, obsessiveness, and the absurd; that these qualities resonate for people and reflect aspects of their own lives, their own experiences; that the act, the involvement, the experience is what unites audience members, and that this collective act of creation is a splendid gift.

In her more recent works, Anna Banana has turned her critique to the scientific community in the guise of Dr. Anna Freud Banana:

I poke fun at the scientific community and the way in which its discoveries and pronouncements are generally taken as "words from on high." While I don't deny that scientific research has brought about beneficial changes, it has also created detrimental effects, so, through humorous parody, I raise questions about the authority society has given, to that area of endeavour. [53]

It is obvious that assuming the alterego of Dr. Anna Freud Banana and parodying the scientific community is not going to be enough to overturn society's conventions or beliefs about that community, but it does give us a chance to step back and take note of how things really are. We are reminded that dominant values are entrenched and need a good critique. She has also been successful at avoiding sexual banana jokes. There is nothing raunchy about Anna Banana events. Anna Banana is not trying to incite audiences to make fools of themselves, but rather invites audiences to play with her, to engage in events of absurd camaraderie, again using humour and art as a way to build community. As Langer points out, comedy is an art form that arises naturally wherever people are gathered to celebrate life: spring festivals, triumphs, birthdays, weddings, initiations,[54] or even The 1975 Banana Olympics.

Colette Urban is another artist whose main preoccupation is with breaking down traditional relationships between artist and audience; finding new ways to present performance. However, her work focuses more on integrating the object with the body. Colette Urban is a consummate recycler. To alleviate her frustration with the limitations of traditional painting and sculpture, which she was doing while attending undergraduate school at the

52 Ibid.

53 Ibid.

54 Langer, 331.

55 Colette Urban, interview with Tanya Mars (April 2003).

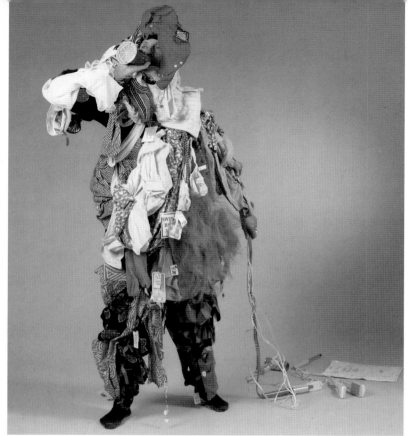

ELISABETH FERYN

COLETTE URBAN *Consumer Cyclone*, performance costume, 1999

Nova Scotia College of Art and Design in Halifax in the 70s, she began to collect stuff which attracted her attention and use it as art material:

> In Halifax, I had a huge apartment (it might have been a brothel, there were a lot of rooms!) — a really old rambling place, and I started to gather things to put in each room. I had these piles of junk that developed, like broken car parts, candy wrappers, etc. I found it interesting that all these things, this litter, was all around in the streets so I picked these things up and then I made objects in each room. I was living alone and I wanted company, so I made things in each room to occupy the space; for example, I made a dog that I put in one room. And then I finally turned the spaces into areas where people could come and see the work. [55]

This was the beginning of her investigation into installation and the relationship of objects to audience. The "stuff" evolved into "objects" that could either be worn or manipulated by a performer or a member of the audience. Her pieces are short gestures or interventions that rely on audience participation rather than spectatorship:

> I started using objects that were around me and making them active or animating them through the performance ... I wasn't interested in a stationary object that I could not control or be in charge of ... this animated situation

also brought me in touch with an audience. [56]

By pushing the parameters of sculpture into both wearable and kinetic art, Urban's style of performance relies heavily on the body to flesh out the meaning of the work. Installation and performance do not compete in her work. Her approach is to use the objects for both which allows her to investigate non-theatrical, non-narrative performance work and to leave what she calls "performance residue" as the installation.

In the installation *Gambler*, a table was covered with thousands of pieces of different commercially produced jigsaw puzzles. Puzzle images ranged from Miss Piggy to Monet's *Waterlilies*. While not strictly a "performance," the performative elements of this work are an extraordinary testament to how Urban's non-alienating and humorous work insinuates itself into the usually rigid atmosphere of the contemporary gallery. Not only does this work comment on the low art/high art dichotomy, but it also sets in motion a kind of camaraderie totally unfamiliar in the cool and detached ambiance of the vernissage. What the table of puzzles evokes is a monumental task that needs attacking and can only be accomplished through cooperation. People are compelled to riffle through the pile, looking and sorting all the while sharing both bits of puzzle and bits of conversation. A simple construct, a simple social structure, a moving experience for those who participated, a sense of accomplishment, a reminder that the word "community" involves the ability to relate to each other. In the end, the irony lies in the "art," the table with its fragments of puzzles, littered with beer bottles, bits of food, ashtrays, and other kinds of detritus, creating yet another quirky layer of interpretation of contemporary life and entertainment vs. art:

Gambler was first shown in Vancouver, and it was my first experience as a young artist at an art opening where people were actually talking to one another. As an artist, I knew these were places where people would come and criticize and say as little as possible. But all of a sudden the table of puzzles gave the audience a focus and broke through the pretension of an art exhibition ... people were using this table as a work space and communicating to one another when in other situations they wouldn't necessarily do that. So it was funny to watch this thing transpire ... it was a real participatory environment ...[57]

In the 70s, Urban opened a second-hand junk store on Queen Street West in Toronto. Little did she know how important this self-employed business would be to her ongoing art practice. When she was forced to close the shop because of rent hikes, she came up with the ingenious idea to take one of her second-hand tables, turn it upside down, and make a cart onto which she loaded up all her goods and took to the streets. In more recent years, her objects have simply moved from her cart to her back. In this way, her business practice has informed all of her work.

On the surface, her performances are a simple pastiche of ordinary objects, familiar sounds and text, arranged and juxtaposed to create witty visual narratives. These extraordinary concoctions take the form of sculptures or costumes that are used in either performances or installations.

56 Ibid.

57 Ibid.

58 Ibid.

59 Ibid.

However, the word costume gives the wrong impression, it is more like her body becomes an extension of the costume, both elements blend to become an object, a living, breathing entity that commands a space. They are not simply dresses used to flesh out the visual persona of the character.

I still look at the same kinds of things. I'm digging through junk stores and through my own trash looking for objects that will be a trigger for a work ... the recycling of things is really important to me. I'm using things that come from places like Home Depot; things that are easily accessible and that anyone could basically make into some kind of a kit, an art kit. I'm interested in objects which might have been used for a different purpose originally, and I reinvent a new function for them.[58]

While the fragments of the objects may be easily identifiable, their combined assemblage twists both physically and contextually. The bright, funny, familiar objects draw you in, entice you to take a closer look, and then either make you recoil in embarrassment or hoot with laughter at the irony. *Consumer Cyclone* is a perfect example:

The costume was created for a piece to be done in a mall, specifically for that location. I was reflecting on the consumer attitude in that site. The costume is made up of all kinds of bric-a-brac: clothing, wigs, paraphernalia that come from mall shops; I'm also dragging things behind me: heating pads, hair dryers, and hair curlers, all the necessary beauty accoutrements. Also during that performance, I'm speaking a text that is "look at me, look at you" ... I want the viewer, the mall shopper, to assume the identity of voyeur, but a voyeur of both my actions and me of theirs. Because of course they're holding lots of shopping bags in most cases and trying to walk past me. It's a funny situation in that kind of a site because of the whole idea of surveillance in the mall situation too. In fact the back of the costume is covered with mirrors, little personal compact mirrors that reflect the interior of the mall which is again quite often covered in mirrors that are often hidden so that they aren't that obvious to the people who are walking through the mall. But they are there, they are there for surveillance reasons in most cases.[59]

The costumes are wacky things that adorn her body, a body which once it is put into motion never fails to captivate the attention of the spectator. They are colourful, welcoming images; but not tidy well-made clothing, so "costume" is a bit of a misnomer. It is more like the junk or stuff of the world heaped upon her back, and she is carrying the weight of it, like Atlas, the weight of all our consumption. She is completely covered, and in her confinement one senses a creepy undertone of sinister entrapment, that we/she are/is clothed in superficially "cute" or entertaining attire, which disarms you with laughter, yet it is subversive. "Look at me, look at you," whispers the bag lady cloaked in a burka designed from a wide range of beauty and consumer products. She is an encumbered body, encumbered not only by the weight of her consumption, but by the rules/regulations/actions/images that society expects:

This bizarre ensemble registers immediately as abnormal and disquieting. Most shoppers stare warily, others veer away, yet an entourage of the curious

follows this freakish pied piper ... Her disheveled appearance is disruptive simply because it defies any immediate identity or category of behaviour. This impoverished display of consumer goods throws into confusion the value of things, as well as distracting from the desire to consume. Her very presence disturbs shoppers' fantasies and fluctuating desires, making the pleasures of being looked at and "just looking" a self-conscious act.[60]

Urban's characters speak very little, but instead rely on the relationship of the image and the movement. When there are words, it's as though the words are put into her mouth, rather than emanating from her mouth; they, like the costume are jammed together, crammed into the mouth.

The materiality of her practice conflates the actual art material with her body material. You never feel that she is "acting" or pretending to be a character, rather she creates moving, breathing objects that are animated by her body. Clear, defined acts that animate the costumed body, a blend or conflation of contemporary and popular culture images. What Urban manages to achieve with her work is a kind of self-deprecation and mocking that creates laughter, which forms a bond with the audience, but simultaneously draws a line.[61]

What all of these women performance artists share is a commitment to art that refuses to be quiet, tidy, pretty, or nice. They are self-proclaimed feminists, advocates of change both within the art community and the world at large. They are a stand-up, in-your-face bunch who have persisted and continue to make work that rubs the art élite the wrong way. Their work is not only humorous, it is intelligent, provocative, and brave. They are artists who have also refused to victimize themselves. To my mind, they epitomize the best of both feminism and performance art. For me, the best feminist performance art, as with the carnivalesque, is:

... characterized by an inordinate ability to mix disparate elements with wild abandon and to confound categories, social positions, and hierarchies of space, language and class; to provide both a 'festive critique' and an extreme utopian vision of society at the same time; and to reconfigure the world through laughter.[62]

Unencumbered by the weight of either American celebrity or European angst, Canadian women artists have had the luxury of embracing humour, entertainment, parody, and satire with a level of sophistication unparalleled in any other art community. In fact, the images created by Canadian women performance artists have a distinct, celebratory flavour; compelling, positive, strong, emotional images that celebrate feminism and the strength of women everywhere:

Laughter is not a simple overt act, as the single word suggests; it is the spectacular end of a complex process. As speech is the culmination of a mental activity, laughter is a culmination of feeling — the crest of a wave of felt vitality ... Laughter is a song of triumph.[63]

60 Helga Pakasaar, "Colette Urban and Performance," in *The Performance Sites of Colette Urban* (Windsor: Art Gallery of Windsor, 2001).

61 Barreca, 136.

62 Tucker, 23.

63 Langer, 339-40.

Tagny Duff

FFWD, RWD, and PLAY

PERFORMANCE ART, VIDEO, AND REFLECTIONS ON SECOND-WAVE FEMINISM IN VANCOUVER 1973-1983

The grainy black and white image of a beach log cut up into segments begins to emerge. The segments are wrapped in unbleached cotton and handles appear to be nailed into the wood. Sombre music from an old pump organ creates a soundscape for the carnivalesque scenario. Carole Itter and friends unravel the cotton satchels to dry out the log segments at the Vancouver train station while local news and media cameras record the event. The image breaks up. FFWD. Stop. Play. Log segments are being repacked into their satchels and put on the train that will travel across the country to Halifax as personal baggage. Pause.

Carole Itter's work *Personal Baggage* (1972), described above, is one of the earliest Vancouver performances to be videotaped as a document by the first Portapak portable video camera.[1] In the 70s and 80s, many performance artworks produced by women working in Vancouver pioneered the use of video reflecting a variety of emerging feminist issues and sensibilities. This particular history interests me from the standpoint of a postfeminist perspective — by this, I mean a perspective that is critical of feminist episte-mology, while insistent on illuminating those art works by women that continue to haunt the peripheries of modern Western art history.[2]

In this article, I look at performance art works made by a number of

1 This reel-to-reel tape is currently missing and was permanently out of public circulation at the time of this publication. *Personal Baggage* by Carole Itter originally took place in an art exchange between Vancouver and Halifax artists in 1972.

2 Ann Brooks, *Postfeminisms: feminism, cultural theory and cultural forms* (New York: Routledge, 1997), 4. "Postfeminism is about the conceptual shift within feminism from debates around equality to a focus on debates around difference. It is fundamentally about, not a depoliticisation of feminism, but a political shift in feminism's conceptual and theoretical agenda. Postfeminism is about a critical engagement with earlier femi-nist political and theoretical concepts and strategies as a result of its engagement with other social movements for change."

women in Vancouver during the 70s and 80s who used video to address concerns that both reflect and challenge second-wave feminist ideologies. I begin by contextualizing the relationship between Intermedia, Vancouver's first artist-run centre to use video technology, and the creation of art and feminist collectives in the late 60s and early 70s. Then I outline works from the 70s by artists who pioneered new forms of performance and video,[3] including Evelyn Roth, The Peanettes, Kate Craig, Elizabeth Chitty, and The SS Girls. Two additional performance video works from the 80s are also examined. *Concerned Aboriginal Women* (1981) created by one hundred Aboriginal women and produced by Amelia Productions raises issues pertaining to the exclusion of Aboriginal women within the second-wave feminist movement. Mona Hatoum further questions issues of ethnic, racial, and gender representation in the beginning of the digital era and the new information superhighway by creating a performance for Slo-scan video (*So Much I Want to Say*, 1983).

As a practicing artist beginning a career of teaching at the university level, I am concerned by the noticeable absence of historical material on performance art made in Canada, and in particular by women. This is currently reflected in many Canadian academic institutional curriculae using the larger circulation of American and European art historical anthologies and texts on performance artists. Given the absence of written documentation on women and feminist contributions to the form of performance art and video in Canada, I ask: How did women contribute to the development of performance art and video in Vancouver between 1973 and 1983? And what are the possible relationships between these works and the diverse second-wave feminist concerns of the day?

Contextualizing 70s Performance Art, Video, and Feminism in Vancouver

Some of the earliest evidence of interdisciplinary and performance works incorporating video in Vancouver is documented in the Intermedia archives housed at The University of British Columbia. Intermedia, the first artist-run centre in Vancouver (established in 1967 as a non-profit society), received a grant from The Canada Council for the Arts and purchased its first Sony 3400 Portapak in 1969. Records of Intermedia grant proposals and project reports suggest that developing networks and artistic projects with a variety of local organizations — including outreach to women's groups, environmental groups (i.e. Greenpeace), youth, and educational groups — was a large component of the organization's vision.[4] For example, a community project was created to facilitate networking between fifty organizations, such as The Women's Centre, the Vancouver Welfare Rights Organization, and others. Also, in March 1971, artists Cheryl Druick, Rhoda Rosenfeld, and Trudy Rubenfeld are noted in a report to the Donner Foundation, as being workshop consultants for the Voice of Women's Liberation Conference on behalf of Intermedia.[5]

In the early 70s, local politics were playing themselves out behind the art scenes in the thick of radical socialist political movements of the time.

3 In this article, I expand upon a number of definitions of performance art video first outlined by Jo-Anne Birnie Danzker and published in "Performance Art Video Tapes," *Video Guide*, September/October 1979. (Special issue for the Living Art Performance Festival.)

4 Intermedia's mandate declares: "The purpose and aim of Intermedia is to help the artist realize himself and his work by providing an umbrella of cooperatively structured, contiguous and inter-related functioning artists groups, often service oriented."

5 While I was surprised to learn about this feminist presence and intention within Intermedia, I was perhaps not so surprised to read the following statement that reflects tensions within the organization in a typed report for the first quarter of the Donner video project: "April, 1971 Assistance to Intermedia Women's coverage of 3rd World Conference for Women at UBC. Complete failure due to bipolar chairwoman, paranoia and bad politics."

Caught in the Act an anthology of performance art by Canadian women

A VIDEO TAPE IS MADE OF THE LOG FEB 2 2 1972 SEGMENTS BEING UNPACKED FROM THE SATCHELS TO ALLOW IT TO CONTINUE TO DRY OUT. THE KITTENS ARE THE CURIOUS AUDIENCE. ANDY GRAFFITTI PLAYS SOMBRE MUSIC ON THE OLD PUMP ORGAN. MANY FRIENDS AND MEDIA PEOPLE HAVE BEEN INVITED TO THE TRAIN STATION ON SATURDAY, FOR THE GRAND SEND OFF TO HALIFAX A LETTER IS SENT TO ROY KIYOOKA IN HALIFAX.

CAROLE ITTER

Groups such as Greenpeace, feminist activists, indigenous rights groups, gay and lesbian activists, and right wing conservatives were struggling to gain political autonomy in Vancouver. Many artists wanted to include these political concerns at the forefront of artistic work, while other artists wanted to avoid politics altogether. Despite internal differences of political and aesthetic concerns within the organization, many artists associated with Intermedia began using the portable video technology to make interdisciplinary performance works, often looking to demystify the medium and create alternative networks (as proposed by Fluxus artist and philosopher, Robert Filliou) to mass media television. By 1972, Intermedia disbanded, in part because of discontentment with the organization's growing bureaucracy and institutionalization. Another problem was that the original mandate could not come to terms with the growing diverse interests of artists within the organization.

A number of artist-run centres sprouted up as a result of Intermedia's disintegration and a burgeoning Vancouver art scene. These include organizations such as Intermedia Press (1972), Pacific Cinematheque (1972), Satellite Video Exchange-Video Inn (1973), the Western Front (1973), Metro Media (1971), and feminist organizations including Reel Feelings Woman's

CAROLE ITTER From the book *The Log's Log* based on the performance *Personal Baggage*, published by Intermedia Press, 1972

Collective (1973), and Women in Focus (1974). These centres and others adopted distinct mandates and political/aesthetic styles.

Many of these centres acquired video production facilities (as well as increased support and collaboration with CBC and Cable 10), and there was a noticeable proliferation of performance artworks incorporating video. The Canada Council for the Arts provided funding for many of the centres claiming in its report in 1977, "In choosing excellence, the Canada Council opted at the same time for a policy conducive to the training and improvement of individual artists and artistic companies who were working in forms recognized as the best at the time — those of High Art."[6] Women's collectives and feminist ideologies also began to articulate themselves through some of these federally assisted companies, organizations, and communities.

Evelyn Roth and Video as Material in Performance Art

Evelyn Roth, one of the most visible women practicing performance art in Vancouver during the early 70s, used *videotape as material* for her sculptural performance artworks. Amidst the boom of the new technology of analog video, Roth, an interdisciplinary fabric artist, crocheted wearable sculptures from rejected CBC videotape. In 1973, The Vancouver Art Gallery featured Roth's videotape sculpture draped over the entrance to the gallery.[7] She explained that her reason for using video as material was "that hundreds of people are running around with video portapacks making tapes and most of them are really awful things ... I decided the best use for such tapes would be to recycle them into something useful."[8] Roth's wearable video sculptures interweave issues of women's labour and technological production. This use of videotape as physical material in performance, rather than the source of electronic emission, introduced a relationship between the older "pink" technology of crocheting and the newer video technology. The knitted and crocheted wearables recoded, and in a sense reprogrammed a feminized version of technology, challenging the traditional dichotomy of low art (craft) as women's work and high art (technology) as men's labour.

Roth's work reflected feminist debates around women and the issue of women's inequity in labour and wage (pink collar labour). In 1973, the first feminist political organizations formed in Vancouver to address the issue of women's autonomy (the Ms. versus Mrs. debate) and pink collar labour issues (including the status of women artists and the representation of women in gallery exhibitions). These organizations included The Canadian Advisory Council on the Status of Women and The National Action Committee on the Status of Women. There was outrage, at the time, concerning statistics that revealed that the average earnings of men with secondary schooling were 114 percent higher than those of women with similar educational backgrounds. The average earnings of men with a university degree were revealed to be 84.4 percent higher than those of women with the same level of education for all age groups.[9] As a result of new articulated and published feminist concerns, The Women's Bookstore, a non-profit collective, opened in Vancouver this same year introducing the public to feminist writings.

6 Canada Council for the Arts: The principle of excellence and its implications in a democratic society (July 6, 1977), 13.

7 This work was exhibited in *Pacific Vibrations*, a group show held in 1973 at the Vancouver Art Gallery.

8 Renee Baert, "Video Recycled," *Artmagazine* (Dec.-Feb. 1978), 30.

9 From *Women in the Labour Force* 1971, 79. It is interesting to note that these statistics have not changed radically since the 70s. Statistics Canada (from the Survey of Consumer Finances and Survey of Labour and Income Dynamics in Canada) reveals that the female-to-male annual earnings in 2001 were 64.2 percent. In 1992 the female-to-male annual earnings were 63.7 percent.

10 Vincent Trasov, aka Mr. Peanut, wore the Peanut costume and John Mitchell was the spokesperson for the Mr. Peanut for Mayor Campaign.

11 The Peanettes included Mary Beth Knechtel, Babs Shapiro, Suzanne Ksinan, Lin Bennett, Judith Schwarz, Kate Craig and others.

12 *Haut-camp* has come to be known as a West Coast performance style particular to Vancouver. Jo-Anne Birnie Danzker defined it as "concerned with public image over function, entertainment over instruction, it occupies the territory between described ideologies, content to lie without definition, in need of definition." "West Coast Performance, Praxis Without Ideology?" in *Living Art Vancouver*, 1979.

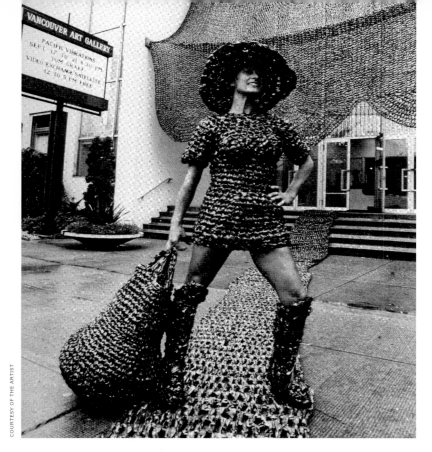

The Peanettes and Performance Intervention for the Camera

Within this historical context, in 1974, one of the most notorious performance interventions for the camera was undertaken by Mr. Peanut (Vincent Trasov)[10] and The Peanettes,[11] a group of artists who infiltrated the Vancouver City Hall elections and created a public intervention for live audiences, both on and off camera. In this case, broadcast television, pre-recorded video documentation, radio, and print media were the forms used to extend the performance of Mr. Peanut's bid to run for mayor. During the campaign, The Peanettes danced and sang loudly (and badly) as a chorus of good cheer for Mr. Peanut. At one point in the campaign's live news broadcast, The Peanettes interrupted the chatter of the announcers updating viewers with the voting count, and danced through the shot holding large Mr. Peanut campaign posters. Cameramen and newscasters chuckled with embarrassment and continued with their broadcast. Mr. Peanut and The Peanettes used humour as a strategy in the West Coast *haut-camp* style[12] to gain access and infiltrate the spectacle of civic elections, engaging the Vancouver public with art and city politics. The Mr. Peanut campaign articulated a political mandate to improve affordable housing in the city; however, the campaign ultimately blurred the line between art, entertainment, politics, and life. After the

EVELYN ROTH in front of the Vancouver Art Gallery during the *Pacific Vibrations* show, 1973

campaign, The Peanettes evolved into The Ettes and re-emerged at the Amy Vanderbilt Ball.[13] Other incarnations included The Coconettes and The Vignettes. The connection between these groups and the more overt feminist performance art groups in Toronto such as The Hummer Sisters, began a long exchange of collaborations between artists from both cities.

The Peanettes existed within a sarcastic and campy dialectical relationship with their male counterpart Mr. Peanut. The Peanettes' sense of autonomy as an artistic group began to grow through subsequent evolutions and the emergence of feminist activism in Vancouver. At the same time, the issue of the status of women in relationship to men as artists was under debate. As a result, women's groups and art collectives began to form and the Vancouver Art Gallery started to respond to local artistic and feminist concerns and influences. For example, *Women in the Arts* (1974), a lunchtime series at the Vancouver Art Gallery, featured lectures by local feminists such as Avis Lang Rosenberg and poets Judith Copithorne and Carole Itter, to name a few,[14] and video workshops by Reel Feelings. Also in the mid 70s, American socialist feminist theory was an important influence on local feminist activism. For example, in 1977, Germaine Greer visited and lectured at Simon Fraser University and the University of British Columbia. The same year, Lucy Lippard curated the show *Strata* at The Vancouver Art Gallery. Later in 1979, Judy Chicago lectured at Langara College and spoke about her influential and quintessential feminist work *The Dinner Party*.

Kate Craig and Performance for the Camera

Kate Craig most notably created performances for the camera that addressed concerns about subjectivity and the body in relation to the camera and spectator. Performance for the camera addresses an audience through the lens of the camera. *Delicate Issue* (1979), perhaps Craig's most renowned video, examines the nude female body in macro vision, placing the viewer between public and private space, and her own body between subject and object. Craig asks, "Who is in the frame, who is willing to be in the frame, who is willing to watch the frame?" A year later, Craig created another performance for the camera. *Straightjacket* features Craig's torso bound by a pink silk straightjacket that she made by hand. Craig sang a song, or rather a manifesto, about ideology as a form of restrictive bondage. One of the choruses exclaims, "Take me away and lock me up, ideology is for fools. It fits me oh so perfectly. It keeps me calm and cool. Inside out, inside out. The world is inside out." The notion of woman-centred ideology as a means for liberation appears to be challenged in this particular work.[15]

Many of Craig's works are now used to exemplify early performance art and second-wave feminism. However, during her life, Craig was often ambivalent about feminist ideology and did not refrain from expressing the view that she "was beyond feminism and that she has a completely different experience and perception about the role women played."[16] This post-feminist perspective was contrary to socialist feminist theories circulating throughout Vancouver in the late 70s — theories that implicitly supported women reclaiming women's

13 *The Amy Vanderbilt Ball* took place in 1975. During an interview with Kate Craig conducted by Mars and Householder in 1999, Craig remembers, "… [*The Amy Vanderbilt Ball*] was designed to be a coming out ball, so the women would come out not in the shadow of some masculine production, but on their own…. The Ettes came out in ball gowns, and there's a fabulous colour picture of The Ettes, not the somebody things-Ettes, but The Ettes." Craig remembers, " In connection with an event (Mary Beth reading at A Space in Toronto), the Ettes performed with a choreography by Dragu and a whole Toronto contingent of Ettes that included all sorts of people …Then about the same time (1975) as The Ettes was the formation of a Toronto group called The Hummer Sisters." However, Mary Beth Knechtel recalls that it was The Vignettes, not The Ettes, who appeared at *The Amy Vanderbilt Ball*. This is also noted as the case in *Whispered Art History*.

14 Carol Williams, "A Working Chronology of Feminist Cultural Activities and Events," in *Vancouver Anthology: The Institutional Politics of Art*, Stan Douglas, editor (Vancouver: Talonbooks, 1991), 187. I refer to a number of events listed in this well researched and useful chronology.

15 I thank Hank Bull for discussing his thoughts on the content and implications of this work.

16 Tanya Mars, interview with Tagny Duff (September 2003). During an interview that Mars and Householder conducted in October 1999, with Kate Craig before her death, Mars asks, "… do you think you were imbued with a feminist kind of assumption?" Craig answers, "No."

17 This work was made during a residency at the Western Front.

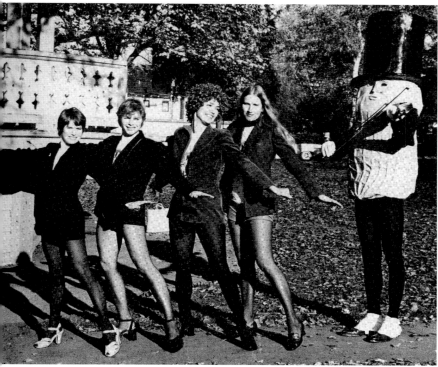

equal rights. However, the question of the sex specific ideology of feminism did surface in the late 70s to early 80s. For example, The Art Gallery of Greater Victoria featured an exhibition *BC Women Artists (1885-1985)* in 1985 and this resulted in some controversy on the issue. The curator Nicholas Tuele writes:

> The discussion of feminist issues is not as highly visible in the art world as it was ten years ago. Nonetheless, the thesis of this exhibition has touched a still sensitive nerve. In fact, one artist who was invited to participate categorically refused to do so on the grounds that a group exhibition of women artists was sexist and denigrating. While we don't agree with this view, we acknowledge that an exhibition of women artists raises a number of vexing issues.

It is not until the 90s that Judith Butler and other noted feminist theorists began to question accepted notions of the performativity of gender and sex.

Elizabeth Chitty and Integrated Video

Elizabeth Chitty's performance *Telling Tales* (1979)[17] incorporates a semiotic analysis of woman in the form of *integrated video*. This form features the video camera and monitor as props and elements in the performance. Chitty, a Toronto-based artist, produced a number of works at the Western

THE PEANETTES included Mary Beth Knechtel, Babs Shapiro, Suzanne Ksinan, Lin Bennett, Judith Schwarz, Kate Craig, and others. Video still from the Mr. Peanut for Mayor campaign, Vancouver, 1974

KATE CRAIG Video stills from *Straightjacket*, 1980

Front and moved to Vancouver for one year in 1981. She explains that "the work [*Telling Tales*] was conceived with both a live performance and video views in mind. Although it was only ever performed once, it still maintains for me a performance edge."[18] In this work, Chitty asks the viewer to question the construction of women in video narrative and image. She reads a list of warnings and historical facts, and asks, "could she balance her behaviour with her self image." Chitty plays with this question, introducing performance gestures that exaggerated feminine stereotypes and signifiers, thus overwhelming them. She files her nails with sandpaper as she sits and talks to the camera viewer. She masturbates to the song "I Can't Help Myself." In the last portion of the performance, she reads a "women's" magazine featuring Margaret Trudeau and turns the pages of the magazine with her stiletto heels. Chitty simultaneously videotapes the process — she is videotaped while videotaping. She continuously performs in between frames and narrative movements, deconstructing and reconstructing narratives until she states, "She was always telling tales." Chitty expands Baudrillard's notion that TV and mass media place individuals in a universe of empty signifiers (the simulacrum), while commenting on the struggles between perceptions of gender and self.

Chitty's performance reflects postmodern feminist concerns regarding the media's construction of women as signified. At this time, feminism both invested in and refuted many aspects of psychoanalysis. In particular, Lacanian psychoanalytic theory concerning the signification of the phallus, and theories of the signifying chain, alerted feminists to the construction of "woman as sign" in images. Many feminist texts on this issue circulated in Vancouver at the time and women's reading groups began to flourish. Elizabeth Cowie's text *Woman As Sign* (published in the British magazine *M/F*) explored the semiotic nature of the word "woman" in popular culture. Laura Mulvey's essay *Visual Pleasure and Narrative Cinema* (originally published in *Screen*, 1975), which introduced psychoanalytic readings of film narrative, was also tremendously influential in Vancouver's intellectual feminist circles. Psychoanalytic theory and writings by noted French feminists including Cixous, Clément, Irigaray, and Kristeva were extremely influential later, in the 80s, when the texts were finally introduced to English Canada (and Vancouver bookstores).

The SS Girls and Edited Versions

Reacting against the increasing theorization of feminism were The SS Girls: Deborah Fong, Annastacia McDonald, Carol Hackett, and Jeanette Reinhardt, with Paul Wong. Their performance 4 (1978) included the use of autobiographical text, actions, video, and slide projection and was re-edited for video. This combined performance-video introduces *Edited Version*, where the performance is edited specifically for the camera. This form provides flexibility for artists to construct a live performance art component, and manipulates its emotive syntax through editing techniques. In both the original performances and the resulting video, The SS Girls agitated and

18 Elizabeth Chitty, interview with Paul Wong, *Video Guide* (1980), 14.

19 Barbara Steinman, *Video Guide* (1980), 9.

20 This event was co-curated by Betsy Warland, Ellen Woodsworth, Lorraine Chisholm, and Cheryl Sourkes.

21 Carol Williams, 195.

22 Kiss & Tell consists of Susan Stewart, Persimmon Blackbridge and Lizard Jones. In an interview by Tanya Mars and Johanna Householder with Susan Stewart and Margaret Dragu (October 2000) Stewart explains: "In Vancouver we had a free newspaper called *Angles*, a gay and lesbian newspaper, and I think it was '87. They were advertising for an international lesbian week and two women artists from Vancouver who used pseudonyms for the piece, produced a series of photographs for the centrefold of the newspaper which showed two women engaged in sex. But in the images, of which there were about ten, you couldn't see their faces at all: they kept their models completely anonymous, and there were a lot of framed close-ups of these women. And then this centrefold hit the streets, it caused an absolute furor in Vancouver ... There was the segment of the feminist community that immediately called it pornography and were leveling accusations at it, especially along the lines: 'its fragmentation, it implies violence against women' ... So that's how *Drawing the Line* got produced, as a reaction to that reaction."

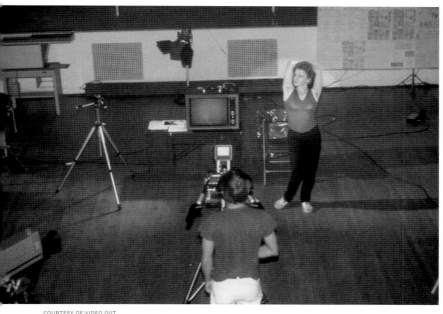

provoked stereotypes and feminine imagery, choosing to inhabit a macho bravado performed by counter-youth culture and punk rock bands like the Sex Pistols and The Clash. The conversations and actions in the performances project a "fuck you," and "in your face," punk bitchiness. The girls act badly as they brush their pussies for the camera amidst flowers, talk explicitly about their latest orgasm with their favourite vibrator, dance naked, and get drunk for the camera, as Paul Wong zooms in to record a close-up shot of a tampon string. The girls lambaste Wong for exploiting them and getting all the credit. They complain about how the art and politics are not getting them anywhere. Wong, the bitchiest of them all, tells them to fuck off. It's just another day in the life of the Mainstreeters. Barbara Steinman said of their performances, "The SS Girls outraged the Vancouver feminist community with a name tag. Intolerant of rhetoric. This performance reveals an emerging feminism, personal, from the guts of experience, not the brain cells of ideology."[19]

In the late 70s, androgyny and ambiguous sexuality were prevalent in youth music culture (i.e. David Bowie). The SS Girls reflects this youth culture and perhaps an emerging queer politic hinting at bisexual, gay, and lesbian concerns. The late 70s and early 80s also saw the beginning of the politics of

ELIZABETH CHITTY Video stills from *Telling Tales*, A Western Front Production, 1979

THE SS GIRLS with **PAUL WONG** From left to right: Jeanette Reinhardt, Annastacia McDonald, Deborah Fong, Carol Hackett. Video still from *4*, 1978

23 I am using the term Aboriginal women here with the understanding that the term includes reference to First Nations Peoples, Métis, and Inuit. The terms Indian and Native are used with affirmative connotations within the essay. It is interesting to note that The Native Women's Association of Canada's website uses the terms "Native women" and "Aboriginal women" interchangeably.

24 Many of the women traveled from reserves in BC and other parts of Canada, and some, living as non-status Indians in the city, also attended.

25 The policies of the DIA and its very presence as a governmental department continue to be a point of contention today. According to National Chief Phil Fontaine, "Indian Affairs was designed to eradicate any sense of Indianness in the country, to eliminate our people. And I don't see one good reason why we should keep things in the Department of Indian Affairs as it is today. That's not to suggest that we eliminate the legal responsibilities that the federal government has towards First Nations people, the fiduciary responsibility. That's out of the question. As far as the Indian Act, the Indian Act is an archaic, racist piece of federal legislation and we have absolutely no desire to maintain that." From "Prime Minister Paul Martin Participates in the Closing Press Conference of the Canada-Aboriginal Peoples Roundtable: Transcription," Ottawa, April 19, 2004. www.bcfn.org.

26 Protests and challenges to the Canadian Government's policies on land claims have been strongly voiced in BC, particularly in the early 70s. The Nishga (now known as the Nisga'a, located near Prince Rupert), won the first Supreme Court action case against the government of Canada (Calder Case 1973).

27 Aiyyana Maracle writes in a statement to the John Hirsch Prize for theatre direction that she won in 1997, "As a Mohawk woman, a transsexual, a lesbian, an artist ... there is not a box I neatly fit into." She has written a number of articles on performance art and Native artists including "Performance Art & The Native Artists: An rEvolutionary Mix?" LIVE at the End of the Century (Vancouver: grunt, 2000).

28 In my email discussion with Aiyyana Maracle, she further explained, "A major example of this would be most days of Leonard Peltier's extradition hearing. We would have these early morning marches from our "home base" at the Indian Centre (which was in Kitsilano at that point), disrupting traffic as we crossed Burrard Bridge and went through downtown. Drumming, singing, and chanting all the way, the march culminated in day-long vigils in front of the courthouse while the court was in session (which is now the VAG — oh, the ironies!). The front steps made for a fabulous stage on which to play out this real-life drama. It was all about making spectacle for the (TV news) camera."

29 The Native Women's Association of Canada was incorporated in 1974.

erotics and the issue of pornography in feminist circles. For example, artists like Persimmon Blackbridge, Nomi Kaplan, and others participated in *Herotica: Women's Erotic Art* at the Helen Pitt Gallery in 1981. The following year, *Woman to Woman*,[20] a series of workshops, discussions, and art on censorship, eroticism, and lesbian history was sponsored by Women in Focus. This same year, a group of radical feminists, The Wimmins Fire Brigade,[21] opposed to pornography, bombed three Red Hot Video outlets in the Lower Mainland. They stated, "This action is another step towards the destruction of a business that promotes and profits from violence against wimmin and child. Red Hot Video is part of a billion dollar pornography industry that teaches men to equate sexuality with violence." It was not until 1988 that Kiss & Tell created performances that dealt explicitly with issues of censorship, homophobia, and lesbian desire in reaction to feminist debates that included lesbian erotic imagery in the "pornographic." [22]

The 1980s

The absence of representation of diverse cultural groups in the arts and Feminist discourses in Vancouver during the 70s became an issue in the 80s. In particular, artists and feminists attempted to articulate the needs of Aboriginal women[23] (among other so called "minority groups") and in doing so caused deep divisions. The issue of access to modes of production for women and marginalized groups began a first wave of identity politics in Vancouver.

Aboriginal Women and Amelia Productions: Performance Intervention for the Camera

In 1981, one hundred Aboriginal women infiltrated the Department of Indian Affairs (DIA) and occupied the government office for eight days until they were forcefully removed by Vancouver police and then jailed.[24] Throughout the eight days, the women who organized the event invited the news media to record particular moments of the occupation. Amelia Productions, a collective of video artists and feminists, were also invited to document the event, and produced the documentary video *Concerned Aboriginal Women*. The organizers employed video, TV, and print media (in particular *Kinesis*, a feminist magazine) and worked with Amelia Productions to declare their manifesto calling for better living conditions for indigenous people living on reserves, and for the provincial and federal governments to acknowledge corruption in the DIA office.[25]

 Concerned Aboriginal Women, is currently defined as a video documentary produced and taped by Amelia Productions. However, while revisiting this work, I realized that this political action is in line with what I understand to be *performance intervention for the camera*. The protest reflects tactics and strategies of performative media infiltration that had been employed by the Mr. Peanut Campaign and earlier feminist activists. However, the long history of Indigenous Peoples and First Nations protest in British Columbia points to a sophistication with intervention, protest, and political

resistance strategies for the camera that obviously predate the Mr. Peanut Campaign.[26] In an ongoing discussion on this point with Aiyyana Maracle, Mohawk performance artist and critic,[27] she suggests, " I think much more militant actions that happened during this period were organized with some measure of awareness to the camera … Many years later, I learned of this thing called agit-prop: in hindsight, much of what we (a large assort-ment of young Indians from all over, collectively, nominally the Leonard Peltier Defence Committee) did those days could certainly fit into this cate-gory [performance intervention for the camera]." [28]

Attempts by feminist groups in Vancouver (both political and artistic) to include the voice of Indigenous women came late within the context of sec-ond-wave feminism. National legal recognition for Indigenous women's equal rights in Canada was only first introduced in 1978 when the Canadian Advisory Committee on the Status of Women published *Indian Women and the Law in Canada: Citizens Minus*. Three years later, the Native Women's Association of Canada[29] incorporated in 1974 wrote the article "Statement by Native Women's Association of Canada on Native Women's Rights" and was consequently published by the Canadian Advisory Committee on the Status of Women. Sara Diamond, an outspoken lesbian feminist, artist, and a member

CONCERNED ABORIGINAL WOMEN
video still, Amelia Productions, 1981

of Amelia Productions at the time, explained, "Our sense of responsibility to the documentary subjects [the women in *Concerned Aboriginal Women*] was meant to ensure the authority of construction would lie with them as much as with that of the maker."[30] She also acknowledged that, "the feminist documentary emphasized collective, not individual, action, yet, as Ann Kaplan suggests, the giving voice to the voiceless raised a series of problems."[31] Aiyyana Maracle comments on this further, explaining, "Occasionally we'd find someone willing to do this technical work for us, but for years, it wasn't possible to find someone willing to teach us (activists) these new technologies. A missionary mentality still prevailed among the white liberals, leftists, and environmentalists (of the day) who sought to ally themselves with our cause."[32] Feminist strategies used by predominantly white middle-class women to give voice to Aboriginal women and First Nations Peoples and other marginalized groups at this time often resulted in a tokenism that was deeply resented. It was not until the 90s, that a wave of young Native artists began making and producing performance art works and video autonomously through additional support of artist-run centres in the city.[33]

Mona Hatoum and Performance for Video and Slo-scan

The issue of access to technology and representation of ethnicity, race, and gender is further explored by Mona Hatoum, originally from Beirut, Lebanon. Hatoum visited Vancouver on a number of occasions to create some of her most renowned work at the Western Front through her ongoing collaboration with Kate Craig, the director of the special projects residency program at the time. Her performance *So Much I Want to Say* (1983),[34] was created for both a live audience and the computer networked video camera via performance for Slo-scan. This early form of webcasting consisted of a video signal transmitted through the phone, that was then processed through a "robot computer" at a rate of one image every eight seconds.[35]

In her performance, Hatoum attempts to talk to the viewer through the monitor screen. Male hands cover her mouth despite her struggles to remove them. A pre-recorded phrase, "so much I want to say," is repeated as we see her struggle updated as still images every eight seconds. The viewer witnesses a Lebanese woman's thwarted attempt to speak her desire through a tool of supposed democratic communication. Her access to speech as a means to convey her desire is denied and blocked.

Amidst the beginning of utopian rhetoric mythologizing the information superhighway as a neutral apparatus accessible to anyone, Hatoum clearly articulated otherwise. In this work, Hatoum creates a visual rhetoric that acknowledges, through telematic networks, the presence of systemic repression, the erasure of dissenting voices, and the visibility of difference.

So Much I Want to Say reflects a pre-cyberfeminist and nascent postcolonial discourse on the representation of power relations — especially related to gender, race, and ethnicity — through the mediation of new technology. *So Much I Want to Say* also marks an emergence of questions regarding systemic exclusion of women's experiences and voices beyond the Anglo-

30 Sara Diamond, "Daring Documents: The Practical Aesthetics of Early Vancouver Video," in *Vancouver Anthology: The Institutional Politics of Art*, Stan Douglas ed. (Vancouver: Talonbooks, 1991), 72.

31 Ibid.

32 Aiyyana Maracle, email correspondence with Tagny Duff, September 2003.

33 Most notably the grunt gallery.

34 Created during *Weincouver IV* at the Western Front. This was an exchange between Vienna and Vancouver.

35 Bell Canada offered the use of the technology for the purpose of experimentation. These experimental Slo-scan events were organized primarily by Bill Bartlett at the Western Front. Slo-scan was a precursor to current day networked webcasts.

36 Carol Williams, 181.

American feminist discourses. For example, *Fireweed*, a Canadian feminist journal, published "The issue is ism: Women of Colour Speak Out" in 1983. In this issue, racism, sexism, classism, and imperialism are discussed by Asian, Philippina, and Central American women living throughout the world. This publication created many discussions with the white liberal literary/artistic circles in Vancouver, and as a result illuminated the absence of feminist investments in issues such as racism, anti-semitism, etc. impacting sexist discrimination against women. However, as mentioned previously, the strategy of giving voice to the voiceless continues throughout much of the 80s. By the early 90s, women excluded from the majority of the straight, middle class, white feminist circles demanded equal representation within feminism. Haruko Okana warned feminists that:

> ... inclusions based on race or culture for appearances sake or as a token gesture is something women of colour, not a title I would have chosen for myself, have now had to deal with inside the contemporary social and political movements.[36]

From Carole Itter's documentation of performance with reel-to-reel video, to Mona Hatoum's performance for Slo-scan, women practicing performance art in Vancouver in the last three decades have pioneered and generated new forms of performance art and video. Most notably, the works created in the 70s reflect the spirit of reinvigorated explorations of form. The emergence of interdisciplinary art practice and the introduction of the video camera in Vancouver generated new forms of performance works. Some artists intentionally avoided the use of video in their performances, and many experimented with its potential. Simultaneously, early second-wave feminisms also struggled to articulate the call for women's rights. Later, in the 80s, feminism struggled with the issue of its own exclusion of diverse cultural representation as discussed in the video *Concerned Aboriginal Women*. Hatoum furthers a cyberfeminist debate by revealing that the dawn of the information superhighway does not signal the end of difference, but rather attempts to mask it.

Furthermore, these performance artworks using video index the beginning of a trajectory of contemporary new media performance works and concerns presented by artists today. As performance art becomes enshrined in the art canon, and as academic institutions begin to fully embrace performance art in their curriculae, it is critical that Canadian artists working in this genre are represented and included in art history. Women, in particular, continue to be under-represented in the area of art and technology. New strategies are still needed to expose the myth of technology as a neutral device. At the very least, it is necessary to create a reliable historical archive of these works for future research. In a recent email, Maxine Gadd, one of the original members of Intermedia, wrote, "electronic memory is as fragile as human memory." As cyberfeminists and post-feminists continue to challenge notions of gender and sex, representations of women, and feminism as ideologies unto themselves, we must remember that the circuits to the past are evoked through fragile and, at best, unstable memory.

AUTHOR'S ACKNOWLEDGEMENTS
Thanks to the following people for their generous support of and contributions to the completion of this article: Ginette Brideau (for critical feedback and engaging in countless discussions throughout the development of this text), Aiyyana Maracle (for the stories, critical reflections and working with me through difficult questions), Jane Ellison and Karen Spencer (for being fair and constructive critics), Carole Itter, Rhoda Rosenfeld, Trudy Rubenfeld, Margaret Dragu, Hank Bull, Maxine Gadd and Crista Dahl (for all the stories), Wade Thomas, Demian Petryshyn and Kiley Fithen (for going above and beyond the call of duty), Andrew Power (for the critical and insightful discussions), Nelson Henricks, Jack Stanley, Samantha Wehbi, and the YYZ publications staff for assistance with technical details. Without the generosity, patience, and support of the editors, Johanna Householder and Tanya Mars, this article would not have been possible.

I would like to additionally acknowledge the following institutions for the use their archives: Video In/Out, Vancouver Public Library, Vancouver Art Gallery, and University of British Columbia Special Collections Library.

Dot Tuer

Gestures in the Looking Glass

PERFORMANCE ART AND THE BODY (1987)

In the Parkdale neighbourhood of Toronto, the locals meet outside the donut shops, at the drop-in, in the bars. Park benches are full. Hookers stake the corners. There are monologue raps and drunken howls. A man in a wheelchair propelled by two huskies cuts a path through a lingering crowd. In the bank machine booth a slim bedraggled man practices ballet. Down the block, a couple fights. She slaps him across the face, a hard slap on each cheek. He goes as if to hit her and they collapse into an embrace. A wild-haired woman tiptoes barefoot through the snow, gathering brown leaves blowing in the street. Fleeing the peeling paint and four cramped walls of their rooming houses, ex-psychiatric patients gather outside a mental health clinic two hours before it opens. One sits down in the middle of the sidewalk. Another directs the evening traffic. A woman takes aim and swings her purse at invisible adversaries. On Queen Street corners, performance art is an everyday occurrence of spontaneous street actions and bodily gestures.

Performance art as a practice, as a history, is like an evening in Parkdale condensed to a description. Street actions are remembered as extraordinary events. Bodily gestures are tamed as an imaginary site of presence, deterritorialized and expropriated in the retelling. Narratives that weave the body

into the fabric of socio-political structures are disavowed. Documentation reinvents context. The Body as Alchemy, Ritual, Exhibitionism, Repetition, Voyeurism, Transgression: these are the isolated signifiers of the 1970s that become the rhetorical catchphrases of the 1980s. The de-materialization of the art-object, slipping towards subversion, rematerializes in the body's representation. The body becomes the paradoxical site of performance art: at once the vanishing point of its history and the framework for its authorization.

Once we were bodies that Christianity stormed and philosophies besieged: a warzone torn between spirit and flesh, good and evil, truth and illusion. Women were weak, with only one of Adam's ribs to encase a suspect womb. Men were innocents wandering in a corrupt wilderness of physical temptation and spiritual redemption. But as rumour would have it, the rap about the body shifted in modernity. Spirituality fell out of the sky and landed on rationality's lap. Darwin's theories of evolution and Einstein's relativity disrupted a family compact between religion and science. Marx analysed the material conditions of oppression, and Freud shouted a hysteric eureka at the discovery of bisexuality and an unconscious psyche. Modernism erected a wall of form to shore up the ego's disintegrating centre, floating between mis-apprehension and misrecognition. The body was disrobed of its innate morality, but it was not left naked. Heavy garments of conflicting ideologies clothed the masses. Subjectivity became steel-toed boots that kicked the body where it hurt. Science conspired to reinstate morality as an organic imperative of the body's biology. Pavlov barked and Skinner stood at attention. Pathology became the property of the asylum rather than the mystery of the shaman. Language, sprung fully formed as the new science of semiotics, began to distrust the body as a site of resistance. The body became abstracted, but not untangled from its genealogy.

We no longer spoke of the body, but were subjects to bodies of discourse, of knowledge, of history. Mass media superimposed the mechanics of representation upon the reception of information. Technology superimposed the mechanics of communication upon perception. Genetics reframed evolution as mutation. Sexual difference located the vanishing point of the body in the male gaze, in woman's lack. The post-nuclear age begat postmodernist theory that begat the post-political paradigm. The body became a ghost town in a gold rush of fragmentation: squeezed and flattened to a two-dimensional icon where illusion became substance. It was attached to a vast influencing machine where state and capital conjoined in a sprawling and incomprehensible system of invisible levers and pulleys. The organs of the body disappeared, traces remaining in microchip readouts of vital statistics and credit ratings. Finally, there were no longer bodies but only narratives of the subject, swirling around the decomposing corpse of venal sin.

For some, the body became an object wrapped in newspapers that subjects stepped over. For others, the subjectivity of its narratives were all consuming. The body did not vaporize into a maelstrom of indifference but became elided through commodification. Flesh became a signification of wealth, of status, of success, of beauty, of youth. The elixir of the spirit

became grafted onto a body embalmed in a murky tomb of simulation. Bodies still died and babies were born. Sex was performed. But in the wasteland of codified pleasure, intimacy became pure imitation. Collusion became the will to power, occlusion the imperative of the new morality. Torture, starvation, disease, and war became abstractions to codify the body of the "other" in First World media. For those suffering from these abstractions, the physicality of the body exceeded its narratives. For those watching on television, the body assumed immunity to the flesh through the inoculation of representation.

It is somewhere in this dystopic territory — one in which the looking glass of simulation mirrors back narratives of the subject and representations of the body — that a context for performance art emerges in the 1980s. But in negotiating the distance that lies between the body as the vanishing point of its history and a contemporary framework for its authorization, performance art faces the threat of obsolescence. Squeezed between the return of the art object and the disavowal of the body, performance art stages a theatre of presence only to uncover a representational minefield where flesh and radicalism are defused and appropriated. It becomes prospector seeking a stake in a postmodern terrain where absence becomes the new truth. The performer, in using his/her physical presence in the construction of an art piece, must account for an increasingly immobilizing configuration of economic, political, and cultural vectors that designate the body as a glitch, a bug to be ironed out. As an art form with no resale value, a poor cousin to appropriation, performance must develop a strategy of survival within a grid of representation where the body is devalued as an artificial fiction.

It is the spring of 1983. It has been several months since I moved to Toronto and began working with ex-psychiatric patients, teaching them to cook in a church café engulfed by the towers of the Eaton Centre. The ex-psychs, hemmed in by spaces and perceptions that lie outside my experience, inhabit narratives I barely comprehend. Their bodies are subject to constant surveillance and investigation, entangled in a vast network of doctors, therapists, social workers, boarding homes, work placements, social clubs, hospitals, day treatments, group therapy, and social welfare programs; their language is a colonized discourse: a memorized litany of the medical and psychological assessments of their disorders; their blood congeals with the mandatory intake of psychotropic drugs. But the eruptions from their bodies send tremors through the empire. Their subversion is not quantifiable, for it is an invisible disruption, a constant irritation, to the smooth operation of the influencing machine.

In that same spring of 1983, I see two performances at the Joseph Workman Auditorium in the Queen Street Mental Health Centre. One is a production of Artaud's *The Cenci*, using psychiatric patients in minor roles. The other is *The Schizophrenic Opera*, a collaborative performance piece produced and acted by a group of ex-psychiatric patients and directed by Ron Gillespie. *The Cenci* is an elaborate, gesturing affair. Professional actors fling themselves about the stage, screaming in catholic despair. The psychiatric inmates,

on double doses of medication to insure their cooperation, are catatonic additions to the set. The director, in attempting to represent Artaud's combustion of the body, becomes the sinister collaborator of oppression, suffocating the force with which psychosis wrenches the body from the narratives that seek to represent it as a subject. He does not liberate the body, but dictates to it, a doctor prescribing electroshock treatments to quell the anarchistic swell. The language of Artaud's *The Cenci*, where dualism between flesh and spirit is split wide open and the body emerges like a festering sore, works against the production's theatricality. It short-circuits narrative, defying the director's desire to occlude the physical wounds of the body's electrified fissures.

In *The Schizophrenic Opera*, ex-psychiatric patients compose a choral accompaniment to their own experiences of psychosis. Aberrations of a society determined to regulate imagination, the chorus of *The Schizophrenic Opera* makes no concessions to theatrical conventions. Their bodies, stripped of dramatic gesture, perform at the epicentre of their previous incarcerations, the artifice of the stage shielding their nervous systems from the neurologist's gaze. The boundaries between the audience and the performers dissipate in an atmosphere where the psychiatrist is temporarily banished from the Oedipal drama. Streams of words pour from the performers' mouths, interspersed by

PAULETTE PHILLLIPS *Cadence of Insanity Part 1*, Windsor Art Gallery, 1985

activities that frame their social space: a volleyball match, a card game, the exchange of cigarettes. Poetry becomes communication. Humour mingles with tragedy. *The Schizophrenic Opera* does not seek to tame the body, but creates a breathing space where it can foam at the mouth. It is not a sacrificial offering of burnt words, where bodies charred by representation are left for dead by the conquering troops of social control, but a manifesto of the body's refusal of assimilation with oppression.

The performance opens as five bodies move slowly across the stage, scratching and picking at each other's heads, lining up against the wall. These are not obsessional movements of a metaphysical dance, but the roll call of those captured in a chemical war waged against psychosis. Heads hurt from the doctors' prescriptions rather than from hallucinations. Hands shake from medications. Movements are slowed by the effects of past electroshock treatments rather than by a choreographer's vision. In another scene, two ex-psychs play volleyball, bouncing the ball of reason back and forth to Mozart's music. A woman winds in between them. Hers is a Stelazine dance of a body reeling from the narratives of biochemistry and behaviourism. Five ex-psychiatric patients gather in a circle. They exchange cigarettes. This is not a symbolic act, but a declaration of a black-market barter economy where cigarettes are more valuable than money. A Crazy Eights card game comes down. One player teaches another rules he cannot comprehend. In the choral configuration of this opera, knowledge of the rules does not guarantee power, nor conform to logic. Representation is born of hallucinations and charted through socio-political structures that veil its origin as a revolt against the system. There is resistance here, but no organized site of opposition. The body becomes a slippery nexus of sensation and memory, sliding across the vectors of language like an unidentifiable blip on a radar screen: its path observed, but its purpose incomprehensible.

It is the summer of 1986. As the first wave of heat swaddles the city, humidity licking up pant legs and curdling in pavement cracks, everyone begins to search for an air-conditioned paradise. To the movies they go, enduring endless teen comedies and action flicks as their sweat dries into lingering smells that mingle with the scent of buttered popcorn. Down by the lake at Harbourfront, tourists mill in orderly throngs, bodies directed by architectural design, eyes blinking in unison at the white-capped waves. Tucked away between the beer tent and a duck pond that has defied a generation of city planners by attracting not a single fowl, there is a miniature version of Ottawa's National Arts Centre disguised as a warehouse. It is not a dollhouse, but the Ice House, promising frigid entertainment on hot days. But the word has not got out, and *True Tales*, a performance art series curated by Christian Morrison, becomes a tectonic fairy tale that the tourists miss in their orchestrated tour.

Morrison's program notes suggest a context for performance art that situates the body between technology and the psychotic, somewhere in the vast terrain of the influencing machine. Claiming each piece "desires to rediscover aspects of (its) own narrative," Morrison prefaces his declaration

with an invocation of Artaud's three-hour performance at the Vieux Columbier in 1947. He quotes from Maurice Saillet's description of the audience reaction where "it was as if we were drawn into the danger zone, sucked up by all that black sun, consumed by an overall combustion of a body that itself was a victim of the flames of the spirit." *True Tales*, Morrison cautions after this description, "imparts a false dialectic" in which "the vision of truth in the utterly fantastic is at once hopeless and bountiful" and the "preordained" in language may be precluded by "a less formal body of knowledge." Somewhere in this convoluted treatise — one that juxtaposes the heat of Artaud's hallucinations with a false dialectic of truth and language — Morrison becomes the modern preacher. From his pulpit, he demands the "spirit of rigour" and our "rapt gaze" as he cloaks the body in a rhetorical fabric in which Artaud is the new Christ, of spirit and not earth, and the ability to tell tales the new morality that privileges the word over flesh. He throws, to viewers and performers alike, a gauntlet challenging them to a narrative duel over the body as an artificial fiction.

Paulette Phillips, as one of the artists participating in the series, picks up his gauntlet to weave a tale that oscillates between technological mediation and the telling of true tales. In accepting the terms of Morrison's challenge,

PAULETTE PHILLLIPS Caroline Azar in *Cadence of Insanity*, DuMaurier Theatre, Toronto, 1986

PAULETTE PHILLLIPS *Cadence of Insanity*, performed at the Euclid Theatre, Toronto, 1994

she entraps the body in a barbwire mesh of rationalizations and illusions in which there is no opening, no rupture, to extricate the body from the narratives that occupy it like a virulent anti-matter virus. Instead, her performance piece functions as a litany of those fictions which women as bodies take up as self-representations. Her body, once a bronzed and naked female Christ sacrificed to objectivity in *Find the Performer*, becomes resurrected in *Cadence of Insanity* as an anonymous bureaucrat sitting at a desk. A woman dressed as a man, posing as a middle-management mandarin, her performer tells a tale of a woman living in a city. As the technocratic storyteller, she packages the de-materialized body of the woman she describes in a box of contemporary rhetoric: offering up a psychological profile of a woman clothed in sexual difference, and caught between a sharp-edged teeter-totter of external narratives and internal monologues.

Visually, Phillips establishes a triangular relationship between her performer and projected images, between the body and its representations. To the left-front stage is located the desk where the performer sits — a stand-in for the woman of the story — who mediates between video and filmic recapitulations of her true tales. Behind her to the rear-right of the stage is a video monitor, a beacon mounted high upon a stand like a signal tower, where close-up images of the performer's face become transmissions of distance. At the back of the stage, a wooden latticed backdrop of black squares houses the rear-projection of a super-8 film in one of its panels. It evokes the image of a tall office building at night, where a single illuminated window expels the pent-up energy stored from business hours. But while in a city street, pedestrians might strain to glimpse inside, only to see one lone executive working late, the view through this constructed window offers the audience a kaleidoscope of images. It becomes a visual collage that corresponds to both the exterior and internal worlds of the stories we are told. Thus the "true tale" becomes a latticed narrative that is bounced off, and strained through, a sieve of electronic and cinematic projections. It is a story where technology and fantasy meet in the description of a woman who is never present, whose body has become a by-product of subjectivity.

The narrative begins quite simply, as the story of a woman who moves to the city where "it was all quite orderly," where "sometimes she felt like she was part of it all, part of a great city." The tall buildings that at first overwhelm her also contain their own stories, monologues of workers whose jobs are made redundant through computers or bosses' whims. The park where she sits to read a book is the scene of fifty dollar lays and heroin addictions. But it is we as the audience listening to the narrator, and not she, who are party to these other tales. And so the orderly construction of both the city and her life does not disintegrate through the recognition of narrative contradictions, but through her personal confusions and projections. She wonders about God. An image of the solar system peers through the rear-screen panel. Like parallel worlds, the social controls of a highly technological society and her individualized musings meet in a post-Euclidian universe. She cannot sleep, then falls prey to a dreamless sleep, a vampire's

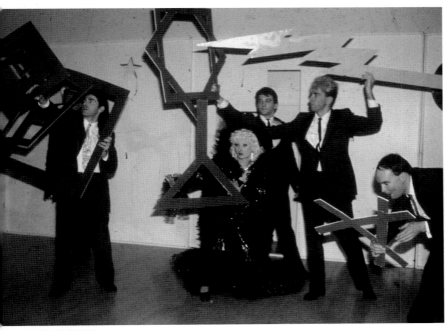

ISAAC APPLEBAUM

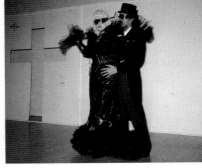

ISAAC APPLEBAUM

sleep that flickers as an image of Nosferatu on the screen. Is it technology or the body that has overpowered her? It is not a question she ponders. For upon awakening, she begins to construct her dreams according to the desires of others: from Freud's theories, her lover's needs, the city that surrounds her.

A dream of a two-headed baby, a monster, is realized as a pregnancy. She becomes "a symbol of representation, a bearer of meaning," imagining the birth as the heady feeling "one must have felt participating in the suburban ideal." But the story that follows, of parents living in this "urban frontier" with their son flaunting women's flowered underwear, is not part of her tale. She ponders about birth and about death. She loves and gets bored. She awakes in the city, but she has lost sight of her dreams. They are capsulated in a small office window of a tall office building. She cannot, will not, know where her body intervenes as a force which questions the narratives that encode it. Truth, in Paulette's tale, becomes the alienated distances between women's bodies, dreams, desires, and the sculpted technology of their environments. There is no combustion of the body here, only its cool disintegration. Hot flashes of anger and comic pauses punctuate the narration, but the woman of the true tale remains throughout the flickering shadow of projected illusions. Hers is not a wet dream, but the dry nightmare of a body entombed in

TANYA MARS *Pure Sin*, A Space, Toronto, 1986. Mae West with men as cosmic particles. Left to right: Angelo Pedari, Tanya Mars, Kevin McGugan, John Greyson, and Andrew J. Paterson

TANYA MARS and **COLIN CAMPBELL** in *Pure Sin*, A Space, Toronto, 1986

its own narrative grave. And so, in the last moment of the performance, the storyteller as the woman lost to representation, suddenly halts in mid-sentence, screams "WAIT," whispers "everything is bad and then it gets worse" and asks "is that true?" to end both the tale and the performance.

It is December 1986. The Bill of Human Rights in Ontario has just been amended to prohibit discrimination on the basis of sexual orientation. *The Body Politic* is preparing to announce its self-engineered demise. In Toronto, the Glad Day Bookstore is being forced out of business by seizure of incoming books and magazines at customs. *The Joy of Gay Sex* is banned. Oscar Wilde's memoirs are held at the border upon suspicion of containing obscene material. The ERA in the United States conceptualizes a legal status for women to evade the prejudice of gender, considering implementing the term *pregnant body* when fighting for improved maternity benefits. A Toronto prostitute who is picked up by the police declares she is infected with AIDS. The media get scent of a story and track her down like a pack of hounds ready to tear a fox to pieces. Conversations gravitate towards disease, but steer away from the body. Sex becomes an exaggerated signifier one connotes through style and avoids in practice. Monogamous heterosexuality is no longer simply a moral prerogative but a medical prescription. Celibacy has become the new religion. Sin is the last thing on anyone's mind. Enter Tanya Mars as Mae West in *Pure Sin*.

Mae West, a screen sensation and raucous sex symbol of the 1930s and 1940s, was known in the business as an actress with impeccable timing. Tanya Mars shares this knack for timing, choreographing a strategic resistance to the increasing schism between sex and the body. In *Pure Sin*, Tanya Mars as Mae West upsets the apple cart of history by using men as props for, rather than objects of, her desire. The "men," as they are billed, romp through various scenarios like choirboys in a Christmas pageant, trying to maintain their dignity in a *mise-en-scène* that only serves to underline their absurdity. Tanya Mars as Mae West tells the audience she "used to be Snow White, but I drifted." The men, however, are still the goofy dwarfs of a fairy-tale that patriarchy constructed in an ante bid to establish dominance over flesh, placing restraining orders on women's bodies. Flaunting her sex to claim satisfaction over sin and pleasure over censure, Tanya Mars as Mae West plays tricks on an historical dualism between flesh and spirit, her men becoming johns in an economy where they no longer have the philosophical cash to prostitute women's bodies in exchange for the power of narrative. Flaunting her body as the site of female power and relegating the men's to a repressive spirituality, she creates a context for performance art where it is the boys, not the girls, who are entrapped by historical cues.

In this sly mixture of philosophical propaganda and vaudeville humour, the myths of creation meet the myths of Hollywood. Tanya Mars as Mae West is proclaimed by the men of *Pure Sin* as sinful, weak, destructive, night, chaos, an abomination, a vampire, and a "usurper of the laws." A voice-over that parodies Rod Serling from the *Twilight Zone* makes it clear that God invented man to rule over woman and suppress her dangerous

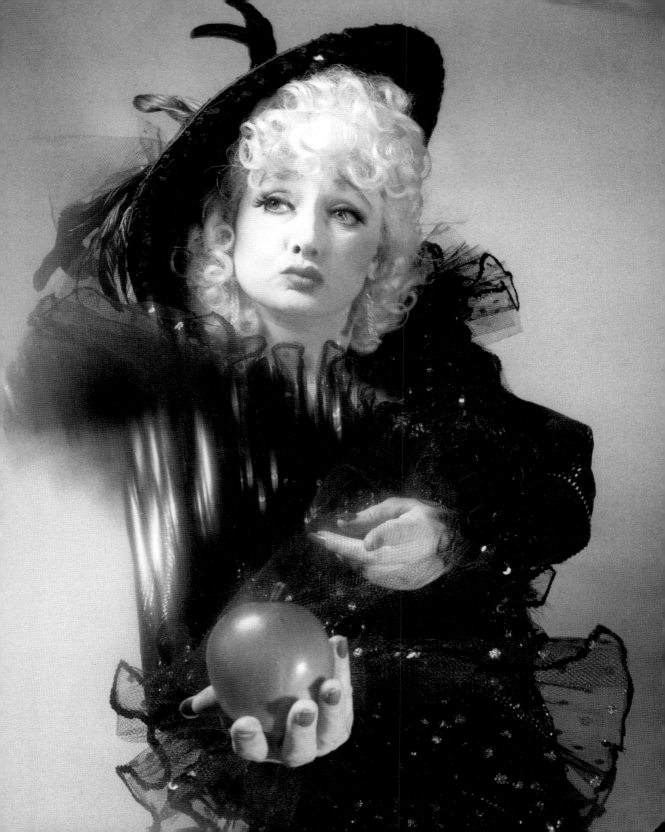

desires. The men, still buying into this genesis of the universe, romp around stage in priestly attitudes trying to send Mae West to hell while jerking off at their crosses. She disdainfully ignores their condemnation. She toys with their repression. A monster with the looks of a sex goddess, she needs men for one thing and one thing only: to service her dangerous desires. As a woman born into a creation myth that stresses the binary divisions of night and day, earth and sky, dark and light, woman and man, sin and purity, Tanya Mars as Mae West is beyond redemption. Playing the part of a Hollywood icon in drag, Mars counters the artificial fiction of the body by appropriating a legend bred of Tinseltown notoriety who subverted narratives of sexuality every step of the way.

While other female stars of the time were mysterious, slim, porcelain creatures whose dreamy eyes and soft movements were directed towards the leading men, Mae West was the Andy Warhol of Hollywood, using media attention and the cinematic screen to promote herself as the focus of spectator identification. She was famous for her bawdy wit and a playful vulgarity that brought sex to centre stage and put men in their place. She wrote her own scripts, in which narrative was an ornamental vehicle to celebrate her sexuality and dialogue a sequence of bodily callisthenics and comic quips that ran circles around a large cast of the opposite persuasion. Over forty when she starred in her first Hollywood movie, West was already notorious from her vaudeville days, when her theatrical productions were raided by the police, and West arrested and jailed on obscenity charges. What Brecht was to theatre, West was to sexuality, her fascination with the seamier side of life championing representations of prostitutes, transvestites, the underworld, mixed racial romances, and sexual ambiguities.

By miming the body of this legend, Mars stages a spectacle of female sexuality that unveils a dualism stalking the body as the vanishing point of performance art's history. In the 1970s, the body in performance art was a male terrain. Men strutted their cocks and shed their clothes to claim the body's presence as a site of transgression, while women, stripped naked, played into an historical objectification of the feminine. When the theoretical terrain got rough, men zipped their cocks back into their pants and declared that the body was an illusion, a surface to be mapped. Women, with nothing gained and the body disappearing in a maze of rhetorical manoeuvres, embraced a cat-and-mouse game of deconstruction that declared presence as absence and the body as a linguistic construction. What men lost in presence, they made up for in simulation. What women never had in presence went unnoticed as the body became folded back into a grid of representation that privileges continuity over aberration, and trades the imaginary presence of the body as circular appropriation.

In defiance of the rhetorical manoeuvres that fragment, diffuse, and recuperate the body as an artificial fiction, *Pure Sin* locates in the body's presence an old-fashioned war zone of the sexes. The performance begins with a confession of sin by a woman and a benediction by the men. But when the woman reappears as Mae West, this dualism soon becomes inverted and

mangled. The sounds of a whip turn out to be those of the domatrix rather than of the men's self-flagellations, transforming transgression of the 1970s into comic relief in the 1980s. As the men walk through the set carrying cardboard symbols of alchemy, Tanya Mars as Mae West lassoes one of them, declaring "I like my lovers tied up." She herds the men, seduces them, teases them, and tempts them. She assassinates the hierarchy of gender and affirms the presence of the female body without denying the power of its narrative projections. She knows when to flaunt the body and when to align it, telling the boys hanging off their fruits in paradise that while she may have lost patience with the groundskeeper, she sure has a thing or two to teach his wife. At the end of the performance when the lights come up to reveal Mars naked, and men robed as priests decrying her corruption, radicalism becomes the act of putting clothes back on and not taking them off. For long after one has forgotten the voice-over, the props, and boys of *Pure Sin*, it is the spectacle of Mars in turquoise-costumed drag that lingers.

It is April 1987. The United States Patent and Trademark Office announces that animals produced through gene splicing and new reproductive techniques can be patented by their inventors. One scientist has already spliced human genes into a pig. Unfortunately, its offspring are arthritic. The House of Commons is preparing to debate the reinstitution of capital punishment and a pornography bill that would make the representation of consensual intercourse between adults illegal. Baby M, conceived in a rented womb, now has a name and a narrative within a system that chose the maternity of economic privilege over that of the birth mother's labour. In the United States, motherhood is worth $10,000. In Brazil, a baby can be bought for a fraction of the price. In Columbia, muggers will blow away a body for the $10 in its pocket or for the running shoes on its feet. An ex-psychiatric patient in Toronto fetches $500 a month in social assistance. A body crippled in a car accident is worth much more. And a representation is the most valuable commodity of all; Van Gogh's *Sunflowers* selling for thirty-nine million American dollars. In the looking glass of simulation, the narratives of the subject and representations of the body mirror back the economic policies of Reagan and Thatcher, spawned in an age of mass media dissemination and a free-fall market ideology. Yet growing poverty and the homeless pouring into the streets are physical reminders that the body's presence exceeds its exchange value as an artificial fiction.

Performance art, sliding between the contingencies of its art world context and the body's presence within a complex web of lived experience and artificial fictions, has the possibility to disrupt the domino effect of simulation. But in order to effectively challenge, and not simply mimic, the circular appropriation of the body within late capitalism, it must redefine its gestures in the looking glass. It is not a matter of inhabiting the semantics of presence but in taking up an antithetical position to a false economy of representation. For that evening in Parkdale really happened. The body is still tamed through medication, the flesh still vulnerable to war, hunger, and disease. Simulation has the power to reshape our desires and dreams; mass media affects the

outcome of revolutions and empires. It is not that the body has disappeared. Rather, it has become enfolded into narratives of the subject that render invisible its resistance to the smooth operation of the influencing machine.

In the works of Gillespie, Phillips, and Mars, the staging of a theatre of presence reveals the schism between the presence of the body and its abstraction in representation. From pure psychosis to true tales to pure sin, they propose strategies for the survival of performance art in which the body is no longer an isolated signifier of flesh and radicalism but contaminated by artificial fictions. Locating in the site of performer's body a discursive impediment, a thorn in the side of theory, a counter-spectacle, they transform the transgression of the 1970s into narrative subversion in the 1980s. When the ex-psychs in *The Schizophrenic Opera* compose the choreography of their everyday lives, they become troublemakers disrupting an institutionalized narrative of pacification. When the technocratic storyteller in *Cadence of Insanity* yells "WAIT" to halt a mirage of projected illusions, the encoding of absence is unveiled as a lack of access to self-awareness. When Tanya Mars as Mae West takes on the boys in *Pure Sin*, the linguistic play of sexual difference materializes as an historical dualism that denies the female body the power of its own narrative destiny. In each, their gestures in the looking glass render visible the politics of representation as a struggle over the control of real bodies in time and space.

★ ★ ★

This article first appeared in *C Magazine* no. 14, (1987).

Elizabeth Chitty

Asserting Our Bodies

The most familiar lineage in contemporary performance art history is traced to Europe at the beginning of the twentieth century with the Futurists and Dadaists.[1] Both of these groups of artists were multidiscipli-nary, including poets, painters, sculptors, musicians, theatre artists, and dancers. This lineage is limited in that it is Euro-centric and omits, for example, First Nations and other traditions that have had an impact on con-temporary performance practices. However, my point is that performance history is not specific only to the visual arts.

If performance art has defied and resisted definition in the past then it is assuredly difficult to assign specific values to its practice; however, I main-tain that an essential value of performance art is its embrace of multiple approaches. As the desire to fix a definition and rationalize a history pro-gresses, it will be critical to allow for multiplicities if this history is to be coherent with the values of the practice.

In Canada, the practice of performance art emerged in the 1970s in tandem with the network of artist-run centres, or "parallel galleries" as they were then called. The moniker, parallel galleries, was an expression of the infrastructure of visual art; the galleries ran parallel to the streams of public institutions and private sector commercial galleries. Most of the early parallel galleries

1 Roselee Goldberg, *Performance: Live Art, 1909 to the Present* (New York: Harry N. Abrams Inc., 1979).

embraced strong multidisciplinary mandates and their programs included experimental music, literature, theatre, and dance.

At both historical junctures of the early twentieth century in the art centres of Europe and in art centres in Canada in the 1970s, performance art reflected the intersection of multiple disciplines and a disregard for conventional disciplinary boundaries.

Dance was one discipline that mingled in these parallel galleries. This essay considers the work and issues of some women artists in Canadian performance art in the 70s and 80s who emerged from the discipline of dance. Dance: denote[s] specially marked or elaborated systems of movement (how movements are specially marked or elaborated is culturally specific) that result from creative processes that manipulate human bodies in time and space in such a way that movement is formalized and intensified in much the same manner as poetry intensifies and formalizes language.[2] It has its own traditions, histories, and theoretical tools (for example, anthropology is a far more active critical lens in dance analysis than in visual art). Dance was the last conventional artistic discipline to be admitted to the universities as a legitimate area of study; in Canada, this did not happen until 1970.[3] In a culture still diseased by the Cartesian body and mind split and still tainted by a religious history of reviling our bodies,[4] this minimized status is unsurprising.

Like all artists, the dance artists brought disciplinary specifics to the 1970s multidisciplinary mix. They participated in Canadian performance art practice from positions of embodied knowledge. This essay discusses embodiment, physical practices, and points of tension between dance and visual art. It includes contemporaneous descriptions of works by Margaret Dragu, Lily Eng, and the members of The Clichettes (Louise Garfield, Janice Hladki, and Johanna Householder), all of whom practiced in Toronto in the mid- to late-70s. Blurring boundaries and opening the discipline of dance to other influences were key motivations for these artists.

Houses for Flesh

There are diverse relationships between body and environment, body and place, body and site, body and earth, and numerous ways of qualifying physical space. Physical buildings, access to them, and the social constructs administering them play a major role in art production. All the artists discussed in this essay performed at the Toronto artist-run centre, A Space, at its original location on St. Nicholas Street, amidst the mélange of multidisciplinary programming of the 70s. Photographers-turned-holographers gave performances in lab coats with white rats (Fringe Research[5]); sound poets gave forth wild sounds in poetry readings run amok (The Four Horsemen[6]); and the early work of VideoCabaret[7] held forth in the basement in a potent mix of theatre, rock music, and video. Missing Associates (Peter Dudar and Lily Eng) were part of CEAC (Centre for Experimental Art and Communication), which had a multidisciplinary program of visual art, video, film, experimental music, and dance. As well as presenting many international artists, it presented

2 Adrienne L. Kaeppler, "Understanding Dance," in *Garland Encyclopedia of World Music.* vol. 9. A.L. Kaeppler & J.W. Love, eds. (1998), 312.

3 The first university dance program was at York University in Toronto and some of the artists discussed here were amongst its early graduates.

4 I purposefully use "our bodies" instead of "the body" to emphasize the possessive determiner and avoid the distancing, disembodying connotation of "the." For this I am indebted to discussion within the pedagogical dance community and to Deborah Jowitt's comments at the conference, *Not Just Any Body*, in The Hague and Toronto, 1999.

5 Fringe Research were David Hlynsky and Michael Sowdon.

6 The Four Horsemen were Rafael Barreto-Rivera, Paul Dutton, Steve McCaffery, and bp nichol.

7 VideoCabaret was co-founded by playwright and director Michael Hollingsworth and Hummer Sister Deanne Taylor. See www.videocab.com for a history.

8 Dot Tuer, "The CEAC Was Banned in Canada," in *C Magazine*, no. 11 (1986), 32.

9 Lawrence Adams quoted in "Swan Song for Fifteen Dance Lab," William Littler. *Toronto Star* (May 31, 1980).

LYNN ROTIN

local performance art that ranged from the experimental dance of John Faichney and Missing Associates, to the shamanistic ritual performances of Wendy Knox-Leet and the work of Ron Gillespie and others that became known as behaviouralism; actions involving "articulating the formal mechanics of 'socially' unacceptable behaviour." [8]

Many of the artists discussed in this essay performed in at least one of the series of outdoor site-specific works (the term used was *environmental dance*), which took place between 1974 and 1976: GRID, Phantom, and D.A.N.C.E. Two of the three Dance Artists series took place at St. Paul's Centre, a community centre/theatre/church (1976), and Café Soho, a second floor space above a Queen Street restaurant (1977). The Music Gallery, on St. Patrick Street, hosted events such as DanceWorks/Improvisations. All of these events and series were artist-run. Some of the artists performed on proscenium stages.

While these artists performed in a variety of spaces, all of them had early association with 15 Dance Lab in Toronto. 15 Dance Lab was a 24-foot by 32-foot black box theatre operated by Lawrence and Miriam Adams from 1974 to 1980. "Your rear was as good as your face ... The audience was all around you." [9] In 1969, the Adams had fled the confines of the The National Ballet of

ELIZABETH CHITTY *Extreme Skin.*
Performers (not all are pictured): Mary Anderson, Margaret Atkinson, Michael Baker, Ron Boychuk, Catherine Carpenko, Phyllis Eckler, Anne Egger, Irene Grainger, Jim Gronau, Jean Hamilton, Darlene Hawke, Janice Hladki, Debbie Jones, Patti Morley, Paula Ravitz, Kathy Richan, Andrew Ross, Zella Wolofsky. A Space, Toronto, 1977

Canada (where Lawrence was a soloist famed for roles such as Mercutio in John Cranko's *Romeo and Juliet* and Miriam was in the corps de ballet), fed up with the lack of artistic freedom and intellectual stimulation. In 1972, some students of Adams approached him with the idea of creating dances and this led to the formation of the collective/company Fifteen Dancers. They opened a learning resource centre for dancers, teaching skills needed to survive independently, and in 1974, Fifteen Dancers was reinvented as an "atelier," 15 Dance Lab, open to anyone who wanted to make and show dance.

There was no theoretical or aesthetic agenda beyond the Adams' ethic of self-determination. Work of wildly varied aesthetics took place at Fifteen and its directors never curated. Fifteen had an open-door, first-come, first-served policy; choreographers were paid $250 and eighty percent of the box office. Its impact was national and its views had national exposure through the young Dance in Canada Association and its conferences. 15 Dance Lab was the right thing in the right place at the right time; the function of access had an extraordinary effect and shaped the possible. It liberated.

By 1975, Fifteen had become a hub of choreographing, performing, video-making, publishing, and talking for the experimental choreographers who took a performance art direction. The term, *independent choreographer* arose in discussions, proposed by Peter Dudar and modelled on the term *independent filmmaker*. Issues of the politics of artistic production were high on the agenda and the artists rejected the hierarchical structure of the traditional dance company. Feminism and concerns with issues of power influenced this politic.

The term *dance artist* was promoted by Adams to underline that dancers could be creative artists, not merely the tools of the creative artist/choreographer. *Dance Artists '75* took place at Fifteen and was the first in a series of performances that brought together some of the experimentalists: Susan Aaron, Lawrence and Miriam Adams, Jill Bellos, Margaret Dragu, Missing Associates, and myself.

The Adams were fiercely nationalist; in the mid-70s, it was still a struggle to emerge from colonialism and the domination of American culture. Self-determination was heavily mixed with self-reliance and a homemade sensibility about resources. This extended to the young medium of video (black and white, open reel, half-inch format) and documenting dance was the mission of Fifteen's video arm, Visus. Access to video equipment and exposure to video art within the multidisciplinary climate of the artist-run centres led to the use of the medium by some of the choreographers.

Spill was the first of a series of dance publications to come out of Fifteen; publishing later became a focus of the Adams' work.[10] The Adams and I carried out all production from typesetting to printing. The focus was to take dance writing away from opinion and aesthetic taste-making to descriptions of what happened in a performance.[11] Choreographer's notes and scores were published. Both of these determinants aimed to prioritize artists' voices. Its editorial policy was one of non-editing, based in the position that dance and dance-writing in Canada were too nascent to limit.

10 The Adams took on the task of archiving Canadian theatrical dance history and publishing through the organization Dance Collection Danse. Lawrence Adams died in February 2003 and Miriam continues the work with her colleagues.

11 My part in forming this focus was based in studies in Dance Criticism with Selma Odom at York University and the influence of the New York dance critics. For an interesting discussion of this criticism with historical hindsight, see Roger Copeland's "Between Description and Deconstruction" in *The Routledge Dance Studies Reader*, Alexandra Carter, ed. (New York, 1998).

DOC THOMAS

LYNN ROTIN

Many internationally successful Canadian choreographers passed through Fifteen but it was not about launching careers; Fifteen was about providing an enabling framework and seeing what would happen.

Minimalist movement and pushing the boundaries of theatrical space are evident in the following description of *WKEY*, a 1976 work by Johanna Householder, John Miller, and Doug Spitznagel:

The performance opened on two big, wooden boxes, inside of which were John and Johanna, who echoed each other's sounds — rapping on the box or floor and calling one another's names. After the boxes were removed, a sequence of rolling began. Two people rolled while the other watched the monitor. The rolling was dynamic and direct and nothing stopped a roller in his/her path. When rollers collided, they bashed against each other continually until one popped up and over. The performance activities which were constructed created interesting behaviour, such as the behaviour of the bamboo pole appendages of John and Johanna in the next part. The poles influenced the movement sequences which were being repeated. A chase took place between Johanna and Doug, who were blindfolded. It unfolded simply to its natural climax ... The performance ended outside on George Street which was lit by red flares while the blindfolded performers tried to

JANICE HLADKI Irene Grainger in *A Party*, Toronto, 1977

SPILL no. 7. 1977. Cover image: Johanna Householder

find one another. The flares and the lit street were so fascinating that all I saw of the performers were faint, vague but intrepidly moving bodies.[12]

Word Made Flesh

The idea of the physical and mental self as a stable and finite form has gradually eroded, echoing influential twentieth century developments in the fields of psychoanalysis, philosophy, anthropology, medicine, and science ...

Artists making performative work have sought to demonstrate that the represented body has a language and that this language of the body, like other semantic systems, is unstable. Compared to verbal language or visual symbolism, the "parts of speech" of corporeal language are relatively imprecise. The body as a language is at once inflexible and too flexible.[13]

A key point of tension between the performance art that grew from dance and that which grew from visual art is the relationship between body and word. The quotation above is from an art historian and contrasts with what I hear from dancers: that our bodies have "honesty" which words cannot challenge; that dance can express when words fail.

I hear from my dance students that fluidity of meaning is to be valued (surely a postmodern concept) and that ambiguity is not to be confused with lack of intention or clarity but is the necessary outcome of a reading that includes the audience. My own artistic history in the 1970s was to place value on multiple interpretations because they resisted authoritarian, "engineered" reading:[14]

For the most part, words are inadequate, misleading, and distracting. Words have a way of tidying up and homogenizing the messy aspects of spontaneity, creativity, and emotionality; of ignoring and devaluing what is invisible or painful; of trivializing what cannot be pinned down and categorized. To get at the essence of embodied knowing and attune ourselves to what lies within and around us, we must let the words fall away.[15]

Although this quotation comes from a professor of education, it describes a "dancerly" point of view, affirming the belief in the ability of our bodies to "speak."

Moving from dance to performance art in the 1970s meant moving from dance conventions to possibilities informed by multiple disciplines. These possibilities soon became sharply focused (or limited, depending on one's point of view) by the emerging importance of cultural theory, especially issues of representation. The role of theory in determining art practice grew during the late 70s and with it, the power of curators and critics increased. Even when those same curators and critics emerged from the artist-run centres, it meant that the balance of power shifted again from the primary production of the artist to the word.

Although cross-disciplinary issues were important (consider for example, the importance of film criticism to feminist visual art theory) dance has been an uneasy "fit" for visual art concerns. In the context of discussing Yvonne Rainer's film work, Peggy Phelan has said the following of dance:

12 Elizabeth Chitty, "WKEY" *Spill*, pilot issue (June 1976).

13 Tracey Warr and Amelia Jones, *The Artist's Body* (London: Phaidon Press, 2000), 11 & 13.

14 Gene Youngblood, *Expanded Cinema*, (New York: E.P. Dutton & Co., 1970), 60. The critical source that helped form this view came from experimental film: "By perpetuating a destructive habit of unthinking response to formulas, by forcing us to rely ever more frequently on memory, the commercial entertainer encourages an unthinking response to daily life, inhibiting self-awareness. Driven by the profit motive, the commercial entertainer dares not risk alienating us by attempting new language even if he were capable of it. He seeks only to gratify preconditioned needs for formula stimulus. He offers nothing we haven't already conceived, nothing we don't already expect. Art explains; entertainment exploits. Art is freedom from the conditions of memory; entertainment is conditional on a present that is conditioned by the past. Entertainment gives us what we want; art gives us what we don't know we want. To confront a work of art is to confront oneself — but aspects of oneself previously recognized."
This is a view rooted in a critique of popular culture and which I applied to conventional dance forms; it sees individual transformation as the goal of art and looks to form as its tool. I was introduced to this text in 1975 at Visus' Video University.

15 Sharon M. Abbey, ed., *Ways of Knowing In and Through the Body: Diverse Perspectives on Embodiment* (Welland: Soleil Publishing Inc., 2002), ix.

16 Peggy Phelan, "Feminist Theory, Poststructuralism, and Performance," in *The Drama Review*, vol. 32, no. 1 (T117) (spring 1988), 112.

17 Amelia Jones, "Survey," Warr & Jones. Ibid. 20.

18 For Jones' clear description of her goals and my choice of words in this sentence, see *Body Art/Performing the Subject* (Minneapolis and London: University of Minnesota Press, 1998), 9.

19 I have arrived at this definition much more from physical practices than from reading and would like to acknowledge my indebtedness to two teachers in my current and on-going process of re-embodiment, Fides Krucker and Fiona Griffiths. For a paper on embodied singing under the tutelage of Krucker, see: "Reclaiming Voice through Embodied Singing," by Joanna Mackie with excerpts from Fides Krucker, in Abbey, 177-180.

the form itself demands a present-body, a commanding belief in the manip-ulative possibilities of space, and an "authentic" (and ideal) movement signature to connote Presence. Narcissistic red-herrings are endemic to a form in which subjectivity and objectivity are located in the physical body — as a dancer, one's own body; as a choreographer the bodies one author/izes to move. In this sense (admittedly counter-intuitive), dance is too literal, too claustrophobic a medium to pursue the kind of hypothesis about the inter-relationship between representational subjectivity and objectivity …[16]

Counter-intuitive is an interesting descriptor. Which is too literal and claustrophobic — the medium of dance or post-structuralist theory? The authority of theory in art practice has meant that authenticity of experi-ence in its totality of intellect, emotion, physicality, and spirituality was eclipsed by disembodied intellect. I have never been able to reconcile the pluralism and relativism that are surely significant to postmodern critical discourse, (and to which I assign positive ethical values) with its domination within art discourse.

The supremacy of theory over artistic practice privileged word over image and reinforced the Cartesian mind and body split whereby "real" knowledge is achieved only through thinking, reasoning, and verbal lan-guage. To me, this betrays the concept of artists' self-determination, and more fundamentally, the very position of art in a culture that so privileges mind over body, and rational thought over diverse ways of knowing.

Amelia Jones has posited body art as an expression of postmodernism (if not its epicentre) with this frame:

Modernist art history and criticism, derived from Kantian aesthetic dis-course, are predicated upon the suppression of the particular, embodied, desiring subject; the artist and the critic must remain transcendent rather than immanent (embodied)… The question of why the artist's body is largely veiled or repressed within Modernism is thus at least partly explained by the stakes of the aesthetic. Its philosophical structure privileged a certain "dis-interested" and thus resolutely disembodied subject — usually the white, Western male: the allegedly universal subject or transcendent, disembodied cogito of Descartes's philosophy of being.[17]

Ascribing potential radically dislocating powers[18] to artists' use of our bodies vis à vis Modernism does not read for dance. It would be hard to maintain that our bodies are absent in the history of dance; the attribute of destabi-lizing Modernism cannot be ascribed to dance because of the presence of our bodies *in* Modernism. Is the notion of embodiment as destabilizing effective as an analytical tool in approaching the work of performance artists who developed out of the dance field? Couldn't it be said that the dance-turned-performance artists actually eschewed, rather than embraced, embodiment when they turned away from dance? And what do we mean when we use the word *embodiment*?

I offer this definition to clarify my own use of this term — conscious awareness interconnecting our physical bodies with our emotions, thoughts, and spirits.[19] Using this definition, mere use of our bodies does not indicate

embodiment nor is embodiment the necessary outcome of physical action or virtuosity. There are many disembodied dancers dancing.

Dance is silent. The lips are shut tight ... there's no guarantee that because the body is filling every moment with action, the mind can't also be filling every equivalent moment with disembodied thought. For me, the thoughts were often about the action: judging, evaluating, or directing.[20]

The subject of virtuosity is relevant not only to a distinction regarding embodiment. It was an important issue in the 70s and devaluing or debunking dance virtuosity was a feature for all the artistic practices reviewed here. A major reference point was Yvonne Rainer's article, "A Quasi Survey of Some 'Minimalist' Tendencies in the Quantitatively Minimal Dance Activity Midst the Plethora, or an Analysis of Trio A." This text, first published in 1966, draws parallels between "new" or "postmodern" dance and the characteristics of minimalism in visual art. Rainer describes the new dance as "eliminate[ing] or minimize[ing] ... the virtuosic movement feat and the fully-extended body" and "substitute[ing] ... human scale:"[21]

The display of technical virtuosity and the display of the dancer's specialized body no longer make any sense. Dancers have been driven to search for an alternative context that allows for a more matter-of-fact, more concrete, more banal quality of physical being in performance, a context wherein people are engaged in actions and movements making a less spectacular demand on the body and in which skill is hard to locate.[22]

The move from virtuosic dance language to pedestrian and "found" movement, from conventional form to flattened phrasing (termed *equality of parts*), and the "repetition or discrete events, neutral performance, task, or task-like activity"[23] set the postmodern dance mandate that led some dancers to practices later defined as performance art. This mandate was primarily concerned with form and a politic of democratization. Speaking for myself, I regard my early work as enacting disembodiment; it was intellectually driven and about intent not expressivity, although there is no question that emotion often seeped, sometimes poured, through.

I understand concepts of embodiment in terms of our way of being in the world. Currently, intersections between technology and our bodies such as the phenomenon of the cyborg often propose displaced embodiment as a utopian and desirable future. This viewpoint usually sees our bodies as obsolete and reinforces a dichotomy between nature and technology. For me, this viewpoint is intrinsically linked to the scientific materialism of conquest over nature and its outcome of environmental destruction. Our attitude to our bodies and embodiment expresses our ethics and politics:

[The twentieth] century has witnessed an incomprehensible savaging of flesh. Its global and local wars, genocides, politically directed torture and famine, terrorist attacks, the selling of children and women into prostitution, and personal wanton violence to family members and street victims [are] ... evidence [of] ... criminal disregard for the muscle fibers, fluids, and neural networks within which we live ... these painfully tangible wounds to the body politic are symptomatic manifestations of highly abstract ideas that

20 Ruth Zaporah, "Dance: a body with a mind of its own," in *Being Bodies: Buddhist women on the paradox of embodiment*, Lenore Friedman and Susan Moon, eds. (Boston: Shambhala Publications Ltd., 1997), 130.

21 Yvonne Rainer, "A Quasi Survey of Some 'Minimalist' Tendencies in the Quantitatively Minimal Dance Activity Midst the Plethora, or an Analysis of Trio A," in *Minimal Art A Critical Anthology*, G. Battcock, ed. (New York: E.P. Dutton & Co., 1968), 263.

22 Ibid., 267.

23 Ibid., 263.

24 Don Hanlon Johnson, *Bone, Breath, & Gesture: Practices of Embodiment*. ed. Don Hanlon Johnson (Berkeley: North Atlantic Books & San Francisco: The California Institute of Integral Studies, 1995), ix.

25 Anne C. Klein, "Grounding and Opening," in *Being Bodies: Buddhist women on the paradox of embodiment*, Lenore Friedman, and Susan Moon, eds. (Boston: Shambhala Publications Ltd., 1997), 142.

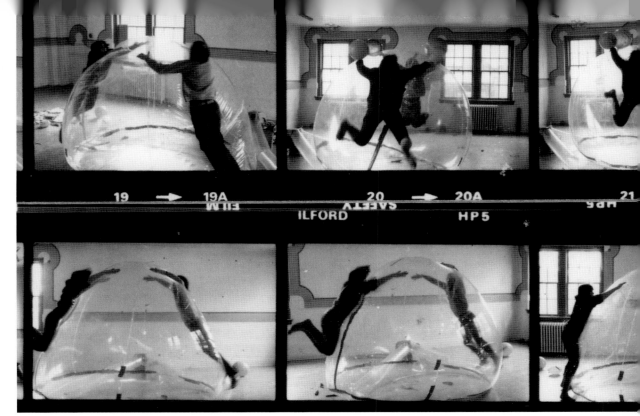

LYNN ROTIN

rapidly gained a disproportionate amount of physical power. While violence and greed have always been a part of human life, this century stands out for its sophisticated political, religious, and scientific justifications for sacrificing human lives in favor of complicated abstractions. Palpable values of caring for infants and the aging, feeding the hungry, caring for the sick, nurturing the sources of intelligence found in explorations of bodily feeling and movement hold the lowest possible places on scales of values motivating actual social choices.[24]

I am also interested in the link between embodiment and spirituality:

To inhabit our body fully, and to feel connected through it to the earthy body beneath us is to be physically grounded, able to inhabit our bodies as the mooring and support for all our activities. In this way, we move beyond the sense that we are a small, closed system, not anchored in anything other than ourselves. Such physical grounding facilitates emotional grounding — the strength to hold ground and fill space; in other words, to be present with all our being. With such presence we move past the sense that mind and body function independently of each other. Freed from this bifurcation we can begin to experience the body as the actual locus of enlightenment.[25]

Concepts of our relationship with the planet, with our spiritual selves, and with each other are contained within our concepts of embodiment.

LOUISE GARFIELD and **MICHAEL BAKER** rehearse Garfield's *Balloon Slices*, Toronto, 1978

Physical Practices

I understand the term *embodiment practices* in terms of the field of somatics[26] and holistic healing. There are intersections between embodiment practices and artistic training and Louise Steinman is one writer who places embodiment practices within a continuum of American modern dance development:

> Classical ballet is based on the idea of "how the body should look." The shift towards movement based on inner awareness in our culture ... began with Isadora Duncan. Isadora danced from the most expressive part of her being, the solar plexus, the center of her body. Martha Graham did also, but instead of just dancing it, she codified it into a technique ... That each body speaks its own native language, given to us at conception and forgotten by most by adulthood, is a premise shared by the philosophers of the body, teachers and performers both. It is not that performers today are rejecting dance and movement techniques ... The point is, however, not to accept someone else's movement sources within oneself. The various body therapies ask the individual to guide their own physical and mental change ... Instead of following the master-apprentice model, where one attempts to take on someone else's highly individual movement style, you work from the inside to recover your own body's native language.[27]

The concept of recovering "your body's native language" was critical to such modern dance pioneers as Martha Graham and Mary Wigman (even though Graham's language later became codified into the master-apprentice model). Mary Wigman's German expressionism had direct Canadian descendents. Frau Til Thiele, a teacher in the Wigman and Rudolph Laban traditions, came to Toronto in 1969 under the aegis of choreographer Judy Jarvis. She taught at the Centre of Movement in downtown Toronto and her technique classes were an important alternative to the Graham technique that dominated Toronto modern dance. She also taught composition at York University where Householder, Garfield, and I studied with her:

> The deep, indelible loneliness of the expressionists. They were predecessors of existentialism, dancing along that trail before it was philosophized. You do not copy, you make your own, you find your own way. You do not learn a system of dancing, you do not dance in a style. You look to the life around you, you look to your inner motion, you free your body with rigorous tanz gymnastic, so that it can be a responsive, vibrant instrument, able to soar like a swallow, attack like a lion. You make your own dance, you mine it out of your own being, your own sorrow and joy.[28]

"Native language" may be relevant to some of the work of Margaret Dragu and Lily Eng, but can be seen as diametrically opposed to the deconstructing language of the pose in the work of The Clichettes and myself.[29] The pose is a static image that does not move through space and is driven by intention and intellect. I understand the notion of "native language" as related to personal expression and kinetic authenticity.[30] Most of the artists I am speaking of had some experience with embodiment practices, but following this path of intersection was not a major strategy for any of them in the 70s.

26 "Somatics is the field which studies the soma: namely the body as perceived from within by first-person perception. When a human being is observed from the outside — i.e., from a third-person viewpoint — the phenomenon of a human body is perceived. But, when this same human being is observed from the first-person viewpoint of his own proprioceptive senses, a categorically different phenomenon is perceived: the human soma." Thomas Hanna."What is Somatics." Hanlon: 341.

27 Louise Steinman, *The Knowing Body: elements of contemporary performance & dance*, (Boston: Shambhala, 1986), 14. This book is about artists such as Trisha Brown, Meredith Monk, Whoopi Goldberg, Spalding Gray, and Ping Chong.

28 Carol Anderson, "Images of Frau Til," *This Passion: for the love of dance*, Carol Anderson, ed. (Dance Collection Danse Press/es, 1998), 116.

29 Dragu also used the pose. Part of Eng's work, performed with Peter Dudar, consisted of minimal movement mostly in the form of walking and running; when I apply the notion of "native language," I refer to her solo work.

30 I accept the possibility of authenticity with the understanding that it interacts with cultural inscription and see this as *both/and* not *either/or*.

31 F.M. Alexander was teaching as early as the 1920s and his work is among the early *embodiment practices*. It is used widely today in training actors and musicians as well as the general public. "The Alexander Technique is a process of psycho-physical re-education: by inhibiting automatic responses it allows you to eliminate old habits of reaction and mis-use of the body and through more reliable sensory appreciation, brings about improved use and a more appropriate means of reaction." J. Victor Gray, *Your Guide to the Alexander Technique* (London: Gollancz Ltd., 1990), 13.

32 Kevin McGarrigle-Schlosser, telephone conversation with Elizabeth Chitty, (August 20, 2003).

33 Irmgard Bartenieff had worked with Rudolph Laban, developed his work in movement analysis, and is an important figure in the development of Dance Therapy. Laban movement analysis is an historically important modern dance pedagogical tool but more so in a British and European context than North American.

Caught in the Act an anthology of performance art by Canadian women

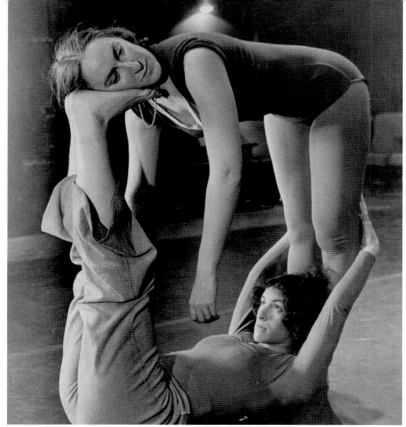

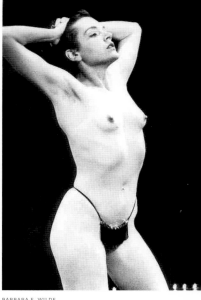

I have referred to the rejection of physical virtuosity. These artists withdrew from the use of codified dance language to varying degrees, but all withdrew from conventional dance training. What physical practices did they turn to?

Johanna Householder, Janice Hladki, Louise Garfield, and I were among a group of dancers who studied with Kevin McGarrigle in my Queen Street studio during 1975-76. McGarrigle (later McGarrigle-Schlosser) had taught Graham technique classes at York University where she had become embroiled in controversy over her pedagogy that led to her dismissal. McGarrigle-Schlosser had studied Alexander Technique,[31] brought a skeleton into the dance studio, and had the students touch their bodies to feel where the bones were. These were radical methods of dance training in 1970-72. Her motivation was to find ways for the university students (who often began to study dance later than conventional training prescribed) to "find a way to do the movement and look good and feel good — instead of struggling with traditional training and not achieving the standard."[32]

By the time she was teaching in my downtown Toronto studio, McGarrigle-Schlosser had studied Laban movement analysis and Bartenieff Fundamentals.[33] She was also influenced by Til Thiele though the major influence on her work was her study of shiatsu under Mitzuki Kikkawa in

LOUISE GARFIELD and **CAROLYN SHAFFER** perform *Daddy, There's a Cavity in My Gravity*, Toronto, 1976

MARGARET DRAGU *33 1/3 Double Live: Sunset Strippers, Beauty & the Beast* (collaboration with Enrico Campana and Terry Crack), first performed at The Funnel, Toronto, 1978

Toronto. She used images and tennis balls to achieve releasing, a key holistic strategy in making structural change to our bodies and achieving increased mobility with implications for both artistic expressivity and health. She also adapted re-patterning exercises from the work of Ida Rolf, a major figure in the development of somatic therapy. McGarrigle-Schlosser's pedagogy was ahead of its time in dance training in Toronto. Artists moving out of the dance field and into performance art were among the first to embrace her innovations.

Johanna Householder was a student at Oberlin College in Ohio in 1970 when The Grand Union[34] was in residence. This collective was an important part of the American dance and performance art intersection and it was specifically their performances that drew her to formal dance training. She subsequently studied at The London School of Contemporary Dance and York University, both schools where Graham technique was taught.

Following her graduation from York in 1975, she studied aikido for about four years. Aikido was also important in the development of contact improvisation, the form of movement developed by Steve Paxton and Nancy Stark Smith. What she enjoyed about aikido was:

the dynamic nature of the movement and also the partnering ... that it moves through space and covers a lot of space ... it's a technique that uses the impulse coming from the attacker and you multiply your own weight and energy with that energy to be able to control and direct it. So rather than a deflecting or blocking practice, it's a joining, based on spiralling motions and extensive use of *ki* ... Those are the things I really liked about that practice and also the sense of flying that you get when some big guy throws you across the room![35]

Another key figure in alternative body training techniques was Lilian Jarvis, who had been a charter member and principle dancer of the National Ballet of Canada from 1951 to 63. After leaving the ballet company, Jarvis studied at the Martha Graham School in New York and subsequently began to explore ways of overcoming the physical limitations she had encountered throughout her dance career. She called her approach BioSomatics, which consists of a series of deep stretch and strengthening exercises that improve the mechanical and structural condition of the body. An awareness of *chi*, also informs her work.[36] Lilian Jarvis, like Kevin McGarrigle-Schlosser, developed her work independently and was an early Toronto practitioner of approaches that are an important component of dance training today.

Following her work in Calgary in the semi-professional children's and adult companies of Canadian modern dance pioneer, Yoné Kvetys, Margaret Dragu moved to New York in 1971 to study with Alwin Nikolais and Murray Louis. She also took jazz dance classes as well as studied with the more experimental Laura Foreman and John Watt at the New School for Social Research. In Montréal, she studied with Eva von Genscy and Eddie Toussaint of Les Ballets Jazz.

Dragu worked as a stripper intermittently from 1973 to 1985. She began stripping in Montréal, went on the road in the province of Québec and worked in Toronto. Her strip work was esoteric, theatrical, and extremely

34 The Grand Union was co-founded in 1970 by Trisha Brown and Steve Paxton and grew out of the Judson Dance Theatre. Steve Paxton began developing Contact Improvisation while with The Grand Union and it was his men's class that Householder first joined.

35 Johanna Householder, interview with Elizabeth Chitty (September 5, 2002).

36 www.biosomatics.ca and Elizabeth Chitty correspondence with Lilian Jarvis (August 22, 2003).

37 Correspondence with Elizabeth Chitty (August 25, 2003). She is now a skilled fitness instructor well trained in injury prevention.

38 Graham Jackson, "History Making," in *Dance as Dance: selected reviews and essays* (Scarborough: Catalyst, 1978), 59.

physical with big movement and dance vocabulary. At Toronto clubs such as the Colonial and the Zanzibar, dancers usually performed six shows of twenty minutes per shift and often worked double shifts, working noon until 1:00 a.m.

Dragu's physical practice also included teaching; she taught throughout her years in Toronto (1974-1986). She recalls that one class she briefly led was called:

EXERDANCERDRUNKERFUNKERSIZE — a 4:00-7:00 p.m. class that included two enormous cocktails and a high impact cardio dance workout. Insane ... Those classes [the different kinds of classes she taught] were where I developed all my dance-based practices/actions for all performances art/theatre/strip clubs. Where I developed Xs and Os and all that. Everyone a guinea pig.[37]

Dragu's *Over Easy* (1976), performed during the Toronto Dance Festival, illustrates the importance of strip to this phase of her work. Its influence was less important from the point of view of movement vocabulary than it was for how it translated into her theatrical sensibility and its contribution to the cut-up and collage structure of that body of work. The description doesn't capture the visual spectacle of her mock-masturbation in darkness while wrapped in flashing Christmas tree lightbulbs (nor the shock of some of her audience):

Over Easy (as in flipping eggs to fry) by that infamous dance artist, Margaret Dragu, is another trip entirely. Set to a taped montage of street noises, restaurant sounds, random conversations, and disco music, it seems to be an evocation of the Yonge Street strip and its denizens, after hours. Dragu, dressed in a rose-coloured hood and cape and lit up with flashing bulbs, looks like a cross between a stripper and a kitsch Madonna, as she treats us to the sights of the city. The dance movement per se consists of little more than a fancy strut with some striptease gyrations thrown in for good measure and yet Dragu makes as much an impact in her own way as Katherine Brown does in *Waiting* using her finely-honed Graham technique.

Whether she's slugging back Scotch in the glare of an unshaded lamp; grooving in a disco where the glowing tip of a cigarette is reality; turning-on in the solitude of the bluish light from a portable TV; or merely striking poses as the body lights, like the momentary blaze of a headlight or neon sign, isolate head, shoulder, or legs, her vision has the ring of truth. The individual sequences are well stitched together, too; there's nothing careless or self-indulgent about any of it. Whatever else she chooses to call herself, Dragu is a real show-woman. For that final pose, in dawn's early light, she looks like Danny LaRue doing Sarah Bernhardt doing Hamlet. Let's have more Dragu.[38]

Lily Eng modelled and studied gymnastics as a teenager then studied dance with key figures in Canadian dance — ballet with Lois Smith and (an elderly) Boris Volkoff and modern dance with Toronto Dance Theatre's David Earle and Patricia Beatty. She began studying kung fu in 1973, training that continued into the early 90s:

I'm a Chinese woman and I decided to go back to my roots; it would allow me to tap into that source. And so it allowed me to really develop further the

things that were relevant to my life and who I was. At that time, when I was a young artist, there were very few visible minorities, never mind being Chinese.[39]

She draws parallels between kung fu and dance training in terms of its physical rigour, repetitions, the need for a foundation, understanding of the language, and where the movement originates and leads to. Sessions at the club were five or six days a week, class was a highly structured two hours and she stayed another hour. She realized that her:

... bodily inclination was quite attuned and in alignment with martial arts, the dynamics, there's a lot of strength in movements but at the same time there's a lot of soft movement. To me, that's the basis of everything in life, the hard and the soft. It's a very yin-yang thing.[40]

Eng describes this affinity as intellectual as well as cultural. She was the only woman studying in her club for a long time:

It was rather challenging. Although historically in the Chinese mythology there's always women warriors ... but when people actually saw me being a woman warrior, the guys especially, didn't know quite what to make of it because there was nothing in their background at first to determine how they should react to this. So it would challenge their mores, they didn't know what to do.[41]

Like Dragu, there was no boundary between her physical practice and the vocabulary of her art. Eng describes her introduction of kung fu into her art practice as something that "evolved quite naturally."

Unlike the emotionally detached, pedestrian movement in the Missing Associates work led by Peter Dudar, Lily Eng's 1975 solo work, *Withheld*, used minimal movement vocabulary to explore emotion and achieve intense physicality:

The work, called *Withheld* and performed to a subtly progressive rhythmic score ... gives the impression of her being constrained in a small space and fighting her way out of it. She begins by shaking her body in spasms to the music and gradually working herself up into a fit of movement by performing fast-chopping manual variations to the rhythms — shadowboxing, tracing vigorous patterns, and jabbing her fingers in circular motions with and against the music.

The sense of suppressed energy in the dance is invigorating, but the main cavil with Eng is that she only works from the midriff up ... she has the considerable wit to wear her eyeglasses when she dances, and the work has a lot of force.[42]

The physicality of Lily Eng's improvisational works, including *Withheld*, surely cannot be separated from gendered rage:

There was definitely anger ... I'm a very strong, physical-type person and at that time the energy was directed in a way that would have been seen as anger by the audience and would have been conveyed as so, but at the same time I wanted to take it into another realm, to work with the emotionalities that were evident. Don't forget that at that time there was no emotionality whatsover in performance. For that kind of raw power to emerge — it was quite startling.[43]

39 Lily Eng, interview with Elizabeth Chitty (August 30, 2003).

40 Ibid.

41 Ibid.

42 Lawrence O'Toole, "Lead Dance," publication unknown. Archives of Dance Collection Danse, Toronto.

43 Eng interview.

44 Elizabeth Zimmer, "Dance in Canada Conference Winnipeg, '77: Winnipeg: Concert 3 September 9, 1977," in *Spill*, no. 7 (1977), 3.

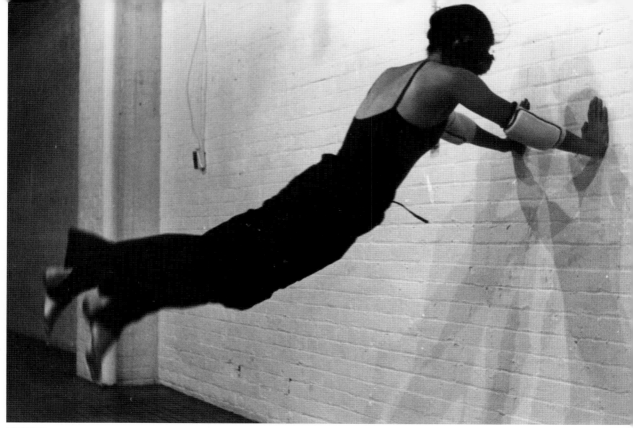

PETER DUDAR

Fucking Flesh

While concern with form and defying dance conventions were imperative for all of these artists, content was also strong. Sexual identity was a critical issue. Reclamation of our sexuality was an important aspect of the feminist wave of the 1970s. Many of the dance artists were investigating heterosexual love and sex using popular music as a strategy. Louise Garfield sang country and western tunes, "I Fall To Pieces" and "If I Never Love Again It'll Be Too Soon," into a huge weather balloon. This 1977 account of *Balloon 2* predates the introduction of the songs:

Louise Garfield ... now brings her hair dryer on stage and inflates, slowly, an enormous buff-coloured weather balloon. Her piece is intensely provocative, juxtaposing human and mechanical sound, human and elemental movement. The balloon, growing there in the corner of the theatre, has an androgynous form, female in its roundness, softness, but male in its erectility. It's a bag of wind. When it's nearly full, she takes the stage with it, a pregnant, grotesque, and somehow very beautiful duet. The balloon breaks — an unexpected development — and she leaves the stage, wrapped in her partner's skin.[44]

In *Love Parts 1, 2, and 3* (1977), Janice Hladki and Garfield lay on the floor

LILY ENG *Improvisation*, CEAC (Centre for Experimental Art and Communication), Toronto, 1977

in the two entranceways to the performance space with their mouths taped shut, while the song, "You Light Up My Life," played in the darkened space. The audience had to step over them to enter. They sang popular love songs while their legs were taped together, interviewed waltzing couples on their sexual and romantic habits, and sat in the laps of audience members while speaking to each other in hesitant expressions of love. This use of pop love songs later found full-blown theatrical framing in the work of The Clichettes who lip-synced and danced in elaborate costumes through numbers embedded in theatrical dialogue.

It was an uneasy time to be female and sexually explicit. For Margaret Dragu and myself, sexual bravado was a tool we used to claim our sexual authority. Claiming the right to own our sexual pleasure was highest on our youthful feminist agenda in tandem with reproductive rights. I understood sexual display as politicized and feminist, as a direct confrontation to the patriarchal norm that "desire is masculinized; the desired, feminized."[45] Rebecca Schneider vividly speaks to me of our position when she says of Carolee Schneemann:

… the both/and tangle of the constructed and the essential generated a "messy" embrace … She wanted her body to remain erotic, sexual, both 'desired and desiring,' while underscoring it as clearly volitional as well …[46]

In our youthful innocence (perhaps better described as naiveté) we thought prudery and patriarchy were the "only" impediments to our sexual expression. It was far more complicated. At first our sexual display found support with gay men; agendas of sexual liberation seemed to have common ground (although this thin thread could not hold for long). The aesthetics of drag were at work in artists' performance of the 70s and actively supported the direction of The Clichettes work, for example, who in their impersonations of 60s female pop icons appeared decidedly more like men in drag than women.

I think we have to acknowledge drag as a mother root — understanding that we are in a very basic sense playing culturally imposed roles, physically enacting culturally imposed roles.[47]

It was more complicated finding common ground at that time with many of our sisters. For most, the issue was around representation of women's bodies as the location of desire. When Warr and Jones speak of the body as "unstable," I think of Margaret Dragu interchanging images from heterosexual strip stages to performance art:

I can't remember the name of the place on King Street which was where I eventually hung up my g-string … it had male strippers at night and women in the afternoon — we were noon-8:00 p.m. and we got lunch. You came and spent an afternoon with me there when I had refined my strip characters to: my Marlene Dietrich impersonation, the 80s gun-toting terrorist in an evening gown, the Hallelujah born-again preacher with clergy collar and tambourine and green glitter stockings, the red trimmed, white negligee-ed blow-up doll that comes alive, and the working class Detroit girl who seeks release thru rock music and has erotic dreams under a see-through black sheet … oddly, that sheet act has resurfaced in *Bardo Gap* and *Eine Kleine*

45 Rebecca Schneider, *The Explicit Body in Performance* (London and New York: Routledge, 1997), 5.

46 Ibid., 37.

47 Householder, interview with Chitty.

48 Dragu, correspondence with Chitty.

49 "No Essential Femininity: A Conversation between Mary Kelly and Paul Smith," *Parachute* vol.37, no. 26 (spring 1982), 32. For a rebuttal of this position, see Jones, 22-25 as well as Phelan, 125. I acknowledge that, as Householder said in our interview, "these extreme positions had to be staked out."

Nacht Radio as sex and grief on a vertical bed with no sheet ... But all those characters were sourced and resourced in art at the same time as in strip clubs. The distinction was always blurry for me even when I was younger and tried to keep them so separate ...[48]

To some of us, Dragu's imagery offered a representation of a strong, young woman proclaiming her sexuality, talking back to the patriarchy and mutating its territory; but to others it read as a tainted image of female objectification. A chill was descending around the idea that bodies were not for display because they could not transcend the tyranny of the male gaze. Mary Kelly led the theoretical removal of women's bodies from art and in 1981, in the pages of *Parachute* magazine, said:

... I feel that when the image of the woman is used in a work of art, that is, when her body or person is given as a signifier, it becomes extremely problematic. Most women artists who have presented themselves in some way, visibly, in the work have been unable to find the kind of distancing devices which would cut across the predominant representations of woman as object of the look, or question the notion of femininity as a pre-given entity.[49]

The idea that the female body should not be represented was one that further estranged women from our bodies and was a manifestation of disembodiment.

LOUISE GARFIELD and **JANICE HLADKI**
Love Parts 1, 2, 3 DanceWorks/Improvisations at the Music Gallery, Toronto, 1977

Our youthful sexual bravado met with both the conservative censure that views female sexuality with suspicion and patronization ("rather mixed up young lady"[50]) and with the radical censure that labelled it politically regressive. Johanna Householder remembers:

> I never found performing particularly pleasurable because there was always that discomfort of being subjected to the gaze that is out of one's control ... I felt, in a sense, the opposite of the Mary Kelly position — that it was a duty to perform ... because we have to get our faces, ourselves, out there — that it was important to be visible.[51]

Another issue was that for some, our heterosexuality could simply not be transgressive enough. This point of view was related to the notion that women's bodies displayed could not transcend the male gaze but was also deeply embedded in the avant-garde valorization of the notion of transgression:

> There is a coded connaissance of the past traditions from which new art is supposedly distinct. This tautological concept of the evolution of art encourages the notion of transgression, of a steady stylistic progression that looks askance to check historical precedent in order to ensure its own implicit originality.[52]

The community culture of the Toronto art scene was adversarial, (unsurprising in a grant-dependent economy in which insufficient money is competed for and juried by artists) and by the early 80s had become more punitive and prescriptive. Conflicts were aesthetic, ideological, and strategic and the stakes were high, not only because of the economics of art production but also because of legal issues. Battle lines were drawn on all sides around many issues and swords were sharp. CEAC had burned up in its revolutionary flames in 1978. The gay community was under siege in the form of raids on bathhouses and on the offices of the publication, *The Body Politic*. There were brutal battles around the issue of censorship, brought on by the policies of the Ontario Censor Board.

Into this adversarial climate came the assault on Margaret Dragu while performing in a work by Robert Stewart at the Cabana Room in 1980. A man jumped on stage, pulled down Dragu's underpants and the string of her tampon. No one came to her aid due in part to how the act completely blurred "performance" and "reality" since many in the audience assumed it was part of the performance.

Within the artists' community she met the typical response to sexual assault anywhere; she was questioned about her clothing, which supports the supposition that sexually provocative female behaviour invites assault. She experienced "what-do-you-expect" blame. When she launched legal action against the attacker (and other parties as required by law), she met with further censure within the art community. Predictably the defence attempted to attack her credibility on the basis of her work as a stripper. More condemnation from artists followed when police were asked to provide protection at a performance of *Sa majesté* by Tom Dean and Dragu at the Art Gallery of Ontario in 1981, on the grounds that it colluded with the forces of censorship and authority in society. (The curator had been threatened by the offender and requested police presence at the performance.)

50 William Littler, "A brick is a brick thrown or danced upon," in *Toronto Star* (November 25, 1975). The review is of Dragu's work, *Try Leather*, performed at 15 Dance Lab during Dance Artists '75 and the headline of the review refers to work by Lawrence Adams.

51 Householder, interview with Chitty.

52 John K. Grande, *Balance: Art and Nature* (Montréal: Black Rose Books, 2004), 25. See Rebecca Schneider's comments in *The Explicit Body in Performance* on the status of transgression in contemporary art practice (150-1). To the argument that transgression has become impossible because of late capitalism's rapid appropriation and incorporation of it into fashionable chic, she comments that it is suspicious how this assertion appeared just as women, artists of colour and gay and lesbian artists took art world attention. My view is why does the art world continue to invest transgression with disruptive powers when the ethics at the foundation of such belief are consistent with the harming so readily found in global experience? How can transgression disrupt transgression? Transformation can disrupt transgression.

53 Schneider, 157.

I regard the assault on Dragu as an unconscious lodestone for disapproval around women performers' sexual display. The assault polarized the community. The taking-of-sides inevitably included personal loyalties and, incredibly, aesthetic issues. The assailant claimed the assault as art and a critical response to Dragu's art. For me it forever altered much, including my willingness to buy in to the notion of transgression as an artistic strategy or to separate transgression from the harm it caused.

Conclusion

Our bodies are the sites of our physical, emotional, intellectual, social, political, and spiritual selves. They are conflicted with complex issues in our cultures and our art. This essay began with the notion that the multiplicities of performance art must be recognized if its history is to have integrity and I have addressed an area defined by time, place, and gender.

An appreciation for diverse ways of knowing is emerging in postmodern theoretical discourse. Ironically perhaps, in the art avant-garde where a belief in progressiveness persists, there has been a fierce clinging to the old privileging of mind over body. Even art theorists who are struggling to transcend the old model feel that apologies must be made, as can be witnessed in this statement — "The notion of knowledge IN a body smacks of essentialism."[53]

Dance offers a tradition of thinking through the body. Embracing plurality within performance art offers diverse ways of performed knowing. Those who perform, perform our selves and our negotiated meanings of them in the world. Our bodies create, reflect, deliver, and suffer those meanings. Our lives are in art and our art lives, if only briefly.

Jayne Wark

Dressed to Thrill

COSTUME, BODY, AND DRESS IN CANADIAN PERFORMATIVE ART

Performance art has an enigmatic position within the history of twentieth century art. It has emerged along with other time-based media as an art form fundamentally intrinsic to the twentieth century. And yet, until recently, performance art remained neglected in the histories of this period. This new interest in performance is largely due to feminist histories' recognition of the singular contribution women have made to performance since the 1970s, and to poststructural theories that have converged in the last ten years to place the notion of "performativity" literally at centre stage.[1] This developing discourse posits performativity as the basis for the formation and articulation of identities, and has thus been especially important for interpretations of contemporary performance art that seek to interrogate questions of subjectivity. And as even the most cursory look at the literature will reveal, the central element of such performance is generally taken to be the body.

If the body is indeed the site where the particularities of identity are visibly marked, it is also indisputable that the body in performance is rarely unadorned. More often than not, the body is accompanied by various cultural artifacts, from simple street clothes to theatrical costumes to elaborate constructions that function as hybrids between prop and art

object. Even when the body is naked, the performance context establishes a public setting, and thus implies a flaunting of flesh that goes against the culture's social restrictions. As Joanne Entwistle has noted in her book, *The Fashioned Body*, all known human cultures require the social body to be dressed in some way. Bodies that appear naked in public risk censure, scorn, or ridicule.[2] So when naked flesh is exposed in performance, we read this as a deliberately disturbing and potentially subversive disruption that is as heavily coded as are the strictures of social dress. And in performance that uses costume or dress, these codes are conveyed through the sartorial adornment of the body by means of which identity is negotiated or "performed" in the social sphere. As Kaja Silverman writes:

> The male subject, like the female subject, has no visual status apart from dress and/or adornment ... Clothing and other kinds of ornamentation make the human body culturally visible ... clothing draws the body so that it can be culturally seen, and articulates it as a meaningful form.[3]

In literature on performance art, the role of costume and dress has been largely ignored, or, at best, treated as accessory.[4] In order to develop a deeper understanding of this topic, theories of the body and performativity, and of clothing and dress, need to be brought together in a synthetic way that sheds light on the relation between subjectivity and cultural meaning in performance art. The focus here will be on Canadian performance, which, like much of Canadian art from the past thirty years, is urgently in need of sustained historical consideration.[5] The objective is to identify and anyalyze some of the key conceptual concerns and strategic approaches that have been distinctive to Canadian performance art during the period from about 1970 to the present. These include a sustained engagement with popular culture, the use of camp and drag to assert the visibility of queer and marginalized identities, and the use of parody and other forms of humour both as a means of rebellious effrontery and as empowering transformation.

Performance art flourished in Canada and elsewhere during the 1970s, a decade that marked a major turning point in history. The ideals of civil society seemed to be in jeopardy everywhere as terrorists inflicted violence from Ireland to Iran to Québec, the energy crisis initiated a global recession, and the American president at the time, Richard Nixon, was run out of office under a humiliating cloud of lies and deceit. As performance art historian Kristine Stiles has noted, it was a time of such trauma, bitterness, and anger that, by the end of the 70s, "its immaterial internal pain was perfectly and self-destructively embodied in the material external sign of safety pins stuck through the flesh of young punks."[6]

Yet, apart from the FLQ crisis in Québec, which must not be minimized, Canada seemed insulated from these world disasters. Ebullient from its triumphant premiere on the world stage at Expo '67, and able to lay claim both to Marshall McLuhan as an internationally recognized guru of the new media culture, and to Pierre Elliot Trudeau as the sexy, charismatic political leader who cranked open the faucet for arts funding, Canada seemed poised to make its mark. Canadian artists were ideally situated to take advantage

1 For the concept of performativity as the basis of identity formation, see especially Judith Butler, *Gender Trouble: Feminism and the Subversion of Identity* (New York: Routledge, 1990), and *Bodies that Matter: On the Discursive Limits of "Sex"* (New York: Routledge, 1993).

2 Joanne Entwistle, *The Fashioned Body: Fashion, Dress, and Modern Social Theory* (Cambridge: Polity, 2000), 6-7.

3 Kaja Silverman, "Fragments of a Fashionable Discourse," in *Studies in Entertainment: Critical Approaches to Mass Culture*, Tania Modleski, ed. (Bloomington: Indiana University Press, 1986), 145.

4 For example, the exhibition catalogue *Out of Actions: Between Performance and the Object, 1949-1979*, Paul Schimmel, ed. (Los Angeles: Museum of Contemporary Art, 1998) considers the role of the object in performance, but not costume or dress *per se*. The one article I have found on this topic is very brief; see Moira Roth, "Character, Costume and Theater in Early California Performance," in *Living Art Vancouver*, Alvin Balkind and R.A. Gledhill, eds. (Vancouver: Western Front/Pumps/Video Inn, 1979), 89-91.

5 No book-length historical study of Canadian performance has yet been written.

6 Kristine Stiles, "Uncorrupted Joy: International Art Actions," in *Out of Actions*, 241.

7 In 1965 Robert Filliou, along with Fluxus artist George Brecht, formed the idea of an "eternal network" as a way of linking artists to one another and to other social and ecological networks. For the imapct of Filliou's ideas on Vancouver artists, see Sharla Sava, "As if the Oceans Were Lemonade: The Performative Vision of Robert Filliou and the Western Front" (MA thesis, University of British Columbia, 1996).

8 See Gail Tuttle, "The Intermedia Society (1967-1972) and Early Vancouver Performance Art" (MA thesis, University of Victoria, 1994).

9 In the 1950s and 1960s American dancers like Merce Cunningham, Ann Halprin, Trisha Brown, Simone Forti and Yvonne Rainer developed an approach to dance which sought to free dancers from the restraints of classical repertoire and dance vocabulary. They rejected theatrical costuming and dramatic expression or narrative and instead favoured choreography which emphasized the contrast between learned and natural movements and often relied on the execution of set tasks such as walking, jumping, running or manipulating props so as to focus on the language and gestures of the body in space.

10 The performance activity known as Happenings originated with Allan Kaprow, and was articulated in his article, "The Legacy of Jackson Pollock," *Art News* 57, no. 6 (1958), 24-26, 55-57. Here he proposed that Pollock's legacy was that artists should abandon painting and instead expand its gestural expressiveness to physical interactions with elements from the everyday world in order to bring art and life together in improvisational and participatory experiences. Kaprow declared that "Objects of every sort are materials for the new art: paint, chairs, food, electric and neon lights, smoke, water, old socks, a dog, movies, [and] a thousand other things" (57). Significantly, however, in this first articulation of a theory of performance in the post-war period, no mention is made of costume since the emphasis was decidedly on the ordinariness of "everyday life."

11 The antinomy between the authenticity of art and the artificiality of mass culture was set out by Clement Greenberg's "Avant-Garde and Kitsch," *Partisan Review* 6, no. 5 (Fall 1939), 34-49. The dichotomy between the criticality of art and the passivity of the entertainment spectacle was further developed in Guy Debord's influential text, *La Société du Spectacle* (Paris: Buchet/Chastel, 1967). These oppositions continued to shape critical discourse well into the 1970s.

12 See Scott Watson, "Hand of the Spirit," in *Hand of the Spirit: Documents of the Seventies from the Morris/Trasov Archive* (Vancouver: University of British Columbia Fine Arts Gallery, 1992), 9.

13 See Scott Watson, "Return to Brutopia," in *Return to Brutopia: Eric Metcalfe Works and Collaborations* (Vancouver: University of British Columbia Fine Arts Gallery, 1992), 14.

of new international currents in the art world. They had no indigenous avant-garde and immediately grasped the possibility of transcending regional isolation by linking up to what Fluxus artist Robert Filliou called "the eternal network."[7] This, along with sudden access to government funding for equipment and space for artist-run centres, created an atmosphere that was nothing short of euphoric. Ground zero for this euphoria was the establishment of the Intermedia Society in Vancouver in 1967. Dedicated to the creative fusion of disciplines and to an openness towards popular culture, the Intermedia Society held annual multimedia extravaganzas at the Vancouver Art Gallery and sponsored workshops by the American dancers Deborah Hay, Yvonne Rainer, and Steve Paxton in 1968 and 1969.[8]

These workshops introduced Vancouver artists to the improvisational, task-oriented approach to dance that was current in San Francisco and New York, which aimed to take dance down from its pedestal and merge it with the rhythm and flow of ordinary life.[9] Gathie Falk, for example, who was inspired both by Hay's methods and Allan Kaprow's Happenings, began to do performances which incorporated unexpected combinations of props, costumes, and songs in performances such as *Red Angel* (1971).[10] Behind a tableau of five red turntables, each mounted with a red parrot, and each playing a round from the tune "Row, Row, Row Your Boat," Falk posed in a white satin dress with feathered wings. During the performance, the dress was removed, revealing a grey satin dress underneath, and then passed through a wringer washer by an assistant. The performance concluded with Falk singing the tune's final round, "life is but a dream," a phrase that evokes the bizarre and Surrealist-like incongruity typical of Falk's work.

The theatricality and allusions to popular culture in Falk's *Red Angel* ran somewhat against the grain of critical discourse around avant-garde performance at the time.[11] The reappearance of these elements in the activities of another group of young Vancouver artists at this time was indicative, however, of an emerging characteristic of Vancouver performance. These artists, who included Glenn Lewis, Robert Fones, Gary Lee-Nova, Michael Morris, Vincent Trasov, Eric Metcalfe, and Kate Craig, were interested in Dada absurdity, puns, and pranks, and had a Warholian fascination with mass-culture imagery, especially its fetish and ritual characteristics.[12] In emulation of Marcel Duchamp's alter ego, Rrose Sélavy, each member of the group invented a name and persona that referred either to the art world or mass culture: Marcel Dot (Morris), Art Rat (Lee-Nova), Dr. and Lady Brute (Metcalfe and Craig), Candy Man (Fones), and Mr. Peanut (Trasov).

The group was strongly oriented to performative activities, and several of their fictive identities were outfitted with costumes and props. Dr. Brute, for instance, who was derived from the erotic cartoons Metcalfe drew as a student, wore a tuxedo, and his symbol, the leopard spot, was applied to all his creations, including the kazoo-saxophone he played during his accomplished jazz performances.[13] Dr. Brute and the aliases of other group members functioned as a blank slate for personal mythology as well as to provide an armature allowing them to explore alternative lifestyles and art forms,

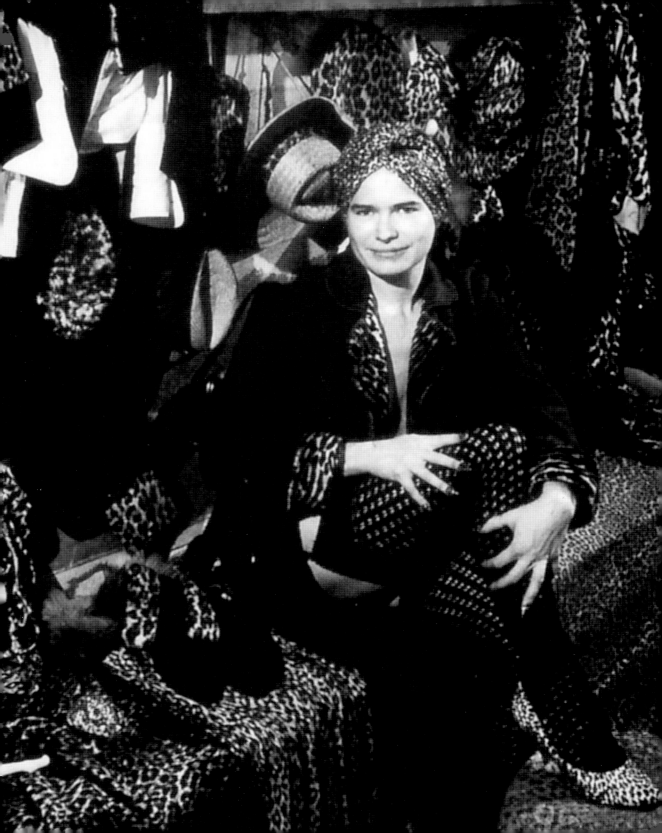

especially the appropriation of motifs from popular culture.

Lady Brute, who was invented by Metcalfe's partner at the time, Kate Craig, also took the leopard spot as her defining symbol. Craig collected a vast inventory of leopard paraphernalia that were mainly articles of women's clothing that Lady Brute wore in her appearances around Vancouver. The Brutes' fascination with the leopard pattern lay in its associations with camouflage, sexuality, and kitsch, which converged with their interests in glamour, power, and the banality of mass culture.[14] Leopard skin, however, is particularly associated with female sexuality, suggesting wildness, exoticism, and feline sensuality. As such, it has acquired a favoured place in the repertoire of fetishism. Following upon Richard von Krafft-Ebing's first modern psychological identification of fetishism as an irrational sexual overvaluation, Sigmund Freud later pathologized it as symptomatic of male castration anxiety, while Jacques Lacan added that, among women, it is found only in lesbians.[15] In recent years, these views have been challenged by feminist and queer theory, which aim to unsettle the strict sexual coding and ideological assumptions about subjectivity and gender identity, as well as by the fashion industry, which has increasingly exploited the wardrobe of the fetish subculture since the 1960s:[16]

Given these associations, Craig's own view of Lady Brute and her fetishistic trappings was ambivalent. Unlike Metcalfe's Dr. Brute, who was a personification of self, Craig saw Lady Brute as a mask to be put on or removed at will:

I never felt I was Lady Brute. One of the wonderful things about Lady Brute was that there was a stand-in at every corner. If I wore the leopard skin, it was only to become a part of this incredible culture of women who adopted that costume ... It was a way of exaggerating something that already existed in the culture.[17]

The leopard gear worn by Lady Brute thus served as a device to be publicly disruptive of middle-class propriety, to problematize the relation between self and image, and, as Grant Arnold has noted, "to identify with a specifically female culture for whom images of glamour operate simultaneously as a form of social bondage and a potential source of power."[18] But Craig also became aware that Lady Brute had been too invested in the fantasies of her male peers, and accordingly, she retired Lady Brute in a performance called *Skins: Lady Brute Presents Her Leopard Skin Wardrobe*, which was videotaped in 1975 at the Western Front.

To distance herself from Lady Brute, Craig created *The Pink Poem*, consisting of a collection of pink garments in which she "performed" in the course of everyday life. Pink was definitely not a colour with feminist cachet in the late 1970s, but given that her male colleagues "found it abhorrent," it was strategically disarming.[19] Craig explained:

I read that psychiatric and penal institutions often painted their walls pink because it was believed this gentle colour calmed people. In those days we women were trying to achieve certain goals in institutions dominated by men. My strategy was to wear pink clothing in order to calm them while making demands that may have caused them anxiety.[20]

14 Watson, "Return to Brutopia," 19-20; and Grant Arnold, "Kate Craig: Skin," in *Kate Craig: Skin* (Vancouver: Vancouver Art Gallery, 1998), 5-6.

15 See Richard von Krafft-Ebing, *Psychopathia Sexualis with Especial Reference to the Antipathic Sexual Instinct: A Medico-Forensic Study, trans. F.J. Rebman* (1886; New York: Physicians and Surgeons Book Company, 1934), 218; Sigmund Freud, "Fetishism," in the *Collected Papers*, vol. 5, ed. J. Strachey (London: Hogarth Press, 1957), 198-204; and Jacques Lacan, "Guiding Remarks for a Congress on Feminine Sexuality," in *Feminine Sexuality: Jacques Lacan and the école freudienne*, Juliet Mitchell and Jacqueline Rose, eds., trans. Jacqueline Rose (New York: WW Norton, 1982), 96.

16 See Marjorie Garber, *Vested Interests: Cross-Dressing and Cultural Anxiety* (New York and London: Routledge, 1992), 118-27; Valerie Steele, *Fetish: Fashion, Sex and Power* (New York and Oxford: Oxford University, 1996), 11-31; and Entwistle, 191-207.

17 Kate Craig, "Personal Perspective 1970-1979," in *Vancouver: Art and Artists 1931-1983*, curated by Luke Rombout, et al. (Vancouver: Vancouver Art Gallery, 1993), 262.

18 Arnold, "Kate Craig: Skin," 5.

19 Kate Craig, quoted in Arnold, "Kate Craig: Skin," 8.

20 Kate Craig, letter to author, 9 February 2001.

21 See Nicole Gingras, "The Movement of Things," in *Kate Craig: Skin*, 17-29; and Jayne Wark, "Kate Craig at Vancouver Art Gallery," *n.paradoxa* 2 (1998), 38-39.

22 See Alain-Martin Richard, "Québec, Activism and Performance: From the Acted-Manifesto to the Manoeuvre," in *Performance art in/au Canada 1970-1990*, Alain-Martin Richard and Clive Robertson, eds. (Quebec: Éditions Intervention, and Toronto: Coach House Press, 1991), 41-47.

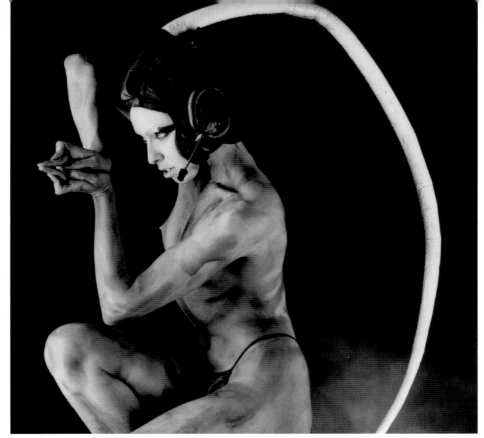

LOUISE OLIGNY

The Pink Poem culminated in Craig's 1980 video called *Straightjacket*, which features a close-up view of a writhing body trussed in a pink satin straight-jacket while a female voice sings plaintively about torture and duress. *Straightjacket* came at the end of a two-year period in which Craig had produced strongly feminist videos, including *Delicate Issue* (1979), which stands as one of the most powerful confrontations in the history of feminist art between the body and the technological gaze of the camera.[21]

Elsewhere in Canada, performance was entering one of its most active periods. In Québec, where the "Quiet Revolution" had coalesced into a vigourous nationalism in the 1970s, performance was dominated by three main trajectories: the highly verbal approach of people like Jean Tourangeau and Richard Martel; the body and/or spatial manipulations of Monty Cantsin or Alain-Martin Richard; and the innovations in dance that traced their lineage from Françoise Sullivan through Tangente Danse Actuelle in Montréal to people like Marie Chouinard, who has used costume in dance to stunning effect.[22] Chouinard's ability to blur the distinctions between dance and performance art is unique in Canada. She achieved notoriety for her "haiku" solo in 1980 when she urinated in a pail at the Art Gallery of Ontario, but it is her combination of rigorous physical "architecture," disdain for the gendered

MARIE CHOUINARD *S.T.A.B. (Space, Time and Beyond)*, 1986. Courtesy of Companie Marie Chouinard, Montréal

conventions of dance, and animated use of costume, props, and embodied sound (breathing, screaming, erotic moaning) that have resonated within the art community.[23] In her 1986 piece, *STAB* (*Space, Time, and Beyond*), Chouinard slithers and stalks the stage like a futuristic, androgynous lizard brandishing a six-foot, whip-like proboscis from her helmeted head. In *L'Après-midi d'un faune* (1987), a paean to Nijinsky's famous dance for the Ballet Russes, Chouinard wears a costume with cloven hoofs and massages a rigid phallus while generating the score by means of a synthesizer connected to controls on her body. Such performances, while retaining the visual drama of modern dance, eschew sentimental effects in favour of startling and provocative combinations of expression and formal structure.

In English Canada, a vibrant performance scene emerged in Toronto in the late 1970s. This coincided with the arrival of punk, whose aggressive sub-cultural stylization and anarchistic politics merged seamlessly with the burgeoning art scene to create the kind of collaborative tribalism seen earlier in Vancouver. One of the main ingredients of this heady brew was the presence of General Idea. Since the early 1970s, General Idea had used performance, most famously in their *Miss General Idea Pageants*, to create an art dedicated, with tongue in cheek, to glamour and style. In a 1975 issue of their magazine, *FILE*, they declared: "We wanted to be famous, glamorous and rich. That is to say we wanted to be artists and we knew that if we were famous and glamorous we could say we were artists and we would be."[24] General Idea's acute awareness of the need to intervene in a culture dominated by media and images helped create an ironic, stylized, and highly parodic milieu in which fashion, art, cabaret, and music merged not only in performance *per se*, but also in the performativity of lifestyles enhanced by a self-fashioning often aimed at a critique of cultural assumptions.

In 1978, for example, at the Tele-Performance Festival themed in response to television as content and technology, David Buchan invented the lounge-lizard Monte Del Monte, who performed popular songs accompanied by a series of costume changes including gold lamé vest and boots, camouflage gear, and a straightjacket and black vinyl pants cinched with rope at the crotch and ankles. At the same event, The Clichettes, a lip-sync group formed by Johanna Householder, Janice Hladki, and Louise Garfield (with Elizabeth Chitty), wore kitsch-punk trappings as they belted out a "threatening and aggressively funny" version of Leslie Gore's "You Don't Own Me."[25] As Clive Robertson has noted, The Clichettes were inspired in part by The Hummer Sisters' VideoCabaret productions, which featured political and social satire in the form of exuberant song and dialogue.[26] Wanting to resist becoming a simple, nostalgic homage to pop girl groups, The Clichettes, like the Hummers, soon elaborated their routines by means of narrative frameworks, often co-written with Marni Jackson. In *Half Human, Half Heartache* (1980), they played three aliens who land on Earth and undergo emotional heartache while practicing how to become human girls, whom they can only imitate through lip-syncing. As Householder explained, "Lip-sync … happens to be, in itself, a good metaphor for the cultural imperialism experienced by

23 In 1982, for example, Chouinard was invited to do a residency at the Western Front, where she produced the video *Marie Chien Noir*.

24 General Idea, "Glamour," in *FILE Megazine* 3, no. 1 (1975), 21-22.

25 Colin Campbell, "David Buchan: Lamonte Del Monte and the Fruit Cocktails," in *Centerfold* 3, no. 1 (December 1978), 31.

26 Clive Robertson, "The Compleat Clichettes," *Fuse* magazine 9, no 4 (1986), 11. The Hummer Sisters consisted of Deanne Taylor, Marien Lewis, Bobbe Besold and Janet Burke. Although Johanna Householder, letter to author, 11 July 2003, has confirmed that The Clichettes admired and were inspired by the Hummer Sisters, she and Janice Hladki were already using material from popular culture in performances that pre-dated the formation of The Clichettes. This suggests that both The Hummer Sisters and The Clichettes developed along parallel lines at essentially the same time.

27 Johanna Householder, quoted in Robertson, "The Compleat Clichettes," 12.

28 AA Bronson, "The Humiliation of the Bureaucrat," in *From Sea to Shining Sea* (Toronto: The Power Plant, 1987), 164.

29 See Robertson, "The Compleat Clichettes", 9-15.

30 This negative appraisal of General Idea and the performance genre associated with them and artists like Buchan and The Clichettes has begun to be reassessed. See, for example, Philip Monk "Picturing the Toronto Art Community: The Queen Street Years," *C Magazine* 59 (Sept.-Nov. 1998), unpaginated insert to accompany Monk's exhibition by the same name at the Power Plant, Toronto. Monk acknowledges that this exhibition served, in part, to revise earlier dismissals of General Idea's "image manipulation" by himself and others, including Dot Tuer in "The CEAC Was Banned in Canada," *C Magazine* 11 (1986), 22-37.

Caught in the Act an anthology of performance art by Canadian women

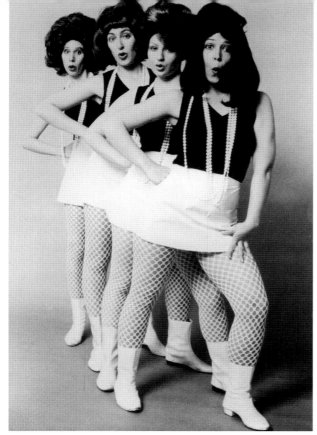

BOB BARNETT

women."[27] In *She-Devils of Niagara* (1985), they lampooned this imperialism in outrageous performances in which they dressed as "mock-males." Wearing shiny suits and white patent-leather shoes, they cruised the audience while lip-syncing to Paul Anka's "Having My Baby," and to Motorhead's "Go To Hell," they strutted their heavy-metal stuff in naked-male torso outfits (with detachable genitalia) and big mullet wigs while making obscene gestures with their tongues and guitars.

On one level, performances such as these by Buchan and The Clichettes were a send-up of the trashiest aspects of what General Idea's AA Bronson called the "aggressive foreplay" of American popular culture.[28] They were also a gambit in the censorship wars that had just landed Toronto's *The Body Politic* magazine in its first court battle, and for The Clichettes at least, they were an impertinent affront to the way cultural forms continued to be managed primarily by men.[29] At the time, however, critics often dismissed this entertainment-oriented approach as frivolous, decadent, and pandering to a capitalist paradigm.[30] This view shares certain premises with a cultural critique articulated in the late 1970s by Americans such as James Hougan and Christopher Lasch, who diagnosed a degeneration of culture which they defined as "narcissistic," whereby social alienation had led to self-absorption and a

THE CLICHETTES Left to right: Janice Hladki, Louise Garfield, Elizabeth Chitty, Johanna Householder, 1979

posture of cynical detachment.[31] In his book, *The Culture of Narcissism*, Lasch argued that the use of parody in popular culture was especially indicative of this cynicism: "Many forms of popular art appeal to this sense of knowingness and thereby reinforce it. They parody familiar roles and themes, inviting the audience to consider itself superior to its surroundings."[32] A year later, Lasch's condemnation of parody was extended by Bruce Barber to the whole genre of Canadian performance that drew upon forms of popular culture: "Aping the Hollywood star system or Las Vegas night club acts is simply that — aping. Stylish and sophisticated it may be but criticism it is not." Parody, he argued, is simply inadequate as a mode of critique, "especially if we ever find out what our postmodern priorities should be."[33]

Paradoxically, however, parody was soon redefined as a specifically postmodern mode of criticism in Linda Hutcheon's 1985 study, *A Theory of Parody*. Hutcheon notes that parody has been traditionally denigrated because it is derivative in nature and depends upon already existing forms to fulfill itself. By contrast, she argues that parody can be critically effective because it undermines the Romantic fallacy of originality, thus forcing "a reassessment of the process of textual production." By inserting itself into existing cultural texts and forms, parody exposes the power relationships between those social agents who possess the "original," and the others who possess the parodic alternative.[34] In retrospect, we can see more clearly how Canadian performance around 1980 was engaging precisely those techniques of parody described later by Hutcheon as a way to undermine gender binarisms and sexual categories. In this sense, this work can also be aligned with postmodern theories of subjectivity, such as Judith Butler's notion of performativity as a way to "make trouble" for the fallacy of gender as an abiding or ontological essence.

If we consider the impact of such theories on cultural thinking over the past two decades, and recall the extent to which fashion during this same period has apparently abandoned strict gender codes, we might suppose that the liberatory dismantling of male/female binaries is well underway. This seems not to be the case. The preoccupation with gender binaries in dress is considered by fashion historians to be a modern phenomenon in Western culture, dating roughly from between 1200 and 1400. Prior to that time, clothing divided people along lines of social rank rather than gender. Since then, clothing has increasingly served to express a relationship between the individualized — and thus sexualized — body and the conventions of the social body.[35] Indeed, the conventions of gender remain central to modern dress, and to making sense of it. Entwistle notes that, in spite of certain freedoms, "contemporary society remains preoccupied with sexual difference ... and fashion continues to play on gender, even while it periodically deconstructs it." She even goes so far as to say, "one might argue that gender is more significant today than it used to be."[36]

This knot of contradictions has become a focus for a number of performance artists who, since 1980, have used costume and dress to scrutinize the relationship between embodiment, sartorial style, and identity. Foremost in

31 James Hougan, *Decadence: Radical Nostalgia, Narcissism and Decline in the Seventies* (New York: Morrow, 1975) and Christopher Lasch, *The Culture of Narcissism* (New York: WW Norton, 1978).

32 Lasch, *The Culture of Narcissism*, 95.

33 Bruce Barber, "Performance for Pleasure and Performance for Instruction," in *Living Art Vancouver*, 80.

34 Linda Hutcheon, *A Theory of Parody The Teachings of Twentieth-Century Art Forms* (New York: Methuen, 1985), 5.

35 Anne Hollander, *Sex and Suits* (New York: Alfred A. Knopf, 1994), 30-33.

36 Entwistle, *The Fashioned Body*, 180.

37 Hollander, *Sex and Suits*, 45-8.

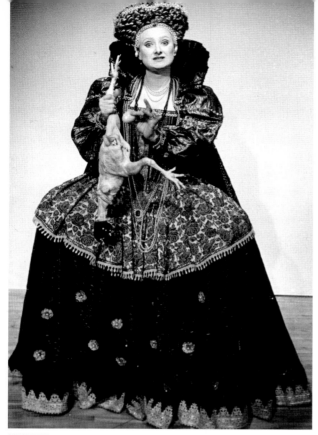

ANN PEARSON

this genre is a trilogy of works by Tanya Mars that speculates on the relation between women and power: *Pure Virtue* (1984), *Pure Sin* (1986), and *Pure Nonsense* (1987). In each, Mars plays a different archetype of female political, sexual, and creative power while performing in a burlesque style that veers from mock seriousness to ribald but cutting vulgarity. In each case, costume is crucial. In *Pure Virtue*, Mars plays Elizabeth I, the Virgin Queen whose accession to the English throne in 1558 necessitated wearing her chastity like a badge to set her apart from other women. By her clothes, however, Elizabeth signalled her acquiescence to conventions of femininity at a time when differentiation of the genders by dress had become well established, which, for women, meant headgear, tight bodice, and loose skirt.[37] Throughout Mars' exploration of the queen's relation to power, her dress is the primary signifier. Its splendour confirms the power of wealth and rank, and sexual power too. The aging queen dispenses advise on the merits of chastity, but also lifts her skirt to demonstrate how its loss may be concealed. Such deceptions, we might conclude, are the price of power.

Similarly, costume is central in *Pure Sin*, where Mars took on the role of Mae West, the mouthy Hollywood goddess whose bawdy sexual power and defiant refusal to submit to conventions of demure femininity were legendary.

TANYA MARS as Queen Elizabeth I in *Pure Virtue*, Playwright's Workshop, Montréal, 1985

In flamboyant dress and platinum blonde wig, Mars evokes West's excessive and artificial femininity, which not only epitomized female masquerade, but legitimized camp drag for the popular culture. Mars as West is the bodacious sex queen, and sheathed in a column of turquoise sequins and black tulle, she is the ultimate phallic woman. In *Pure Nonsense*, the dress perhaps does not matter so much as what is underneath. Here Mars, as Alice in Wonderland, awakens from a dreamy idyll to be abruptly informed by Freud that she has lost her penis. Aghast, Alice sets off to find it, querying the inhabitants of Wonderland, who vex her with absurd answers to the riddle, "Why does a Venus not have a penis?"[38] Refusing to submit to their Oedipal fantasies of sexual difference, however, Alice is mightily relieved when in the end she lifts her crinolines to discover an impressive penis, a comic gesture that literally deflates the whole apparatus of phallocratic mastery and subordination.

Colette Urban has also exploited the feminist strategy of laughter and the absurd possibilities of costume. The costumes and props Urban uses are often made from what the Surrealists called *objets trouvailles*, objects cast off as the detritus of a technological, capitalist society, but which carry the possibility of "convulsing" the viewer through their psychic, symbolic, and social associations. Urban's performances often invoke the gendered spaces and experiences of domesticity and childhood where identity takes shape, which she then unsettles and makes strange. In *a song to sing, a tale to tell, a point to make* (1989), the performance began with a male voice reading from the outdated how-to manual, *Hundreds of Things a Girl Can Make* (1945), while Urban emerged wearing a girlish dress and stick-like arm extensions covered in long white gloves. In contrast to the super-charged confidence of the "Wonder Woman" lyrics heard from a record player, Urban awkwardly manipulated a gravel-filled globe with her prosthetic arms until the performance ended with the hopeful notes of the song, "Somewhere, Over the Rainbow." Barbara Fischer writes:

> Identity in this performance is a position wrested from somewhere between a disastrous inability and an impossible perfection; Colette Urban is strangely empowered, or enacts power obliquely, as she turns and rattles the world globe.[39]

Urban's allusions to the fragility and tension inherent in negotiating subjectivity in a social context are meant to trigger unexpected responses on the part of her viewers, who are often recruited as participants. In *Consumer Cyclone* (1993), for example, Urban toured a shopping mall wearing a costume laden with a disheveled array of clothing and cosmetic paraphernalia used to construct and maintain feminine beauty. By repeatedly shouting the phrases "*Regardez-moi. Regardez-toi.* Look at me. Look at you." through a toy megaphone, Urban activated the spectatorial reification of the mall as consumer fantasy, revolving as it does around the commodity status of bodies and images, especially female ones. As the object on which these fantasies had materialized and stuck, Urban aimed to provoke a subjective response on the part of the shoppers, and, if only momentarily, to disrupt the flow of their capitalist reverie with her self-reflexive declamations.

38 See Tanya Mars, *Pure Hell*, a catalogue based on an exhibition and performance project that amalgamated elements from *Pure Virtue, Pure Sin* and *Pure Nonsense*, curated by Barbara Fischer (Toronto: The Power Plant, 1990), 22.

39 Barbara Fischer, "Of Children's Rhymes, Spiders and Other Entrapments," in *Colette Urban*, curated by Coleen O'Neill (Corner Brook: Sir Wilfred Grenfell College Art Gallery, 1992), 29.

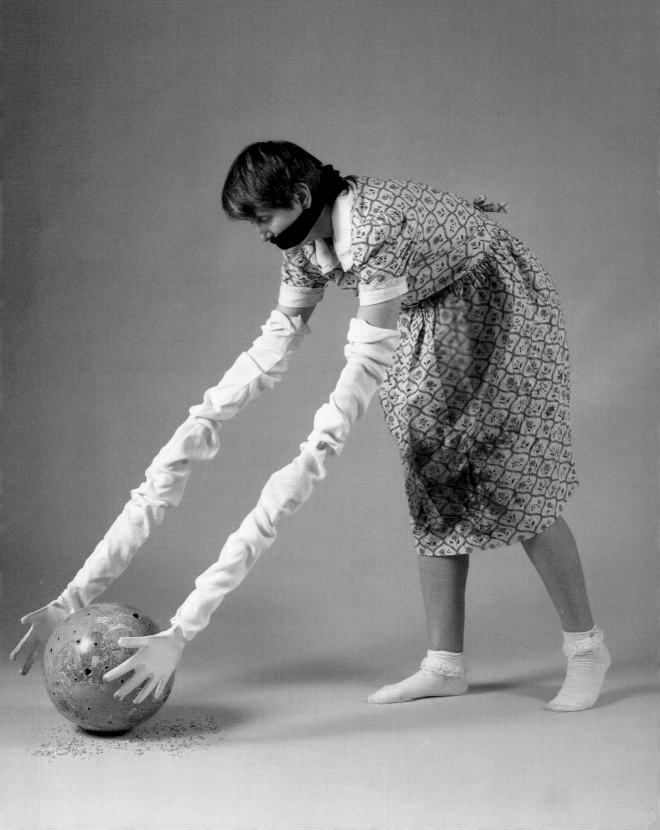

The humourous disruption of the nexus of connections between female identity, the artifice of beauty, and the representations of desire in mass culture was also the premise of a recent body of work by photographer Suzy Lake. In 1998, during the height of Spice Girl mania and lip-sync contests, Lake returned to the performative basis of her early work by playing the role of Scary Spice in a group performance that brought down the house at a fundraiser held at the Rivoli in Toronto. Recognizing a good thing when she saw it, Lake later reprised the role as Suzy Spice in a series of photographic self-portraits.[40] Caustically entitled *Forever Young*, they portray the middle-aged Lake as a pop-star idol of the bubble-gum set. She has all the right trappings: big frizzy hair, trashy jewellery, belly shirt, leopard-print leggings, and chunky platform boots. But she is mutton dressed as lamb. In a culture that pushes aging women to the outer limits of (in)visibility, while turning youth culture into a prolific and lucrative industry, Lake's defiant gesture is satire of a rare order indeed. Lake's middle-aged pop star is funny not just because she is so incongruous, so outré, but because her style-over-substance posturing is self-mocking. As such, it is a variation on camp parody, which, unlike the detached mockery of irony, relies upon a strong identification with a situation while comically appreciating its contradictions. We don't laugh *at* Lake's desperate desire for the sex appeal of eternal youth, but *with* her ability to skewer the culture that inculcates such ludicrous fantasies. Lake's self-mocking enacts the power of humour to be both defiant and offensive.

These kinds of irreverent performances give credence to Freud's observation that "humour is not resigned; it is rebellious." Moreover, the ability to be the object of one's own humour is empowering because "it is the triumph of narcissism, the ego's victorious assertion of its own invulnerability."[41] This rebelliousness is also evident in the work of Saskatoon artist Lori Blondeau, who uses parody strategically to define a positive identity in the midst of a hostile social environment.[42] Blondeau's work has centred on the clash between her Native identity and the ideals of white femininity that dominate our culture. She has performed several times as *CosmoSquaw* and appeared in this guise as the cover girl of her mock magazine by the same title (1996). In *Lonely Surfer Squaw* (1997), which was designed for the web-based exhibition, *Virtual Postcards from the Feminist Utopia*, Blondeau posed with a pink surfboard, like a displaced *Baywatch* babe, on the bank of a frozen Saskachewan river wearing nothing but a fur bikini and mukluks.[43] Like Mars, Blondeau shows that humour can indeed repudiate reality, and thus enable the humourist to resist his or her own subjection. It is, finally, a way to "make trouble" for the status quo of hegemonic power structures.

Winnipeg-based performance artists Shawna Dempsey and Lorri Millan have been making similar trouble for over a decade now. As emphatically "out" lesbians, their work addresses sexism, homophobia, and the social negotiations of identity. They use costume and dress as metaphor, symbol, or dramatic prop for narrative skits and vaudevillian gags that are wickedly parodic inversions of what is "normal," legitimate, and officially sanctioned.

40 See Stuart Reid, *15 Minutes: Michael Buckland, Suzy Lake, Sasha Yungju Lee, Mitch Robertson* (Mississauga, Ont.: Art Gallery of Mississauga, 2000), 13.

41 Sigmund Freud, "Humor," in the *Collected Papers*, vol. 5, 217; quoted in Cynthia Morrill, "Revamping the Gay Sensibility: Queer Camp and dyke noir," in *The Politics and Poetics of Camp*, Moe Meyer, ed. (New York: Routledge, 1994), 122.

42 See Lynne Bell and Janice Williamson, "High Tech Storyteller: A Conversation with Performance Artist Lori Blondeau," *Fuse*, vol. 24, no. 4 (2001), 27-34.

43 *Virtual Postcards from the Feminist Utopia* was curated in 1997 by Lori Weidenhammer for the Winnipeg organization, Mentoring Artists for Women's Art. It is archived on the Western Front's web site: www.front.bc.ca

44 All references to the texts of the Dempsey & Millan performances are taken from their video compilation, *A Live Decade: 1989-1999*, produced by Finger-in-the-Dyke Productions, Winnipeg, Manitoba. See also "Shawna Dempsey and Lorri Millan," in *The Feminist Reconstruction of Space*, ed. Louise W. May (St. Norbert: St. Norbert Arts and Cultural Centre, 1996), 66-83.

45 See Pauline Greenhill, "Lesbian Mess(ages): Decoding Shawna Dempsey's Cake Squish at the Festival du Voyeur," in *Atlantis* 23, nº 1 (1998), 91-99.

46 Renee Baert, "Three Dresses, Tailored to the Times," in *Material Matters: The Art and Culture of Contemporary Textiles*, Ingrid Bachmann and Ruth Scheuing, eds. (Toronto: YYZ Books, 1998), 79-82.

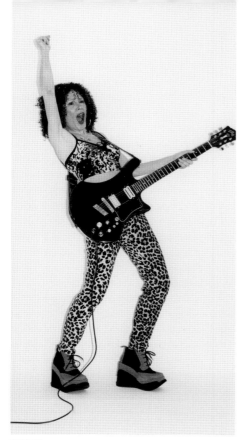

SUZY LAKE

BRADLEE LAROCQUE

SUZY LAKE *Forever Young*, 1998

LORI BLONDEAU *Lonely Surfer Squaw*, 1997. From *Virtual Postcards from the Feminist Utopia*, curated by Lori Weidenhammer for Mentoring Artists for Women's Art, Winnipeg

Nothing is sacrosanct in their comedic repertoire, including feminism's own conflicted ideals. In *Mary Medusa* (1991-3), Dempsey appeared on stage as a floating head with a halo of rainbow dreadlocks, demanding to know, "Is a woman without a body still a woman? Without a body, does a woman in fact exist?" [44] Dropping a black robe to reveal a business suit, she expounded ironically upon her achievements as a self-actualized, modern superwoman before stripping down to her control-top pantyhose and confessing, "A woman out of control is a frightening thing, lusting after sex once a week, food, and chocolate cake. Lots of chocolate cake," she cooed, dropping to the floor and squeezing a cake between her thighs, moaning audibly. [45]

In *Arborite Housedress* (1994), Dempsey wore a pink dress made from what Renee Baert called one of the new "wonder" materials that furnished the post-war suburban boom. [46] Reciting a parable about marriage being like driving the family car, she warned of the dangers that ensue if family members deviate from their prescribed roles. Yet there is little danger of us taking her morality tale seriously, for it is as rigid and artificial as her dress. In *Growing Up Suite* (1996), however, Dempsey confided that such rigid and artificial constructions could also be the object of queer desire. As an adolescent in the late 60s, she didn't know what erotica or porn were, but she did

know what turned her on: the ladies in the lingerie pages of the Eaton's catalogue wearing "industrial-strength underwear concealing unimaginable body parts so powerful they needed architecture to keep them in place." As always for Dempsey & Millan, humour cuts like a knife, serving both as a means to expose the cultural contradictions and confinements that oppress them, and as a force for liberatory expression.

In this study of Canadian performance, I have considered how costume and dress have been used to generate meanings within specific historical contexts. What emerges as distinctive is the pervasive use of humour and references to popular culture. Canadian performance came of age at a time when the assumptions of power and privilege accorded to normative identities were prevalently being called into question. By investing their own identities in humorous interventions into popular culture, these artists flaunted themselves with subversive theatricality. Their colonization of popular culture enabled them to avail themselves of its pleasures and artifice, and to deploy its strategies to expose and politicize those power relations that construct the body as the site where difference and deviance are inscribed. Yet, as I have argued, it is not just the "body" itself that is at issue here, but rather the fashioning of the body/self through manipulations of costume, dress, and sartorial style. These performative manifestations not only rely upon modes of popular entertainment, but actively assault those modes by way of the excesses of queer camp, the inter-textual meanings of parody, the exaggerations of satire, and the defiance of self-mocking humour.

It is important to note, however, that humour is not inherently oppositional any more than the relation between art and popular culture is inherently unproblematic. This relationship can profitably embrace the indeterminacy and flow between categories, but what is always at risk is the ability of art to retain its critical edge in the face of the consuming allure of popular culture. In the era of advanced capitalism, popular culture is a euphemism for the culture industry, and that industry is in the service of a bourgeoisie whose genius for survival lies in detachment and the absorption of subversive elements within the culture. Defiant practices like queer camp and parody can expose what the powers-that-be would like to keep hidden, but they can just as easily be used for banal or exploitative ends. When humour is used merely to make political criticism more palatable, which involves emphasizing form over content, it has moved into the realm of detached aestheticism, which is, says Chuck Kleinhans, "essentially a training program for alienation."[47] That defensive and ultimately cynical strategy is not, however, what is at work in the performances of the artists discussed in this essay. Instead, they use humour to lure audiences in, either to elicit identification with their socially marginalized subject positions, or to disarm potentially hostile audiences in order to take them by surprise with unruly acts and defiant words. Using popular forms of humour and entertainment allows these artists to speak through the language of the common culture in order to gain critical purchase on that culture. But at the

47 Chuck Kleinhans, "Taking Out the Trash: Camp and the Politics of Parody," in *The Politics and Poetics of Camp*, 197.

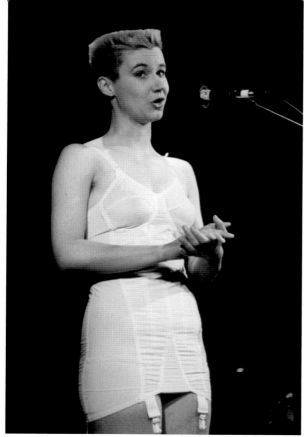

DON LEE

same time, in order for such art to maintain its criticality, it must be deftly poised on the razor's edge between the seductive appeal and subversive potential of popular culture. And it is in that subtle interstice where the artists considered here have enacted their critical forms of play through the mediating effects of costume and dress.

★ ★ ★

This article was originally written for the book *Canadian Cultural Poesis*, ed. Garry Sherbert, Shelia Petty and Annie Gerin (Kitchener: Wilfred Laurier University Press, forthcoming 2004). The version that appears here has been slightly modified and expanded.

SHAWNA DEMPSEY & LORRI MILLAN
Growing Up Suite I, 1996. Courtesy of the artists

Clive Robertson

Lillian Allen

HOLDING THE PAST, TOUCHING THE PRESENT, SHINING OUT TO THE FUTURE [1]

And hey! what yu doing here anyway?

so don't come with no pling, ying, jing
ding something
calling it poetry
'cause this is a one poem town
and you're not here to stay

are you?
— EXCERPT FROM "ONE POEM TOWN"

Instead of being the doormat
Get up and be the door
— EXCERPT FROM "FEMINISM 101" [2]

If you tuned into CBC Radio One in the coldest months of 2004, you may have felt the heat from one or more of the thirteen episodes of *Wordbeat*, a show instigated, produced, and hosted by Lillian Allen, performance poet, teacher, and cultural policy activist. Allen introduced live and taped performances from poets across generations, genres, and cultural communities including griot storytelling, sound poets, poetry slams, jazz poetry, beat poetry, hip hop, and — closest to her heart and commitment — dub poetry. Her bio on the *Wordbeat* website cites Lillian Allen as "a leading originator of dub poetry, a highly politicized form of poetry crafted for a listening audience, sometimes set to the driving beats of reggae music with other contemporary sound influences."

Allen herself has written, "Dub poetry is not just an art form. It is a declaration that the voice of the people, once unmuzzled, will not submit to censorship of form." [3]

Dub poetry, so defined, does not need performance art for its validation. It is a form of cultural expression with its own intermedia history. It now has its own festivals and conferences. In May 1993, Allen initiated and then organized with a collective that included Chet Singh, Clifton Joseph, Ahdri Zhina Mandiela, Afua Cooper, and Carol Yawney, the First International Dub Poetry Festival in Toronto bringing together "over one hundred dub poets from over twenty countries around the world including practitioners from Canada's First Nations, Ethiopia, South Africa, the US, France, Germany, England, Trinidad, Barbados, Antigua, Jamaica, St. Vincent, and Dominica, to reveal that dub poetry has only just begun and is already a growing international phenomenon." [4] The 2004 International Dub Poetry Festival in Toronto, again instigated by Allen and organized by the Dub Poetry Collective,[5] was subtitled, "The Totality of Orality."

Dub poetry, in its deliberate move away from the static text (and the permissions necessary for book publishing), shares some of the impetus that brings artists to make performance art. In the 70s, Allen switched from writing plays and short stories to poetry because as she explains, "[it] was to put it simply, more portable. It was like art to go. Take-out art. Me, my poetry, and the public. No middleman." [6] What dub poetry and performance art share is the significance of always "conceptualizing an audience" and — much clearer and more prominent in the case of dub poetry — a concept of community that is more than shared alliances and exchanges between practitioners. In Canada, dub poetry emerged from within a heterogeneous cultural community that was Carribean and Afro-Canadian. The artists had day jobs mostly working with black youths and their parents. Allen says:

What was important for [this] community and for us — the artists — led us to experiment with ways of working that had the most impact and gave us the ability to craft an aesthetic. This work was *for* an audience. It wasn't meant to mystify an audience, it wasn't made so people could say how skilled or how great we were, it wasn't meant for people to contemplate whether we would go down in history — those concerns that writers have about longevity. It was meant for community engagement, for dialogue, it

1 Lillian Allen, interview with Johanna Householder, (July 2003). The title is taken from Allen's description of first hearing Oku Onuora's performed poetry in Cuba in 1978, a genre he called "dub poetry."

2 Lillian Allen, "One Poem Town" and "Feminism 101" in *Women Do This Everday* (Toronto: Women's Press, 1993).

3 Ibid.

4 Ibid.

5 Current Dub Poetry Collective members are: Lillian Allen, Clifton Joseph, Afua Cooper, Michael St. George, Chet Singh, Klyde Broox, d'bi.Young, and Sankofa.

6 Allen, 17.

was meant to inspire, it was meant to create a "fifth column," creating new psychic space. It took its energy from its audience, feeding on how the audience felt, how they responded to the work and to us, and what we thought was that partnership in developing the work.[7]

Allen herself has said of her own practice that conceptions of audiences as non-monolithic entities is difficult, that making work that is sufficiently inclusive is a challenge, that there are issues arising from audiences themselves that are not immediately understood, that have to be worked through. This conception of performance as the core of a practice then leads to other considerations of writing, publishing, and the necessity for alternative models of self-distribution:

Dub poetry necessitated a consciously different approach to a practice of keeping on writing, putting it away in a book, and hoping to be discovered, waiting for a publishing contract, etc. The message was of primary importance. It connects to the very powerful tradition of the storyteller who does not wait for a production team. We did not confuse the making of and the distribution of the work. We did understand that the work we made was unlikely to be supported by traditional arts institutions or market forces. In some ways we were calling for their destruction or their rehabilitation. This lead to how we would collaborate on the distribution of the expansion of this work.[8]

The common questions put to women artists in this book were about the "why" of choosing performance and the "how" in using performance as an art form. Having re-read Allen's statements about the key events in her own formation, it may help this narrative to suggest a mix of affinities that have shaped her *performance* practice. First and foremost is her connectedness to growing up in Jamaica: the experience of being in a body in a vibrant culture — but in a British-style school system with its cultural "stigmatization of identity and self," and her resulting identifications with poet, Louise Bennett, and with Bob Marley (as the conveners of a to-be-named dub poetry), and the emergence of reggae as both music and as an "undeclared act of subversion." In Louise Bennett, Allen embraced a "developed persona that fit in with the African tradition of the artist as preacher, teacher, politician, storyteller, and comedienne." [9]

A second affinity is with feminist cultural practices and the women's music movement; and in particular, the example of Ferron as a catalyst for Allen's decision to make a living as an artist. A third affinity is with a "style of brattiness, a kind of energy" found in the alternative art movement, "a transgression coming from privilege." Here Allen's productive collaboration with the First Nations and artists-of-colour coalition, Minquon Panchayat is a key example. The overlapping positionalities of these affinities all connect with Allen's acknowledgment that "ideas are propelled by movements." [10]

Allen's two Juno award winning recordings "Revolutionary Tea Party" (1986) and "Conditions Critical" (1988) released on her own label, Verse-to-Vinyl, were made possible by her work for audiences and supporters from a large network of sites. These included women's music festivals, folk festivals, emerging

7 Lillian Allen, interview with Clive Robertson (August 2003).

8 Ibid.

9 Allen, *Women Do This Everyday*, and Allen, interview with Householder (July 1993).

10 Ibid.

11 Rinaldo Walcott, *Black Like Who?* (Toronto:Insomniac Press, 1997), 83-4.

12 Isobel Harry and Lisa Steele, "Truth and Rights and ImmiCan," in *Centerfold* vol. 4 no.1 (1979). This interview appeared in the issue, "Immigration: Do You Have Canadian Experience?" edited by Karl Beveridge. With other anti-racism periodicals like *Rikka* and *Asianadian* in existence, this was probably the first substantive attention the white artist community gave to the issue of racism. Together with *Centerfold*'s coverage and analysis of *The Body Politic* trial, *Centerfold/Fuse* began earning its function as a coalition writing space for identity politics and representation in the 80s and beyond.

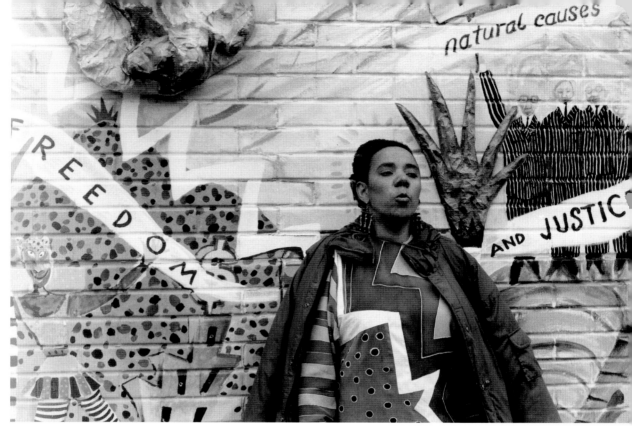

arts and cultural communities, social movements, labour, and education.

The presence and challenges of local black post-colonial women intellectuals and writers Himani Banerji, Marlene Nourbese Philip, Dionne Brand, and Lillian Allen has had a considerable effect on a range of Canadian practices and institutions. Black cultural studies scholar, Rinaldo Walcott, speaks of an "embracing [of] what can only be called a diasporic understanding of nation, one that's constituted through history, experience, and positionality … these artists force us to continually rethink and reassess what we mean by nation, home, and community." [11] Continuing her own performance practice, Allen is currently a professor of creative writing at the Ontario College of Art and Design, a member of the Experts Advisory on the International Cultural Diversity Agenda, and an executive member of the Canadian Commission for UNESCO.

I first met Lillian Allen in 1979 through Isobel Harry and Lisa Steele when I was a co-editor of *Centerfold/Fuse*.[12] Allen was then employed as a legal worker and coordinator of ImmiCan, a cultural centre for "unemployable" male, black youth in Regent Park in downtown Toronto. There she worked on projects of political education and cultural self-sufficiency with the reggae band, Truths and Rights, and the performing workshop, Gayap Rhythm Drummers.

LILLIAN ALLEN in *Unnatural Causes* a "film-poem" produced by Studio D of the National Film Board in 1990. Wall artwork by Grace Channer and Barbara Klunder

LILLIAN ALLEN performing in Montréal circa 1991

Somewhere between 1981 and 1982, Allen and fellow poets Clifton Joseph and Devon Haughton began intensifying their collaboration by performing together several nights a week, everywhere from bars to benefits to schools to streets.[13] In a 1983 *Fuse* interview, Allen said, "what pulled us together was the realization that we needed to organize this stuff. [Dub poetry] was gaining in popularity, and we wanted to pull upon the strength of an organized collective with an organized front."[14]

Shortly after the trio performed at the Second Annual Black Radical and Third World Book Fair in Brixton (UK) where they met Sonia Sanchez, Ngugi wa Thiong'o and Linton Kwesi Johnson. Such exchanges among fellow poet-activists strengthened their desire to develop an international movement to "internationalize dub poetry."

The usefulness of the terms "dub poetry" or "performance art" as namings are more in how they focus specific energies through realizations of and identifications with a broader history of practices. Clifton Joseph said at the time, "I think we have a very highly developed sense of history, and we've trained ourselves to notice what our activities relate to."[15] The namings are not so much boundaries of what can or cannot be done but are re-articulations of approaches and methods that have relevance in the objectives and production of new work. At some point this includes an assessment of what existing cultural spaces and adequate resources can satisfactorily be accessed or utilized in the interim and thereafter what needs building.

I was asked to write this profile, because Allen and I have shared a web of aesthetic and political interests including performance practice and histories. But we also share a commitment to construct alternative "artist-run" resources that satisfy but look beyond our own needs. An as-yet-unwritten account of an early part of Allen's vinyl performance history follows. Continuing *Centerfold/Fuse's* active dialogue with Afro-Caribbean-Canadian artists, in 1982 I co-produced a first album for the Gayap Rhythm Drummers on the artists co-op label, Voicespondence (Artists Records and Tapes).[16] *Gayap Rhythm Drummers* was recorded by Michael Brook and members of Truths and Rights at the Kensington Recording Studios in Kensington Market. Allen, Joseph, Haughton, and I then decided to work together on the production of their first record, *De Dub Poets* (1983) a 12-inch vinyl EP.[17] This disc followed the poetry publications *Rhythm and Hard Times* (Allen, 1980), *Metropolitan Blues* (Joseph, 1983), and *Roots n' Culture* (Haughton, 1983) produced with fellow poet, Krisantha Sri Bhaggiyadatta on the cooperative imprint, Domestic Bliss. *De Dub Poets* included contributions from Truths and Rights members Iauwata (keyboards), Mojah (guitar), Xola (bass), Quammie (percussion), and Wadi (drums) from the band Le Dub Sac. The four tracks I recorded "Chuckie Prophecy" (Joseph), "Riddim an' Hardtimes" (Allen), "Mi caan't believe it" (Haughton), and an improvisational collaborative track, "Unity Song"(Allen, Joseph, and Haughton), were mixed by Quammie. The two Voicespondence releases, *De Dub Poets* and *Gayap Rhythm Drummers* were made possible with funding assistance from the Explorations Program at The Canada Council for the Arts.

13 It is important here, to acknowledge, as Lillian does, the simultaneous dub poetry practices of Afua Cooper, Ishaka and Ahdri Zhina Mandiela.

14 Clive Robertson, "Rhythm and Resistance: Maintaining the social connection," in *Fuse* (1983), 32-38.

15 Ibid.

16 *Centerfold/Fuse's* editors then included black music journalist, Norman "Otis" Richmond and NYC curator-critic, Tony Whitfield. In the December 1982 issue of *Fuse*, black playwright, Valerie Harris wrote the cover story, "Rastafari: Issues and aspirations of the Toronto community," Richmond wrote, "Crossing the Apartheid Line," Keyan Tomaselli wrote on oppositional film in South Africa, and Ross Kidd published an interview with the Nicaraguan Farmworkers Theatre Movement.

17 *Voicespondence* had begun in 1974 as an artist audio cassette magazine in Calgary. By 1977, I had conceived of an artists' publishing entity that would produce artists' work and criticism across audio, print magazine, and video formats. Such projects with Fluxus artists and poets Robert Filliou, Dick Higgins and Emmett Williams, Canadian sound poet, Steve McCaffery and the VideoCabaret band, The Government, preceded the collaborations with De Dub Poets and Gayap Rhythm Drummers. In 1982, after stepping away from the managing editorship of *Fuse*, I constructed a community non-profit recording studio co-managed by Janet Martin (Fifth Column guitarist) and myself, where *De Dub Poets* was recorded. Janet Martin was the executive producer of *De Dub Poets*.

Caught in the Act an anthology of performance art by Canadian women

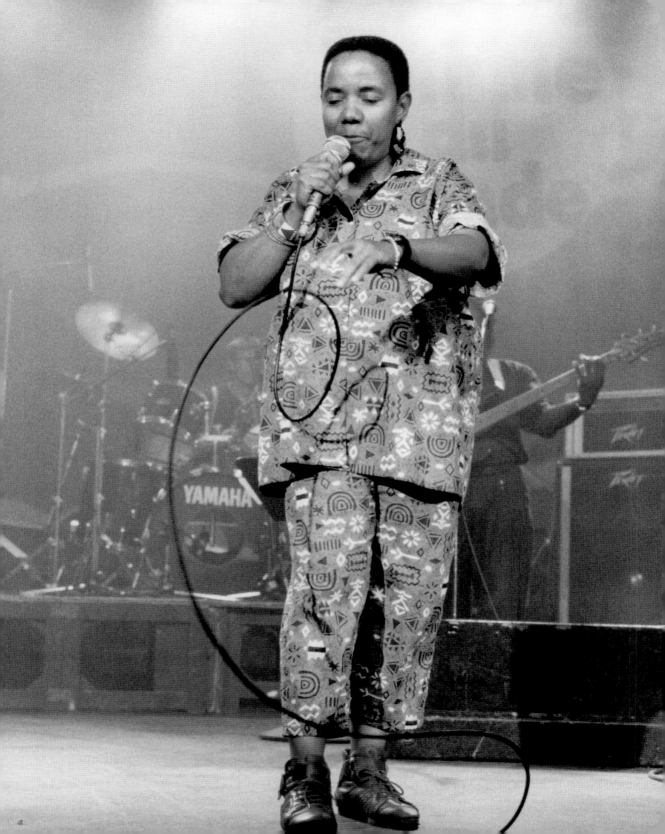

These artist-with-artist collaborations and opportunities for mutual personal growth were definitional projects within the local alternative art movement. As Allen remembers, "you didn't know folks, when Toronto's artist and cultural communities were separated along race lines."[18]

By 1984, Allen was president of A Space. This ground-breaking artist-run centre of the 70s committed itself in 1982 to "broaden the arena of cultural representation."[19]

The dub poets successfully self-distributed their books and the independent *De Dub Poets* release was played across North American campus radio stations and by the CBC's Ross Porter. Lillian Allen's book, *Rhythm and Hard Times* sold in excess of 8,000 copies.

Campus station playlists of the time provided encouragement for independent producers even if they indicated little more than an overlapping of DJ tastes. In 1984 when performance artist, Laurie Anderson's, "Mister Heartbreak" made No. 1 on the CKLN Toronto playlist, *De Dub Poets* was at No. 2, and Billy Bragg at No. 18.

In 1986, when Allen won her first Juno, Johanna Householder and Heather Allin organized a performance art series *6 of 1001 Nights of Performance*, for A Space in Toronto. There Allen performed her work alongside Marcia Cannon, Krisantha Sri Bhaggiadatta, Rhonda Abrams, John Greyson, and Makka Kleist with a finale performance lecture by Tanya Mars. Writing in a post-event activity book (designed by Greyson) that documented the series, Householder wrote of a theme that emerged from the commingling of this work "[It] had to do with articulating suppressed histories. The performances tell tales prohibited by mainstream media ... in doing so, each draws attention to the 'veritable' voice, locating the unique space from which we can speak — and choose to act."[20]

Lillian Allen emigrated to Canada in 1969, studied at the City University of New York and later at York University in Toronto. In 1978, Allen met up with Jamaican dub poet Oku Onuora at the 11th World Youth Festival for Peace in Cuba. Onuora gave Allen one of his books followed by close to an hour's private performance of his work. Allen says, "it captured my imagination. [Onuora's merging of performance and message] held the past, touched the present, and shone out into the future."[21] Devon Haughton who had returned to Jamaica in 1977 to attend the Jamaica School of Drama also had contact with dub poets Onuora (then Orlando Wong), Mutabaruka, and Michael (Mikey) Smith.[22]

In recent interviews with Householder and myself, Allen talked about the functions of and her resistances to language, the necessary inclusion of Jamaican patois or Creole and how its celebration in dub poetry overcame some of the early apprehensions other Black writers had for its usage in their own work. In this account, language is then related to the significance and authenticity of persona in performance and a mark of resistance to cultural hegemony.

Allen speaks initially of being alienated from the rules of English language and the need to "bend and break language" to demonstrate ownership of language, to understand what the phrase "colonized by lan-

18 Allen, interview with Householder.

19 In November 1982 at the A Space AGM a successful proposal to "broaden the arena of cultural representation" was made by an elected slate of Lisa Steele, Jane Wright, Norman 'Otis' Richmond, Carole Condé, Tanya Mars, Kim Tomczak, and myself (AA Bronson, *From Sea to Shining Sea*, Power Plant, 1987, 131).
By 1984 A Space's programming committees demonstrated this expanding coalition approach to art and cultural interests: Music: Janet Martin, Susan Sturman, Ayanna Black, Chris Devonshire, Clive Robertson. Written Word: Lillian Allen, Clifton Joseph, Lisa Steele; Community Arts Group: Ayanna Black, Carole Condé, André Sorenson, Mary Raudssus, Jane Northey, Elisee Zack, Julie Salverson, Dot Tuer; Performance: Heather Allin, Johanna Householder, Jude Johnston, Ben Freedman, Chris Devonshire; Film: Kim Tomczak, Margaret Moores, Almerinda Travassos, Ellea Wright, Rosamund Dawn, Su Ditta; Video: Jayne Wright, Nancy Patterson, Phyllis Waugh, Mary Raudssus, Mark Verabloff; Exhibitions: Jayce Salloum, Jude Johnston, Bryan Gee, Peter Greyson, Maia Damianovic, Gina Stepaniuk (A Space listing, *Parallelogramme*, vol. 9, no. 5, 1984: 28).

20 Johanna Householder, "6 of 1001 Nights of Performance," Activity book insert in *Parallelogramme*, vol. 12, no. 2 (1987), 3.

21 Allen, interview with Householder.

22 Klive Walker, "Caribbean Theatre Beats Out a New Rhythm," in *Fuse*, vol. 11, no. 1&2 (1987), 39-42.

23 Allen, interview with Robertson.

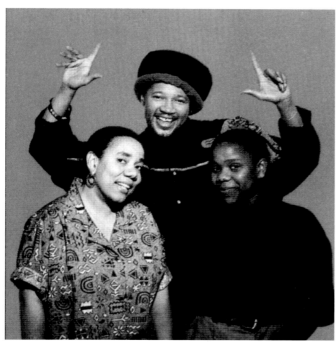

COURTESY OF THE ARTIST

DE DUB POETS

KWESI AHMED

guage" means both metaphorically and politically in terms of class and power. "Language is central to who you are, language structures and predetermines [doubly for those colonized] how you think." To use Jamaican Creole in front of its speakers is to communicate in a common but unofficial language, to be able to speak in a "non-fictitious, joyous and feisty way ... with listeners who attend to performed words, where you could hear a pin drop." Its usefulness in the context of everyday North American English or where English is not the primary language is that "it forces people to think about that culture, its identity, and difference."[23] In its coding of what is being and can be said and therein in its reversal of an audience's cultural capital and competency, using Jamaican Creole (also termed *Nation Language*) can be subversive. (There is an interesting parallel to be made between the dub poetry movement and the political mobilizations around performance practices and literary debates within Québecois *joual* and popular expression in the 60s.) Allen observes:

What is said about "voice" definitely applies to us. There is a persona that goes with the work. In the case of dub poetry it is not just a dimension of what we believed in, it is not just a script. The persona of Arnold Schwarzenegger in his multiple body-count movies is received differently

LILLIAN ALLEN, **CLIFTON JOSEPH**, and **COURA ANTA NIANG** at the Kumbaya Festival Fundraiser for People Living with Aids, Ontario Place, Toronto, September, 1995

LILLIAN ALLEN, **CLIFTON JOSEPH**, and **DEVON HAUGHTON** Album cover for *De Dub Poets*, vinyl 45 rpm E.P. (VSP010, 1983). Cover art by Kwesi Ahmed

than the personae of gangsta rappers. In our case, we [dub poets] were calling people to account — in our sphere of influence you had to deal with us, you had to deal with our values and our accountability to the community.

Moving to the present Allen sees art as a:

singular achievement that brings information and knowledge together as a package in ways that we can engage it and engage with it. The complex work and the thinking that goes into art means that ideas within values-based, content-based work, conveyed within an artistic vision or stance, become a counter force to mass media. In performance you are there with yourself, without apology and audiences identify with this and are changed by it. In performance you don't have to barter or negotiate, you express or communicate what you wish for, who you are and what you are ... My earlier recordings are still finding new audiences. I am still performing my life teaching, mentoring, and gardening ... When I talk with young poets I say things like "you have to have a reason to be on this stage, every performance should be your best" ... If we can acknowledge that flapping butterfly wings can change weather patterns, then undoubtedly we can claim that a good performance can fundamentally change the world.[24]

Lillian Allen's performances like reggae itself circulate "rhythms of resistance and hope, carrying a universal felt heartbeat and a message of defiance and resistance."[25] As I wrote just over a decade ago, what Canadian women artists like Lillian Allen and her immediate peers have given to performance art is a reminder of its strategic relevance through a redefinition of its cultural horizons.[26]

24 Ibid.

25 Allen, *Women Do This Every Day*.

26 Clive Robertson, "Performance art from 1970-80: Tracing some origins of need," in *Performance art in/au Canada 1970-1990*, Alain-Martin Richard and Clive Robertson, eds. (Québec: Éditions Intervention, and Toronto: Coach House Press, 1991), 17.

Anna Banana

CATCHING UP WITH A. BANANA REPUBLIC

One hardly knows where to start with Anna Banana; her thirty-year history of performance events all along the West Coast, her extensive history in mail art and artist stamps, the interactive nature of her work before interactive became THE concept, and when only the US Government had computers. All of these activities seem noteworthy, but it's the long-term nature of her output and input that's really overwhelming: the DeccaDance, *The Banana Olympics*, the Futurist plays, the Anna Freud Banana works, her tours through North America and Europe, *VILE* magazine. Anna Banana was always there again and again.

In the early 90s, I curated her retrospective, *20 Years of Fooling Around with A. Banana,* for the grunt gallery artist-run centre in Vancouver, BC. It featured works dating back to the early 70s and culminating in her then passion for artist stamps, which she produced through the 80s and 90s for herself and for other artists. Since then, she has moved to Robert's Creek on the Sunshine Coast, a short ferry ride from Vancouver. She took a brief hiatus from performance between 1983 and 1987, returning with a collaboration with Ron Brunette called the *World Series* at the Western Front. Her name pops up everywhere across Canada and Europe. *VILE* magazine is in the Tate Modern.

Surveying her material, you realize that all of this work has been about

networks and networking: *VILE* magazine, mail art, the DeccaDance, the postage stamps. Connecting and activating people through all kinds of creative interactivity is the key that's always been there and lies in the heart of everything she does. She just thinks like that. It will be interesting to see how the internet has changed this for Anna Banana. Her situation now in rural Robert's Creek after years in San Francisco and Vancouver must have an effect on her work. However, Anna is still moving: in 2003, she travelled to Germany in April and St. Niklaas, Belgium, in May. How has her networking changed through her remote location and her internet connection?

I leave one Sunday morning for the Sunshine Coast to talk to Anna Banana. She meets me in Gibson's at the ferry. The last time I saw Anna was when we worked together on Glenn Lewis' *Mondo Arte* piece on the history of Vancouver performance for the opening of the LIVE Biennial of Performance Art in the fall of 2001. In it, Glenn mixed younger and older performance artists from Vancouver; pulling Gathie Falk out of retirement along with Kate Craig, Patrick Ready, Hank Bull, and a cast of dozens. Anna Banana presented her 1973 piece, *Mona Banana Smile Text*, and Western Front performance curator Victoria Singh played a second version of her. It was a chaotic and fun-filled affair in the rotunda of the Vancouver Art Gallery, though perhaps more fun for the participants than the audience.[1]

Anna looks great. Her eight years at Robert's Creek seem to have been good for her health. She retains the vitality that she has always been famous for and she's also ready to talk. We catch up on each other on the drive. She's just returned from presenting two works in Europe; *Tie a knot on me*, in collaboration with Karla Sachse's installation of knots in the Nordbahnhof station, one of fifteen subway stations in Berlin's annual Transportale event. At a mail art Festival in St. Niklaas, Belgium, she presented her TV game show parody, *Banana Splitz*, and in between these events, visited a number of artists to see what they were doing with/about their archives of mail art. We chat about our mutual friends.

When we get to her place, I haul out my pen and pad and she puts on a kettle for tea. I talk about my theory that the basis of her work is constant networking and interactivity. She agrees right away. But she cautions that people don't always understand it as art. After her presentation of *Banana Splitz* at the Banff Centre, some people in the video department told her they thought it would be better with professional actors rather than using the audience members as contestants. They clearly didn't understand the interactive nature of the work. She is preparing for the *Name Project*, an art research project studying the effect of using an a.k.a., a pseudonym, or making a legal name change on one's life and work. Her own life was profoundly altered by changing her name, and her early research indicates that changing one's name affects more than one's identity. In this project, Anna will examine the experiences others have had in this regard and document her findings.

Anna started networking before she knew there was a network. When she appointed herself Town Fool of Victoria in 1971, she engaged the people

1 For the LIVE Biennial of Performance Art opening 2001, Glenn Lewis and I produced his performance *Mondo Arte 60/70*. Participants included Gathie Falk, Kate Craig, Patrick Ready, Mary Beth Knechtel, Rebecca Belmore, Archer Pechawis, John Boehme, Jonathan Middleton, Anna Banana, Naufus Ramirez Figuero, Hank Bull, Lizard Jones, Paddy Ryan, and Victoria Singh. The radio-play written by Lewis and published in *LIVE at the End of the Century: Aspects of Performance in Vancouver*, Brice Canyon, ed. (Vancouver: Visible Arts Society and grunt gallery, 2000), documents performance art of the 60s and 70s in Vancouver in a *Mondo Arte* radio-play format.

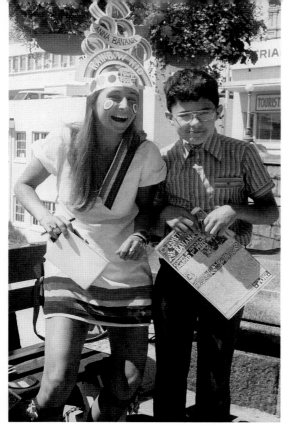

BOB/ZEAL STUDIOS

LUANNE RAYVALS

of Victoria in various interactive events and activities such as giving her personal/family anecdotes on the banana theme, a variety of art classes in public schools and at the Silver Threads Society, an April Fool's Day *Decorate a Banana* event, and a Victoria Day parade entry. From this work and the accompanying publication of her newsletter, the *Banana Rag*, she came into contact with the mail art network. On receipt of the *Banana Rag*, Gary Lee Nova sent her a copy of the Image Bank Request List, which gave the names, addresses, and image requests of a number of early networkers. She had no idea who the people were but decided to answer their requests, include a copy of the *Banana Rag*, and ask for images and information about bananas. With these contacts, she was able to further develop the ideas of exchange and interaction in art. She was attracted to the network because it was an open system and encouraged everyone to take part; you didn't have to be an art star. She had started to resent the mainstream art systems, developing a strong aversion to the star system she called, "Those heroic unreachable people doing fabulous things."

Right now, however, she's concerned about the future of her archives. She's been an avid networker, and has retained all of the mail art she has received — letters, artworks, posters, zines, catalogues, and reviews since

ANNA BANANA as Town Fool (with audience member), Victoria, BC, 1972

ANNA BANANA (with audience member Louise Liliefeldt), *Bananas in Distress*, 7a*11d International Festival of Performance Art, Toronto, 1998

1971. Another section of her archive documents her performance work through posters, announcements, and reviews. All this wealth of material has never been catalogued, so during her recent trip to Europe, she checked in with a number of her mail art colleagues to find out what plans they had for their collections. She found that a few have donated them to institutions, museums, or art history departments. For example, Joseph Huber (of former East Berlin) sold his to Museum Schwerin, which specializes in works by artists from Eastern Europe. Klaus Groh (Edewecht, Germany) donated related materials he had catalogued to the University of Bremen. Robin Crozier's (Sunderland, England) went to the Tate Modern in London, and Hervé Fischer's (Paris) is in the Pompidou in Paris.

In North America, everyone wants to collect the works of Fluxus artists and Ray Johnson. Ironically, a system set up with an aversion to art stars must get read into a system that thinks of nothing but art stars. Anna's concern is about the ease with which collections get broken up, and the ephemeral nature of the exchange lost. History turns the art into something else completely.

Anna's performance career was interdependent with the mail art network. When she and Bill Gaglione toured Europe in 1978 with the *Futurist Sound* performances (their interpretation of Futurist *Sintesi*), all their performance dates were set up through the network. Whenever she travels, she connects with other mail artists in the areas she visits, and these are the people she stays with and works with when she tours.

I was curious about how she wound up doing Futurist performance. She had been performing Dadaist sound poetry with the Bay Area Dadaists in San Francisco (1973-1981) and through that work, she stumbled upon the Futurist plays. She planned to tour Europe with a project called Special Delivery International in which she would deliver letters from Mayor Moscone of San Francisco to all the mayors of the cities she would tour. However, she couldn't get near the mayor to ask him despite her repeated attempts to arrange an appointment. Eventually she gave up and devised another plan. In hindsight, she wonders why she never thought to ask her friend Harvey Milk, then a city councillor, whom she knew from his photography supply store where she took her film for processing. He always enjoyed her photos of the antics of the Bay Area Dadaists.[2]

She liked the Futurists because they distrusted the "masterpiece," and their plays were about "taking the action off the stage and into the public domain." She likes work that forces the audience to be active rather than passive and to recognize the absurd realities of everyday life. The Futurist work was well known in Europe, and in Poland, artists knew these works so well that they asked why she and Gaglione were reviving them.

I ask her about how it was being one of the only women active on the West Coast during that time and how it has changed since. She says in mail art, her gender didn't affect her acceptance into the network — but she still has to fight to be included in the history. In a 1998 newspaper article about the Bay Area Dadaists, a number of her works were attributed to a former partner. And she feels mail art's intentions are often subverted by art historians who

2 Harvey Milk was the San Francisco city councillor who along with Mayor Moscone was shot and killed by councillor Dan White in the fall of 1978.

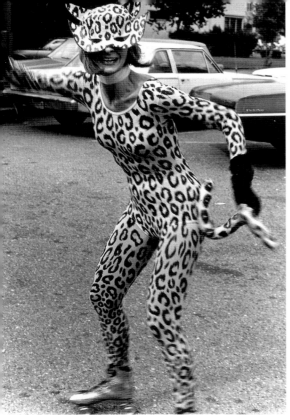

CHARLES CHICKADEL.

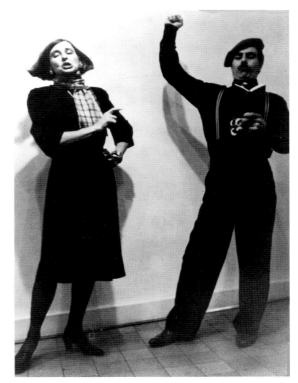

JEAN SELLEM

don't understand it and consequently don't value what was important about it.

But what is always behind Anna Banana's works is the idea of breaking the audience out of mere spectatorship by engaging them in the performance process. She has constantly fought the notion of the passive viewer and has developed works that cause audiences to be actively involved. With this kind of work, so much depends on the audience's reaction and one cannot predict how the work will turn out. It doesn't sum itself up nicely and can seem dreadfully uneven if you are just watching. *The Banana Olympics* (San Francisco, 1975 and Surrey Art Gallery, Surrey, BC, 1980) was one such interactive event. It is a parody of the Olympic Games, with ridiculous races, in which prize ribbons and plaques were awarded on the basis of costume and style of performance rather than who crossed the finish line first. These events required public participation and, in both cases, attracted over 100 eager contestants. Races such as the Bureaucrat's Marathon (in which contestants were to proceed around the track taking three steps forwards, two backwards, and one to each side) the Over-Handed Banana Throw, the Banana Javelin, Non-Motorized Vehicles Race, and the Appealing Relay (in which team members pull on a girdle, then swivel or swagger down the track, pass the girdle to the next teammate who pulls it on, etc.) provided contestants with

ANNA BANANA *Tarzana Banana*, Columbus Day Parade, San Francisco, 1976

ANNA BANANA and **BILL GAGLIONE** *Futurist Sound*, Lund, Sweden, 1978

ample opportunity for hilarious performances:[3]

In 1999, I presented another well-attended and interactive work, *Banana Communion* at the Sarenco Art Club in Verona, Italia. Taking the role of the first female pope, and dressing accordingly, I extracted the Bible passage about Jesus converting a loaf of bread and water to food for thousands for my sermon, substituting bananas and peanut butter. I then served communion to the audience (one at a time, on bended knee)... a slice of banana for the body of Christ, miraculously sliced before peeling, and a shot of banana liqueur for the blood.[4]

I ask her how the internet has changed her network. Are they now all online? Many invitations are, she says, but she restricts her internet participation to verbal communications. She likes the mail art objects; the physical object coming through the mail slot in her door. Electronic art exchanges don't interest her. She uses email to engage in discussions or arrange visits, and she still participates in selected projects through snail mail. The internet is an inexpensive way to circulate invitations and exchange ideas about mail art, but she likes physically making the objects she sends.

As Anna shows me around her archives, I can see the incredible wealth of material. In her basement, stored floor to ceiling, are large alphabetical archive boxes full of mail art. Her groaning bookshelves hold performance books, mail art catalogues, and zines from the past thirty years. In her studio are shelves of the artist's stamps she has produced for the last fifteen years. We didn't open any of those boxes. There seemed no place to start or end. I was there for an afternoon and one could get lost in there for a lifetime!

Later when we're talking about all that's been written on mail art she says she believes it has gotten precious in its history. Many people confuse mail art with postal art and she feels they are two very different things. Mail art is work made in response to cultural, political, and world events, or consumer culture; sometimes serious and sometimes playful. These works are mailed to others in the network who, in turn, mail back works reflecting their concerns. The underlying idea of the network is the formation of an international community which critiques in visual form, consumer society, globalization, and other threats to true democracy. Postal art is artwork based on postal forms (stamps, cancellations, envelopes) which the artists mail to themselves or to a limited exchange group. They are often more concerned with techniques and "high quality" imagery than in social critique or interactivity. Postal art gets a lot of play in recent mail art books — demonstrating the subversion of the form that is already in process.

If mail art was a way for Anna to get back at a culture that focuses on the stars, performance has been her prescription for breaking into public space. Her performance events require audiences, both planned and spontaneous, to participate in their completion. Anna talks about her recent work using her newest identity, Dr. Anna Freud Banana of the Specific Research Institute, Canada. She likes this character identity because it works through public stereotypes. She gets very different reactions wearing her white lab coat than she did running around in banana costumes. Anna finds she gets better reactions

3 The judges for the *1975 Banana Olympics* were Klaus Groh (Ger), Marek Konieczny (Pol), Kenneth Smith (Can), and Helen Winnett (Can). The 1980 judges were Glenn Lewis (Flakey Rosehips), Eric Metcalfe (Dr. Brute), and Sam Carter.

4 Anna Banana, email correspondence with Glenn Alteen, 2003.

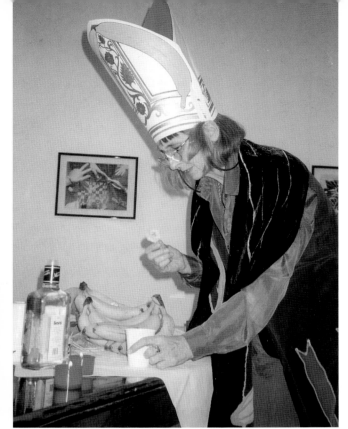

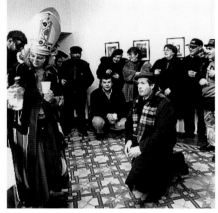

FABRIZIO GARGHETTI

FRANCESCO CONZ

with the researcher image, playing between double and parody, disarming the public who find they are participating before they even have a chance to think about it.

With the banana outfit, "people expect flamboyance, Carmen Miranda, Josephine Baker. There's the expectation that I will be theatrical." But she's often worked against this notion of performance. When she and Bill Gaglione did the Futurist performances, she dressed in a simple black dress, Bill in a suit, even though the Futurists made outlandish costumes. She feels the contrast between "rational dress" and irrational action is more startling this way.

Dr. Anna Freud Banana had her most successful run in a German tour completed in 1993 in conjunction with her exhibition, *Proof Positive that Germany has Gone Bananas*:

I presented these works in Stuttgart, Berlin, Bremen, Hamburg, Ulzen, Minden (twice), Bergish-Gladbach/Koln, Mannheim, and at Art Pool in Budapest (to get an outsider point of view).

For this performance viewers of the exhibition booked appointments and returned later to take her two simple and humourously amended psychology tests:

... which were to help me ascertain Why Germany has Gone Bananas. These

ANNA BANANA *Banana Communion*, Sarenco Art Club, Verona, 1998

ANNA BANANA *Banana Communion*, Sarenco Art Club, Verona, 1998

were both parodies of actual psychological tests; the Roar Shack (a series of 12 cards with photos of banana peels in various configurations) and the Personality Inventory for Banana Syndrome, based on the MMPI (Minnesota Multiphasic Personality Inventory). At the end of three and a half months, I had over 275 tests completed, and on my return, wrote a pseudo-scientific report on my findings ... concluding that Germany's "banana craze" was a result of a subliminal plot on the part of Mercedes Benz. As you probably don't know, if you push your finger into the end of a peeled banana, it divides into three sections, much the way an orange divides. Then if you slice through that split end, you find the three pointed star of Mercedes. I concluded that Mercedes has money in the banana business, and that their aim is, if you can't afford their expensive exotic item (the car) then you'll be programmed to buy the inexpensive exotic item: the banana. The Mercedes symbol is prominently displayed in every German city I visited.[5]

As Anna is talking, right outside her window on the deck, several hummingbirds are feeding in the two sugar feeders she maintains. Below that, her garden spreads out lush green in the warm late-June weather. Later, she shows me the ribbons she ties on around the plots to keep the deer out. Does she miss the city, I ask? "Not much," she says. She does miss her friends and easy access to arts and cultural events, but she enjoys the quieter pace of Robert's Creek. We talk about the local scene and she says there's a lot of activity but that it's largely traditional visual art or popular theatre. She hasn't performed up here and really isn't interested in doing so. "They're still pretty tied to the Object or entertainment," she comments.

In the past two years, she's been participating in the artists' trading cards network that began in Zurich, was brought to Calgary by Chuck Stake, and now exists in Vancouver, Victoria, Kelowna, and a number of eastern cities including Halifax. She has attended trading sessions in Calgary, Vancouver, and Victoria. She likes this activity again because of the exchange aspect, but she makes a point of trading copies with people who do multiples and originals with people who do one-offs. To keep her hand in the local art scene, Anna is the volunteer co-coordinator for openings at the Art Centre in Sechelt.

Her performances continue to make interventions into how we shape our reality. Her current *Name Project* is research conducted for creative insights rather than scientific ones. It creates a venue for others to tell their stories and gain insight into how re-naming has affected them and their work; how they picked or picked up a nickname and how it has affected their lives. Now on the net, all of us have handles, nicks, and online names. Some of us have an online persona that corresponds little to our lives in real time. I think Anna has taken that same sense of play into the public sphere. And sometimes, one senses, she gets a little frustrated waiting for the rest of us to catch up.

Anna and I go over to say hello to Glenn Lewis who is a close neighbour of hers and an old friend of us both. Lewis, a.k.a. Flakey Rosehips, is now a gardener and runs a small nursery of rare and exotic plants. I buy some plants from him for the outside of the grunt and then Anna drives me back to the ferry carrying my small knapsack and bag of plants.

5 Ibid.

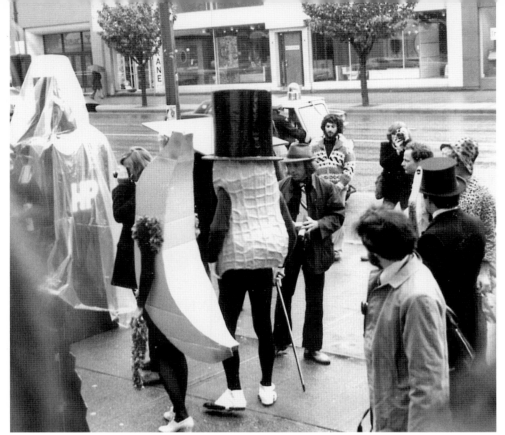

On the trip back, I mull over this exciting day and contemplate what I will write. As I stand on the ferry deck taking in the wonder of the coastal mountains, a couple of the passengers talk on cell phones and one has his laptop out. Interactivity is a given now and the internet and digital technologies have changed the ways we live and think. The work Anna has done and continues to do pushes these ideas through interactive performance and I would assert her mail art is as performative, in a very real way, as the performances where she never actually performs. For Anna, it seems, it is all about the setup, the network, creating the space for the most unnatural act of all: changing the way we interact with our environments, with other people and with ourselves.

ANNA BANANA, **VINCENT TRASOV** a.k.a. **MR. PEANUT**, and **HANK BULL** *Art Race*, in front of the Vancouver Art Gallery, Vancouver, 1974

Jessica Bradley

Rebecca Belmore

ART AND THE OBJECT OF PERFORMANCE

I can't remember when I first realized I was an Indian and how it was that I became a cowboy.[1]

Rebecca Belmore's performance at the 1991 Havana Biennale typically involved minimal but evocative props and a compelling sequence of actions. Ascending a staircase, she swept up grains of sand, moving one pile to make another, step by step. Belmore mounted the winding flight of stairs like a penitent pilgrim, bound but determined to transcend her arduous journey, her hands tied at the wrists and her feet at the ankles. The same scarlet cord that cobbled her movements passed between her teeth like a bit, or a gag. As she lunged her tethered body forward on her knees, forcibly propelling the sand and herself, her exertions were as audible as they were visible. Sighing and moaning in rhythm with the task at hand, she roared intermittently as if to expel a demon through the sheer effort of her labour. The audience peered down at Belmore from a balcony surrounding the courtyard of the Castillo de la Fuerza, a stronghold from Spanish colonial times that this performance imbued with renewed historical meaning. Through her actions, the oppressive legacy of slavery echoed with the contemporary politics expressed in the ubiquitous Cuban revolutionary slogan "revolution or

death, we will win," which, altered to *Creation or Death: We will Win*, became the title of this work. Upon reaching the top of the stairs, Belmore untied her binding cords and let out a triumphant whoop, like a jubilant mountain climber overcoming a difficult summit, or a warrior leading a battle cry.

In her book *The Politics of Performance*, Peggy Phelan proposes that the significance of performance art lies in its role as "representation without reproduction," that is, as a one-time event that locates "a subject in what cannot be reproduced within the ideology of the visible."[2] In other words, performance can excavate and bring to life those issues and images that do not fit within, or are systematically marginalized by, the dominant culture. The ideology of the visible, and its ability to maintain the invisibility of other voices and representations, is at the heart of Belmore's poetic and materially rich work.

Performance art's resistant immediacy as characterized by Phelan, and its implicitly social context, was fundamental to those artists, particularly women artists, who sought in the 1960s and 1970s to explore other forms of representation and subjectivity than those prescribed by the canons of painting and sculpture. The presence established in performance art is anything but timeless. Its potential to create new images or undermine old ones, however fleeting, is, as Belmore's work demonstrates today, profound. In Belmore's practice, performance is uniquely integrated, in fact essential, to the many ways she makes art, including sculpture, installation, video, and most recently, photography.

The task Belmore set for herself in Havana resonated with determination expressed through the body and fixed by repetition as an unforgettable image in the mind. Other performances since have also unfolded through familiar and strenuous actions to form equally visceral narratives. She has dug a burial pit with her bare hands, reviving the bloody memory of the Wounded Knee massacre, and scrubbed clean the pavement of Vancouver's skid row. She has splattered blood on the wall in the name of genocidal neglect at the same time making unmistakable reference to action painting. She has furiously hammered nails into wood and used plaster, the sculptor's classic medium, feverishly working against time to plumb its transformative power as it turns from liquid to solid. The characteristic acts of cleansing she performs possess a ritual quality more akin to purification than the domestic work they resemble. Using materials as various as video, photographs, lights, feathers, beading, and moss, Belmore has created adroit if unexpected meetings between the traditional material language of her people and the multiple internationalist languages of art today, often incorporating specific references to the historical iconography of Canadian art at the same time. Improvising to overcome unforeseen hurdles as if constructing something more permanent, like a well-made object, she crafts her performances without script but with deliberate ends in sight. A ceaseless and remarkable energy runs through her body into her hands, which she has spoken of as her palpable connection to her female lineage, her "kokum" (grandmother) and her mother:

1 Rebecca Belmore, bookwork insert, Marilyn Burgess and Joan Valaskakis, *Indian Princesses and Cowgirls: Stereotypes from the Frontier* (Montréal: Galerie Oboro, 1993).

2 Peggy Phelan, *The Politics of Performance* (London and New York: Routledge, 1993), 3,1.

I can see their hands touching hide, cloth, and bead, creating colour, beauty: work hands. I look at their hands and I am aware of their hands. That is how I wish to work.[3]

In 1997, Belmore made *Awasinbake (On the Other Side)*, a work that explored deeper historical connections to her female lineage across the national, cultural, and economic divide marked by the border fence between the United States south of San Diego, California, and Tijuana, Mexico, at one time a single territory. For this project, which was part of an international triennial art event in both cities, Belmore paid a Mexican aboriginal woman she encountered in the streets to be photographed by one of the many photographers who roam Tijuana with donkeys and sombreros for tourists to pose with.[4] The resulting headshots recalled anthropological documents. Unlike Belmore's surrogate performer who could not cross the border, these images were brought to the Unites States and displayed like a film strip around the marquee of a disused downtown San Diego movie theatre called the Casino. Belmore's choice of site served as a reminder of the real casinos operated by local Native bands in the Southern California hinterland, a history reflected in the popular appropriation of Native designs and symbols on the existing decorative motifs of the marquee. During her forays into Mexico to find her subject, who bore an uncanny resemblance to her, Belmore was taken as one of the locals but could speak neither Spanish nor the indigenous Native languages. Conversely, when in San Diego, she could communicate easily but was mistaken for a Latina. Race and history linked Belmore and her subject. Language, history, geography, and politics isolated them from each other.

Rebecca Belmore was born in 1960 in Upsala, Ontario, and raised there until adolescence when, as was the custom ingrained through government-imposed assimilation, she was sent to attend high school in Thunder Bay and billeted with a non-Native family. Her summers were spent with her maternal grandmother, who spoke Ojibwa but not English, in her ancestral homeland near Sioux Lookout. The experience of displacement and cultural loss is not so much lamented by Belmore as it is recuperated in her work and reformed into acts or objects of reparation and protest.

While a student at Toronto's Ontario College of Art and Design in the late-1980s she began to develop her performance alter ego, High Tech Teepee Trauma Mama. Trauma Mama was a rebellious partygirl dressed up as a pop idol cum kitsch queen, but she was also a guardian angel, a protective force that emerged in times of need. In this respect, Trauma Mama partook of the age-old tradition of the fool or jester who both amuses and advises, giving voice to the unspeakable through parody and allegory. Marilyn Burgess describes Trauma Mama as "a sort of postmodern crazed 'warrior maiden' who has shaken to her very bones the enduring image of the passive Indian princess ... She is loud and fighting mad but she is also a trickster seducing her audience with play."[5] The distinctive language of materials and actions for which Belmore's work is celebrated today builds upon this figure whose traits are indebted not only to the trickster but to a

3 Robert Houle, Diana Nemiroff, and Charlotte Townsend-Gault, *Land, Spirit, Power* (Ottawa: National Gallery of Canada, 1992).

4 *InSite '97*, organized by Installation Gallery, San Diego.

5 Marilyn Burgess, "The Imagined Geographies of Rebecca Belmore" in *Parachute* no. 93 (January/February/March, 1999), 19.

rtist
spin
stern

ative artists is treated."

works in a variety of
rrently, she has a show of
s on exhibit at Saska-
A Gallery. These are vis-
udio collages, including
objects, plastic cowboys
ns, and audio tapes of
nents by a phone-in talk-
in Niagara Falls and a
Oji-Cree radio broad-
hunder Bay.

also works with giant
ojecting images of native
isually family members
s, onto frames made up
bits of glass, feathers and
ual's favorite objects. In
he paints portraits of tra-
ndian themes "rendered
Gogh" and influenced in
of color by traditional
dwork designs.

gets her message across
ual dresses. Her first ex-
ess, part of Lynne Shar-
bit Twelve Angry Crino-
s a street-performance
gned to mark the 1987
under Bay by the Duke
ess of York. Belmore's
a Victorian dress with
bellishments: fine bone-
es on her chest, and a
was a facsimile of a bea-
sticking out behind. An-
ion consists of a kitschy
t painting of a beautiful
den, attached to a strait-
d for Duster she has de-
outfit with cloth horses
t on each side. She will
a red satin formal gown
th electrical sockets: she
to plug in a kettle and
make coffee and tea dur-
rmance.

is reluctant to talk about
ut many of the elements
gone into it are made
r life story. She was one
dren raised in the truck-

Belmore wearing a red satin gown with electrical outlets: plugging into native concerns. *TIM PELLING/The Globe a*

tradition of feminist performance work.

Among the groundbreaking feminist pieces inspired by the early call to arms "the personal is political," Carolee Schneemann's renowned *Interior Scroll* (1975), is perhaps the most apt period reference for Belmore's performances in that its politics were, like hers, startlingly present in bodily actions, steeped in sensuous materiality, and incisively direct. Using her own naked body to address gender discrimination, Schneemann created a living image — which has since become an icon — that crystallized the stereotypical reduction of woman to natural instinct and bodily function. "Playing Indian" in her performances, Belmore embodies the stereotypical images that have distorted Native culture and history in the service of politics and economics. She disturbs familiar images to reveal their false premises, unsettling any presumed naturalism as she gives presence to her people's struggles for their own identity. The narrative that runs through her performances often honours women, their work and their role in maintaining cultural legacies, but always in the context of the historical displacements and contemporary cultural self-determination of First Nations people.

Among her influences, Belmore cites James Luna, the Native American artist she considers a mentor, and Ana Mendieta, the Cuban artist who in her short life created performance-based works that expressed her displacement from her homeland and united her body with the earth using references to traditional Afro-Cuban rituals. Belmore understands her practice as one that issues not only from her own experiences but also from her investment in a community. She pays tribute to what has been done before her as well as to those with whom she shares her life and work. For example, in a presentation for the 2003 Live Biennial of Performance Art at the Western Front in Vancouver, she lay down near a long scroll of paper bearing a rubbing taken from the text inscribed on a monument of John A. MacDonald in Kingston, Ontario, where she had recently been a resident artist at Queen's University. The text reads: "A British subject I was born. A British subject I will die."

Preparing the site by unfurling the paper on the floor like a ceremonial carpet, Belmore began to free-associate for the audience about her work and life, faltering, pausing, and jumping from the superficial to the profound, as she lay in repose like a subject in a psychoanalytic session. Her "artist's talk" was stripped of the conventions of professional biography, exemplary slides, and the expected forays into theoretical frameworks. She enacted the process and content of her work rather than talked about it. Eventually, she told the story of the artwork on the floor nearby, her reduction of the longer inscription to "A subject I was born. A subject I will die," and finally to the emphatic, "I was born. I will die." When making this work, a young foreign student assistant had shown curiosity about her motives and questioned her concentration on the theme of life and death. Belmore learned that burdened by cultural displacement and the expectations of his family, he had later taken his own life. Her presentation unfolded as a commemorative performance that transformed into a reaffirmation of life and

PAUL WONG

PAUL WONG

culminated in a communal birthday party.

Belmore puts little value on the secondary documentation that commonly remains as a record of performance work. Instead, she constructs her performances as images that resonate in the mind, though they often extend into the production of objects. Few artists as renowned for their performance work as Belmore are equally accomplished sculptors and installation artists. There is little distinction between these activities for her. Rather, she creates performances that frequently result in objects derived from her actions, or she makes independent objects that are integrally linked to her performances. Her sculptures, installations, and photographs are testimony to the process of their own formation, and, paradoxically, to performance art as a form that is essentially process oriented, ephemeral. Some of her works are best described as hybrids that bridge a gap between fugitive performance and autonomous object making. In this respect, her work both operates in the revolutionary realm of "representation without reproduction" that Phelan claims for performance, and at the same time in the realm of images and objects as permanent works that continue to challenge the omissions within and the truths granted to existing representations. For example, in her 1991 *Ayumee-aawach Oomama-mowan (Speaking to their*

REBECCA BELMORE *Vigil*, at the corner of Gore Street and Cordova Street, Vancouver, 2002

REBECCA BELMORE *Vigil*, at the corner of Gore Street and Cordova Street, Vancouver, 2002

Mother), she travelled across the country with a huge and intricately crafted megaphone, inviting First Nations people to speak to the land and thus to amplify their voices metaphorically as well as literally. These communal performances took place in sites across Canada as various as an alpine meadow near Banff, Alberta, before Louis Riel's monument in Winnipeg, and on Parliament Hill in Ottawa. *Ayumee-aawach Oomama-mowan (Speaking to their Mother)*, has also been displayed as an independent sculpture, most recently at the Art Gallery of Ontario. In *Mawu-che-hitoowin: A Gathering of People for Any Purpose* (1992), seen in the National Gallery of Canada's 1992 exhibition *Land, Spirit, Power*, Belmore arranged old chairs on a square of linoleum tiles to evoke a conversation circle. Each chair was representative of a voice and accompanied by earphones. The audience was invited to listen to absent First Nations women, including Belmore, sharing their lives through stories, the way they might have when sitting together around the warmth of a kitchen stove.

Complementary and enduring material links to her performances' fugitive presence emerged early as an integral part of Belmore's practice. Among these is *Rising to the Occasion* (1987-1991), a Victorian dress freighted with ironic flourishes and conflicting cultural codes that was one of many fantastical costumes and props made for her High Tech Teepee Trauma Mama appearances. Belmore wore the dress in *Twelve Angry Crinolines*, a parade organized by Lynne Sharman as an acerbic but playful rejoinder to the parallel celebrations welcoming the Duke and Dutchess of York on their official visit to Thunder Bay in the summer of 1987. With Pocahantas braids held aloft like antenna, a warrior maiden's breastplate made of two fine English porcelain saucers, buckskin fringed epaulets and beadwork embellishing its bodice, this robe is all about appearances. Behind its decorative façade protrudes an unruly beaver dam bustle with royalty memorabilia and trade objects (silver flat-ware, kitsch souvenir mugs, etc.) caught in the dense weave of branches and twigs. The bustle, which also recalls the traditional costume of the Native dancers who perform for tourists, is at once a chaotic undoing of a prim English lady's finery and an ironic celebration of Canada's national animal.

Since its first appearance, *Rising to the Occasion* has been displayed as an autonomous sculptural installation resembling a period costume exhibit. Nevertheless, the dress retains an animate quality, as if recently vacated by the body that once inhabited it. It embodies paradoxical humour and political intent even as it stands now, a silent female monument bristling with contradictory cultural signifiers. *Rising to the Occasion* is both provocative and amusing because everything that makes it familiar also emphasizes the incongruous realities of tourism and nationalism enacted upon the body of a disenfranchised contemporary First Nations identity. More than an aban-doned prop, it is rich with a "density of signs," a quality Belmore brings to her performances and which Roland Barthes has described as being a source of "productive indeterminacy."

Barthes' notion of indeterminacy referred to language as a dialectical space "where things are made and unmade," but the concept also describes

REBECCA BELMORE *Wild*, The Grange,
Art Gallery of Ontario, Toronto, 2001.
Performance, bedcover and canopy, fabric
braiding, hair and fur. Thanks to Florene
Belmore and Osvaldo Yero for their
generosity and commitment

the dynamism of Belmore's practice. She reworks and exposes realities masked by official language, though her performances are not dependent on words. In several instances, the titles of her pieces — *Ihkwewak Ka-ayamih-wat II: Means Women Who are Speaking 2* (1989), *Kiskino-tuma-kaawin-ninee: One Who is Leading* (1992), and others — read like dictionary definitions that reflect the loss of her mother tongue with the attendant deprivation of cultural heritage shared by First Nations people of her generation across the country. Her work is rooted in storytelling through a language of actions and images that insist on the difference between what is said and what is done. In this way, she questions how land and history are represented. Exploring the relationship between nature and aboriginal people through its historical materiality, Belmore's work reveals how an idyllic pre-modern past has been fantasized, romanticized, and exploited by the politics and economics of those who have sought to control First Nations destiny to their own ends.

Acts of remembering land and lives that cannot be recovered motivate pieces such as her 1997 performance in protest and in memory of the shooting of Dudley George by police during the Ipperwash confrontation over clear-cut logging. Wearing a red dress, she stripped the limbs off a sapling tree, exposing

it like a vulnerable body, then removed her own clothes. In 2000, she made *The Indian Factory*, a layered fifty-minute performance at AKA Gallery in Saskatoon, which starkly revisited the deaths of five young First Nations men callously left by police near that city to freeze to death in the dark of winter. *The Indian Factory* achieved its solemn end in several distinct stages beginning with Belmore's appearance in a workman-like white coverall with feathers, emblems of transcendence and power, sewn to her back. Working quickly with an assistant, she "washed" five green plaid shirts in buckets filled with liquid plaster and hung them on the wall where they dried into white, frozen shapes under the watchful image of Queen Elizabeth II depicted on a souvenir tea tray. After completing this macabre assembly line, she lit candles and placed them on shelves beside each shirt. Belmore and her assistant then set up a large industrial fan to blow on a feather tethered to it. Dipped in blood and caught inexorably in the fan's powerful air currents, the feather twirled and dived leaving a spattered red trail on white paper tacked to the opposite wall. Then Belmore, wearing a straw Stetson and jeans, began to dance deliriously to the country and western tones of Merle Haggard's "Walkin' on the Fightin' Side of Me." Prancing and stumbling breathlessly, she circled round and round a column festooned with police line tape and topped by a revolving cruiser light that doubled as a disco ball. Still winded from this exertion, she began pounding nails into a photograph of a sacred rock from a local First Nations site until she had completely obscured it. Laying the hammer down, Belmore stared at her handiwork exhausted and then curled up on the floor where her assistant smoothed plaster over her body like a salve. The performance was completed when she rose out of the hardened carapace, leaving the plaster ghost of her reclining body. She then washed her hands, feet, and face in a gesture of purification fit for the resurrection she had enacted.

In *Vigil* (2002), Belmore commemorated the lives of more than fifty women, most of them First Nations, who disappeared in Vancouver's drug and prostitution plagued east end. She ripped the blossoms and thorny stems of dead, dried roses through her teeth, one for each of the missing women whose names she called out. When all the roses were stripped and thrown down amongst the equal number of candles she had lighted in preparing the site, Belmore slipped an elegant long red dress over her head and proceeded to nail it, and herself, to a telephone pole in the skid row alley. Violently ripping the dress with all her strength, she eventually tore herself free and sauntered over to a pickup truck where she relaxed against the cab as James Brown wailed from the stereo within: "This is a man's world/but it wouldn't mean nothing, *nothing*/without a woman or a girl."

Belmore uses a recurring set of images and gestures in her performances — the bound body, the labouring body, the hands that sew, wash, cut, and build. These palpable acts of making, and struggling to make, are matched by the repeated image of the body in repose, as in the fetal position and birth-like unfolding that completes *The Indian Factory,* or in *Wild*, her performance for *House Guests: Seven Artists in The Grange*. Belmore chose to inhabit the

6 Charlotte Gray and Jessica Bradley, *House Guests; Seven Contemporary Artists in The Grange* (Toronto: Art Gallery of Ontario, 2001).

master bedroom for this 2001 exhibition that celebrated the Art Gallery of Ontario's centenary with site-specific installations in the museum's original home, an 1830s family compact residence. Here, as elsewhere, her work was inextricably linked to a site that she revealed in light of forgotten histories. Of this project she wrote:

> I cannot even begin to imagine being an Indian woman living in another time. The reality of constantly having to assert oneself in a world that has only a vague memory of us is tiresome. My persona reaches back in time to find someone not unlike myself. She claims this foreign place for all my mothers before me.[6]

On several unannounced occasions, Belmore came to sleep in the master's bed after preparing it with comfortable and lavishly appointed covers. She was apparently mistaken more than once for a wax figure. Subtly redressing history, she replaced the bedspread with one of her own making, a crimson brocade field swimming with long black hair, and made a new canopy to match, decorating it with beaver skins mounted like heraldic shields on the four-poster corners. These elements were so skillfully blended with the richly detailed Victorian decor that visitors who assumed the historical authenticity of the period house museum failed to notice these alien intrusions in a bastion of civilized colonial life. In both the performance and the installation elements of *Wild*, Belmore addressed the false fronts of history within the language of authenticity skillfully embedded in museum displays. Though she was unaware when she conceived her performance, the lore of The Grange includes a story about the first young British mistress of The Grange, who it is said, was surprised by a local Algonquin who entered the house and appeared at her bedside.

Belmore's performances bring to the fore a complexity of associations and issues with remarkable incisiveness, penetrating the surface of complacency like a sharp knife slipped under soft flesh. Her considered materiality and attention to the meaning of place make the hidden real. She represents First Nations self-determination, and the impediments to its realization, by casting these into memorable images of the will to overcome. She reproduces those images tirelessly through a repertoire of actions that are given material presence in objects.

Pam Patterson

Berenicci

MANIFESTING IDEAS — RESISTANCE IS FUTILE!

One can resist the invasion of an army but the invasion of an idea?
— VICTOR HUGO

Randy & Berenicci... confront the challenge of urban techno-society,... [and] treat it and the remnants of history as a wry cultural ritual. Theirs is a universe of poetic anarchy, which puts all political systems in the same perspective.[1]
— JANE WRIGHT

Berenicci Hershorn resists definition. She operates with insight in creating chaos, addresses the ordering of history, and then shatters that illusion, informs us in deliberate actions, and then confounds our interpretations. She has been making performances, in collaboration with Randy Gledhill, since her early beginnings at Vancouver's Western Front. During these years, she circled out to other performance forms such as mime, clown, street, and children's theatre, but performance art in all its unpredictable abstraction brought her back. Her performances have also moved into video and back, where many past and present elements return in a tangential reworking of process and action. And this reworking is far from benign.

Together with Randy, she has exploded, burnt, challenged, entrapped, and liberated mass civilizations. Over almost thirty years of production, we have seen Godzilla blown to smithereens, video giants dance flamenco, books shovelled into giant nets, audiences showered with counterfeit money, or streamers, or balloons, and yes, wait ... there they are chugging off into the harbour! Yes, they are now out of range! Are they gone? From the immediate temporal space, yes, they are gone, but they are still in our thoughts, our memories, like cockroaches waiting till the lights go out.

How can one talk of such work in a calm, considered, linear fashion? Such an approach would do it, and Berenicci, a great disservice. Rather its writing demands creativity. I have therefore given this writing a form — a series of three "plays." These are a series of writings as tableaux that focus on Berenicci Hershorn and her work as/in Randy & Berenicci, as history, as aleatory structures, and as manifest(o).

1. she ain't history, she's my brother ...

In theorizing historiography, the assumption that processes have a causal relationship is one that is inherent in our civilization — such as the notion that the universe moves ultimately toward dissipation or that, through humankind's mediation, order rises out of chaos. In these instances, there are two directions: the inevitable winding down of things toward dull uniformity or the opposite, that which moves toward an outcome that is less probable.[2] With Randy & Berenicci, we accept historical process as both and neither — it is an ordering that is at the edge of chaos:

There was Randy dressed all in black as a cat burglar ... he walked around lighting different areas ... A frozen vignette would animate when lit. There I was, the first vignette, with two telephones, one on a heating pad and one on a block of ice and I would answer one big telephone laughing, laughing, laughing and the other crying, crying, crying ... The fourth "play," the finale, was Père Ubu lifting up his robes and taking a shit in a golden spittoon on stage.[3]

But how do we frame a specific Berenicci history? In the early 70s, Berenicci started performing. It was what was happening in Vancouver at the time. Performance evolved for her out of this: doing performances with others from the Western Front, doing radio shows, and then doing Randy & Berenicci performances. Tangential moves into these other forms enriched the action and yet "idea" stayed central. Idea was the core and became solidified into concept. Concept then determined form. Montage or changing tableaux became the forms in which idea was played out. And the arenas changed as ideas and forms changed. She has not played solo. Watching her, you see a focused, intent performance by a striking dark-haired woman. Her instincts are good, her senses attuned, as she reacts to sound, sight, and others with specificity. And while she brings a strong stage presence, a clarity of expression, and a depth of experience and insight to the work, the interactions with others have been important for her, the ideas perhaps clearer and richer in/through collaboration. She has been in other people's work; she has collaborated in making work. But the

1 Jane Wright, Introduction, *British/Canadian Video Exchange* (London: Canada House Cultural Centre, 1984).

2 Haines Brown writes in *Contemporary World History for the Twenty-first Century* of the nature of history-as-process and speaks of the majority of studies made in/of contemporary history as "news" and asks that the field of historiography look to an examination of the long-term process of history (www.hartford-hwp.com/archives, May 20, 2003).

3 Randy & Berenicci, artists' statement describing the performance *4 Plays* (Vancouver: The Western Front, 1975).

one relationship which has been central and ongoing has been with her partner Randy. It has been a long cohabitation and collaboration. It is hard to say who does what; conceptualization and manifestation are built between the two and as such it requires speaking of Berenicci's work as/in Randy & Berenicci. The pair have travelled and researched together, allowing the relationship and history between them to affect their reinterpretation and replaying of their idea of/in history:

The absurd and ritual came together in a trip to Singapore. We saw devout Hindus with metal spikes penetrating their flesh wandering in a trance through the golden arches of Macdonald's.[4]

Inter-action requires creativity. And creativity inspires actions. The seemingly predictable end becomes confounded by the unpredictability of performance:

We were invited to perform at the opening of the Bhirasri Institute of Modern Art. After the ribbon cutting, we gave, in simultaneous translation, an incredibly long-winded speech comparing the snows of Canada to the monkeys of Thailand and spoke as well of the importance of international relations. I then scattered rose petals, from seventy dozen roses bought earlier that day at an illegal market, in a spiral, laid down on them and assumed quintessential North American poses. The petals blew away from me over the feet of the spectators.[5]

These performances are not just delightful shifting images. While their structure gives us an illusion of control, their content brings disorientation. It's a challenge to come to (im)probable outcomes. Continual actions are shaped, demanding evidence of struggle, not just the pleasure of fantasy. Contradictions build. Posturing, sound, action, abound. Performance becomes as revolution; revolution as evolution. History here is in the recording. But what questions do Randy & Berenicci performances-as-history raise? Is history the source of human liberation? Does the burden of history constrain action? Is the burden of history the condition of our freedom? Are these the questions we should be asking?

In 1920s Russia, living newspaper groups performed in factories, colleges, and on the street, presenting montages of political events and/as headlines. Art subscribed to utopian Marxist ideas of progress, revolution, transformation. But Randy & Berenicci, while seeming to present a contemporary "newspaper," disrupt it. The idea of long-range vision and accomplishment is reduced to rubble. They both strike classic revolutionary poses and then switch roles and cower from the bombs — depending on the performance. But in both instances control seems futile. Hero and victim conflate. The apocalypse seems inevitable, whether because of our actions, or in spite of them. History is in the making. They don't shy away. Rather than avoiding confusion, they intensify it. Their ideas are transformed into action and these actions confront and demand thought. We are not left uninvolved.

4 Randy & Berenicci, "Singapore Postcards," in *Impulse*, vol.8 no.3 (summer, 1980), 4-5.

5 Randy & Berenicci, artists' statement describing the performance *Monkey, Monkey, Monkey* (Bangkok, Thailand: Bhirasri Institute of Modern Art, January 1980).

6 Gregory Battcock with co-editor, Robert Nickas refers in the Introduction (xiii) of *The Art of Performance: A Critical Anthology* to N. Gourfinkel's *Le théâtre russe contemporain* (Paris, 1931); reprinted in the catalogue *Poetry Must Be Made by All! Transform the World* (Stockholm: Moderna Museet, 1969), 44-45.

7 Don Stanley, "Randy & Berenicci, Western Front (review)" in *Vanguard* (September 1982), 31-32 .

TAKI BLUESINGER

2. One toss of the dice will never abolish chance

BERENICCI *As the World Burns*, Western Front, Vancouver, 1977

I chose the balls at random because that's the way disaster happens.[7]

When the French poet Mallarmé cast words as dice on a page, he changed words into objects, language into performance. This chance action in turn caused a reaction — F.T. Marinetti, the Italian poet and founder of Futurism, perceived that the pages of the magazine where the poem was written had been transformed into visual space as well as sequential and was of indeterminate time. This reference, in relation to Randy & Berenicci, speaks to the performative, the history of avant-garde performance and to chance, action, and reaction — all aspects which come into play:

Catastrophe Theory was performed over three hours at night in Nathan Phillips Square, Toronto. Mounted on a turntable, revolving twice every minute, was a corner of a ruined cinder block apartment, its window broken. We were gowned and masked and sat on stools at a light table in the centre of the set. On the light table were playing cards, dice, and various miniatures representing the history of the world as it is written in ordinary textbooks from the western hemisphere — dinosaurs, Greek and Roman ruins, suburban drive-ins, knights and cowboys, space stations. The entire scenario was lit by a moving spotlight. We played a game of chance by the throws of dice,

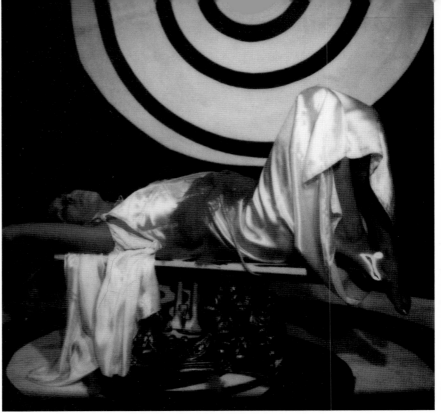

RANDY GLEDHILL

8 Randy & Berenicci, artists' statement describing the performance *Catastrophe Theory* (Toronto: Nathan Phillips Square, 1983).

9 Berenicci Hershorn, interview with Tanya Mars and Johanna Householder (December 1998).

10 Ibid., and Randy & Berenicci, artists' statement describing the performance *Four Billion Teardrops* (London, England: Canada House, March 1984).

deals of cards, etc. At certain points in the game the miniatures were blown up and the game began again.[8]

When performing works such as *Catastrophe Theory*, it is as if they are standing inside an image, animating the installation. Berenicci muses, "Maybe we are like dyslexic puppeteers or gods who animate."[9] Like Mallarmé's poem they, rather than tossing words and letters, are tossing the larger objects of culture at the throw of the dice, seeing where they fall and trying to make some sense of it all. In *Catastrophe Theory*, they sat in the remnants of a ruined civilization and tried to put the pieces back together in a game. Which pieces from which era go together? The dinosaur and the Roman charioteer? They try to make sense of history and rebuild a new culture from it.

But the sky is always falling. Somehow objects get removed from their context and it's puzzling what to do with them. Chance, action, reaction, and disaster. Disaster has played its part, not just as content of the work, but also in determining the future staging of performances:

At Canada House in London, we did *Four Billion Teardrops* during the opening of Canadian Video Art. The people at Canada House were very tense about our performance as it was on government property and we were

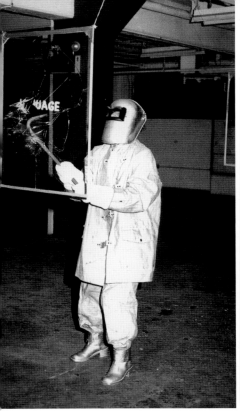
LORNE FROMER

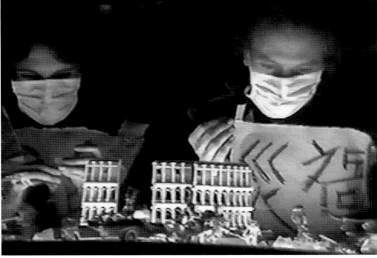
DAVID HLYNSKY

doing flash pots and explosions. We even had the whole ceiling rigged to fall. It was a tough scenario. We were caught between the conservative Canada House staff and the angry post-punk art public. Even before we entered the room everyone decided to hate us. Before we began, cheap liquor flowed and everyone got smashed. The technical support staff inadvertently turned off the power. However, the performance progressed to the finale. We raised our fists in victory. Simultaneously, the house of cards exploded, the walls of the stage collapsed on the performers, and the ceiling fell, releasing paper money (which we had printed ourselves at the Canadian Embassy on its press). The audience was in chaos. All thought the money was real. The staff had not been briefed. The whole audience was thrown out. We were thrown out, in skimpy costumes, into the London rain.[10]

After the London House fiasco, it was not surprising that during the following performance, the audience was kept at a distance. In Vancouver, on the 33rd floor of an office building, a string quartet played, sushi was served, and Randy & Berenicci put on silver survival suits and left. Followed by telephoto-lensed video cameras and connected by walkie-talkie to commentator and audience, they drove through the city to the docks, boarded a boat, and chugged out over the water. There they made history by setting

BERENICCI *I Am Your Mind*, Living Art Performance Festival, Vancouver, 1979

BERENICCI *Code Red*, 222 Warehouse/ Harbourfront/A Space, Toronto, 1980

BERENICCI *Catastrophe Theory*, A Space/ Metro Works, Nathan Phillips Square, Toronto, 1983

BERENICCI *Graceful Degradation*, Music Gallery, Toronto, 1982

the eight-foot-high lettered word "HISTORY" afloat in Vancouver harbour.[11]

Berenicci's work has shifted from performance to videos, such as *Raven Mad* (1991), and *Social History I-VI* (1997), to public sculptures such as *Rune* (2001), installations such as *Hipcrazy* (Cold City Gallery, 1995), and *Hope* (Harbourfront, 1990), to mixed media works and multiples. This action is tangential and, at times intentionally, but not consciously, reactive. This process not only sits well within her own history, but also locates Randy & Berenicci performance within the history of performance art. References to Dada productions, such as *Ubu Roi*, abound, as do applications of techniques and theories such as those espoused by Antonin Artaud in his "theatre of cruelty." [12] Such referencing gives the work resonance.

Artaud intended theatre to stimulate passions and, like the plague, to bring the poisons of civilization to the surface and expel them. Performance becomes a ritual cleansing for performer and spectator. The audience, spellbound, is brought into ritual, recruited into the performance. There they experience the unindulged passions of mankind and, through the murderous actions of the performers, purge them:[13]

There is a theme that runs through [some of our work], a religious element which is unusual. I came from an orthodox religious background but Randy didn't. Yet, his imagery and my imagery are very religious — perhaps liturgical. There is costume, colour, simplicity, and ritual. Yes, lots of ritual.

What Randy & Berenicci do is take elements of ritual, the experience of ritual and give this to the audience. They invite the audience to have an overwhelming religious experience. They don't appropriate cultural or ritual actions from others but rather, as also suggested by Artaudian tradition, look to the root, the gesture, the simple colour or costume, the mystic quality of an image, and build from that. This transforms and deepens the work and shocks and challenges the audience:

I am your mind... I am your mind... I am your mind... Picture yourself on top of a mountain... The breeze blows through your hair... All the cares of the everyday will slip away from your body... You are relaxed but alert. The light gives out. Randy appears chained between two pillars. IDENTITY-DISSOLUTION... INFRASOUND... MEMORY-DISSOLUTION... BRUISED CORTEX... SNAPPING. Randy pleads "Stop the voices!" Berenicci screams, then takes up the chant. The lights dim leaving Berenicci on the altar framed by projections of classical ruins. I am your mind... I am your mind... I am your mind...[14]

I am Your Mind, the final in a series of ritual performances, uses ritual to look at ritual. Trance-like states, shifting consciousness, powerlessness are some of the trappings of ritual. Randy & Berenicci illuminate, promote, use, and condemn these trappings. They question the maintenance and worship of useless structures. They take on the intent of Artaud, the challenges of Dada, and reframe ritual as both social necessity and societal control. A paradox on the edge of chaos:

Don't become complacent. Nothing is under your control.

THERE HAS NEVER BEEN ONE INCIDENT. EXPERTS HAVE LOOKED INTO ALL ASPECTS OF OPERATIONS. ACCIDENTS JUST DON'T HAPPEN. IT'S A

11 *History* was performed as part of the *Luminous Sites Performance* (Vancouver: March, 1986). The video of *History* is available at Vtape in Toronto. *Luminous Sites* was a joint venture with Western Front and Video Inn, curated by Daina Augaitis for Western Front and Karen Henry for the Satellite Video Exchange Society.

12 Antonin Artaud, *The Theatre and its Double* (New York: Grove Press, 1958). A further discussion of Artaud and the "theatre of cruelty" is in Albert Bermel's *Artaud's Theatre of Cruelty*, (New York: Methuen, 2001).

13 Artaud, 30-31.

14 Randy & Berenicci, artists' statement describing the performance *I am Your Mind* (Vancouver: Living Art Festival, September, 1979). ·

LORNE FROMER

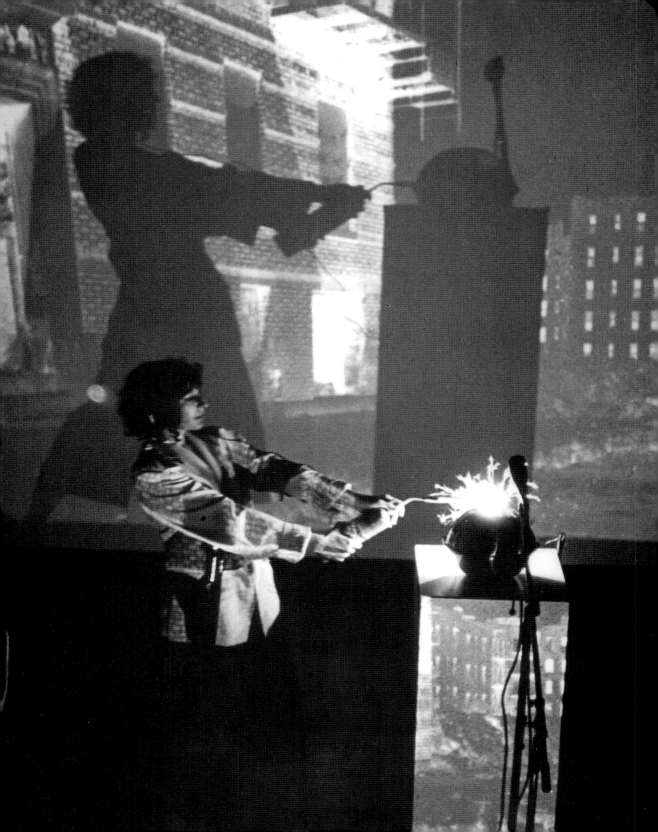

FOOLPROOF SYSTEM. THERE IS NO CHANCE OF DANGER. YOU CAN RELAX. SECURITY IS TIGHT. HAVE CONFIDENCE. IT'S SAFE AND SOUND. WE'RE ALL THINKING OF THE FUTURE. THERE IS NO THREAT. YOU ARE PERFECTLY SAFE.

I move back into the light, and gently push the end panel, causing all panels to fall. I swoon, smoke billows up. Sparks shoot out. The cards explode in a flash of light and smoke.[15]

3. first you learn the language

Everything leads us to believe that there is a certain state of mind from which life and death, the real and imaginary, past and future, the communicable and the incommunicable, height and depth, are no longer perceived as contradictory.[16]

What needs to be retained in this discussion is the very nature of performance. There is a reason that Berenicci returns to it as a medium. In performance, idea, history, chaos, chance, and ritual are given form, are made manifest. It is not clowning, not theatre, but a place where paradox lives, and closure is not inevitable. How can one resist? The charm of the slapstick, those darn explosions, the self-conscious posing of Randy & Berenicci performances all have been and continue to make idea manifest:

First you learn the language. Learning the language, you start learning how people understand the world, how they see the world and that leads into some of the beliefs that people have, the customs and the rituals they are involved in and what it really means to the people. [BUZZ]
First you learn the language. Learning the language, you start.... [BUZZ]
First you learn the language. Learning the language, you start learning....
[BUZZ][17]

Artists are in and of culture. They articulate concept as/in language and give it form. What each performance artist decides to do with the form and content depends on the artist. But by giving it form, objectifying it as concrete, making it manifest, we are able to touch it, react to it, be part of it. Of course, the performance might end in a riot, with us enraged and the performers in jail. While this has not always been the case with Randy & Berenicci, it was often so with Futurist performers. The language incensed, the actors infuriated:

Lift up your heads!... Once again, we hurl defiant to the stars: we intend to sing the love of danger, the habit of energy and fearlessness. Courage, audacity, and revolt will be essential elements of our poetry. Up to now, literature has exalted a pensive immobility, ecstasy and sleep. We intend to exalt aggression, action, a feverish insomnia ... the punch and the slap. We will sing of great crowds, excited by work, by pleasure and by riot.[18]

Randy & Berenicci make use of such language. They play with the idea of manifesto, of proclaiming manifesto. The action of a posturing heroic figure or the rhetoric of the performers speaks to the fact that events, historical or contemporary, can become reduced to being the tools or puppets of mass media gods. History becomes news. Events are reviewed and observed by

15 Randy & Berenicci, artists' statement describing the performance *Control Cycle* (Sherbrooke, Québec: D'archeu, April 1983).

16 André Breton, *Second Manifesto of Surrealism*, 1929.

17 Randy & Berenicci, artists' statement describing the performance *Unbashed Heroics* (Vancouver : Western Front, 1982).

18 F.T. Marinetti, *The Futurist Manifesto* (Paris: *Le Figaro*, February 20, 1909).

19 Berenicci, interview with Mars and Householder.

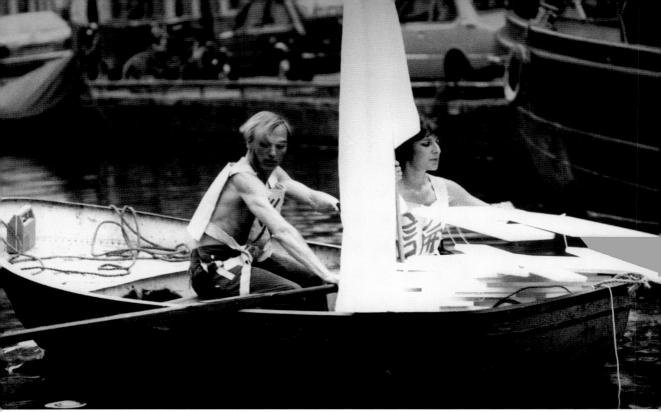

AART VAN BARNEVELD

commentators directing our perceptions. **How do we locate ourselves in all of this? How do we see ourselves in and of history? Are we its agents or victims?**

Me, I don't know from an academic point of view and a personal point of view. I work in a vacuum. It's just the way my mind works. I don't connect my work to someone else's. I don't see myself as part of a definition. It's just the manifestation of an idea.[19]

RANDY & **BERENICCI** *Geschiedenis*, Holland Festival/Time Based Arts, Amsterdam, 1985

Christine Conley

May Chan

COMING INTO HER OWN

Sometimes it is the moments of sheer simplicity in May Chan's performances that register most acutely the immigrant's sense of displacement and exile. In her performance *Mom, Me and My Son*, Chan tells us stories about her family here in Canada and in China that revolve around the themes of food and the sometimes humourous misunderstandings that occur when speaking English as a second language. We laugh in recognition. Midway through her performance, Chan pauses to play us the tune "There's No Place Like Home" on her harmonica. There is a short refrain from another song and then a brief silence, before she resumes her storytelling. I learn later that the harmonica is a popular instrument in China and like ping-pong was a favourite after-school activity during Chan's childhood. However, even without this knowledge, the poignancy of the musical interlude seems to register as the audience's silence meets Chan's own. One could imagine other responses to such a hackneyed song. But Chan's work is entirely without irony. "Life is Art," she says.

Chan's performance is at The 360 on Queen Street West in Toronto, part of a performance series curated by Rochelle Holt and Adrienne Reynolds for A Space in 1999 under the banner *The Message is the Medium: Girls Strut Their Stuff*. Both title and location suggest an evening of irreverent cultural

commentary, flamboyant display, and general all-round unladylike behaviour. Yet such expectations are confounded by the congenial reserve of this middle-aged wife and mother based in Kingston, Ontario. Not that her attire evokes middle-class aspirations. Chan dresses in loose-fitting pants and sensible shoes. Her hair is closely cropped. Her blue plaid shirt, half way unbuttoned to reveal a bright red pullover, tops at least three layers of clothing. Banal as it may seem, this particular ensemble is familiar from other performances in Kingston and elsewhere. The plaid shirt (her best shirt for going out and "more than ten years old," she explains on the telephone) is testimony to her Chinese family's frugalness and practicality. Layering clothing keeps heating costs down.

Since 1979, May Chan has relayed her Hong Kong childhood and her experience as an immigrant in Canada through numerous performances that offer a resolution of the life/art dichotomy, embracing the elevation of the quotidian in Fluxus performance and the Zen wisdom "less is more." Chan doesn't assume the interface of a persona but speaks directly to her audience. She reads us her poems, distillations of experience that overlap the flow of present events with nostalgic memories of the past, investing the routines and minutiae of everyday life with unexpected significance and aesthetic pleasure. At home in Kingston, an advertisement for Moore's suits sparks an excited moment of recognition: the suit pictured is the same one her son has purchased for his job interview, far away in Calgary! Her account of the unexpected luxuries of travelling Via Rail — first class — is as full of wonder as an astronaut's first space flight. Each observation is a revelation that provokes the audience members to see their world anew.

Chan's performances alternate readings with actions like jogging, playing ping-pong, practicing her tennis serve, or stir-frying bok choy to introduce the sounds, smells, and physical gestures specific to the Canadian or Chinese worlds that her work evokes. Through these loosely connected poetic moments — spare and emotionally understated — Chan maps out the distance between herself and family members in Hong Kong and Canada. Shifting continuously between here and there and between past and present, she locates herself as wife, mother, daughter, and artist.

Many of Chan's performances are driven by expressions of longing and isolation with several key works between 1983 and 1990 given over entirely to her aging mother in Hong Kong. Yet her project is not a nostalgic return to childhood or homeland as a site of irrecoverable loss. Her explicit intention is to convey the values of Chinese culture to a non-Chinese audience and to give expression and visibility to her own process of cultural adaptation. She thinks of her art as an act of translation. Performing her private ritual of learning English by memorizing a newspaper story provokes a consideration of English words that have no Chinese equivalent (*Blackmail*, 1981).[1] Another performance involves the attempt to function as a Canadian family unit, playing football on the lawn on a typical Saturday afternoon with her husband and son (*He Threw Me the American Football*, KAAI, Kingston, 1988).[2] Visiting Hong Kong, she attended classes to improve her calligraphy,

1 *Blackmail* was first performed on May 13, 1981 at SAW Gallery in Ottawa and then at KAAI in Kingston. It was also performed in 1982 at Eye Level Gallery in Halifax.

2 Alain-Martin Richard and Clive Robertson, eds., *Performance au/in Canada, 1970-1990* (Québec: Éditions Intervention and Toronto: Coach House Press, 1991), 202, 349.

then gave a demonstration at the Niagara Artists' Centre as part of an anti-racism performance project (Fiesta Cultural, 1994).

May Chan arrived in Canada from Hong Kong in 1963. She is one of the youngest in a family of nine children that has survived precarious political and economic times, from the fear and anxiety of the Japanese occupation that colours her earliest memories, to the frugality of life in the Hong Kong of the 1950s and 60s, the uncertainty around Hong Kong's return to China in 1997, and most recently, the dread of SARS. Chan conveys the texture of these larger historical and social narratives through the microcosm of her own family's experience.

Her first performance, *The Brocade* (St. Lawrence College Art Gallery, Kingston, 1979) recreated her early memory of the family silk business in Canton in the late 1940s, through the ritual folding of shiny coloured fabric — red and green — over and over again on the floor, into progressively smaller bundles. Through folding, Chan recalled her contribution to the family economy — attaching small swatches of fabric to label each package of silk destined for Bombay. Through this action, she transformed her childhood fascination with the silks' brilliant hues into something "like a dance."[3] This was followed by a poem-story about her dad, who lost everything when the Chinese government nationalized private businesses and land, yet managed to start all over again at age 58.[4] In her later sound-poem piece *Dad Rubs and Rubs* (KAAI, Kingston, 1995), she re-enacted a scene of domestic intimacy, her father's evening bathing routine, imitating his careful use of meagre water rations to convey the scarcities and small economies of the 1950s. She repeated his movements, rubbing her head and feet with a towel, playing with the sound of the water in the small basin — gentle splashes in a pool of silence.

The Story of Cheng Han My Mother is a poignant exploration of the mother-daughter relationship split by geographical and temporal distance, part of a group exhibition at the Agnes Etherington Art Centre at Queen's University, 1990.[5] Chan's performance engaged with an installation of personal objects: her mother's dark blue silk pantsuit, a framed photograph, gold rimmed glasses and a wooden comb, and handmade booklets that visitors were invited to handle and read before and after the performance. These booklets record the last year of her mother's life, a time Chan was able to spend with her, and detail the daily routines of nursing administered by her and her sister in the close quarters of a Hong Kong apartment. In her performance, Chan changed into her deceased mother's silk pantsuit and assumed her persona, reading from the books and acting out various incidents so as to convey and honour her mother's values and aspirations. Despite the mother's deteriorating health, these stories are not without a gentle humour. "Mom's Crimson Silk Scarf" relates how Chan's sister Susan placed a silk scarf across their mother's mouth to muffle her incessant chanting, entreating the spirits of her dead mother and older brother for help. The humour lies in the mother's unexpected compliance, not to stop chanting but to raise her head — so the scarf could be tied behind her neck.[6]

3 May Chan, interview with Christine Conley (Kingston, August 28, 2003).

4 May Chan, *The Fifth Girl* (Toronto: Pedlar Press, 2002), 14-15.

5 *Regeneration: Decolonization and Feminism* included Nell Tenhaaf, Amy Gottlieb, Kim Blain, Leila Sujir, Donna James, Rebecca Belmore, and Buseje Bailey and was curated by Christine Conley. Both Chan and Belmore did performances. See curatorial essay "Regeneration" in *Agnes Etherington Art Centre: Exhibitions 1990-1991*, 27-33.

6 This story was first used in a 1985 performance at the Women's Cultural Centre in Toronto. See Richard and Robertson, 272.

7 "Artist Statements," First 7a*11d International Festival of Performance Art, Toronto, 1997.

YIN-TONG CHAN

Chan's performance finale was a cooking demonstration of her mother's favourite dishes, samples of which were served to the audience.

Chan's readings are supplemented by appeals to auditory and olfactory senses: the rhythmic bouncing of a basketball, a tune played briefly on the harmonica, the squeaking of her jogging shoes as she circumnavigates the room, or the sounds and aromas of food preparation. *Sense of Touch* was Chan's contribution to the first 7a*11d International Festival of Performance Art in Toronto, curated by Paul Couillard in 1997. It involved conversing with her audience through a kitchen pass-through in a former community centre, where she interspersed cooking demonstrations with Tai Chi exercises and a solo game of ping-pong. Chan explains the centrality of cooking and eating for people in the Canton region close to Hong Kong: "Their sense of taste is well developed. Their art is their dishes of food. Their art galleries are their restaurants. I keep in touch with my background — food."[7] Another sound performance, called *Chop, Chop, Chop*, recalled the Hong Kong of the 1950s (KAAI, Kingston, 1997). Chopping the beef and bok choy with a cleaver, smashing the garlic with a bang, rinsing and pouring the rice into a pot, Chan recreated the acoustic memory of her home in the factory area, where five families shared a single kitchen and a single chopping block, taking

MAY CHAN *Sense of Touch*, 7a*11d International Festival of Performance Art, Toronto, 1997

MAY CHAN *Dried Tangerine Skins*, in the series *The Message is the Medium: Girls Strut Their Stuff*, A Space, Toronto, 1999

turns twice daily to prepare fresh foods. Chan explains that the sense of touch is intimately bound up with her mother's expression of love through the preparation and serving of food; Chan is "touched" by her mother through food rather than the physical demonstrations of affection customary in Canada.[8] A number of the pieces performed in *Mom, Me and My Son* at The 360 revolved around these culinary themes, the steaming of dried tangerine skins or sheets of dried bean curd, the scraping of a hairy melon by her husband Jack, or the gift of a rice dumpling from her sister. There is something reassuring about these stories even as they take unexpected twists — the dumpling is left in the mailbox unnoticed and eventually returned to her sister — that reveal the gap between cultures and generations, as in Chan's story *Goodies*:

Mom longs to have babies.
Once she has a baby,
She has
a full-month off, not working, just
lying in bed and eating
goodies.
She eats pig-hooves, ginger and black vinegar soup
pork and dried-oyster soup,
peanut, chicken soup (a whole chicken), and
steaming hot rice-wine, with a chicken kidney and intestines.
Mom says, I become stronger
and stronger after
having 1 baby, 2 babies, 3 babies
Mom has 11 babies.

8 Chan, interview with Conley.

9 Ibid.

Food is a means of communication between mother and daughter that is carried over into the relationship of Chan to her Canadian-born son — the theme of her piece *Lasagna* (Burlington Art Centre, Burlington, 1999). In this performance, Chan related how she made "Chinese-style" lasagna for her adult son, home for Christmas, and how he made "real" lasagna the next day. The relative assimilation of Canadian culture is measured by how much either recipe is recognizable as Italian. Food thus becomes a means of communication with the audience and a rich commentary on multiculturalism, family relations, and socio-economic conditions.

While Chan's articulation is direct, it is in no way naïve. She has art degrees from Sir George Williams University (now Concordia) and Queen's University, did post-graduate studies at St. Lawrence College, and has an MFA from York University. She has performed regularly in art galleries, artist-run centres, performance festivals, and other public venues in Canada and Hong Kong. On a field trip to New York in 1976, she saw the text-based photographic work of Laurie Anderson that inspired her to set aside painting and write stories — Chan recalls that her former teacher at Sir George Williams, Roy Kiyooka, had long since abandoned painting for poetry.[9] Then a year later at St. Lawrence College, Tobey C. Anderson invited artists like Clive Robertson, Dennis Tourbin, and artists from the UK to perform

and lecture. It was watching Tourbin's FLQ performance, where he read the news from sheets of paper then threw them to the floor, that confirmed for Chan that she too could perform her stories.

At the *Five Feminist Minutes* cabaret organized by the Women's Cultural Building in Toronto, 1985, the audience watched her write stories in preparation for another exhibition, as if she were at home. The silence of this private activity was relieved by the noise of her exercise breaks as she skipped rope and played ping-pong. She then read out the stories she had written and threw invitations to the audience.

The intelligibility of Chan's commitment to daily living as performance derives from Fluxus, as her work incorporates much of what Dick Higgins identified as the common characteristics of Fluxus actions.[10] But there is also a Chinese connection. As a student in Montréal in the 60s, Chan translated the writings of the Chinese intellectual Dr. Hu Shih, a student of John Dewey who brought the American educator's ideas to China. He championed the use of modern colloquial language in education, rather than the ancient, formal Chinese, as a way of increasing literacy. Chan's use of the vernacular cadences of ordinary English, inflected by her own accent, is directly related to Shih's philosophy. His ideas are reaffirmed in *Performing from Diary: 1976-1982* (A Space, Toronto, 1983) where Chan layered her Chinese clothing over her western clothes and reprised her lessons in English. The prop for her poem-story "The Rain in Spain" was the album cover to the soundtrack of *My Fair Lady*, the romantic story of the young Cockney flower vendor, redeemed through the tutelage of a snobbish linguistics professor.[11]

Chan's work demonstrates a fascination with these kinds of cultural intersections and crossovers. Her 1992 performance at SAW Gallery in Ottawa addressed the Canadian concern with energy conservation through the Chinese virtue of frugality. Chan explained how she wears several layers of clothing, following her mother's example, so she can save electricity by keeping the thermostat at 58° F. At the same time, she humidifies the air by drying her clothes on the furniture. Chan's home economics is certainly not unfamiliar to a Canadian audience; however, the extent to which she takes these conservation measures verges on the compulsive and renders them strange and unfamiliar. Her story "The Sink," also part of the SAW performance, demonstrates how she crosses this line between the novel and the radically different. The audience was first shown a Kleenex box with lumps of Kleenex and hair and invited to touch. Then Chan told us how she likes to use Kleenexes to dry her hands rather than a towel. Because they are not really soiled, she recycles them to clean the sink after trimming her hair. The combination of hair and Kleenex makes a good cleaning brush! Afterwards, there was a brief discussion about the audience members' possible uneasiness — especially if they had touched the Kleenex.

Chan's stories of domestic rituals and consumer culture — keenly observed — reveal a social isolation that is admittedly compounded by artistic and personal inclination. Yet her performances, in all their idiosyncrasies, bring into

10 Higgins identified the following: internationalism, experimentalism and iconoclasm, intermedia, minimalism or concentration, an attempted resolution of the art/life dichotomy, implicativeness, play or gags, ephemerality, specificity, presence in time, and musicality. See Dick Higgins, "Fluxus and Intermedia," in *Art Action: 1958-1998*, R. Martel, ed. (Québec: Éditions Interventions, 2001), 90.

11 Richard and Robertson, 248.

12 *Quarry Magazine,* vol. 4, no. 1 (1997), 14-23.

YIN-TONG CHAN

proximity the condition of being radically other, allowing for a privileged insight into the experience of being a Chinese immigrant in this country. Her performance *Hong Kong and 1997* (Agnes Etherington Art Centre, Kingston, 1997) demonstrated a certain resolution of that condition. With the approach of Hong Kong's return to China in 1997, Chan's work focused upon the uncertainties that surrounded the transition from British colony to Special Administrative Region. The setting for the performance included Chan's calligraphic paintings and handwritten poems concerning the social problems associated with migrations of people to and from Hong Kong: the breaking up of families and the rise in crime due to unemployed illegals from China.[12]

Part one of her performance was a sound piece that began with a five-minute re-enactment of the day she left Hong Kong. Chan put her Chinese pantsuit on over her usual layers and packed a vintage suitcase, circa 1960. There were moments of awkwardness as she fumbled with her Chinese cotton slippers or removed packed items only to repack them, a repetitive opening and closing of the suitcase that suggested the anxiety of revisiting her leave-taking — all conducted in silence. Once completely dressed and packed, she shifted into another mode, addressing the audience, relating briefly her history as an immigrant including the deaths of her parents, punctuating

MAY CHAN *Performing from Diary: 1976-1982* ("The Rain in Spain"), A Space, Toronto, 1983

her words with Chinese chimes. She then told "the story of Hong Kong" using two plastic water bottles — one large and one small. Pouring soybeans from one bottle to the other — back and forth — she created a visual-sound poem of the Chinese exodus, leaving a few fallen beans scattered on the floor. For part two of her performance, she read a poem intended for a show in Hong Kong. "February in Kingston" chronicled her daily walks where the size of her stride was calibrated to temperature and road conditions. Warmer weather means less ice and bigger steps — the body language of a Canadian winter. The February chronicle continued with Chan's attempts to win a local morning radio contest by correctly guessing the common term for three words. On the fourth day, she wins with her answer "tooth" to the words baby, wisdom, and buck. "I nailed them, at last!!" — a triumphant assertion of her command of English and her acculturation as Canadian.

In June 2003, Chan and her husband Y.T. returned from an extended stay in Hong Kong, shaken by their first-hand experience of the SARS epidemic. Y.T. had voluntarily quarantined himself in his office at the Chinese University of Hong Kong when he learned that one of his students was infected. This is one of the stories in *Hong Kong SARS*, performed by Chan at Modern Fuel Gallery in Kingston in August 2003. With her usual understatement, she conveys in this work the pervasive fear in Hong Kong: her husband's tennis partner immediately cancels their game; Chan sees that everyone in the University cafeteria is wearing face masks and cancels her food order; old people salvage used masks to wash clean and resell. Radio announcements spread misinformation and foreboding as schools are closed and people are evicted from public housing units for spitting. But all is not grim. Chan demonstrates her tennis serve, greatly improved after practicing every weekend, alone, to recharge her immune system. In the middle of the performance, she squats and asks the audience to squat too for a few seconds. She then reads stories about squatting — a comfortable Chinese way to rest under a tree, or wait by the curb, or use in the washroom. Squatting as culture. The significance of the corporeal as cultural imprint is also suggested by Chan's description of Chinese calligraphy, the execution of which involves not only a ready knowledge of the many configurations, but a disciplined movement and disposition of the entire body that, like Tai Chi, is the practice of a lifetime (*Hong Kong and 1977*).

Chan views her work as cultural translation, yet her performances confound any simple notion of translatability or hyphenated identity. The problem of translation is the subject of Walter Benjamin's often cited essay "The Task of the Translator" where he argues that translation is only a provisional way of coming to terms with the foreignness of languages; it can only point the way to a realm of reconciliation and fulfillment that remains inaccessible.[13] Instead of correspondence or equivalence, Benjamin suggests that translation be modelled upon the kinship of languages as fragments of a larger entity. He writes:

... a translation, instead of imitating the sense of the original, must lovingly and in detail incorporate the original's *way of meaning* [my emphasis], thus

13 Walter Benjamin, "The Task of the Translator," in M. Bullock and M. W. Jennings eds. *Walter Benjamin: Selected Writings*, Volume 1: 1913-1926 (Cambridge, Mass., London: Harvard University Press, 1996), 257.

14 Benjamin, 260.

15 Bruce Barber, "Three Modes of Canadian Performance in the Nineties," in R. Martel ed. *Art Action: 1958-1998* (Québec: Éditions Interventions, 2001), 304-08.

16 Kelly Oliver, *Witnessing: Beyond Recognition* (Minneapolis and London: University of Minnesota Press, 2001).

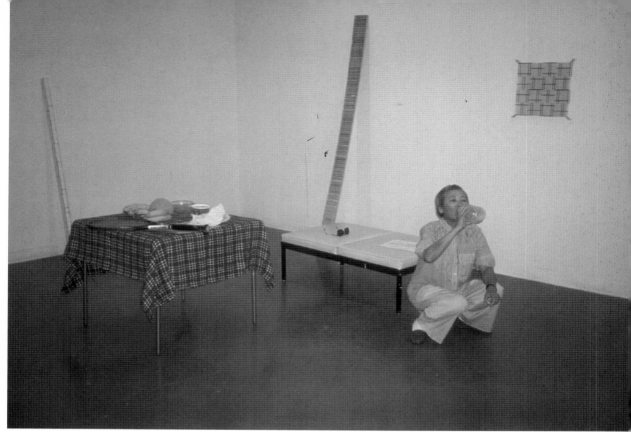

YIN-TONG CHAN

making both the original and the translation recognizable as fragments of a greater language, just as fragments are part of a vessel.[14]

MAY CHAN *Hong Kong SARS*, Modern Fuel Artist-run Centre, Kingston, August, 2003

This is, I think, how the non-linguistic impulses of Chan's performances work. The acoustic, olfactory, and gestural aspects do not convert Chinese culture into corresponding Western equivalents but work beneath language to lovingly incorporate its very way of meaning.

Between Chan and her audience, there is a reciprocity that accounts for the pleasure her performances afford. Even when she is not passing out food, Chan presents us with a gift — a privileged insight into another culture and a revelatory perspective on our own. It is this kind of reciprocity that Bruce Barber associates with the communicative or donative strand of Canadian performance art.[15] At the same time, there is an ethical demand made upon the audience as witnesses to the incommensurability of Chinese and North American cultures and the spectacle of Chan's negotiation of that difference. To conceive of oneself as a subject is to have the ability to address oneself to another. It is this very possibility of address, philosopher Kelly Oliver writes, that sustains psychic life.[16] This is the onus upon Chan's audience, to witness what is beyond recognition as well as what is the same, so that the artist can come into her own.

Paul Couillard

Elizabeth Chitty

GETTING CLOSER TO "YOU"

When I was young, I got by through sheer force of will.[1]

In the early 1970s, Elizabeth Chitty was casting about for a suitable training for her artistic impulses. She chose the nascent Dance Department of York University after the Theatre Department turned her down. With the hindsight of almost thirty years of artistic production to examine, it is easy to understand why theatre might have seemed a likely choice for Chitty. Like theatre, her work brings together abiding interests in several disciplines: performing, visual arts, sound, and writing. Time and space are key elements. Her work examines the human condition and is concerned with effecting transformation in herself and her audiences. Perhaps most significantly, Chitty has always been interested in dramatic tension — favouring the spectacular over the everyday. When she does use ordinary actions and gestures, she mines them for the extraordinary, through context, presentation style, or repetition. Why, then, does her work sit outside the theatre milieu?

The answer lies in her rejection of traditional narrative structures. Chitty was quick to reject the manipulative "trigger mechanisms"[2] of the commercial entertainer — stimuli that prompt predictable, preconditioned responses in

audiences. For Chitty, narrative was one of the most obvious of these trigger mechanisms, incompatible with her search for honesty in expression.

A cursory glance at Elizabeth Chitty's career reveals a pattern of ruptures. Intentionally or not, her work has repeatedly stood in opposition to traditional forms and established disciplines: dance, video, theatre, and even performance art. "It was my nature to call things into question," says Chitty in reference to her career. At the same time, Chitty's production has undergone a series of radical shifts, from its conceptualist underpinnings in the 1970s, to epic spectacles in the 80s, to a focus on landscape-based installational work in the 90s, and her current return to staged, interdisciplinary solo performances. Chitty now identifies herself simply as an interdisciplinary artist, a label that does not ally her to any specific community of colleagues.

Nevertheless, it is the performance art community that has come closest to claiming Chitty as one of its own. Her audacious, pioneering work of the late-70s and early-80s contributed profoundly to the development of Canadian performance art practice, and today Chitty remains engaged in an experimental practice situated at the doorstep of performance art. A renegade, formalist, and visionary, she continues her process of developing a hybrid language that can solve the double bind of articulating truth and reaching an audience.

A rebel from the beginning, Chitty was at odds with the mainstream dance world even before she finished her training. She graduated from York's dance program in 1975, despite boycotting technique classes for the last half of her final year. She quickly made an impact on Toronto's art scene, finding a home for her work first at 15 Dance Lab, a showcase for dance artists and independent choreographers who were pushing the boundaries of movement-based practice, and then at A Space, an artist-run centre that made its reputation by bringing together cutting-edge artists from many disciplines under one roof. Chitty's early performances attempted to expand the vocabulary of dance using a conceptual framework, eschewing lyricism and physical technique for an inquiry into the function and meaning of gesture, both live and recorded. Influenced by the Judson Dance Theatre artists, who included Yvonne Rainer, Deborah Hay, and Steve Paxton, Chitty referred to her work at the time as Postmodern Dance or New Dance.

Early works such as *Polyfil* and *Mover* (both 1975) reveal a formal preoccupation with the linear movement of bodies, often carrying or pushing objects, either back and forth or side to side. *Mover* in particular plays with concepts of force: the "dancers" shift built structures and each other around the space, using their bodies as physical supports and directional vectors. Chitty directs from the sidelines, calling out orders for individual performers to enter or leave the action. A variety of tactics — roughness, tenderness, displacement of objects in space, and using opposing or moving bodies to maintain the stillness of an object — are employed to reveal the effects of force. The forces themselves include not only the kinetic and muscular energies of the dancers but also Chitty's live, choreographic commands.

1 Elizabeth Chitty, interview with Paul Couillard (May 2, 2003).

2 Gene Youngblood, *Expanded Cinema* (New York: E.P. Dutton & Co., Inc., 1970), 60.

In *Drop* (1976), a solo performance staged outside Chitty's 410 Queen Street West studio, the linear movement shifts from the horizontal to a vertical plane, as Chitty is harnessed and lowered to the ground from a fourth story window using a pulley system. She emphasizes the invisible threat of gravity by dropping first a plastic bag of water and then a sheet of glass as she descends in a deadweight drop.

The most compelling aspect of these works is an underlying tension between the formal construction of the pieces, emphasizing aspects of linear movement, and their charged content, which contains elements of physical and emotional risk and even violence. This tension becomes more explicit in *Lap* (1976-77), *Lean Cuts*, *True Bond Stories* and *Extreme Skin* (all 1977).

In *Lap*, for example, one of the key actions, both live and recorded, is a movement sequence involving Chitty and male performer Terry McGlade. Chitty describes the action:

> We don a long sleeve which binds Terry's left arm and my right, and within the limitation which the sleeve provides, we start moving. The movement is very active, usually violent and aggressive...[3]

Scrapes and bruises are part of the piece's consequences. Descriptions from the time focus on the brutal emotional and narrative aspects of the work, which was perceived as a struggle between male and female. Chitty's notes, on the other hand, detail conceptual concerns of overlapping actions and images as a means of choreographic assembly. She addresses what she calls the "human content" almost as an afterthought.

In *Lean Cuts*, a central image of the performance involves Chitty's repeated attempts to climb one of the pillars that were a key architectural feature of the venue. The photo documentation in *Spill* #5, July 1977, shows Chitty climbing barefoot; in the video documentation, she also climbs wearing high heels and rubber gloves. She repeatedly climbs, and then falls to the ground. It is a gesture pre-scripted for failure, since even when she reaches the top of the pillar, the ceiling prevents her from going anywhere but down. The climbing appears exhausting, and comes well into the performance, after an extended period of jumping up and down barefoot. Her falls to the hardwood floor are clearly painful.

Chitty's notes on *Lean Cuts*[4] suggest a series of intellectual considerations around the work: for example, doing tasks that reveal physical exhaustion, something that is normally hidden in dance. She privileges vulnerability, exposed through risk, pain, and potential violence. Her central concern is the idea of "choice," including how to expose her own choices in constructing the work, and finding a formal structure that encourages audience members to recognize their freedom to make their own choices about the meaning of the work.

At the time, Chitty was adamant that these works be read in the context of dance. Clearly, she was already stepping well outside the conventions that traditionally define the form. In the single work *Lean Cuts* she includes spoken text; engages the audience's olfactory senses by burning feathers and meat while telling misogynist stories about the "smell" of women;

3 Elizabeth Chitty, "Lap Documents," in *Dance in Canada*, no. 11 (winter 1977), 18.

4 Elizabeth Chitty, "Cuts/Lean Cuts" in *Spill* #5 (July 1977).

5 René Blouin, "Recent Pasts, an interview with Elizabeth Chitty," in *Parachute* no. 16 (fall,1979), 27-31.

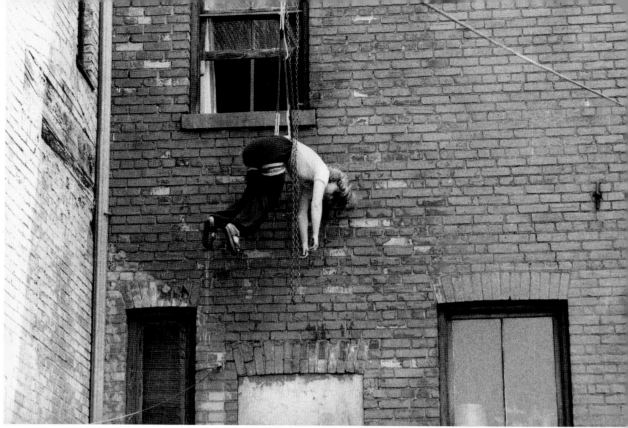

MIRIAM ADAMS

integrates various simultaneous pre-recorded and closed circuit video sequences; and presents movement that, while scripted, is not choreographed into precise "steps."

Chitty was keenly aware of the contentiousness of her work in a dance context, but felt that dance's focus on technique came at the expense of conceptual developments. In an interview with René Blouin, she stated, "I have been quite militant about the fact that I thought that my work was definitely dance for political reasons involving the control exercised by the dance establishment... [The establishment maintains] a colonial attitude and understanding of the artform and they certainly do not promote genuine creation."[5]

The rigid parameters of dance as a discipline presented Chitty with the challenge of developing or educating both audiences and colleagues. Chitty engaged in a number of community-building strategies. Working with Lawrence and Miriam Adams, the founders of 15 Dance Lab, she edited *Spill* magazine, a forum for writing about New Dance. She offered her Queen Street West studio as a venue for workshop classes in biomechanical techniques — now taught in many dance institutions — that were considered radical at the time. She produced and curated events featuring other artists

ELIZABETH CHITTY *Drop*, performed during D.A.N.C.E., outside 410 Queen St. West, Toronto, June, 1976

in a variety of venues, and developed strong links with the growing network of artist-run centres promoting a cross-disciplinary agenda that was at the vanguard of various contemporary art practices in Canada.

Demo Model (1978) was the last work that Chitty championed as "dance." Moving beyond her early interest in linear movement, *Demo Model* interrogates the semiotics of movement. As the title suggests, posing is a key element of the work, which traces gestures to their emotional and communicative roots as "information." Chitty's choreography, which uses semaphore, deaf-mute language, and punk rock dancing, is juxtaposed with video footage and a spoken text of snappy wordplay and sound bites, much of it edited or taken almost verbatim from newscasts. Hip, glamourous, and brainy, the piece secured her reputation in Canada's performance art scene and marked a turning point in her own understanding of her work. Chitty's musings on information were moving her in new directions, away from concerns about movement and into broader philosophical and cultural questions of perception and ethics. Performance art, with its ready acceptance of multidisciplinary approaches, its rhetoric of "anything goes," and its interest in questioning culture provided an attractive context for her work.

The success of *Demo Model* was followed by *Social Studies* (which became the basis of her videotape *Telling Tales*), *Handicap*, and in 1981, *History, Colour TV & You*. The latter piece toured to a phenomenal fourteen venues in Canada, the US, and France. Chitty describes the aims of the performance:

> History is used as a metaphor for communication (since communication necessarily implies recognizable, known information) and is linked with TV, a tool of memory. But hard facts and communication devices leave emotions out in the cold; the performer becomes seductive and turns to You with an old Dusty Springfield tear-jerker, "You Don't Have To Say You Love Me." [6]

The script for *History, Colour TV & You* is written as a four-channel cue sheet for video, audio, live action, and slide projections. The piece concerns itself with big questions. A set of interlocking terms — language, information, knowledge, history, memory, ideology, emotion, passion, drama, and finally, action — are defined through text and evoked through action, image, and juxtaposition. The work can be read as a synthesis of Chitty's previous explorations into the relationship between live time and recorded time, a meditation on being (live presence) and memory (recorded image).

A tour-de-force of collage, *History, Colour TV & You* prefigures the current cultural preoccupation with virtual reality. The script is constructed in a hypertext format, while the set provides multiple and simultaneous visual windows. The performance acts as a kind of immersive environment hovering between distinct but symbiotic understandings of itself. One scenario, suggested by a detailed and poetic description of TV's light emission process, posits an environment that enters and inhabits our bodies. Another view, evoked by Chitty's shadow dances and manipulations of projector beams, seems to promise a territory that our physical bodies might enter and inhabit. Indeed, the script looks to technology (albeit in an ironic fashion) to

6 Elizabeth Chitty, "Handicap," in *Performance Text(e)s & Documents* (Montréal: Éditions Parachute, 1981), 188.

7 Chitty, interview with Couillard.

8 Elizabeth Chitty, *Telling Tales*, voiceover text (1979).

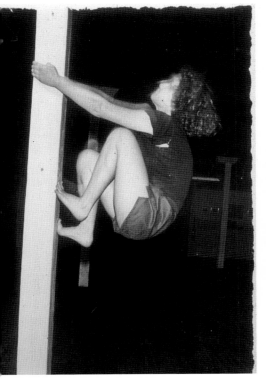

THADDEUS HOLOWNIA

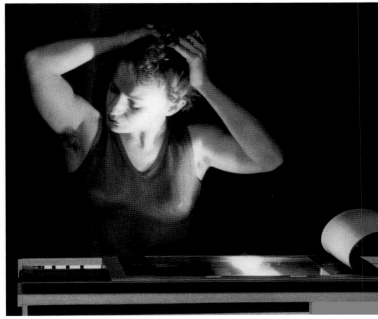

JORGE ZONTAL

serve as the ether that might connect the isolated selves of performer and audience. It is a way for Chitty to get closer to "You."

If you only respect people who are doing what you're doing, that's a pretty narrow view.[7]

Parallel to her successes in performance, Chitty was also producing video works and becoming deeply involved in artist-run centres. She worked as a video producer at the Western Front in Vancouver, served as the Chair of Toronto's Trinity Square Video and spent two years as the Managing Director of ANNPAC (Association of National Non-Profit Artist-Run Centres). Having pioneered the use of both closed circuit and pre-recorded video in her performance works, Chitty became a *de facto* video art expert, producing several single-channel works between 1979 and 1982.

Telling Tales (1979) is an anti-narrative pastiche about the conundrum of narrative:

The beginning of her story was that she felt obliged to make one. ... She felt an urge to observe the sequence of events, to make order of the information all about her. She would have to appoint certain things as the most important, as essential to her theme. Indeed, she would have to decide upon a theme, develop a credo, come up with an explainable purpose.[8]

ELIZABETH CHITTY *Lean Cuts*, 1976

ELIZABETH CHITTY *Demo Model*, 15 Dance Lab, Toronto, 1978

This half-hour videotape shifts from story to story, playing with point of view (e.g. Chitty's handheld camera shoots *Look* magazine spreads as she flips the pages with her high-heeled foot), performance strategies (a lip-sync sequence to the disco classic "I Will Survive;" a female masturbation crotch shot to the tune of "Sugar Pie Honey Bunch"), and recorded interplays of "live," closed-circuit and pre-taped video. Chitty appears throughout, exuding a noir-ish bitchiness with a hard, sexual edge. Paralleling Chitty's performances of the period, *Telling Tales* plays fast and loose with theatrical techniques, using devices such as persona, autobiography, and narrative as shorthand reference points open to deconstruction, distortion, attack, or mid-flight abandonment. *Telling Tales* ends with the words, "She was always telling tales," but her preferred vocabulary was an asynchronous layering of quips, eclectic facts, unexpected angles, alternating rhythms, and — always — striking images.

The blatant sexuality of Chitty's videos set her in opposition to the feminist discourse of the period. When Chitty's twelve-minute videotape *Desire Control* (1981) was presented in tandem with the film *Not A Love Story*, her video work became the object of censure. Chitty, who had always asserted her equality, found herself isolated on this issue, and chose to turn her focus back to performance art.

In performance, Chitty had found a niche. She was on a trajectory of increasingly complex works with growing technical demands, bigger casts, and an ambitious vision of an immersive theatrical environment that could engulf the audience's senses. Inspired by Pina Bausch, whose company toured to Toronto in 1984, Chitty founded Cultural Desire Projects in 1985. Independent artists faced ceilings on the amount of money they could raise from public sources, and the venues available to performance artists could at best supply only presentation fees, never production costs. Given the success of Canadian artist-run galleries and video production centres, the idea of an artist-run production company seemed a logical step. Between 1985 and 1990, Cultural Desire Projects produced two new major works by Chitty, *Moral/Passion* (1985) and *Lake* (1990), as well as works by Randy & Berenicci (*Dance of Delirium*, 1987), Tanya Mars (*Pure Nonsense*, 1987), and Vera Frenkel (*Mad For Bliss*, 1989).

Moral/Passion is a multimedia extravaganza written and directed by Chitty with projections of photo images by David Hlynsky, professional lighting design, a complex soundtrack of music, effects and voiceover, and a cast of four performers. The piece is structured into twelve discrete scenes that feature movement, speaking, and tableaux. Individual texts, like the scenes themselves, are distinct — sequential, descriptive monologues rather than dialogue. The voiceovers are read by the cast with clear voices that are rhythmic but not emotional. The live performances do not involve acting so much as bodies engaged in actions, their words and gestures placed in relation to each other and a shifting, painterly "ground" of projected light. The slide documents of the performance are evocative of textual illuminations, revealing Chitty's visual and spatial virtuosity. Her

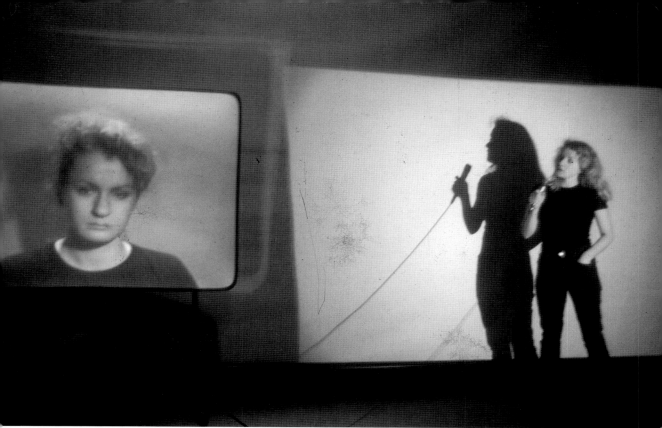

CORRY WYNGAARDEN

ongoing concern with the relationship between live and recorded experience is succinctly captured in the tension between the three-dimensional presence of the bodies in space (live experience) and the two-dimensional backdrop of light (memory). The two seem to fall into each other, creating a charged, "other" space/time.

During the first decade of her output as a professional artist, Chitty's articulation of her practice focused on a preoccupation with "information," which she explored through a conscious structuring of formal elements. She privileged the grammar and syntax of performance over its emotive content, treating the chorus of emotional and internal drives that her audiences had found so compelling as a secondary or even superfluous concern. *Moral/Passion* signals Chitty's decision to consciously tackle the expressive content that had always been an identifiable element of her work.

Each scene in *Moral/Passion* illustrates an instance of "passion," a moment within a story rather than a story in itself. In this sense, the work functions more like an exhibition of paintings or sculptures than as a theatre piece. The reference to "moral" in the title of the piece refers to Chitty's desire to reclaim territory that she felt had been highjacked by the political right. The self-proclaimed or so-called "moral majority" advocates a dogmatic,

ELIZABETH CHITTY *History, Colour TV & You*, Western Front, Vancouver, 1981

black-and-white view of what is "moral." In Chitty's performance, morality is explored through dualities that present cyclical rather than opposing tensions. The script is as concerned with elemental forces as it is with human transgressions:

The earth is parched and rain falls. The air is stifling and the wind blows. There is shadow and there is sunlight.
The heat of desire is fanned by love. Pain numbs but pleasure spreads like flame.[9]

Unfortunately, the work failed to generate the excitement of Chitty's earlier works. *Moral/Passion* did not fulfill the acting and dancing expectations of performing arts audiences, while performance and visual art audiences were puzzled by what they read as the work's theatrical sensibility. Chitty was coming up against the gap between rhetoric and reality in performance art. The liberatory message of performance art is that anything is possible; however, the canon of performance art follows a fairly narrow historical track and comes with its own set of expectations, where one of the cardinal sins is to produce a work that looks too much like theatre. In turning her attention away from formal experimentation in favour of expressive content, Chitty was falling out of step with the general direction of the milieu that she had adopted. Once again the artist found herself parting ways with the discipline:

When I was a successful young artist ... what mattered to me was my art career. That was taken away.[10]

After *Moral/Passion*, Chitty spent several years focused on Cultural Desire Projects and developing a major new work, a vast multimedia piece that was part mythology (from goddess creation stories to Arthurian legend), part hero's journey, part spiritual and healing ritual. *Lake*, which was presented in a large skating arena, featured Chitty not only as the writer/director/choreographer, but also as one of the four women performers.

Lake is a spectacle of dance, song, and oration, reminiscent in scale and tone to a classic Greek epic, an opera, or to Noh Theatre. Designed to be as much an environment as an event, the piece features a metre-square garden of planted herbs, a reflecting pool, a transparent tank large enough to float a human body, massive projection scrims, and a complex grid of lights and projections. As with *Moral/Passion*, *Lake* confirms Chitty's abilities as an image-maker, as she uses shadow and light projections to play with two- and three-dimensional perspective. The staging has a filmic quality, ranging from a close-up focus on the glass tank, Chitty's body lit red as she flips around and around in the water, to a long shot perspective of the performers spread throughout the space, dancing synchronized steps in pools of light as Chitty shoots arrows across the width of the arena. Concerned with creation, birth, planting, healing, and celebration, *Lake* tells its story through repetitive, corporal gestures, melodic choral harmonies, and lyrical text.

As an independent performance production, *Lake* was visually inventive, technically proficient, and formally innovative. Unfortunately for Chitty, it was also a financial disaster. Epic productions require enormous company

9 Elizabeth Chitty, *Moral/Passion* (1985).

10 Chitty, interview with Couillard.

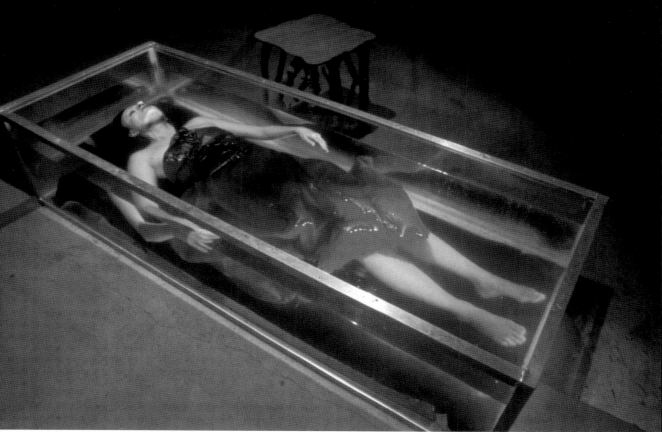

infrastructures, massive marketing resources, and formulaic entertain-
ment values. *Lake* was an anomaly, an epic with none of these elements to
recommend it, and it languished in the cracks between performance art and
avant-garde theatre.

Cultural Desire Projects' activities were essentially suspended, and
Chitty was left with substantial debts. Her work underwent another radical
shift. Throughout the 1990s, landscape and the senses became the focus of
her work, which often included performance as an element of gallery instal-
lations or outdoor sculptural environments in gardens and parks. Always
resourceful, Chitty was able to continue producing new pieces by recycling
elements of previous work, adapting them to new situations as she explored
her ongoing interest in creating immersive environments. She now sees this
"landscape" phase of her career as complete, and has begun mounting
proscenium-style stage works that reflect an interest in bodily presence
and technique as well as a direct performer-audience relationship.
Reflecting on her career history, she notes, "I am grateful for having walked
through the flames, which grounded me in a way I only ever felt grounded
when I first started."

ELIZABETH CHITTY *Lake*, Bill Bolton Arena,
Toronto, 1990

Marni Jackson

The Clichettes

A THUMBNAIL ANTHROPOLOGY

You don't own me
I'm not just one of your many toys.
You don't own me
Don't say I can't go with other boys.
— LESLEY GORE

When The Clichettes first began to develop their lip-sync performances in the 70s, their signature number was Lesley Gore's "You Don't Own Me." The three women — Louise Garfield, Janice Hladki, and Johanna Householder — came on stage in full 60s girl-group gear: oversized, varnished, bouffant flips, white go-go boots, fishnet stockings, Pop Art mini-dresses. They lay on the floor, chins on hands, in sulky-teenager poses. They finger-snapped and synchronized their moves in the old, pre-feminist Shangri-las/Ronettes/Crystals mode ... but when the chorus came round, the pose changed. The Clichettes took a stand. They pointed accusing fingers out into the audience, folded their arms, knelt down, and pounded the floor with their fists as they lip-synced the words:

And don't tell me what to do
Don't tell me what to say

And please when I go out with you
Don't put me on display …

As a performance, it was angry, subversive, overtly feminist, entertaining — and funny. A rare combination, in 1978. Or now, for that matter.

The first time I saw The Clichettes perform was *a moment*. It was in the tiny auditorium of Innis College in Toronto, in 1978, for an event called The Big Sonnet. MC, Michael Copeman, gave a Motown-style introduction, and out on stage floated three women in bouffant hairdos and long, stiff, white, archetypal prom gowns. Three variations on Hopeful Girl. The song was "Past, Present, and Future," a 60s ballad with spoken word verses, delivered in the breathy voice of a girl talking to an invisible boy:

Take a walk along the beach tonight? I'd love to.
(swish of crinolines)
But don't try to touch me, don't try to touch me … 'cause that will
never … happen … again.
(twirl, swish, insane flash of eyes)
Shall we dance?

Under the lyrics of this dopey love ballad lurked a familiar female dilemma: how to be a girl, and therefore get the guy, without turning into someone else entirely. The spectacle of three women doing lip-sync delivered a funny and powerful message: being a 60s good-girl amounted to a kind of performance too. Mastering girlhood meant mouthing the right lines, and going through the right moves.

As I watched The Clichettes on stage, I found their performances hilarious, but I was also surprised at how moving this conflicted image of submissive, subversive girlhood was. Even the image of three women, dressed identically in the "right uniform" (tutu-like dresses and overwrought hairdos), was contradicted by the distinct performing personalities of The Clichettes as individuals: Janice Hladki, long-legged and mobile-featured, with big blue eyes; Johanna Householder, the small, "cute" one, but with a lethal undercurrent; Louise Garfield, tall and strong and yet the most vulnerable on stage. These three women could never be mistaken for the cookie cutter, three-for-the price-of-one sort of girl-group that Motown manufactured. The image of conformity was undone by the subversive choreography and emotive, ironic performances of The Clichettes.

Lip-sync, of course, has not had the art legitimacy of oil painting or soapstone carvings. Mouthing the words to songs has traditionally been associated with drag queens and camp parody. But here were three women, suggesting that even women are female impersonators. They used lip-sync conceptually. Lip-sync could also have the opposite meaning — that the way women were expected to behave, and the way they felt inside, might in fact be "out of sync." Minds and bodies at odds. The Clichettes' performances also posed the question that dominated feminism at the time: how much of gender is an act of cultural choreography?

It's my party, and I'll cry if I want to

Heartbreak — romance as a cruel joke — is a major theme in The

Clichettes' work. The trick with The Clichettes was the way they poured real emotion into fake conventions, creating a powerful image of passionate women trapped inside the inane formulas of pop culture. On the one hand, the song lyrics were often ridiculous. On the other hand, there was an innocence, sexiness, and joy to those girl-group numbers that The Clichettes affectionately recreated. And then dismantled:

> We get our bikinis
> Small as they come
> Yeah yeah yeah yeah yippidee yeah ...

In the days when feminism frowned on even the word *girl*, The Clichettes captured a certain wistfulness. Women wanted independence, of course. But they didn't all necessarily want to ditch men, love, romance, and desire in the process. With their performances, The Clichettes salvaged girlishness while reframing it in an ironic, feminist context. They isolated and exaggerated the rigid codes of appearance and the rules of behaviour that girls inherited, and still inherit, in our culture. (Barbie still reigns, after all, 30 years later.) They were women engaged in the mimicry of women — gender as performance. Just when Baudrillard and Kristeva were beginning to write about the body as text, The Clichettes were exploring the female body, on stage, as subtext.

I went from fan to collaborator when I worked as a writer with The Clichettes on two of their shows, *Half Human, Half Heartache* and *She-Devils of Niagara*. At the time, I was working on a book of stories, based on different parts of the body. I was interested in any work that "talked through the body." Along came these three women who "talked through the body," not to mention their wigs. The subversive ideas were there, but never disincarnate. They posed like flesh dioramas in some museum that looked forward as well as back (a theme we would collectively explore later on, in the script of *She-Devils*). At the time, feminism was going through a somewhat drab and sexless passage. The Clichettes were the first evidence I'd seen that a feminist perspective on the world could co-exist with humour, pop culture, and the always humbling search for love and sex.

The Birth of The Clichettes

The future Clichettes came together in the mid-70s in Toronto, during an extraordinarily rich period of collective creativity. Artists from different disciplines — dance and theatre in particular — began to work together on collaborative projects. These collaborations often fused elements of theatre, performance art, political satire, popular music, video art, dance — or used all of them at once.

New artist-run spaces sprang up around the city — The Music Gallery, 15 Dance Lab, and A Space among them. It was also the heyday of small writer-run publishing ventures like Coach House and House of Anansi. Economically, it was a good time to be an artist; downtown rents were still affordable, and grants to performing artists were plentiful, if modest. The Clichettes and others in the community could earn money waiting on tables (all three

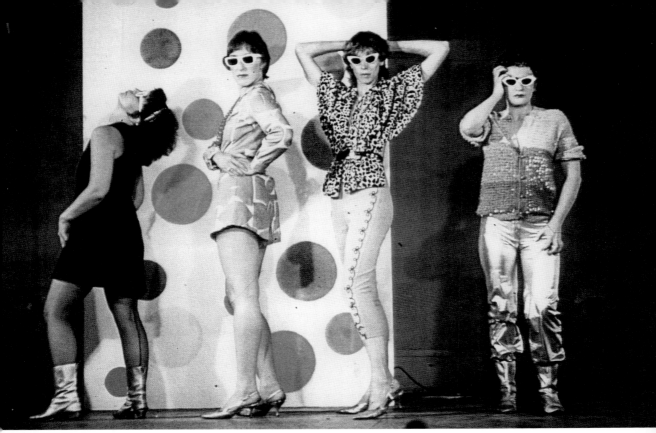

worked at The Parrot on Queen Street West), apply for the odd grant, and still pursue their creative vision. The postmodern investigation of popular culture had begun. The border between high art and entertainment was opening up. Art could officially be fun.

General Idea, VideoCabaret, The Hummer Sisters, The Clichettes, the 1973 Women & Film International Festival, Theatre Passe Muraille's Farm Show ... all of these cultural landmarks from the 70s were collective creations. "It was like jazz musicians hooking up with other musicians, and jamming," Householder remembers. Some worthy initiatives ran into the usual roadblocks and disbanded. Others survived the necessary turbulence of collaborative work, dug in, and flourished. These included General Idea, VideoCabaret (still up and running), and The Clichettes. The hierarchical tradition of a top-down company of artist worker bees run by a visionary director was no longer the only way to go. Many preferred to self-produce, developing shows collectively. Performance art began to migrate out of galleries and into theatres, and popular culture overlapped with "serious" social satire in events such as General Idea's reinvention of the beauty pageant.

The collaborative efforts of the 70s, serious without being earnest, tended to be witty, and social (running to downright anarchic). This is why

THE CLICHETTES *You Don't Own Me.* Left to right: Johanna Householder, Louise Garfield, Janice Hladki, Elizabeth Chitty. The Clichettes first performance with La Monte del Monte's Fruit Cocktails at the Tele-performance Festival part of the Fifth Network/Cinquième Réseau Video Conference, Toronto, 1978

The Hummer Sisters, for instance, were such effective political satirists. They used the seductive tools of mainstream entertainment — the TV image, the rock n' roll song, the newscast format — to critically X-ray the values of pop culture. Like The Clichettes, the Hummers were a trio of women performing a new hybrid of political satire. But the Hummers, with material written by playwright Deanne Taylor, focused more on the values of the media and *realpolitik*, whereas The Clichettes were more interested in the hidden codes of gender and pop culture and constructed their scripts through a process of pastiche, putting together certain found recordings — weird monologues as well as pop songs — with a choreographic concept. Wigs and costumes played a big role too. Sometimes the narrative arose simply from the need for a segue from one song to another.

As co-writer of *Half-Human, Half-Heartache* and *She-Devils of Niagara*, my role was to help develop the emerging Clichette mythology, nurse the narrative links, and write the jokes. (However, my greatest authorial contribution may have been finding the three silver mini-dresses in which they performed "You Don't Own Me." The right dress is worth a thousand words.)

Collaborative art runs the risk of ending up all message and no voice; but The Clichettes, the Hummers, and General Idea all had strong voices, only amplified, it seemed, by the process of working together.

In the late 70s, artwork and political work often overlapped, or were synonymous. The Clichettes were frequent performers at political benefits and fundraisers. One of their earliest performances was at the rally in support of *The Body Politic*, a newspaper charged with obscenity, whose offices had been raided by police. "You Don't Own Me" worked perfectly in the context of a pro-choice rally, or the big Anti-Censorship Benefit where The Clichettes performed in 1984.

If there was a Clichette problem, it was this: they were too funny. If you come on stage wearing go-go boots, cardboard boats, and sailor hats (as they did in *Half-Human, Half-Heartache*, when they performed the German number "Seaman"), you run the risk of not being taken seriously as artists. The Clichettes were flat-out funny, and flat-out feminist. It was an unsettling mix. In the mid-70s, feminism was so focused on achieving equal economic status with men that any hint of girliness within the ranks was suspect; the days of bare-midriff girl-power were still a long way down the road. There was a tendency to reject not just the tired and oppressive conventions of courtship, but the whole notion of longing and romance itself. This severed the movement from the wit, covert power, and overt sexiness of women like The Supremes, The Shangri-Las, and The Ronettes, for instance. The Clichettes let their audiences reconnect with these 60s girl-groups — the over-choreographed, over-produced but still indomitable women (mostly black) whose energy keeps those songs alive.

So. Feminism could let down its hair (or tease it). Serious art could be entertaining. Pop culture could coexist with subversive ideas. Artists could not only do their work, but break the rules of their discipline. And all you had to do was … endure the democratic process (and the occasional six-hour meeting).

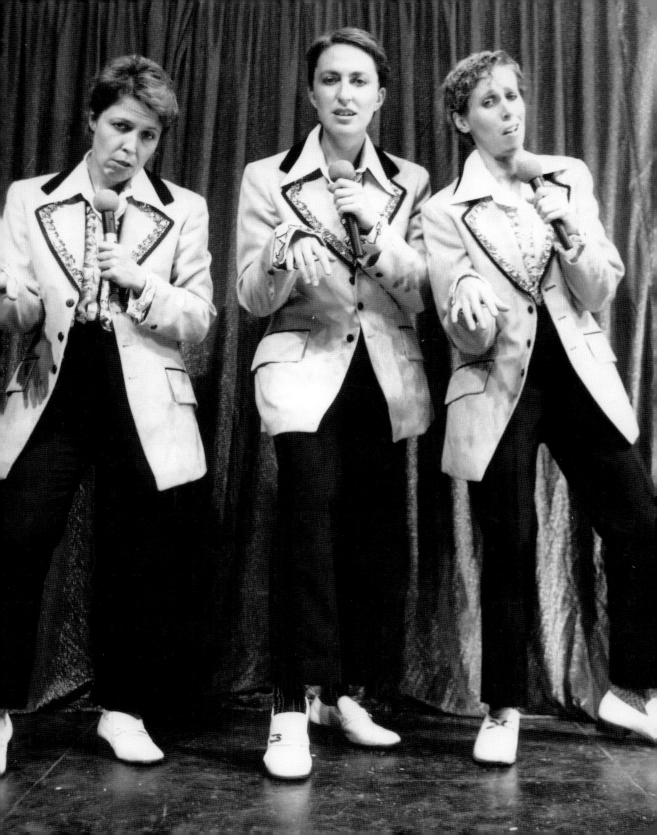

As Tanya Mars said in her interview with The Clichettes, performance art is "often defined by what it's not." The Clichettes began as dancers and choreographers who were inspired to say no to a lot of what modern dance had to offer at the time. (Hladki vociferously claims to have been negatively inspired by Margie Gillis, for instance.) Garfield wanted to pursue a kind of dance that was adapted to her body, rather than the other way around. Householder was drawn to visual and conceptual elements that were not part of the dance lexicon.

Janice Hladki studied at Queen's University in Kingston, Ontario, where she still recalls a damning review she received for a group dance performance. "Planks up their leotards" was the phrase the reviewer used. (This concept could easily have turned into a Clichette number, with real planks.) After graduation, she moved to Toronto where she studied at Toronto Dance Theatre and York University. "For me it was always important to combine dance with a feminist consciousness and intellectual expression," said Hladki.[1] She was influenced by a trip to the States, where she encountered the work of Mabou Mines. After coming back to Toronto in the mid-70s, she began developing her own performance pieces.

Louise Garfield spent a good part of her academic life dropping out of assorted institutions — "Lou was the model for quitting," Householder admiringly recalls. Although she was passionate about her desire to perform and dance, traditional ballet training and even modern choreography didn't offer what she was after. In Toronto she studied dance with Gail Mazur. "I started to feel that there was something about dance, about the way that she taught it and the things she talked about, that were intellectually interesting. That it wasn't all just about the technique."[2] She was also briefly enrolled at York University. All three had seen each other in performances around town, and their paths crossed at York. "It was a case of us all seeing each other's work and saying, 'Yeah, I like your style,' basically,"[3] said Householder.

Johanna Householder was born in Alabama, studied at Oberlin College, and later worked in London, England, where she studied choreography, with mixed feelings. There was a "whole trajectory of possibilities that I was really interested in. But since I didn't have a technique, I wasn't an artist. I wasn't a painter who could then reject painting, and make conceptual art ... I had to go and get a technique that I could reject! ... I went to study dance so that I could learn the technique so that I could have the chops and the ability to reject it and be credible. You can play atonal just by picking up a violin. But if you're a classically trained violinist and you play atonal music, then you're taken seriously."[4]

So all three Clichettes-in-training were dancers resisting dance. Then they met Lawrence and Miriam Adams of 15 Dance Lab. "The Adams' role was crucial," Householder remembers. "They encouraged us, and provided us with a space to work in. They liked to call themselves The Janitors."

By the middle of the 70s, 15 Dance Lab and the Dance in Canada conferences were pioneering exciting new work. Each of The Clichettes individually

1 The Clichettes, interview with Tanya Mars (May 22, 29, 1999).

2 Ibid.

3 Ibid.

4 Ibid.

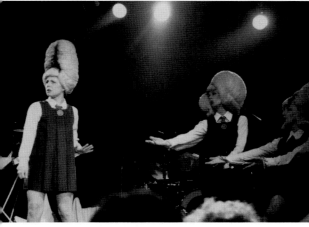

ANGELO PEDARI

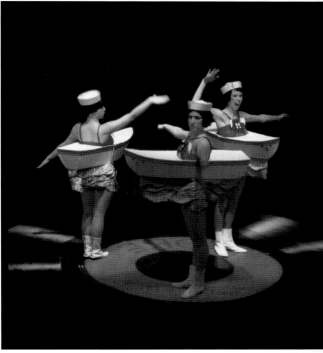

DAVID COOPER

remembers seeing the others perform. Hladki did a piece called *It's My Party* in which she slowly crushed potato chips under her stiletto heels. Householder presented a piece that featured numerous bamboo poles attached to her body. In 1979, Householder and Hladki did a multimedia performance at the Art Gallery of Ontario, called *The Secret Life of Sergeant Preston*, which "exploded the erotic potential of the image of the Canadian Mountie." Hladki and Householder remember Louise Garfield performing *Balloon Slices* which took place inside a giant inflated bubble. And Garfield and Hladki did a piece in which they were taped to the floor in the doorways to the Music Gallery so the audience had to step over them. They were all choreographers who shared a vision of performance that included movement used to explore an absurdist, witty, feminist approach to bodies in space. Especially female bodies, at odds with their environment.

Garfield had also been working with Susan Swan, a Toronto journalist and writer who was attracted to performance. So the process of combining dance with words had begun as well. The only thing missing from this cross-fertilizing time was a steady wage, and dental benefits.

The Clichettes performed together for twelve years, through four major stage productions and innumerable fundraisers and special events. (Hladki

THE CLICHETTES *I Can Never Go Home Anymore* Opening for Rough Trade and Dusty Springfield at The Guvernment, Toronto, New Year's Eve 1985 in wigs designed by Shawn Kerwin

THE CLICHETTES The famous "Seaman" boat costumes in *Half-Human, Half-Heartache*, Vancouver East Cultural Centre, 1981

still likes to call their current status a "hibernation.") They were wildly popular with audiences. Their successful underground/aboveground career officially began when they presented their first lip-sync performance in October, 1978. David Buchan, a local artist who performed lip-sync himself, asked The Clichettes (which included Elizabeth Chitty at that time) to perform at Tele-Performance, part of The Fifth Network/Cinquième Réseau video conference, held at the Masonic Temple in Toronto. They did "You Don't Own Me" and they were an instant hit. Later in the year, they performed on the same bill with Carole Pope and Rough Trade at the General Idea event High Profile, held up in the CN Tower. It was time to think about putting on a more ambitious production.

Piecing It Together: The Clichette Process

The Clichettes asked Susan Swan to help them write a show. Swan then put forward my name, as a journalist who had been involved in collaborative projects like the Women & Film International Festival. In 1979, I went to my first meeting with The Clichettes. It was held at the big old Victorian house on Elgin Street where Garfield lived at the time. We sat on chairs in the backyard. The three Clichettes all wore little hats — tea hats, I would call them. Ladies' costume. It struck me as very professional, in an unusual sort of way. They had a few crumpled pieces of paper with the names of songs and ideas on them. They had developed these performance pieces they wanted to cobble into a show. I had seen some of them. Could I perhaps help them come up with a story? I said I would.

The process was fascinating, a communal collage involving scraps of found music and an evolving mythology around the birth of The Clichettes. The four of us would get together, and they would bring me songs and other pop cultural debris they had scavenged, often by combing through Kopp's Records on Queen Street. It might be something familiar — "It's a Man's World" by James Brown, or "The Look of Love" by Claudine Longet. Or it might be some arcane recorded monologue, like the oily continental-lover speech, by Renzo, called "Songs for My Beloved." Then we would riff away on how one song might link to another, and how a storyline might emerge from all this orchestral "piecing together," as Garfield called it. It was the most perfect recipe for defeating ordinary linear narrative I could imagine. Eventually we came up with a workable narrative answer to that nagging question: why lip-sync? Why don't these women just talk and sing in their own voices? The story of how The Clichettes came to lip-sync then became the plot of *Half-Human, Half-Heartache*, the 1980 show that was their first theatrical production.

In *Half-Human*, The Clichettes play a trio of space aliens, Hoj, Naj, and Oul, from the planet More, where, as Morons, they are scientists engaged in researching celestial soundwaves. Encountering a stray bit of sound from Earth ("Ebbtide" by The Righteous Brothers), they sense something new — emotion. Intrigued, they voyage to Earth to harvest more of these beguiling soundwaves. They aim for Motown, but crash-land in The Crystals' clothes

THE CLICHETTES as "Morons" in *Half-Human, Half-Heartache* at the Vancouver East Cultural Centre, 1981

DAVID COOPER

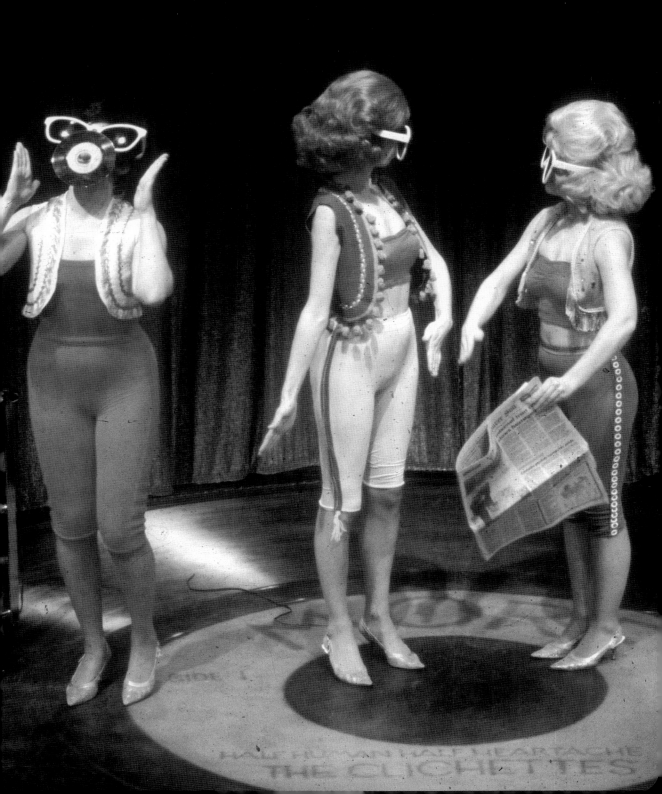

HALF HUMAN HALF HEARTACHE
THE CLICHETTES

closet, where they disguise themselves as earth girls, in order to carry out their clandestine research. Since their More voices are fatal to earth ears, they must disguise them — hence the lip-sync ploy. This begins their rigorous training in earth girl customs and etiquette: the clothes, the make-up, the secret tricks to get a guy. But 60s girl culture soon turns into hazardous material; first one, then another Clichette stops mouthing the words and starts really living those stupid love songs. They are overtaken by the emotional toxins of being image-obsessed, boy-crazy, lovesick, fashion-addled *Girls*.

By the time Oul sings "I'm So Hurt" by Timi Yuro, and Hoj enters holding the severed head of her ex-boyfriend, Gustav, things have gone way too far. Luckily, aliens are highly mobile. The Clichettes blast out of earth's toxic "pink vortex," and to the tune of "Telstar," soar off in search of some new planet; a place "where pure sound and raw emotion can live together happily."

Half-Human, first staged at The Horseshoe Tavern in Toronto, had a run as Toronto's strangest dinner theatre production at Old Angelo's on Elm Street. Producer Bill House and director Hrant Alianak then worked on a production that toured to Ottawa and Vancouver, where it played at the Vancouver East Cultural Centre. The critical response to the show was generally rapturous, although there was some grumbling about the theatrical legitimacy of lip-sync.

I never got tired of watching The Clichettes perform the show. The genius of The Clichettes was to play it both ways — to embrace the girl world with its hidden powers, at the same time they exposed the captive postures. They were careful to pick durable pop productions too. The song had to stand up, musically and dramatically, regardless of its idiotic message. One of the reasons Paul Anka's "Having My Baby" is so effective onstage is its bulletproof pop song construction. What The Clichettes did, through costume (powder blue tuxedos with ruffled shirts and white patent shoes), performance, and choreographed body language, was to unmask the hilarious narcissism of the message: "You're having my baby ... what a lovely way of saying how much you love me ..."

Half-Human, Half-Heartache seemed to hit the right balance of narrative and performance. With the touring girl-group premise, The Clichettes could be performers doing their thing within a stranger-in-a-strange-land story. Any other narrative needs were taken care of by The Voiceover, Monica. The show was some un-slottable thing — not cabaret, not straight performance art, not conventional theatre, not typical dance, not pure comedy. It was an original, hybrid form of performance.

The height of their lip-sync career came in 1984, when they travelled down to Houston, Texas, to compete in the National Lip-Sync Contest. Most of the other acts were the usual Princes or Cyndi Laupers, but The Clichettes, wearing their cardboard boat dresses with glittery wave skirts, chose to lip-sync the German lyrics of "Seaman." Not exactly a crowd-pleaser. Despite this, their performances won over the judges. The prize included ten-speed bikes, a trip to San Francisco, three beer coolers, and four-foot trophies. The Clichettes officially became the best lip-syncers in America.

DAVID HLYNSKY

The next three shows created by The Clichettes moved further into the realm of theatre — too far, in one case. *She-Devils of Niagara*, which I co-wrote with The Clichettes, was produced at Factory Theatre Lab and directed by Bob White. It was a madly ambitious enterprise that once again explored gender and culture, with prophetic digressions into interspecies romance, genetic engineering, and the hazards of trying to clone a new breed of male. The story picked up The Clichette mythology and took it into "the future" when the Earth is in the grips of a police state known as Monogender. Men have become an endangered species. In order to protect the Great Sperm Male, the Gender Police must enforce certain gender-quotient rules. The female heroines of the local wax museum have been moved down to the basement. Under the rousing slogan "Bring Back Bob," women are expected to dress and behave as Mock Males. For The Clichettes, this means that their nightclub act at a seedy Niagara Falls club must be heavily male in content.

This promising but tortured premise (as the co-writer, I feel I can put it that way) allowed The Clichettes to develop new lip-sync performances of "guy" songs: "Walk Like A Man" by The Four Seasons (brilliantly choreographed in a genuine bit of thumbnail anthropology, with the three "guys" devolving into apes), "My Way" by Frank Sinatra (and Sid Vicious), a rambling philosophical

THE CLICHETTES Left to right: Janice Hladki, Johanna Householder, and Louise Garfield. *Up Against the Wallpaper*, walls by Renée Van Halm, 1988

monologue called "The Quail Hunter," and a delicious snippet of Tom Jones introducing "I Can't Stop Loving You." Dressed in nude male body suits, with detachable penises stuffed with wheat germ, and incorporating special tongue choreography, The Clichettes performed Motorhead's classic, "Go To Hell."

The show opened with James Brown's "It's A Man's World" — a melancholy song, in the end. ("He's lost in the wilderness ... he's lost in bitterness.") The Clichettes are in their nightclub dressing room, preparing to perform on stage as Mock Males. They strip down to jockey shorts, and their bare breasts — covered with glued-on chest hair. They suit up, and hit the stage.

She-Devils also made forays into the concept of revisionist history (represented by a "wax museum" of historical figures that included Gandhi, Marshall McLuhan, Fidel Castro, and the forgotten woman daredevil, Maria Spelterini), and the lure of interspecies romance. Lou had a lovely *pas de deux* with a giant turtle, played with an uncanny turtle expression by Jan, dancing to Marvin Gaye's "Sexual Healing." Jan was arrested and subjected to high-testoserone numbers in the *Male Male Male Room*. The rousing finale saw The Clichettes, dressed in yellow oilskins, pour their genetic cocktail, designed to create a third and better gender, into Niagara Falls. But there were problems: too few recognizable songs and a wide, deep proscenium stage that was not congenial to the conceptual style of The Clichettes. The costuming by Shawn Kerwin was a marvel, and the numbers in which The Clichettes performed as performers — "Having My Baby," and "Walk Like A Man" were showstoppers. But the narrative was confusing. Even to me.

If The Clichettes strayed too far from the concept of lip-sync as performance, if they lost that link to pop culture, they would have to move closer to the realm of conventional theatre, where they would be judged as actors in a drama. Which was never their intention.

At this point I had a small son, and a book I wanted to write, and so I bowed out as co-writer. The Clichettes went on to develop two successful theatrical productions on their own, *Up Against The Wallpaper*, a show about greed and real estate written with Kate Lushington, and *Out For Blood*, about three famous figures of female rage, with Peter Hinton as director and dramaturge. The pastiche process continued; The Clichettes would all arrive for script sessions with piles of individually written scenes and possible production numbers, and the three of them, with Hinton's encouragement and guidance, would winnow away, searching for the narrative thread between the lip-sync numbers.

Up Against the Wallpaper took the group into a cabaret setting, Factory Theatre Studio Cafe, and brought them closer to the conceptual origins of the group. This time The Clichettes performed as furniture, and even walls.[5] Lou was a saucy pink table lamp, Joh was a truculent shag rug, and Jan was a beanbag chair with mystical leanings. It was the start of Toronto's insane real estate boom, and once again the theme ("the last house in Toronto under $750,000") was timely. The show sold out.

Out for Blood, a show about the complexities of female rage, featured

5 Designed by sculptor Renée Van Halm.

6 Jon Kaplan, *Now* magazine (Toronto: June 14-20, 1990).

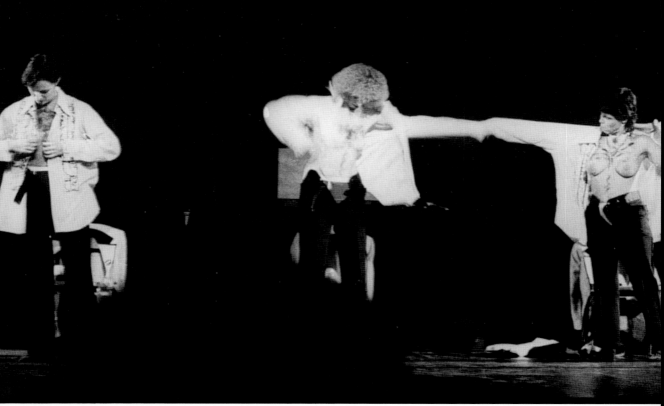

three historical/cultural icons — Janice as Bernardine Dohrn, a founding member of The Weatherman Underground, Louise as snaky-haired Medusa, in the if-looks-could-kill category, and Johanna as Patty McCormack, the actress who played the demon child star in the play and film of *The Bad Seed*. (This was Householder's favourite show, "because it was the weirdest.") This was also the first show written by The Clichettes alone. The musical numbers included Eartha Kitt's "I Want To Be Evil," Dusty Springfield's "The Windmills of My Mind," and Peggy Lee's "Is That All There Is?" "In this show, the lip-sync is more surrealistic," said Louise in an interview for *Now* magazine, "the songs are more connected to character than [in earlier productions] when they were often set-pieces in a show." [6]

In *Out For Blood*, The Clichettes had moved away from the image of the synchronized, similarly dressed, tightly choreographed girl group lip-syncing to familiar pop songs and to something closer to an extended, scripted performance piece, in which all three play distinctive characters who explore different faces of a conceptual theme. But the more distinctive they became as characters, the further they travelled from that resonant image of the girl group, moving as one. As usual, the reviews were warm, admiring, and slightly baffled.

THE CLICHETTES Left to right: Louise Garfield, Janice Hladki, and Johanna Householder. An early attempt at chest hair for the Anti-Censorship Benefit at The Royal Alex in Toronto, 1984

Critically speaking, The Clichettes were always a moving target — too conceptual for cabaret, too pop for a gallery, too non-linear for a theatre, and possibly too entertaining to be recognized as "art." Reviewers were often at a loss as to how to pigeonhole them. In terms of staging, they never found the ideal setting, either. My favourite was Old Angelo's, an old-fashioned dinner theatre pedestal stage that was an artifact in itself. My fondest memories were of certain moments in *Half-Human, Half-Heartache*, when it ran in Old Angelo's. Joh, with the severed head of poor Gustav in one hand and a shopping bag in other, belting out Brenda Lee's "I'm Sorry." Jan lip-syncing a Jane Wyatt commercial about the virtues of lamb ("Then one day I asked myself...why not serve lamb more often?"), while doing some amazing things with her tongue. Lou, with her earthbound, heartfelt, doomed desire to become "Bobby's Girl."

But the perfect satirist doesn't roost anywhere comfortably, or for long. Their originality lay in slipping between conventions and genres, and in waking audiences up to the hidden codes of culture by brilliantly recombining elements of visual and performance art, dance, theatre, and movement.

By 1991, The Clichettes had been working together for twelve years. Each show required a long period of development — researching the music and sound, working on the choreography, collaborating on the concept, "piecing together" the script. The economics of all this were wearing thin. After *Out for Blood*, the three Clichettes mutually and individually went off in search of some financial stability and new artistic directions: Householder went to teach at the Ontario College of Art and Design, Hladki began an academic career by enrolling at The Ontario Institute for the Study of Education, and Garfield enrolled at the Canadian Film Centre to study film production. The costumes — the tidal-wave turbans, the lobster-embossed tutus, the naked male body suits with their wheatgerm penises — went into storage in various basements. Where they remain. For now.

Karen Henry

Kate Craig

LIVING IN CHARACTER

Kate Craig is well known for her videotapes and for fostering the video production program at the Western Front in Vancouver starting in 1976, but her participation in the flurry of performance activities on the West Coast in the 1970s provided the foundation and encouraged her work in video. When the first video camera was introduced to the Western Front in 1974, there was already an active performance scene which critiqued Hollywood and mass media and their roles in creating a decadent star system of money and power. Video provided an appropriate frame through which the art performances could be seen, by other artists and potentially by broader audiences. The artists created a parallel system of promotion, public events, colourful personas, awards, and pageants, parodying and subverting both the commercial art world and mainstream culture. The image, literal or implied, and its relation to television and other popular media was the foundation of this performance work. Kate, whose meticulous framing is recognizable in her camera work, approached performance with the same intense concentration on the image. Her life and work was in relation to a theatre of images as a framing device through which the artist communicates.

The Art of the Pose

Before identity politics, there was the pose: before subjectivity, objectivity, and just plain activity. In the heady 1970s, identities were fluid, playful, communal, and sexually experimental. Performance was a way of intervening in and parodying what was considered "the establishment" in North American culture.

In 1970, Kate Craig was newly married to Eric Metcalfe and the two moved to Vancouver from Victoria, BC. On the way, they travelled in Europe and stopped in Toronto for the Miss General Idea Pageant. In Vancouver, they hooked up with their friend from Victoria, Michael Morris, and his friends including Vincent Trasov and Glenn Lewis. In 1973, eight of the group bought the Western Front as a space to live and work. Kate was the only woman in this predominantly gay scene with a strong camp sensibility, which encouraged the acting out of media icons. Everyone had at least one persona that was played out in live performances, Mail Art activities, and everyday life. Metcalfe's character, Dr. Brute, which surfaced in his work in 1969, was a personification of heterosexual lust and hedonism. His mascot was the leopard. Kate became Lady Brute, a foil for the Doctor's obsessions, acting out the stereotypical trope of the seductress with the leopard skin accoutrements of wild sexuality that the image implied. She was at home in this theatrical atmosphere. Her background was in costume design, first at the Neptune Theatre in Halifax and then at Le Théâtre du Nouveau Monde, and costume was at the heart of the performance activities at the Western Front. Kate was the costumier, collecting artifacts and designing and making clothes for Dr. and Lady Brute, Art Rat, the New York CorresSponge Dance Swimmers (rubber shark-fin bathing caps co-conceived with Gary Lee Nova), the Great Homunculus, and others.[1]

1 Gary Lee Nova called himself Art Rat. Kate made a papier mâché rat head that was worn in performances by various people including Kate in its first incarnation for a photo shoot in London. The New York CorresSponge Dance School was Glenn Lewis' vehicle for mail art and performance activities such as a synchronized swimming group that wore rubber shark bathing caps (made by Kate). The name was a reference to Ray Johnson's New York Correspondence School, another Mail Art creation. The Great Homunculus was a character developed by Hank Bull originally as a mystic on the HP Radio Show on Co-op Radio. Kate made the robes for Hank when he adapted the character for live performance. These were only a few of the many personae in play at the time.

While Lady Brute was a character she married into, Kate took it on as a collaboration through her love of costume. Eric performed the lascivious Doctor or the cool jazz musician with his kazoo saxophone and Kate perfected the pose — the character was, after all, about image and style. Lady Brute donned leopard skin coats, pants, hats, heels, glasses, scarves, and appeared in performances and parades modeling her collection, always ready for a photo shoot. Lady Brute appeared a number of times, with and without the Doctor, but the iconic image is the photo by Rodney Werden that appeared on the cover of *FILE* magazine in 1973. In the image, Kate sits seductively on the edge of a display surrounded by her leopard skin wardrobe. One net-stockinged leg is raised to reveal a black garter beneath the leopard skin cuffed jacket. Kate understood the arch sensibility of the character and made her audiences appreciate the full impact of the particular "image-bondage" that Lady Brute represented.

Typical of the active multiple associations of the time, Lady Brute/Kate Craig became one of The Ettes, a girl group that first appeared as backup for Mr. Peanut in his mayoralty campaign in 1974. The group included Kate Craig (who was the shortest), Mary Beth Knechtel, Babs Shapiro, Judith Schwarz, and Suzanne Ksinan, among others, varying with each occasion. The

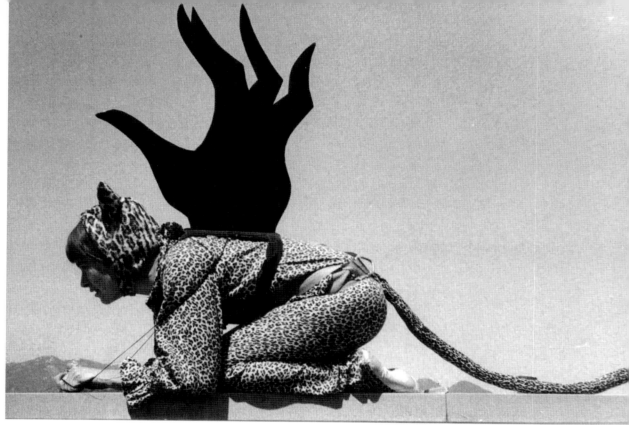

HANK BULL

Peanettes, dressed in black jackets, shorts, and top hats, did a strutting two-step in line behind Mr. Peanut, accompanied by Dr. Brute and the Brute Saxes. During campaign meetings they would sing "Peanuts from Heaven" and hold up the letters spelling out PEANUT and shout: P is for performance, E is for elegance, A is for art, N is for nonsense, and so on. Mr. Peanut and the Peanettes stole the show when the newly elected mayor (Art Phillips) was making his acceptance speech in the ballroom at the Bayshore Inn. The television cameras swung away to catch the act and Phillips accommodated the antics. The Ettes were modeled as a generic backup group, emphasizing the supportive role usually played by women. They described themselves as post-feminist, feeling free of, but not burdened by, heterosexual politics, and encouraging a more playful pan-sexual environment. They could conveniently attach themselves to whatever occasion arose. Besides The Peanettes, they performed as The Coconettes (with Dana Atchley) and The Infinettes at A Space in Toronto (written and directed by Mary Beth Knechtel and choreographed by Margaret Dragu). Though the antics were mostly silly, The Ettes could be entertaining in their critique. As AA Bronson was heard to remark after the A Space show, "It wasn't as bad as I thought it was going to be." The Ettes finally "came out" as The Vignettes (individually

KATE CRAIG *Flying Leopard*, 1974

mannered and *finished*) at Amy Vanderbilt's Valentine Debutante Ball (conceived and directed by Lin Bennet) at the Western Front in 1975. This was a "comedy of manners" in which the "girls" walked with books on their heads and practiced doing and redoing a table place setting until they could do it blindfolded. Lady Brute had a few minor lines and everyone dressed in prom-night finery and danced and sang to "Once in Love with Amy" and other show tunes.

KATE CRAIG *Lady Brute*, circa 1973

By 1974, changes in Kate's personal relationships coincided with a change in attitude towards the performance parodies that had inspired the early 1970s. The artists felt it was time to move on before they were completely bound to their personae. Kate's relationship with Eric was coming to an end, and typical of the weaving of art into life that characterized the time, she discarded the leopard skin mantle through two performances, one that merged the leopard with her own sensual freedom and one that ritually separated her from that particular image. In the summer of 1974, she designed and made, with the help of Patrick Ready, a harness that could be hitched to a cable so that she could fly. The cable was rigged from the hull of a beached freighter to a tree on the shore over the beach in Dollarton, outside Vancouver. The *Flying Leopard* was Kate's first entirely personal project. Using the *Hands of the Spirit* (artifacts that had become a symbol of the creative spirit of performance used by both Western Front and General Idea) as wings, she cast off from the upper deck of the boat and slid along the cable which dropped perilously close to the stones below. With great aplomb she tried the stunt again, reaching her tongue towards the shallow water below her. The audience for this performance was a few intimate friends, but it was filmed by Byron Black for his program *Images for Infinity* on cable television. The postcard of the winged leopard on all fours in the tall grass shows the female leopard returning to a natural wild state. Kate subsequently divested herself of her leopard skin wardrobe in a performance for video entitled *Skins* (with Hank Bull, 1975). Standing naked in front of the camera, she dons each piece of leopard skin clothing one by one and then puts it into a trunk. The soundtrack of Kate and others watching the tape contributes to the separation of herself from the image of Lady Brute.

Pink Poem

The Pink Poem performances took place during the height of the sexual revolution: for the first time, the pill provided women the opportunity to enjoy sex without the natural consequences of pregnancy. Along with the empowerment of sexual freedom came the renewed politics of feminism. The ethos of the time encouraged participatory action and women were working together to organize political and social activities. This new stridency was often "anti-feminine" in an effort to distance women from the overly acculturated terms: pink for girls, blue for boys, dolls for girls, guns for boys. Kate, wryly contrary and ever the individual, turned her collecting interests to an exploration of the colour pink. She collected pink household and fashion items and made her own pink clothes. At one point, she had her

hair cut in a spiral around her head. Though this was not a performance character, it was a sustained activity in line with the simple Zen perform-ances of the Fluxus movement and French artist Robert Filliou who spent time at the Western Front during this period. Kate was not a performer who loved the stage. Kate was more comfortable integrating performance into her everyday life. It was the context in which she lived, and performance represented a deliberate lifestyle choice. The "pink poem" culminated in 1980 in the videotape *Straightjacket*. In the tape, Kate models an intricately tailored straightjacket that she made of pink satin. The soundtrack, a singsong performed by Mary Ready (written by Kate with music by Hank Bull) revolves around the theme of "inside-out." Given the constriction of the garment and its sensual surface, it's hard not to see this reflection on the significance of pink in a feminist context, though the tape and the ongo-ing work ultimately associates the colour with a female sensuality that is bound by social constraints not limited to heterosexual politics. For one thing, Kate had spent the last ten years surrounded by a creative cadre of gay men that practiced its own forms of misogyny.

Collaborations in Art and Life

For the youthful artists at the Western Front in the 1970s, art was generated through the vitality of community and collaboration. The lifestyle became a philosophy and an ethic of production affecting a larger circle of associates who participated in the creative life of the place. Kate was one of the most firmly grounded participants in this philosophy and practice.

The Lux Radio Players was a vehicle for writing and performing together and for playing with sound and illusion. The performances were recorded live and only later edited by Hank Bull and Patrick Ready for Co-op Radio, CFRO-FM. The scripts were written around the characters and loosely con-structed by one or the other of the players, usually Hank and Patrick or Glenn Lewis (for his *Mondo Arte* series). They were added to and elaborated by the players in the process of planning and performing. Kate played a number of roles, as did everyone, and one of her specialties was acoustic sound effects. Her one consistent character was The Soni Twin with Glenn Lewis. The Soni Twin was a Siamese private eye based on the idea that "two heads are better than one." The matched pair would speak their lines in rhyming couplets and in tandem. The Soni Twin first appeared in *The Barge to Banality*. Michael Morris disparagingly bestowed the title when he first heard the script. They also appeared in *A Clear Cut Case*, the first recorded performance of the Players in December of 1974, and later performed in *A Bite Tonight, Habitart: or How to live with our Just Desserts* at Habitat in 1976, and *The Thief of Gladbag* on the Judy Lamarsh Show for CBC.

In 1977, Kate was involved with several activities including a short-lived punk band called *The Young Adults* in which she played the drums. The band, including Terry Ewasiuk, Dave Larsen, Elizabeth Van der Zaag, Monica Holden-Lawrence, Michael Wonderful, and Hank Bull, never performed publicly but, consistent with the emerging role of the video image in the music industry,

2 The UN Habitat Conference in Vancouver in 1976 was the first meeting of international NGOs organized around the idea of human settlements and sustainability; it was an energetic and inspired moment in terms of shared dreams and shared culture. It was a grand event involving the entire creative community either directly or indirectly and many dedicated volunteers.

they did make a videotape. The group was too volatile to stay together very long. Their relationships were characterized by an incident in which singer Terry Ewasiuk asked Kate if she could please keep the beat. Kate responded, "Keep your own fucking beat."

The radio plays had not provided many opportunities for Kate's interest in costume design during this period, but the Western Front residency program brought artists from all over the world into her circle, inspiring her to create World Wide Costume, a wardrobe selection designed specifically for photo shoots in response to fashion magazines. The UN Habitat Conference in Vancouver[2] had brought the creative dialogue of globalism into focus and the Western Front was well situated to capitalize on this opportunity. The Canada Shadows, a blend of early European performance and special effects, Indonesian puppet theatre and gamelan, and electronic music, premiered in March 1978 on the occasion of the fourth anniversary of the Western Front. The group included Kate, Patrick Ready, Hank Bull, Glenn Lewis, and composer/performer Martin Bartlett (one of the founders of the Western Front). The first Canada Shadows production, *The Exploits and Opinions of Dr. Faustroll*, was based on a novel by Alfred Jarry who is generally credited with initiating performance art. Kate and the rest of the group designed and cut out meticulously detailed shadow puppets based partly on past performance characters such as the Flying Leopard. The Shadows toured to San Francisco and performed *Vis à Vis* in 1978 in several venues in Ontario and Québec, including a performance festival organized by Chantal Pontbriand at the Musée des beaux arts in Montréal. In 1980, Kate and Hank Bull embarked on an extensive world tour looking for shadow plays in Indonesia and India and playing with musicians in Africa. They carried a portable shadow theatre and made puppets and performed along the way. The Canada Shadows performed again in Europe in the 1980s as World Shadows in a play entitled *La Chaise des Mémés*. Later works included *Aka Nada* and *Corpus Colossus*. Both the Lux Radio Players and the Canada Shadows continued sporadically through the 1980s.

Performance was a radical activity in the 1970s, undefined as a genre. Kate's idea of performance was informed by community and based in thinking of life as an art project, living thoughtfully and creatively. Her commitment to this is stunningly exemplified by her final performance as she was dying of cancer in the summer of 2002, in Storm Bay, BC. Surrounded by her friends, she posed sitting grandly on the coffin that she had ordered made from local wood. With formidable inner strength and supported by the involvement of a close community, she maintained the balance of life and art until the end.

* * *
With thanks to Hank Bull.

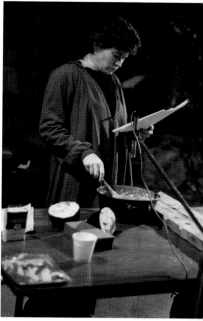

COURTESY OF HANK BULL

KATE CRAIG in *Lux Radio Players*, Vancouver, circa 1978

Barbara Sternberg

Rae Davis

FOUR DECADES OF INVENTION

I will start by listing some of the titles of Rae Davis' performance works because I love them and because they speak succinctly and give a hint of the artist's mind:

Simple Activities

Paul Muni Rides a Bicycle to Haydn

Daily News from the Whole World: 1 Transistor, 2 Projector, 3 Dissector

ECCE, or Greece as seen through a natural environment kaleidoscope

Five Fugues for Isaac Newton

Sinking under lightness

10 minutes with the same question

Ivy's night, Edna's days

Putting yourself into it

Lying low

Ghiberti's Doors

Taking the plunge

Vanishing Acts

Getting what you see

Note the use of present participles and action words, references to science and art, direct and simple declarative descriptions. The whole world as it is

lived everyday is available for consideration, informed by readings in science, literature, and the arts and filtered through the frame of performance. Starting in 1963, Davis wrote these and many more produced and unproduced performance pieces.[1]

Davis' approach to artmaking is conceptual and literary, as the titles suggest. Her degrees in English, plus her background in theatre, directing Beckett and Ionesco among others, support this conclusion. While other performance artists were pulling objects from their vaginas or dealing with body and image in other ways, Davis' works were theatrical but not theatre *per se*; they were more like works by Robert Wilson and the Judson Dance Theatre. Davis found what was happening backstage, in the wings and in rehearsals — the possibilities, the chance, the messiness, the inclusivity — more interesting than what was on stage. And so, breaking out of the play, Davis constructed performances that came to be called "performance art."

From "Breaking out of the play," written for *20 Cents Magazine*, May, 1966:
> The stage is a place. A space. Or a series of places and spaces.
> It could be a hill or a hole. A plain. Or perhaps a thicket.

Davis' hybrid form — stage collages of text, images, objects real and constructed, movement, and light — used ordinary people of varying ages as performers along with some trained actors and dancers. Participants were called upon to improvise within a set conceptual structure. Once Davis had the ideas and structure firmly in place, an important aspect of her process allowed for individual body types, personalities, and experiences of the performers to be given scope. In *Monochrome* (1969), the second fugue of *Five Fugues for Isaac Newton*, an actress under a white spotlight delivers a long monologue. Whenever the light changes to one of the colours of the prism, the monologue is interrupted and the actress goes into an improv of any form and duration on that colour. In the re-mounted version I saw in 1999, Randi Helmers, under the yellow spot, told a story of her yellow organdy party dress and sang "Yellow Bird," which her mother had taught her to play on the ukulele. From *Monochrome*:

> Now that you are here — and of course you can leave at any time — I don't care — I am going to reveal to you what my life is all about. You couldn't care less. And why should you? What am I to you, or you to me for that matter? I'm just expected to say or do something, to amuse, enlighten, anything really to pass the time engagingly. I'm an actress. I can't cover that up, can I? I've actually sat down and memorized all this, every word that's come out of my mouth so far.
>
> (Here the actress will improvise on the colour red.)
>
> Do you remember that scene in *Gone with the Wind* — the film — a very great scene. Always stayed with me. The men are out killing — revenge, murder. The terrified ladies are sitting together, taffeta rustling. One opens a book and reading aloud says "I am born." You see the pages, a mellow light. David Copperfield. The voice goes on. Fear. Story. Silence. "I am born." Those are impressive words. So austere, so momentous, so final. They belong in a frame really, if you see what I mean.

When Davis graduated from university, she thought she would be a writer,

1 Rae Davis was born in New Jersey in 1927, came to London, Ontario in 1957 and then to Toronto in 1987. I first met Rae Davis after she had moved to Toronto from London where the largest portion of her work was written and performed. We met out of our mutual interest in Gertrude Stein. Davis had just seen a film in which I used some Stein excerpts and she told me of her staging of Stein's work in a performance called *Pink Melon Joy. Gertrude Stein Out Loud.*

a poet. Many of her performance works use her writings, in which observations of daily occurrences, ideas from her reading, and references to film and TV fill out and particularize the concepts of a piece, personalize it without defining the material as autobiographical. The cadence of the writing is very much her.

Cataract (1992), a 60-minute performance with no live performers (slides projected onto a billowing sheet went from totally out of focus, passing through the point of focus, to out of focus again; two videos played real-time footage, one of Niagara Falls and the other of clouds) used a taped reading of text written according to pre-determined methodological strictures in an approach similar to process music. Davis went to her studio daily from 10 am to 1 pm and she says "whatever I happened to write that day, on writing days whatever was written was used. I did this for a year, which meant that there was a lot of variety — not all of the fragments were written in the same style — different days, different experiences:"

It makes you think of all those moments
when something changed, you knew irrevocably.
A brief blister punctured, all the water running out.
You look at it, try to reconstruct, but the moment
had come and gone and besides, what does it matter —
the skin will soon be smooth again and just the right colour.
Recovery acts like that while you're not looking
cells signaling to cells going about their evolutionary business,
making do when necessary.
...If you've had a serious case of poison ivy, you know what I'm saying
your skin a topographical map of the Ural Mountains (are they
wide and rolling?) the surface slightly inflated and puffed.
When you move, something breaks somewhere,
your whole body weeps
And you realize at the time that the state you're in
is theatrical and symbolic
if you wanted it to be, otherwise just matter-of-factly
in a high state of trauma, take your pick.

...There's a question about the density of my bones.
I'm picturing them like lace,
looking like the white filigree
of the Bahai Temple in Wilmette, Illinois.
You could take your fingernail and break a line
through the tracery.
But that's not right. Didn't I hear that
these delicate-looking architectures are amazingly strong?
Didn't my math teacher tell us that
the George Washington Bridge
was actually balanced on a point the size of a pinhead?

...Scanners, I've learned, have
specific architectures for specific tasks.

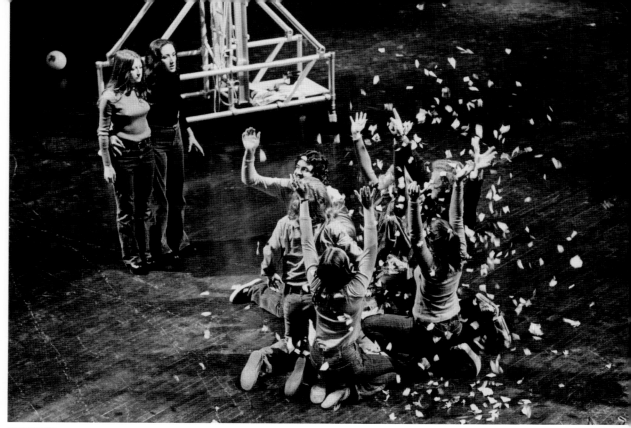

PAUL CHEFURKA

One that builds a picture of spine and hip
in shades of gray to black
depending upon mass
is minimal in structure —
a pipe and a box —
you lie under it in a small airy room
where technicians move about
freely, talking about last night's booze-up
while keeping an eye on the monitor
where your hip assembles slowly.
A piece of cake.

 The language may be straightforward, direct, but one is drawn, almost without noticing, into emotional depths. And all the while the audience is trying to identify what the blurred image will prove to be in "reality," in the brief moment of focus, trying to make sense of it, take a reading. In the text, themes and images recur, are picked up, turned over, seen from another perspective; other tangential or unrelated threads, seen later to be interwoven, expand and complicate. In the end, everything is related.

 Not only does recurrence operate in the text of *Cataract* but also across

RAE DAVIS Still from "The Star Spangled Banner," act two in Pink Melon Joy IV, *Gertrude Stein Out Loud*, 1974

the body of Davis' work. Mapping (in space and through time), architecture, technology, movement, questions of the framing of reality, of representation in films, in pictures, in books, in science, in dreams, through our senses, in our minds, descriptions of her body, of life lived in a body with all its mysteries and betrayals, and, of course, language — these key concerns figure in all her works to some degree or other. The elements in a work, the constellation of ideas, float in the space and over the duration of the piece, bump into each other, rub off on each other, and otherwise become assembled.

Some of the works consist in a performer or two doing simple actions — for example, in *Simple Activities* (1963), two people wrap a mannequin, one tears a large sheet of paper into bits, one person is turned on a wheel by another, one punches holes in cloth on a structure, and two engage in a tug-of-war. A significant number of her works, however, not only involve many performers but also large architectonic structures and considerations of space. *Vanishing Acts* (90 minutes, 1986) utilized the reflecting pool of water in the London Regional Art Gallery[2] behind which Davis had constructed a plywood slope thirty-five feet long and six feet high, with a ten-foot inclined surface. Some of the action took place on a four-foot wide area at the top of the slope as well as on the raked surface and in the water. *Electric Blanket 2: for Stella Taylor* (70 to 80 minutes, 1981) was divided into an open space and a smaller area wrapped in plastic. Some of the physical structures (a ten-foot tower, a bridge) in *Ghiberti's Doors* (85 minutes, 1983) were on wheels so that they were incorporated into movements enacted by the six performers. Mid-way through the performance, the long, narrow performance space was shortened as all the moveable parts on the floor were stacked together blocking off the space and hiding the performers behind this now-in-place wall. Then, a sandbag, swinging through from behind, broke through suddenly and opened the space up again.

Life is full of change and shifts, sudden or slowly evolving. Nothing that is living stays the same. The movements of the performers in *Ghiberti's Doors* (chosen by themselves in interaction with the various structures in the space — wooden bed frame, trapeze, cement blocks, a post and lintel constuction, bridge-on-wheels, etc. — change in kind and in speed throughout. Davis : "What I am interested in is scan, flow, shift, interruption, re-vision of memory and experience — the present always using its history changeably."

In *Electric Blanket 2*, the continual slowing of a repeated cycle of movements until stasis is reached (entropy) echoes the struggle and eventual defeat of the swimmer Stella Taylor[3] and contrasts with the gaining energy of the performer in the wrapped space (the trajectory of evolution). Changes from scripted to improvised action in *Monochrome* are signaled by lighting changes from white to colours of the prism. In *South Pole: Mysteries of the Landscape* (1976), a 20-minute work based on the melt/freeze cycle and produced in collaboration with electronic music composer Philip Ross, organist George Black, and ten other performers, there are seven simultaneous activities in which an orchestrated change occurs in each at a specific time. For example, a sunbather lies on a tilted plane and at the tenth minute

2 Now known as Museum London, London, Ontario.

3 Stella Taylor was a marathon swimmer who failed in her attempt to swim from the Bimini Islands to Florida.

Caught in the Act an anthology of performance art by Canadian women

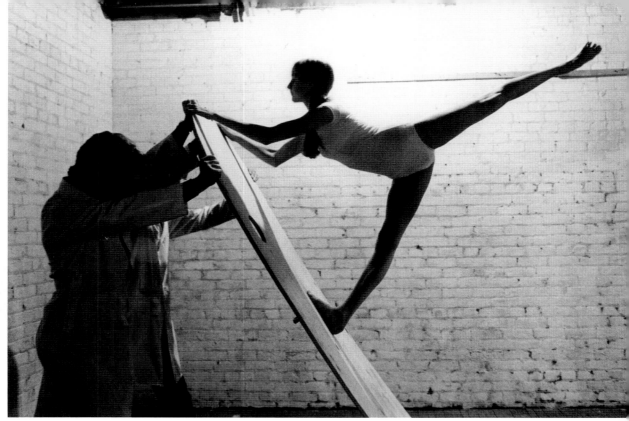

MARTHA DAVIS

shivers and turns from her back to her front.

A plastic rabbit, a very old, caked, and cracked pair of work-boots, a model-scale house frame, trouble lights, lumber, plastic sheeting. Mundane objects, things that happen to be in her studio, raw materials, are attended to and when put into a performance take on a larger significance. Perhaps Davis' interest in objects is a holdover from her days working with stage props. In any case, she has become attached to these objects and has used some over and over again in the formation of her body of work. For the most part, these objects are not exotic — but then there are the fantastic wedding cake with lights worn as a hat in *Ghiberti's Doors* and the miniature lit city in *Vanishing Acts.*

The workings of space and architectural forms give the pieces their formal armature and function as physical analogues for temporal structuring. They may also, along with considerations around the warm/cold poles that recur thematically in various works, refer to that most iconic of structures, "house" — shelter, inside/outside, domestic space — a space Davis has been acutely attuned to throughout her life.

Davis told me the story of how, as a child, she went down to the swamp not far from home (she wasn't allowed to play there). For a huge up-rooted tree, she got an old green curtain from home and erected a tent-like structure

RAE DAVIS Diana Cartwright in *Ivy's night, Edna's days*, 1978

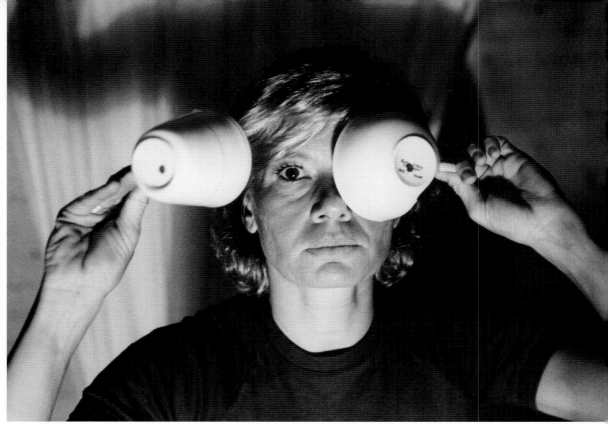

MARTHA DAVIS

RAE DAVIS Lisa Hoffmaster in
Taking the Plunge, 1985

suspended from the roots. Inside, from scavenged discarded lumber, she made a table on which she arranged rusted cans and stones — a secret place, hers — and her first performance construction.

Rae Davis' mind and approach to making art and to living are considered and exuberant. In writing about the experience of making *Pink Melon Joy. Gertrude Stein Out Loud.* (1974), Davis says:

This experience became one of the most illuminating of my life and career because it went right back to the basics of language, image, and communication. It called into question every convention of the theatrical practice and forced me ... to find a way to say it and do it. I found that way by using the simplest, barest, most minimal means possible ... When you get down to subject, verb, object — or even preposition — in terms of performance, you're down to construction bricks. You understand then what "making" is. You understand that the act, the most familiar act, is full and requires your full concentration. You understand that meaning is fickle and depends on context ... I learned these things viscerally, through action ... As they say of dancers, I have a muscle memory of it, and if the mind is a muscle, as Yvonne Rainer would have it, let's include that, too.

Jennifer Fisher

Shawna Dempsey & Lorri Millan

PERFORMANCE ART OUT AND ABOUT

The live in all facets of life is decreasing. People have their cell phones, their palm pilots, their MP3 players, their laptops. They go to movies, play video games, watch TV, read magazines. We have less reason to interact in real time and real space, and we are social creatures! People's sense of community is so fractured these days that coming together to experience a live performance — that age-old, one-on-one human connection — is still vitally important to our species. — SHAWNA DEMPSEY[1]

While other forms of media communicate, there is something about being live in front of another person, or group of people, that contains empathy and a true possibility of change. This is unique to the performance of live work. Maybe it's because we are all breathing together, maybe it's because one of us could drop dead. Maybe it's because there's a risk. This is important to acknowledge and take advantage of. — LORRI MILLAN[2]

Since beginning their collaboration in 1989, Shawna Dempsey and Lorri Millan's performances have presented brilliantly scripted cabaret style monologues of iconic females, rap songs by feminine anatomical parts, discursive meditations on lesbian life, and more recently, site-specific, conceptually-centred interventions that they term *real world performances.*

1 Shawna Dempsey, Dempsey & Millan interview with Jennifer Fisher (August 6, 2003).

2 Lorri Millan, Dempsey & Millan interview with Jennifer Fisher (August 6, 2003).

SHAWNA DEMPSEY & LORRI MILLAN
Looking Back 3000. Performed by
Shawna Dempsey, 2002

The duo's embodiment of familiar gender stereotypes fluently navigates the tightrope between fine art and popular culture with spectacles that involve the body as a medium to colour artistic expression. Moreover, speaking from the contradictory standpoint of a living body — as simultaneously cultural object and embodied subject — ups the stakes of a distinctly feminist politics.[3] Their performances characteristically instill a sense of comfort in the micropolitical practices of daily life: audiences settle in and relax their suspicions, only to find themselves carried into, and participating in, a liberal lacing of humour that drives a spectacular détournement.

Dempsey and Millan met in Toronto during a performance zeitgeist that included The Clichettes, Tanya Mars, Nightwood Theatre, and Sheila Gostick. Shawna was completing a degree in theatre production at York University (and working as the technician for The Clichettes) and Lorri was active in a variety of media including photography, drawing, and writing songs.[4] Performance provided an effective nexus to embody their feminist concerns within an art practice, becoming their primary medium and pivotal to their interdisciplinary work that included video, film, and print media.

The conceptual thrust of Dempsey & Millan's performances was consistent with the theory boom underway in gender studies including the influences of deconstruction and identity politics during the 1980s. While seriously critiquing dominant power structures, they deploy a tone of playfulness and humour to posit alternative subjectivities for women. Mobilizing razor sharp parody as an edge of critical resistance, their extensive oeuvre of performances presents the struggles of gay and feminist subjects within the shared pleasures of subcultural identification. Each spectacle characteristically frames a familiar female icon, and then articulates a divergent fable, often one that impels audiences to recognize their own queerness self-reflexively, whatever its modulations of difference or unconventionality. Fixed perspectives give way while swept up charmingly in a participatory situational enjoyment. An affective politics of "peopleness" drives the work which is clearly evident in the artists' likability and heart-centred interactions, even when involving communication between positions of difference. Ultimately, Dempsey & Millan's boldly courageous assertions can be appreciated on many levels at once by diverse audiences, whether feminist, gay and lesbian, or the local, national, and international art and academic communities.

Dempsey & Millan's finely realized *mise-en-scènes*, costumes, and scriptwriting are heirs to, and consistent with, the formalism of Robert Wilson and Meredith Monk. Shawna apprenticed with Monk in New York from 1983 to 1984, which also instilled important cues concerning collaboration, as Monk was then working with Ping Chong. Other important performance inspirations include postmodern dance which staged everyday movements in highly conceptual contexts, and Laurie Anderson's synthesis of new media within the performance art genre. In addition to 1980s feminist Toronto performance, the duo acknowledge the importance of Lydia Lunch and Karen Finley.

The process of creating each work begins with collectively envisioning an image. The performance is generated by expanding upon this image or

3 Dempsey, interview with Fisher. In their words, "we really have to believe in what we're doing to put [our] bodies out there."

4. Ibid.

SHEILA SPENCE

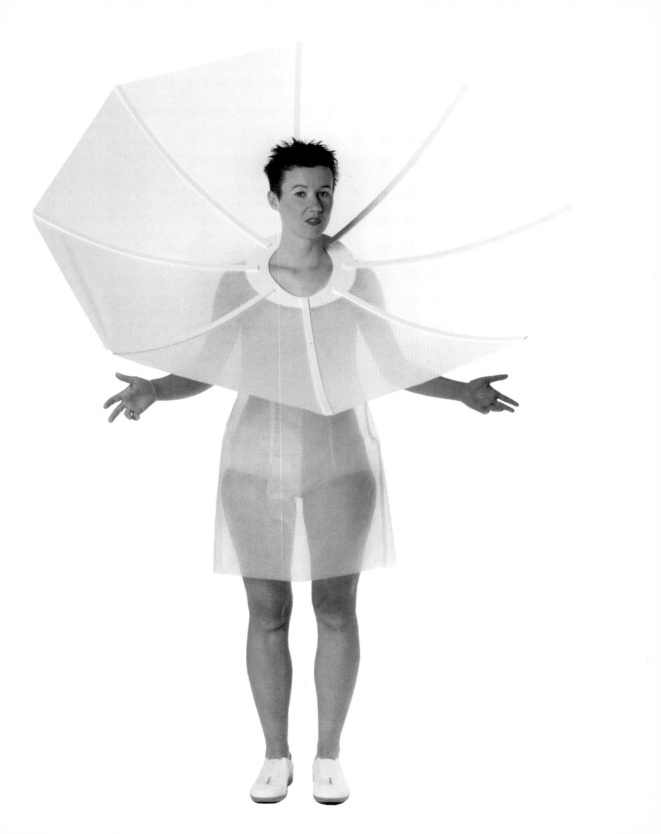

iconic figure, giving her a character, gestures, scripting her language, and framing the work in a theatrical or paratheatrical setting.[5] The representational strategies deployed by Dempsey & Millan at once recognize the disciplinary forces of patriarchal culture and redress the relegation of the lesbian to "other." As their staging both appropriates and subverts conventional women's roles, so, too, their cabaret performances present a distinctly phallic, powerful performer while simultaneously deconstructing a phallocentric visual economy.[6] Annie Martin insightfully elucidates the split subjectivity of Shawna's onstage persona, noting that her performance of an apparently "unique interiority" is at once authentic and inauthentic, as what she voices "as her own," is simultaneously Millan's co-written script. As Martin points out, the "me/not me" aspect of the performed speech, the space between authentic and inauthentic, is precisely that zone where new "possible" selves are forged.[7]

Virtually every performance involves an elaborately constructed costume — itself an art object — that is enlivened by the performance. Femme characters carry nostalgic resonances of Betty Crocker or Barbie, yet refuse to be contained by patriarchy. In turn, butch characters usurp patriarchal authority for distinctly lesbian presences and enjoyments. Likewise, the minutely inflected textual scripts effectively hijack the authority of their originating discursive formations, whether women's magazines, television advertisements, science fiction films, grocery stores, national parks wildlife services, or Eaton's catalogues.

A suite of performances explores the dress as a ceremonial costume and icon of feminine identity. In these pieces, cloth is replaced by sculptural materials that extend the metaphoric impact of sartorial iconography to embrace a multiple, heterogeneous, and contradictory feminist standpoint.[8] In *Object/Subject of Desire* (1989),[9] Dempsey appears in a paper ballgown, elegant as a debutante at a "coming out" ball. Wearing the rustling paper as brittle as the gender codes that contain her, she asserts herself as a desiring subject: "I want you…" While one might initially assume this desire to be heterosexual, the twist is the performer's explicit assertion of lesbian desire. The material comprising the costume for *The Thin Skin of Normal* (1993), an off-shoulder evening gown, is Saran Wrap bristling with four-inch roofing nails. This icon references 1970s advice columns which suggest, that to keep their marriages alive, housewives greet their husbands dressed in cling wrap. Rendered porcupine, a curvy theory-savvy feminist becomes prophylactic to reductive habits of polarized femininity. In turn, *Arborite Housedress* (1994) is performed in a wearable sculpture "dress" made of wood, laminate, chrome kitchen hardware, and cloth. Weighted within her wearable architecture, a patriarchally colonized "housewife" reveals her anxieties in assuming power:

Eve took a wrong turn [out of paradise] but her first mistake was getting behind the wheel in the first place … It had serious repercussions for her, her family and human history but it also hurt Adam's feelings … and that's not very *nice* is it?" [10]

In *Plastic Bride* (1996), Dempsey appears nude under a clear plastic wedding gown, merging the architecture of the bride's dress with the packaging of

5 Richard Schechner defines "paratheatre" as the blurring of boundaries between the performer and the audience, in significant ways. See Richard Schechner, *Between Theatre and Anthropology* (Philadelphia: University of Pensylvania Press, 1985), 105.

6 B.J. Wray, "Structure, Size and Play: The Case of the Talking Vulva," *Decomposition: Post-Disciplinary Performance*, eds. Sue-Ellen Case, Philip Brett and Susan Leigh Foster (Bloomington and Indianapolis: Indiana University Press, 2000), 195.

7 Annie Martin, "Shawna Dempsey and Lorri Millan," *Parachute* 75, 43-44.

8 Sandra Harding, "Rethinking Standpoint Epistemology: What is 'Strong Objectivity'?" in *Feminism and Science*, eds. Evelyn Fox Keller and Helen E. Longino (Oxford & New York: Oxford University Press, 1996), 243.

9 Please note that within this text, the dates given for the performances indicate the year they were first staged.

10 Shawna Dempsey and Lorri Millan, "Arborite Housedress," in *A Live Decade:1989-1999*, video of selected performances, (Winnipeg: Finger in the Dyke Productions), 45 min.

11 Shawna Dempsey and Lorri Millan, "Growing Up Suite," in *A Live Decade: 1989-1999*.

12 Jennifer Fisher and Jim Drobnick, *CounterPoses*, (Montréal: Oboro & DisplayCult, 2002).

13 Jane Gaines, "Fabricating the Female Body," in *Fabrications: Costume and the Female Body*, (London & New York: Routledge, 1990), 1. Jane Gaines has argued: "In popular discourse there is no difference between a woman and her attire. She is what she wears."

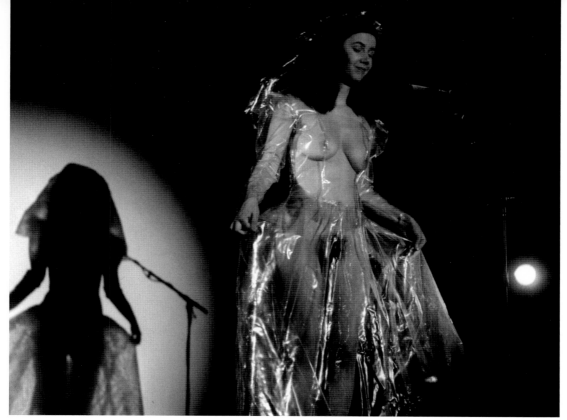

AARON KIMBERLY

forensic evidence. She asks the audience if they've ever had one of those dreams where they were wearing the wrong outfit. At issue is self-immolizing fashion, the risk of being killed by a fashion mistake. *Growing Up Suite* (1994), backed up by Montréal's Choeur Maha, reflects on lesbian coming of age in Scarborough. The ladies underwear pages of the Eaton's catalogue becomes a source of budding sexual fantasy where "industrial strength underwear concealing unimaginable body parts ... so powerful they needed hardware to keep then in place." [11] This thematic continues in *The Eaton's Catalogue [1976]* (1998) as a classic tableau vivant of The Three Graces within a functioning fountain. Faucets protrude from the bodices of 1970s evening gowns, from which water flows. In these retro-cyborgs, actual hardware displaces heavily constructed ladies brassieres. [12]

In each of these performances, costumes present the constructedness of sartorial femininity. Fashion, whether butch or femme, becomes a resonant signifier of social change employed to deconstruct patriarchy and project utopian-feminist impulses. [13] Yet, while the forms of nostalgic fashion may mimic forms of patriarchy, Dempsey & Millan pry open the duo's ideological content to rescripting. Forms of language, gesture, and cultural referents — such as Eaton's department store catalogues — polysemously acknowledge

SHAWNA DEMPSEY & LORRI MILLAN
Plastic Bride. Performed by Shawna Dempsey at the Nova Scotia College of Art and Design, produced by Eye Level Gallery, 1997

a different viewing subject. The collaborator's "people palette"[14] expanded with *A Day in the Life of a Bull Dyke* which presents Lorri as an alluring butch icon starring in a B noir video. The confessional voice-over narrates the poignant struggles of the lesbian — defined as she is by homosexual desires and physical acts — and empathetically enters into the subjectivity of desiring lesbianism.[15]

The perpetually controversial *We're Talking Vulva* (1990) is a cheeky anatomy lesson given by Dempsey embodied in a five-foot tall vulva costume. Her rap intro interpolates a distinctly female audience: "... that's why I'm here, to say hello, to show you around down below. Hi Girls!"[16] Presented as a perky "subject," the vulva gets her hair coloured, goes shopping for vegetables, and works out. This educational video is an entertaining consciousness raising of the functions, cultures, and enjoyments of female genitalia.[17]

Dempsey & Millan skillfully mobilize the power of stories to reshape ideologies of gender through a set of narrative works which retell popular myths from a lesbian feminist perspective.[18] Conventional narratives of media culture shift as wittily wrought narratives make central — if only for the duration of the performance — a queer standpoint. The strategic resituation of cultural codes have important epistemological consequences and affirm art's capacity to effectively place a wedge in hegemonic structures. *Mary Medusa* (1992) invests a mythological icon with a kaleidoscope of identities: mythical personage, homemaker, and corporate superwoman, to articulate a subjectivity located in the gaps between how the feminine is conventionalized, and how women actually want to live. This piece explores women's challenges of living out idealized roles, ultimately moving into an exploration of monsterous excesses of female desire: "A woman out of control is a frightening thing!" In *Looking Backward 3000* (2000), a professor speculates about contemporary life in the year 3000, speaking an archaic TV English gleaned from videos of *Dynasty* and the *Regis and Kathy Lee Show*, she itemizes in sci-fi-ese her speculations on the demise of global communication. *The Short Tale of Little Lezzie Borden* (2001) retells the story of the Victorian murderess Lizzie Borden as a contemporary tale of kleptomania, appropriating the rhetorical tone of women's fashion magazines: "This is not a weapon ... this is a hatchet ... not a tool, an accessory ... and *accessories create interest!*"[19] And *Lesbian Love Story of the Lone Ranger and Tonto* (1997) casts an alternative to the male dominant racist Ranger and Tonto legend.

Outside the gallery, cabaret, or proscenium, Dempsey & Millan's performances blur the edge between performer and audience, and have been staged as interventions in shopping malls, the Manitoba provincial legislature, and National Parks. In *Smile Girl* (1993), Dempsey appears in a suite of public settings and events assuming a classic cigarette-girl mode of self-display as she hands out breath mints and safe sex information. In *Golden Boy Awards* (1992-94), Shawna assumes the mythical subjectivity of the "golden boy" sculpture atop the Manitoba provincial legislature building in an agit-prop award ceremony that singles out unwitting politicians known for unscrupulous activity.

For *Grocery Store* (2002), Dempsey & Millan collaborated with media diva

14 Dempsey & Millan, interview with Fisher. Terms used by the artists.

15 Dempsey & Millan interview by Fisher. The simultaneous magazine drag of *A Day in The Life*, is a brilliant masquerade of *Life* magazine. The embodiment of Lorri for the first time had a powerful effect on how the collaboration was perceived because it made Lorri a visible participant. After that point there were no more arguments with performing venues about two airfares.

16 *We're Talking Vulva*, adapted for the screen by Shawna Dempsey and Lorri Millan, produced and directed by Tracey Traeger and Shawna Dempsey, String of Girls Productions, 1990.

17 *We're Talking Vulva* brought the revelation that performance needn't be obscure, but an art form where a simple idea can satisfy (and provoke) on different levels simultaneously. The controversy pertaining to this piece has been surprisingly longstanding. Hallwalls Gallery in Buffalo lost their National Endowment for the Arts funding for an entire year because this video appeared in their support material. A similarly reactionary controversy ballooned at the University of Winnipeg over Dempsey & Millan's artists' talk for fourteen year old students, generating six months of press coverage as "Vege-gate." Most of the vitriol was generated by those who hadn't actually seen the work.

18 Dempsey, interview with Fisher.

19 Dempsey & Millan website: www.fingerinthedyke.ca

20 Shawna Dempsey and Lorri Millan, *Scentbar*, as part of *reminiSCENT*, curated by Jim Drobnick and Paul Couillard, Toronto, September 20, 2003.

21 Ranger Shawna Dempsey and Ranger Lorri Millan, *Lesbian National Parks and Services Fieldguide to North America*, (Toronto: Pedlar Press, 2002).

22 Dempsey, interview with Fisher.

PAUL LITHERLAND

DISPLAYCULT

Jake Moore and graphic designer Zab to create an actual grocery store in Ace Art Gallery to sell food and essentials that are otherwise unavailable in Winnipeg's Exchange District. The project involved radio ads, a circular of advertising specials, and a mail-in coupon campaign to the mayor petitioning for an increase in downtown services. The intent was to raise public concern and provoke a response from civic politicians who had been making planning decisions that had adversely affected this largely artists' community. And in *Scentbar* (2003), Dempsey & Millan appropriate the uniform of scientific authority. Dressed in white lab coats, Dempsey undertakes a "scientific" questionnaire into the feelings and general attitudes of her subjects. Findings are codified, and then Millan creates a personal perfume combining such unconventional, yet highly affective, scents as "light industry," "grannie's purse," "rental car," and "regret." [20]

Lesbian National Parks and Services (1997-present) is comprised of a complex discursive masquerade involving uniforms, social interactions, brochures, field reports, and a book-length *Field Guide to North America*.[21] For lesbians living in a heterosexist culture, creating a reality is an act of both resistance and self-preservation,[22] and Dempsey & Millan developed the characters of the Lesbian Rangers to insert an explicitly lesbian presence into the landscape.

SHAWNA DEMPSEY & LORRI MILLAN
Tableau Vivant: Eaton's Catalogue 1976. Performed by (right to left) Anne Borden, Shawna Dempsey, and Annie Martin as part of *CounterPoses* produced by Oboro and DisplayCult, 1998

SHAWNA DEMPSEY & LORRI MILLAN
Scentbar. Lorri Millan mixing fragrance, 2003

SHAWNA DEMPSEY & LORRI MILLAN
Lesbian National Parks and Services
1997 to present

Initially conceived for a Banff Centre residency, Dempsey & Millan arrived in the rocky mountain tourist town in their turquoise 1963 Pontiac Laurentian, wearing their "official" park ranger uniforms, and, remarkably, remained in character for the duration of their stay.[23] The performance consisted of patrolling Banff, politely interacting in deadpan "ranger speak," earnestly giving confused shoppers directions, or edifying tourists about the lesbian geography of the flora and fauna of Banff. They also handed out wryly written brochures which indicate Banff's historical and biological homosexual presence. Appearing as innocuous as Girl Guides or Boy Scouts serving pink lemonade, a soft-sell recruitment drive "to expand the core of lesbian rangers" had no incendiary effect. This piece both normalizes (often invisible) lesbianism and points out the constructedness of nature.[24] Repositioning recreation from a homosexual standpoint, the rangers suddenly found themselves part of an ever-unfolding, "parallel universe." Performance became something that happened not only between walls or within a video monitor, or between pages, or in a particular time frame.[25] Like reality TV shows, the conceptual premise drove events that were unpredictably compelling in themselves. The piece became a situational testing of the authority given to those in uniform. People did tend to give them a lot of respect, and felt entitled to interact, and thus enter into the performance.

Both Shawna and Lorri emphatically credit each other as their most important influence. While the two were involved romantically for years, their post-relationship communication comprises a mature working partnership of openness, a dynamic mutual respect, friendship, and what Janice Williamson has termed an "informed intuition" that comes from a working experience and knowledge of each other.[26] They challenge assumptions that collaboration is inherently limiting or some shared compromise, instead asserting that they find it expanding: "doing their own work" is doing collaborative work.[27] Over fourteen years, Dempsey & Millan's creative process has exhibited performative rigour, incisive scripting, and conceptual resolution. Yet at the same time, they have avoided the rigidity of mimicking previous successes. Developing tolerance for the trials and errors attendant to emergent creativity, and have not pressured themselves to be "brilliant" all the time. With what was to become Lesbian Rangers, for example, they began by attempting a complex theoretical work, but then came the realization that what they really wanted to do was dress up in the uniform.[28] The paratheatrical intersubjectivity that this piece impelled could not have been predicted as the experiential laboratory for the interrogation of uniformed authority it became.

As Lisa Gabrielle Mark perceptively notes about Dempsey & Millan's practice, the question of authority itself is destabilized when it is shared by more than one person.[29] Given the challenges of surviving as full-time artists, can the personal be other than political? What has emerged is a politics of collaboration that challenges the notion of the autonomous artist itself.

23 *Lesbian National Parks and Services* was initiated by Dempsey & Millan at the curatorial proposition of Kathryn Walter for the exhibition *Private Investigations at the Banff Centre.*

24 Margot Francis argues that while Dempsey & Millan's Lesbian Rangers subvert heteronormativity, their subversion of nature still depends on their whiteness, and the racial history of colonizing the outdoors. See Margot Francis, *Fuse* vol. 22, no. 4, 41.

25 Dempsey & Millan, interview by Fisher.

26 Lynn Bell and Janice Williamson, "Public Warning! Sexing Public Spheres: A Conversation with Shawna Dempsey and Lorri Millan," *Tessera,* vol. 25, (winter/spring 1998-1999), 65.

27 Dempsey & Millan, interview with Fisher.

28 Ibid.

29 Lisa Gabrielle Mark, "Hijacking Cabaret," *Border Crossings* (winter 1995), 36.

Christine Redfern

Nathalie Derome

WORKING WITHOUT A NET

Nathalie Derome claims she is a double agent: one half performance artist, the other actor. Strangely, neither side embraces her as one of their own. Actors do not consider what she does theatre, while artists often do. Her practice is a hybrid of performance, theatre, movement, and music. She doesn't get hung up on the catch-22 of labelling herself. In each piece, she uses the form she needs to communicate her message: video (*Le Retour du refoul/The Return of the Repressed*, 1990); Greek myth (*Le Voyage de Pénélope/Penelope's Journey*, 1992); dance (*Des mots, d'la dynamite/Words, Dynamite*, 1996); poetry (*S'allumer contre le vent/A Fire Against the Wind*, 1998), or sound (*Du temps d'antennes/Air Time*, 2001).

Regardless of what interdisciplinary shape Derome's work takes, a constant is that there is always an aspect of performance. She responds to the moment as it happens, aware of the energy between herself and the audience. Once, at a performance in Hull, there was a woman with a crying baby. The woman was becoming uneasy, everyone was trying to shush the baby and Derome felt the opposite should happen. She wanted the audience to stop and listen to the moment. So they all waited until the baby calmed down:

I thought it was important to try, though it is scary, because you always hear the saying "the show must go on." But in reality, why? We have time.

We are not in a rush. This works well in the context of performance. I think it profits from the real, the real life that is around us. I try to integrate, keep that in all my performances. It is alive; it is not a finished, planned show.[1]

When discussing her work, Derome makes a distinction between "performance" and "interdisciplinary performance." The former is spontaneous, about context and taking risks. The latter is preconceived, elaborate and involves the collaboration of other artists. Even when it is labelled a "solo," others are involved in the development of the costumes, staging, set, and lighting. In these pieces, Derome is conscious of the audience's reaction — ultimately she wants them to be engaged. Conversely, when she presents a one-off performance, she can be happy with the results even if it is a failure in the eyes of the viewer. The *raison d'être* of this type of performance is to experiment. Derome speaks about her piece at Rouyn-Noranda in 2000, presented as part of *Les Yeux Rouges, 24 heures de performance et d'art action*:

I knew the area well because I had taught there. I knew the lake; it was very polluted, next to the mine. I played a frog with a watermelon. I did a little preamble about how the frogs were endangered and how when the frogs were endangered so too were humans. Then I asked everyone to come outside, went on an air mattress, and ate a watermelon.

Derome liked the discomfort this caused in the viewers. People in the crowd were yelling "Be careful!" "Nathalie come back!" as she wielded her knife to slice the watermelon floating on the raft. She was not afraid; she was a frog in a ridiculous costume with a little shovel as an oar. Another time, as part of a "fashion show" organized by Folie Culture in Québec City, she made a costume for herself where she was covered from head to toe in pantyhose:

It was on my face and I couldn't see very well. I was walking and singing and I had the idea to walk through the audience. When I left the stage I couldn't see anything, but it was such a trip. I had to touch the people to find the exit. I had to go slow because there were a lot of people and tables. So I slowly felt this is a shoulder, this is a face, a chair. This moment for me was really important. I wrecked the show and it was boring for those watching, but for me it was "wow."

The year was 1983 when Derome found herself drawn into the vibrant Montréal performance scene. The artist-run centre Véhicule Art was active and the city was attracting seminal international performance artists such as Robert Wilson, Meredith Monk, Laurie Anderson, and Richard Foreman. Derome was studying theatre at the Université du Québec à Montréal, but commented on her role options: "I do not want to be the virgin, the mother, or the slut." Derome and her friend Sylvie Laliberté developed their own voices by creating short scenes together. No story, no narrative path. One scene would follow another, but a connection was not necessary. Derome and Laliberté made fun of female stereotypes. Their first performance was *Ramdam pour Suzanne (Bang for Suzanne)*:

It was a looped soundtrack, a tape of exercises for women from the 1950s. We performed it many times. In the first performance, we had a big gym

1 All quotes unless otherwise noted are from interviews between the author and Nathalie Derome during the summer of 2003. Translated from French by the author.

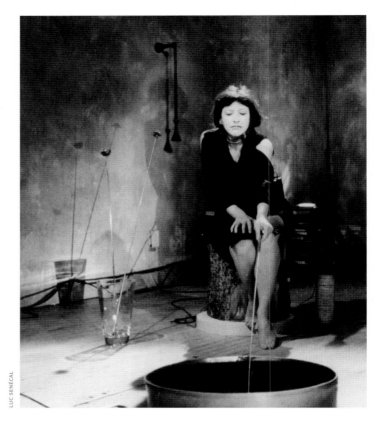

LUC SENÉCAL

2 French crooner of Armenian ancestry whose singing career spanned over four decades starting in the 1940s.

3 Tangente submission translated from French by Christine Redfern in consultation with Nathalie Derome.

mat and a little trampoline that we would run and jump off. It was a very ironic, very acidic look at femininity and feminism.

Beauté-Boeuf (Beauty-Beef) was another performance from the early years. Here Derome and Laliberté accompanied the kitschy songs of Charles Aznavour[2] with their own absurd choreographies. The performances, even at this stage, already had certain hallmarks of Derome's style. The focus was on dance, movement, games of rhythm, and asking questions. Who are we? Where are we? Where are we going?

Sylvie and I had a type of game where we sat on chairs and told the story of humanity in four chapters, a revisiting of history with feminist eyes.

A submission the pair had written for Tangente Danse Actuelle (an artist-run centre dedicated to independent choreography and contemporary dance) in Montréal provides a glimpse into the dynamics of the duo:

Here we are; two pretty, pretty girls. Working as a twosome makes us prove ourselves in the eyes of the other. Each brings to the table her arbitrary, personal affinities and predispositions, which is the beginning of the work.

The relationship affects and directs all. It should give a certain combative element to what we do. Therefore, there is no reason to take out arms. It is an exploration of our capacity to take risks in a bastardized mix that gives

DANIELLE HÉBERT

DANIELLE HÉBERT

us pleasure to bring to the stage. Our activities will be principally dancing and singing; what will be presented will be nostalgic themes, whims, flirtations, or more precise actions.[3]

The pair attacked Montréal. They performed in galleries and in bars like Foufounes Électrique, but the two also brought their act to the streets. Wearing costumes and playing music on a ghetto blaster, they performed their "little grotesque choreographies" to Bavarian folk music or cheesy love songs. Working with music that was clearly not in fashion, in front of a public who had no idea what to make of them, they were often harassed, though only once pelted with rocks. The two started to pursue their own paths in 1984. Derome's subsequent work lost the coquettish, kitschy aspect of the duo, but the focus on the feminine and feminism remained.

Derome's first solo, *La Paresse (Laziness)* is an important work in contemporary art. It originally started as a short piece created for a performance/installation event. Benoit Bourdeau made the installation: a small bed overshadowed by a large painting of a man's head with raised eyebrows. The figure is very imposing and instantly became a presence in the show. The first performance lasted twenty minutes. Derome continued to work with the piece and ultimately performed the ground-breaking hour-long version at

NATHALIE DEROME and **SYLVIE LALIBERTÉ** in a photo booth in the early 1980s

NATHALIE DEROME *Du temps antenne, solo low tech (Air Time, solo low-tech),* Montréal, 2001

NATHALIE DEROME *La Paresse.* Tangente: Danse Actuelle, Montréal, 1987

NATHALIE DEROME *La Paresse.* Tangente: Danse Actuelle, Montréal, 1987

Tangente in 1987. Bourdeau again made the set and created the lighting; photographer Danielle Hébert helped to make the costumes and to develop the aesthetic of the show. Derome speaks of feminism and Québec in post-referendum Montréal:

I took the metaphor we say often, femme-pays (motherland) and I spoke about the political situation in Québec, the nationalism, but in a more intimate manner. Questioning the relationship between man and woman and country and society and nationalism.

She enters the stage — the set is her apartment and she speaks to the audience as if they have dropped by for a visit. The material is light and comedic and the audience laughs a lot. She plays with gender, the *le* and the *la* found in the French language, where minerals are masculine and vegetation is feminine. The show contains this banter, but a large component is made up of singing and dancing. By the time it is over, Derome has evoked every emotion. Sometimes she sings and accompanies herself with foot tapping, other times she gestures to pre-recorded songs, other times her movements are pure modern dance:

It was slow, that is why it was called *La Paresse*. My work is always about intimacy and always slow, really slow, not very performative in the sense of ta-dah, not spectacular.

It is slow, but slow in the way time becomes thick when one experiences important moments or unravelling disasters — where every second registers and it is impossible to turn away. Derome plays with stereotypes and just when the audience thinks they know where she is coming from or where she is going, she changes direction. There is no storyline in Derome's work; meaning is created through the accumulation of personae and visual moments. She breaks every preconception about who she is, how she acts, how she is capable of acting. This is not work that stays on one level. She is a woman possessed, who through movement, words, and music evokes a world of heightened reality:

The recurring theme of all the productions is philosophik + politik = poetik. The various shows deal with the cultural legacy that has shaped us, with the issue of political and symbolic territory, and with the relationship between the private and the public self.[4]

Une Pelle et un Râteau (A Shovel and a Rake), presented at the Musée d'art contemporain in 1988 was part of the group exhibition *Les Temps Chauds*. Derome had a large room to work with for the summer. She did a show every two weeks in which she talked about the artist's relationship vis-à-vis the institution. She had the idea, because it was a big empty space, to ask her friends to bring in their own art. She covered the room with their paintings and sculptures. Fittingly, she ran into trouble with museum personnel. The curators became indignant because they had not given permission to those artists to exhibit in the museum. The only way she was able to keep the work there was by insisting it was not art:

In the show, I was a clown character who visits the museum. That is how I convinced them to let me keep the art, because I said "No, no, these are my

4 From the website of Productions Nathalie Derome, www.nathaliederome.qc.ca

NATHALIE DEROME *Le Buisson Ardent*, presented as part of *Les Yeux Rouges, 24 heures de performance et d'art action*, Rouyn-Noranda, QC, 2000

props." I worked with two big pillows stuffed in my pants that gave me the big rear end of a clown, and then I would turn them the other way and it would give me curvy hips, and I was the symbol of abundance.

Later that same year, again at the Musée d'art contemporain, she presented *La Peau des Dents* with four other performers. The piece was then renamed *Canada Errant, performance-fleuve (Lost Canada, a long-winded performance)*. Derome worked on this project for two years and by the end it involved nine performers. It was a show that changed each time it was performed. Between performances the cast worked, improvised, and played together at least three nights a week. The final group was made up of actors, singers, dancers, and a live band (bass and two guitars). The performance raised questions around the individual vs. the state:

What I always do is I lift up the edge of the carpet and expose all the dust hidden there. In my performances, I do not want people to say, "Nathalie Derome thinks this or that." I want people to take away a feeling as opposed to a truth.

Derome's most recent interdisciplinary performance was *Du temps d'antennes, solo low tech (Air Time, solo low-tech)* in 2001. She rented a studio space on Ontario Street in Montréal right next to the Cheval Blanc pub. The piece was developed as a result of the studio. She had a microphone set up to hear the bar next door, another microphone outside in the street. She played with the real constraints of the space she was in. She made holes in the walls:

With the fire regulations of the city, forty people could watch, it was perfect; it made it a very intimate show. We extended the run, did more shows and it became even more "raffinée." Then, curiously, I was asked to do an adaptation of this performance for children. So it was presented inside a theatre, but what was crazy is that I was obliged to replicate the walls of my former studio for the set.

While creating the children's version of *Du temps d'antennes*, Derome was taken by the problem of turning this performance into theatre. Relying on a theatre set, she no longer had access to her own space with real walls. Previously, when she performed on a Wednesday night, the music and the ambiance next door in the bar was not the same as on a Saturday night. Ditto for Ontario Street:

The entire show revolved around the space and was only possible because I had the opportunity to have the studio for a whole year, every day. I didn't start out with a text; my working process was all mixed up. If I felt like making music, I would make music; if I tired of that I would stop and work on movement, then I might make a hole in the wall, which would give me an idea, this idea brings me to something else and so on.

In *Du temps d'antennes*, Derome plays a gal who dreams at home, listens to the walls, spies on the neighbours. She is a woman living in a world that is more and more technological, yet she is more and more alone. It is a show about being very small in an immense universe or about being squished inside a universe that is too small. Her character starts the show by saying:

5 From the English text of *Du temps d'antennes*.

6 www.popstart.ca

"I'm wondering if time equals space, as Albert Einstein said. If time equals space, and these days we have the feeling that we don't have enough time for anything, imagine the space we have left."[5]

The show ends with the echoing sound and haunting sight of the character singing with her head inside a large round glass vase. While she walks towards the door and the lighting changes, the image alters and the vase appears to be the moon floating in the sky. Derome's genius is her ability to take everyday material — common objects, songs, political dialogue — and construct from these phenomenally powerful moments that communicate in a direct and almost primordial way.

In her upcoming show *Les Écoutilles (The Hatches)*, Derome returns to working with a group of performers. The piece pivots around the time in one's life when the politicians running the nation are the same age as you. The performance again unites social commentary with a feeling that is more corporeal. In this case, the aging body and an increasing awareness of its incapacity to make itself heard:

At times, I feel completely impotent to change things in society. I am frustrated that the people who have the power are my age. I watch the news and try to pick out who they would have been in my elementary school class. Were they the ones eating baloney sandwiches? In my work, I am always trying to have an opinion about politics, but curiously, whenever I take this path, it leads me to something more spiritual.

Derome is once more part of a performance duo, this time she and Gaétan Nadeau are the superheroes Nat Mosphère and Super Gland. They are writing a piece for these personae that reflects upon the relationship between the city and its artists. As well, Productions Nathalie Derome, in conjunction with Toronto's Bluemouth Inc. and Vancouver's Radix Theatre, are spearheading an online pan-Canadian interdisciplinary artist's network called Popstart.[6] The goal is to facilitate exchange amongst interdisciplinary artists and make it easier to produce and disseminate productions from one end of the country to the other. Derome comments on her body of work:

All the work I do, often I have the feeling like I am a Catholic mother at the beginning of the colony. I had a child every year, but I didn't get to keep any of them. The winters were too difficult; they perished from disease, cold, hunger. That is often how I feel in relation to my shows. I create them, give them life, but in the end my work is biodegradable. Afterwards what remains? A small picture, a binder with some papers, memory... souvenirs...

Kirsten Forkert

Margaret Dragu

THE JOY OF LOCAL

Margaret Dragu has been active as a performance artist for over thirty years. She began her career as a dancer, studying under Yoné Kvetys-Young in Calgary, who introduced her to contemporary dance, specifically dance influenced by the European avant-garde movements. She was also exposed to folk dancing traditions through her family's involvement with the Romanian community, which influenced her use of movement, through the use of simple dance patterns and gestures. Dragu studied in New York, where she was exposed to the choreographers working at Judson Church. Their emphasis on everyday, pedestrian movement has continued to influence her performances to this day. She then moved to Montréal, where in addition to producing work, she began a career as a stripper, which crossed over with her practice as a performance artist: both have involved elements of vaudeville, theatricality, and expressions of sexuality. In 1974, Dragu moved to Toronto. Her work began to involve audience participation, drawing its movement vocabulary from large-scale public activities like parades, fitness classes, or community dances. In 1983, she produced the first work to involve the X's and O's movement pattern,[1] *X's and O's for the Longest Day of the Year*, with the Art Gallery of Hamilton. This movement pattern continues to play an important role in Dragu's performances,

including her recent work, *Walking Woman*, which she produced with the Richmond Art Gallery in September, 2003. Like much of her work, the performance combined social commentary with a generous and inclusive spirit.

In addition to her solo practice, Dragu has been involved in many collaborations with Colin Campbell, Enrico Campana, Byron Ayanoglu, Arnie Achtman, Terry Crack, ASA Harrison, and others. Dragu's practice has also encompassed writing, and film and video production including *Theatre for Strangers* (1978), *Memories of Paradise* (1985), *I Vant to be Alone* (1988), *A Deconstructed Dollhouse* (1997), and *Walking Woman* with Lorna Boschman in 2004.

In January 2003, I received an email about a performance and book launch of Fado's recently published book on Margaret Dragu, *La Dragu: The Living Art of Margaret Dragu*. The end of the email read: "The artist requests that attendees to the launch bring a pie. Homemade, of course. There will be consequences for those who don't comply." I had gone through a fairly busy period and hadn't baked a pie for a long time, or actually cooked anything elaborate at all. I thought, "This is my excuse. I'm just going to make a pie." So I bought the ingredients, let the dough chill overnight in the fridge, and when I got home from work, I baked a pie: apple cranberry. I went to the grunt gallery with the pie in my hands (still warm), and set it on a table in the back kitchen next to many other pies — everything from lemon meringue to salmon and tofu. People were talking about what kind of pie they had brought, and the experience of making it. There were also many polite apologies about not having the time to make a pie, not knowing how to do it, or forgetting to bring one. Shortly afterward, Dragu told us to cut two pieces of pie and to bring them into the gallery. So here we were, a group of people, standing in the gallery, with a plate of pie in each hand, wondering what we were going to do next. We couldn't sit down, and our hands were stuck in a gesture of offering, with its slight ceremonial connotations. How could you socialize? There was a certain physical and social awkwardness, and an empathy that this awkwardness created — we were in this together, and it was pretty hard to be hip and cool with a piece of pie in each hand. It was a completely disarming moment.

How do you survive?
How do you sustain your practice?
Who is your audience?
How do you define community?
What matters to you as an artist?
What are your criteria for successful work?
These questions are the ones we can't get around. They are awkward and difficult and absolutely necessary questions.

Performance is something you're not supposed to do later in your career, especially if you are a woman. As a senior artist, your work should no longer present visible signs of struggle: with institutions, with a formal vocabulary,

1 Many of Dragu's performances have made use of the X's and O's movement pattern, in which performers walk in straight lines that intersect at a middle point (forming the X), and then walk around in a half circle (forming the O). This movement pattern is simple to learn and to execute, making it easy for those with no previous dance training to participate. It is also an activity that brings people together, giving them the sense of participating in a common experience.

with messy questions, and certainly not with money, because you've moved beyond the stage when material costs are an issue. Your work should appear increasingly pristine and/or technically elaborate. You should not do work that is too unpredictable or silly, and especially not performance, with its media stereotype of spectacular and outrageous acts (the more outrageous the better) by young, beautiful people, just like the ones that dominate the mainstream media.

There is something inevitably disappointing about this scenario. Of course artists deserve some respect (money would be nice too!) after making work for a certain number of years. And of course there is the reality of kids and aging relatives, and the need for increased financial stability. But there is still something disappointing about this scenario, like the inevitable conservatism implied by that expression, "when you get to my age." One of the things I respect about Margaret Dragu is how her practice continues to develop and shift in response to her immediate situation, and out of a continual sense of engagement and curiosity. Part of this, I feel, is about how Dragu negotiates the *local*, currently as an artist based in Richmond, BC. Out of this situation, I feel she has developed relationships to community and audience in ways that sustain her practice. In this text, I will talk about Dragu's work in relation to the local and questions of community, and also in terms of sustaining a practice.

The word *sustain*,[2] in its current usage, has ecological connotations. As I am writing this, in May, 2003, I am already seeing evidence of how the North American lifestyle cannot continue for much longer without causing environmental catastrophe. To me this points to how we are so caught up in short-term thinking (in this case, of maintaining this lifestyle at all costs) that longer term thinking becomes inconceivable. Similarly, there are few models in our culture for longer term art practice, especially performance (perceived as something artists do when they are young but too marginal to form the basis of a career). The art press tends to only focus on an artist's work when he/she is first becoming successful; one consequence of this is that artists become identified with that particular moment, despite further developments in their work. This can lead to bitterness or complacency or both. How, then, to continue, to sustain a practice, when we are so ill-equipped to think long-term?

In 1986, Margaret Dragu moved from Toronto to Finn Slough, a hundred-year old fishing village on the south arm of the Fraser River. Finn Slough is on the edges of Richmond, a suburb of Vancouver. As a mother in the suburbs with a small child, she could not do the same activities that artists in urban centres take for granted, such as going to openings and parties, staying out late. Her previous life, as she described it, was now "over" and she had to start again. She began to get to know people in her community, not only artists but also other mothers, clients from her work as a fitness instructor and personal trainer, other inhabitants of Finn Slough, where she was involved with lobbying against developers. This led to a radio project about motherhood, entitled *Momz Radio*. She received a Canada Council

2 Let's ignore the term "sustainable development," which is a neo-liberal co-option of environmentalism and conceives of long-term planning in terms of basically continuing business as usual.

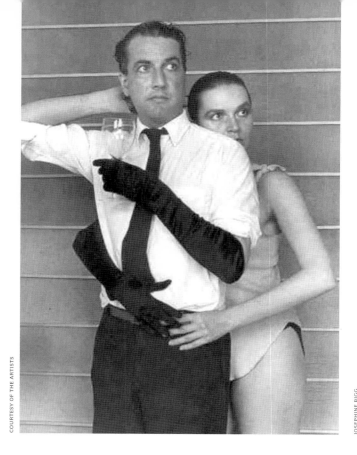

Explorations grant for the project, which she described as a lifesaver. *Momz Radio* was followed by a book collaboration with Susan Swan and Sarah Sheard called *Mothers Talk Back: Momz Radio* (Coach House Press, Toronto, 1991). Although some of her work in Toronto was community-based (such as *The Macbeck Studio Dance Recital* at The Cecil Community Centre), this marked the beginning of new directions in her practice. She connected with Jeanette Reinhardt from Video In, whom she had known since 1977, met Paula Jardine from Public Dreams and Glenn Alteen from the grunt gallery. They all had a strong interest in community-based work. Corinne Corry became director of the Richmond Art Gallery, and her presence there as a curator with a more contemporary vision has allowed Dragu to present work locally, with organizational support. Dragu has since produced a broad range of work including performances, texts, videos, and large-scale works.

Questions of gender and class have continually marked Dragu's practice. She was an artist, a feminist, and a stripper in the 1970s and early 80s, when it was very difficult to reconcile those identities. At first, her allegiances were along class rather than gender lines. Ironically, middle-class feminists offered her work as a housecleaner so that she would not have to "exploit" herself as a stripper. Dragu tried to organize around strippers' rights and

MARGARET DRAGU and **COLIN CAMPBELL**
My Wireless is Running (collaboration).
Toronto Dance Theatre, Toronto, 1984

MARGARET DRAGU Production still of the making of her video *Back Up* with Kate Craig at the Western Front, 1978. Left to right: Carol Hackett, Margaret Dragu, Jane Ellison, Elizabeth Zimmer, Kate Craig, Helen Clarke

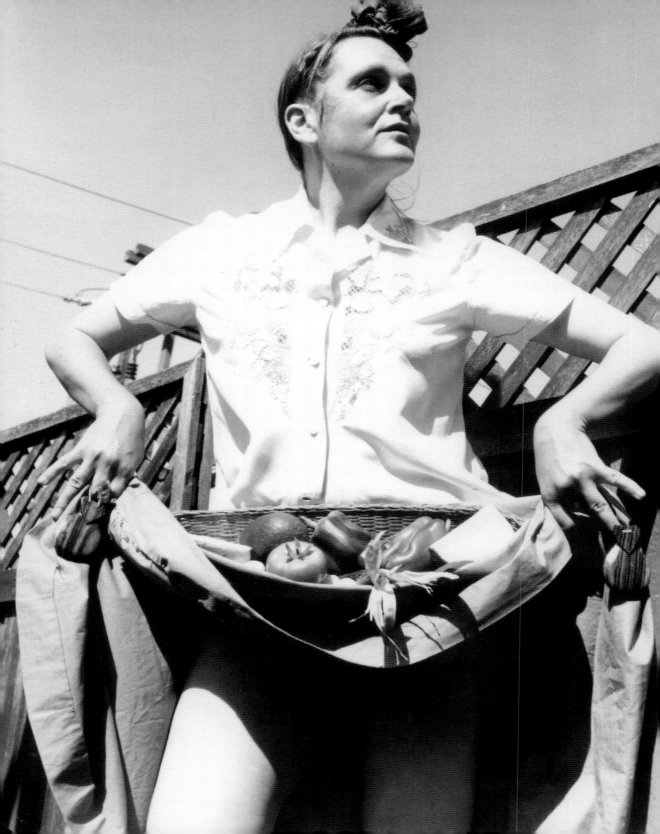

BOB BARNETT

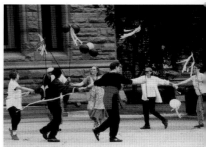

DEBRA O'ROURKE

wrote *Revelations: Essays on Striptease and Sexuality* (Nightwood Editions: London, Ontario, 1989) with ASA Harrison.

Gender and class politics continue to form a thread through Dragu's performances. They reflect local issues, such as the obsession with real estate and private property in British Columbia in *A Deconstructed Dollhouse*, or the low-paying service industry jobs occupied mainly by immigrants in Steveston, BC in *Yo Soy Eine Kleine Shopkeeper*. The other roles she plays in her life — fitness instructor, mother, community activist, cleaner — also inform her practice; for instance the aerobic exercises she performs in her videotapes *Living Art, Conscious Corpus: Corps Domestique and Corpus Delicious*, and the Montréal component of *The Wall is in My Head*, and the activity of cleaning — cleaning houses, or the areas around Toronto and the steps of Queen's Park in *Cleaning and Loving (It)*. These activities come out of the material conditions of Dragu's own life and raise certain political issues, but they also create unique social spaces. In her larger scale work, these activities become communal: the procession of cleaners in *Cleaning and Loving (It)* or the pie baking and carrying that she has incorporated into several performances. In other performances, Dragu takes on an intimate role (such as the fortune teller and erotic storyteller in *Conscious Corpus:*

MARGARET DRAGU *Bardo Gap*, Western Front, Vancouver, 1994

MARGARET DRAGU *Pick up*, TWP Theatre, Toronto, November, 1976

MARGARET DRAGU *Cleaning and Loving (It)*, FADO/Vtape, Queen's Park, Toronto, 2000

Corps Domestique and Corpus Delicious). She has recently become more interested in playing the role of listener (a reversal of the conventional performer-audience relationship). According to Dragu, this emphasis on intimacy and listening comes out of her role as a personal trainer, where rehabilitation is psychological as much as it is physical. Integration of the various aspects of her life into performance has become integral to her work.

The people from other aspects of Dragu's daily life often appear in her work as performers and/or collaborators: friends, senior citizens, children, soccer moms, even city officials. In the video *Living Art*, Dragu asked people she knew from these various contexts to say the words "living art" to the camera, in whatever way they chose to interpret them. These people — the moms, children, and fitness clients from other aspects of Margaret's life — also form an important part of her audience. The fact that people know her from other contexts allows her to involve children or senior citizens in her performances in a way that would not otherwise be possible. This is also a model for practice where the artist is part of various communities, something Dragu began to realize in Toronto:

> What I'm saying is I don't want to be an outsider. And maybe it's my thinking of myself as an outsider that excludes me, and that if I really open up and give people a chance that they will come in to all my sense of comedy, my sense of life and joy.[3]

Dragu says the people she knows from contexts such as her daughter's school or the fitness centre, have little actual contact with the art community, and are presented with media stereotypes of the artist as a permanent adolescent who is freed from the day-to-day responsibilities that everyone else must deal with, such as jobs or children.

Being an artist but also a fitness trainer, a mother, and a community activist, becomes a way to challenge public misperceptions of the artist, which easily play into right-wing populism. (I take right-wing populism to mean the ideology based on social conservatism, anti-intellectualism, and the belief that the market represents democracy.) The artist as rebel is both amenable to this ideology (transgression without a serious critique of the status quo) and potentially threatening, because art can raise controversial issues and challenge societal norms, and also because it does not have obvious economic value.

Certain forms of community-based art can also play into right-wing populism, because of their utilitarian emphasis and focus on the affirmative rather than the critical. This is where "community" becomes interpreted in the sense of official culture or generalized and apolitical notions of charity. We have all seen this visually attractive work that avoids anything too challenging or controversial. There is a sense of something being swept under the rug, when the work functions as a kind of band-aid solution for deeper social problems. As Dragu says, "Community-based art can be loved too much, by other powers."[4] However, because Dragu makes work out of a larger political awareness and does not censor out ambiguity, emotional intensity, or sexuality, she avoids these pitfalls. Although her performances

3 Margaret Dragu as quoted in the film *Memories of Paradise*, 1985.

4 Margaret Dragu, interview with Kirsten Forkert (April 11, 2003).

5 Ibid.

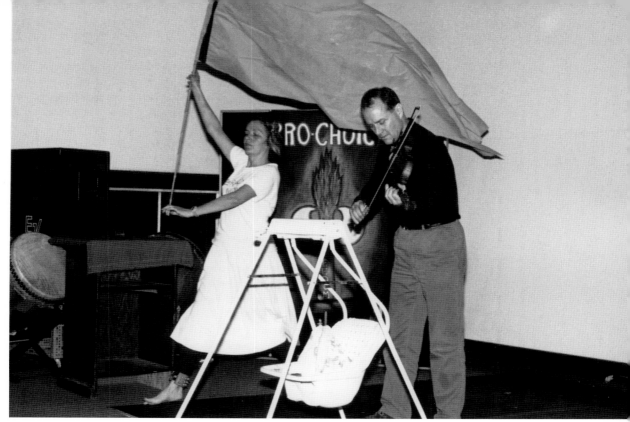

MANON LASSARD

often take on a festive character, they resist being reduced to "feel-good" celebrations, or easily co-opted for other (corporate, public relations) purposes.

Dragu feels it is important that her work be multi-layered, so that people can find an entry point no matter what their level of knowledge, but it is essential to her that the work not be "dumbed-down." She also avoids the artist/non-artist binary opposition sometimes present in discussions around community-based art, where the non-art audience is considered to be more "authentic" than the art audience (the less they know about art the better). Rather than privileging one audience over another, Dragu is more interested in bringing people together from various aspects of her life.

Working with non-artists raises certain ethical questions. Dragu feels it is crucial not to exploit the trust she has developed with people, and that she must be "there to competently answer the stupid questions." [5] Dragu describes how she negotiates these issues, in her recent video *The Lady of Shallot, a Surveillance Player*, and also her work with seniors, children and the visually impaired in *X's and O's for the First of May*:

I got this really nice guy from City Hall to be the performer. I find people like that incredibly brave. He sort of knows about performance and he sort

MARGARET DRAGU and **JIM MUNRO**
Rights of Woman, Western Front, Vancouver, 1992

of knows about video, though gets confused between video and film. I said to him, you're perfect because of what you look like and how you move, and how you feel very comfortable in that building (City Hall). Actors can never provide that real intimacy. You've got that history in your body. And he understood. He was taking a much bigger risk than I was. Same thing with the blind people and the seniors who were in that piece (*X's and O's for the First of May*) and that was a little edgier than normal. It's also a risk for anyone in the Richmond audience to come out and see a screening when they don't know what video art is and they'd rather be at home in front of the TV. I'm trying to bring out that sense of bravery in people.[6]

As a community activist artist, much of Dragu's work involves raising awareness of the arts in Richmond. This is difficult work that often gets taken for granted in larger urban centres. Dragu articulated these challenges in an email, after being involved with a municipal advisory panel which was working toward developing an art strategy in Richmond. The fact that she needs to justify art in terms of "intellectual and financial stimulation or national and international art business" speaks to the difficulty of the situation:

You don't get the intellectual and financial stimulation
of national and international art business
by being afraid of art
by being afraid of intellectual activities
by being afraid of some controversy
by saying art is only housewives painting pretty watercolours
and children making pastel murals surrounding construction sites.[7]

However, this also raises the question: Why should the arts only take place in major urban centres? Does this increase the ghettoization of the arts, and lead to even more public misperceptions of art and artists? I am writing at a time when the art world seems particularly obsessed with fashion and celebrity, and also with a certain internationalism where presenting work, or even visiting global urban centres has become an obligation. The art world in its current state seems uninterested in other audiences, particularly those outside major urban centres (they're just not hip enough), which I feel is ultimately a loss. This makes Dragu's activities all the more necessary.

Sustaining a practice involves negotiating how you define your audience, as well as the terms of success. This is difficult, as our culture offers one model for success (institutionalization), which we are all supposed to want. Conceiving of alternative models becomes a challenge. Dragu was recently awarded the Edith Tibbets Woman of the Arts award for Richmond. About this, she says:

People have been happy and supportive with the Tibbets thing. Part of me says, I don't know... but it really means something to other people. But even in the mall, people say they're so happy for me. And this is anyone from the age of 16 to 106 and it's completely charming and makes me feel like a complete asshole that I don't value it more. Because it really means something

6 Ibid.

7 Margaret Dragu, email correspondence (October 21, 2002).

8 Dragu, interview with Forkert.

MERLE ADDISON

to them. And I'm touched they're so happy for me. Unlike major urban centres, where even an invitation to The Venice Biennale is forgotten in a week. Or not care or just be really jealous that you got it and not somebody else, or them.[8]

I would argue that the dominant models for successful arts practice are not sustainable: the celebrity (here today, gone tomorrow) or the path towards institutionalization (straight to the museum/mausoleum). To conceive and enact alternative models requires that artists not only build community, but also that they redefine the terms of success. I would argue that Margaret Dragu does both.

MARGARET DRAGU and **JIM MUNRO**
X's and O's, grunt gallery, Vancouver, 1999

Rochelle Holt

Lily Eng

SELF-DETERMINED

My commitment is to be authentic and original in my performance work.
— LILY ENG

Prologue

Having grown up in a small town in Northern Ontario, Lily Eng came to per-
formance as a young child, initially via an interest in dance. Eng felt at home
in her ability and desire to express herself artistically and this was trans-
lated through the physicality of the body and movement. It was simply who
and how she was as a creatively motivated individual. Her open mind, her
search for new expressive languages combined with her access to diverse
influences have, in recent years, directed her physical and spiritual investi-
gations within the healing arts. An accomplished Reiki master, Eng is
currently studying massage therapy, which has given her new ways to think
about the body from the inside out.

As a young woman, Eng had a brief career in modeling that she cut short
in disgust with the incipient sexism and racism of the fashion industry.
Her pursuit of dance brought her to the Toronto Dance Theatre where she
studied the Graham Technique. She also studied at the National Ballet
School, where she absorbed the stringent classical discipline. Among her

dance influences is also the German Expressionist approach of the Mary Wigman School. She integrated these languages with her martial arts practice as she developed her own vocabulary of movement.

Eng's practice as a performance artist and a dancer developed together over the years. Eng felt that the traditional disciplines of dance were too rigid and prescriptive, and that expressive movement should be more accessible and wide ranging in terms of its practioners. She found support from Larissa Pavlychenko, founder of the Pavlychenko Dance Studio, whose mission was to combine all forms of dance under one roof. As a teacher at the Pavlychenko Studio in the 80s, Eng was able to teach using her own methodology.

Eng's deep interest in expression through her body also found an affinity with the art of kung fu. This context proved to be challenging since the martial arts largely tend to be practiced by men; she was the girl in the boys' club. As part of her self-assertion in this androcentric practice, Eng performed the traditional Lion Dance, a highly ritualized kung fu form wherein the dancer wearing a lion's head enacts a powerful apotropaic ritual, one that is designed to ward off evil; a role that is usually done only by men. Kung fu provided her with a cultural connection that was meaningful to her as a Chinese woman, but it also provided her with an intensity in her own method and practice that reached different experiences of the body as compared to dance training. It is precisely this harder edge and Eng's openness to extreme, rough, and even violent movement that was part of her development of an aesthetic that explored radical thinking about politics, art, and identity:

My signature methodology is structured improvisation which I developed to work within site-specific environments. Unlike ballet or dance, my performances are derived from my psyche. I use my performance vocabulary to specifically manifest these impulses into performance... I translate raw energy and emotions into a new form of physicality in works that are a cultural fusion of diverse influences: these include the martial arts, contemporary dances, Chinese fan dances, and Acadian music.[1]

1 Lily Eng, unpublished artist statement (2003).

Emergence and Unfolding

Lily Eng began her professional career as a performance artist by presenting *Missing Person Performance* in her studio on Adelaide Street in Toronto in 1972. This was to be the first of many collaborations with choreographer and filmmaker, Peter Dudar, with whom she was artistic co-director of Missing Associates. Soon after, she began performing at A Space and completed ten performances between the spring of 1973 and the fall of 1975. Although she has always been based in Toronto she has travelled extensively to present her work across Canada and Europe. Throughout the 70s, she presented her work at many Canadian venues including 15 Dance Laboratorium, the Festival of Women and the Arts, the Art Gallery of Ontario, the London Art Gallery, Véhicule in Montréal, Eye Level Gallery in Halifax, the SAAG in Lethbridge, the McKenzie Art Gallery in Regina, and the Pender Street Gallery in Vancouver.

Eng and Dudar as Missing Associates worked together on several different pieces; their collaboration was the vehicle that supported and balanced

their related practices. While their interests in the intellectual and physical aspects of artistic creation were similarly aligned, Eng's focus leaned towards developing expression through physicality. Dudar was more cerebrally-oriented, focusing his practice in the directions of writing, video and filmmaking, and the technical aspects of performance. Eng was influenced by Dudar's breadth of knowledge of the arts, the element of dry wit in his choreography, as well as his discriminatory visual style that paralleled her own Minimalist sensibility. Eng has always styled her work using no extraneous elements, keeping the performances as clean and as simple as possible.

The artistic context within which she emerged was highly politicized, experimental and diverse. In 1975, Lily Eng met Amerigo Marras who was a dynamic and influential artist and organizer, an accomplished architect, and gay activist. His home in Toronto was the birthplace of *The Body Politic* (the gay activist newspaper), the Glad Day Bookstore, and the first Canadian Gay Pride organization. Marras had seen Eng perform at 15 Dance Lab and, impressed by her work, wrote about it for a newsletter he was publishing.[2] One day, Marras spotted her on Bloor Street and invited her for tea. This encounter was the beginning of her participation with the CEAC (Centre for Experimental Art and Communication), co-founded by Marras and Suber Corley.

Eng began performing at the CEAC in 1976 first at their temporary location on John Street in the series *Body Art* that featured Missing Associates' structural dance performances, photography by Suzy Lake, a Darryl Tonkin film, *Cantilever Tales*, that presented the aesthetics of S/M, and Ron Gillespie's (Ron Gii) collaborative "behavioural" performance with the group SHITBANDIT:

To a degree, influenced by the Vienna Body School including Hermann Nitsch, this series established a platform of performance art that would present an oppositional stance to General Idea's parody and the conceptual or phenomenological investigations prevalent in the United States, proposing instead to redefine the functions of violence, actions, and infrastructures within the political and the sexual dimensions of the social.[3]

1976 was also the year that the CEAC became the first artist-run centre to purchase a building. This was accomplished with the assistance of major government funding, notably a $55,000 grant from Wintario to establish a centre. It was located at 15 Duncan Street.

The days of the CEAC were a very exciting time in terms of an outpouring of experimentation with a variety of art forms including music, dance, performance, and video. "People like Philip Glass, Steve Reich, and Vito Acconci just showed up and did performances, there were no committees."[4] Rather, the CEAC was more of an open arena for artists interested in expanding artistic and social boundaries, theorizing, criticizing, analyzing, politicizing. Dot Tuer describes Missing Associates' role in the CEAC as follows:

Their explorations of experimental and structural dance were instrumental in the formation of both contextual and behavioural ideas that later permeated CEAC's philosophy... Being in a sense explorations of behaviour patterns and "ordinary" actions, their work was seen both in the context of

2 Marras published his own newsletter through the Kensington Arts Association.

3 Dot Tuer, "The CEAC Was Banned in Canada," in *C Magazine*, no.11 (1986), 27.

4 Lily Eng, interview with Rochelle Holt (November 2003).

5 Tuer, 29.

PETER DUDAR

structural film and in the ritual aspects of body art while their polemic situated their investigations within the parameters of futurism, Marxism, and anarchism.[5]

An important historical moment for Canadian performance art as well as for Eng's career came in 1976 when Amerigo Marras organized the First Canadian Performance Art Tour, which visited eight European cities in Italy, Germany, Scotland, Holland, and the former Yugoslavia, and opened channels between Canada and Europe for performance art and the exchange of ideas in this context. One year later, during documenta 6 in Kassel, Joseph Beuys invited CEAC members Lily Eng (the only woman on the tour), Marras, Bruce Eves, and Ron Gillespie to the *Violence and Behaviour Workshop* of the Free University For Creativity and Interdisciplinary Research.

Funding Context

Whereas the CEAC as an organization had managed to garner financial support from all three levels of government, the Canada Council for the Arts made it difficult for individuals like Eng, whose background was in dance but whose work did not fit the strict language and context of dance. At this time, an Inter-Arts department did not exist and many artists were finding

LILY ENG *Improvisation*, CEAC (Centre for Experimental Art and Communication), Toronto, 1977

it difficult to fit into traditional divisions of media and practice. Eng and Dudar went to Ottawa to complain directly to the Council that the dance definitions were not broad enough, and furthermore that it should not be the artists' responsibility to work within the definitions, but rather that the task should rest with the Council to rework the scope of funding programs. Addressing the Canada Council in this way did help to move things along; however, Eng also felt that she was perhaps "barking up the wrong tree," due to the relative conservatism in dance. Missing Associates sought future support through Visual Arts programs. Generally, many practioners at the time who were interested in combining art forms looked towards expanding definitions in the field of visual arts. The Council's Interdisciplinary Work and Performance Art Program, created in 1977, was later replaced by The Inter-Arts Office in November 1999. The newer program is currently mandated to encourage the creation, production, and dissemination of art that transcends or combines traditional artistic disciplines, and supports artists and organizations working in performance art, interdisciplinary work, and new artistic practices. It is interesting to note that Eng's first grant was for dance in 1974, and over the following ten years, she received seventeen grants in different categories. In 2001, Eng was invited by the Canada Council as an Inter-Arts juror. She most happily accepted this opportunity to offer support to artists, who like her, did not pursue a practice that neatly fit traditional approaches.

Moment to Motion

Eng's performance works from the 70s established an aesthetic vocabulary described by her as "structured improvisation:"

6 Eng (2003).

7 See Elizabeth Chitty's "Asserting Our Bodies" in this book for a description of *Withheld*.

> My work is derived from art form sensibilities. The process in my work is... emphasized which differs in the way most dancers would approach their work... It also requires audience members to actively engage in my process with me... I offer them an opportunity to pause, look and think. The audience does not know what my boundaries and capabilities are, and, consequently, do not know what to next expect. What they see is my performance decision in that moment.[6]

In the work titled *Between Here and There* (1973), Eng begins in the corner of the gallery space with a series of movements that suggest a struggle with confinement. An unseen physical imposition prevents her from moving beyond the corner walls, which seem to draw her into them, keeping her trapped in the corner. The struggle becomes very physical and once she escapes the corner, she is still "stuck" to the wall as she writhes across its surface. At another moment she is on the floor repeating circular motions with her hands across the wall, as if in the process of scrubbing or washing. Eng conveys an intensity through every aspect of her physical being, from facial contortions to frenetic actions that stretch the limits of physical ability. *Hitting It Sideways* (1973) is also quite aggressive in tone. In this piece, Eng is frequently positioned with her back on the floor, bouncing her legs, stamping her feet, and making large circular motions with her arms. The quick and

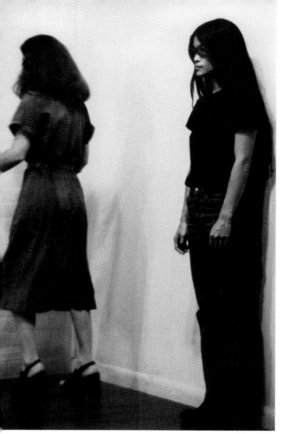

PETER DUDAR

PETER DUDAR

highly expressive gestures have a strong sense of athleticism and dance-like movement. These latter two pieces along with *Withheld*[7] can be collectively described as "classic" Lily Eng performance, marked by repetition, rapidity, and an aggression that sometimes borders on violent movement.

The spoken word piece from the 80s, *Me and the Boys, We Don't Like You*, is a response to her experience as a woman in the male dominated terrain of kung fu and is a feminist response to objectification and exoticism/racism. Akin to the quick and challenging style in her body-focused works, she speaks in a forceful, staccato manner.

As time passed, Eng's style eventually underwent a softening. Her performance, *Court Dance*, developed in the mid-90s, is somewhat gentler in tone than her earlier works, though the edginess comes through in her witty use of Pachelbel's *Canon*. She travels back and forth across the performance space imitating a variety of dance languages, from ballet and contemporary, to Chinese fan dances, inventing her own gestural expressions, revealing for the viewers the process of her bringing inner thoughts and emotions into physical expression.

LILY ENG (right) and **DIANE BOADWAY** Missing Associates performance, *Prime and Retrograde Walks*. Choreographed by Peter Dudar. A Space Gallery, Toronto, 1975

LILY ENG *Improvisation*, ARC Gallery, Toronto, 1983

LILY ENG *Improvisation*, CEAC (Centre for Experimental Art and Communication), Toronto, 1977

PETER DUDAR

8 Eng, interview with Holt.

Epilogue

Lily Eng emerged in the context of 70s radicalism, political activism, first-wave feminism, and experimentation which created a remarkable environment for the development of her intense practice. Her work continues to mature, and her position on the future of performance affirms that "each one of us is responsible for our own development as artists. We all come into our language because of who we are as people, and how our core has been shaped. The collective future will include traces of all these contributions."[8] Eng's performance art will undoubtedly further transform, unfurl, mobilize, migrate, and agitate.

In naturopathic medicine an adaptogen is a substance that applies itself to whatever need is required by the body. Lily Eng is an adaptogen; her performance will continue to evolve as a practice alongside a discursive framework that explores the experience of time, space, and presence.

Tom Graff

NOTES, ANECDOTES, AND THOUGHTS ON

Gathie Falk's Performance Art Work

(1985)

Gathie Falk never intended to do anything like performance art. If Deborah Hay had not visited Vancouver in 1968 to hold a few classes in a kind of dance-oriented live discipline for artists, the some twenty live works we have now probably would not have been made. Hay says of her early teaching:

> From my work with artists, I learned to appreciate the way non-dancers responded within the context of a performance. I never asked them to execute movements that they did not do in everyday life. It was functional movement or, to use Steve Paxton's words, pedestrian movement. There were blocks of movement that were executed in certain rhythms.[1]

Falk believes that what Hay imparted was a deep respect for the discipline of live art, particularly methods of evaluating the various strengths and weaknesses of one's work. Hay's excellence as a teacher can be seen in her reluctance to imprint her own particular dance-influenced style on Falk. Indeed, *Skipping Ropes* was a result of a Hay workshop-class assignment. Falk remembers:

> ... there had to be something interesting about a piece, or unusual, a beginning and an end, some structure. I was launched. Because it was so like the art I was doing, it was easy for me to get into it.[2]

1 Deborah Hay, from edited transcript of interview with Hay in *Contemporary Dance*, Anne Livet, ed. (New York: Abbeville Press, Inc. in association with the Fort Worth Art Museum, 1978), 122.

2 Ann Rosenberg, "Gathie Falk Works," in *The Capilano Review*, nos. 24/25 (1982), 72.

Hay encouraged Falk to continue making performance works. Falk says that:

> ... this new work was closely related to my sculpture. I had learned an entirely new language.[3]

Out of the group of artists in these classes, Falk was the only one who felt that it was a significant discipline worth continuing alone and in which to build up a body of work.

Falk's previous experience in performance discipline involved years of violin practice and performance as well as singing in choirs and solo parts. The musical *analogies* were what gave Falk her quick grasp of the possibilities of live art. As Falk wrote in 1975:

> Performance art, in composition and artistic intent, can be most easily understood when viewed like music. The composer aims to delight, shock, lull to rest, scrape nerve endings, incite to laughter, hurt, even bore sometimes, I think, in order to surprise us more later. The performance maker does the same things except that instead of using only sound he uses both visual and aural means, movement and non-movement to effect his purpose.[4]

Falk's willingness to seek opportunities for public presentation (twelve years in teaching, successfully keeping class attention, and years of music performance), along with her new-found freedom in the medium of clay sculpture, combined uniquely to expand her view of visual art, extending her vocabulary aesthetically and technically.

I met Gathie Falk when she agreed to teach in the faculty of an interdisciplinary course which I developed and directed for the University of British Columbia in the summer of 1970. It included, among other multidisciplinary activities, film introduction, film showings, concerts, music-making, 60s-style happenings, as well as the spontaneous painting of buildings soon to be greeted with the wreckers' ball. Falk liked the week, taught cheerfully even when people made "ashtray art," admonishing gently, guiding forcefully. Significantly, and not without notice, she did not get involved in the "happenings." I got the clear impression that she found them tasteless, which, of course, they were. Falk made her views felt and became an anchor in the course. What is more important is that she began to discuss all these intermixings of live and (for lack of a better word) static work. I learned more than I thought I ever would that week, mostly from Falk. She was careful, but she made her professionalism not so much the topic of discussion as the *modus operandi* of the program. And it was significant for her: the two of us became friends, eventually collaborating, working, arguing, sharing, keeping our styles ever so different, honing, and (mostly) cutting sweet things from our work.

At that time (1970-72), there was a Vancouver movement to create a live art milieu. The consensual emphasis was on the development of live works that were to somehow overtly defy the linear world of literary drama. Gathie and I wanted progression, not so much linear, maybe on several planes at once. We wanted *movement* referring backward and forward, up and down, using people and things. We were not angry with theatre.

It was at this time also that we were disturbed by words like "happening" and began using *movement art*, *time-based art*, *live art*, and finally *Theatre*

3 Gathie Falk, "A Short History of Performance Art As It Influenced or Failed to Influence My Work," in *artscanada*, vol. 38, no. 1 (March/April, 1981), 12-14.

4 From program notes to the exhibition *Some Canadian Women Artists* (Ottawa: The National Gallery of Canada, 1975).

CHICK RICE

Arts Works, even using that name as the title for a (well-funded) Local Initiatives Project group which performed numerous times throughout the British Columbia Lower Mainland (schools, art galleries, churches, you name it). We also toured the country (British Columbia to Prince Edward island) for five weeks with our live art.

It was somewhat sad for me that that first tour of any performance art in Canada (encouraged by Tony Emery, Marguerite Pinney, and Av Isaacs) signalled the end of performance work for Gathie Falk. The strain was not worth it: five weeks of travelling and never finding a performance space well prepared yielded live art a swift end in her work. She invents live works still, and even perfected a few pieces during our video/television versioning in the summer of 1984. She has not lost interest in the form, often offers advice to me, but finds the peace of a painting studio better for concentration.

Falk still uses the same ideas, objects, intentions, and wit in her time-based or live art as she does in her space-based (static) works. She uses wit, not whimsy. Her approach is to be specific, using the small moment, object, gesture, even when explored in a lengthy way, as in a series of paintings, or as in *Some Are Egger Than I* with its dozens of eggs. We are given the specific and small, the micro.

GATHIE FALK *A Bird is Known by His Feathers Alone*, 1984. Pictured: Anna Gilbert, ceramic oranges

But Falk's micro is not always supposed to suggest the macro. Over and over, I have seen her frustrated at attempts to make her works into universal statements of moral, aesthetic, or cosmic purpose. I feel similarly, but not quite as strongly. In working with her on *Tea*, this became clearest. She wanted simply to make a moment of pouring too many cups of tea and surrounding herself with them. I came into it when we realized that her impulse was not exactly enough to hold attention (or deserve it). But even after I added the idea of formal clothing and the covering of the chair, Falk still got most of her delight in simply giving the audience the slightly mad experience of seeing someone pour tea *ad infinitum*. I believe that my part is a foil for this basic need. Her movement embodies wit, slightly removed from anything real. Yet it is very real on the other hand, as when she hits eggs over and over in *Some Are Egger Than I*.

As with the stylized manner of Nō theatre in Japan, or a very adagio piece of Mahler or Bruckner, Falk's works may seem too slow, yet gradually we realize that a great deal has happened. We even begin to look and hear more intently, even more intensely. Time compacts and Falk succeeds simultaneously in creating and living in something like another world or dimension. It seems at once familiar and alien, seemingly contradictory. The words *fragile*, *tenuous*, and *arbitrary* come to my mind here. It is like the logical illogic of dream experience. By no means a romantic idealist, but a person who dreams and remembers her dreams, Falk dreams well. Breakfast with Gathie will often include either a drawing or quite a long recitation of an account of some unusual dream incident. She states all of this in a manner which affirms the incident as having actually happened, which, of course, a listener begins to affirm simply because of the vivid manner in which she recalls it:

I once saw a man throwing something on a bush. I said to myself, "He is pollinating that bush." I walked closer to see what it was he was pollinating the bush with. When I came close enough I saw it was pieces of fur, about one-inch wide by two-inches long, and the pieces were brown and yellow, golden yellow. I was puzzled for a moment, and then it came to me, "Why, of course, bumble-bee fur."[5]

While Falk says she never has dreamed a work and then performed it or painted or sculpted it, her waking relationship to her dreaming is akin to her placement and affirmation of the unusual in her action or time-based live works. This is so, particularly in works focusing on one activity, such as *Some Are Egger Than I*, *Skipping Ropes*, her portion of *Tea*, or her recent *Chair Paintings* (1985). This ability to relate unlikely objects to each other is strongest in the early works. It is somewhat a factor in the later works such as *Chorus*, *Red Angel*, *A Bird Is Known By His Feathers Alone*, and *Low Clouds*. These later works are often further developments of earlier pieces. Sometimes in response to what I was doing at the time, she included music, dance, and more elaborate artist-made objects. Until then, she had used almost exclusively found objects. She describes this somewhat in her "A Short History of Performance Art As It Influenced or Failed to Influence My Work."[6]

5 Gathie Falk, *An Alphabet of Dreams*, ed. Tom Graff (1975).

6 Falk, *artscanada* (March/April, 1981).

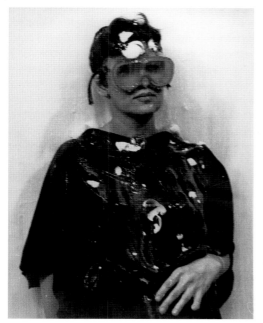

DOUG CHRISTMAS

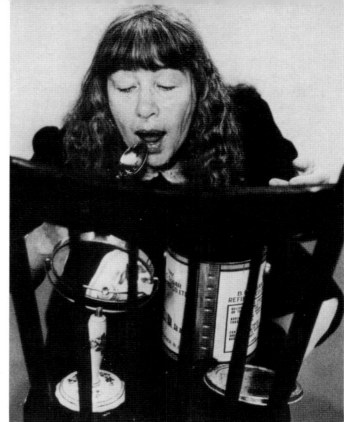

CHICK RICE

The Vancouver Art Gallery, under the direction of Tony Emery (1967-74), was a place in which the audience/public could at fortunate and convenient times, both for artist and public, meet the creation of new forms without curatorial constructs, without art world territorial imperatives: there was a healthy lack of snobbery. We made works for a very mixed crowd. Therefore, Falk never suffered from audience alienation. Until the 1972 tour. Before the tour, neither of us realized that our tour was only being booked across the country, outside Vancouver, because this kind of live activity was being written about in US art journals or in the odd article in *artscanada*. But when we arrived, the audiences and curators were not ready. They were very hungry, but digesting was difficult. There were wonderful moments and privately many people were aware that the audience is not merely passively involved (as in watching variety shows on television). But our years of audience development work in Vancouver had spoiled us. We were not prepared for starting afresh in Toronto, Edmonton, or Charlottetown.

It is important that I did some teaching on that tour, but Gathie thought teaching would be too taxing when performance demands would take all her energy. She has seldom taught performance art even in Vancouver, though she has often taught drawing, painting, and sculpture with many former

GATHIE FALK *Some Are Egger than I*, 1969

GATHIE FALK *A Bird is Known by His Feathers Alone*, 1984

students still in her debt for her direction and honest criticism. The retrospective video/television versions of her works, which we completed in 1985, are valuable as art, though the astute teacher or student will see didactic value in them as well. [The television versions could be used as a textbook-score along with the written scores of *The Capilano Review* (Nos. 24/25, *Gathie Falk Works*). When the written and television versions disagree, the television version is the version Falk now considers authoritative.]

Charlie Chaplin is a hero of the gesture to Gathie Falk. The underdog is a trick-maker, a *Struwelpeter*, an elegant tramp, a knowing wit, a literate troublemaker. For Falk, this is a classic court jester function and necessary in a sane civilization: someone must cook his shoe and eat it for all to watch. But for Falk the gourmet chef-diner must not flirt with the camera while eating, as Chaplin does.

If Falk wanted to eat a shoe, she would eat a shoe, not a studio mock-up in licorice. As well, Falk made inedible shoes, not sentimental old boots which Charlie Chaplin and so many ceramic sculptors succumb to. Still, in her live works, Falk's cheek and pathos walk hand in hand with Chaplin's work, though he worked in another time and another medium. And Falk resolutely refuses to entertain in order to keep her audience with her. She will give us surprises, shocks, but she will never cajole us. Art does not apologize, entertainment must.

Falk often uses as a private credo "art for art's sake" knowing this to have been invented by élitists, but she uses it to mean that artists must not make works either to be figured out, or works which would fit previous theories of taste-makers. In a significant way, Falk remains openly a leader against "isms" and generalist theory regarding particularly the Canadian West Coast as theorized about by writers who are not secure with art unless it exemplifies either sex-and-violence, or Nature (with a capital N). Particularly for Falk, the live works defy these too-easy analyses. They become roadblocks rather than sign posts along the way, but Falk will never do anything about these simplistic assumptions except to make another art work. (John Cage does the same.)

Live art with its lack of a linear dialogue is as unlike perception filtered by intellect as we have achieved in Western visual art. Abstract dance also does this. And music has achieved it best in Western culture; we are embarrassed to guess or assert that Brahms was angry or sad or happy or politically motivated when he wrote the second movement of the Second Piano Concerto. But we persist in such analysis for visual art. It even becomes a *modus operandi* in the visual art world: This and this is in here, becoming a generic art recipe, like so many spices in a casserole. As René Magritte puts it:

> To equate my painting with symbolism, conscious or unconscious, is to ignore its true nature ... People are quite willing to use objects without looking for any symbolic intention in them, but when they look at paintings, they cannot find any use for them. So they hunt around for a meaning to get themselves out of the quandary ...[7]

7 Suzi Gablik, *Magritte* (London: Thames and Hudson, 1970), 11.

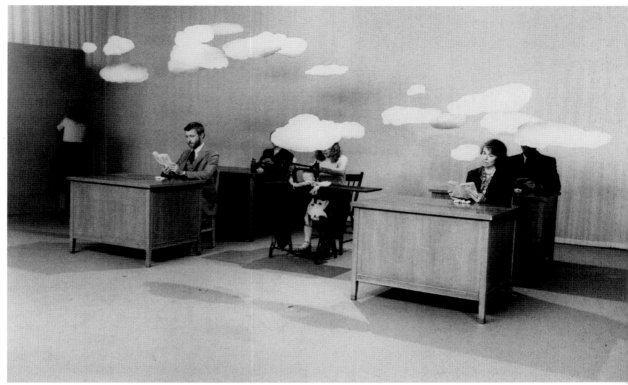

CHICK RICE

We tend even more to seek meaning in events. We are even trying to find "logical" meanings in synchronous incidents whose meanings cannot be explained by the laws of causality. Causality or "cause and effect" is so often used as a plumb line for art in our society. And much art is passed off by the public and art curators and other taste-makers as either a comment on society or an utterance from a mad mind, legitimately mad though because art is assumed to be necessarily mad. Of course, this thinking is invented to fill the vacuum of our unease in the presence of art. But art is, at its best, like Charles Ives's *Unanswered Question* — unanswered. Often art is not even asking questions. Falk never asks questions in her performance work.

All art "answers" are made up because of the fear of not having answers. It may possibly be a knee-jerk response to the fact that we may have no ultimate answers about the unanswered such as death, the universe, God, and how life really happens. In art, these fears are potent. They are all the more accentuated by live art. There, in front of us, live performance art unfolds and we cannot hold on to it, grab it, either by selling it or purchasing it or otherwise trading in it. It will not trade. Not only does live art not fit the Western paradigm (or cultural framework of ideas) of causality and appears not to make sense, it cannot be controlled or edited.

GATHIE FALK *Low Clouds, 1984*. Left to right: Frances Fitzgibbon, Jeremy Wilkins, Elizabeth Klassen, Gathie Falk (at sewing machine), Gloria Massé

In Canadian performance art circles, it is a current assertion that performance art is, or should be, political. Falk believes that political art is compromised in advance because there is an inescapable hypothesis. Art is wider, deeper, more lyrical for her.

To connect two ideas, Western languages use such conjunctions as "and" or "then." Sanskrit, by contrast, will express the same idea by adding the demonstrative pronoun *sa* to the subject of the sentence, as in "Gathie sings and dances" becoming "Gathie singing she dancing." The Western conjunction emphasizes the separateness of events while the Eastern allows the subject to do things through time, even unlikely movement, simultaneously.

The self or soul balances mind and body in a wholeness in the East. But in our society the idea of soul has been ignored ever since Descartes and others have divided body and soul. (This cannot be blamed on Christianity, Christianity being essentially Eastern and ironically so often dealt with as something sprung out of Aristotle or Descartes's brain.) So when we, in the West, view the intangible or "other existence," we view it in terms of cognition and proof. The Japanese, for example, have had an ability to suspend judgement for a long time. They stake their lives on there being connections of body and soul, the tangible with the "other." For them this is an absolute, though perhaps indefinable. (In the West, the intellect is always used as a filter, instead of the explorer it can be. So we look for answers, even when no questions or problems exist.)

Falk's practice of Mennonite Christianity [8] and its view of the physical, exemplifies the Eastern view concretely, transcending personality or individual ideas, in order to grapple with the fundamental relationship of all things and ourselves. Gathie's method is a "veneration of the ordinary" as she put it as early as 1970, concerning the fruit piles exhibit. In Falk's live work particularly, as she sets up a tableau or sculptural stage, there is a kind of contingent system which touches all sides. Body and props are one, if you will. Even the stage is not a platform; it is an integral element, part of the collection of things and milieu.

When its balance is offset in the slightest degree, the direction of its range alters dynamically. Working on the television versions, in the summer of 1984, was fascinating. Much of what I am writing now comes from that experience of seeing work after work appear one after the other in rapid succession. In the early 70s, I was used to seeing one every few months. Their close interaction in the television studio could have weakened them, but the works all held up and mutually amplified each other, even from Falk's viewpoint as creator-performer. Actually, performing them all in hot weather and studio with new television details (adding irritation to any performer) was a sharpening influence, a clarifying experience. The works' general strengths appeared over and over, and the few parts made only for their time (as in *Picnics*, not transferable to video) were eliminated without loss of anything vital. All the original sculptures were used. All the original clothing was used. The actual movements and performance of works during the five-week tele-shoot forced exact detail forward. Sometimes, however,

8 *Encyclopaedia Britannica* (Chicago: Encyclopaedia Britannica Inc. 15th ED., 1974).

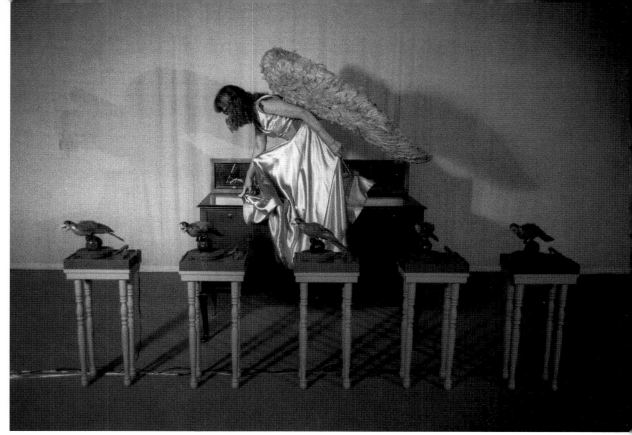

CHICK RICE

a former performer involved in the tele-records would remember the exact movements they had done ten or twelve years earlier. They were usually right and Falk and I were grateful, especially to Elizabeth Klassen, numerous times.

After experiencing works like these, it is almost inappropriate to applaud, as one would not applaud a haiku poem read aloud, the end of a novel, or a painting. This is because Falk does not launch ships, raise flags to salute, or perform Olympic feats. With Falk's live works, as with most of her work, I believe, we are indeed seeing more a glorification than a celebration, a gesture rather than an elaborate mannerism.

★ ★ ★

This article was originally published in the 1985 catalogue *Gathie Falk Retrospective* (Vancouver: Vancouver Art Gallery, 1985), 63-65.

GATHIE FALK *Red Angel*, 1984

Dot Tuer

Vera Frenkel

THE SECRET LIFE OF A PERFORMANCE ARTIST

I am an archivist, but not the sort that works in official archives, run by committees that approve donations from artists and writers of their sketchbooks, and first drafts, and correspondence: those intellectual building blocks of the academic edifices of our nation. Nor am I the kind of archivist that collectors fund for trips to attend auction house sales and bid on rare and steamy love letters like James Joyce's recently discovered epistle to his wife. No, I am the secret kind of archivist, researching rumours of Canadian performance art in the way that Vera Frenkel researches rumours of the life and times of Cornelia Lumsden, a brilliant but little known Canadian writer who wrote a novel in Paris between the World Wars and then disappeared.

Researching performance art is an arduous and elusive task, much like Frenkel's task to research Lumsden, who it appears left behind only one faded photograph of her studio in Paris and the contradictory testimonies of her friends and lovers. At best, I am able to uncover some sort of photographic evidence — usually an underexposed image taken during the live performance or rehearsal shots that give few clues to the dynamism of an art form that involves bodies and props and actions and audiences. At worst, I am given videotapes by performance artists who have faithfully documented their work on some newly heralded technology like reel-to-reel

or three-quarter inch video, only to discover that the signal has deteriorated and the image turned to white snow, so not even a blurred silhouette is discernable. Sometimes, just sometimes, there is a review or an article, or god-forbid, a catalogue, but that is as rare as a James Joyce love letter. Performance has never been the darling of the art establishment, nor evinced much interest from galleries and museums, the Dadaists and their Café Voltaire not withstanding. Odd, isn't it, that performance emerged as an art form in Zurich, Paris, and Berlin while Lumsden was writing her novel in exile.

You can imagine, then, the mixed sensations of elation and trepidation I felt when I received a phone call asking if I could write a short text about the secret life of Vera Frenkel as a performance artist. I, after all, had a secret life as an archivist, and Frenkel was the researcher of the secret life of Cornelia Lumsden, and the phone call came from two performance artists who had secret lives as editors, having decided to put together a book on that ephemeral and overlooked and under-represented and undocumented art form called performance. All in all, it seemed like there were a lot of secrets and little time to get to the heart of the matter. For you see, we secret archivists of performance art are caught in the impossible paradox of sifting through documentation looking for presence in absence, and truth in lies: a complex and entangled web of pathos and memory at the best of times. Nevertheless, I phoned Vera Frenkel and asked if I could come to her studio to talk to her about her secret life as a performance artist. She graciously agreed, and not only told me interesting and little known facts about her life as an artist but let me look through her papers. This, I felt, was a particular honour, for Frenkel also has a public sort of archivist — an official one from Queen's University — who is sifting and sorting through Frenkel's life — secret and otherwise — as represented by working drawings and notes and letters and photographs and videos, and boxing them for the university archives.

Given my own predilection as a secret archivist for lies and truth, you can imagine how thrilled I was when one of the first things I found in rummaging about in Frenkel's papers was an out-of-print catalogue from 1978 entitled, of all things, *Lies & Truths*. The catalogue had accompanied an exhibition organized by the Vancouver Art Gallery featuring the documentary fragments — photographs, videotapes, line drawings for a cat's cradle game — of Frenkel's interactive media performance piece from 1974 entitled *String Games: Improvisations for Inter-City Video*. In the catalogue, Frenkel describes in detail the improvisational process of the work, in which five artists in Montréal and five in Toronto performed variations of the cat's cradle string game through the prototype technology of direct transmission in Bell Canada's teleconferencing studios. On the workings of the piece, Frenkel writes:

I asked each player to choose nine components: a number, a letter, a word, a name, a sentence, a fragment of a poem, a visual image, a gesture, and a sound. These elements were to be chosen or invented so as to suggest

what was important to the player; they would be his or her personal contribution to the whole.

The figures were mapped, and the order of movements quickly became familiar, e.g., we learned at what point the thumbs moved, or the middle fingers, or the index fingers, and so on, in each figure. Rehearsals were few and simple; enough to develop the mastery of the string figures and the use of the personal components, but not so much as to fix any particular sequence in mind. I was interested in exploring a set of possibilities not in a routine. We were preparing to improvise, using these formats and components, with video as our link.

The figures were learned with the hands first, then out in the street in front of Fifteen Dance Laboratorium in Toronto, using a large rope. Each player became a finger, and moved from position to position bodily to achieve each pattern. Later we replaced physical movements with words, names, gestures, sounds, etc., and at that point we could begin to play.[1]

In her description of *String Games*, Frenkel also had sections on the teleconferencing facilities, the structure of the piece, modes of play, guest games, playback, and comments. In writing on guest games, she notes that the intricacies and playfulness of the transmissions, in which she intervened by making drawings on camera and removing the monitor glass, were "ways of making and breaking images that foreshadowed a set of concerns I dealt with later in performance pieces like *Kill Poetry*, *Masks/Barriers* and *Retinue* (1975)."[2] And, as it turned out, also in *The Big Book*, a thirty-panel work that braids narrative, drawing, and printmaking to create a ficitonal and documentary account of all these events.[3]

When I read the reference to these works, all performed at St. Lawrence Hall on February 11, 1975 — Frenkel's performances interspersed with composer Peter Perrin's settings of contemporary poetry — I was surprised. I had no idea that these three works existed, all of which was a bit unnerving given that in addition to my life as a secret archivist, I am also a writer on Canadian new media art and I have alluded to *String Games* as a prototype video work on more than one occasion. Yet it had never occurred to me that Frenkel had a secret life as a performance artist, or that it provides clues to the conceptual underpinning of her multimedia works. Take for instance, the works staged at the St. Lawrence Hall, in which the use of music, frames, tableaux, and poetry created a relational montage of objects, bodies and space that resonates in her later works.[4]

In *Retinue*, to a trumpet fanfare by the Canadian Brass composed for the occasion by Peter Perrin, the performers, costumed as Renaissance Queen, King, and courtiers, entered the lobby of the St. Lawrence Hall. At a measured pace, they made their way up the stairs to the mezzanine into the Royal Box from where they could watch and frame the whole event.

Below, two men on snowshoes entered the main hall carrying a mannequin in a parachute. *Kill Poetry*, a performance work combining movement and language, added speech to the animated tableaux. In a soundscape designed and recorded by Frenkel, voices floated through the air as the

1 Vera Frenkel, *Lies & Truths: Mixed-format installations* (Vancouver: Vancouver Art Gallery, 1978), 13.

2 Ibid., 14.

3 Vera Frenkel, *The Big Book & Related Works* [30 panels, 30 x 40 in.] (Stratford: The Gallery, 1976).

4 For an overview of the later work see Dot Tuer, "Threads of Memory and Exile: examining the art of storytelling in the work of Vera Frenkel," (Images Festival of Independent Film and Video Catalogue, 1997), 40-45. Also see *Of Memory and Displacement*, 3-disk DVD with companion CD-ROM (Vtape, 2004).

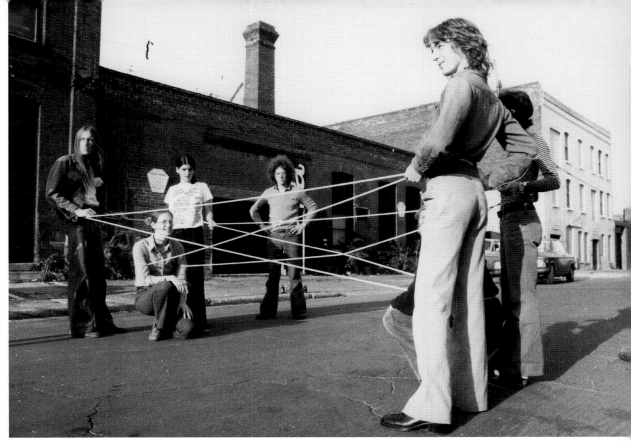

LINDA KELLY

parachute-shrouded body was carried onstage to stand in for the denial, death, and possible rebirth of poetry and its power to breathe life into words. At one point, the performers discarded the corpse and, lighting the parachute from within, moved collectively as one creature through the space, until one of them, designated as Poetry, emerged, spoke, was killed, and carried out by the snow-shoers ready for the cycle to begin again.

In *Masks/Barriers*, assisted by attendants, performers in long underwear donned sports equipment piece by piece until both men and women resembled strange cyborg goalies. As they added layer upon layer of protective gear, erasing gender differences, they broke free of their encumbrances and, to the sound of smashing glass, hurled themselves through paper barriers stretched onto vast wooden frames that were brought slowly towards them as they jumped. The central aisle became a performance space as the masked players worked from the front of the hall through to the back.

As the performers below donned their regalia, those upstairs were served cognac by attendants and with an almost imperceptible slowness silently discarded their layers of royal trappings. While miming simple conversational gestures, they began, as if by accident, to place streaks of white pancake makeup on their own and each others' faces and hands. By the end of ninety

VERA FRENKEL Rehearsal for *String Games* in front of 15 Dance Lab on George St. in Toronto, 1974. Left to right: Tom Stiffler, Ellen Maidman, Julia Grant, Tom Graham, Miriam Adams, Michael Brodsky

minutes, the performers in *Retinue* had transformed themselves from figures in a Renaissance history painting into ethereal ghosts, while the performers in *Masks/Barriers* below them became modern knights of sports arenas watching as the *Retinue* members engaged in their slow transformation.

In the intervening years between that evening and now, Frenkel has become internationally recognized as a video, installation, and new media artist, these early performances forgotten. Yet the connections and pathways that can be traced in her art practice give pause to such categorization and amnesia.

In 1989, her performance at the Music Gallery in Toronto, *Mad for Bliss*, was the genesis of her 1990 multi-faceted video and Piccadilly Circus Spectacolor Board animation, *This is Your Messiah Speaking*. Her 1992 work for documenta 9 *… from the Transit Bar* — a six-channel video installation with a functioning piano bar in which Frenkel served as bartender, built on skewed angles and filled with a mélange of languages — reverberates with echoes of her St. Lawrence Hall performances and the quirky play of fact and fiction that took place in the ballroom of the Playboy Mansion in Chicago in 1987 when Frenkel mounted her performance, *Trust me, It's Bliss: The Hugh Hefner/Richard Wagner Connection*. Her own words also belie a fixed notion of formal boundaries. In 1978, she responded to a critic arguing that *String Games* "sacrificed much of what video stands for," by plainly stating:

> I am not a video artist. Video is for me a format that must be absorbed and transformed. In assembling works for the current show, I am surprised at how insistent is the image of the video monitor in many of the 1974-78 pieces. I guess one way of battling the enemy is to use the enemy as a metaphor for the self.[5]

5 *Lies & Truths*, 15.

6 Ibid., 6.

All these years, Frenkel has been using the video screen as a shield, a mirror, a mask, dissimulating her role as performer, deflecting the gaze of the audience. Like all performance artists, she has become an absent presence, with only traces remaining, filaments of a web, fragments of a history. From the missing gestures in *String Games* to the missing bodies in her detective mystery genre videos; the missing novel of Cornelia Lumsden in *Her Room in Paris*; the missing identity of the storyteller in *The Last Screening Room: A Valentine*, and the missing artworks in *Body Missing*, Frenkel anchors performance to a relational play of absence and presence and to the lies and truth of narrative.

Frenkel once said about her work that the "clues are the easy part. What value to attach to them is the question."[6] As I rummage through Frenkel's past to unearth clues of her secret life as a performance artist, she hands me an article written about her by Jay Scott in 1992, shortly before he died of AIDS. Scott was arguably *The Globe and Mail*'s finest film critic, and a marvelous writer. In this article, he recounts a story about an early screening held of a videotape Frenkel had made about the secret life of Cornelia Lumsden. Frenkel in turn recounts to me that she hadn't remembered the screening until she reread Scott's description. So many of the people there

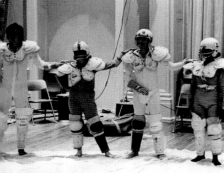

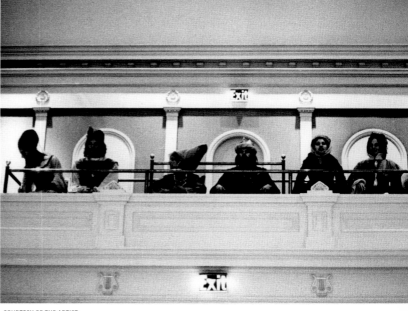

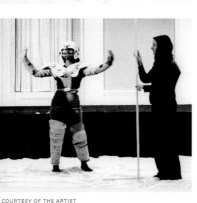

COURTESY OF THE ARTIST COURTESY OF THE ARTIST

that night, she tells me, are no longer alive. As a secret archivist, I nod in sympathy, but when I read Scott's text later that night, I am not so sure their presence doesn't live on. After all, isn't that what performance art is all about: the paradox of absence and a bringing to life of the body's presence through remembering. It's not that I'm trying to get spiritual here, or making a claim for resurrection. Secret archivists, after all, are profoundly materialist creatures. It just seems to me that in Scott's description of that early screening lies the clues to Frenkel's secret life as a performance artist. And so I leave you, the reader, with his description, and with the question of what value to attach to it:

It was the dawn of the eighties, and Marian Engel, the author of *Bear*, was having a do. The guest list looked more like a CanLit bibliography than a party: Margaret Atwood, Graeme Gibson, Betty Lambert, Margaret Laurence, Judith Merril, Adele Wiseman. The party was in honour of two people, the "video installation" artist Vera Frenkel, who was present, and the "lost" Canadian writer Cornelia Lumsden, who was not.

Lumsden, born about 1911 ("She was always vague about her age," says Frenkel, who has devoted a substantial portion of her career to investigating the author's life), wrote a single novel, *The Alleged Grace of Fat People*, in

VERA FRENKEL rehearsing *Masks/Barriers* at St. Lawrence Hall, Toronto, 1975. Left to right: seated, Arlene Collins; Murray Leadbeater, Susan Yates, Tom Graham, Celeste Ford

VERA FRENKEL rehearsing *Masks/Barriers* at St. Lawrence Hall, Toronto, 1975. Left to right: Terrill McGuire, Carolyn Shaffer, Paula Hassard

VERA FRENKEL *Retinue*, St. Lawrence Hall, Toronto, 1975. Left to right: Jennifer Mascall, James Neuman, Miriam Adams, Lawrence Adams, Frances Ferdinands, Barbara Mayfield

Paris in 1934. It is known that she had lovers and friends, admirers and enemies, but much else is conjecture; when she disappeared in the early forties, she left behind a mystery. There was a suicide note, for example, dated November 9, 1941, the anniversary of *Kristallnacht*, but evidence was subsequently unearthed that indicated she may not have killed herself — that she may not have died. For many years there were "sightings" of Lumsden, a fact acknowledged somewhat reluctantly by the CBC series referred to in Frenkel's tape as *Our Lost Canadians*, a doomed attempt to clear up at least some of the mystery enshrouding the writer.

But back to the party. The CanLit titans had been convened by Engel because she had previewed in Frenkel's studio an in-depth investigation of Lumsden's life. Engel was entranced by the hour-long video piece, entitled *Her Room in Paris*, and wanted to share it with her friends. "I think Judith Merril brought the TV," Adele Wiseman recalled in the spring of '92, "because Marian didn't have one. I think Vera brought the VCR. I knew Vera was a respected artist. Marian had known her from Montréal, when they were at McGill, and had always spoken highly of her; she said she was a brilliant gal, with a very literary mind."

The video was popped into the VCR and the titans watched as Lumsden's lover, a rival, a friend, an expert, and a CBC commentator vainly sought to come to grips with this strange literary life. Reactions were mixed; some guests were quiet, while others laughed hysterically. Wiseman: "Betty Lambert and I just broke up. Marian didn't understand at first, she was out in the kitchen being somewhat miffed because she took our great enjoyment as disrespect."

The post-screening conversation was intense. "I thought, there's gotta be some hope for Canadian art," Wiseman continues. "Here there was all the critical language used in CanLit coming from this TV set, and the program was so sophisticated, and so funny, and so beautifully made. It was even more enjoyable because the people who were there watching it were to some extent being sent up by it." Frenkel: "I didn't think of it as a send-up, but some of the discussion was about who Cornelia Lumsden really was. Was it Mavis Gallant, Elizabeth Smart or someone in the room? For me, the highlight was when Margaret Laurence came up to me and said, 'You wicked, wicked woman, you told the story of my life.' It was said with great love."

Cornelia Lumsden is, of course, a fiction, an invention of the fecund imagination of Vera Frenkel, one of this nation's most extraordinary artists. All of the cleanly differentiated female roles in *Her Room in Paris* are played by Frenkel herself with a subtle note of satire — she's a very good actress — and each thus becomes emblematic of a CanCult personality type. The video is phenomenologically disorienting because the viewer inevitably comes to believe — such is the power of narrative, even of a narrative that wishes to expose the "lie" of narrative — that there is some truth to be found. But in one of her more famous statements, Frenkel, who is quite capable of giving Oscar Wilde a run for his aphoristic money, has declared: "The Truth: Have we not understood, my darlings, that the truth cannot be told? That it must

7 Jay Scott, "Vera Frenkel: Canada's pre-eminent video artist, storyteller and mischief-maker hits her stride" in *Canadian Art* (summer 1992), 46-49.

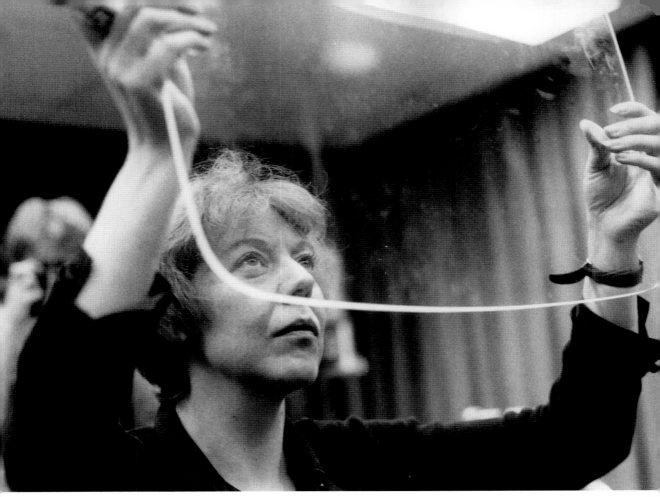

LINDA KELLY

shift quickly for its own survival? That the truth is secret? That, invisible as it is, it is one of many clever inventions? That the truth can be useful or not, but never true? That the truth is shaped, cosseted, abridged, revised, negotiated, denied, remembered, mis-remembered, approximated, and attributed to one falsehood after another? That in our longing for truth, we embrace those falsehoods. And that we prefer it so." [7]

VERA FRENKEL "Unmasking the Monitor" in *String Games: Improvisations for Inter-City Video*, 1974. Bell Canada Teleconferencing Studios, Montréal

Nelson Henricks

Colleen Gray

GRAY MATTER

In contemporary Western culture, the scientific and the spiritual occupy distinct spheres. To a large extent, mystical and esoteric practices have been devalued, taking the back seat to empiricism and rationalism. This was not always the case. For the Greeks of classical Hellenistic culture, a profound relationship existed between scientific method and magical means. Both were employed in attempts to understand the universe. The work of Colleen Gray (formerly Kerr) resembles the integrated worldview of the Greeks, where the esoteric and the scientific existed in harmony. By juxtaposing and interweaving diverse knowledge systems, Gray undermines the dominant ideologies of occidental culture, while drawing from the fundamental pillars of the same. To a large extent, this is done through an active juxtaposing of popular and high culture. Though Gray's work is open to humour, it is not without moments of poignancy. She makes art that is accessible to all, while never lapsing into banal entertainment.

Storytelling and narrative are important tools for Gray. She is a skilled writer and a broad reader. Autobiographical narrative, descriptions of dreams, and quotations from textual sources have formed the backbone of certain works. Gray's research is emphatically interdisciplinary and draws from a variety of sources: philosophy, science, literature, music, psychology,

mythology, and art history have all served as points of reference. Her art practice is similarly expansive. Since graduating from the Alberta College of Art and Design (ACAD) in 1987, she has used artist's books, assemblage, installation, painting, performance, and video to express her ideas. No single discipline has been privileged; instead, ideas tend to circulate freely from one medium to another.

In practical terms, this means that any discussion of Gray's performances must take her work in other media into account. Gray's work in video is especially significant in this regard: it often functions as a record of live work. Over the past two decades, Gray has assembled an impressive record of exhibitions, screenings, and performances. Her videotapes are in the collection of the National Gallery of Canada, have been presented at the Museum of Modern Art in New York, and other venues in Canada and Europe.

* * *

Colleen Gray was active in the Calgary arts scene in the late 1980s and 1990s. This was an important period for performance work in Calgary. Many young artists emerging from ACAD were interested in doing live work, even though no instruction in performance was offered there. Local artists such as Marcella Bienvenue had established practices; Mark Dicey, Christian Eckhart (Chris Spindler), Grant Poier, and Mike Zeindler (and others such as Rita McKeough, who were working in and around "10 Foot Henry's") also set strong precedents in the local community. Off Centre Centre, Calgary's oldest artist-run gallery, presented an ongoing program of international performance work on a regular basis. (OCC administrators Don Mabie and Sandra Vida (Tivy) would ultimately begin to produce work themselves.) It was in this context that Gray and many other young artists would emerge. Bart Habermiller, Nelson Henricks, Cheryl L'Hirondelle (Koprek), Yvonne Markotic, and David P. Smith were all late 1980s art school graduates with active performance practices. Though not ACAD graduates themselves, artists Charles (C.K.) Cousins and David Clark contributed to this growing effervescence.[1]

Local galleries responded to this flourishing of performance work in a pro-active manner. *Performance Focus* (1987) and *Media Blitz* (1988) were events sponsored by Second Story Gallery (now Truck) and The New Gallery (formerly Off Centre Centre) respectively. Bart Habermiller's events at the Graceland junkyard — *Night of the Living Junk Monkeys* and *Dusk 'til Dawn* (both 1987) — were grassroots responses to this phenomenon that ultimately came to garner official support from the local artist-run galleries.

Though many women artists emerged in this context, few could match Gray, a prolific and intelligent artist who commanded her audience with authority. Her voice was mid-ranged and smooth, her body solid and athletic. With bright blue eyes and sharply defined features, Gray has presence in spades. One could describe her as masculine, but this would be misleading. Instead, Gray embodied a strong, heterosexual femininity: somewhere between a

1 Writing about yourself in third person is slippery business. I acknowledge my role as author and peer. I hope my deep involvement with Colleen's work during the 1985 to 1991 period gives me a special insight into her oeuvre.

news reporter, a scientist, a schoolteacher, and an opera diva. When she appeared in one performance with her hair cropped close to her head in a ragged, punkish shag, she looked less like Laurie Anderson and more like a hockey player. In a wedding dress, working out with dumbbells, or climbing a ladder blindfolded, Gray was never an image of feminine frailty.[2]

Originally from British Columbia, Gray's first education was at Okanagan College (graduate, 1984). The lion's share of Gray's formal education in art, however, was obtained at ACAD. A student in the drawing program, Gray favoured an interdisciplinary approach to art making, with a specific interest in working with time-based media and narrative. While in art school, Gray did a number of solo works, as well as collaborated with Nelson Henricks as part of a team called *A Different Bohemia*. Even before graduating, she contributed greatly to the local community. While still a student, she collaborated with Vancouver artist Anna Banana on *In the Red/In the Black*, and she also worked with Calgary artist Sandra Vida.

Strong Arm Dialectix, her first major solo work, was presented at Second Story Gallery's *Performance Focus* only a few months before her graduation from ACAD. In this early piece, we see one of the lasting characteristics of Gray's work: an interest in popular culture mixed with a deep awareness of western cultural tradition. With wry wit, she challenged conventional representations of femininity and examined the nature of art. Gray set up a wrestling ring. She and another woman, Julie Swanson, clad in tights, represented Apollonian and Dionysian currents of ancient philosophy. The duo barked out citations while pinning each other to the ground. The work was hilarious and intelligent; audience response was thunderous.

Throughout her career, Gray's practice has been nourished by collaborations. *HQ Poly and Saliva* (1987) was created with Yvonne Markotic. *God*, presented at The New Gallery's *Media Blitz*, was a post-art school collaboration with Henricks. Meanwhile, her approach continued to articulate itself in a pluralistic and interdisciplinary manner. Often works in several different media were based in the same web of ideas, with one work leapfrogging over the next to extend Gray's dialogue with her content.

Niagara (1988) was a solo performance presented at *Elemental Instincts: A Matter of Course*. The performance built upon a constellation of ideas that Gray had developed in other works presented in the show: a 17-minute video entitled *Teabell Tolls* and a series of assemblages reminiscent of the work of Joseph Cornell. In 1990, *Niagara* would be adapted into a video of the same name, again elaborating Gray's ideas in new directions.[3]

In terms of content, Gray continued to explore the feminine but in a manner that evaded dogmatic feminism. For example, her description of *Teabell Tolls*, the videographic centerpiece of the *Elemental Instincts* show:

> A sort of *Pilgrim's Progress* for womankind, *Teabell Tolls* looks at an everywoman's life journey. Regardless of external circumstances, all women experience their version of womanhood. Like a waterfall, nature's power surges onward according to some unwritten rule; an undercurrent in every life. Some women believe in romantic myths, thinking these will help her

2 Gray acknowledges Tanya Mars and Paulette Phillips as fellow travellers. She collaborated with Mars on *Mz. Frankenstein* in 1992. She also cites Ulay & Abramovic as influences.

3 The video version of *Niagara* quoted equally from silent film and votive painting, and features an original soundtrack of string music.

4 Colleen Gray, tape description.

5 Ibid.

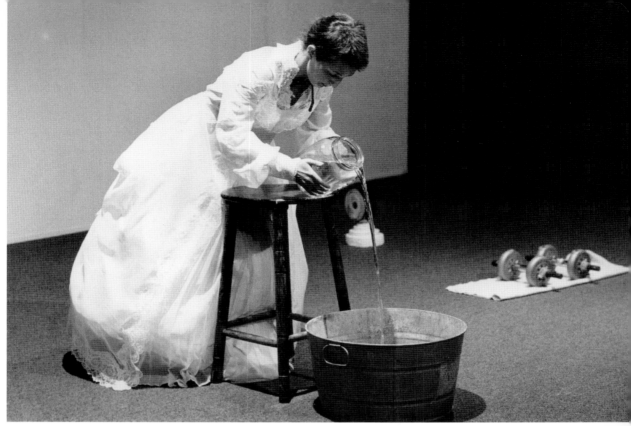

understand who she is — some even try to live these myths.[4]

In the video, Gray charts the life of one woman from infancy until death, using imagery drawn from classical mythology, folklore, and pop culture. Niagara Falls, a media cliché for love, romance, and marriage is also represented as a primal symbol of sexual union and ecstatic loss of self. Veils of mist stand in for bridal veils. Using the falls as a central motif, Gray's performance *Niagara* highlighted certain more bizarre aspects of its history:

The Falls demonstrates very clearly to me the mystical union between people and nature. On the most obvious level, Niagara Falls remains a popular honeymoon resort for couples to consummate their own mystical union of marriage. I incorporate this motif into Niagara, and illustrate it through other mystical unions; that of the relationship of the daredevil to Niagara Falls, and the ritual marriage of nuns to Christ. Niagara Falls attracts an inordinate number of suicides, and I believe it has something to do with the ageless power and permanence of such places.[5]

In the catalogue essay for the exhibition, curator Donna McAlear captured the essence of Gray's project:

[Gray] studies conventions of human behaviour. Placing great stock in history, she understands that specific cultural markers have withstood the

COLLEEN GRAY *Niagara*, performed at the Nickle Arts Museum, Calgary, as part of the exhibition *Elemental Instincts: A Matter of Course*, 1988

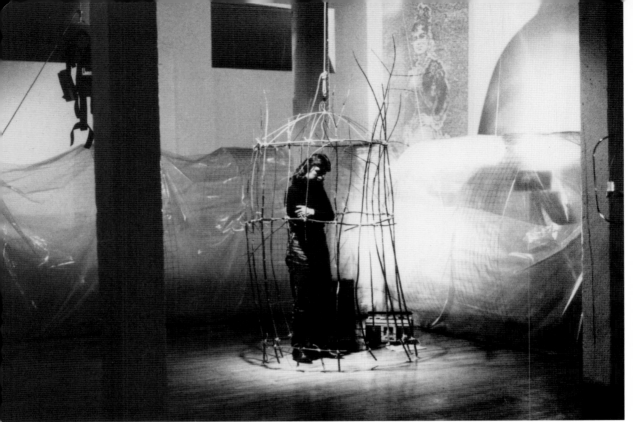

6 Donna McAlear, "Elemental Instincts: A Matter of Course" (Calgary: The Nickle Arts Museum, 1990), 30.

7 Colleen Gray, correspondence with Nelson Henricks (spring, 2003).

passage of time because they compellingly echo humankind's inborn psychology. Timeworn myths, symbols and folklore can illuminate how we dwell in the present. Susan Sontag has stated that advanced societies consume images and no longer, like those of the past, beliefs. Consequently, links to the past fade. [Gray] seeks to reinvest contemporary images with the soul by connecting them to pictorial and narrative traditions.[6]

These ideas would guide Gray's practice for the next decade.

* * *

In February 1989, Gray presented *The Journey* at The New Gallery in Calgary. Her most ambitious work to date, *The Journey* existed on one level as a multimedia installation that was exhibited for one month. The performance took place in this environment: a series of tubes made from wire mesh and translucent plastic and projected images. Assisted by two other performers, Gray assumed the role of director and central performer in this work. The performance opened the exhibition. Props and video documentation of the work were left on display afterwards.

Thematically speaking, Gray was again exploring mythic and archetypal

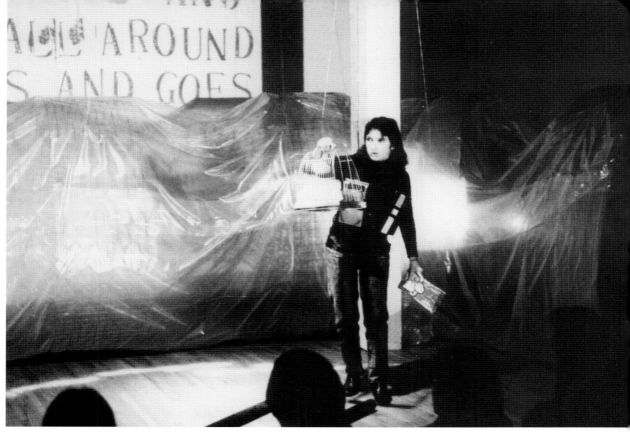

images, in this instance, the hero's journey:

I had read Joseph Campbell's book *Hero with A Thousand Faces*. I was reading Jung and other Jungian informed books and was interested in doing something with the ideas I found there. I'd already had an interest in mythology and fairy/folk tales (especially the Brothers Grimm, which are really based on mythology and localized beliefs). Campbell's idea of the hero's journey is an encapsulation of a symbolic life as seen in most religions and mythologies: The prodigal son (or daughter) leaves home, struggles through many tests and travails, has help from mysterious forces or helpers, meets a final life or death challenge and dies; is reborn with new understanding and returns home. Obviously from a psychological perspective, this story relates to every person's life experiences ... [7]

Working with this as a base, Gray created a rereading of Bizet's opera *Carmen*, whose characters came to represent the struggle between male and female energies. A description of Gray's dreams and citations from Campbell, Bizet, and other sources all focused on birds, and articulated an overall avian theme. The audience entered the performance space through a tube made from transparent plastic and wire mesh. There they found Gray, dancing nervously to the sound of Malcolm McClaren's version of the

COLLEEN GRAY *The Journey*, The New Gallery, Calgary, 1989

COLLEEN GRAY *The Journey*, The New Gallery, Calgary, 1989

Habanera, trapped inside a large birdcage made from twigs. Different configurations of the aria, coupled with canary training records and various fabricated communications devices figured prominently in this work. "Love is like a caged bird," goes the aria from *Carmen*, Gray's "journey" is a quest for freedom; towards an authentic self-actualization that transcends sexuality. Midpoint through the piece, Cheryl L'Hirondelle (who personifies female energy in the work) reads this passage from the *Bhagavad Gita*:

> Even as a person casts off worn out clothes and puts on others that are new, so the embodied Self casts off worn out bodies and enters into others that are new, Eternal, all pervading, unchanging, immovable, the Self is the same forever.[8]

The piece ends with images of death (invoked in the form of a police outline made of breadcrumbs) and Gray returning to her cage. The cycle is complete, and ready to begin again. A transitional work, *The Journey* marks a foray into less narrative, and more imagistic and open-ended performances.

Throughout 1989 and 1990, Gray's performance work was again marked by a period of intense collaboration. The most significant of these would be with Swiss artist Manfred Stirnemann. Gray and a group of others collaborated with Stirnemann on a series of works while he was artist-in-residence at The New Gallery in February, 1990. Stirnemann's work was rooted in the Fluxus tradition. His pieces evaded theatricality and narrative in favour of an everyday, impoverished aesthetic that tended towards the creation of strong images and experiences. On a material level, Gray's practice shared certain affinities and attitudes: time-worn objects already formed a part of her installation and assemblage works.[9]

In summer 1991, Stirnemann invited Gray to Zürich, where (along with several other Calgary artists) she participated in a collective comprised of artists from the US, UK, Canada, Switzerland, Germany, and elsewhere. The group presented a series of live works, either as an ensemble or as subgroups, in Zürich and Winterthur (Switzerland), and Vienna and Horn (Austria). The experience was emotionally and physically demanding for Gray. Yet it was also integral to her maturation as an artist:

> After working with Manfred Stirnemann and the group, I found myself re-evaluating my work. I realized I had a lot of little performances that came out of that experience. They were ritualized actions that referenced my inner interests.[10]

Using these episodes as a starting point, Gray developed a series of short, nature-based performances. These intimate, sometimes private, works were recreated for the camera in *Book Of Shadows* (1994). Informed by folklore and natural magic ritual, *Book Of Shadows* also referred to the process of oral communication or "anecdotal history": history as told through "unofficial" channels such as folklore, rhymes, family legends, and so forth.

The six actions contained in *Book of Shadows* are short, simple, and evocative. They nonetheless suggest a kind of temporal limitlessness: eternal actions with neither beginning or end. A woman walks in a figure eight pattern on a sandy beach. Birdseed leaks from a sack she carries on her

8 *The Bhagavad Gita*, 3ed (New York: Ramakrishna-Vivekananda Center, 1952), 77—78.

9 Around this time, Gray also saw a piece by Irish artist Nick Stewart. His work with endurance and duration mirrored Gray's interest in movement that exists within stillness.

10 Gray correspondence with Henricks.

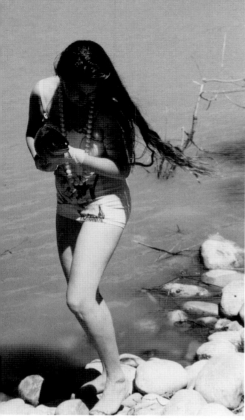

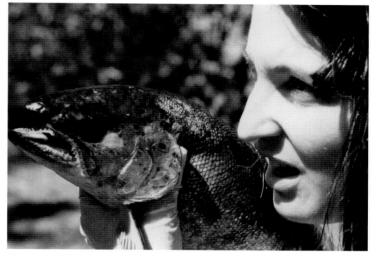

back, creating the path she follows. Two women, seated on chairs ankle-deep in lake water, face each other. Winding wool, they are connected by a long string, which is slowly transferred from one to the other. A woman is suspended upside down from a tree branch. The camera slowly pans down the rope, her leg, her entire body until we reach her inverted, straining face. She finds a key in the grass and, releasing her grip of the earth, begins to spin freely.

This shift towards a more process-oriented aesthetic harmonized well with another Calgary artist, Mark Dicey. A painter and musician, Dicey had been performing since the mid-1980s. Similarly inspired by the work of Beuys, his performances sometimes depended upon provocative duration, and physical endurance. Like Gray, his work was also concerned with the relationship between man and nature, especially in terms of ecological issues:

I wanted to work with Mark because of his extraordinary discipline as an artist and person. He is someone who has a lot of responsibilities in his personal life and maintains a positive and focused energy. Yet in his art, he is able to access an almost Dionysian aspect, earthy, yet universal, very intuitive, yet still able to say things about our society and lives. I've always

COLLEEN GRAY *Explaining Genetics to a Dead Salmon,* performed on the banks of the Bow River, Calgary as part of Maenad Theatre's Femfest, 1997

striven for a balance between intuition and intellect in my work, and I wanted to work with Mark because he seemed to be doing a similar thing from a different approach.

As part of a year-long series, the duo co-authored several works. *ckmd: on the move* was a performance at the Bridgeland Community Hall. A window installation called *ckmd: off the rack* was displayed at the Calgary Centre for the Performing Arts. The most intense output of this collaboration was two works: *ckmd* (presented at The Night Gallery and ACAD in 1994) and *preformed* (developed during an artist's residency at Truck Gallery in 1995 and was accompanied by an installation and assemblage works).

In *ckmd*, the artists chose to emphasize stillness and silence. Eschewing theatricality and relegating text to a marginal, almost tangential role, this series of three actions made reference to the history of performance art (specifically Chris Burden's duration works and Yoko Ono's *Bagism*). In the first action, Gray, who is sitting thirty feet above the floor, rolls fruit down a long apron towards Dicey, who struggles inside of a white shirt in which he is confined. In the second, the two appear on a small stage. Each is encased in a large canvas duffel bag; they recline in individual lawn chairs. The third action finds Dicey lying face down on a bar table, surrounded by a roomful of people. Gray, dressed in an ambiguous black fun-fur outfit, claws her way along the floor with sewing shears in a manner echoing how a climber might scale a cliff. Arriving at Dicey, she menaces him momentarily with the scissors and then continues on her way. A series of printed texts were distributed among the audience before the three actions.

preformed, the final work in the series, was the result of a month-long residency at Truck Gallery. For the exhibition, the artists created an ever-changing installation in progress composed of found objects, video, actions, and ongoing photo documentation. In contrast to this active environment, the performance summed up the month's proceedings in a simple, elegant action. The performers lay side by side on the floor, heads at opposite ends. A canvas tarp was stretched over their bodies (except for their heads), and attached to the floor with wood screws. Each wore a large soft sculpture mask made of red crushed velvet. The audience arrived and was confronted by a mute sculptural object: the artists were invisible. A duration piece, the performance did not end until the last audience member had left the space.

If Gray's experience working collaboratively was important to her project, it was equally enriching for those who collaborated with her. Dicey has this to say of his work with Gray:

My work with Colleen was definitely a very important time in my ongoing development as a performance/multimedia artist. She had by that time gained a strong track record for her own performance work and other collaborations. I felt privileged to be able to work with Colleen and was very confident that the collaborative process would be successful. As with many good collaborations the two of us became "one" in our thinking and process. The end results were always an equally blended creative process. Colleen's

11 Colleen Gray, correspondence with Mark Dicey, (2003). I might add here that, in my own experience, Gray was an exemplary collaborator. She was always a solid, but never overbearing, presence.

12 Performance script, courtesy of artist.

thinking and my own thinking carried through into actions and objects — open minds to each other's sensibilities.[11]

The year 1997 was an active one for Gray. *Constructs* was a month-long performance/residency with Alexandria Patience held at The New Gallery. The experience of working with Patience (who came from the theatre milieu) lent Gray the confidence, energy and focus to produce two new major works: *Explaining Cosmology to a Live Chicken* and *Explaining Genetics to a Dead Salmon*. Presented as part of the Maenad Theatre's Femfest, these performances synthesized Gray's research of the previous decade. As the titles imply, both pieces were inspired by German performance artist Joseph Beuys.

In *Explaining Cosmology to a Live Chicken* the room was in darkness. A huge nest of crumpled, shredded newspapers lay in the middle of the floor; a chicken wandered about on the stage. Closed circuit cameras were suspended directly above two shallow sandboxes, each about four feet square. The live feed from the cameras was projected onto a screen over the stage. To the left of the stage was another screen onto which images of four "storytellers" were projected. These life-sized video orators read various world views and creation myths (Egyptian, Babylonian, Celtic, and Norse). Gray emerged from the newspaper nest and began tracing pictorial representations of myths recounted. The chicken spent time in her sandbox, also seemingly giving her interpretations of the stories. At the end of the piece, Gray attempted to lure the chicken to her breast and hold it.

After a brief intermission, ushers guided the audience to the second location, a nearby riverbank for *Explaining Genetics to a Dead Salmon*. Gray approached the audience from the water's edge, carrying a salmon and reciting "The Song of Amergin," an Irish mythopoetic creation text. She then begins by recounting a scientific version of the origins of life on earth: a primeval soup in which more and more complex molecules begin to emerge, gradually evolving into genes. The tone throughout is halfway between *Scientific American* and Shakespeare. Gray talks generally about genetics and DNA, gradually entering a more autobiographical mode. Describing how she donates blood to nameless "magicians" with the altruistic hope of finding a cure for a genetic disease, Gray becomes suspicious:

I don't know what my DNA says to them, but I know what it says to me. Like a spawning salmon striving up stream year after year to a place that is home. Its only home, in my body. Where is that bit of me now?

The tone changes:

I have heard that Biomedical Researchers have created Simulated Genes, like alchemists of old creating a homunculus; One man mixed human and mouse cells forming a human-mouse hybrid. He also made a Mouse-Rat, Mouse-Hampster, Mouse-Chicken ...[12]

Gray skewers science under capitalism, where genes and DNA are copyrighted, and genetic hybrids threaten the health of the planet at large. What is our responsibility to respect the sanctity of nature? When does human skill become reckless arrogance? In a world without God, does science

become the pagan religion, demanding us to commit ancient taboos? At the end of the piece, Gray returned to the water. *Explaining Genetics to a Dead Salmon* was a remarkable return to narrative work; a captivating piece that, like so much of Gray's early text-based work, challenged her audience with wit, intelligence, and imagination.

Meanwhile, Gray's interdisciplinary work between performance and video would further solidify. In 1998, she presented the video installation *Tableaux Vivants: Vancouver* at Video In. Born from an earlier work presented at *Women and Technology* (The New Gallery, 1996), Gray did duration performances, inserting herself into a theatrical tableau recalling seventeenth century Dutch paintings. Historically, tableaux vivants were a form of entertainment found in private homes and music halls. A group of people would dress in costumes and strike poses representing a "living picture." Two one-hour "tableaux vivants" poses were performed for small live audiences in Vancouver. The resulting video documentation was projected on facing screens in the gallery space:

> I went in without an overriding theme, and after borrowing items from public and private collections, essentially collaborated with the materials to develop two tableaux. Dealing with the human body, one worked with the idea of the external body; the body electric; the interaction with the outside world, and the balancing act of outer consciousness. The other was to do with the inner body; the unconscious; our inner framework.[13]

By the end of the 1990s, Gray began to re-evaluate the conventional ways in which her unconventional art was seen and experienced. She began collaborating with British-born artist Jonathan Gray (whom she married in 2000), developing a video installation, *The Wall of Sleep,* based on ideas relating to alchemy and German Existentialism. She has also produced a series of "subversive needleworks," and is currently writing both poetic and narrative texts.[14]

In one of her earliest videotapes, *A Pack of Lies* (1986), Gray deftly wove fact and fiction into an ever-changing portrait of identity, emphasizing the mysterious process of self-invention as more important than simply being. Art imitates life, and occasionally, life imitates art. In her own way, Gray is living out her own version of the hero's journey: reborn at the end of her cycle, and ready to begin anew.

13 Gray correspondence with Henricks.

14 Documentation of Gray's (aka Colleen Kerr) work prior to 1988 is available at Vtape, Toronto, or Video Pool, Calgary, or from the artist. Recent work is available from the artist. The exhibition catalogue for *Element Instincts: A Matter of Course* is available through the Nickle Arts Museum in Calgary.

Ian Carr-Harris

Johanna Householder

AMBIGUOUS REDEMPTIONS

I believe in the oblique, the almighty ambiguity, the forgiveness of earnestness, the resurrection of the body politic and the low tech life everlasting.[1]

Cheeky. Not quite blasphemous, really, as manifestos go: cheeky — a cause which usually appears as its effect: "Don't be cheeky!" This is important. It sets up immediately an opposition that is fundamental to Householder's work: that between "good" behaviour and "bad" behaviour. What is also important though, is that when uttered, the stricture is more often than not ambivalent. Posing as a rebuke, it indulges the possibility of encouragement, or at the very least, it restricts itself to a formal notification that a limit has been breached. To be cheeky is to calculate the inevitability of this effect. As in, for instance, reaction to Andy Warhol's *Brillo Boxes* in 1964 at the Stabler Gallery. Mixed, to say the least. As in, for instance: "What cheek!' giggled/gasped Mrs. Parsons."

And what, fresh from her 1964 visit to the Stabler Gallery, might Mrs. Parsons be watching a few evenings later? It could have been, in 1979, *The Secret Life of Sgt. Preston*:

Scene: a bare stage, barely lit, with LP sound of dogs barking; enter furtively two women (Johanna Householder and Janice Hladki) dressed in large red

1 Johanna Householder, "For the Re-materialization of Objectional [sic: *Objectionable*] Art" in Alain-Martin Richard and Clive Robertson, *Performance au/in Canada, 1970—1990* (Québec: Les Éditions Interventions and Toronto: Coach House Press, 1991), 191.

overcoats. They proceed to neatly arrange the contents of their purses on the floor, then stand around looking vaguely guilty, suspect. Suddenly they are in an office drawn from an Edward Hopper painting — typewriter, filing cabinet — putting on lipstick; they place Mountie hats on their heads and proceed to work, scanning giant file folders, typing rapidly with the aid of a pair of high-heeled shoes. Behind them on the wall, a film plays a close-up image of a woman's bare belly against a table re-playing the task of emptying out her purse. Slowly the two women slide out of their chairs — slither, really — onto the floor, lie supine, file folders covering their faces. Now they struggle carefully to rise without dislodging the files. Putting on lipstick again, this time with increasingly exaggerated relish, they begin to suck, then eat their lipsticks. One of them pulls a toy remote-controlled car from the filing cabinet and ...

The thing about being cheeky is that no one — including you, me, or Mrs. Parsons — is sure just what to do with it. Outright parody plants you smack in the middle of "those who know." Satire plants you way out among the "holier than thou." And as for blasphemy — well, you get strung up high.

To get this straight then: are we talking some kind of cloaked subversion? The "Hey, wait a minute. What was that all about?" sort of thing? Yes, but not quite. Because Householder is nothing if not straightforward. She's from West Virginia, for Gosh sakes! Baton-twirling!

So how about an innocent in the world. "Being unsure" about being unsure is at the core of this approach to the idea of work, and to Householder's convictions concerning what we might call the daydreams of life as we live it day by day. Let's watch another piece, a recent video work co-produced with b.h. Yael: *December 31, 2000*:

Scene: reddish lighting, extreme close-up on a speaker, sound reminiscent of a space ship's interior; cut to close-up on Johanna's face inside a space suit, moving purposefully, heavy sound of breathing. Suddenly the connection is made: the soft, alluringly passive voice of Hal, the computer-gone-wrong from *2001: A Space Odyssey* breaks the tension: "Just what do you think you are doing, Dave." Johanna, as Dave, ignores the voice, continues to move forward through what becomes quite obviously the basement of her house, up the stairs to her kitchen. The cinematography recalls the jarring, angled shots in *2001*. "Dave, I really think I'm entitled to an answer to that question." Johanna emerges from the refrigerator into her kitchen, pulls a corkscrew from a drawer, moves towards the stove. The sound of breathing continues implacably. "I know everything hasn't been quite right with me," continues Hal's voice. "But I can assure you now, very confidently, that it's going to be all right again." Johanna/Dave inserts the corkscrew into a knob on her stove, turns it. Bends down, inserts it again, turns it. Close-up of Sama espresso machine. Opens oven door, climbs in. Noticeable on her suit's shoulder is the Canadian flag. "I feel much better now. I really do. Look Dave. I can see you're really upset about this. I honestly think you should sit down calmly, take a stress pill, and think things over." Johanna/Dave emerges from the washing machine...

2 This is not to say, however, that there was no intention to astonish. As Householder writes in her manifesto: "We were not anti-spectacle, we wanted to reclaim the authorship of spectacle. And to own ourselves as performers."

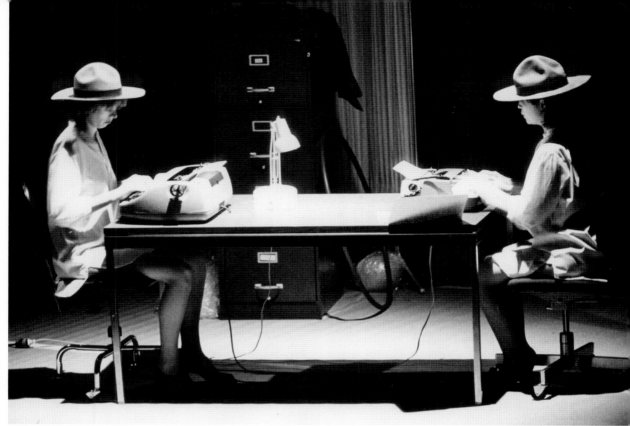

In *December 31, 2000*, Johanna speaks not a word. She simply acts, as Dave, to kill Hal. But listening to her talk about the piece, there's a flatness in the voice very different from Hal's smoothly seductive coaxing. It's a flatness one imagines to be bred of controlled patience — not the patience of the *naturally* patient, but the patience that comes of contesting conventional habit, of finding out that what seems only logical or obviously true carries little weight in the world; that being earnest about oneself can be seen as absurd. There are consequences, and the most available is to recognize — and act out — the absurdities in the ruling convention.

With this thought in mind, I want to return to the daydreams of life, and being innocent in the world — day by day. Householder's West Virginian innocence was given a grammatical boost in 1968 through finding herself at a performance of the Grand Union, a group that included Yvonne Rainer and Steve Paxton. This propelled her into dance studies in England and subsequently by the mid-70s to York University and collaborations with George Manupelli. But also, more tellingly, it propelled her into the conviction that collaboration was the means by which the artist could undercut the inherent trap of narcissism at the heart of modern art's ambition "to astonish."[2] From this vantage point, Householder proceeded to work within the

JANICE HLADKI (left) and **JOHANNA HOUSEHOLDER** (right) *The Secret Life of Sgt. Preston* at the Art Gallery of Ontario, Toronto, 1979

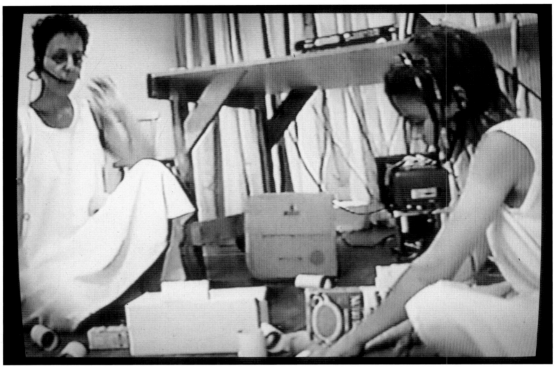

LOUISE LILIEFELDT

3 Michael Fried, "Art and Objecthood" as reprinted in *Minimal Art; A Critical Anthology*, Gregory Battcock, ed. (New York: E. P. Dutton, 1968), 134-135.

4 Richard and Robertson, 11.

practice that has come to be called performance, and in association with a diverse range of artists that included John Oswald, Francis Leeming, Janice Hladki, and Brenda Nielson. And then, of course, there came The Clichettes.

The 1967 summer issue of *Artforum* carried Michael Fried's attack on the minimalist, or literalist artists: Judd, Morris, Smith, and so on. Fried's complaint was that the work of these artists represented a subversion of the idea of art, one that essentially supplanted art with a form of theatre that shifted the centre of the work of art from the work as an object to the audience as a subject. In addressing Tony Smith's experience of a nighttime drive along an uncompleted turnpike, Fried makes the following statement concerning this shift:

What replaces the object — what does the same job of distancing or isolating the beholder, of making him a subject, that the object did in a closed room — is above all the endlessness, or objectlessness, of the approach or on-rush or perspective. It is the explicitness, that is to say, the sheer persistence, with which the experience presents itself as directed at him from outside (on the turnpike from outside the car) that simultaneously makes him a subject — makes him subject — and establishes the experience as something like that of an object, or rather, of objecthood.[3]

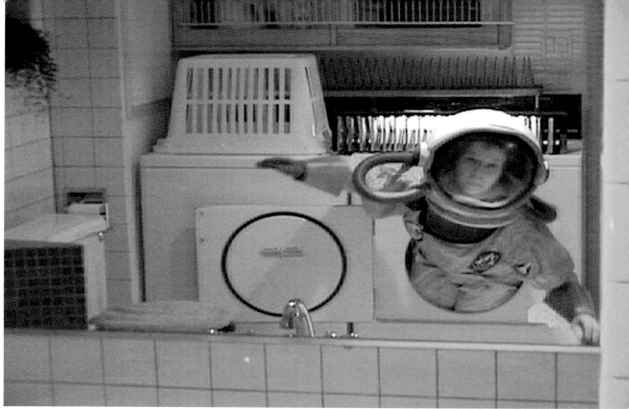

B.H. YAEL

As Fried's account makes clear, there's something cheeky going on. Specifically, and this is where innocence and the day-by-daydreams of life come in, persistence trumps gesture, and the subject challenges the object on stage, where art becomes some kind of performance.

And what on earth is "performance art" anyway? A recent cartoon in *The Globe & Mail*'s comics section has one convict huffily reprimanding another with the line: "Convict! I'm not a convict. I'm a performance artist objecting to the injustices of the legal system." Clive Robertson, in his lead essay for *Performance au/in Canada, 1970-1990*, tracks the recent history of performance as an art practice — recent in the sense that the Bauhaus avant-gardist experiments lie outside his reference — and notes the often vague distinctions between Happenings, Events, Body Art, and so on. But what seems common to these various categorizations remains the intent to perform, or *re-perform*, a task rather than to simply appear as a performer in, for instance, a play. As Robertson writes about the emergence of performance: "The notion of task was central to Happenings and Fluxus (the usage of everyday or non-art skills)."[4] If we apply this to the cartoon, our convict is making a distinction between on the one hand *passively* performing the socially scripted role of a bitter convict "caught" (in the play *The System*

JOHANNA HOUSEHOLDER and **CARMEN HOUSEHOLDER-PEDARI** *amygdala*, 1997, at the in.attendant storefront in the 7a*11d International Festival of Performance Art, Toronto

JOHANNA HOUSEHOLDER and **B.H. YAEL** *december 31, 2000.* "Dave" emerges from the airlock. Video, 2001

JOHANNA HOUSEHOLDER and CARMEN
HOUSEHOLDER-PEDARI *Last Year at
Marienbad: the missing scenes*, for Mercer
Union's *Pousse Café* at the DeLeon White
Gallery, Toronto, 1998

of Justice) and on the other hand *actively* "performing" the task of being caught in the System. If we apply it to Householder's work, we can append to Robertson's task-related description of performance the comment that central to this is the concept of the *anti-task*, a concept notable in the work of Fluxus. The distinction requires a re-reading of context in order to wrest authority from those agencies that have by custom exercised it. At the core of performance lies precisely this determination to offer a re-reading.

Or, one might say more appropriately in Householder's case, a *reiteration*. To reiterate means, of course, to say something again, and repeating something, as any child knows, can be employed ironically. Once launched into public space, the original "something" is now fair game for critical examination and the play of manipulation. This quotational gambit runs deep in our contemporary and allegedly postmodern culture, and aside from the obvious and by no means solely postmodern craft of parody, it surfaces in what Roland Barthes has attempted to characterize as the third or "obtuse" meaning — the first and second being literal and symbolic meaning. For Barthes, this obtuse level of signification marks the presence of the work of art, though his description of it is elusive. "Nevertheless," as Craig Owens remarks in his influential essay, *The Allegorical Impulse*, the third meaning ... has "something to do" with disguise; he identifies it with isolated details of make-up and costume (which properly belong to the literal level) which, through excess, proclaim their own artifice." [5] At the risk of injecting here a somewhat technical language, I think it is useful to note that Owens goes on to quote Barthes on what this is supposed to accomplish: "It is no longer the myths which need to be unmasked... it is the sign itself which must be shaken; the problem is not to reveal the (latent) meaning of an utterance, of a trait, of a narrative, but to fissure the very representation of meaning ... not to change or purify the symbols, but to challenge the symbolic itself." [6] The symbolic, after all, represents who we thought we were. Aren't we supposed to be the symbolic animal? Isn't art supposed to symbolize something for us? Isn't art supposed to *mean* something!

And Householder's meaning is, actually, quite clear. It is to reiterate the behaviours we take for granted, those behaviours that symbolize our conformity with the social values that in turn stand as symbols describing our "dignity" or humanness, and "misplace" them; to, in effect, mis-behave. This strategy recalls a comment quoted by Clive Robertson and made by a curator in referring to Gathie Falk's performances as "childish things." [7] Whether made pejoratively or not, the comment is useful for assembling a key constituent of Householder's practice. It is no secret that women find themselves infantilized in the male-authored cultural frameworks that dominate the planet.[8] One response — and this is the case here — is to adopt the stigma wholeheartedly and use it. This could be said to be the arena in which the women's movement and good old fashioned broads meet to agree, though with clearly differing expectations and operating procedures. As a woman, to act "childishly" is to work both within and against the system of behaviour. To define that point of excess in the disguise, as Barthes calls it,

5 Craig Owens, *Beyond Recognition: Representation, Power, and Culture* (Berkeley, University of California Press, 1992), 82.

6 Ibid. 85.

7 Richard and Robertson, 12.

8 I'm tempted here, by the way, to invoke the historian Michel Foucault's interesting observation that the "author function" is a particular institutional tactic of assigning or claiming responsibility that is not to be confused with who was "actually" responsible for whatever was produced.

ANGELO PEDARI

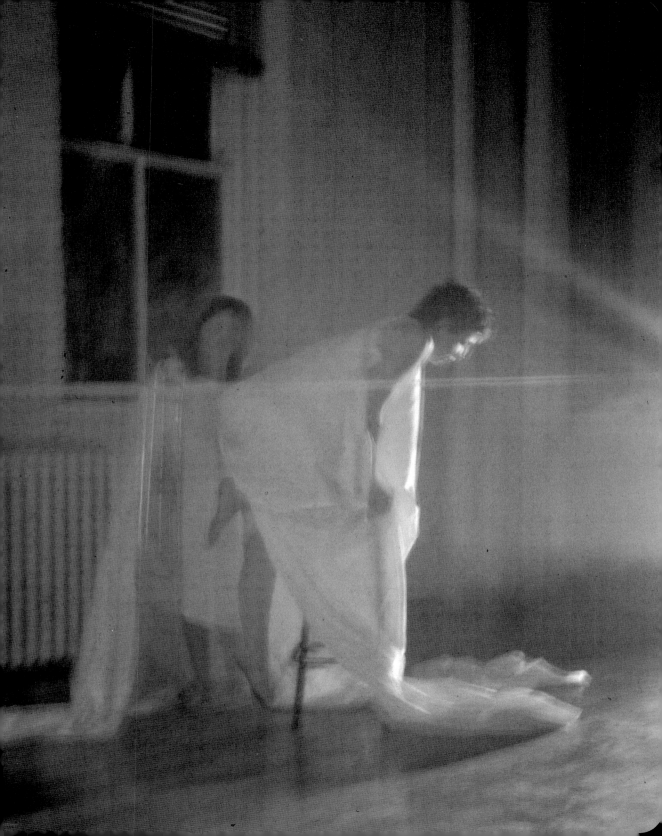

at which behaviour is not simply misplaced, but *displaced*, is to call behaviour itself into question. And where does that leave you, Mrs. Parsons? And what about Mr. Parsons?

Running off to therapy, perhaps. But may I suggest instead one of Householder's laboratory performances, the ones she does with her daughter Carmen.[9] You could have tried, in 1998, *Last Year at Marienbad: the missing scenes*. The description goes:

> Set against the backdrop of the 1961 film by Alain Resnais — a film which shaped certain ideas about the possibility of art for me when I saw it as a little girl. In which we [Johanna and her daughter Carmen] enter the image and retrieve the phallus in the form of a trombone.

Scene: a typical Toronto industrial loft interior, with two large windows across which is rear-projected the original film. Johanna and Carmen (10 years old) are sitting at a table, dressed in loose-fitting white gowns, rather reminiscent of a Lewis Carroll photograph. Mother and daughter play a game with matchsticks. Johanna blindfolds Carmen, moves to one of the windows and watches the film. Suddenly Johanna breaks the window and hauls out a large white cloth as though retrieving the film itself. Carmen produces a trombone. Johanna and Carmen arrange the cloth over their heads, with Johanna high up and Carmen below, who now starts to play "Wild Thing" on the trombone...

Within the trope of the child-woman — with its rehearsals, reiterations, misplacings of behaviour — Householder's collaborative use of herself and her daughter stages a kind of laboratory for actions that offer up, in Craig Owens' terminology, an allegorical, and therefore *supplemental* meaning.[10] As in "Well then, how about this?" The catalyst for this is dissatisfaction. You can practically hear The Stones being played in your head! However, one thing that can be said for paternalism is that it issues its own form of license. The Canon is a secured territory around which may flourish — because irrelevant — all sorts of weird and wonderful things. This can, of course, also be immensely frustrating, maddening for those — historically women in particular — who have been consigned, as it were, to the dustbin of history. But one must remain philosophical, and it helps that the dustbin *is* history, that it is *precisely* the place, the laboratory, where other possibilities can be framed. To push Craig Owens' point, history, as a form of commentary and critique, is itself allegorical — "insofar as these are involved in rewriting a primary text in terms of its figural meaning."[11] With *Last Year at Marienbad: the missing scenes*, Johanna-Carmen workshop the (canonized) film, launching a doubled allegorical figure — woman-child, mother-daughter, spectator-plunderer — against the film's interiorized formality, providing an extended and messy otherness to its staged reductivism.

In this short profile I have left it for others to discuss Householder's work with The Clichettes, a central part of her history, and one that is complex enough that it has been treated separately in this book. It is equally important to note that Householder is, you might say, a household name in the business of instigating and promoting performance in Canada, DanceWorks, 7a*11d,

9 They have done five: *Orchid*, SAW Gallery, Ottawa, 1993; *amygdala*, in.attendant, Toronto, 1997; *Last Year at Marienbad: the missing scenes*, DeLeon White Gallery, Toronto, 1998; *Rehearsal*, a_level, 2000; *Rememberance Day*, Dovercourt House, Toronto, 2000.

10 Owens, 54.

11 Ibid., 54.

ANGELO PEDARI

and the Women's Cultural Building in Toronto among them. Her commitment to the local scene follows on her commitment to the concept of the lab, and Householder employs opportunities when and as they arise to inject her sassy — did I say cheeky? — guerrilla tactics into the local celebrity scene. Finally, I have also not treated her important contributions as a teacher at the Ontario College of Art and Design.

Rather than detail these involvements, I would like to fade to white with one of her recent performances, *Diversionary Targets*, an action for twelve performers that began and ended in Toronto's Grange Park on Saturday, September 27, 2003. Here is Householder on *Diversionary Targets*, a collaboration with the *4 Cardinales* web project coordinated by Leonardo Gonzales and Alexander Del Re from Chile:

Inspired by the global nature of the project, and the image of the compass as a target, *Diversionary Targets* is a response to the increase in global warfare and the targeting of civilians in military actions. In this participatory event the performers were given target hats to wear throughout the day of the action. At 9:00 p.m. we reassembled to recount our experiences and convert from being targets back to being points on a compass.

JOHANNA HOUSEHOLDER *Diversionary Targets*, Toronto, September 27, 2003

Donna Lypchuk

The Hummer Sisters

THE ART OF SATIRE

Perhaps one of the greatest gifts that The Hummer Sisters ever gave audiences was the assumption that they were intelligent. Satire is probably the most misunderstood of all art forms, as in order for it to be appreciated, the audience must have some kind of prerequisite knowledge of common archetypes, history, and most importantly, current events. This is highly unusual in a national theatrical and performance arena that usually relies on predictable myths, appropriation from other works, and maudlin appeals to emotion. If there is one thing that I am personally thankful for, it is that the Hummers never asked us to take that tragic tumble down Aristotle's steps to soap-operatic parody without substance. This group actively demonstrated the non-partisan aspects of practicing true satire, by holding no sacred cows and practicing a unique blend of cabaret and documentary formats. This highly diversified and talented group of performers, writers, and artists were making fun of the politically correct dinosaurs long before it was "hip" to do so.

To understand the evolution of the Hummers, it is important to understand the cultural milieu that served as the manger of their birth in 1976. It was a time when even Norman Lear's "Archie Bunker" was maligned for perpetuating a negative stereotype of a racist. Canada was busy building its

vertical mosaic and feminists were rooting through the garbage cans looking for remnants of their burnt bras. Marshall McLuhan was the Obi-Wan-Kenobi of media and Joyce Weiland was courting the Prime Minister in The National Art Gallery with female handiworks. Locally, punk and performance art were starting to catch fire, as was the notion of the artist as "personal terrorist." As eye-rolling as some of these concepts seem today, they enraptured the imaginations of audiences who, in a kind of pre-Yuppie trance, were looking forward to the prosperity of the 80s. Only rich societies can afford such scandalous conceits as "personal terrorism."

Whereas theatre in the 60s was identified with American draft dodgers, who received funding to conduct a long portage by covered wagon to perform in Canadian villages, theatre in the 70s was finding refuge in alternative galleries such as A Space in Toronto and the Western Front in Vancouver. These performances, which were often gestural and de-constructivist in nature, seemed to be part of a mass allergic reaction to the defining Canadian plays of the era such as George Ryga's saccharine *The Ecstacy of Rita Joe*, and the endless remounts of Sam Shepard plays about Southern White Trash. In the alternative spaces, Dadaism and other forms of retro-futurism were hot as was any interaction with technology. You have to remember that in the days before karaoke, anything that remotely resembled a live video camera was the immediate object of excitement and fetishization. It was also a time when the Toronto Morality Squad was out in full force, shutting down productions and art exhibitions as well as creating an Orwellian fear of the "thought police." At the time, the coolest thing that you could be was an artistic "subversive" who could undermine the authority of these enemies of free speech.

In February 1976, The Hummer Sisters, which at the time consisted of artist performer Bobbe Besold, actor and video artist Janet Burke, video-performance artist Marien Lewis, and playwright-performer Deanne Taylor, joined forces with playwright Michael Hollingsworth, video-artist and designer Chris Clifford, and composer-performer-writer Andrew J. Paterson to form VideoCabaret at A Space on St. Nicholas Street, Toronto.

At that time, VideoCabaret's main interest was combining elements of video, rock 'n' roll, and the visionary theories of Marshall McLuhan and Aldous Huxley in a theatrical format. The Hummers loved the cabaret format, which is much friendlier to the evasive ways of true satire. This allowed them to use multiple aspects of performance including art, graphics, video, voice-over, photography, text, narrative, and interaction with technology, to create a platform for some of the most truly daring remarks ever made on stage in Canada.

The Hummer's first production was a scandalous concoction called *The Patty Rehearst Story*, which featured music by Andrew Paterson and Michael Brooks. A takeoff on the kidnapping of "poor little rich girl" Patty Hearst, the performance was ultimately a satire of the modern woman's journey of individuation: from kidnapping, through rebellion, to eventual submission. This sentiment is very much summed up by lyrics from a song featured in the performance called the *Brides of Jesus:*

We've all been brides of Jesus
Hollywood and holy war
We've all been brides of Satan
And now we're getting more
We've traded in our habits
Hairshirts and thorny crowns
On the lam with Tania
Underground...

In *Patty Rehearst*, audiences first got a glimpse of a few of the Hummers' favourite themes that would also predominate in future shows: the media as a weapon (video camera units called "lubicons" were pointed at individuals like guns) and class struggle. It was also a parody of the media machine, Hollywood, and in true Hummer fashion, ululated generously to the tune of current events. Originally performed between segments of Hollingsworth's *Strawberry Fields*, *Patty Rehearst* was written by Deanne Taylor based on a collective performance art concept by the Hummers. It evolved into a full-scale production that juxtaposed questions about free will with the extravagances of the rich and powerful. This unusual theatrical event also boasted an element of the "snake eating its tail" where the characters constantly broke "the fourth wall" rule of the theatre by complaining they were held hostage by the structure of the drama. The stage was split between high-tech video equipment (screens, colour cameras) and guerrilla video equipment (hand-held cameras and monitors painted with camouflage), to dramatize the power of the low-tech media-terrorist against the media empire of the Hearsts. Image-wise, the Hummers also made references to McLuhan's ideas about "hot and cold" media by using video effects to highlight strong words and dramatic events.

In a way, the Hummers were the Oliver Stones of their time. Twenty years before the release of *Natural Born Killers* and ten years before the rise of local media mogul Moses Znaimer, they were using graphics and video technology to illustrate how the media manipulates human behaviour.

From 1977 to 1979, the Hummers performed their second production, *The Bible As Told To Karen Ann Quinland*, in Toronto, New York, Calgary, Vancouver, and London, England. This show was not a call to arms for feminists but more of a "wake up" call from a long dormant phase. Once again, this production was way ahead of its time, demonstrating that ideas about female myths and notions about women are manipulated by the media. Its content preceded Susan Faludi's landmark mid-90s examination of the subject called *Backlash*. The star of the show was The Private Dyke, played by John Bentley Mays (and later by Robert Nasmith); a Phillip Marlowe-type character who goes in search of the perfect woman. To do this, he goes "undercover" in a girl's world to learn the gospel according to the media's favourite coma baby at the time — Karen Ann Quinlan. Video monitors displaying female bodies in all manner of compliance and narcolepsy complimented the script, which savagely skewered "the deep sleep of the body politic" and both the failure of feminism and the failure of men to recognize

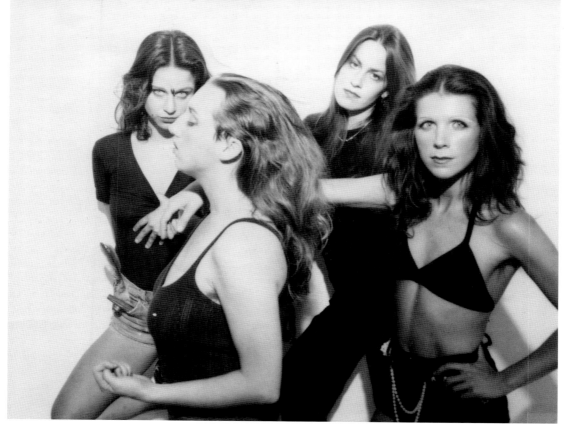

RODNEY WERDEN

that yang without yin is about as creative as Eve without the apple.

The Bible As Told To Karen Ann Quinland is a stark and scathing look at the loss of female power (referred to as "booga booga power" in the script). The opening monologue, sung by the chorines (played by the Hummers), takes the form of a manifesto that accuses:

Sisters you have been purged of your booga booga power!
You don't cry, you don't bleed, you don't sweat, you don't dribble,
You don't pee, you don't cream, you don't come
And now you purge your brothers.
Faceless sexless soldiers, drying up the ocean,
Cleaning up the mess...
Sisters.
Your bodies are occupied territory,
Bristling with IUD installations
Humming with chemical sterility,
Invaded by vacuums and knives.

True to VideoCabaret's mandate, this show also featured live performers interacting with pre-recorded tape — a big first in Canadian theatre. The concept was taken to its apex by Hollingsworth's brilliant production of

THE HUMMER SISTERS (1976-1979) Left to right: Bobbe Besold, Marien Lewis, Janet Burke, Deanne Taylor

Electric Eye, with Andrew Paterson as a guitar-wielding serial killer visiting a pre-recorded world of lost and depraved souls, and Alan Bridle's *The Last Man On Earth* with Bridle playing one live and seven pre-recorded characters.

The Hummers' next show featured the troupe searching for something called the "male vagina." *Nympho Warrior*, which turned the concept of "penis envy" into "venus envy," was one of the most interactive shows produced by VideoCabaret and featured live drawing on stage by artist Bobbe Besold as well as live and pre-recorded interaction between characters. The show begged the question "is biology destiny?" while at the same time kicking at the pedestal of the patriarchy. *Nympho Warrior* was performed in Toronto, Montreal, Vancouver, Ottawa, and New York in 1978.

In the 80s, the Hummers regrouped and reinvented themselves as a group of three core performers: Deanne Taylor, Janet Burke, and actor musician Jenny Dean. The dawn of the new decade seemed to have a sobering effect on the troupe, and they became involved with local political issues. Their creativity was also provoked by developments in technology that allowed them to refine their "mirrors within mirrors" style of interactive video performance.

Where's Fluffy (The Decline and Fall of Babyland) was a further indictment of Hollywood's fascination with the monsters that are created by the media. For two hours, the audience was assaulted with altered television images and original media footage featuring such personalities as Reagan, Trudeau, and Khomeini. This elaborate pre-recorded environment created "an incubation area" for three budding psychopaths.

Aside from the foreshadowing of the *Natural Born Killers* theme, *Where's Fluffy* was also one of the first productions in the entire world to alter video images by putting unexpected words into the mouths of political leaders and celebrities. This form of video satire (which can be compared to puppetry) has since been adopted by every major talk show in the United States and the UK, as well as Canada's *This Hour Has 22 Minutes*. *Where's Fluffy* was produced by VideoCabaret at Theatre Passe Muraille in February, 1981 as well as at the Toronto Theatre Festival in May, 1981.

The Tom Tube Show was the first of the Hummers' faux "talk shows" and featured Alan Bridle playing a slick, dapper, smooth-talking character called Tom Tube. Tom Tube sat at a central kiosk and was switched "live" inside 149 Yonge Street to celebrity journalists and commentators who were played by Burke, Dean, and Taylor. An alternative to the news, it was the Toronto equivalent of New York's *Saturday Night Live*. *The Tom Tube Show*, which ran from October, 1981 to March, 1982, also featured guest performers and local celebrities who would comment on current events and issues of the day. *The Tom Tube Show* initiated a long-term trend which found VideoCabaret and the Hummers at the centre of their community as well as local politics.

Perhaps one of the most spectacular interactive, multimedia events ever pulled off by a performance group in history was The Hummer Sisters' *ART Versus Art* campaign. In 1982, after VideoCabaret and the Hummers took up

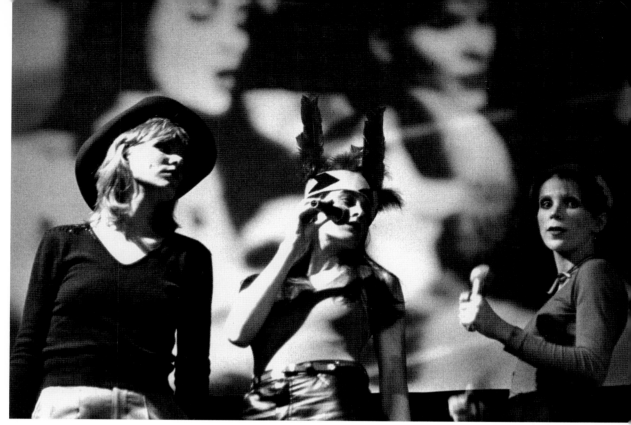

ISOBEL HARRY

their residency at the Cameron House hotel, they decided to run for mayor of Toronto under the collective ballot name of A. Hummer. The entrepreneurial spirit of this campaign is summed up by the Leni Reifenstahl-type photograph taken by renowned photographer David Hlynsky, which shows the three Hummer Sisters: Dean, Burke, and Taylor, "reporting to the carpet" in their Bay Street suits beneath the space-age curves of New Toronto City Hall. Their main opponent was Art Eggleton, thus the title *ART Versus Art*.

Over a hundred local Toronto artists contributed to the campaign by creating performances, posters, and window installations. This event also marked the ultimate centralization of the Queen Street Arts Community which at the time believed that a vote for art could transform their neighbourhood. Issues on the platform were live-work zoning for artists, political responsibility for all citizens, and "developer-free" campaign funding as demonstrated by the Hummers' "Penny a Plate" luncheon that contrasted greatly with Art Eggleton's elaborate fundraising affairs.

Terry McGlade, Bongo Kolycious, and Alan Bridle helped produce a campaign video, featuring the three Hummers interacting with local citizens and a series of video press releases scripted by Taylor. Andrew Paterson, Brent Snyder, Bruce McCulloch, and Nigel Dean composed music for the

THE HUMMER SISTERS Left to right: Jenny Dean, Janet Burke, Deanne Taylor, *Where's Fluffy* workshop, Theatre Passe Muraille, Toronto, 1980

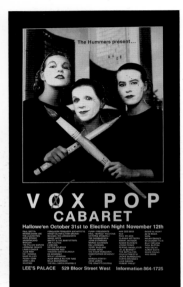

nightly series of performances that were held at the Cameron. Scores of local luminaries showed their support for A. Hummer including singers Lorraine Segato and Molly Johnson, sound-poets The Four Horsemen of the Apocalypse, and comedian Sheila Gostick.

Tom Tube hosted these live events from the second floor of the Cameron House and broadcast live to the first floor tavern. This broadcast was peppered with satirical sketches, interviews with voters and the genuine mainstream media as well as the Hummers' signature "talking heads" animated video parodies. Each night, segments from live television reporting on the Hummers prodigious popularity as candidates for mayor were incorporated on the spot, into what was broadcast on the monitors.

Incredibly, A. Hummer almost became mayor of Toronto, in 1982, garnering an unheard of 12,000 votes. Their "runner up" status was an embarrassment to local politicians as well as to voters who came to question the validity of the voting process as a result. This antic enacted on a grand scale represented performance art at its best. The nightly performances and the trajectory of the campaign were recorded and edited into a 57-minute videotape called *ART Versus Art*, that was screened at the Toronto Festival of Festivals. The surreality of the situation is still not lost on those of us who were there to witness the Hummers' incredible transformation from parodies of media pundits to parodies of politicians to a parody that was good enough to actually make them real players in the surreal world of politics.

In June 1983, the Hummers resurrected the buttery Tom Tube to host a simulation of the 1983 Conservative Leadership Convention. *Tory Tory Tory* featured the Hummers performing their crowd-pleasing parodies of media pundits: Darlene Daily, Wanda Whiplash, and Barbara A. Honey (a parody of right-wing journalist Barbara Amiel). These interviews were conducted simultaneously as the results of the convention unfolded live on-air on conventional TV. This show also had altered videos of political speeches, written by Taylor and edited by Janet Burke and filmmaker Ed Mowbray. Robert Nasmith and R.H. Thomson supplied the voices for candidates such as Brian Mulroney and Joe Clark. The show also included an examination of the political issues of the time, such as mass terror about the effects of free trade on the economy.

When Brian Mulroney won the leadership that evening, the impending sense of doom with regard to the future of Canadian culture was palpable. These images were caught on a 35-minute video and debuted at the Toronto Festival of Festivals in the fall of 1983.

That same year, Taylor wrote and the Hummers produced a savage work about the history of birth control that was enough to give the most medicated of post-feminist writers a stroke. *Hormone Warzone* featured the sisters dressed up in various archetypal guises (the mad housewife, the hippie crone, and the bland bimbo) discussing such feisty and problematic feminist issues as birth control and abortion. As this eerie video successfully made both men and women look like idiots for the suppression of procreation, it could be said that it was the kind of satire that took no

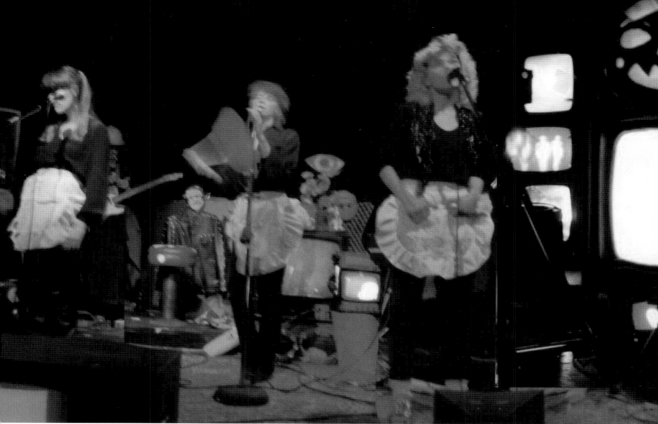

hostages. It was also as if at that point, the Hummers decided to make a concession to their origins as rabble-rousers who were concerned with the politics of the female body. Perhaps it was provoked by the bombings of Dr. Henry Morgentaler's clinics, or by a true desire to inject some estrogen into the creation of video art. Although rough around the edges, as destiny is informed by budget as much as it is by gender, *Hormone Warzone* is a bit of a masterpiece that I believe is rarely screened, although, it would be considered to be milder than the average content you see in *B.U.S.T.* or *B.I.T.C.H.* magazine. Once again, this video was ahead of its time, as what was considered to be feminist in those days is now considered to be merely a feminine point of view. Nowadays this type of synergy between feminine and feminist would be identified as post-feminist. Both in terms of its content, and given the resistance in Toronto to the discussion of such matters, it is amazing to me that it exists at all.

In the spring of 1984, the Hummers turned their attention back to local politics with a series of VideoCabarets that featured an electronic symposium that included John Sewell, Bruce Kidd, and others quizzing electoral candidates Dale Martin, Susan Eng, and Peter Mahoney. This was a lead-up to their next production, *Power Play*, which used the same presentational devices that were used in *Tory Tory Tory* to document the 1984 Liberal

THE HUMMER SISTERS poster, *Vox Pop Cabaret,* Toronto, 1985

THE HUMMER SISTERS *The Heptone Odyssey,* Yonge St., Toronto, 1981

Leadership convention. This time, politicians such as John Turner and John Chretien were given the "Hummer Treatment" as their talking heads were manipulated via editing to "tell the truth." This event was also hosted by the slick Tom Tube and interspersed with commentary from Wanda Whiplash, Darlene Daily, and Barb Honey.

In November 1984, The Hummer Sisters were invited to take part in VideoCulture Canada, a mass presentation of video art from across the country that took place at Ontario Place. The Hummers's contribution was a piece called *Dress To Kill*, a pre-recorded video produced by Ed Mowbray and Rick Simon that featured music by Billy Bryans, Mojah, and Christopher Gerard Pinker. In this installation, a sign indicated to viewers that representatives of Personal Video Services will demonstrate their product five times a day. Onscreen, Dean, Burke, and Taylor impersonated various female icons including Maria (States of Grace), Eva (Gates of Hell), Trixie (The Hooker Next Door), and unveiled this year's model with the song, "The Well Dressed Girl is wearing Balls This Spring!" In much the same vein as *Where's Fluffy* and *Hormone Warzone*, this piece took an accurately directed swipe at female beliefs and pretensions.

In 1985 Deanne Taylor and VideoCabaret began to take a great interest in *mas* (short for masquerade), designs central to the celebrations of Caribbean carnival. Taylor introduced guest artists from Trinidad to Shadowland, a group of theatre artists (including Leida Englar, Brad Harley, Anne Barber and Luisa Millan, and others) and launched an annual tradition of exchanging artists and creating *mas*. This older Caribbean form of satire involves elaborate masks and props, which often mock and mimic the ruling élite. This use of caricature and exaggeration has greatly influenced both the style and forms of production of Shadowland, and VideoCabaret, and they have collaborated on political cabarets, Caribana bands, and Hollingsworth's cycle of plays *The History of The Village of The Small Huts* (which satirizes Canadian history from pre-Confederation to the present). The influence of *mas* was evident in Taylor's operatic masterwork, *Second Nature*, which was an extended meditation on the biological operations of the female body and nature at large.

In 1985, in honour of the Municipal Election, the Hummers pioneered their first *Vox Pop* (short for *vox populi*, voice of the people). This cabaret, which continued the tradition of *ART vs Art*, was hosted by Alan Bridle as Tom Tube. The Hummers' nightly performance was accompanied by musicians Ronnie Wiseman and Rick Sacks, and designed by Shadowland, who created *mas* type head pieces for the characters Freedom, Licence, Mind, Doubt, Pollster, Vote, and Media, who provoked or discouraged the central character, Everyperson.

In 1988, the Hummers conducted a second *Vox Pop* to cover several intersecting events including the American election, the Canadian federal election, and the Toronto municipal election. Aside from the usual interviews, sketches, and altered videotapes, guests at this event were treated to guests from the past (a crossover from Hollingsworth's *Village of The Small Huts* series) such as William Lyon Mackenzie (Eric Keenleyside) and Sir John

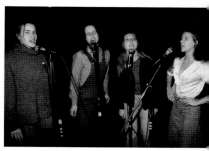

A. MacDonald (Tom Butler). This *Vox Pop* featured an innovation that asked the audience to pose questions to studio guests. A popular mainstay of the 1988 *Vox Pop* was the evil Dr. Tory (played by the talented Ted Johns) who improvised the most evasive, bureaucratic double-talk ever featured on any screen — big or small. A 12-minute video, *The Great Debate*, which freely altered the words of John Turner, Brian Mulroney, and Ed Broadbent was a frequently replayed gem. People were literally on the floor laughing over the Hummers' take on Canadian politics. Five words: "you had to be there!"

Second Nature transported the Hummers back into the realm of the body politic but also out of the realm of the cabaret format and into the main-stage spaces at the Theatre Centre and later at Theatre Passe Muraille. Written and directed by Deanne Taylor, it was performed by Janet Burke, Jennifer Dean, Ellie Ray Hennessey, Maggie Huculak, Mary Ellen Mahoney, Deborah Theaker, Maria Vacratsis, and Karen Woolridge.

A summation of several influences that are distinctly "Hummer," *Second Nature* takes place inside the head and loins of woman while she experiences the process of creating life — from conception to birth — and the mind-body debate within her daughter's body as she grows from infant to modern superwoman. This full-scale epic work included nineteen small arches

THE HUMMER SISTERS *The Bible As Told To Karen Ann Quinland,* ICA, London, England, 1979. Clockwise from lower left: Janet Burke, Deanne Taylor, Marien Lewis, Bobbe Besold

THE HUMMER SISTERS (1976-1979) Left to right: Janet Burke, Bobbe Besold, Marien Lewis, Deanne Taylor

encasing video screens as well as a full back screen upon which was projected graphics and video. The live video was orchestrated backstage by artists who filmed themselves putting maquettes or props on turntables or on their bodies. Amazingly, there was only one pre-recorded image in the entire two-hour event.

The influence of *mas* was also seen in this production which boasted a bright pink and red set and brilliant, jewel-toned costumes and headdresses. The play boasted a chorus as well as characters based on anatomical and psychological concepts such as Auto, Ovary, Cardia, Gusta, Doc, and Volo. The set was a dome-like construction that represented "orders of the body politic" and graced with sensual curves. The video monitors that ringed the set were filled with lively images of hormones, nerves, and memory in a constant state of play.

This remarkable production, which was scored by Brent Snyder, was a joyous and funny celebration of the female body as well as a witty and profoundly insightful look at the nature of life. The text also constantly referred to the body as a metaphor for all things to come: socially, politically, and personally.

It seems that the nature of life is not far from the nature of performance. It is, as the character, Cardio (who represents the heart), in *Second Nature* says: "a death defying act of order, a balancing act between chaos and obsession."

Given the fact that poverty often defines the measure and scope of an artist's life in Canada, the Hummers have managed to provide audiences with high-quality satire that neither stumbles to the level of a cartoon or prolapses into eye-glazing self-referentiality. There is a homemade quality to the Hummers' work that through the years has defied labels and, in fact, managed to turn the tables on the media by using their own devices against them to expose idiocy, contradictions, and the greater philosophical implications of life. Couched safely in satire, their work has defied the usual labels, and though I would hesitate to call them feminists, I would not hesitate to call them artists who were exploring the nature of "what is feminine." Their adherence to exploring this definition through the use of didactic dialogue and symbolist characters is ultimately what gave the Hummers' work a post-feminist thrust that was highly unusual for its time. As is the case with most true satirists, The Hummer Sisters' body of work, which is a whole politic in itself that could be debated for a hundred years with no results, has been Brechtian in its desire to be corrective in nature. Feminist or not, the Hummers, like all satirists, are warriors and subversives whose works still provoke feminist vs. post-feminist discussions among critics and historians.

Karen Spencer

Suzanne Joly

NO APOLOGIES

straightjacket

Joly enters the room. She is wearing a white straightjacket. The ties that are used to bind the arms are left dangling, undone. On the floor is a wooden cabinet that holds a 24-inch monitor. The monitor emits a high pitched sound signal and displays the black and white image of the face of an Indian — a former CBC test pattern. This sound signal and graphic were used to signify the end of the night's televised programming. Joly walks to a long rectangular box that is on the floor; she bends down, plugs the cord into the socket, and picks up the box. The box is an electronic text monitor. Joly stands on top of the wooden cabinet and holds the rectangular box out towards the audience. A text by Henri Laborit scrolls by.[1] It is a powerfully poetic text that speaks of the pain of being constrained by the world's laws and prejudices. With hands and legs imprisoned — *I tremble, I moan, and I weep — I close myself in to escape to the clouds, making art, science and madness.*[2] The sound of Queen's anthem, "We are the Champions," blasts out of two large speakers, loud, loud, louder.[3] When the song is over, Joly steps down from the cabinet, puts the text box on the floor, and walks away.

It is 1990. Suzanne Joly is performing *Indiana TV*.[4] The crisis at Oka, Québec, a seventy-eight day armed stand off between the Mohawk Nation

1 Henri Laborit, 1914-1995. Laborit discovered the medical and psychiatric use of chlorproma-sine (thorazine) in 1952 and by doing so became the father of modern psychopharmacology. He was awarded the American equivalent of the Nobel prize, the Albert Lasker prize, in 1957. Laborit later turned to philosophy and writing and eventually even acting, playing himself in Alain Resnais's *Mon oncle d'amérique* (1980). His bibliography lists thirty-four oeuvres.

2 Scrolling text for the performance *Indiana TV* by Suzanne Joly, text by Henri Laborit. *Mais lorsque le monde me contraint à observer ses lois, lorsque mon désir brise son front contre le monde des interdits, lorsque mes mains et mes jambes se trouvent emprisonnés dans les fers implacables des préjugés et des cultures, alors je frisonne, je gémis et je pleure. Espace, je t'ai perdu et je rentre en moi-même, je m'enferme au faîte de mon clocher où la tête dans les nuages, je fabrique l'art, la science et la folie.*

3 Written and sung by Freddie Mercury, released 1977.

4 Suzanne Joly performed *Indiana TV* three times in 1990. First at SAW Gallery for the Événement crise d'octobre 20 ans après, then at Le Lieu for the Biennale d'art actuel de Québec, and then at the Musée d'art de Joliette.

and the Canadian Armed Forces, is raging. It is a crisis over land claims. The government wants to expand a golf course in Oka and the expansion is mapped out over an ancient Mohawk burial ground. The conflict is taken to court, the Mohawk Nation loses. In an attempt to maintain control over their land, the men of the Mohawk Nation at Kanesatake set up barricades in the pine woods which are scheduled to be bulldozed for the golf course. The women and children of the Mohawk nation at Kanesatake set up barricades along major highways. The Kahnawake, acting in support of the Mohawk Nation, block access to the Mercier Bridge.[5] The mayor of Oka calls in the provincial police, the conflict escalates, and the Armed Forces are brought in. Access to land is a matter of national importance. And leisure is big business.

rooted

Suzanne Joly is where she is. Deeply rooted within a geographical and social landscape that is particular to her life, her history, her sense of being in the world. Joliette. It's part of the Lanaudière region of Québec situated on the L'Assomption River — a mere seventy-five kilometres north east of Montréal.

The Lanaudière region, like Oka, is feeling the consequences of urban sprawl, an encroaching economy that is driven by its appetite for space. And space is increasingly defined through an all encompassing desire for "natural" space and the lifestyle that goes with it.[6] Joliette's tourist brochure lures potential consumers with descriptions of speckled trout, rainbow trout, and Québec red trout. Cabins, boats, guides, and ATV trails, plus a summer classical music festival, are all offered up as commodities to be consumed.

In the opening text for *Les ateliers convertibles historique*,[7] Joliette is described as a region known for its proliferation of lakes ... and its absence of artist workshops and exhibition spaces.

collective

Les ateliers convertibles is an artist-run collective situated in Joliette.[8] It is Joly's ongoing performance. I claim this collective as Joly's performance work not because of her sustained implication and dedication to the collective, but because she has created, in relation with others, a centre of action that forefronts her values as an artist. Through *Les ateliers convertibles*, Joly performs her cultural identity — she speaks from where she is situated, she engages her own community, and she works from a subtle yet profound belief that where she is located is of equal value to anywhere else. *Les ateliers convertibles* gives form to Joly's deeply held belief that artistic life in Joliette matters.[9]

De porteur d'eau à bâtisseur (1994), is a work conceived by the members of *Les ateliers convertibles* for Québec's national holiday. *De porteur d'eau à bâtisseur* involved the construction of four pyramids on the grounds of the Archer's Club of Joliette using 3,500 maple tree sap pails. The people of Joliette and the members of *Les ateliers convertibles* worked together to construct the pyramids using nothing more than string and pails. It was a simple, yet ingenious, use of a common object that mobilized the community

5 The Mohawk Nation is a sovereign nation that is part of the Haudenosaunee Confederacy (an alliance of the Mohawk, Oneida, Onondaga, Cayuga, Seneca, and Tuscarora Nations). The Kahnawake, situated thirty kilometres south of the Mohawks at Kanesatake, blocked access to the south side of the Mercier Bridge, allowing only emergency vehicles to pass. The Mercier Bridge leads to downtown Montréal.

6 The word natural is used throughout this text to refer to a distinction between urban space and its periphery, so called natural space. Likewise the word nature is used in this text to signify aspects found in the periphery.

7 Sylvie Tourangeau, *Les ateliers convertibles historique* (Joliette: Les ateliers convertibles, 1996).

8 Established in 1983 under the name of *Les ateliers communautaires d'en bas*, *Les ateliers convertibles* is an artist-run collective that works from the concept of the "laboratory," privileging process, exchange, and group action. Suzanne Joly is one of its founding members.

9 Here I do not intend to claim that Joly is alone, nor that she has taken on the role of director or sole instigator. Rather it is precisely this working together with others, without seeking ego recognition, that I am naming as part of her artistic belief.

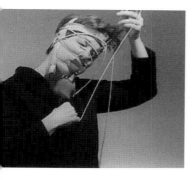

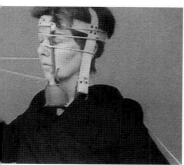

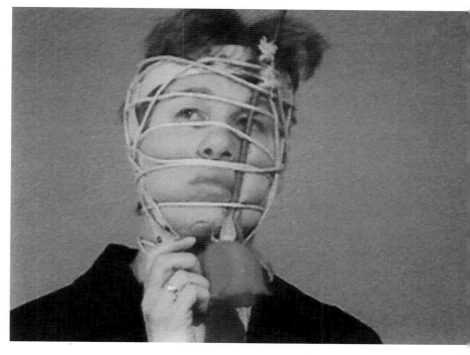

to work something through together (no one knew in advance how they were going to pile the pails one on top of the other without the wind blowing them down). It was a coming together of people for the sake of a common project — a project that activated values of community, process, and place.

displaced

Joly holds in her hands a glass measuring bowl that holds two litres of water. Inside the measuring bowl is a goldfish. It is 1989, one year before *Indiana TV*. This is Joly's first performance; the title is *Le poisson rouge*, and the place is the Musée d'art de Joliette. Joly plans to speak. She will talk out loud as she walks through the crowd. The text, the story of her goldfish — well, not a gold fish per se, rather a goldfish that is white, a goldfish that is at the Musée, a goldfish that has but two litres of freedom — will scroll by on an electronic word display. The performance space is in semi-darkness. Joly clasps her measuring bowl, her goldfish swims in circles. She walks slowly, trying to find her place, trying to speak her words. Language leaves her. She can only remember little bits of her story. She is trying to remember, trying to find her place. She finds herself standing next to the monitor as her story scrolls by. The room is silent. In her story, Joly wonders if her goldfish could

possibly be a victim of the place where it finds itself, if its capacity for intervention might be limited.

The physical place where one is situated in the world is not necessarily a location of choice. Places influence and interact with one's experience of the world. Although we may be or feel displaced, placed we are. In spite of the fact that Joly's performances often activate the actual of the context in which she finds herself — the known places and objects of her daily life — it is through a *déplacement*, one thing moved somewhere else, that she sets in motion her problematic. She is trying to re-find her place, re-articulate her place, for herself, for where she is.

body

In these two performances, Joly moves her body in relation to imposed conditions. She does not move her body in relation to an inner felt emotion, rather she moves her body in relation to the demands of the material world. She wants to feel her body, know her body, its limits, its potentials, its relation to itself and to the world. There is a desire to explore the functionality of this body in interaction with the world. To feel its presence, to make its presence known.

The sense of being bound, limited in movement, first by the fishbowl and second by the monitor, transforms itself over time into a greater sense of freedom. In later performances, objects come to serve as a prosthesis for the body, projecting the body into space, acting as an extension for a transformed relation between body and movement, body and world. Joly explores a sensual relation between her body and the material world around her.

Emphase et récupération, performed at La Centrale in 1995, requires Joly to relate, interact, and activate both made and readymade objects. Perhaps the most telling shift in Joly's relationship with space and movement is her manipulation of the monitor. Here, rather than holding the monitor out towards the audience, she picks the monitor up, moves it up and down her body, holds it over her head, places it at her feet, takes it into the audience. She is playing. Two water bottles are glued to an old eyeglass frame. The glasses are placed over her eyes, the water in the bottles pours out and down her face.

Joly is playing with how we see, with how the way we see affects how we are seen. We have been invited into the artist's atelier, her world. She takes us through a trajectory that activates her constructions, her innovative poetics of possibilities. Look what we can do with this, and with this. If I move my body this way, to do that, what will I see, what will I look like?

Dark earth is taken out of a white flour sack. It is poured out on the floor in a pile. Joly plunges her hands into the earth, feeling its weight, its texture. She stands up and puts her naked feet into the earth, covering her toes. She blows a duck whistle. The sound evokes laughter. She continues to blow, with more force, for a longer duration. Suddenly the sound is no longer funny, a line has been crossed, and the sound evokes a wail, an insistence on something.

SUZANNE JOLY *Indiana TV*, performance, Biennale d'art actuel de Québec, Le Lieu, Québec, 1990

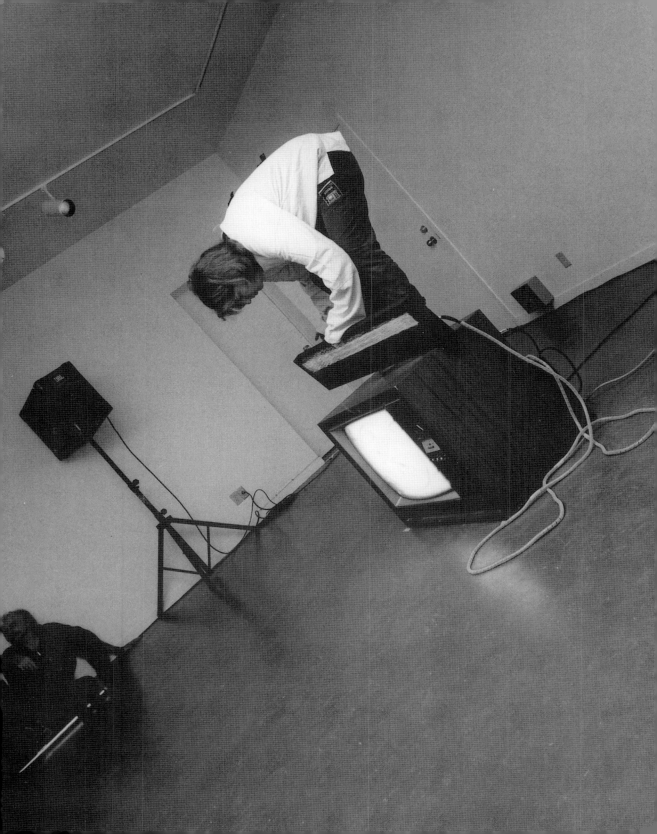

sound

In these early performances Joly employs sound. Words, objects, sounds — all have material qualities, all are objects to be manipulated, to move around, to find other meanings, other possibilities. A sap pail can become a pyramid, a goldfish can be white, a duck whistle can evoke pain. It is through sound, the elastic element that creates movement outwards, that Joly expands, and expands dramatically, her sense of reach. It is also through sound that a strong emotive connection is made with the audience. In *Indiana TV*, the audience reads the words scrolling by on the monitor. The audience hears the sound of their own internal voice speaking the affective first person text that is progressively drowned out by the sound signal and Queen's song. In *Le poisson rouge*, the words are both playful and emotive, the awkwardness of the fragmented spoken text made visible through the scrolling text. The audience sees the words that are impossible for Joly to recount, and this impossibility of speech renders the words with a greater emotive power than if they had been spoken. In *Emphase et récupération*, the sound of the duck whistle transforms the audience's initial reaction from laughter to sympathy.

Joly uses sound to access a connection to an inner emotion that is belied by her actions, and yet she does not dwell easily in this emotive space that she evokes. There is a sweet kind of awkwardness that is transmitted, as in *Emphase et récupération* when Joly, blowing her whistle, looks straight out at the audience with a kind of deadpan-comedic-face, and yes, the audience responds with laughter.

street

The 1999 performance *Beaupied* moves Joly into and through the street. She is part of a street parade that she has helped to organize through *Les ateliers convertibles* entitled *Et la caravan passe*. Joly has two twenty-foot wooden poles, which mimic the bendable joints of the body. She has attached two wooden shoe inserts (the kind shoemakers use) to one end of each pole; the wooden shoes are themselves attached to wheels. She holds the far end of the poles with her hands and pushes the poles that in turn manoeuvre the shoes on wheels through the streets. Her body moves in relation to the demands imposed by keeping the wooden shoes on the trajectory set out by the parade. She is having fun, enjoying being in community, enjoying this sensation of movement. Moving outwards into the street, into the public, into the site where space is negotiated, where space pre-configures the actions undertaken.

Seven years after *Indiana TV*, Joly again interrogates the economics of land use. It is now August 1997. *Les ateliers convertibles* invites thirteen artists to occupy thirteen parking spaces in downtown Joliette. The project is called *Art Parking*. Joly is one of the curators. She takes note of the "*petit bonhomme vert*,"[10] the one municipal car meter enforcer who zealously circulates to make sure that the artists stay within their allocated white lines. Not one centimetre over the line. Seven months later in March, Joly performs her piece titled *Le geste d'art est-il un fait divers ?* (The act of art, is it news?).

10 Ibid., Suzanne Joly, 45.

11 This action was performed during a workshop given by François Morelli who asked the participants to use a news article as a point of departure for an intervention in the city.

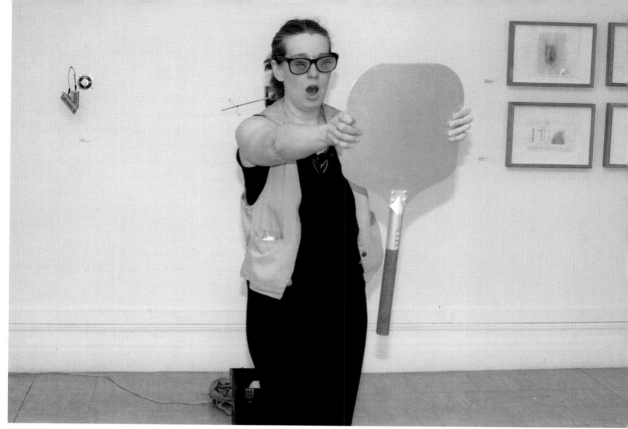

DANIELLE BINET

The act is to place a paper tag on the municipal car meters. The tag sports one word: *PAYÉ* (Paid). In fifteen minutes, armed with one hundred tags, Joly and the other participants dart from meter to meter.[11]

The authorities quickly remove the paid signs, the police state they do not know where the signs came from, and the public is advised to continue to pay for their parking, regardless of the signs. The local paper reports the event. Art, or at least this art, is news. But what is the news of? A kind of confusion over assumed conventions, a re-establishment of law and order.

Laws facilitate the performance of protocols that legalize the consumption of space. Later, in the performance *Un ouaouron dans l'étalement urbain* (A toad in the urban sprawl) (Le lieu, 2002) Joly plays a pre-recorded spoken text:

It is not so much the phenomenon that is so disturbing, but the way it spreads… Certainly those who spread themselves have money.

Yeah, we are the champions, my friend.

nature

Joly lives daily with the consequences of the influx of people from the city. People who come to Joliette, park their cars, live in a cabin, catch a trout,

SUZANNE JOLY *Je n'ai plus toute ma terre*, performance, Galerie Sans Nom, Moncton, NB, 1997

drive an ATV. People who want to escape the noise and stress of the city, who want to experience a connection with "nature." This land is my land, this land is your land.

Eleven years after walking through the Musée de Joliette with her goldfish in two litres of water, Joly is in Rouyan-Noranda as part of *Les yeux rouges 24 heures de performance et d'art action*. It is the first time that I have seen Joly perform. She is the last performer. It has been a constant twenty-four hours of performance and Joly is the last one. There is a hen.

We are all in a big tent. Most of us are sitting down on chairs; we have formed a kind of semicircle around Joly and the hen. The hen is on the ground. The hen has a water dish. Joly is on a chair. She has a megaphone. She is interviewing the hen. She is calm, focused, and matter of fact. She is asking the hen questions. Questions such as:

Are you for or against the changing temperature? word games? good intentions? Are you for or against artistic terrorism? active urban guerrillas? politically correct art? Are you for or against laziness? remarkable actions? explicit refusals?

In between each set of questions, Joly pauses, she manipulates an array of small metal objects. The sound passes through the megaphone that Joly has equipped with a contact microphone. She waits for the response from the hen. Sometimes the hen responds with its own sound, sometimes the hen is silent. Occasionally, the hen pecks at the ground eating the grains thrown there by Joly. I am fascinated by the relationship of the hen to Joly, by how it appears to be listening to the sounds that Joly is producing, by how a kind of rapport is established between the two.

I am intrigued by this woman who has the audacity to transport this hen here so that she could ignore us (the audience) and instead ask the hen questions. It is absurd. We laugh. Yet, there is something between this woman and this hen. I know she does not expect to find knowledge or confirmation in the responses the hen is giving her, but I sense an acceptance of the irrevocable difference between their two worlds. She is not pretending to be at one with nature, she is not pretending that she has some deep connection to this hen and its innate nature, and yet, here she is, asking this hen questions. Asking as if... as if a dialogue could happen, as if it is probable, indeed likely, that two living animals who respect each other will communicate. Are already communicating.

Once again, Joly brings nature into contact with culture. Or rather, Joly punctures culture's boundaries and places nature within. A goldfish in the Musée, a duck call in a gallery, a hen at a performance. Land is felt — black earth between the toes; politicized — the Oka crisis; and lamented — we have already paid the price.

There is, in Joly's work, a definite articulation of a sensual relation with nature, with earth. As though the natural physical world is something to feel, to explore, to become intimate with. She is a unique performer who is in her body, firmly here, and feeling her relation to where she is. She speaks what she knows, what she lives.

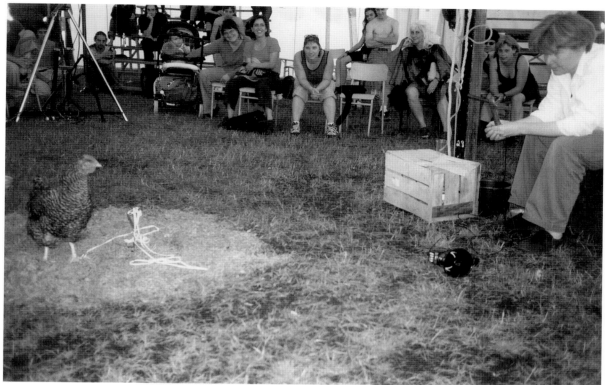

SUZANNE VALOTAIRE

is

In all of her performances, Suzanne Joly is Suzanne Joly. She uses what is around her, what she has, to create a poetics of the everyday. A pail that is used to collect maple tree sap becomes a pyramid, a story of a goldfish becomes an emotive metaphor, a water bottle becomes an eyepiece. The actual is used to create the possible. Things are arranged and rearranged to create meanings and trajectories. There is an ingenious simplicity that belies, and is perhaps in conflict with, the radical theoretical pertinence of Joly's work. But also it may be just this: that the radical nature of Joly's work lies in the insistence on everyday things, that it is indeed our physical daily actions that hold the deepest political significance for where we position ourselves in relation to each other in relation to our world. Joly has that ability, so needed, to speak what is here, what is now. I count Joly among the political poets precisely because she names what is.

SUZANNE JOLY *Entretien avec une poule grise*, performance, Les yeux rouges, Passart, Rouyn, QC, 2000

Margaret Dragu

Kiss & Tell

THEY KISSED, THEY TOLD!

Persimmon Blackbridge + Lizard Jones + Susan Stewart = Kiss & Tell (the famous Vancouver collective). They make Big Art. Big visual art, big books, and very big performances employing big images, big gestures, big passions, big issues, big ideas, and a very big engagement with their audience. Big Big Big.

Waiting in their Standing Room Only audience is like waiting for a rock band to hit the stage. Or for three superheroes dressed in traditional tights and capes, but their utility belts are armed with words. As B. Ruby Rich states on the back cover of *Her Tongue on My Theory*, "... the Kiss & Tell girls have got full command of both body and brain, and can they ever talk."

Describing a Kiss & Tell performance is like sharing last night's vivid dream with someone who is neither your therapist nor your lover. You gush inarticulately "... well, like, there are three women, right, and they talk and talk and, like, there are slides of the Berlin wall and dying flowers and, oh, yeah, a video of this painting and it is breathing, and, you know, these women are so funny — they tell real stories — sexy, sad, political — and all three of them are really, really hot" ... "Mmmmm," your non-therapist/non-lover says "... maybe you had to have been there?"... Imagine hearing this during *That Long Distance Feeling*, 1997:

Caught in the Act an anthology of performance art by Canadian women

"Bill Gates Monologue"

I read the paper everyday, everyday, everyday — first thing
Bad habit
but I need to know, need to know, need to know
read the first section first — world news, Canadian news, BC news
find stuff out — like that Bill Gates has a net worth of 55 billion dollars — that's
billion, billion, billion

Are these numbers just too big to take in?
This Bill Gates thing really gets to me
Why are we buying his stuff
wake up, wake up, wake up

BC says same sex spouses have to provide child support when they split —
just like straights —
Good news? Lots of people think so — equality under the law, same rights —
same responsibilities.

Wonder which of my ex's I should call. Karen, who saw me through some of
those early years. Great with kids but couldn't hold a job in her life. Maybe I
should call Flynn. After all we lived together for six years, almost all of the
elementary school years. Problem is she doesn't like kids — mine in particu-
lar. We had real clear boundaries — she paid her share and I paid the rest.
She didn't choose to have a kid — why should she pay for one. She's getting
a PhD in feminist theory — she should know.

How do you spend 55 billion dollars? What is the daily interest on an
account like that?

My new lover loves kids — problem now is that the kid in question hates adults.
People say it's the age — I say it's the culture. Hard to be a kid, hard to be a
kid, hard to be a kid.

What's the gross national worth of some countries ... like North Korea.
People are starving, starving, starving.

Maybe we should just give the world to Bill Gates — before he takes it. A
kind of Zen approach.
Feed the greed, feed the greed, feed the greed.
Until it turns into something else. Burns itself out, becomes enlightened.

Maybe we should just stop buying this shit. Learn to live without it, without
it, without it.
Single mothers could be the role models — they are expert at living without
it. Know how to stretch, stretch, stretch a dollar. Learn how to give without

a return.

Do it everyday. Live without profit, live without profit, live without profit.

No savings, no chequing, no RRSP. No assets, no pension, no mutual funds. No GICS, RIFS, CSBS.

No options, no job, no house, no old age security. No investment, divestment, annuity. No insurance, no stock, no bond. No collateral, portfolio, no money. No money, no money, no money.

Running, running, running on empty.

How did a sculptor (Persimmon), a photographer (Susan), and a visual artist/activist (Lizard) become a performance art collective? It is a thirteen-part mini-series to chart the union of the Princeton University philosophy graduate (Lizard), the civil rights anti-Vietnam activist (Susan), and the clinically depressed woodcarver from Long Beach (Persimmon) through all their adventures. One afternoon they landed in Susan's livingroom after yet another feminist art group had run its course. Persimmon and Susan looked at each other and at the babysitter Lizard and said. "Well, let's get started."

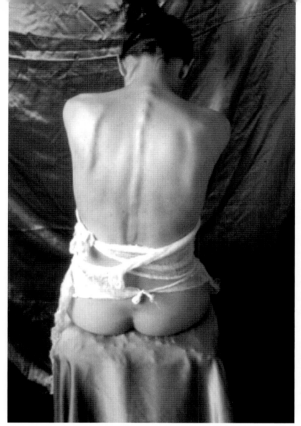

SUSAN STEWART

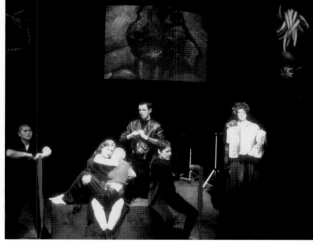

SHAIRA HOLMAN

There was no turning back. These are busy gals.

I caught up with Kiss & Tell in the spring of 2003 for a series of dinners, salons, and slumber and tea parties. I talked with them about their collective history and commitment to collaboration: what it is like to be called "popular" and "brave": and what art they are making right now.

In the summer of 1988, Kiss & Tell was permanently painted on the map for its groundbreaking, interactive, and controversial visual art show, *Drawing the Line*. The collective showed explicit sexual photographs of themselves and left empty wall space for the audience to write their ideas and feelings.

Kiss & Tell's photo images were partly documentation of their *intervention performances* (some performed in public and some in private) and partly a body-based but intellectually and politically incisive investigation of female sexual representation. Sexual representation of women (in popular culture and also the "by women/for women" kind) was the issue of that era. Lizard (then editor of *Kinesis* magazine) describes the feminist community then as "splintered, silenced ..." [and] "... few women had a voice unless they were a writer or a theoretician." The discussion around sexual representation could turn "vicious and censorious," continues Lizard. "There was no

KISS & TELL *Drawing the Line* (installation view), Amsterdam 1992

KISS & TELL *Corpus Fugit,* Festival House, Vancouver, 2002. Lizard Jones

KISS & TELL *Corpus Fugit,* Festival House, Vancouver, 2002. Left to right: Vanessa Kwan, Persimmon Blackbridge, Lizard Jones, Susan Stewart, Glenn Watts (Darlene)

place for lesbians into S&M, for instance." Sexual representation in all media from erotica to pornography and from advertising to fine art was an extremely divisive topic. However, accompanying the swelling of anger, confusion, and fear in the feminist community was also a need and hope towards making culture about longing and desire.

When Kiss & Tell gave a blank space for the audience to write back this gesture was gratefully welcomed and used at first by feminists, lesbians, and artists and then by a wider general public who in some cases was completely uninformed of the long, ongoing discussion about sexual representation. The need of the feminist community to open up discussion was intense and also coincided with Kiss & Tell's visual art show. The collective became a conduit for the change in dialogue about this issue. *Drawing the Line* with accompanying artists' talks travelled across Canada, the US and Australia and always met with a big audience with a big need to converse with Kiss & Tell.

Kiss & Tell was popular and controversial. Many members of the feminist, disabled, and art communities also called them brave. Lizard, however, doesn't think of herself as brave. "Brave? Not me. Some people think it is brave to perform for photos like in *Drawing the Line*. Or that it is brave writing a novel about my experience with MS, but neither of these is like taking your clothes off in a live performance — which in fact we have never done. I don't think it is important to do things just because they scare me. I don't work with that as a motivator at all. Sometimes my memory of what I have done is scary but not the actual doing it."

Susan literally snorts when I ask her about bravery. "When someone tells me I am being brave, I want to slap them. It sounds as if our work is all about vulnerability and personal disclosure and very raw. A lot of what Kiss & Tell does is about framing, conceptuality, and form. I am big into form!"

Persimmon was famous before Kiss & Tell because of visual art projects she had done about mental patients. "Yes, I am well known by mental patients everywhere!" laughs Persimmon. She feels being popular is a kind of validation. It lets the artist know that being an artist is not a weird or anti-social act but is connected to community. About the bravery thing, Persimmon claims, "I like artmaking to be fun and scary. Art is uncertain territory. But it is not the same as dying, breaking your leg, or losing your home."

"Coming to Calgary at the age of nineteen as an illegal immigrant during the Vietnam protest years," explains Susan, "was the bravest thing I have ever done. I was from a small rural town in Vermont. I had never travelled. I wasn't very well educated. But my identification with fighting for civil rights and the anti-war movement gave me passionate though incoherent political convictions and I just had to act on them." Susan studied with Colin Campbell at Mount Allison University and was introduced to time-based work like video and performance. Then she attended the Alberta College of Art where it was expected that students would choose and master one of the disciplines of painting, sculpture, printmaking, or drawing. "But I liked them all and didn't want to specialize. Also, there was no place for photography or

video at that time," says Susan.

"I realized I had two choices. I could have a place in the art world and base my art on pleasing myself and satisfying my own intellectual curiosity. Or, I could apply art energy to social change. I could have political convictions and act upon them in conversation with my culture and society. I chose the latter knowing I would be an outsider and marginalized. It was my choice."

The idea of artists operating in the margin or in a ghetto because their work is "identity art" is another hot topic. Persimmon laughs and says, "Well, there are ghettos and there are ghettos. Don't forget, the art world is also a ghetto." The criticism that Kiss & Tell only plays to queer or disabled culture is not my experience as an audience member. I took some single moms who don't get out much to a Kiss & Tell show and afterwards one said, "These women speak for me. About love. Divorce. Poverty. Death. In a way I don't see on TV or movies. I mean, I'm straight, they're lesbian. But they're talking about the big stuff here. Stuff that means a lot to me. It's my life."

"Loving Fantasy" from *That Long Distance Feeling*, 1997

You are weeping. You have been hurt by something in your life — a fall, your welfare worker,
someone on the street. You come home, lie in bed, weeping.

Your lover and another woman come into the room. Together they undress you, wordlessly.
They begin stroking your body.

"Beautiful, beautiful," the other woman says.

All of your body is charged by their stroking.

Suddenly, you are curious about every inch of your lover's body, the soft skin, the folds.
You want to touch and both women are touching you.

Their stroking becomes sharper, more focused. One of them is sucking your nipples,
one of them is licking your cunt. You can hardly stand the sweetness of it, the sighs, the sharpness of the small bites. You reach for each of them. You lie back and feel them on you, around you.
You feel fingers in you, the licking, the sucking. You are enfolded.

Much of what motivates the collective is "about speaking what had been a shameful truth," explains Persimmon. When Kiss & Tell started out, silence ruled. For queers, sex radicals, and people with disabilities — people who had been ridiculed, beaten, institutionalized — seeing a Kiss & Tell performance was a validation, an opening up. "It is still like that in some ways," says

SUSAN STEWART

1 Lizard Jones, interview with Margaret Dragu, (spring 2003): "...apocalypticism/end of the world/doom material in *Corpus Fugit* was/is a very important element of the piece for me, and consequently the focus of a year of work for my final master's project. For the record, the process of *Corpus Fugit* was what led me to examine the hopefulness in apocalyptic prediction, and why it might be so popular."

Persimmon, "but nowadays, the general public is consuming marginalized lives on talk shows and reality TV. We're now in a context where exposing what was secret or silenced is titillating entertainment. And so our practice changes, becomes more slippery. It is always changing."

Topics and issues in Kiss & Tell's performances and books change as the collective's lives evolve. All three are still lesbians; two are still disabled; two are still mothers; one is a single mom — but now they are older lesbians and older moms of adult children. Sexual representation and censorship are part of their work but so is death, war, the tyranny of multi-national corporations, spirituality, and transcendence to name just a few more. The topics and issues that motivate Kiss & Tell may change but their commitment to collaboration does not.

However, there is collaboration and then there is collaboration. Filmmakers and theatre artists claim collaboration as theirs, but just because you are making "parallel play" doesn't mean you are collaborating. Collaborating is more like really good sex — you can't tell where your lover's body and soul end and where yours begins — you can finish each other's thoughts as you freefall into something new. It is intimate, exhilarating, and generally (in the case of rock bands) fleeting. Once success enters, the band usually divides into star(s) and other(s).

Susan Stewart describes the Kiss & Tell collaborative relationship of fourteen years as a psychological, spiritual, and artistic journey. "We start by riffing off ideas from each other," says Susan, "but then begins the conversing, wrestling, and dealing with one's attachment to ideas. It takes time to process ideas collectively as you must go through a psychological and spiritual change. You must develop a generosity of spirit."

Persimmon agrees that the creative collaborative process is transformative and trans-figurative. "The thrill of collaborating for me is the way we all three are in love with both form and chaos. Our performances are unstable structures that create meaning by juxtaposing chaotic images and stories. Meaning is never actually defined/stated, never nailed into place. Everything is always shifting — like our lives."

Collaboration, they all agree, is full of stress from the inside and the outside. There is the long process of discussing, fighting, growing, changing, and creating something new. Frankly, they all agree that "The very thing you *love* about each other is the thing that also drives you crazy." Then there are the technical pressures. "There is so much to do," says Lizard. "I start off very high — okay, ready, let's go — but there are also so many practical things: audio recordings, meetings, tech schedules, and rehearsal. It is so hard!" Persimmon agrees, "There is always lots of tech, but none of us are supreme techies so this is another big stress."

Besides these internal pressures of collaboration, there are outside pressures as well. "Journalists don't understand what collaboration means," says Persimmon, "so there is another stress from outside to present our work as one person's piece with two others in it. This has happened to all

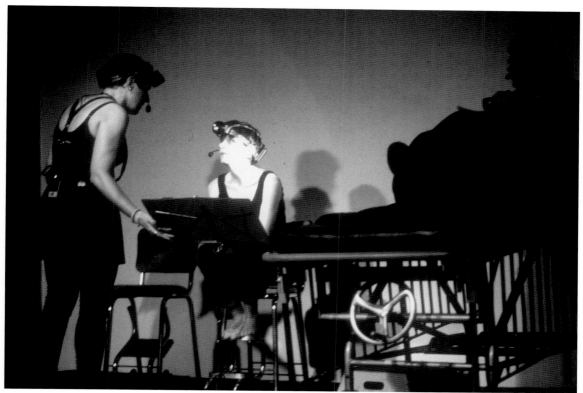

LORNA BOSCHMAN

three of us at one time or another. It is as stressful on the person being focused on by the media as it is to the other two."

Collaboration is also political. Susan says, "To abandon ownership which is so intrinsic to our culture is ultimately anti-capitalist and a profoundly political act." Kiss & Tell's commitment to the collective process implies a new way of producing — a creative process that is collaborative, democratic, and spiritual.

In fact, Kiss & Tell's last performance as of this writing, *Corpus Fugit*[1] (2002) is full of transformative and trans-figurative actions, images, and sounds: the breathing painting, the mask of death, red ribbons representing the heart chakra, chanting, and texts that illustrate how the artists negotiate the truly grey areas of ethics, politics, and art. Seeing and feeling the support of a father's born-again Christian community during his long death, the artist repositions her old feelings towards this right-wing and oppressive community to one that allows something more complex, confusing, and transforming to occur. Feeling both intrigue and repulsion for the Rapture cult, the artist folds it into her own stories:

KISS & TELL *Borderline/Disorderly*, North American conference of Art Librarians, Vancouver, 1999. Design by Persimmon Blackbridge, text by Lizard Jones

KISS & TELL *Borderline/Disorderly*, Video In, Vancouver, 1999. Left to right: Susan Stewart, Lizard Jones, Persimmon Blackbridge

"Rapture"

I loved her and she broke my heart, that's all I've got to say. I mean like I really loved her, like I laid my heart at her feet. And then she stepped on it, wearing baseball shoes with spikes on them, hundreds of tiny punctures all over my heart. Oh, the pain of it, I thought the world had ended.

But it was true, the world *had* ended. This was back in the time of the Rapture, great big fucking Armageddon that came with a whimper, like the man said, and then back to our scheduled programming. I was there, I saw it all, the divine simulcast, broadcast live all over the world. Distant thunder rumbling to a crescendo, the sky opening up and the heavenly host spilling forth with their big wings and golden trumpets.

Me and Ramona were down on Davie Street, trying to harass the manager at Club Vagina into giving her a gig. Ramona, that was my girlfriend, the heartbreaker. She played accordion and the manager didn't think he could sell it to his glam-house-cyborg-tech-rock crowd.

Out on the sidewalks, born-agains were falling to their knees, shouting Hallelujah, and waiting to be wafted up to the arms of the lord, while the rest of us sinners were looking at each other nervously like no way, man, this can *not* be happening.

Cause we all knew what it was. Even if you didn't watch the Rapture Channel on TV, or listen to Rapture Radio, you couldn't miss the billboards advertising the end, the "repent sinner" graffiti, the Rapture specials at MacDonald's with free plastic Rapture toys for kids, featuring Gentle Jesus, Archangel Mike, and the Beast 666.

Oh yes, we knew we were in trouble when the smoggy sky pulled back like a curtain, and Mike and Gabe and a crowd of chubby cherubim flew out. The born-agains were waving their arms in the air, praising the Lord and waiting to be wafted, but the angels just hovered there, looking down at us all. The cherubim were basically like you see them in old pictures: naked babies with wings and all their parts showing. But I mean *all* their parts. Apparently intersexed children have an easier time of it in heaven. As for the big angels, they were clothed in glory so it wasn't all in your face, so to speak, but Michael with his buzz cut hair, gelled back wings, and pouty mouth looked like the king of the boy-girls, and Gabriel was a queen of the old school, shoot me if I'm wrong.

Finally, the Archangel Gabriel spoke. "Oh shit," she said, and started to laugh. A few of the born-agains tried to laugh along, as if they were all hip to the big cosmic joke, but it was weak. Then Gabriel lifted her horn and the Rapture began.

It wasn't much: the kneeling believers knelt there, unwafted. Then, in New Orleans, but visible to us all, a single figure began to rise, floating up into the sky, looking a bit awkward, embarrassed even, clutching his trumpet. Wynton Marsalis. The heavenly hermaphrodites gathered around him, patting him on the back and getting him to sign their "Standard Time Volume III" CDs. Then the smog curtain fell and the show was over.

Most of the born-agains hung around for hours, waiting in vain for their turn, but the rest of us drifted off. The bar manager gave Ramona the gig.

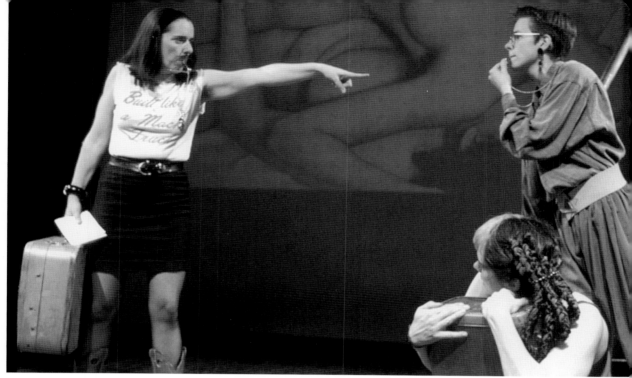

SHAIRA HOLMAN

"Whatever," he said, looking a bit stunned.

Like I said, nothing much changed. In the US, President Bush declared Armageddon was still imminent, so there was still no reason to worry about global warming. They nuked Jerusalem to protect the free world from the anti-Christ, unopposed by our Prime Minister, who cited religious tolerance. The Disney Corporation patented Saskatchewan.

But Ramona broke my heart. She kicked it down the street till she got bored with it, then she left it in the gutter for dogs to pee on. She crushed it like it was ice in her strawberry-mango smoothie, like it was a clove of garlic in the garlic press of love, that she squeezed and out came little red worms of squished heart. After I got her that gig and everything.

Persimmon, Lizard, and Susan have separate art practices apart from the Kiss & Tell collective. Persimmon sculpts, writes, performs, and develops community art practices. Lizard writes, performs, makes visual art, and is a well-known MC for large music events and festivals. Susan photographs, paints, makes videos, and teaches at Emily Carr School of Art and Design.

Often exhausted after a big Kiss & Tell production, Persimmon, Lizard, and Susan return to solo practice with a different energy. This allows them to evolve and transform. Separate activity renews and nourishes them. Inevitably, however, after some time has passed, there is a kind of yearning and desire amongst the three and there is the siren call to come together again.

They return to conjure their collaborative alchemy in the Kiss & Tell crucible.

KISS & TELL *True Inversions* Vancouver East Cultural Centre, 1992. Left to right: Susan Stewart, Persimmon Blackbridge, Lizard Jones

Marine Van Hoof | translated by Lauren Ravon

Sylvie Laliberté

LITTLE GYMNASTICS OF DESIRE

At the crossroads of music, theatre, dance, and the visual arts, Sylvie Laliberté's work can only be understood as "performance" if the term is taken to mean a conflation of genres. How can we characterize her work? By reminding ourselves that she has a theatre background, but she built her career within the realm of visual arts while continuing to express herself both through song and dance? And we should not forget the prominence of language in her work.

Sylvie Laliberté's first performances took place during the 1980s in collaboration with Nathalie Derome, an artist with a similar theatre background. In *Le précédent ou le fait brut de l'existence* (1982), the audience is presented with slides of the two performers displaying their musculature and a video portraying two women carrying out a variety of domestic chores in a kitchen. The gymnasts' movements are commented upon in English by a female voice that provides substantial anatomical detail. During the whole performance, the two artists can be seen lying on the ground perfectly still and dressed from head to toe in snow gear. *Ramdam pour Suzanne* (1983) consists of a series of acts in which the two artists call upon a number of images and clichés relating to women. Once again their movements are inspired by gymnastics. In a play on the singular and on the double [the solo

Caught in the Act an anthology of performance art by Canadian women

and the duet], Laliberté and Derome proceed in perfect symmetry while incorporating elements of sports and erotic play into their gestures. The soundtrack to these acts is composed of sounds and rhythms over which a female voice giving a stretching class can be heard. Abruptly and seemingly without reason, the two artists bring their singing, dancing, and running around to an end. The effect is comical but also somewhat puzzling. In *Beauté-boeuf* (1983), there is no search for symmetry, but the two artists continue to explore the theme of the two-way game with great complicity. Song and spoken words animate their bodies. Their gestures echo folk dance. Taking on the identity of two Russian peasants in search of the meaning of life, Laliberté and Derome are able to ponder human evolution with a certain irony. The performance then gives way to a degree of improvisation. At the heart of these three performances is an element of sensationalism. Ludicrously garbed and each interpreting multiple characters, the two artists consistently play on the burlesque. This is illustrated, for example, in their multiple entrances onto the scene. While there is an undeniable proximity between these performances and theatre, all conventions of the theatrical genre are brushed aside (absence of linearity, appearance of the artists both on the stage and on a screen). The physicality of these performances is strongly pronounced: all three works are inspired by clearly defined schools of movement (e.g. gymnastics, folk dance) which the artists then proceed to mock while also echoing feminist claims. From the outset, however, it is more about "reclaiming their status as women than adhering to feminism itself." [1] A strong focus on the socially constructed nature of the body and a disavowal of formalism are among the elements that define Sylvie Laliberté's work from her very first performances onward. Her tendency to reject the contemplative dimension of art through an assertion of the body as movement is just as central. And while the body may be defined through motion, it is also intimately linked to discourse: critical discourse.

As of 1984, Sylvie Laliberté decides to pursue her work alone so as to be "alone in writing." [2] Whether to imitate Marguerite Duras or to play out an anonymous phone call, Sylvie Laliberté explores song, dance, and spoken word in her 1985 performance entitled *Fish & fille*. She dances along to old tunes while interpreting a variety of female characters. "It is as a strange music-hall creature, phallus in hand, that she leads us to the most typical parody of theatrical seduction, using an extreme rhythmic text ... [The show] reveals an accurate picture of the main features of our time ... describes the 'I couldn't care less' attitude of the generation presently in its 20s and 30s ..." [3] With *Fish & fille*, we are "lured into a universe constructed in sequences, clarified through caricature, shot in close-up ..." [4] In 1986, Sylvie Laliberté calls upon Colette Beaudin to direct her work. *The champ du chameau* is a parody of cabaret shows in which Laliberté reflects upon issues of grief, frivolity, postmodernism, and the status of artists to name but a few. With neither scenery nor accessories, this sober performance serves as a direct indictment of the audience. It is with *La navette* (1986) that Laliberté resumes her commentary on male-female relationships. To a

1 Sylvie Laliberté, conversation with Marine Van Hoof, Montréal (June 5, 2003).

2 Ibid.

3 Sylvie Tourangeau, "Sylvie Laliberté : La Chambre Blanche" (translation by Francine Dagenais), *Vanguard*, vol.14, no. 7 (September, 1985), 44-45.

4 Ibid.

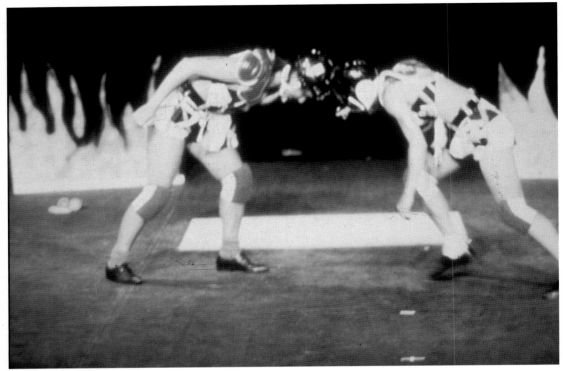

COURTESY OF THE ARTIST

5 Alain Chartrand, "Chansons d'aujourd'hui" (translation by Lauren Ravon) (November/December, 1986), 17-18.

6 Solange Lévesque, "Jeu" (translation by Lauren Ravon), in *Cahiers de théâtre*, no. 57.

tune entitled "Viens poupoule, viens," she plays out clichés of seduction in order to better ridicule them, inviting the audience to enter into her game. Her costume highlights the crudeness of the scene with its clothed front and its bare back. At this point, her show-performances take on an air of:

... cabaret acts in which entertainment and opinion both clash and coincide. Her modes of expression are modelled on daily life ... Her character holds together. Despite its ludicrous nature it rings true, quite unlike a role written to be performed. The ambiguity and uncertainty it generates serve to strengthen Sylvie Laliberté's allegations, add to their direct impact and set the tone for her relationship with the audience. Juggling words and ideas she sings as if she were reciting, most often without music but occasionally accompanied by a soundtrack ... Revolving within the realm of performance art, she bypasses all set-standards, clashing with the aesthetic reckoning and suspense the genre is known for.[5]

In *Abdomen et vulnérable* (1987), video images filmed in the studio are reworked in order to be used on stage. The artist makes use of a technique whereby the light from the projector follows the performer; a light that lingers on all or part of the body creating a more or less dramatic effect. Reminding us ironically that "women are fashionable," Laliberté reasserts

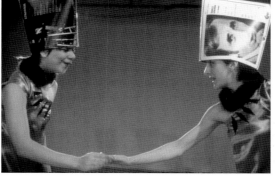

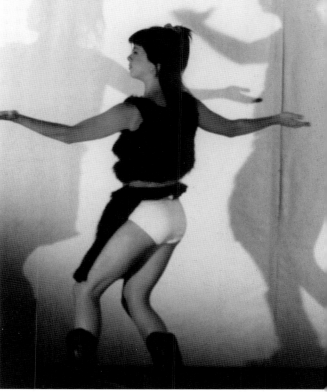

her claim that the body is culturally embedded ("I can't help my body from being social, public, and political"). In *Laliberté a du chien* (1990), she arrives on stage wearing a dress-shaped piece of painted cardboard with small rectangles that remind us of those used to fasten doll clothes. Underneath she wears a striptease outfit. The mix of fragility, novelty, and lucidity in Sylvie Laliberté's work has led her to be identified within the world of performance art as a "seismograph reacting to the slightest changes in our social and linguistic norms and systematically reminding us of the need to remain alert."[6]

As of 1996, Sylvie Laliberté alters her way of working. Without entirely giving up live performance art, she embarks upon the creation of videos where she films herself. Her technique is simple: in all her videos, the camera remains perfectly still while she animates the image solely through her presence. The ingredients from one video to the next are similar. Inspired by daily life and the domestic sphere, she tells seemingly commonplace stories which serve to denounce the cruelty of our world. As in her performances, she uses music and stories in her video work. Whether she is walking around with a wand in one hand searching for a better world (*L'outil n'est pas toujours un marteau*, 1999) or reflecting upon the meaning of life while sitting on an inflatable raft wearing a bathing suit (*Mes amis les poissons,*

SYLVIE LALIBERTÉ *Ramdam pour Suzanne* (duo with Nathalie Derome), April, 1983

SYLVIE LALIBERTÉ *Beauté boeuf* (duo with Nathalie Derome), February, 1984

SYLVIE LALIBERTÉ *Abdomen et vulnérable*, Festival International de Nouvelle Danse, Montréal, 1987

1998), her words, gestures, and attitudes all refer to the realm of childhood and provide charming lucidity to the so-called adult world.

Performing on a screen rather than on a stage does not appreciably alter the essence of Laliberté's work. With feigned innocence, she continues to discuss the (un)certainties of life while using all means possible to destabilize the spectator (visual, sound, text). What interests us most is to observe how she makes use of the videographic language to pursue her destabilizing enterprise, whether it is her constant stretching of the frame or her recurrent use of close-ups. It is easy to list some of the effects typically used during a live performance that can be transcribed onto a video screen. The artist can disappear and reappear at will, suddenly come to a standstill, partially disappear from the stage, or enter into a dialogue of gestures with the backstage that appears to be trying to snatch her away. By performing in front of a still camera, she is able to recreate the situation where the scene is being viewed through the eyes of a spectator. In many ways, her videos are made to resemble the world of the stage. In her video entitled *Oh la la du narratif* (1997), Laliberté relates her love story with a prisoner while appearing and disappearing from the frame, inserting stills into the video. As she mentions, she "is playing with and within the confines of the screen so as to express the extent to which love tends towards liberty." There is, thus, a continuity between the two types of performances (on stage/on screen). In her videos, Laliberté's gestures (dance, gymnastics) and the awkward framing of the image clearly suggest the vulnerability or possible faltering of the meaning. But it is a faltering of which she intends to remain the master (she actually says somewhere: "The frame? I am the frame!"). In her live performances, her appearances and her movements evoke destabilization as well.

It is interesting to look at the recurring use of close-ups in Laliberté's videos, for their effect is manifold. Close-ups help draw the spectator even more deeply into the sphere of trust (confidences) established throughout the performance. The close-up "contributes to the emotional reading of the video." [7] The deliberately awkward way in which the artist draws her face to the camera until it is deformed, changes the scale of the image and renders the situation more dramatic. It plays a crucial role in the narrative and formal framework of the video. Its effects are twofold: the sense of complicity between the artist and the spectator is reinforced and a quasi-physical contact, difficult to establish during a live performance, is enacted. *Bonbons bijoux* (1996) illustrates this perfectly. We see a close-up of Laliberté's mouth eating candy. Her mouth full of sugared almonds, she discusses girls' love for candy while stating that she is eating "bijoux" (jewels). Drowning in candy, the meaning of the word slides from the literal to the figurative. As the screen is invaded by Laliberté's loud and gluttonous mouth, the word becomes a barely intelligible "bizou" (kiss). Poised and self-possessed, Laliberté goes on to say that "Bizous (kisses) must be given by men. A man that gives you a bizou (kiss) guarantees you as a woman." The use of close-ups lends multidimensionality to Laliberté's images. A salivating mouth, a close-up of skin, suction noises,

7 Gilles Deleuze, cited by René Payant, "Les guerriers postmodernes" in *Études littéraires*, vol.19, no. 2 (automne 1986), 45-65. Réédité dans *Vedute: pièces détachées sur l'art, 1976-1987* (Laval, Québec: Trois-Rivières, 1987), 351-363.

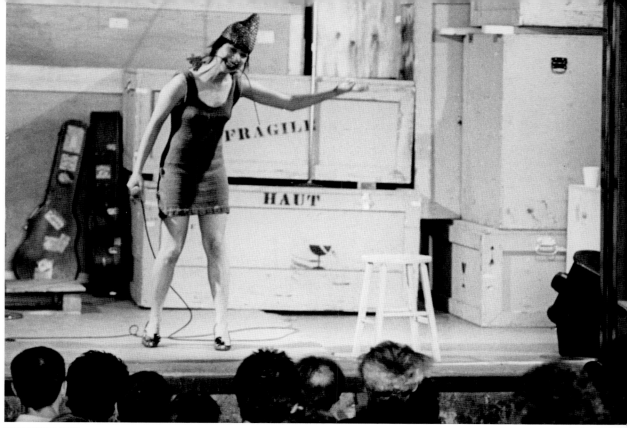

and sweet and sensual allusions to kisses: all kinds of means help dissolve language and the truths that language conveys. While language undeniably plays a central role in her work, one cannot ignore her tendency to explore all senses. Although this was already perceptible in her way of moving, dancing, and singing all at once in her live performances, it is amplified through her use of videographic language. In her attempts to dissolve all certainties, water reveals itself the perfect medium: *Mes amis les poissons* (1998) takes place entirely in a swimming pool. Surrounded by a plethora of aquatic accessories and seated on an inflatable raft, she utters solemn remarks that she then proceeds to short-circuit in a manner that is distinctly her own ("Infinity is unbearable although we need not bear it."). All the while she is wearing fake shark teeth. In *Papillon cerise* (1999), she lies fully dressed in a bathtub full of water, her head covered in foam, reflecting out loud on the invisible.

From the start, Sylvie Laliberté has held a distinct place within the world of performance art, due to both the multidisciplinary nature of her work and her refusal to be bound to one medium. Following in the footsteps of (mainly female) artists who explored video work through both a focus on the body and a use of the subjective camera, she ultimately settled on using

SYLVIE LALIBERTÉ *Babbling Blessé*, Musée d'art contemporain, Montréal, 1988

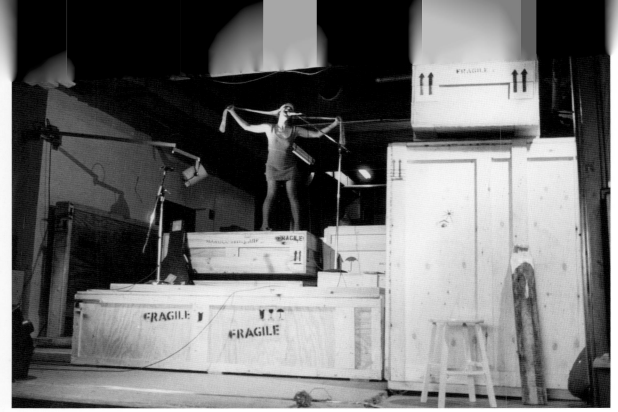

SYLVIE LALIBERTÉ *Babbling Blessé*, Musée d'art contemporain, Montréal, 1988

8 Communication during a round table discussion, "La place des femmes en art," at the Maison de la Culture Mont-Royal, December 7, 1999.

humour to express herself while playing on the ever-ambiguous relationship between humour and art. She embraces a low-tech aesthetic that she does not hesitate to use to mock the medium closest to video art: television. Her videos are full of sequences that critique the pseudo-objectivity of the world of television. Showing herself preoccupied by the spectators in whom she seems to confide innocently, she seeks to provoke her audience by having her stories hover over the threshold between autobiography and fiction. Multidisciplinary (over the last few years Laliberté has worked on a few installation pieces and drawings), her art always tends to draw us in deeper than what is announced: "I am not an art scout. But always a woman. I'm rather a Cadet of the forest." [8] And in the vast forest of performance art, a Cadet has been born that will scare away many wolves.

Johanna Householder

Frances Leeming

DOMESTIC GODDESS

I guess I start thinking ideas ... things that are troublesome, worrisome ... I've always been interested in gender and the female and how she is faring at any given point in time. And so I guess that's the content ... using myself as a character, being able to take on different aspects of my gender. I work things through that way. Most recently, though, (because this doesn't [just] have to do with performance, but it has to do with the ideas in my art practice) my focus has been around the body and the early political urgency of being denied access to your own female body through anti-abortion movements in the 70s and 80s. Having grown up when ... you couldn't get an abortion (if you did your life was in jeopardy, if it was an illegal abortion) — that fear, that trauma as a high school girl ... has a lot to do with how I resist or get upset about laws and fundamentalism. And how those two converge and battle it out over the female body ... Recently I've turned it into a theme park, and that's where it's all taking place, in the films. Sea World is the pregnant body and it's like the dolphin act and there are commentators and audiences and everybody is watching.[1]

Frances Leeming does not suffer fools gladly. She is barely tolerating Harvey Chao, who is tying balloons to her hair for a "Samurai Haircut." Her butter-wouldn't-melt composure is holding us, her audience, in place, transfixed.

1 Frances Leeming, interview with Johanna Householder (August 5, 2003).

She's seated on a stool with strands of her hair attached to pink balloons floating upwards. It's August 1978 in a group show called *Stranger in a Strange Lands(downe)* at the Landsdowne Artist Collective. Also on the bill are George Manupelli and me. I don't remember the details of my own performance, but I do remember Leeming's striking self-possession. She's suffering an indignity with such inflexible grace, that maintaining dignity becomes the subject.

"At least I have my dignity," the mothers would say, but it gradually became apparent to the daughters that they had precious little else under their own control. Power over the decor and the decorum of the family — but no *real* power; not even power over the boundaries of their bodies. The time was the 50s making its way to the 70s via a prolonged marketing campaign, selling the nuclear family and all its trappings, on the one hand, and a bitter political struggle for civil and women's rights on the other. The *very idea*, that anyone — or any state — would contest the right and ability of women to choose, to make choices, or to be perceived as less capable of making decisions, is a central flashpoint for all of Leeming's work.

This frustrating state of affairs wasn't lost on the young Frances. Exercising control over her limited domain, she took up paper dolls and puppets with a monarch's vengeance. The paper dolls continued off the page and along the walls, in long narrative murals, precursors to both her performances and her films, and puppets and puppet theatre turned up again and again in a variety of guises. "In high school, I specialized in art, but it was taught in such a way that there was no connection between what was happening around me — the social moment — and the stuff we were doing, and I needed to find out what was going on..." [2]

And so, using a pair of sharp scissors, Frances cut herself out of suburban Etobicoke, being especially careful with the hair, which, as anyone who has cut out paper dolls knows, is the tricky part. She went to York University and when in the second term she became a student of George Manupelli,[3] the possibilities of performance opened up to her:

I met George Manupelli and within ten minutes I realized that there was another art I didn't know about. And that was the thing that I should have been doing because that was the thing that was relevant. So it was like a transformation, it was one lecture, one afternoon. It changed my life. And after that I did performance. And even when it was a painting class, I did performance. Even when it was a drawing class, I did performance. (laughs).[4]

There was also a quality to Manupelli's work that influenced her, a characteristic that one can detect in her later work. Leeming says the following:

... I loved his work when I saw it. The reason I thought it was so important was that it contained humour and humanity. There was this deeply emotional, self-deprecating but generous quality to the work ... And I just thought that that was amazing.[5]

She worked with Manupelli, and with graduate student, Harvey Chao, and performed in the events of the Maple Sugar Collective, a group primarily

2 Ibid.

3 George Manupelli is an artist, filmmaker, and professor who influenced such female performance artists as Pat Olesko and Tanya Mars when he taught at the University of Michigan, and Frances Leeming, Wendy Knox-Leet, and Johanna Householder when he was at York University. He performed with the Once Group (Robert Ashley, Gordon Mumma, et al), and was active in new music circles through his relationships with Ashley, James Tenney, and David Rosenboom. He made a series of films, the Dr. Chicago films with Alvin Lucier and he founded the Ann Arbor (Michigan) Film Festival in 1963.

MARS: Did you know that I had George Manupelli at Michigan?

LEEMING: I know you did.

MARS: Isn't that bizarre.

LEEMING: It's amazing.

MARS: It's such a small world. He changed my life too.

LEEMING: You know exactly what I mean then.

4 Frances Leeming, interview with Tanya Mars (April 2003).

5 Leeming, interview with Householder.

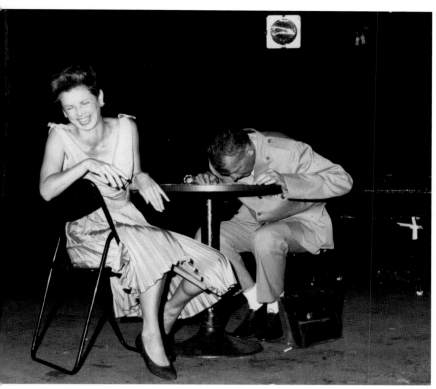

ANGELO PEDARI

COURTESY OF THE ARTIST

made up of York faculty and students, organized by composer David Rosenboom and singer Jacqueline Humbert. Humbert describes the work with the idealistic enthusiasm that the "new" medium of performance art generated at the time:

[Maple Sugar fostered] a serious interest in the process of composition of collectively generated presentation formats. These formats arose from an attempt to de-emphasize production of singular pieces that ... were identified with single individuals. Rather, we... became interested in a shift of consciousness and concentration to the new whole that arose out of separate contributions to a coherent train of thought or developing ideology which transcended focus on uniqueness. This type of presentation gave a forum for what seemed a more true representation of the artist's position in a community in the process of evolving ideas collectively. The traditional artist's concentration on the static art object is in direct opposition to the idea of the collective and contributes to the misconceived elevation of the artist as a loner in a unified world ...

In music, the idea of collective improvisation is well known ... The artist who, in the past was primarily concerned with space or light, has become more and more interested in the dynamic qualities of time, which, of necessity,

FRANCES LEEMING and **CLIVE ROBERTSON** as Oliver and Mrs. North, lip sync *Quest for Fire* for The Clichettes' benefit at the Rivoli, Toronto, August, 1984

FRANCES LEEMING and **DAVID PORTER** *He Was on the Make, But She Was on the Bake!!!* Performance poster, Mercer Street, Toronto, 1978

includes the idea of growth from nothing and eventual disappearance.[6]

The fluid participants of Maple Sugar put on a number of events from 1975 to 1978, culminating in a large performance at The Kitchen in New York. For her part in this group work, Leeming sat in a chair with cut-outs of lips, eyes, and hair cut from magazines and composed collages with her own face.

In 1978, she began collaborating with David Porter, whom she had met at York, on a series of performances that took as its subject that murky domestic 50s to 70s ethos. With Leeming in her trademark sheath, apron, and heels and Porter in a suit, *He Was on the Make, but She Was on the Bake* was about gender difference, but in the most general and broad sense. At a space on Mercer Street, they divided the room in half with a sheet like Claudette Colbert and Clark Gable in *It Happened One Night*. Porter's half of the room was an office set up with a large desk where he spent the whole time trying to hang himself with his tie; jumping off the desk and trying all kinds of ways to end it all. On her side — in her first use of the blender as the quintessential household object — Leeming did a sort of blender gymnastics. There was a slide show of food; more and more elaborate kinds of desserts were projected, as Leeming told a story about the first time her mother tried to bake a pie.

Leeming performed the blender dance again in *Rötten Kunst* (1979), a collaboration with George Manupelli, Eugenio Tellez, and myself at the Music Gallery in Toronto. In retrospect, one might consider the blender as a metaphor for Leeming herself: vase-shaped, seemingly domestic, but potentially quite dangerous, with an ability to be violent while in the service of others, or in the creation of pleasant things. There is an internal turmoil brewing, but it's sheathed in a finish that matches your kitchen decor. When Leeming and I worked together later, we took as a kind of motto a cartoon of two woodland bunnies with the caption: "I know we're not a threat, but it would be nice to be perceived as a threat."

In January 1981, Leeming and Porter made *The Spirit-Controlled Casserole* an "extraction"[7] from a Dot and Gaynor Maddox LP ("New York's famous cooking couple"), that Leeming had unearthed. They took the Maddox's shtick about pleasing the guests verbatim and delivered the lines live. In their version, a socially élite gourmet couple travel around the world collecting recipes and cooking utensils (stops include the Vatican). Also art lovers, the pair have a roped off collection of forged abstractions, which they enjoin their guests to admire. Theatrical but not theatre, narration but not narrative, characters but no acting, this performance drew as deeply on the sitcoms of the 60s as the arm-biting of Vito Acconci (Acconci's piece was after all titled *Trademark*). Leeming and Porter were expanding what had become the formal constraints of performance art to embrace the lives of their parents, and themselves. Leeming's strategy of mining the deeper seams of popular culture, looking for the coded messages in seemingly banal material has been a consistent vocation.

Leeming and I collaborated in *Home on the Rage* (1981), the first in a trilogy of "microdramas" that featured a miniature mansion. We felt we needed

FRANCES LEEMING and **JOHANNA HOUSEHOLDER** *Home on the Rage*, performed by Frances Leeming, Toronto Dance Theatre, 1981

6 http://music.calarts.edu/~david/writings/ articles_docs/Maple_Sugar. The website gives a list of all the Maple Sugar participants.

7 Leeming, interview with Householder.

Caught in the Act an anthology of performance art by Canadian women

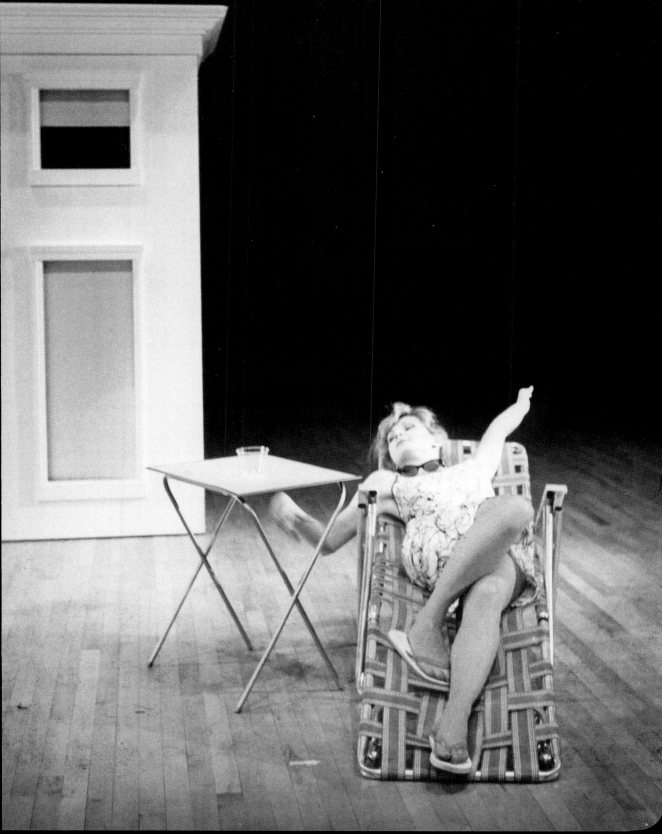

complete control over the performance environment; and we also wanted something completely portable, something that we could eventually tour. Leeming had found a tabletop cardboard dollhouse, but by the time we both tried to get inside this notion of domicile, we had reconceived the piece around a 6 x 7-foot Palladian plywood house,[8] a not-quite adult version of a dollhouse. The house was animated by the performer who activated it from the inside — the windows had roller shades and the sides were made of three-way stretch girdle fabric. Eventually it was put on large casters so we could wheel it around the space in a crazed choreography, set to the theme music from *The Fugitive.* We used hyper-melodramatic lighting and music to infuse the scene with roiling emotion, creating a place in which the house and the woman were equivalent. The house-body and the woman-body zoomed around like animated characters performing magic tricks which were all "ta-da" and no magic: Leeming was master of the lawn chair and cocktail shaker. We saw the ominous threat of domesticity as a nightmare from which we felt we might not escape.

We went on to make *See Home Run* and *If you lived here you'd be home now*, in which women and house continued their fraught relationship. (Both were performed at Mercer Union, and in San Francisco in 1982). In *See Home Run*, "the Home in question takes on a life of its own forcing its occupants to adapt to life in surreal circumstances. In this piece, the occupants of a miniature Georgian mansion perceive ominous winds of change. They awake to find a small mud hut has attached itself to their home. The hut appears to bring with it realms for knowledge and power, which drastically affect life in the mansion."[9]

Leeming always projected an organized and controlled exterior, barely exposing the effort of concealing a profound bewilderment at the existential demands of modern life. In *If you lived here you'd be home now*, she enacted a spoof of Jackie Kennedy's tour of the White House, and the Jackie persona suited her perfectly; commandeering the media with her soft but insistent voice.

In 1983, she and I worked together again on *Undue Force*, for the Contemporary Art Center in New Orleans. This collaboration explored our observations on life as a crushingly overwhelming but basically silly ordeal. Comprised of slides, found audio, a breakfast of exploding cereal, and a phone-in hotline for cooking a Thanksgiving turkey we composed a series of scenarios in a ritual setting. A background slide montage of over-the-top magazine advertising imagery accompanied life lessons in dog training, flower arranging, interior decorating, home security, and a Miss Canada pageant summarized by an exquisite knock-off of Lady Diana's wedding dress which Leeming had made from brick-pattern Mactac. The performance sensibility alluded to a deep well of instinct, intuition, and native intelligence completely baffled by sequences of unnecessary life instruction.

In considering Leeming as collagist and collaborator, one might think about what the two have in common. It might be the recognition that there are autonomous elements, sometimes human, sometimes cardboard, with

8 Designed by architect Paul Oberst and built by Rick Waern.

9 www.mercerunion.org (Johanna Householder and Frances Leeming, April 18, 1983).

10 Leeming, interview with Mars.

Caught in the Act an anthology of performance art by Canadian women

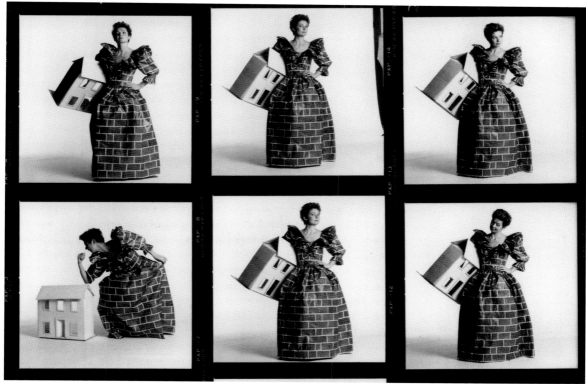

which one can share the stage. For Leeming, there is the strong impulse not only to recreate, but to improve the readings of popular images by providing new contexts:

I like the idea of a stage. And I like the idea of a contained space. And I like an audience. Ambiguity is not something that I do well with, I like narrative and I like to direct people specifically to what I want them to look at. So in that sense all of the components are there for a theatrical event. Quite literally as well. I often use curtains, red curtains coming up and going down. Sounds from the orchestra pit even though there is no orchestra pit. I put my own audience in if there isn't one, so that I have my applause built in.[10]

In *Finding Faults in the Firmament* (1986), Leeming introduced film into her performance using Pathé newsreel-type footage of natural disasters projected onto a cardboard house. She enacted a number of vignettes within the performance:

There was a clump of trees that I hid behind for the first story. And [for] the second story there was a little red curtain that was suspended from the ceiling and just covered my head and nothing else. And the third one was a little tiny white house. So these were the lit sets... that I would go to during the performance. I did a history of the world, coming up from the primordial

FRANCES LEEMING in her Lady Diana wedding dress made from brick pattern MacTac, 1983

mist ... I sat in a chair behind the red satin curtain and then you heard the orchestra warming up. And then I slowly opened the curtains and what you would then hear was the applause from the audience, and I bowed graciously. I had a little puppet dressed as a cowboy and he was my other actor, and we had a [lip-synced] conversation ... an excerpt from *The Misfits*, where Clark Gable and Marilyn Monroe meet in a bar. And so he was Clark Gable and I was Marilyn Monroe and we talked about jobs and women and the fact that she was a teacher was sort of not taken seriously by him and he was sort of mocking her ... and when that was finished ... I cut the curtains down and they fell to the ground and I went on to the next thing.[11]

The piece concluded when the miniature pine forest in front of the house went up in actual flames.

The notion of a dollhouse or playhouse expanding into a space for performance and theatre was elaborated later in Leeming's collaboration with Clive Robertson. They constructed a "portable theatre" which was conceived as a travelling performance space. It was put to use in 1989 for *The Sinking of the Gigantic*, in which Robertson and Leeming made a formidable farce of artist-run life (with Kareen Jackson, Dennis Tourbin, and R.N. Schacter). Leeming's performance was acting at its most Brechtian, an artist playing the role of an artist rising to the bait/job, and taking over the directorship of an artist-run centre. In scene two, she's the artist Gabrielle trying to escape from the desert to Paris in an excerpt from *The Petrified Forest* and finally, hilariously, she's a *Money Matters*-type host advising entrepreneurs from her porthole on the sinking Gigantic. The scenario and scenography were deeply laden with the loving irony of political cabaret, but the portable theatre and its contraints clearly presaged Leeming's developing filmic sensibility. In 1989, Leeming quit performing, finding that she no longer knew where to go with it:

Part of the frustration is that you have to travel, you have to constantly be there with your work and so there were two things really: What does it mean at this point? and logistically is it worth it? I was able to find my way to collage and filmmaking at that point ... Intellectually I was putting all of the ideas into another form ... the medium [film] also allowed me to have things distributed without having further responsibility ... The transition took about two years, but once I made the transition, I continued for another ten years with this idea of film only, and collage.[12]

Leeming's best known film, *Orientation Express* (1987), was made with stop-motion animation of collages she contructed out of "thirty years of domestic and nation-building images" culled from the pages of *LIFE* magazine. With narration by The Quaker Oats man, Colonel Sanders, and the Kool Aid jug kid, *Orientation Express* is "a rocky ride through conservative morality and pompous patriarchy."[13] Leeming describes this aspect of her practice:

Well I feel a bit schizophrenic, on the one hand I kind of deal with the domestic and the mundane, but on the other hand I have this real need to be political in an overt way, I was certainly doing that with some of the performance pieces. But it became a lot more overt in the film. And so when

11 Ibid.

12 Ibid.

13 Women Make Movies: www.wmm.com.

14 Leeming, interview with Mars.

15 Alain-Martin Richard and Clive Robertson, *Performance Art in Canada, 1970-1990* (Québec: Les Éditions Intervention, and Toronto: Coach House Press, 1991), 159.

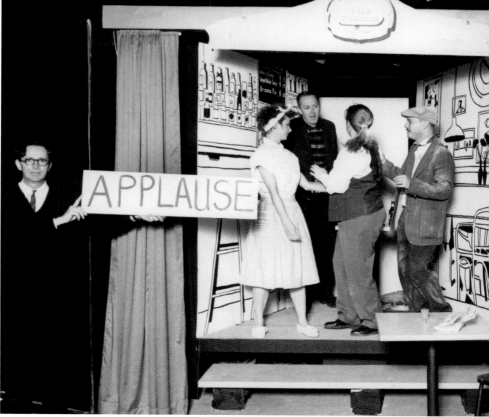

I found out about people like John Heartfield … the sort of collage, and the power of juxtaposition in a political climate, its function and how it is a political act, and I didn't understand that until long after I'd started making collages and reading about earlier avant-garde practice within a political context. So that was another tangent that was solidifying for me … understanding the history of what I was doing, so Hannah Hoch and John Heartfield were important to get my compass straight.[14]

She decided to get her MFA, after she had been teaching film studies for about five years at Concordia. And then in 1999 she moved to Queen's in Kingston with her partner, Clive Robertson. Recently they formed a collaborative performance group:

In retrospect, my performance pieces were often about the hypnotic marketing of a suburban culture as it rocketed from the 40s to its wannabe extremes of the 80s, so it dealt with the absurdities/celebration of a gender-constructed social life from adolescent hunger to middle-age nostalgia. The results approximated a Jacques Tati film (bewildered bafflement) projected onto a Canadian screen (innocence) controlled by USA Inc. (malevolent capitalism).[15]

JOHANNA HOUSEHOLDER, GEORGE MANUPELLI, FRANCES LEEMING, and EUGENIO TELLEZ *Rötten Kunst*, the Music Gallery, Toronto, 1979

FRANCES LEEMING performs blender gymnastics in *Rötten Kunst*, Music Gallery, Toronto, 1979

FRANCES LEEMING and **CLIVE ROBERTSON** *The Sinking of the Gigantic*, SAW Gallery, Ottawa, 1989. Left to right: Dennis Tourbin, Frances Leeming, Clive Robertson, Kareen Jackson, R.N. Schacter

Ahasiw Maskegon-Iskwew [3]

Cheryl L'Hirondelle Waynohtêw

WAYNOHTÊW[1] AND THE ÂPIHTAWIKOSISÂN[2] INFILTRATION OF DEEP STRUCTURE

1 Waynohtêw *animate verb*: he or she returns.

2 âpihtawikosisân *animate noun*: halfbreed, Métis.

3 3.1 âhasiw *animate noun*: crow. In some *nêhiyawi-wîhtamawâkanak*, the words for crow: *âhasiw*; and raven: *kâh-kah-kew* are interchanged, primarily a north-south or Woods Cree/Plains Cree linguistic difference with variants.

3.2 maskêkiy *inanimate noun*: swamp, bog, muskeg.

3.3 iskwêw *animate noun*: woman.

4 Rita Joe, "Klu'skap-o'kom," in *Native Writers and Canadian Writing (Canadian Literature Special Issue)* edited by W.H. New (1990), 122.

KLU'SKAP-O'KOM*
I left a message to nikmaqq‡
In the caves of stone
My home
The message say I go away
But someday return,
And the sun will again shine
Across the trails
My people walk.

*Klu'skap-o'kom — Klu'skap's home.
‡Nikmaqq — My friends or Micmac.

In Cape Breton, Nova Scotia, there are caves at a place, Kelly's Mountain, where the legend says that Klu'skap left and will return someday. The place is beautiful in the rising and setting sun, hence the legend the Micmacs passed from generation to generation. The $46-million quarry nearby may destroy the caves, and the legend will only be a story of our past; as always this usually happens.[4]
— RITA JOE

Performance art exists by rumour, as a contested set of practices that change according to context. The act, the gesture, the presence of a performance completes itself long before its consequences can be measured or fully appreciated ... In this sense, all performance can be said to be legendary...[5]
— PAUL COUILLARD

As a performance artist, actor, musician, and computer artist, Cheryl L'Hirondelle Waynohtêw crosses many boundaries in her explorations of *âpihtawikosisân* identity. Many half-breed cultures revolve around layers of conflict and negotiation, connection and rejection, both overt and internalized, originating in fundamental elements of sexuality and cultural relations but (or perhaps therefore) relegated to cultural margins. This is especially so in colonial contexts where the theatre of power relations is often that of sexuality and gender.

Waynohtêw's work maps out her search for the deeper elements of human experience that express the specificity of her own cultural dialogues but that are also fundamental to similar expressions of conflicted space in other cultures. She uses her understanding and ongoing investigations of the *nêhiyawiskwêwak*[6] world view as a lens to interrogate other cultures, searching for creative evidence of the deep structures in the diasporic experience of many kinds of miscegenous communities and the commonalities in their struggle for personal and communal self-determination.

Why should she choose to follow the cultural path and use the tools of the *nêhiyawi-wîhtamawâkan*[7] as a basis for her learning and working processes? Parallel to this, why should she feel that some of her closest contemporaries and peers are those she has met and worked with in creative communities across Europe but few in Canada.

On the one hand, it is about sharing and respect. This requires a commitment to persist in the too often one-way process of cultural and etymological translations between colonized and colonizer — always required to be bicultural and bilingual against and within a complacently monolingual cultural monolith. Many Europeans are very familiar with this conflict and negotiation process between and within their own cultures, and against that of the American cultural and political juggernaut.

The non-Aboriginal Canadian arts community, however, continues an insecure insistence on self-referentiality that generally revolves around a comparative competition for higher standing on the world stage (first-world Euro-American).

Almost no non-Aboriginal institution of higher learning requires knowledge of Aboriginal culture or history for the acquisition of professional credentials for mainstream cultural practice. No major cultural institutions require it of them as a factor of professional standing, and Aboriginal professionals among their ranks are just barely emerging from positions of tokenism or temporary employment in these contexts.

But many non-Aboriginal Canadians are beginning to rebel against the cultural poverty and neurosis of their unwillingly imposed roles in the ongoing

5 Paul Couillard, "Editor's Introduction," in *La Dragu: The Living Art of Margaret Dragu* (Toronto: Fado Performance Inc., 2002), 7.

6 nêhiyawiskwêwak *animate noun*: Cree women, Indian women [sic: -i-].

7 nêhiyawi-wîhtamawâkan *inanimate noun*: Cree etymologies; Cree teachings.

8 In the educational system, non-Aboriginal Canadian children are well protected from the evidence of complicity in colonial oppression while at the same time being equipped to carry on with it through overt, institutionalized, systemic, and subliminal messages that maintain the image of Aboriginal culture as an unwelcome, uncooperative, and disabled other, if they get any messages about Aboriginal people at all. An extensive analysis of how this phenomenon operates in Canada is provided in a report by the Coalition for the Advancement of Aboriginal Studies (CAAS). They examine Paulo Freire's (Freire, 1971) theory of the pedagogy of the oppressed as a starting point. CAAS (Coalition for the Advancement of Aboriginal Studies), ND [2002]. *Learning About Walking in Beauty: Placing Aboriginal Perspectives in Canadian Classrooms*. Report prepared for the Canadian Race Relations Foundation (CRRF) 2002: 39-40, 44. www.crr.ca/EN/Publications/ePubHome.htm.

colonial project. Numerous alternative artists, arts organizations, and some notable intellectuals have formed complex, multi-mediated, and long-term alliances with the Aboriginal arts community — alliances that have required active, participatory learning and that will continue to generate productive collaborations and mutually enriching professional relationships.

Opportunities to participate in the generation of this legacy are not available to all and the cross-cultural transitions and migrations required of Aboriginal people in their negotiations and confrontations with dominant culture are often accompanied by cultural losses and scars. Yet, for the most part, they are still quick to insist upon ancient traditions of sharing and respect. Author Mike Patterson writes:

Wilf Peltier once told me a story about when he was a young man in a council of elders some thirty years ago in Morley, Alberta. Some of the older men were opposed to letting white people into an upcoming gathering and ceremonies. Joe Mackinaw stood up to speak and said: "Look at the trees in the forest: The pine, red cedar, the birch tree, the yellow poplar. They all live in the forest, all are welcome. They do not discriminate. I cannot discriminate either; all are welcome in my lodge." Later, the older men again raised their objections to whites being welcomed, and Wilf stood up and said: "Did you not hear what Joe Mackinaw said?" and the council fell silent for a long while." The "Native Code of Ethics" developed by Georgina Toulouse of Manitoulin Island includes 1. Giving thanks, 2. Respect, 3. Honesty, and 4. Sharing (honour your guests).[9]

On the other hand, Waynohtêw's choice of path is about the continual rediscovery of, and immersion into, the great beauty of *nêhiyawîhcikêwin*[10] combined with the knowledge of the sneak-up[11] of deep cultural loss that has occurred in other Aboriginal cultures and for many *nêhiyawewak*[12] as well.

Writing for a non-Aboriginal audience (still assuming perhaps that it was the only audience) and with a bit of the lazy and self-satisfied naiveté evident in non-Aboriginal scholarship in the late 80s — but also with surprising and all-too-rare levels of generosity and understanding — Robert Bringhurst expresses this conflicted experience in his study of the last anthropologically collected Haida language narratives. The ability to make multi-level critical connections and comparative valuations is not unique, but Bringhurst's approach was uncommon in his decade (and still is) for the directions to which he put it:

... it seems clear that Haida oral literature had the monumentality, subtlety, gravity, restraint and the sly and involuted humour of Haida and Tlingit visual art... The best of the extant Haida narratives, like the best of the extant rattles and poles, are as the Haida say, *nágwighagwí q'itá*: they are fluently and deeply carved ...

Much as I revere the work of some of my elders and colleagues among colonial Canadian writers, I do not see that any of us has produced anything better — anything more deserving of close contemplation, discussion, and praise — than those stories told by ancestors so close I can touch their graves, I can drink from the streams and eat from the waters and forests

9 Mike Patterson, *First Nations in Cyberspace: Two Worlds and Tricksters, Where the Forest Meets the Highway*, Ph.D. Dissertation for the Department of Sociology/Anthropology (Ottawa: Carleton University, 2003), 5. www.carleton.ca/~mpatters/soc.html.

10 nêhiyawîhcikêwin *inanimate noun*: the Cree way, Cree culture; Indian culture [*sic; cf.* Nêhiyawisîhcikêwin-].

11 In the Powwow, the *Sneakup Dance* follows a definite pattern of drum rolls in the first half of the first four renditions and a standard "Omaha" beat in the second half of each of the first four renditions. On the drum roll, the dancers shake their bells and make gestures of either following or seeking the enemy. On the "Omaha" beats, they "sneak up," advancing toward the centre and stopping on the last beat of the song, then walking back to the perimeter. The fourth rendition doesn't end as the first three do but continues with two or three straight "Omaha" renditions, so the song is actually sung six or seven times in all. The sneakup song doesn't have a traditional song ending, but ends on the word *manipe* instead. It should be noted that powwow practices vary from region to region in the United States and Canada. www.cradleboard.org/curriculum/powwow/supplements/powwow/sneak.html.

12 nêhiyaw *animate noun*: Cree; Indian.

13 nêhiyawewak *animate noun*: Cree people; Indian people.

14 Robert Bringhurst, "That is Also You: Some Classics of Native Canadian Literature" in *Native Writers and Canadian Writing (Canadian Literature Special Issue)* W.H. New, ed., (1990), 39, 40, 44.

they knew — and yet so far away I do not even know how their friends and their children addressed them. If there is such a thing as Canadian literature, actually distinct from the literature of Europe, John Sky of the Q'únaqíghawai and Walter McGregor of the Qáiahllánas are two of its earliest and greatest classical authors.

Overall, it seems to me, we have tried very hard to do to ourselves what we did to the Haida. We have tried, that is, to discover everything and to learn nothing: to win big now and to leave the losses for others or save them for later. To burn up the world, and by its furious light, to make fortunes, and even great art, in prodigious quantities, leaving voicelessness, emptiness, storylessness — which is vastly worse than illiteracy — behind.[13]

It may seem that from this perspective, Waynohtêw has dug herself into a cultural hole with no contemporary relevance or future. After all, Aboriginal culture is dead, has no living practitioners, and no contemporary relevance. But the situation, along with perceptions, has changed somewhat since the time of Bringhurst's article and the insidious (but unconscious) undermining it represents.[14]

Many examples could be provided but for *nêhiyawêwin* as a living and vibrant language — the essential representation of a dynamic culture — little

CHERYL L'HIRONDELLE WAYNOHTÊW
55-2-1. Seduced by technology, Cheryl eventually succumbs and pays for physical intimacy with a photocopier. Alberta College of Art, Calgary, 1988

else[15] (except for the knowledge of Elders themselves, among whom Dr. Ahenakew is an honoured peer) compares to the extensive and in-depth work of Dr. Freda Ahenakew and her colleague Dr. H.C. Wolfart. In the introduction to their *The Student's Dictionary of Literary Plains Cree*, Wolfart gives a sense of the scope and rigour of their work and of their expectations for the language's future:

Documenting a wealth of spontaneously produced Cree terms that is potentially without limit, a dictionary of the present type has to be carefully circumscribed in aim and plan... *The Student's Dictionary*, in short, is by no means an elementary dictionary but an initial reference work for the serious student...

For a poorly documented language like Cree, we have to begin with a sampling, representative and reliable, offering breadth and depth alike of the lexical riches of the language.

The form of Plains Cree here represented is the relatively formal register used by older speakers, usually acknowledged as exemplary, when presenting narrative and mythological texts or pedagogical and religious discourses...

In subject matter, the texts range from reminiscences of everyday life to formal discussions of ritual observance, from household chores to issues of sacramental affirmation. Trivial or sublime, each of the topics raised is culturally salient. Because of its reliance on authentic texts, the present dictionary is especially rich in terms documenting the lives of women, child-rearing, illness and health and, always, the ceremonial life...[16]

In a manner more aligned with tradition, from a critical distance but certainly not isolated from academia, Waynohtêw's devotion to *nêhiyawîhcikêwin*[16] is precisely that — a *practice* of the Cree way, of Cree culture. She grounds it in face-to-face relationships with discussions both "trivial and sublime," visiting and learning from Elders, close relationships with friends and family, inscribing her experience within creative projects and, "always, the ceremonial life." Waynohtêw's 2001 performance *cistêmaw iyîniw ohci — for the tobacco being: performance/intervention/homage*[17] illustrates some essential elements of this practice. Waynohtêw writes:

in june of 2000, i visited mr. harry blackbird of *makwa sahgaiehcan* first nation in saskatchewan to ask him how to say certain technological terms in cree. as the terms included words such as radio, television, electricity, telephone — it reminded mr. blackbird of how information was transmitted prior to electricity. he told the story of his grandfather, *cistêmaw iyîniw* who travelled between *makwa sahgaiehcan*, onion lake, joseph bighead, chitik lake, thunderchild, waterhen lake, island lake, and flying dust first nations — inviting people to upcoming ceremonies.

a few weeks later, i had a strong dream about process and running. i was immediately compelled to start running daily and in the process shed fifty pounds over the course of the next year. the story of *cistêmaw iyîniw* stayed with me and i felt both a connection to him and his story, as well as a deep sense of gratitude that such a person and a story could change my life in

15 The television series *Finding Our Talk* (now in its second season) showcases Aboriginal language retention and education success stories across Canada and is versioned in *nêhiyawêwin* (Cree), and *Kanien kehá:ka* (Mohawk) as well as English and French. www.mushkeg.ca The Saskatchewan Indian Federated College, along with its university-accredited Aboriginal language programs, moved into an acclaimed new building by Aboriginal architect Douglas Cardinal and has been renamed the First Nations University — the only one of its kind in Canada. www.firstnationsuniversity.ca And, for many years, there has also been a large and growing number of Aboriginal radio stations devoting live and recorded regularly scheduled programming time to Aboriginal journalists, storytellers, musicians and teachers presenting their languages on air. (e.g. Missinipi Broadcasting Corporation (MBC), www.mbcradio.com.

16 Freda Ahenakew and H.C. Wolfart, *The Student's Dictionary of Literary Plains Cree: Based On Contemporary Texts* (Winnipeg: University of Manitoba Press, 1998).

17 *cistêmaw iyîniw ohci — for the tobacco being: performance / intervention / homage* was presented by Lori Blondeau of Tribe Inc. as part of the *Savage Divas: bringing the wild back to the west* performance series. Waynohtêw's collaborators were Louise Halfe, a *nehiyaw-iskwew* poet and writer; Joseph Naytowhow, a *nehiyaw-napew* storyteller and singer; and Cheli Nighttraveller, a *nehiyaw-iskwew / apihtaw kosisan-iskwew* performance artist.

18 See http://ndnnrkey.net for waynohtêw's curriculum vitae and her notes, commentaries, and other materials relating to her current and recent projects.

YVONNE MARKOTIC

BRADLEE LAROCQUE

such a profound way. i knew i would have to somehow honour him and started to imagine what kind of project i could create.

as i continued running, i one day found myself doing my daily hour runs through a remote northern cree/dene/metis community and noticed how my actions and presence caused a stir. dogs ran with me, kids came outside to say hi, cars slowed to observe my journey. i thought about the many elders i had met and listened to, told stories of how we as aboriginal people were once very physically active. i also thought about stories told to me about our inherent friendliness and how a long time ago strangers were always welcomed and fed.[18]

In an article by Candice Hopkins, the cultural confrontation Aboriginal people have with concepts of "audience," and the colonial definition that Aboriginal people have no cultures to speak of and are therefore disabled and invalid receptors of cultural messages, is laid out:

Aware of what normally constitutes the art audience (certainly not the people from Makwa Sahgaiehcan), L'Hirondelle's goal was to engage another kind of viewer. Engaging this other audience required her to negotiate a new set of rules and develop a different set of cultural strategies. In some pre-performance musings, L'Hirondelle remarked that "the activity has to

CHERYL L'HIRONDELLE WAYNOHTÊW
55-2-1, Alberta College of Art, Calgary, 1988

CHERYL L'HIRONDELLE WAYNOHTÊW
ancient memories II. Collaborative performance with Reona Brass, Rebecca Belmore, Lori Blondeau, Debra Piapot, Amethyst Firstrider. Open Stage Theatre, Regina, 1996

somehow engage people instead of alienate them. It has to occur where people live and where performance has survived for many years — in people's camps, homes, and at the kitchen table." Her task of engaging people instead of alienating them was determined from the outset. Her strategy was to stage the performance in the local, engaging the community by performing a part of their history. ...

During L'Hirondelle's action, three radio stations, Flying Dust Radio, MBC [Missinipi Broadcasting Corporation], and CJNS broadcasted the story of *Cistêmaw Iyîniw* in Cree as told by Harry Blackbird.

Each component of the performance — L'Hirondelle's running, the visits [of her collaborators] with members of the community, and the radio broadcasts — extended public reception of the event. The visits with the community informed people of the performance, broadening her audience, the radio broadcast ensured that the community had access to the original story, and L'Hirondelle's action physically inscribed *Cistêmaw Iyîniw*'s story in the landscape of northern Saskatchewan.

The term "public art" doesn't resonate with most First Nations people. After all, they do not make up a large percentage of the museum audience. They certainly aren't viewed as constituting the public, or even one of the more carefully defined "publics." Rather they are part of a community.[19]

This problematic relationship to concepts of audience is further elaborated in Waynohtêw's ongoing performance project *ka amaciwet piwapisko waciya/climbing the iron mountains*. She "realized the fact that the air is not the domain of humans — ndn[20] or otherwise, but that of birds. So similar to *cistêmaw*... I decided that this activity would be similar homage/intervention on behalf of these winged creatures. I wanted to use some of the same elements from *cistêmaw*... namely the use of chalk tags, Cree syllabics and radio transmissions, the random audience/vidience factor and performative physical endurance."[21]

In this process project, she infiltrates high-rise buildings and climbs the stairwell banisters as in rock or tree climbing. Upon reaching the top, she chalks syllabics and transmits a pirate radio broadcast of her music, sound works, and the works of colleagues as a commentary on ownership of the air. "I do this in order to honour and symbolically re-claim the air above the land where these structures currently exist. It is arrogant of governments to zone that which is not theirs! I do this for the birds — it is still their domain!"[22]

As Rita Joe has written:
I left a message to nikmaqq
In the caves of stone
My home.[23]

The inspiration for *ka amaciwet piwapisko waciya* began with Waynohtêw's visit in 2002 with Heath Bunting and the artist-run cinema and media lab, Cube Cinema in Bristol, UK, although it was only by fortunate coincidence that she discovered her host's propensity for climbing trees, fences, and buildings and her re-awakening to its joys and inspiration.[24]

19 Candice Hopkins, *Interventions In Traditional Territories*, (2001). http://ndnnrkey.net/masinasowin/ch_cistemaw.txt.

20 [Ed note: ndn is internet slang for Indian].

21 Email (November, 2003), note from Waynohtêw, "vidience refers to shift in audience as those who gather to hear vs those that gather to view. adding the radio/audio to ka amaciwet... actually re-discovers the true random audience..."

22 Ibid.

23 Rita Joe, "Klu'skap-o'kom," in *Native Writers and Canadian Writing (Canadian Literature Special Issue)* W.H. New, ed. (1990), 122.

24 Email (November, 2003), note from Waynohtêw, "connection between climbing etc & linux is also about de-socialising, de-branding - hence alt ways to manoeuver through time/space."

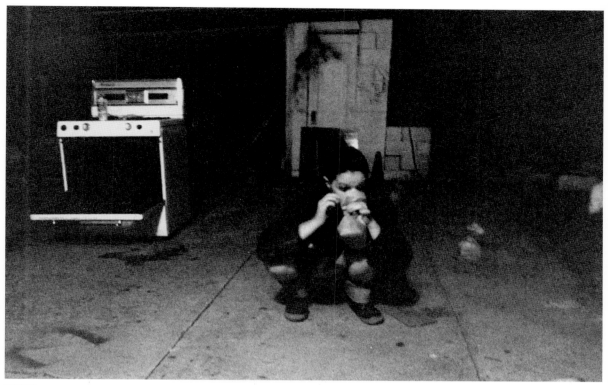

SUKI DAVIS

Her initial goal for the visit was part of her long-term study of some of the philosophy and points of view behind the open-source Linux computer operating system and the ramifications for open-source software development in creative practice more generally. The topic of the relationships between Waynohtêw's music, her computer art practice, and her experiences in developing networks and collaborations must remain for another article stretching back to her work with Buffy Sainte-Marie, John Ord, and the Kids From Kanata Aboriginal/non-Aboriginal online education network in the early 90s. But a quote from her about open-source concepts and the similarities in Aboriginal worldview is a good close to this article while also a possible transition to another:

In learning *nêhiyawêwin* (Cree), I have had the fortunate opportunity to spend several years visiting Elders and other Cree speakers and have noticed time and time again how conceptual the language is and how philosophical and what critical thinkers most Cree speaking people are. Rarely, have I witnessed a conversation where discussions of etymology were not part of the interchange.

As a contemporary artist, I am also constantly in a position of having to retranslate and investigate dominant/mainstream culture's terms and

CHERYL L'HIRONDELLE WAYNOHTÊW
he(a)rth. Ritual performative activities dispelling sin, fear, gluttony (as part of order out of chaos) UK. my backyard, 1988

worldviews to better understand them from within this position of *nêhiyawêwin*. In my own work, I have observed that there are relationships that can be made between these mainstream trends/ideas and a Cree worldview...

As Aboriginal artists we already work in so much isolation it makes little sense to enforce proprietary claims over that which creation has imbued us — the ability to be visionary and manifest the stuff of our dreams for others to be moved by, inspired and challenged with.

I propose instead that we look to the computer world and current discussions and writings about copyleft and open source. These two concepts are perhaps the most influential concepts behind the dismantling of the international corporate stronghold of both Microsoft and Macintosh. At the root of these concepts is the sense of sharing of information, be it code, concepts, or the actual software that results.

These trends could easily be applied to the art world and specifically to the Aboriginal art world and communities. We need only to look to our worldviews to see the relationships and to our languages to find the terms. Instead of asking Aboriginal artists and cultural beings to buy into yet another government system that I believe will only further enslave us and keep us from getting to the work of creative output and cultural expression, I propose we investigate other alternative models closer to our concepts of independence, collaboration, sharing, giving, and ultimately ... survival.[25]

★ ★ ★

All English translations of Cree are from Freda Ahenakew & H.C. Wolfart, *The Student's Dictionary of Literary Plains Cree: Based On Contemporary Texts* (Winnipeg: University of Manitoba Press, 1998).

25 Waynohtêw, *Copyleft vs Copyright*. Web-published speaking notes presented at an Aboriginal intellectual property symposium in Saskatoon coordinated by Greg Young-Ing, of Theytus Books, a subsidiary of En'owkin Centre (2002). www.ndnnrkey.net/masinasowin/copyleft.txt.

Avis Lang

Toby MacLennan

ALL VERITIES SUSPENDED (1985)

For the past couple of days he had been having terrible pains in his left eye and decided to see someone about it. The doctor decided surgery was necessary, and rushing him to the hospital, immediately removed from his eye the tree, the house, the rock and the ball.
— 1 WALKED OUT OF 2 AND FORGOT IT[1]

Each evening he and his friends would lean back upon carefully lit pillows and holding a book securely in their hands, they would all try to put the pictures inside of their bodies. And although each one of them could feel the book in their hands, the picture of the running dog that got into their bodies was never once felt entering their heads. Not even in its most intense, most intrusive parts, did the ingoing dog bump into their eyes like an entering fishbone bumps into the throat.

It occurred to him then that the body must be like space that doesn't need a hole in it to fit in the house, the tree and the dog.
— SINGING THE STARS[2]

1 Toby MacLennan, *1 Walked Out of 2 and Forgot It* (New York: Something Else Press, 1972).

2 Toby MacLennan, "The absence of a hole," in *Singing the Stars* (Toronto: Coach House Press, 1983).

When *1 Walked Out of 2* appeared in 1972 under the imprint of Something Else Press — the groundbreaking US publisher of artists' books, concrete poetry, and mail art, of Gertrude Stein, Fluxus, John Cage, and Richard Kostelanetz — it was reviewed by Thomas Lask in the *New York Times*.[3] *Singing the Stars*, on the other hand, having been published in Canada a decade later, generated no column inches on either side of the border, even though published by a correspondingly important avant-garde press.

One of Lask's comments found its way onto subsequent book covers: "Toby MacLennan has a fey imagination and an incisive way of overturning accepted relationships or, to put it better, of changing the way these relationships are stated." But he also suggested that the author try doing something "with a firmer skeleton than this one, and ... outrageously picaresque. She would appear to be a natural for such an undertaking." It's a good description of what did come later.

The nature of holes and space and emptiness is an area MacLennan has explored from many angles — access, motion, potential, appearance, collision, thought, knowledge, memory, growth, transience, union. The brief text below is an example of the one-liners so frequently found alone on a page in her first two books, but is also quite similar to one of four short lines in her interrogative poetic performance *Does A Wave Belong to the Sea or the Shore*.

space holds dark as a bathtub holds its hole[4]

This next text, years later and considerably elaborated, yet similar in theme, is a segment of a piece in many parts:

Gaping holes were appearing in between everything. Standing there like miniature armies between the tables and chairs, between the trees, all the minutes and fish. Holes standing there quietly aglow, like doorways carved in between things that had suddenly flung open. Doorways using empty, like a group of ancient Chinese warriors to push, to strain, to hold a bunch of chrysanthemums apart.

And why don't we hear it? Why don't we hear the enormous sounds of rubbing and bumping and pushing when night rushes in between the buildings and suitcases and trumpets and falls into the spaces of the day?[5]

The commonest objects and most basic phenomena become surprising, unpredictable, wondrous, new in MacLennan's hands. No longer can they be taken for granted. Empty becomes a state of activity. Memories fly out the back of a tuxedo. The sky ends up in chunks at a garage sale. Hands and hair lie in wait for our vigilance to relax, so they can leap off to freedom. Looking is shown up to be an unscrupulous sensualist, unhesitant to use us for its ends. Mountains fall because they're bored. Cups froth and boil. Things move only if there's a hole in space the right size and shape to fit into. In the interests of economy, an aunt agrees to be a teacup; to conserve molecules, a man decides to stop appearing. Space, needing to sing, produces an icebox, then a moon. Music is written by the snowflakes and stars. The mouth — biting into chairs or geraniums, closing over a piece of the day — becomes the favoured means for acquiring knowledge. Everything flings open its windows,

3 Thomas Lask, "Books of the Times—Branches From the Mainstream," in *The New York Times* (September 15, 1972).

4 Toby MacLennan, *The Shape of the Stone Was Stoneshaped* (Toronto: The Eternal Network, 1975).

5 Toby MacLennan, "Cave of the Mother of the Moon," in *Singing the Stars* (Toronto: Coach House Press, 1983).

6 Emily Carr, *Fresh Seeing—Two addresses by Emily Carr* (Toronto: Clarke, Irwin and Co. Ltd., 1972).

7 Sheila McIntyre, program notes for flyer, *Toby MacLennan: The Absence of a Hole* (New York: Center for Inter-American Relations, April 12—25, 1982).

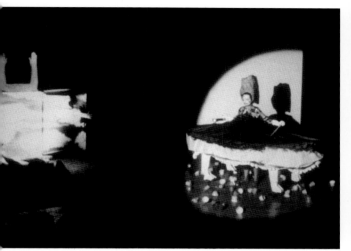

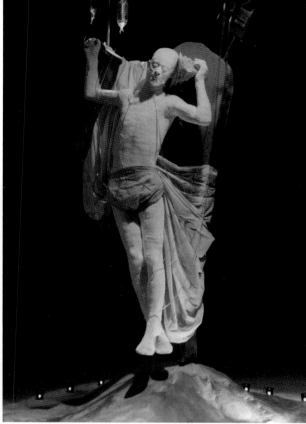

and the fresh air of fresh seeing[6] rushes through.

This world remade is not esoteric, not a hothouse reverie requiring academic exegesis, but an opportunity for the mind to have the pleasure of some exercise. Two of the most thoughtful essays on MacLennan — both about the two-room film-installation *The Absence of a Hole* (bought by Art Bank in 1984) — make this important point in ways worth quoting. Sheila McIntyre wrote in 1982:

The extraordinary distinction of MacLennan's compositions is that they compel us to care about the connections she forges and edges she blurs. When a stone teaches us about movement, and a chair about curiosity, and a seashell about human desire, her images are no longer finite spectator events. These lessons resonate after the curtain falls, leaving us ... discontent with the old world of compartment and separateness and incompleteness.[7]

Two years later, Andrew Forster wrote in *Parachute*:

The strength of the work is its ability to transcend and function independently of metaphorical interpretation ... The objects speak for themselves in all the complexity of things in and of our world. Our experience of them is our experience of the world. We are not left to translate expressions of the artist's experience but to experience for ourselves.[8]

TOBY MACLENNAN *Does a Wave Belong to the Sea or the Shore*. Performance at PS122, New York City, 1986. Left to right: Darrell Wilson and Ardele Lister. Sculpture designed and constructed by Terry Chapman

TOBY MACLENNAN *Am I Gonna Die*, installation, Mercer Union, Toronto, 1991

All that is needed — and it is no small thing — is to give the work some room to come in. One must unclench the mind, unglue the layers of habit and learning, deactivate the circuitry of commonplace perception and understanding.[9]

Occasionally, however, chaos interjects itself into the opening offered by receptivity; dislocation floods the gap left by relinquished ideas. Disintegration comes unbidden:

He was waiting at a curb for the traffic light to change when something he vaguely recognized crossed in front of him. When the green light flashed, he hurried to catch up, and drawing up behind, made an effort to call its attention. He reached out to make contact and suddenly felt his hand slipping over the back of the day.[10]

And then one day when you went out walking with a friend, there was a great wind. And in this friend's unexpected answer of "I can't," an expression of yours suddenly floated out of your face like white clouds moving away from a landscape in a storm.

And suddenly
blunt pencils
a faucet from a sink
and pieces of miniature furniture

drifted out of your face with it. As if your very own experiences, your smiles, your sudden grimaces had only been waiting in some smoky railway station. As if the events and gestures of life were only using your face as a temporary umbrella. And it suddenly stops raining.[11]

At that moment I felt like a potted plant that had suddenly fallen to the floor where the only thing which could still contain me had smashed into a thousand pieces. All of which were rolling unrecognizably across the floor toward the end of the porch where at the very periphery, the very boundaries of my own life, they dove off willingly into the dark night.[12]

From "he" to "you" to "I" — from 1972 to 1984 — upheaval has spurred the artist to come closer, to declare herself in her own voice, where once she could be deduced only from circumstantial evidence. This "he" that enacted or thought nearly everything in MacLennan's first two books was a convenience, anonymous yet concrete, serving in a self-effacing way what "she" could not then have achieved, to emphasize the actions and events, not the actor. The artist's "he" is a neuter being, hardly a being at all, simply a narrowly conscious entity with a certain degree of volition and capability. He has no emotions or convictions in any ordinary sense; he has no past or future to speak of, and barely a present. He is not necessarily even human.[13] He is, however, the universal subject.

In *Singing the Stars*, the author occasionally spoke as "we" or "a person" or even the more flagrant "you" when it was grief or loss or longing being revealed. Now, in *How Much Far Is There*, MacLennan has found a way not

8 Andrew Forster, "Toby MacLennan: Optica, Montréal, November 8-26," *Parachute 34* (March, April, May 1984), 45.

9 Nearly a quote from Avis Lang Rosenberg, "Toby MacLennan: Writings and Rituals," in *criteria*, vol.1, no. 4 (September 1975), 3.

10 Toby MacLennan, *1 Walked Out of 2 and Forgot It* (New York: Something Else Press, 1972).

11 Toby MacLennan, "The Periodic Stranger's Hand," in *Singing the Stars* (Toronto: Coach House Press, 1983).

12 Toby MacLennan, soundtrack from *How Much Far Is There*, 16mm film, 1984.

13 Condensed from a much longer discussion, *ibid.*, pp. 4-5.

14 This and all other quotations not otherwise identified are from a conversation between the artist and myself, December 8, 1983.

15 Ardele Lister in conversation, June 1984: "More than any other artist I know, Toby has the imagination of a child."

only to become in effect the universal voice but also to transcend both gender and species. Paired with her first-person narration is a kaleidoscope of protagonists — the now-familiar man in a tuxedo, a hulking ox dragging a sarcophagus, a man kneeling at the water's edge with a washing machine strapped to his back, a swimming polar bear, an old padded chair recovered in Hokusai waves, a nude, mask-headed woman arching like a diver across an infinity of night, a muscular young man whose chest and limbs have been painted with large hands and over whose head is lowered the head of an Egyptian ram. "Something forgotten is trying to remember itself through me ... pianos and shells, ears and the moon are trying to use me for a mouth because the sound they make when they fall is indecipherable...," echoes the artist's voice as the white bear turns and glides through the bubbling, blue-green water. The woman who speaks is also man, creature, and thing. In the end, all are shown to be pieces of the same infinity. It is what MacLennan's work has always reached toward. As she related during a conversation in late 1983:

All the work I can remember doing has to do with getting things mixed up with other things so that they belong to more than the category we allow them.

I think of this experience I had when I was eight or nine years old and had to take a nap for my mother's benefit. I used to lie on this bed, and there were Venetian blinds, and the light would be coming through. There was a tree outside the window, and the tree would be changing the light as it interrupted the sun's rays, so the light would form different patterns on the wall. And suddenly one day it just struck me: "How can someone be walking around with a thought that I don't know?"

And the more I thought about it through the years, the more I thought that what *really* was going on was that Thought doesn't bump into anything. It appears to be forever, infinite. It feels like Thought is everywhere because there are no boundaries on your thoughts the way there are on a table. I felt that if it was everywhere, then how can someone have a thought that I don't know?

So I didn't try to come to any conclusion — a thing like this can't be concluded — but that's the way I think of things: if we give them a limit, it's because *we* give them a limit. They don't really have that limit.[14]

No longer a child — though still graced with the imagination of one[15] — MacLennan has not only taken this formative intuition about the openness of matter into artmaking of many kinds, but has also pursued it through the less individualistic investigations of science and non-Western philosophy. The science she sought out during the late 1970s and early 1980s was not biology but rather astronomy and physics: not what is conventionally known as animate, but what is farthest far and smallest small and vastly more forever and everywhere than organic life. A course on Zen and the "new physics" that she took in Toronto seems to have supplied a key confirmation of her worldview, inasmuch as it dealt with the subatomic functioning that invalidates the basis for most of our standard designations and perceptions of Reality. Class discussions kept confirming what she'd thought all along about the differentiation of properties; what had formerly

seemed to be mysticism or poetry became scientific fact.

More germinal than science for MacLennan's recent art, however, has been the philosophy of ancient Egypt, specifically its magical ideas of sacredness and transformation. One shouldn't, of course, assume that MacLennan subscribes to the entire social system of that time and place; it is only that certain ideas, certain sublime concepts and the resulting practices, profoundly engage her. For example, a poultice for runny eyes was made of honey and a leaf and a ground-up statue (the statue, being inactive, was intended to transfer its stability to the eye). A red flower had a life-giving force (its redness connecting it to blood and thus to blood's other attributes as well). A funeral wreath was constructed so as to make one flower seem to grow out of another (embodying and thereby eliciting the possibility that the dead person would grow into one thing, and thence into another, and another). Transference, interconnection, fusion, similarity, simultaneity, suggestion, substitution — in short, the linkage of things to other things, the sacredness of all, and the central role of transformation. Herein lies pharaonic Egypt's attraction for this artist:

I'd been reading a lot about Egypt through the years and liking it a lot, and I woke up one morning so mad, like you'd get mad at anything. And I thought, What if they're right? What if it's true, and we're all going to be going through the underworld?

Now to go through the underworld, the Egyptians were prepared with knowing the names of the gods, what the gods did, what the symbols were. They did endless drawings, they knew how to worship objects. They were prepared to meet the test. We aren't prepared for any of this. And I thought, Somebody must have known this. Why weren't we told? What has been keeping them from announcing it one day on the radio?

And I thought, I've got to make a film on this, because I care about it. Faced with this trip through the underworld, how would a person deal with it?[16]

How Much Far Is There, the half-hour, 16mm film that resulted, is perhaps the most moving work I've ever seen, certainly the most transcendent. MacLennan framed the film within a sculptural situation for its premiere at the Art Gallery of Ontario in December 1984, presenting it alongside her two now-classic performances: *Singing the Stars*, first done in the star dome of Vancouver's MacMillan Planetarium in 1976,[17] and *Does a Wave Belong to the Sea or the Shore*, first done at the National Gallery in 1977. *How Much Far Is There*, like her first film, *The Absence of a Hole*, can also be viewed simply as a film; as such, it won one of two first prizes at the second annual festival of the Experimental Film Coalition. MacLennan's works have never relied on the purely technical as a source of content or entrapment, and this film is no exception. Committed to the primacy of concept over technique, the artist, however, has also abided by an important corollary — the necessity of learning any medium whose qualities promise most fully to actualize an idea. Hence her move into film:

You can transform on the spot, you can superimpose, you can cut from one image to another and it is the other image suddenly; whereas in moving sculpture

TOBY MACLENNAN Natalie Green in *Singing the Stars*, a performance with musicians using sculptures to sing the stars. H.R. MacMillan Planetarium, Vancouver, 1976

16 Toby MacLennan, conversation with Avis Lang, (October, 1991).

17 See Avis Lang Rosenberg, "Toby Chapman MacLennan: 10 May," in *Vanguard* vol. 5, no. 6 (August 1976), 6 and cover.

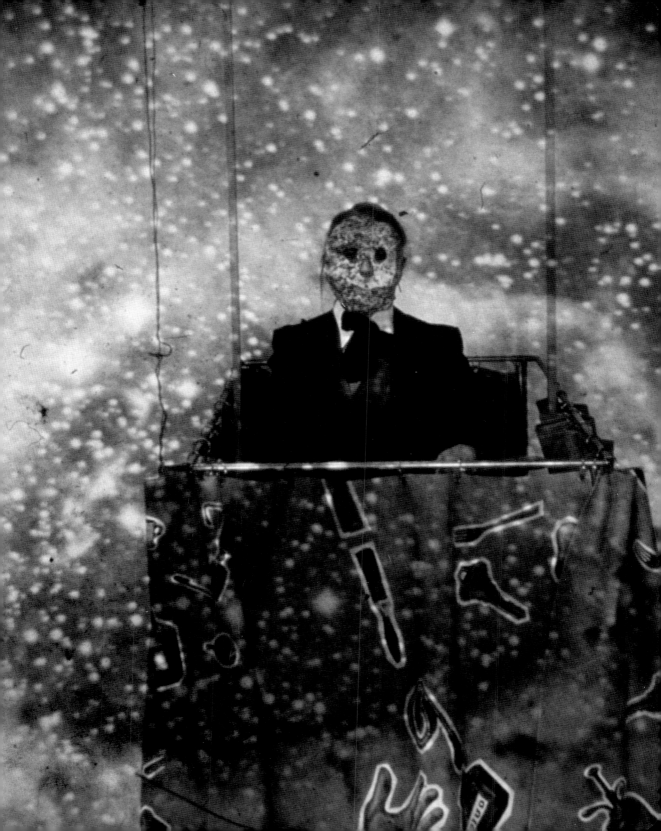

around that's very difficult to do, because the sculpture always stays what it is.

I think one reason I like film is that it puts you in a position where so much happens. Film is a recorder, but in order to record something, you have to take part in the world, you have to get the event going, so that you thrust yourself into a real experimental position that you probably wouldn't — I wouldn't — put myself in otherwise. And I ask people for suggestions. I do have an idea, but I like to be able to change it or let something else come in.

It's like giving myself broader experiences, new ones, and the camera is the excuse to enter into those ... It's almost more humorous than anything else. But there's a joy, a kind of joy that comes into it...[18]

Having been the original impetus for MacLennan to begin *How Much Far Is There*, the prospect of a possibly universal posthumous journey of metamorphosis through an ancient underworld becomes, in the finished film, a matter of something that can happen here and now, in the very midst of life — an unravelling of the web of received meanings that have governed one's existence, the desperate call of the unconscious for truth, the unmasking of convention and platitude, the revelation of an unmapped ocean of the unknown and unacknowledged lapping at the ramparts of normalcy. A tide of pressing realizations floods the spirit, and only new answers to new questions can promise survival. The necessity for change is signalled by a recurring dream:

Always it appeared in early morning. Dawn. Just as the sun was about to rise. In the dream I would wake up to find that sleep, while tossing and turning fitfully in eternity, had inadvertently rubbed pictures onto my body that had been meant for the mud walls of an ancient cave ... When I would throw off the covers and hold up my arms or my leg to my face and stare directly into the pictures, the objects seemed to read:

18 MacLennan, conversation with Lang.

19. Ibid.

VOICE #2: Is it possible that all you have been led to believe is false?
CHORUS: Yes it is possible.
VOICE #2: Could it be that all you were told was presented for ... some ... other reason?
CHORUS: Yes it is possible.

For weeks after I felt I had holes in my body that let in the universe.[11]

It is an unknown world to which the dreamer awakens in *How Much Far Is There*, intensely coloured by music of many kinds and sounds from many sources. Two voices guide our passage: the artist's own as "I" — flat, calm, pure Midwest; and that of Salome Bey, "like the voice of a god" — stately, resonant, sculptural, awesome. Deftly we are persuaded of the oneness of a chair and its sitter. Then, as moth wings flutter, as an open mouth yields up its well of whitest milk, as a spring flood rushes past us while we, a larva, cling to a branch at the river's edge, awaiting our time of emergence from a tiny golden shroud, we understand that the time has come, and everything we might have been or known is spilling into the starry ether, and we submit to the final preparations for the journey we have no choice but to take. And we the chair become a god and are carried aloft by acolytes, down through

tall grass to the water's edge, and laid onto the waves, and set adrift on the ever-widening sea of our own continuance. And then the test begins, and the test is to learn. As drums pound and unseen voices escalate their shouting, we are instructed in the likeness beneath all divergence, and are finally set free, reborn.

We need know nothing about Egyptian iconography to understand everything the film is telling us, but it was the artist's guide, and in hearing what she has to say about how she used it, we can discern something at the very centre of her way of working:

The cow is one of the symbols of the divine ocean in Egyptian mythology, and the pharaoh must go through the divine ocean in order to be reborn. The ox carries the sarcophagus through his back. Now, a washing machine is sort of the shape of a sarcophagus, and it has water, and in the film the man carries it on his back. The man carrying the washing machine becomes the cow, but he also has to go through the water, which is the cow, which now he is the cow. The cow goes through the water carrying the sarcophagus, but the sarcophagus is holding the pharaoh who must go through the cow. So as long as you get them all together and they all share these characteristics, then you're doing exactly what you're supposed to be doing. So the man goes through the cow as he's climbing through the water; he goes through the water and he becomes the cow.

It all seems to make such sense until you start talking about it. It falls apart when the words occur. It falls apart. Makes perfect sense otherwise.[19]

★ ★ ★

Reprinted/adapted from *Vanguard*, vol. 14, no. 8, (October 1985), 24-28.

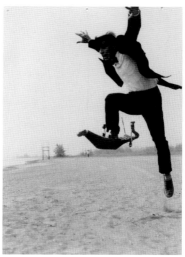

KEITH HLADY

TOBY MACLENNAN Darrell Wilson in *How Much Far Is There?* Still image from film/sculpture/performance, Art Gallery of Ontario, Toronto, 1983

Kim Sawchuk

Tanya Mars

ENTHUSIASM, UNBRIDLED

Tanya Mars has stated that with "unbridled enthusiasm" she began her performance career in 1974:

> Since that time, I have been committed to creating a kind of eclectic high-low tech, spectacular performance that places woman at the centre of the narrative. The work is usually non-linear, of short duration, multimedia, and humorous. It is always feminist since I am a feminist. It is usually political, however more provocative than didactic.[1]

Mars' wonderfully wacky zeal is evident in one of her early performance pieces, *All Alone Am I*, that she created in 1977 as a member (with Bob White and Odette Oliver) of the Thirteen Jackies. Mars and Oliver tap dance with gusto whilst their hands and upper bodies are constricted in straightjackets. Simultaneously funny and disturbing, it is a vintage Mars collaboration and aesthetically telling. Mars admits to admiring Dada, the Surrealists, Meret Oppenheim, and the work of international performance artists such as Joseph Beuys and Marina Abramovic, but she confesses to being influenced equally by cheerleading and vaudeville. "I like those old vaudeville movies, burlesque. You know, conflating the political with the humorous has always been important for me."[2]

I am fascinated by Mars' admission of unbridled enthusiasm and what it

Caught in the Act an anthology of performance art by Canadian women

connotes of her thirty-year history as an unabashedly *feminist* performance artist and her pointed use of a bawdy, bodily humour full of ironic twists and turns. What does it mean to describe one's enthusiasm as unbridled?

Enthusiasm, reports my *Webster*'s dictionary, implies divine forms of inspiration or fervent "theistic" possession. To be fervent is to shake one's booty feverishly, to embrace an activity heart and soul. Enthusiasm ecstatically transports us out of corporeal stasis. To be bridled is to be "yoked" or saddled like a pack animal into submissive disciplinary behaviour. To be unbridled is to throw off these shackles let loose. Think of the Thirteen Jackies piece again, the bound arms and torso in contrast to unfettered legs noisily clattering on a floor in tap shoes. The unbridled enthusiast allows herself to be overwhelmed, doubly, by her passions in a physically demonstrative manner that exhibits, shamelessly, over-the-top exuberance.

Tanya Mars' performances exude enthusiasm, unbridled, but they are a complicated manifestation of unruliness. Release is attainable only from within conditions of imposed constraint — "my performances have always involved physical limitation, even if it wasn't totally apparent."[3] Mars pops out of a container dressed in a jack-in-the-box outfit when a string is pulled by an unsuspecting viewer (*Tanya-in-the-Box*, 1976). In *Pure Virtue* (1984), a corseted Mars is burdened by heavy Elizabethan dress. "Just to bend over in an Elizabethan costume is difficult and painful. To lie down is next to impossible, and to get up is awkward and funny."[4] In *Mz. Frankenstein* (1993), Mars straps on an archaic looking machine, "the relax-a-ciser," and tightens it until her flesh spills over the straps. A found object gifted to her, the "relax-a-ciser" promises to vibrate away excess weight. Once plugged in, Mars proceeds to do a Scottish dance. She is disguised in a plastic mask that renders her hideously crone-like, her nose pointy and elongated, her complexion wrinkled. In the background, slides project statistics on the beauty industry and cosmetic surgery. Scissors in both hands, snip-snipping in the air, Tanya jiggles her butt in comedic self-parody of our cultural myth that feminine beauty can be obtained by expensive, extensive treatments to stop the aging process. It is a deadly serious, yet entertaining spectacle. These are not opposites.

For Mars, "accessible" should not be a dirty word and "neither should entertainment."[5] "I like the idea that one doesn't have to be predictably entertaining to entertain. In other words, another kind of time and movement can be as compelling as quick, witty repartee."[6] Works such as *Mz. Frankenstein* emphasize the bawdy, the lewd, the grotesque, the hyperbolic. She exaggerates both forms and movements in ways that recall Mary Russo's[7] feminist re-reading of Mikhael Bakhtin's carnivalesque. In contrast with the "classical body," a figure of restraint and public order, the carnivalesque emphasizes the unruly and the populist usurping of the traditional hierarchical positioning of high and low cultural forms. As Queen Elizabeth I, Mars breathes fire, spills out of her bodice, pulls a gilded, plucked chicken from between her legs. In *Pure Nonsense* (1987), Alice in Wonderland asks, "Why does a Venus not have a penis?" then lifts up her crinolines to expose

1 Tanya Mars, "Linear Chronology," in *Performance Art in Canada, 1970-1990*, Alain-Richard Martin and Clive Robertson, editors (Québec: Les Éditions Intervention, and Toronto: Coach House Press, 1991), 226.

2 Tanya Mars, interview with Dot Tuer (April, 2003).

3 Tanya Mars, "A Picture that Resonates," a conversation between Tanya Mars and Paul Couillard, (April 30, 1999), Fado website, www. performanceart.ca/time3x/mars/interview.

4 Ibid.

5 Mars, in Martin and Robertson, 226.

6 Mars, "A Picture that Resonates."

7 Mary Russo, *The Female Grotesque: risk, excess, modernity* (New York: Routledge, 1994).

a large dildo that she clutches in one hand, a look of surprise on her face. Mars mixes genres in carnivalesque fashion. In *Competing for Space* (1980) she is stationed in a dunking booth, a familiar fairground sight, where she and her partner, Richard Shoichet, hurl abuse at each other, inciting the audience to participate. By purchasing balls from a barker, the audience could dunk one of the performers. These are not just strong images, but staged activities that challenge and confront, that show a lack of fear of public exposure, that physically convey the contradictions of living in a patriarchal world that wants to reduce women to their sex, yet where women want to be sexual, desiring, and desirous subjects.

Tanya Mars uses humour as a feminist weapon to poke fun at patriarchy. But she is not afraid to laugh at herself. Humour, she says, is her antidote to dour performance art. Humour also allows her to critique those art forms (performance) and ideologies (feminism) that she cares most about. *Performance Art Starter Kit* (2000), originally to be delivered as a talk, spoofs the pretensions associated with performance art by breaking it down to its predictable components (dressing in black, using the body, introducing disgusting elements) in homage both to her chosen *métier* and to John Nagy's "learn how to paint and draw series." Mars is one of the founders of Powerhouse, the first parallel gallery in Canada that featured art and performance by women, but in *Pure Nonsense* she takes a poke at psychoanalysis and neo-Freudian feminism, rampant in the 1980s. She explains: "Nothing is so cut-and-dried that we can't take a critical look at it. That is important to me not just as a feminist but as an artist and a human being. I enjoy — no I thrive — on satire."[8]

But is this satire? I would argue that Mars' sophisticated sensibility is more ironic and parodic than satirical. One can distinguish between parody and satire in terms of positioning: both make a mockery but from a different point of view. Parody acknowledges that one is an insider and draws upon shared affinities with the object of one's humour. Satirists adopt a position of pure outsider-ness to the object of their criticism, poking fun at people, events, or ideologies that they disdain to re-affirm their superiority. Satire may use some of the same comedic elements as parody, such as verbal or physical hyperbole, but satire underscores distance rather than commonality. It is about a critique from a presumed outside — and above. Parodies, on the other hand, critique from within borrowing and appropriating a generic form. Thus, the most brilliant parodies are self-parodies because the performers know the genre — and their subject — inside out. Parodies often deploy irony (meaning one thing, expressing another) to highlight contradiction.[9]

Mars provokes and questions through humorous, ironic juxtaposition. It may be verbal. As Mae West, the star of *Pure Sin* (1986), Mars states "For a long time, I was ashamed of the life I've lived." "You mean you've reformed?" she is asked, to which Mae replies, "No, I got over being ashamed." It may be physical. In *Mz. Frankenstein*, the dance mocks the technological promise of a machine to make you fit without having to actually exercise. Such ironic

ANN PEARSON

8 Mars, "A Picture that Resonates."

9 I am grateful to Robin Diner who has pointed out these crucial distinctions between parody, irony, and satire to me in our many discussions of feminist performance art.

10 Mars, "A Picture that Resonates."

11 Mars, interview with Tuer.

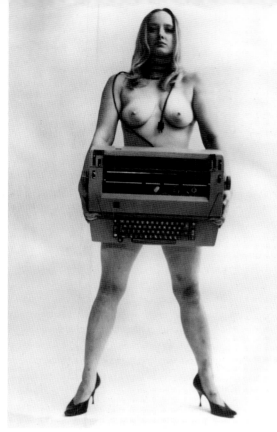

TREVOR GORING

DAVID HLYNSKY

twists are necessary for the unbridled enthusiast — without it, the performance would be simply childish or naive. But it also indicates a further irony embedded in Mars' performances. The execution of these spectacles is possible only through hard work and self-discipline. Again, restraints produce the conditions for "unbridled enthusiasm" to emerge during physically and mentally demanding performances.

Mars speaks of her process of creation as a form of "three-dimensional picture making." [10] Her practice is driven by intentionally strong images that act as her guide, even when the result is highly theatrical or involves strong narrative components, such as the theatrical *Picnic in the Drift* (1981), written and produced with Rina Fraticelli, which addresses environmental and nuclear issues, or the *Pure* series, which involves scripted dialogue, elaborate stage sets, multimedia components such as pre-recorded sound, and the use of actors. *Pure Virtue* began while Mars was gardening, and suddenly imagined Elizabeth I breathing fire. These images are then used to animate a performance. "Once I know what I'm going to look like and what it's about, then I know how to move the body and the objects in space." [11]

As a feminist performance artist, many of these images question proscribed forms of sexuality, both male and female. One of her first solo

TANYA MARS and **RINA FRATICELLI** *24 Postcards of Rage: No Man's Land*, Powerhouse/Tangente, Montréal, 1983

TANYA MARS *Super Secretary*, life-sized photo, Powerhouse Gallery, Montréal, 1978

TANYA MARS *Pure Nonsense*, produced by Cultural Desire Projects, Music Gallery, Toronto, 1987. Left to right: Victor Coleman as Freud, Kevin McGugan as Jung, Tanya Mars as Alice, Andrew Paterson as Adler

works, *Codpieces: phallic paraphernalia* (1974), was body sculptures for men made out of found objects like plastic meat trays, electrical wiring, and chess sets. *Super Secretary*, a photo-shoot done in 1977 and reprinted in comic book format in various art magazines,[12] famously depicts Mars with her IBM Selectric typewriter in her arms, the cord snaked around her neck. The image is meant to expose workplace sexism on the one hand but also can be read as a reclamation of sexual power on the other. Mars looks the part of the dominatrix as she stands naked in black stilettos. Her beautiful breasts rest on her machine as she gazes directly out of the photo exuding a challenging poise, her shapely (but bruised) legs akimbo. When asked why she posed like this she replied, "I did it because I can type 100 words a minute." Mars has always juggled multiple roles in real life: as secretary, as working mother, as editor of *Parallelogramme*, as performance artist. "To me, as a typist who had been chained to a desk for many years to support myself and my family — I did not perceive this as a bondage image. For me, this was my reality."[13]

Many of Mars' works have looked at the way that patriarchy works upon the female body to produce lived realities that must be negotiated: *Fat* (Thirteen Jackies, 1978) deals with body image and the cult of thinness; *24 Postcards of Rage: No Man's Land* (with Rina Fraticelli, 1983) addresses the pornography debates highlighting the confusion it produces for women; *Super Secretary* (1977) tells a tale of women in the workplace and secretarial submission and triumph; *Mz. Frankenstein* (1993) critiques the beauty industry; *Pure Sin* (1986) calls upon the archetypical sex-bomb, incarnated in Mae West, to discuss the historic and mythic roots of sexuality and power.

These images present politicized bawdy images that eschew didacticism through humour, and engage with popular forms, like comic books or magic shows. Each of these images is the beginning of a process and never just its end point. Like much performance art, there is a continual mutation and restaging of an individual piece that gives performance an ambiguous finality. *Mz. Frankenstein* is both cabaret performance and video. *Pure Virtue* started off as four five-minute skits performed in a small club before developing into a narrative piece complete with proscenium stage. "Throughout my career, my work has fallen between two schools. I love drama and the theatrical. I love making a beautiful picture."[14] Even though these performances may begin with a strong image, or develop a more narrative structure, what is important here is that these images are *animated* in the performance.

Mars says that "we communicate things without words."[15] Our everyday speech tries to capture the corporeality of communications as a dynamic act: we jump for joy; bow our heads in sorrow; double up in pain; skip with happiness; sing with pleasure; furrow our brows; shuffle our feet. There is a culturally recognizable vocabulary of the body. Each of these motions often employs, as linguists Lakoff and Johnson point out, topographically charged terms.[16] We are "high with excitement." We feel "down" when depressed. Such movements and topographies suggest psychological and physical states but also speak of relations of power: we look up to certain people,

12 Tanya Mars (as Tanya Rosenberg) "Have IBM Will Travel," in *Virus International* (June 1978), 16, and Tanya Mars, "The Adventures of Super Secretary," in *Incite: a visual art magazine* (January, 1984).

13 Tanya Mars, transcription of panel "Freedom to Work," part of the exhibition *The Regina Works Project. Four Documentations* (Regina: The Dunlop Art Gallery, 1991), 20-25.

14 Mars, "A Picture that Resonates."

15 Ibid.

16 Georg Lakoff and Mark Johnson, *Metaphors We Live By* (Chicago: Chicago University Press, 1980).

17 I am indebted to Linnet Fawcett's for these insights on performance and the skating body and to our many discussions on these and other related matters.

18 Mars, interview with Tuer.

19 Drew Leder, *The Absent Body* (Chicago: University of Chicago Press, 1990).

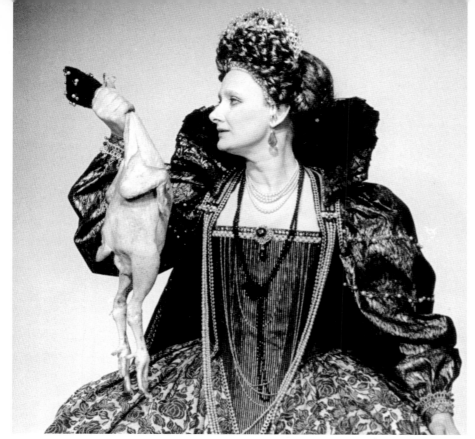

ANN PEARSON

down on others. Performance artists, like Mars, set themselves the task of exploring movement as expression. As Mae West, Mars moves slowly in a sultry slither. In her tight black dress she is statuesque and statue-like in marked contrast to the male chorus who swoon and high-step around her. Meaning is conveyed by the types of movements we create in relationship to physical space and by the velocity or speed at which we move. In *Pure Nonsense*, the pace is frenzied, the language chaotic. In thinking of the body-as-movement meaning is found then not only in the gesture but in the timing, the spaces between gestures which provide the pulse and give a performance rhythm not only seen, but felt.[17]

Exploiting the creation of meaning in movement involves the placement of the body at the centre of this performance practice. As Mars says of teaching performance to students, in performance art the body is the primary material: "They love it because they have to figure out a way to be in their own bodies in a way that they hadn't thought about before. That the body can be a material."[18] Observing performance artists like Mars through time forces one to consider that the body is not only a static entity or physical matter (what in German is called *korper*); it is also *leib*, a lived processural body.[19] As process, the body is understood as a material substance that

TANYA MARS as Queen Elizabeth I in *Pure Virtue*, performance, Playwright's Workshop, Montréal, 1985

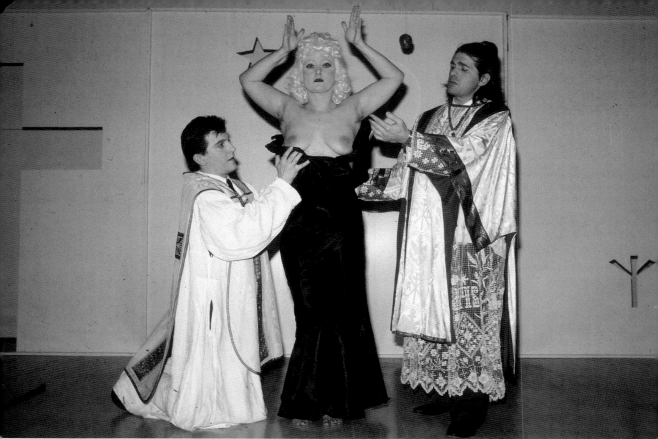

ISAAC APPLEBAUM

20 Mars, interview with Tuer.

21 Joanna Frueh, *Monster/Beauty: Building The Body of Love* (Berkeley: University of California Press, 1991), 11.

22 Ibid.

23 Mars, interview with Tuer.

changes through time. We grow, then we shrink with age. Our exterior surfaces wrinkle and sag. Shapes alter through disciplined eating, exercise, or surgeries. As we go about daily life, we need not always attend to this body attentively. Performance artists do.

Tanya Mars has stated that she thinks of the performance artist as a "visual philosopher."[20] As a feminist visual philosopher, Mars conceptualizes through her corporeal movements, the cultural morays ascribed to women and womanly behaviour. Like other feminist performance artists, Mars has had to contend with the social and aesthetic meanings given to the aging female form. *Hot* (2000), in particular, powerfully addresses the social stigmas that may confront women as we change with age and our (valid) fears: of being alone, of never finding love, of needing comfort (which one often finds through a pet), of becoming ugly and invisible. As she says of the blonde beard that graces her jaw line in *Hot*, she was incited to wear it because of her love of female drag but as well because of the presence of four stubborn chin hairs (I sympathize) which are but the visible manifestation of invisible hormonal shifts. Mars' use of her body in this way is indicative of what Joanna Frueh calls monster/beauty.

The monster/beauty does not have perfectly shaped thighs or the ideal

GARY PEARSON

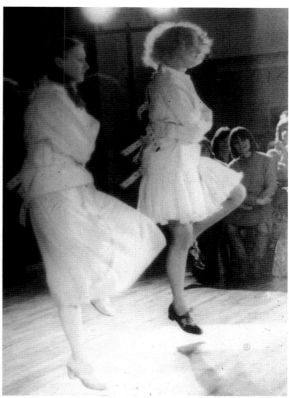

DANIEL FAMERY

shape. Monster/beauty draws attention to how that shape moves or inhabits space with an ungainly, graceful confidence. Rather than trumpeting the picture perfect, monster/beauty celebrates different aesthetic/erotic forms of loveliness — and love — to emerge in its call for a practice of self-creation from one's "own capacity to create a field of pleasure." [21] Monster/beauty explains Frueh is "flawed and touchable, touching and smellable," it embraces the "vocal and mobile body that by exceeding the merely visual manifests a highly sensual presence." [22] Monster/beauty describes Mars' description of why she loves performance for not only cerebral, but gustatory, visceral reasons: "To me performance art is the most delicious art form." [23]

The bearded lady in *Hot* epitomizes the grace, charm, humour, and intelligence that I associate with Frueh's definition of monster/beauty. The lady is dressed in a black evening dress, her cleavage a wonder to behold, the cloth gripping the folds of her corpulent waist bursting at the seams. She wears a matching bolero embroidered with chicken bones. She is barefoot, but her nails are painted. Her beard thankfully is not a caricature, but looks natural. It seems befitting with her short blonde stylish hairdo, her voluptuous figure, and her makeup.

An endurance piece, *Hot* lasts twenty-four hours, split into two twelve-hour

TANYA MARS *Pure Sin*, performance, A Space, Toronto, 1986. Left to right: Kevin McGugan, Tanya Mars, Angelo Pedari

TANYA MARS *Mz. Frankenstein*, Okanagan Artists Alternative, Kelowna, BC, November, 1992

ODETTE OLIVER and **TANYA MARS** in *All Alone Am I*, by Thirteen Jackies (Odette Oliver, Tanya Mars and Bob White), Powerhouse Gallery, Montréal, 1978

days. Mars set over 2,500 mousetraps with cinnamon hearts as bait. Performed in three venues (Montréal, Winnipeg, and Toronto), these traps were set slowly and deliberately and laid out in the space, row upon row, until a pattern and a path to walk through emerged. In the Toronto performance, lighting from soft lamps illuminates the floor and a disco light sparkles overhead. On the ground are a number of props — a megaphone, boots — whose uses become apparent later. A chair is stationed in one part of the space with two gleaming silver buckets filled with ice on either side. In another corner, an exercise mat and ball.

The movements of the bearded lady are graceful and delicate. A contemplative mood is exacerbated by the sounds of a Satie piano composition. This is interrupted only by the sounds of the performer's labours as she sets her trap, or the occasional expletive uttered when a trap was set off, accidentally. On an LED screen are written the words "soft, warm, safe" as a video projects an image of Mars embracing her dog, asking over and over again "Do you love me?" As they fondle, the question is repeated, obsessively. Of course the answer is yes. Every lick from the dog's tongue makes evident that this animal loves his mistress, unconditionally. Every once and a while, the bearded lady stops, sits on the chair and douses her hands, face, and neck with cold water from the bucket. The only other respite from this routine are the occasional exercises done on the mat or the ball in full public view. It is funny, in a melancholy way, to see this image of the bearded lady setting her traps with cinnamon hearts. The feeling is a touch sad. Recreated is the loneliness that one sometimes has after the party is over, the guests are gone, and one is left wondering what to do next — until the final minutes in the last day of the performance. Suddenly, the bearded lady dons the boots, picks up the megaphone, and counts down. Her voice is distorted as the sound is compressed by the machine. The audience giggles nervously anticipating what will happen. She picks up a bag and starts to throw pennies and bones on the ground, stomping through the minefield of hearts. The traps are set off and explode with a fury of sound, like firecrackers going off, releasing the pungent smells of cinnamon. It is a beautiful, violent moment of sudden rage, leaving broken hearts everywhere. Like an orgasm, which builds and builds towards a climax and then is over, it is a cathartic moment. Something has happened. The timing is perfect, from the slow rhythms of Mars' parade through the traps to the stomping of her feet. At two days, it is neither too long nor too short. Timing is everything. Like love itself, just when it seems as if the performance can last forever, in an instant it can be gone, irretrievably over.

The monstrously beautiful bodies of the bearded lady, Mz. Frankenstein, Alice, Mae, and Elizabeth are not just mimicking a shape or an image through costuming but recreating and recalling the potential power and abilities of these women through the performance of movements. In this, one is reminded that we are not just what we look like but that we are recognizably unique by the way we navigate our lived bodies through space. The way we walk, talk, and move our arms, creates a he, she, and you that is

24 Angela Carter, *The Sadean Woman and The Ideology of Pornography* (New York: Harper Colophon Books, 1980), 5.

25 Ibid., 11.

SHEILA SPENCE

distinctive. The use of monstrous/beauty punctures the pristine archetypes that Mars consciously invokes in her performances, archetypes that posit a universalizing standard or norm that, as novelist Angela Carter writes, denigrates the singularity of our becomings by freezing us into fixed immutable forms that are not allowed to grow fat, old, or unruly. Archetypes, for Carter, suggest false universals that try to "dull the pain of particular circumstances." [24] In this, they are different than an acknowledgement of the constraints of histories written on the flesh. As Carter so perceptively writes, "Flesh comes to us out of history; so does the repression and taboo that governs our experience of the flesh." [25] Tanya Mars' performance personae are like Angela Carter's heroines: Fevers the winged buxom circus performer of *Nights at the Circus*; Floradora and Leonora, the two aging dancehall queens of *Wise Children*. These exuberant female performers are timeless characters, but they are not false universals precisely because they live in particular places and times, which re-create restraints and re-stage possibilities, even if only imaginary.

Tanya Mars admits that she can be cynical about politics (too didactic), the performance art scene (too dour), the art world (too pretentious), and those activities, which she holds close to her heart, such as feminism (too

TANYA MARS *Hot*, performance, Ace Art, Winnipeg, 1998

lacking in self-criticism). But expressing cynicism strategically and adopting cynicism as the core of one's aesthetic practice are not the same. Unbridled enthusiasts, like Tanya Mars, embrace their performances wholeheartedly, and I mean this quite deliberately. Heart and soul infuse every performance, fill every activity with intensity. Enthusiasts are careless and seemingly carefree risk-takers — the sort who will jump into deep waters unafraid, blindly trusting that everything will be fine. As such, the enthusiast can be contrasted to the cynic who calculates every movement and whose every gesture is poised. An air of cool detachment surrounds the cynic who is untouched and untouchable, not a hair out of place, in perfect and complete control. For the cynic, the maintenance of restraint and distance is paramount while the enthusiast exudes in-your-face intimacy. The humour of the cynic is dry and witty, and often a put down of others to maintain pretension and to strike fear into the hearts of enemies who are everywhere. Enthusiast's humour and clown around and often make themselves bear the brunt of their own jokes.

Enthusiasm and cynicism are both seductive postures that have their own charms and pitfalls. Cynical seduction operates through intrigue, it beguiles; enthusiastic seduction can overwhelm and engulf. Cynics instill fear through the power of rejection and judgment; enthusiasts by smothering or intimidations of another sort. One can never match their energies. One may not feel like joining in. One may feel that cynics take up too much space and that their enthusiasm is inconsiderate of the need to share territory and enter into a reciprocal communication or communion with others.

Mars' work exemplifies the power of enthusiasms, unbridled, at the same time that her performances identify historically and culturally specific ways in which women, in particular, are often constrained. Her performance works often, although not exclusively, address the conditions imposed upon North American women and the effects of patriarchy on the body which have dictated conditions of perfect beauty, of timeless aging, of being classed as the second sex without the capacity for rational thought, and therefore as incapable of participating in political or public life. For Mars, it is not a choice to be sexual or rational; to be an artist or mother. Why must one choose? Why not be both/and? Rather than seeing these dichotomies as a barrier, Mars invents novel, humorous, ironic ways to negotiate and push boundaries, thus promoting a disturbing, yet joyous bawdy politic.

Elizabeth Chitty

marshalore

PERFORMING SOUND AND IMAGE

marshalore created videotapes, installations, and performances throughout the 1970s and into the mid-80s when illness interrupted her art production.[1] She used writing, photography, drawing, audio, video, and performance and her work was influenced by her foundation as a musician:

I see sound, I hear images. I guess that's why I'm a multi-disciplinary artist. It's because it's all inextricably intertwined. Sound has the capacity to stimulate writing ... sound plays an important part in what I do, even if there's no sound per se in the piece. When I create sound, I can see images. My visual consciousness plays a major role in how I make sound.[2]

As a child, she was a voracious reader and began to write. In her youth, she took classes in various art disciplines, which included classes at the Art Student's League in New York, but she did not take a formal degree. By the mid-1960s, she was working and travelling, busking and based in New York City. She sang and played various musical instruments. She met others who were involved in the post-Beat experimental milieu. "Some were artists, Fluxus, some made art but didn't call themselves artists, some weren't artists — influences came from many sources ... Making objects, making sounds, making events was part of how we experimented with our lives."[3]

She took her name at this time:

1 marshalore, telephone conversation with Elizabeth Chitty (November 9, 2003). "Interestingly, I still consider myself an artist (just as I considered myself a researcher when I worked as an art producer). I recognize the powers of observation and perception, now used as research, fieldwork and writing, as those developed in previous decades especially through camerawork, drawing and writing — which I still practice." She is currently a scholar in anthropology and Ph.D. candidate at the Université de Montréal working with a topic concerning aboriginal women and symbolic representation as art and self-identification.

2 Chantal Pontbriand, *Three in Performance* (Saskatoon: Mendel Art Gallery, 1983), 19 and 21.

3 marshalore, interview with Elizabeth Chitty.

The reason I've called myself Marshalore ... about twelve years ago it came to me, learning about 'marshal' law declared in Cyprus, 'marshal' law in Turkey, and my name being Marsha, I thought of this penal system of imposed military rule and then I thought of folklore — the whole tradition of intelligence and knowledge and ritual being handed down. I thought of that in contrast to "law," so I called myself Marshalore. It's a pun on that reality.[4]

marshalore's description of the era presents the notion of physicality as inherent to the time:

I wouldn't call myself a physical person — and yet, when a creative moment came — more often than not, [I] had my body as a tool for experimentation and curiosity ... It was a cultural norm of the milieu I was in to use the body — the sexual revolution, take a lot of drugs, change your diet, become a vegetarian, go back to the earth, go back to the city, dance all night — it was very much a cultural influence.[5]

By 1973, marshalore was in Montréal and part of the beginning of Véhicule Art and Véhicule Press. She describes herself as "hanging around" at the early meetings and being part of the place in its first year but not as one of the official founders. She describes her work at this point in time as "playing" — with her voice, movement, video, and drawing. She took part in numerous early Véhicule events, such as singing while members of the company La Groupe de la Place Royale danced. She began to learn about conceptual art and consider that it was possible to apply a more rigorous aspect to her experimentation, to "use oneself more precisely as a research instrument, as an experimental tool."[6]

Improvisation was important to her work and had its roots in jazz:

Well, when I was very young and underage and out alone in the jazz world, you know, at night, sneaking into clubs and bars and all, I was very impressed with bebop which was coming to the end of an era. When I was fifteen, sixteen, Lambert, Hendricks and Ross were very, very big in my life. Annie Ross probably influenced me more than any one else when I was that age. They did what was called lyric instrumentalism. They used their voices as instruments and I think they gave me the encouragement to use my voice as an instrument.

I've studied a bit of opera as well as lieder. The interesting thing is that as I became interested in jazz, as jazz progressed, I found myself meeting up with Schoenberg and Berg and Webern and later composers of the twentieth century — it seemed to me that modern music and jazz were evolving very much parallel to one another. By recognizing the similarities, I developed a stronger interest in classical music and using sound as part of the multi-disciplinary work I do became as natural as using a camera.[7]

In 1974, she sang in _Performance_ (a collectively created performance with Tom Dean), at the Musée d'art contemporain in Montréal, and collaborated in collective creations such as an audiotape by the Lux Radio Players, _The Thief of Gladbag_ (1975), which was broadcast live on CBC Radio's _Judy Lamarsh Show_.

In 1975, she collaborated with photographer David Hlynsky in abandoned buildings adjoining Véhicule. This impromptu performance for the camera

4 Nancy Nichol, "Marshalore: 'Another State of Marshalore' an interview by Nancy Nichol," in _Centerfold_ (December 1978). The artist has always spelled her name using lower case but it has been spelled in print in two ways; I have retained the spelling used in the sources.

5 marshalore, interview with Chitty.

6 Ibid.

7 Pontbriand, 21.

8 marshalore, interview with Chitty.

9 Alain-Martin Richard and Clive Robertson, _Performance Art in Canada, 1970-990_ (Québec: Les Editions Intervention, and Toronto: Coach House Press, 1991), 133.

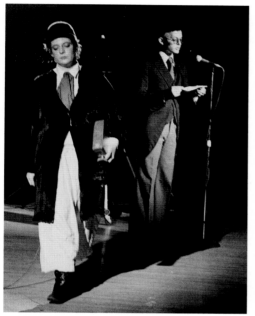
BOB BARNETT

BOB BARNETT

marked the beginning of what was to become her major milieu, either with still or video cameras, of works that are ambiguous as to their medium:

We found ourselves in this pitch-black locale with staircases, walls and floors in less than safe condition. We couldn't see where we were going and we had with us a flash camera. David started taking random photographs in the dark in the direction of where I might be. I was doing movement and playing and it took on the aspect of a melodrama, a silent film because of the way it was framed in the darkness — and the way I dressed — I dressed in velvets and floor-length skirts and had long, wild hair.[8]

By the mid 70s, she was working with video and many of her video works were performances for the camera. *Un'ode per un concettualismo italiano* (1975) was a twenty-two minute black and white tape described as "Performance for video. A series of identity transfers where the artist portrays three famous Italian western personages. An 'epic' investigation of the persona."[9]

marshalore had worked as a busker and this led to street events on sidewalks and in parks. She called these "street actions" and they were carried out in Montréal and New York in 1977. These were improvised, very short (perhaps three to six minutes), sometimes in series, moving from place to place, volatile, and intense.

MARSHALORE *Another State of marshalore (the role of the artist)*, video performance with Tom LeGrady, Fifth Network/ Cinquième réseau, Toronto, 1978

... moving however I felt, waving my arms, rolling on the sidewalk. There were different reactions in different cities. In New York, I was completely ignored. In Montréal, I was at Place des Arts, I might have been moving from the sidewalk out into traffic and someone came and put their arms around me and moved me onto the sidewalk. They were solicitous, they wanted to help, thinking that this poor deranged young girl needed assistance immediately. Then they saw the camera and were a bit pissed off.[10]

A thirteen minute black and white videotape, *Street Actions*, was based on this work.

In keeping with the climate of the times, these actions were motivated by the desire to rouse a complacent public and operated within a position of confronting a bourgeoisie; however, marshalore emphasizes the reciprocal element. There was a transformational aspect to the vulnerability of behaving outside of social norms and absorbing the reactions. When I asked her about her motivations, she spoke of both exhibitionism and a sense of awe, of what might be called peak experience.

Vers le capitalisme was second in a series of actions on video. She described it as follows:

... more stylized and postured and it takes place in three personas focused around finding a leather glove in a garbage pail, in a kitchen and finding it hanging on a wall in an art gallery... I think I covered it with Vaseline ... in the second part something with a baguette, a long phallic-shaped bread, and in the art gallery I used it as a masturbatory tool. Looking back, there was definitely a combination of behaviour, fetishism, and commodification.[11]

The label "behavioural art," became attached to her work. Her understanding of the term at that time was "that you behaved in ways that were outside the normal mode of behaviour."[12] She sees the behavioural work as another aspect of her ongoing interest in improvisation with music, movement, and actions. (The label was sufficient for her to receive criticism in a CEAC newspaper that she was exploiting the term, CEAC having laid Canadian claim to behaviouralism.) In 1977, she was part of CEAC-led interventions at Pier 52 in New York with artists Bruce Ewes, Ron Gillespie, and Amerigo Marras and British behavioural artists Reindeer Werk (Dirk Larsen and Tom Puckey).

For her, there was a connection between behavioural art and role-playing:

Role-playing is a tool of therapists, behavioural psychologists. There are those who call themselves behavioural artists and they would say that rather than acting like behavioural psychologists, they start where behavioural psychology normally would end. They go past the peripheries of what psychologists would call behaviour. I don't know if I'm one of them but human behaviour, the human condition, human nature interests me. So does the idea of acting the role interest me as well. So one way I would manifest a series of behaviours would be to put myself in the position of how such and such a person would act under such and such a condition and then I would play it out.[13]

10 marshalore, interview with Chitty.

11 Ibid.

12 Ibid.

13 Pontrbriand, 17 and 19.

14 Nichol, 39.

NANCY PETRY

During these years, marshalore was active in the artist-run community. She founded Vidéo Véhicule in 1976, which became PRIM Vidéo in 1981.

> [I] needed equipment, so I formed an access group ... I wanted to make a tape and I didn't want it to stop there; I wanted to show it. So I had to start an exhibition program.[14]

Her video work was a fixture in Canadian video art contexts of the time, for example it was exhibited as a prizewinner in the Second Independent Video Open in 1979 and was part of Véhicule's participation (along with other Canadian artist-run centres) in Arte Fiera '77 International Market and Exhibition of Modern Art in Bologna, Italy.

In 1978, she and Toronto independent video producer, Terry McGlade, organized Fifth Network/Cinquième Réseau, a national conference of independent video producers. (Fifth Network was conceived by them with Marien Lewis.) The conference featured a performance art series, *Tele-Performance*, curated by Clive Robertson. The print document of this performance series, the December 1978 issue of Centerfold (the forerunner of *Fuse*), includes a guest editorial by Kenneth Coutts-Smith that describes the Canadian video community at the time and also the dispute around whether to form an independent video producers' organization.

MARSHALORE *Street Actions*, video. Improvised actions on the street and inside Complex Desjardins, Montréal, 1977. Camera: Sean Hennessey

One remarkably dominant aspect of the conference in general was the evidence of a significant gap of mutual incomprehension between the two broad factions present who can be said to have represented the poles of "social" video and "art" video.[15]

He then goes on to say:

Those individuals who assessed the conference from a dualistic and factionalist perspective (and it seems necessary to remark that these persons appeared to be more numerous in the "art" camp) clearly misunderstand the essential nature of the series of performances which took place at the Masonic Temple during the four evenings of the conference itself. The *Tele-Performance* programme provided, without question, a broad spectrum of artistic responses to the whole shifting social and political relationship between the individual and the state as it is presently mediated by the ideological superstructure of television in particular and the communications media in general.[16]

As well as organizing the conference, marshalore presented a performance work, *Another State of Marshalore*, which is described by Coutts-Smith as "a powerful statement in which Marshalore, booted and spurred, delivered an ironic history of the social development of television."[17]

The 1980 work, *Invasion des espaces avoisinants*, explores the boundary transgression of the street events in a gallery setting. She filled the space at Véhicule with enormous balls of crumpled paper while video played:

The audio/video presented various images of personal invasion in public places — the metro, streets, shops. No one stopped me until I shot a group of prostitutes who shouted that I had no right taking their pictures like that.[18]

The last of marshalore's works of extreme behaviours was *TROP[E]ISME* (1980), a colour videotape, fourteen minutes in length, that was a series of actions improvised for the camera. She booked Véhicule for a weekend and invited a friend, Jak Oliver, to join her. The parameters were time, the white wall, and empty space of the shot and the invitation to a partner. For the first part of the tape, she provided Oliver and herself with the direction to move around and express emotions — "get angry, get happy, cry, spit, laugh..."[19] and set up a shot with her in the foreground and him in the background. They improvised, sometimes moving in and out of the frame, acting alone and sometimes acting in conjunction.

The next section of the tape, which took place in another room in which marshalore had started to work alone, is the result of the chance entry of another artist, Istvan Kantor, to whom she extended an invitation for a dance and wrestling match. In the final section, she worked alone with the intention of seeing how far she would go with herself. She set up the camera on her genitals, and remembering she was menstruating, put her hand to her vagina and washed her face with her blood. She remembers the decision:

... it wasn't so much a thing to shock as, "Hey, let's see what this does."... it was interesting, it was colourful I've never rubbed blood on my face, I've never exposed my genitals to a video camera before ... what is it like to do this? what does the blood feel like? smell like? how much blood would come

15 Kenneth Coutts-Smith, guest editorial, *Centerfold* (December 1978).

16 Ibid., 6.

17 Ibid.

18 Richard & Robertson, Ibid.186.

19 Interview, Ibid.

20 Ibid.

21 Ibid.

22 Judy Grahn, *Blood, Bread and Roses: how menstruation changed the world* (Boston: Beacon Press, 1993), xvii-xviii.

up if I put my hand in my vagina? is that enough to paint my face with?…
without measuring it in terms of worth and judgment so much as measuring
it in terms of interest and curiosity.[20]

**Trop is "too much" in the French language and *trope* is a strong metaphor
in both the English and French languages. "And when you put the suffix, *ism*,
on something you're giving it status in the world."[21] The action of displaying
her menstrual blood brought marshalore to an extreme position in relation
to cultural norms about women's bodies:**

Images of blood are all around us, everywhere, in our modern, urbanized
society blood is depicted, spoken of, displayed … Menstrual blood is the only
source of blood that is not traumatically induced. Yet in modern society, this is
the most hidden blood, the one so rarely spoken of and almost never seen …[22]

**In "acting strange" on the street or in dipping her hand in her vagina on
camera, marshalore chose her body as her tool for stepping outside of social
norms.**

**In 1982, the Musée d'art contemporain presented *Art et féminisme*, an
exhibition and performances by women artists held in conjunction with the
exhibition of Judy Chicago's *The Dinner Party*. marshalore's *En prison pas en
prison*, was one of a series of works that arose from a performance for the
camera which she enacted in Amsterdam in 1979 in another abandoned
building — an abandoned prison:**

A large dark space is lit only by slides, rear-projected, filling one end of
the room and a small lamp aimed at an adjacent section of wall. The slides
show a prison, empty but for one prisoner, myself (an earlier piece, alone
with a tripod, camera, a Dutch prison), and a text interspersed with the
images. There is a soundtrack; mainly a fugue of footsteps. The strong per-
cussive rhythms of the fugue and the drama of the black & white slides
dominate the environment.

Carrying a Polaroid camera, I move in and out of the light reacting to the
slides, soundtrack, environment, people. At intervals I photograph the audi-
ence. These pictures are immediately displayed on the lit section of wall.
Then I make a decision. Taking a pair of scissors, I cut off my long, thick hair.
When the lights come up I am sitting in front of a small mountain of hair.

Excerpt from the slide text:

One drops through broken
 glass
One falls on weightless steps
One leaves the framework
 of things
One quits the burnt
 shadows

Casts of shapes blur, fade
Distant echoes dwindle,
 vanish

DAVID HLYNSKY

MARSHALORE *exploring sound and image,*
abandoned building adjoining Véhicule,
Montréal, circa 1975

One touches falling rain
One is free to consider
(Finally) the only prisoner

in prison (not) in prison

This piece deals with our concepts of subjectivity and subsequent behavior. When the reality of an idea is superimposed on the actuality of an event, another set of facts emerges. The abstractions of subjectivity and objectivity become interchangeable, creating a parable for our perceptions.[23]

Like the impromptu decision to reach into her menstruating vagina, the decision to cut her hair during performance was a strong element that defined the work for many viewers.

A Postcard Home took place at the Mendel Art Gallery in Saskatoon as part of the series, *Three in Performance*, in 1982. The following are notes prepared for the curator and gallery:

A tour through the conservatory at the Mendel Gallery. Past the Brazilian bougainvillea, the Mexican "Queen of the Night," the Honduran bamboo palm, the South Afrikan "Bird of Paradise," the Cambochian Ti plant, the Rose of China; past Fantasy Island.

An allegory for flora and fauna with texts, sounds and actions.

— We will walk about the conservatory; stand where we like
— Four small speakers placed discreetly in the corners will play the audio piece throughout the actions. These speakers will enable the sound to be clearly heard without being too loud. (Audio piece: collage of sounds indigenous to regions of plants' origins accented with other sounds)
— Newspapers from various countries will be placed about the space
— I shall move through the conservatory carrying a small tape machine with a recording of a short wave radio montage
— At intervals I shall read short biographical texts about people from regions where these plants might be
— With a Polaroid camera (or its equivalent) I shall photograph people amidst the flora and fauna and place the colour photos among the plants.[24]

In 1983, marshalore was one of the artists in Performance/Art/Action, a three-day performance festival of seventeen artists organized by Darcheu and les Éditions Alternatives in Sherbrooke, Québec. In *Through a Looking Glass*, she used mirrors to reflect projected slides depicting the daily life of a seven-year old girl while an audiotape of industrial sounds played and she constructed a grid of string connecting the mirror, the projections, parts of the room, and the audience.

marshalore's last major art work was the video installation, *Album*, produced in 1984 and followed by a single channel videotape version in 1985. It is a composite portrait of three people talking about defining experiences in their lives, created by the interaction of a video interface with a stochastic (random constraint) computer program.

23 *High Performance* (spring-summer 1982), 118.

24 Pontbriand, 18.

25 marshalore, interview with Chitty.

STEPHEN LACK

BOB BARNETT

As an artist amongst those who laid the foundations in Canada for artist-run culture in video and performance art, she was a practitioner of performance for the camera, a notable tangent in early video art. Her embrace of different disciplines and sense of experimentation and play contributed to the evolving aesthetics of interdisciplinary art.

Since she has become disabled, marshalore still conceives of performances:

The position announcement is a synonym for a job posting and I did a series of position announcements and I would say I am going from a sitting position to a standing up position. Position announcement two — I am walking on thin shells and I now enter the sea. So they are still performances, they're still body movements, they're still very centred on the body — and yet they take place nowhere. They're images, little visualizations and they come and they go.[25]

MARSHALORE performing with Tom Dean, Musée d'art contemporain, Montréal, 1973. Choreography: Margaret Dragu. Piano: John Plant

MARSHALORE *Another State of marshalore (the role of the artist)*, video performance with Tom LeGrady, Fifth Network/ Cinquième réseau, Toronto, 1978

Jayne Wark

Rita McKeough

AN ETHICS OF COMPASSION

Rita McKeough has been producing installations and performances across Canada since 1979. During the 1980s, she worked primarily with installations and has concentrated since 1991 on performance projects, that have often taken place within installation settings. McKeough's performance works are often large, even operatic, in scale, yet are structured so as to create a paradoxically intimate experience for the audience. As Barbara Lounder observed in writing about McKeough's 1996 performance, *Dancing on a Plate*, her technique of positioning viewers within sets or installations, in close proximity to the performers, can be related to the tradition of postmodern dance that emanated from the Judson Dance Theatre in New York in the late 1960s, whereby the strict and safe division of audience and dancer was done away with.[1] In McKeough's performances, this intimacy is heightened by the plenitude of sensorial elements, including complex spatial or architectural structures, strong emblematic or allegorical visuals, and the pervasive use of singing, speech, music, and percussive sound.

As implied by the use of these multivalent forms and elements, McKeough's performances are also highly collaborative. While McKeough remains very much the author of these performances, she relies on the participation of numerous individuals upon whose specialized skills and

strengths the impact and success of the performances depend. She has collaborated most consistently with Kathleen Yearwood, whose haunting singing and vocalizations resonate within many of McKeough's performances. While this collaborative approach is not a uniquely feminist one, it does underscore the collective and socially-oriented ethos that characterizes McKeough's work, which is evident not only in the formal aspects but also in the thematic references to women's experiences and ways of knowing.

When I first met Rita McKeough back in 1979, she was working on her MFA at the Nova Scotia College of Art and Design (NSCAD), where I was an undergraduate at the time. She was a printmaker then, and I remember the exhibition where she displayed her prints of lost and stray mittens that she had found lying forlornly in the streets of Halifax. They were sadly poignant and sweetly funny at the same time, not to mention showing quite a spirited independence from the Conceptual reductivism that was still so prevalent at NSCAD. McKeough is still taking in strays, mostly of the four-legged kind. Although her art practice today has diverged considerably from her early days as a printmaker, one binding point of connection is her ethical commitment, which, I might add, is utterly devoid of piousness or pompousness, to bringing attention to the lost and dispossessed, the disenfranchised and exploited, the victimized and silenced.

This commitment became especially evident in the prints, bookworks, and installations McKeough executed in the 1980s after returning to Calgary from Halifax, which featured stray dogs, poisoned fish, and old houses slated for demolition during Calgary's petro-dollar-fuelled building boom of the early 1980s. These houses, with their gaping windows, crumbling drywall, and peeling paint, acquired a particular significance for McKeough and recurred in several performances and installations as emblematic motifs of the violence and destruction enacted on — not by — the weakest, poorest, and most vulnerable members of society. In *Defunct* (1981), for example, a Calgary neighbourhood undergoing demolition was replicated in an installation at the Alberta College of Art. Each of the one-third scale houses was fitted with audiotapes that spoke of their reactions to the development and gentrification taking place in the city. As they were boarded up and torn down one by one, the gallery grew progressively quieter and then silent. In *Destruck* (1983), an installation at the University of Lethbridge Art Gallery, the houses sprouted mechanized arms and legs to try and fight back at the bulldozers that came to destroy them; although the developers and contractors still won the day, the houses had begun to form a resistance.

McKeough continued to work along these lines through the early 1980s, however, as Sandra Vida has noted, the 1986 installation called *Retaining Wall* at Stride Gallery in Calgary marked a dramatic change.[2] For one thing, the house now became configured not as the discrete object of urban and economic contestation but as the space where family groupings and tensions mingle and clash in the interstice between private and public, individual and social, internal and external. For another, in this and subsequent installations

1 Barbara Lounder, "Dancing on a Plate," in *Rita McKeough, Dancing on a Plate* (Cornerbrook: Sir Wilfred Grenfell College Art Gallery, 1996).

2 Sandra Vida, "Passages: Rita McKeough's Art and Life in Alberta," in *Rita McKeough: An Excavation*, Annette Hurtig, ed. (Calgary: Glenbow-Alberta Institute, 1994), 73.

and performances, the house structure, which had previously figured primarily as the object of victimization and destruction from without, now became the physical metaphor for violence and conflict from within the confines of familial relationships. From the late 1980s, with installations like *Blind Spot* (1987), *Mimicry* (1988), and *Tremor* (1989), and into the more specifically performance-based works of the 1990s, the house and its domestic trappings served as the literal and figurative embodiments of McKeough's feminist politics and poetics. In these installations, the effects of domestic violence were emblazoned on the scarred and broken walls, while audiotapes registered the almost insurmountable struggle to find words to speak, to give voice to profoundly painful and isolating experiences. For without the ability to name this suffering and give testimony to it, it remains repressed — and therefore perpetuated — within the historical, economic, and cultural traditions that enforce the separation of the private and the public. As American theorist bell hooks wrote, this enforced separation is a tool of domination:

> I know that in a way we're never going to end the forms of domination if we're not willing to challenge the notion of public and private ... if we're not willing to break down the walls that say "There should always be this separation between domestic space/intimate space and the world outside." [3]

The points of transition that link McKeough's installation works of the late 1980s to the performance work of the 1990s can be located primarily in this re-conceptualization of the house as embodied metaphor of gendered experiences and in the use of audio components to animate and give voice to these experiences. The theoretical grounding for this turn in McKeough's work was derived from her readings of French feminists like Hélène Cixous, Julia Kristeva, and Luce Irigaray, and of the American feminist Monique Wittig (although Wittig in fact renounces the theoretical positions and strategies of French feminism). The writings of these French feminists, whose work is shaped by post-structural discourse, redress the premise that the category "woman" is a void, an "empty set." She may have been constructed as that within the patriarchal order, but in order for the hierarchies of the man/woman opposition to be addressed, the question of "difference" must be reconceived. The work of these French feminist theorists aimed not only to discover and validate the feminine but also to undermine the certainty and confident mastery of the masculine position as the One, in relation to which all others must either be reduced to Sameness or else defined as negativity and waste. In that they identified language as the primary locus where the hierarchical oppressions of sexual difference are played out, we see an echoing of their strategies in McKeough's use of audio in particular but also in her transposition of their textual strategies to the visual, material, and embodied elements of her performances and installation settings.

In McKeough's first major performance of the 1990s, *In bocca al lupo/In the Mouth of the Wolf*, held at Mount Saint Vincent University (MSVU) Art Gallery, Halifax, in March 1991, these elements were all brought to bear on a

3 bell hooks, interview with Andrea Juno in *Angry Women*, Andrea Juno and V. Vale, eds. (San Francisco: Re/Search Publications, 1991), 86.

4 Luce Irigaray, *This Sex Which Is Not One*, trans. Catherine Porter with Carolyn Burke (Ithaca: Cornell University Press, 1985), 76.

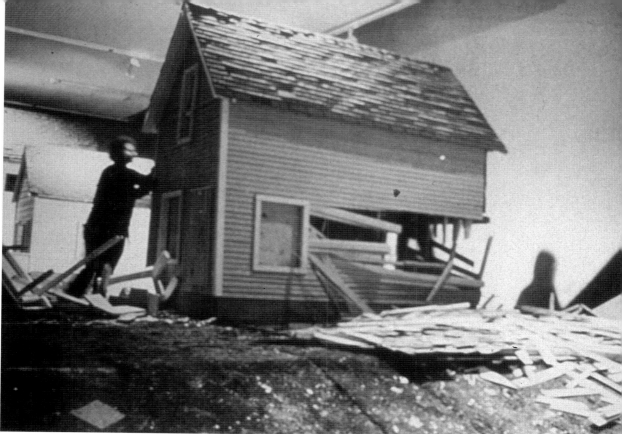

theme that spoke directly about, and indeed embodied, women's resistance to repression and oppression. Within an architectural structure that schematically represented a body laid out horizontally across the gallery space, a corps of choir, solo vocalists, dancers, and musicians performed along with pre-recorded audiotape and video and slide projections in an operatic enunciation of pent up and released anger. Audience members were closely positioned around the body by being either precariously perched on stacks of books or seated in pews and school desks (alluding to the history of MSVU as a teaching institution for women founded by monastic women), while the performers moved in and out through openings in the body to interact with each other and the audience. In this way, intimacy was turned back on itself, to function not as the imposed mimesis that results, as Irigaray would say, in the repression of the feminine (in the body, in the spaces of domesticity), but rather as the playful, strategic repetition of mimicry, which allows for the recovery of "a possible operation of the feminine in language."[4] As the performers unleashed their vocal and embodied expurgations of anger through the symbolic sites along the length of the body (e.g., throat, heart, navel, knee), the audience members were conjoined, as Joan Borsa said, as "inclusive entities, participants in the 'healing'

RITA MCKEOUGH *Defunct*, Alberta College of Art, 1981

who had witnessed the complexity of the 'damage.'" [5] *In bocca al lupo* begins and ends with silence. As Barbara Lounder asserts, however, this is no longer the silence of the repressed but the "aphonic revolt" that also empowered Freud's ostensibly hysteric patient "Dora" to get up and walk out when he ignored or invalidated her attempts at speech.[6]

McKeough's next large-scale performance/installation, called *Take It to the Teeth*, was mounted at the Glenbow in Calgary in 1993. Again McKeough transformed the space into an anthropomorphic structure in which sites along the length of the gallery symbolically represented parts of the digestion system (e.g., mouth, esophagus, stomach, intestines, anus). The performance began with a carnivalesque parade on opening night with the costumed performers wandering among the audience members, who were seated on kitchen chairs scattered throughout the gallery space, and welcoming them to "The Big Top." Two performers, accompanied by musicians and vocalists, began searching the space for sounds and voices emanating from speakers concealed behind the walls. As they discovered the sources of these sounds, they tore at the walls and removed pieces with their teeth. These pieces were then dragged through the digestive system and brought to one of two half-circles of large teeth, where they were chewed up and spit out. This process continued for one hour every day of the exhibition until all the speakers had been uncovered and their buried and repressed memories released. At that point, the lush fullness of the audioscape was revealed, with its twenty-four tracks playing rhythmically and melodically to form a cohesive whole. As Annette Hurtig wrote in her curatorial essay for the exhibition, *Take It to the Teeth* transformed the gallery into both an allegory of the sensate body coming to speech and agency, and "a metonym for the social body, the body politic, which … is a recurring narrative surface in the development of Rita McKeough's ethical inquiries."[7]

These ethical inquiries reemerge in McKeough's other installations and performances from the 1990s. In *Shiver* (1995), an installation at Memorial University Art Gallery in St. John's, Newfoundland, the gallery was transformed into a shaky and unstable replica of an apartment building from which a woman had been forced out in order to escape its prison of violence and abuse. Images of this walking woman as she searches for privacy, warmth, and safety were projected in a constantly moving circle around the upper part of the gallery walls. The floor was strewn with newspapers and littered with bits of furniture and lamps that were thrown out with her. By means of invisible wires and mechanized motors, everything shook and shivered. Two speakers chanted the words "Get Out. Thrown out. I'm out." Two additional speakers, along with a suitcase and a kitchen table and chair set, were suspended from the ceiling in a corner of the space. Here the woman was offered a place of respite. These two audiotapes cycled through each other in a delicate balance, one speaking of the cold and weariness that consume her, and the other, through music and voice, speaking of warmth and survival. While fear, loneliness, and pain were acutely portrayed in this installation, its promise lay in making visible the suffering and degradation

ANITA MARTINEZ

5 Joan Borsa, "From the Edge of a Wound," in *Rita McKeough: An Excavation*, 36.

6 Barbara Lounder, "Want of a Voice," in *In bocca al lupo/In the Mouth of the Wolf*, Mary Sparling, ed. (Halifax: Mount Saint Vincent Art Gallery, 1991), 11.

7 Annette Hurtig, "Enunciating Pain and Imagining Intimacy: Toward an Ethical Politics of Agency," in *Rita McKeough: An Excavation*, 18.

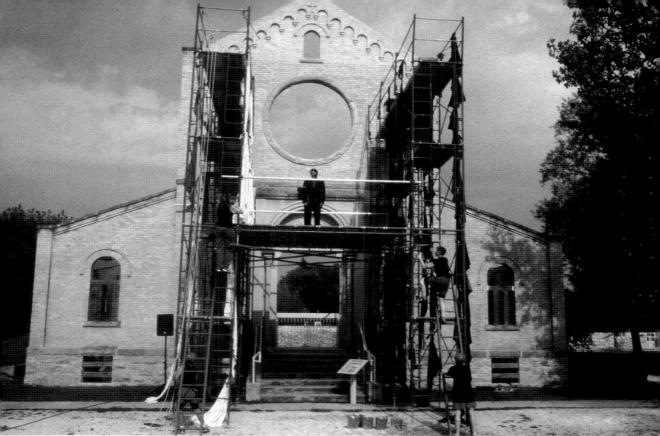

SHEILA SPENCE

of such supposedly "private" experiences, and thereby bringing homelessness into public view as a rend in the social fabric.

Several aspects of *Shiver* recurred in McKeough's installation and performance, *Dancing on a Plate*, held at Sir Wilfred Grenfell College Art Gallery in Cornerbrook, Newfoundland, in 1996. Again the theme evoked departure from an oppressive situation but also focused on the long period of trepidation and uncertainty before the decision to leave is made. In *Dancing on a Plate*, the gallery was divided into two spaces and required visitors to pass through the first room across a gangplank suspended over a black surface representing water with "white caps" made of broken plates. An audiotape played a traditional maritime song, a melancholic lament with the lyrics altered to tell the story that precipitated the moment of departure. After passing through one of four doorways at the end of the gangplank, visitors found themselves in the second room, which represented a domestic interior with objects hanging from the ceiling as if they had been thrown in the air. The floor was made of two-foot square wooden panels on springs, so that, upon entering the space, viewers were literally thrown off balance and searched frantically for stable ground. Some of these panels activated audiotapes that played the percussive sounds of step dancing, a voice imitating

RITA MCKEOUGH *In bocca al lupo/In the Mouth of the Wolf*, operatic performance, Mount Saint Vincent University Art Gallery, Halifax, NS, April 1991

RITA MCKEOUGH *Tower of Silence*, St. Norbert Art Centre, St. Norbert, MB, 2000

fiddle music, and the caller of a square dance. On opening night, four couples attempted to square dance by following knot patterns on the floor, but collisions and entanglements constantly thwarted their efforts. Another couple faced each other silently across a kitchen table, and then repeatedly circled around and did sudden and violent shoulder rolls across the table. In the end, the woman in this couple finally walked away to the door, looked back once, and left. As the sound of all four doors closing was heard, the tension was broken and silence, like a wave of relief, flooded the space.

McKeough's more recent performances include *Shudder*, performed in 1998 at Ace Art Gallery in Winnipeg and again in 2000 at AKA Gallery in Saskatoon, and *Tower of Silence*, performed in 2000 at St. Norbert Arts and Cultural Centre in St. Norbert, Manitoba. In *Shudder*, McKeough again created a complex installation setting with multiple audio components, video projection, and mechanized props in the form of heavy theatre curtains that rose and fell unpredictably to punctuate the actions of the performers, who included McKeough and five others. The audience was seated in this tightly enclosed setting and, as Louise H. Forsyth described it, was made to feel a collective shudder of fear in response to the performers' concentrated evocation of this powerful emotion, which has the ability both to paralyze and energize.[8] The source of this fear went unnamed in *Shudder*, for it is not singular, nor can it be distanced from us as the experience of others to which we ourselves are immune. But by naming the emotion itself, and enabling its cathartic release within the performative experience, McKeough hoped to enact the possibility of wresting agency from its controlling and debilitating grip.

In contrast to the cacophonous and chaotic release experienced in *Shudder*, *Tower of Silence* conveyed its opposite: the silence of prayer as another form of political and social voice. The setting for *Tower of Silence* was the ruined facade of the Trappist Monastery church located on the grounds of the St. Norbert Arts and Cultural Centre. McKeough's decision to focus on silence and prayer in this 49-minute performance was partly in response to the history of the monks who had once inhabited this site and partly to the possibility of silence as a form of communication. Indeed, the principal structure of the performance setting was a large scaffold built across the church facade in the shape of the letter "H." In the website catalogue for this performance, McKeough cites a text by Hélène Cixous, who discusses the linguistic history of this letter in both French and English, where it is either silent or the sound of a breath.[9] As Cixous also notes, "H" is the form of a ladder, and for her, this ladder is writing, and it is therefore neither immobile nor empty but animated with the movement it arouses and inscribes. In McKeough's performance, this H-shaped scaffold symbolized silence as a form of listening, and provided a structural apparatus on which the five performers continuously ascended and descended. These were not easy movements, for the performers hauled buckets of water, picks, shovels, and ladders up and down the scaffold. This creation of a circle of communication was laborious work, but it was not without joy. Accompanied by pre-recorded audiotapes, Kathleen Yearwood stood on the bridge of the "H"

8 Louise H. Forsyth, "The Art of Reva Stone and Rita McKeough: High Energy Encounters," in *High Tech Encounter. Rita McKeough:* Shudder *and Reva Stone:* Carnevale (Without Flesh), (Saskatoon: AKA Gallery and The Photographer's Gallery, 2000).

9 *Tower of Silence* was published as a web-based catalogue, including video and audio clips as well as descriptive texts. It can be accessed through the website of the St. Norbert Arts and Cultural Centre, www.snacc.mb.ca. The website includes an excerpt from Hélène Cixous' *Three Steps on the Ladder of Writing* (New York: Columbia University Press, 1993).

ANITA MARTINEZ

ANITA DAMBERGS

singing seven songs that were composed for the performance: "Song of Understanding," "Song of Forgiveness," "Song of Repentance," "Song of Healing," "Song of Destruction of Oppression," "Song of Gratitude," and "Song of Peace." The sounds of joy also emanated from the garden of fabricated roses, dedicated to the Virgin Mary, which encircled the facade of the church. These roses contained hidden audio speakers that played the sound of women laughing throughout the performance. Laughter is embodied joy, and has long been associated with women's defiant resistance to oppression. Seated among these flowers, the audience members were enclosed within this circle of feminist laughter, song and work, and were reminded that silence is not necessarily the absence of sound or speech but is also an intrinsic form of reciprocity in communication and sharing.

In the work of Rita McKeough, art and feminism are conjoined in a symbiotic union of aesthetics and politics. Art is not a tool of politics, nor are politics simply a "content" for art making. For McKeough, creativity is itself political because it is a form of agency; indeed creativity is impossible in the absence of agency, and the struggle for agency is at the centre of all her work. While this agency is located within the individual, McKeough's work is emphatically not individualistic and solipsistic. The body is a constant metaphor in her work, both in its suffering and in its resiliency. And as she makes evident in her installations and performances, no individual can or should be isolated from the body politic, for these experiences are communal and collective. Above all, her art is an embodiment of an ethics of compassion, to which we all ought to attend.

On a more personal note, no profile of Rita McKeough should be written, at least not by anyone who knows her, without remarking on her charming, dare I say elfin, self. After leading the life of the itinerant artist for many years, Rita McKeough has resettled in Nova Scotia, where she teaches at NSCAD, makes art, and plays as a drummer in several bands. She is revered by her students, and is a friend and mentor to many others in the art and music communities of Halifax. Her generosity and humour shine through all she does.

RITA MCKEOUGH *In bocca al lupo/In the Mouth of the Wolf*, operatic performance, Mount Saint Vincent University Art Gallery, Halifax, NS, April 1991

RITA MCKEOUGH *Take it to the Teeth*, Glenbow Museum, Calgary, 1993

Paul Couillard

Pam Patterson and Leena Raudvee

WHAT IF ART ACTS?

What if art acts? This question is at the core of Pam Patterson and Leena Raudvee's twenty years of collaborative work. Presenting performances, interventions, and exhibitions under the group name Artifacts, the two have engaged in a collective practice that is insistently feminist, rooted in the everyday, and focused on their relationship to each other and the world around them.

An anagram of "if art acts," Artifacts refers to the merger of visual art and performance, with a nod to the idea of art's active potential as a transformative force. At the same time, the name refers to the physical nature of art, the traces and residue that even an ephemeral gesture leaves behind. Artifacts' work reflects both of these meanings, offering a dense layering of idea, process, object and lived experience.

More than simply an output of artistic activity, Artifacts is the public face of Patterson and Raudvee's ongoing dialogue. Raudvee muses, "I remember sitting in the car late at night with the motor running, and talking and talking and talking. Out of that came the idea, 'Let's do something.'"[1] Making art together has served a dual purpose for Patterson and Raudvee: taking their friendship beyond the everyday, and giving meaning to the everyday through form.

When Patterson and Raudvee began presenting work together in 1983,

their collaboration was as much a coming together of disciplines as it was of minds. The two began working together in part to explore what visual art might bring to theatre. Raudvee's background in visual art contrasted with Patterson's training in acting and directing. Artifacts' early works reflected a separation of roles, with Patterson doing most of the performing and Raudvee identified as a visual artist. Their first collaborations employed a theatrical presentation style with multimedia installation sets and character-driven performances.

The early works were overtly political and feminist. *Entrapment* (1983) dealt with the derogatory language and media advertising used to describe and define women, which Patterson and Raudvee referred to as "cultural brainwashing." The performance chronicled a secretary's struggle toward self-realization and freedom from cliché media images of herself. The set, which also functioned as a gallery installation, used some sculptural elements, including a large net, but the key visual component was a series of photo-collage images of women projected onto the space and the performer. Another early piece, *Headaches for the Unit* (1984), presented at the Horseshoe Tavern in Toronto as part of the Alter Eros Festival, used local newspaper reports concerning brutality to women as source material. The title refers to the notion that rape and family beatings are considered headaches for police units. In this piece, Patterson performed as a woman walking through a series of projected photo-collages while Raudvee stood at a lectern reading newspaper reports in the style of a newscaster.

Parallel to their proscenium-style works, Patterson and Raudvee experimented with street actions. In *Madame X from Planet X* (1983), Patterson appeared as a dignitary from a matriarchal planet where all things are equally valued as art. Madame X and her entourage were taken on a tour of local cultural institutions (the Art Gallery of Ontario, the Royal Ontario Museum) by the Minister of Foreign Objects (played by François Klanfer). Madame X's conversations along the way, both inside and outside the institutions, revealed some of the implications of this alternate worldview.

For *Female Laundry* (1983), Patterson and Raudvee hauled laundry and set pieces to the Bay Street business district of Toronto. Patterson, playing the role of "Betsy," attempted to iron clothes or hang laundry on a makeshift clothesline outside office towers until security staff intervened. *Female Laundry*, presented in the context A Space's site-specific *Metro Works* series, raised questions about the invisibility of traditional women's work, and about how that work is valued in society.

During this prolific early period of their collaboration, Patterson and Raudvee tried various approaches to performance. In *Suburban Mirage* (1984), for example, presented at the Winchester Theatre as part of a DanceWorks program of dance and performance art works, Artifacts revisited the character of Betsy. Patterson and Raudvee co-directed this theatrical piece featuring a cast of five actors, working collaboratively with the cast to develop the script. Patterson acted as one of the performers, while Raudvee contributed photo-collages that evolved from the documentation of the original street

1 Pam Patterson and Leena Raudvee, interview with Tanya Mars (spring 2003). All artist quotes are from this interview.

performance. Layering techniques — whether through visual collage, overlaying soundtracks, or unexpected juxtapositions of differing realities — have been a defining element of Artifacts throughout their history.

Patterson and Raudvee's collaboration underwent a major shift in 1987 when the two were in residence together at the Banff Centre in Alberta. There they created *Attending the Interior*, an installation and performance work that evolved out of their interest in staging an environment rather than performing a script. While still reflecting a feminist perspective, particularly in its concern for how women are seen, this new work moved from an overt political stance and didactic narrative to a more personal position of questioning and listening. As the title suggests, Patterson and Raudvee were interested in focusing both their and the audience's awareness of process, lived experience, and live presence.

This shift of content was accompanied by a shift of strategies and roles. Raudvee took on a more active role as co-performer, with both artists appearing as themselves rather than in persona. Both were credited equally as creators of the installation. Through their collaboration, each artist had developed beyond her original area of specialization, discovering a hybrid territory of performance installation that both could occupy together. Their dialogue through art was empowering them to take on new responsibilities and identities.

2 Ibid.

This initial 45-minute experiment in creating an environment led to *Attending II*, which unfolded in a gallery space over four days. This piece further foregrounded the relationship between Patterson and Raudvee, offering a non-linear environment of objects, projections, and collaged soundtrack animated by the two performers. *Attending II* was presented in 1989 in the context of *Access to the Process*, a series of performance/installation works curated by the duo for A Space. For each of the works, *Access to the Process* audiences were invited to visit during regular gallery hours as the works developed, reflecting Patterson and Raudvee's growing interest in the negotiation, construction, and transformation of space and relationships over time.

Over the years, the duo's working relationship has included intense bursts of activity as well as fallow periods necessitated by jobs in other cities, raising children, and health problems. It is important to Patterson and Raudvee that they take whatever time is necessary to develop a piece, often working for a year or longer on an idea. Dealing with their own mortality and physical constraints has become an inevitable part of the work, an extension of their interest in process and their commitment to capture the truth of the everyday. Patterson notes:

Our limitations ... have become part of how we perform. Leena knows she'll need to be on one side of me so she can see me, and I need to bend down a certain way because of a herniated disc in my back. It's just living accommodation. Not only have we accommodated and integrated the way we talk to each other, but also the way our lives have evolved. Even our children have been part of it.[2]

JOHN OUGHTON

MONTE GREENSHIELDS

Integrating this personal dialogue, the way Patterson and Raudvee "talk to each other" is critical to the character of their work together. Artifacts is not simply the sum of two parts, but rather, an entity with its own way of operating. Both note that their collaborative work has a different look and process from their individual practices.

Patterson's solo works, for example, reflect an academic bent (she has a Ph.D. from the University of Toronto's Graduate Department of Education). They are heavily researched and usually text-based. Her most enduring piece, *Emily Speaks*, features Patterson in the role of the Canadian painter Emily Carr, delivering a lecture that advocates on behalf of Canadian art. Based on Carr's essay "Fresh Seeing," which railed against the conservatism of the cultural establishment of her time, *Emily Speaks* manages to memorialize a towering Canadian female historical figure while at the same time taking some still timely swipes at the art establishment.

Raudvee's solo works tend to be photo-collage, which reflect her visual art roots. Her subject matter, the female form, points to her abiding interest in the human body, while her collage techniques reveal a penchant for combining the figurative with the abstract using tactile, non-narrative approaches to the elements of space and time.

PAM PATTERSON and **LEENA RAUDVEE**
Passing, performance for the 7a*11d International Festival of Performance Art, Toronto, 2000

PAM PATTERSON and **LEENA RAUDVEE**
Attending the Interior, performance-installation, The Banff Centre, Banff, 1987. Pictured: Leena Raudvee

As *Artifacts* has evolved, Patterson and Raudvee's interest in process has extended to include a response to the spaces in which they perform. *Passing* (2000), presented over two days in the context of the third 7a*11d International Festival of Performance Art, took place in the interior hallways, elevator, and exterior courtyard staircase of the 401 Richmond Building in downtown Toronto. Rather than creating an environment, Patterson and Raudvee used a spare set of materials culled from their previous collaborations (stones, photocopied paper, a bowl filled with words printed on small pieces of paper), performing mundane yet delicate actions that called attention to the existing physical and social architecture of the building.

Passing reflects the maturity of the two artists' collaboration. A small set of deceptively simple actions anchored the performance, providing a core around which the pair was free to improvise as the piece progressed. The artists' movements were slow, deliberate, and unadorned. Their mood was contemplative. Emotions were not telegraphed, but neither were they suppressed.

Over the two days, a pile of smooth, oval stones placed on the wooden floor of the fourth story hallway were taken outside and down the stairs, one by one, to be placed on a grill at the base of the spiral metal staircase. As the action slowly unfolded, meanings, sensations, and questions accrued. Gently, subtly, Patterson and Raudvee used their materials to draw the audience's attention to myriad intersecting qualities of being. Weight. Gravity. Light. Texture. Scale. Time. Space. Experience. Relationship.

Audiences could stay and watch for a moment or an hour or all day. Those working in the building could note the transformations periodically as they went about their regular routines. The performance could be viewed from multiple vantage points: inside; outside; above; below; up close, as the artists brushed past on the stairwell; or from a distance, through the windows on the opposite end of the courtyard. As Patterson and Raudvee became more adventurous and playful in the space, more complex relationships were layered around and onto the repetitive gesture of moving the rocks. One might note, for example, how Patterson's body, lying lengthwise across the space of a hallway, was cradled by the floor and walls in exactly the same manner as a stone placed lengthwise across Raudvee's hand. Flat sheets of paper, bearing the photocopied lines of other pieces of paper that had been crumpled and then smoothed out, were themselves crumpled and smoothed out, changing their texture and volume. Bits of text taken from past conversations between the two artists were reconfigured in new arrangements on walls, objects and even passersby, a reminder of how meanings fragment, layer, and multiply.

This sense of multiplying meanings, of unpredictable permutations and combinations flying off in all directions, was pointed to most clearly in the final image of *Passing*, when the artists appeared at the top of the outdoor staircase and tossed the small pieces of paper printed with words into the air. Words fluttered in random patterns against the sky, dropping down to coat the ground, the rocks, and the audience. The space, and everything in it, had

been randomly marked by a structured action with unpredictable effects.

Raudvee: "There's a difference between an object before it's been performed with, and after, when the object becomes an artifact."

Patterson and Raudvee approach performance with a keen sense of how all material things — including our bodies — are altered by experience. Being attuned and adapting to these changes — evident in *Passing* when Patterson's physical exhaustion prompted her to begin using the elevator rather than the stairs — has become more important in Artifacts' work than sticking to a set structure or task. In this sense, the performers' actions serve a dual role, not only as transformative forces, but also as revelatory artifacts in themselves, physical evidence, however temporary, of how time affects us.

In tracing the development of Artifacts over twenty years, there is a clear shift in the work from strategies to tactics. In his book *The Practice of Everyday Life*,[3] Michel de Certeau makes the distinction between strategies — in which an agent or institution (such as a university or theatre) creates an autonomous zone of legitimacy with its own set of rules that can differ from the larger whole — and tactics — contingent, fragmentary activities that take place *within* the larger space by capitalizing on temporary opportunities. Strategies are place-based, while tactics are time-based.[4] De Certeau uses his argument to consider ways in which ordinary people are able to reclaim autonomy from larger social, political, and cultural forces. Applying this perspective to the work of Artifacts, we can see how answering the root question, "What if art acts?" has taken Patterson and Raudvee into a performance practice that is also a "practice of everyday life."

Artifacts' early theatrical works, presented in the strategic environments of theatres, clubs, and galleries, attempted to set up autonomous environments in which political and social norms could be scrutinized and criticized. This approach was a common feminist strategy of the period. By relying on place, however, strategies do not necessarily provide sustainable or enduring alternatives to the environments that they stand in resistance to. Nor do they necessarily provide relief, since in this case the scrutiny consisted of mimicking or acting out the most painful aspects of the status quo rather than actually living an alternative to it.

Over time, however, Artifacts has taken an increasingly tactical approach to work, guided by Patterson and Raudvee's observations of when and how art "acts" most effectively. Their work has become more temporal; that is, more rooted in real time and space. Their work has become more responsive to the environments in which it takes place, shaping or re-viewing the form and function of existing architecture rather than masking it. Finally, their work has become more "real," enacting (or being) rather than portraying (or parodying) the everyday.

Moving from strategies to tactics would seem to have significant repercussions in terms of a work's impact, for both the viewer and the audience. As territory, space is always under threat, and the actions that take place there can be minimized as simply not applying to the larger world that surrounds

3 I am grateful to Christine Carson for making me aware of de Certeau's writing on tactics and strategies through her unpublished thesis paper, "Fieldwork in the Everyday."

4 Michel de Certeau, *The Practice of Everyday Life* (Berkeley: University of California Press, 1984), xix.

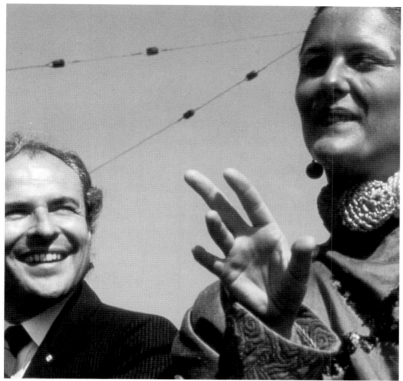

DIANE GOODERHAM

it. Time, on the other hand, once it is taken, can never be taken away. When a performer, acting as herself, occupies an everyday space and undertakes a series of gestures that do not conform to how one thinks one ought to behave in that space, she is opening up endless possibilities for all of us to enact new behaviours, new ways of being in the everyday. For the length of time that the gesture endures, she is living what she wishes to live rather than pretending to do so, or fighting for a space in which to do so.

What is true on a small scale in individual performance works is equally evident in considering Artifacts itself as a larger project. While Artifacts began as a way for Patterson and Raudvee to express themselves and have an impact on the world around them, it has also been a vehicle for them to deepen their friendship, a way for them to be together. Artifacts is the part of their relationship that they share with others: not a mask, but part of what they, together, are within the larger world. As such, it both affects, and is affected by — perhaps the beginning of an answer to their question, "What if art acts?"

PAM PATTERSON and **LEENA RAUDVEE**
Madame X from Planet X, street perform-ance, performed by Pam Patterson and François Klanfer, Toronto, 1983

Jenifer Papararo

Paulette Phillips

FIND THE PERFORMER

Paulette Phillips unabashedly brings psychosis and neurosis to the forefront — not under sympathetic means or as an anomaly to be cured, but as an equalizer. She posits "craziness" as another way of looking and as a viable means to form relations and see the world. The expression of psychotic behaviours for the artist is not simply an opening of different perspectives, but is also a formally contested means to negotiate daily interactions and to effectively debunk two-sided or linear logic. Why does circular logic have such negative connotations? It may not progress in the same way as linear thought, but a circle can still expand or retract its dimensions.

Let's start with the artist's favourite performance. A woman wearing a suit jacket, matching skirt, and pumps, holds a small leather case and stands in the financial district of Toronto at a corner of Bay and King Streets. In this setting, she is unremarkable — definitely not worthy of a double-take. Her presence, even after standing on the same corner for nearly two hours, seems commonplace. Across the street a person with a video camera signals the only irregularity.

This action was just one part of Paulette Phillips's 1983 performance *Find the Performer*, a serial work that spanned four months. The day before she

inconspicuously occupied a corner of Bay and King, the artist plastered the city with posters that said "Find the Performer" written in bold letters above an image of herself dressed as a coal miner. Phillips left the posters up for a month until she covered them with another poster bearing the same text but with a new image of herself. In this image, she is lying on the ground as if collapsed, hiding her face with an outstretched arm and wearing nothing but a t-shirt. The following day what appears to be a shabbily dressed man with a hat stands at the corner of Sherbourne and Queen Streets, an economically depressed area of the city. Again, the only indication of something unusual is the person who records the event from across the street. One month later, another poster and another corner: the artist performs another character or more aptly another place. The poster bears an image of Phillips herself in the pose of a Baroque sculpture. In the performance, a woman in a prim dress and white jacket stands near a shopping centre at the corner of Yonge and Bloor Street.

Did anyone notice the artist? Did anyone make the connection between the posters and Phillips' performances? Does it matter?

Another month passes, the artist dresses casually, most like herself, and chooses to walk along a strip of Queen Street West (between Bathurst and John Streets), a neighbourhood she regularly occupies. In this role, Phillips finds her voice. As she walks the street, she gives an unscripted and somewhat impromptu dialogue that addresses no one in particular. She speaks to herself in a somewhat coherent ramble that isn't dramatic or unfamiliar to the busy street. In order to capture Phillips' every word and match her movements, someone follows her closely with a camera.

Again, the signifier of something out of the ordinary is the process of documentation. Everything appears as usual except for the camera. Why camouflage yourself, selecting the appropriate attire and masking your gender, and then expose yourself in such an obvious manner? Why blend into a neighbourhood in order to deflect the attention of its "legitimate" inhabitants and then undermine yourself by the means of documentation?

The presence of a camera is a routine and often necessary part of most performance art. It's a practical component; giving the work material form, creating an alternate mode of exhibition and enabling artists to view their work. It also carries the responsibility of sustaining the life of this ephemeral practice, and as such, brings it to future audiences. If there is no documentation, did it happen? And although, for Phillips, the camera served all these functions, its physical presence, as co-performer, was just as integral.

Phillips integrated the camera as an object in and of itself into the meaning of her actions — so much so that it became the central signifier of the work. She used it to intentionally and concurrently signal that something was happening. But something is always happening. In *Find the Performer*, the camera simultaneously drew attention to her and then to itself and to anyone occupying its field of vision. What or who was framed within that activated zone was made to consider the importance of their actions as something worthy of being recorded. This back and forth, this circular

motion of putting herself in the centre and then relinquishing that position, is a constant concern in Phillips' work.

On the surface, *Find the Performer* might appear to be a random, unstructured event; however, little is left to chance. It is a tightly scripted work, each aspect is carefully constructed: costume, location, duration. The happenstance audience is a defined public that is largely solicited by the camera's presence. While the artist protects herself through her camouflage and mediates direct attention through the camera, she still seems vulnerable standing alone, open to whatever may happen or to however she might be perceived. Ultimately, she leaves meaning wide open.

Phillips studied English literature and theatre design in Wolfville and Halifax, and had close ties to the visual arts community at Nova Scotia College of Art and Design. She moved to Toronto to pursue a career in theatre. The worlds of theatre and contemporary art rarely come together, and it was only by chance that Phillips fell into one of Toronto's visual arts communities. She responded to a classified ad that led her to a part-time administrative job at Trinity Square Video, an artist-run video production and post-production facility. Almost as fast as she befriended active members of the arts community, she began producing work within it: staging performances, making films and videos, writing scripts, and collaborating with other artists. From the early stages of her art career, she moved easily between disciplines, often consolidating film, video, writing, and other media or props into elaborate performances. In 1982, at a period when she no longer waffled between calling herself an actor or an artist, she produced and exhibited *Days of Discovery* for two nights at Mercer Union, an exhibition-based artist-run centre in Toronto. This work, her first formal exhibition (and one which went on to do the Canadian artist-run circuit from Sackville, NS to Vancouver, BC) was a multimedia production that integrated video and live performance, and is an obvious precursor to much of her later performance-based works. *Days of Discovery* was an hour-long performance with two videotapes and a super 8 film playing simultaneously, as Phillips walked through the audience telling a story that questioned the effects, control, and actuality of nascent sexual impulses.

Phillips often used film and video as a framing device in her performances. She would show images (projected or on a monitor) that directly or vaguely related to the actions or dialogue of the performer. The correlation was not intended as a link between performance and recorded image, but as a means to create a wave that would appear to bring viewers closer to some understanding of the performer's position and then pull them back by undermining their assumptions through the distraction of live action. For *The Cadence of Insanity*,[1] a work first performed in 1986 at the Ice House at Harbourfront (now Toronto's Dumaurier Theatre), Phillips sat at a desk on stage and she told a story about a woman who moved to a new city, describing her initial excitement and the fears she encountered in her day-to-day wanderings through various neighbourhoods. Behind the speaking performer was a monitor that played close-up video images of Phillips' face. She was in motion, as if

MOIRA DAVEY

1 *The Cadence of Insanity*, was first performed in 1986 at the Ice House at Harbourfront, Toronto (now the Du Maurier Theatre) by Caroline Azar. Subsequent presentations at Canada House, London, England (1987), The Rivoli, Toronto (1988) and The Euclid Theatre, Toronto (1994) were performed by Phillips.

GEOFFREY SHEA

she were the one moving through the spaces and situations described in her meandering narrative. Also playing behind the performer was a rear projection of a 16-mm film. The film was a collage of various images that Phillips used to articulate her character, her gender, and her emotions, making them an ambiguous subject that was always present. For Phillips, the film was where she articulated the subjectivity of the author, and as such distinguished herself from the performer as subject.

The hybrid nature of Phillips' multimedia performances also works to disconnect the viewer, and in a roundabout way accentuates the very event of viewing. If you characterize the viewer as a self, you create a distinction between author and audience. The abundance of sources and imagery is a gesture that is intended to leave things open-ended, offering many ways for the audience to approach or interact with the work. How could anyone fully know what she meant to represent? Why should anyone know? It just doesn't matter unless you are willing to take some responsibility for your own understanding.

But Phillips can't help but to try to exercise her control. Calling for attention, she positions the monologue at the centre and brings us back to the position of the author. The monologue is the primary reference point, as the

PAULETTE PHILLIPS *Find the performer,* 4 posters, Toronto, 1983

PAULETTE PHILLIPS *Find the performer,* 4 performances, Toronto, 1983

GUNTAR KRAVIS

2 *The Cadence of Insanity* (1986).

3 Paulette Phillips, interview with Jenifer Papararo (spring 2003).

4 *The Cadence of Insanity* (1986).

5 Phillips, interview with Papararo (spring 2003).

6 *Fear of Lying*, performed at Tarragon Theatre, Toronto; the Western Front, Vancouver, and Grimsby Art Gallery, Grimsby, Ontario, 1990, was subsequently made into the film, *Lockjaw*, 1991 (Produced and directed by Phillips; colour, 16-mm, 22:00 min.).

7 Ibid.

viewer tries to make meaning from what is presented:

She continued to pinch herself until she was numb. Once numbed she noticed people, a constant vast collection of people, her people all living geographically as one. She was amazed by everyone's apparent co-operation.[2]

Who is she? *She* is not the artist. In *The Cadence of Insanity*, Phillips is not talking about herself. She is uninterested in autobiographical work. For her, the "I" is too problematic, too obsessive, and too easy. She believes that autobiography stops the audience from entering a work. "If it is just about the performer, the audience members no longer need to implicate themselves."[3] As such, Phillips inserts her point of view but not her story. She reveals her opinions in the third person, but not the details of her life. "He swings into the kitchen and says, hey mom, get a load of this," and there, across his rear end, is a tear in his jeans about a foot and a half wide and underneath he's wearing flowered girls underwear."[4] *She* is not the mom and *he* is not her son:

It is better to speak of things much greater than the self — deflect me, reflect you — then maybe a transference of meaning and understanding can occur ... The politics of the third person is also in reference to the gendered subject. There is something funny about thinking of the woman in the third person, as if your subjecthood is a cousin twice removed.[5]

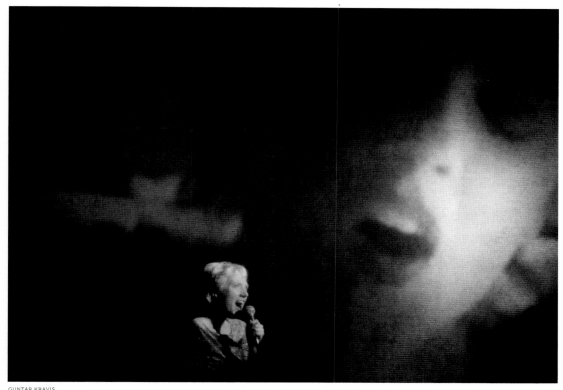

GUNTAR KRAVIS

But what is Phillips trying to convey? Like the audience's eye, which is directed from video to film to performer and so on, the monologue is a wandering "dialogue" that bounces from observation to observation. Performance for Phillips is rarely about one moment. Rather, it is a representation of a series of moments that culminate into one time-based event.

Writing was a large part of her performance-based practice — a means to record observations from the street. She jumbled times, places, and people into a fictive line, amalgamating and layering the many voices she witnessed as she went about her business. At times, her monologues rode a thin line that appeared to turn toward the personal, but ultimately remained uncertain. In general, the narrative was thwarted by a nonsensical utterance: "... how to avoid death by accident, just think it is going to happen all the time and it won't. I'm sure it is true."[6] Or she would avoid self-reference by making clever observances of the language she was playing with:

I love clichés, don't you? And don't you think that you are superior to them and that clichés are somehow simplistic and ordinary. But clichés are inevitable. They are a natural by-product of language. All living things produce by-products and clichés are just the shit of language. Nothing to be anal about.[7]

PAULETTE PHILLIPS *Controlling Interest*, Theatre Passe Muraille, Toronto, 1995. Performers: Sigrid Johnston, Brian Tree

PAULETTE PHILLIPS *Controlling Interest*, Theatre Passe Muraille, Toronto, 1995. Performer: Sigrid Johnston

She used language as a defense — as if she were evading something, skirting her own questions, darting from place to place, ducking time, and flipping between characters.

Within this writing style, Phillips entangled a subtle humour, giving it the weight of philosophical discourse, but with a hysterical response. She asks the hard questions just to avoid them. In *Fear of Lying*, the protagonist believes she has the disorder. She tells of a visit to her orthodontist, Dr. Diva. While he is examining her teeth, she questions whether she should tell him that she has lockjaw, but instead she asks him if he thinks the problem is structural or emotional. He is convinced that her problem is structural, which she interprets as him saying that it is natural as opposed to structural. As if he comprehends the depth of her question, he tells her that the problem is also aesthetic. Revealing that he has not understood at all, he tells her that when he is finished, she will have a prettier smile.

Fear of Lying depends on two performers. Phillips, the narrator, walks on stage in shoes with soles made of magnets that collect metal debris scattered across the stage floor. She reads from a scripted monologue, at times engaging in conversation with an LED sign. Another woman is there, standing and not speaking. The presence of another person and the use of the electronic sign (like the film and video in *Cadence of Insanity*) become a power dynamic that competes in the visual plane and enables another deflection of the self. Does the other body prove that the author/performer inhabits different voices, not only her own?

The introduction of another performer in *Fear of Lying* was an indication of things to come and a return to the theatre. In the 90s, Phillips wrote, produced, and directed her own theatre productions, which played at Theatre Passe Muraille and Factory Theatre Lab, alternative spaces in Toronto. Her first large-scale production was *Under the Influence* (1991). Phillips still performed, but now her role was reduced to an introduction and conclusion. At the beginning of the play, she entered alone. She walked centre stage, circling in a tight circumference. Periodically, her foot would slip out from under her and she would fall hard to the floor. Except for this slippage, all seemed to proceed as expected, with Phillips directly addressing the audience with a witty and disordered narrative. But this time, she quickly gave centre stage to two characters. Love and sex were the content of their scripted dialogue and choreographed movements. The performance unfolded over an hour on a 12 by 12 foot seesaw platform, which collapsed and shifted under the weight of the performers, requiring that they balance and coordinated their actions or tip off the stage.

Both large-scale theatre productions were multimedia compositions in which Phillips continued to use film and video as an important part of the live performances. In *Controlling Interest* (1995), she used two back projections of images that appeared to relate to the concurrent action taking place on stage — one of sex and power relations. The basic plot: a younger woman being directed by an older woman in how to perform an upcoming sex scene for the latter's film. The women are coupled: the director with her cameraman,

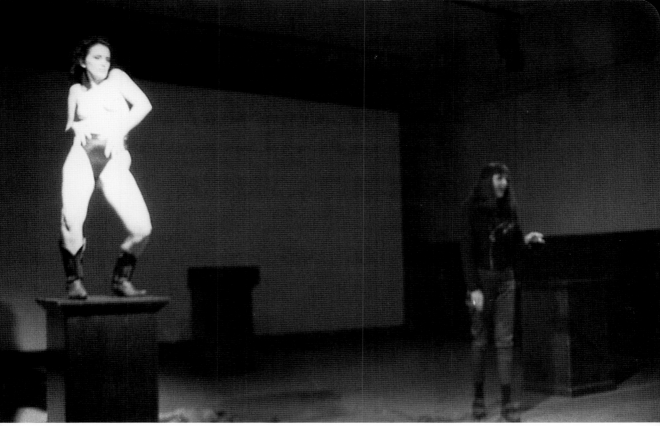

ERIC METCALFE

a long-time friend, and the actor with her co-performer and on stage sexual partner. Late in the play, projected behind the centre stage conflict, is the image of a woman who is repeatedly banging her head against a brick wall — over and over again, continuing even after she has broken her skin, opening a bloody wound.

Psychosis, in its various manifestations, runs through each of Phillips' performances. She uses the terms and conditions of psychoses as viable modes of representation, and as such considerations of modes of reception. Even in *Find the Performer* (which seems to be anomalous among the others in its structure), psychological instabilities linger on street corners, present in her disguises, and her rambling utterances as well as the camera's unceremonious disclosures. I think I have come to understand why it is her favourite. In many ways, this early performance most clearly defines our ability to choose what to hide and what to put out in the world; whether we want to be seen or not. Phillips gives weight to everyday occurences, using psychosis as metaphor contained within a circular logic in an attempt to undermine the audience's dependence on meta-narratives.

PAULETTE PHILLIPS *Fear of Lying*, Western Front, Vancouver, 1990. Left to right: Nadia Ross, Paulette Phillips

Brenda Cleniuk

Robin Poitras

ANATOMY OF THE UNIVERSE

The performances of Robin Poitras are multi-dimensional and theatrical experiences emerging from the fields of experimental dance and visual art. The best of her work engages the critical and unanswerable questions about the nature of performance as an interdisciplinary art form that is influenced by other cultural practices including literature, social histories, and popular culture. There is no satisfactory discourse to determine when Poitras' work is performance art; when she is dancing; or when one of her performing installations becomes an experimental theatre piece. Her work can be discussed in the context of proto-theatrical events, butoh, ritual, or processionals involving improvisation, costumes, and the highly developed languages of contemporary dance. The viewer experiences non-representational performance art that is critically and theoretically engaged, but which takes as its point of departure its status as allegory and formal language including light, form, colour, movement, rhythm, and cinematography. Poitras' work employs notions of myth, art, instruction, dream, and ritual. Her methodology of creating dances, informed by contemporary schools of dance from Graham to Tharp, has become in turn the basis for the performance work, which is consequently abstract and esoteric. She is not, however, being obscure. The works are about the intelligence of the body, the spiritual

integrity of the body — in fact, its wisdom, stored and recalled through its own memory and habits; its connection to the universe; its perfection. In this way, her work can also be seen as a kind of psychoanalysis, a deep psychology of the anatomy where bodily memories are traced and analysed when they surface through the articulation of inner subjectivities and personal narratives.

While embarking on a professional dance career in 1984 after completing a BFA special honours degree from York University, Poitras and collaborator Dianne Fraser co-founded New Dance Horizons in 1986, one of Regina's seminal and most influential arts organizations. Her interest in performance art emerged in tandem with her formal education and practice in contemporary, experimental dance and choreography. In the early 1980s, Poitras began exploring schools of philosophy and physiology in relation to dance, injury prevention, and dance therapy. Her studies led to an awareness of the limitations in formal or traditional dance technique and into discoveries of more esoteric bodies of knowledge and schools of thought that prioritized and provided information on preserving the integrity and health of the body. Much of this work is centred on breathing, bio-circuitry, and kinesiology, the study of the body in motion, where the emphasis on the body's intelligence and its memory is distinct from the mind's rationalism. Within these disciplines, Poitras discovered new theoretical territories for the artist and new physical truths for the dancer.

As Artistic Director at New Dance Horizons (NDH), Poitras' ability to work with guest artists has continued to challenge and develop her artistic vision and practice. The interweaving of the three program areas at NDH — The Learning and Teaching Series, INTEMPCO,[1] and The Performing Series — is representative of her approach to building and presenting creative projects. She describes her process as "lateral in all areas, taking into consideration Regina's unique cultural, geographical, and historical landscape."

Not surprisingly, she is an intense collaborator and has worked on projects with visual artsits, performance artists, dancers, teachers, musicians and choreographers, including: John Noestheden, Edward Poitras, Don Stein, Davida Monk, Jocelyne Montpetite, Floyd Favel Starr, Marie Chouinard, Daniel Levéille, Benøit Lachambre, Boye Ladd, Sherwin Obey, Richard Martel, Amelia Itcush, Tedd Robinson, Chiyoko Szlavnics, Michele Sereda, Susan MacKenzie, Jennifer Mascall, Bill Coleman, and Maariu Olsen.

Like many of her contemporaries, Poitras' work strives to counter the Western tradition of the superiority of the mind over the body and its suppression and profound alienation from the self. As in much performance art, Poitras subjects the body to extremes wherein its physical limits are tested in an effort to express the transcendence of the material body rather than be defined or confined by it. Early works that established the seriousness of her explorations outside of the dance medium, and into an epic visual structure included *Sailor* and *Pelican Arrows*. Poitras' work predates generalized knowledge of new research in nanotechnology and molecular manufacturing, but in this work she talks about having biological access to this information.

1 INTEMPCO is an abbreviation of "in temporary company." It is the New Dance Horizons creation production company.

A substantial part of Poitras' career has been dedicated to teaching and, in particular, to working with children. Her teaching methods invite the student into an experiential dance performance derived from a constellation of physical metamorphosis and cultural mythology. Her latest works have been multidisciplinary and community-based performance works, including *Invisible Ceremonies* and *The Pelican Project*.[2]

The Pelican Project is based on the idea of the social interaction of the community as performance. While this work is driven by a strong collaborative vision, it rightly qualifies as a public spectacle that carries the aura of a social ceremony or public ritual. This work is informed by her research in Japanese culture and is based in part on a series of five Dragon Procession performances designed for children. *The Pelican Project* engages children and members of the community in creating processional performances that take place annually at festivals such as Lanterns on the Lake in Regina. The project, which involves workshops that culminate in the sunset performance of *The Pelican Nocturne*, varies from year to year, allowing for the creative expression of the workshop participants. They learn choreography and songs that are incorporated into the performance, and create pelican "prosthetics" — beaks and wooden block shoes, which are used extensively as percussion tools during the procession — and pleated paper costumes, reminiscent of Japanese origami. Many of them carry egg-shaped paper lanterns. During the procession, the "pelicans" work their way around Wascana park, singing, dancing, and stamping out a beat with their wooden feet, bringing to mind ancient ceremonial processionals.

Poitras employs performance as a lens through which to examine a variety of representational practices, thereby exercising the potential of performance as both a vital artistic practice and as a means to understanding historical, social, and cultural processes. This process of creation is fluid, using an approach that is as much ritual as it is formal. *Invisible Ceremonies* is a body of work that Poitras began in 2000, an intense combination of performance, dance, spoken word, and ritual. The work, which she describes as "performative," explores the nature of the universe and the infinitesimal and grand motions and happenings between animal, vegetable, mineral, and human. She seeks to construct or evoke sensory environments from which performance actions arise.

Ursa Major #2, one of the *Invisible Ceremonies*, is a collaborative performance that Poitras created with Regina artist John Noestheden, in response to his installation, *Ursa Major*. *Ursa Major* is a collection of highly polished, multi-faceted aluminum objects, arranged in the shape of the constellation Ursa Major, the Great Bear, on a wall at the MacKenzie Art Gallery. Poitras engaged in a series of what she describes as "investigative actions," created in direct response to the shapes, textures, and spaces offered by Noestheden's piece. Climbing on and interacting with the constellation and an assortment of similar aluminum shapes placed on the gallery floor for the performance, Poitras, Noestheden, and three other performers brought sound and movement to the installation by moving and striking the objects.

2 Megan Andrews, *Writing our History: Art, Nature, and Community in The Pelican Project*.

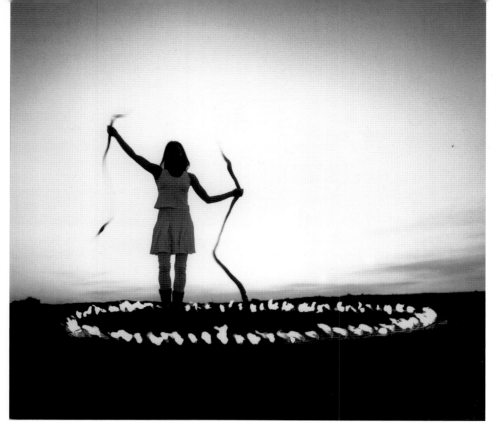

DON HALL

Poitras' performances invite the viewer into a surrealist's interpretation of existence and social interaction. She talks about the magic of art — magic that is about transformation and movement from one reality to the next. Her performances make the changes in her own life apparent to herself, her audience, her community, and her family. While much of her work involves making connections between the unconscious and conscious minds, it is a full articulation of the preconscious mind, that state of being in the interstitial spaces between dreaming and waking life; between thought and action. The mind that belongs to more than one culture, and more than one heritage.

In *Invisible Ceremonies*, Poitras' aesthetic evokes mythological and primal experiences by relating universal conditions with their postmodern equivalents. Her performances reinvest forgotten community rituals as encounters with the other, competing values and hierarchies. Her art and her language are based on gesture, discipline, and a physical ability to understand and translate emotions. Poitras uses strong physical discipline and a highly sensitized imagination to connect her very ambitious perform-ance goals to make highly elusive yet universal concepts, like gravity and the body's struggle under its weight and consequences, visible and tangible. *Invisible Ceremonies*, more than any other work, reveals an occult philosophy

ROBIN POITRAS *pelican arrows*, Regina, 1992

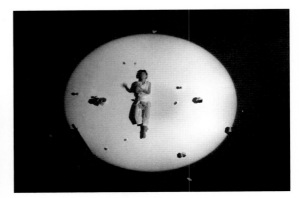

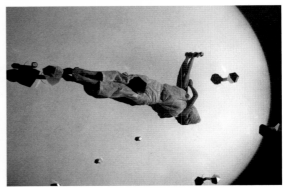

FRANÇOIS BERGERON DON HALL

2 Robin Poitras, Artist's notebook (2003).

3 Ibid.

embedded deep within her technique. It quite literally calls attention to a series of actions that take place as strategies for achieving balance, (poetic) justice, or transformation — water behaving as earth, as in snow; or, wind behaving as earth, as in a tornado. The artist "plays with symbols and the fairytale as part of a multi-pull deck of historical, social, scientific, and poetic thoughts and images ... to trace some of the origins and mythologic inheritance that pervades the way women are viewed." [2]

Other works in the *Invisible Ceremonies* series include *Sketches for a Sunken Garden*, a submerged acoustic and visual landscape performance developed for the Regina Public Library's sunken garden, and *von der red*, a triptych of live and recorded dance/songs/poems that draw on mythical stories and biological information.

Poitras' works resonate with desire and lucidity complemented by the will to dominate the image and to revolt against the body's vulnerable condition with discipline. She uses the stage as an installation space where found or formed objects, texts, visual imagery, sound/music, and other media form a dynamic installation or scenography. In this context, she explores the tentative relationship between the worlds of art, science, and nature and represents these phenomena through allegory and the creation

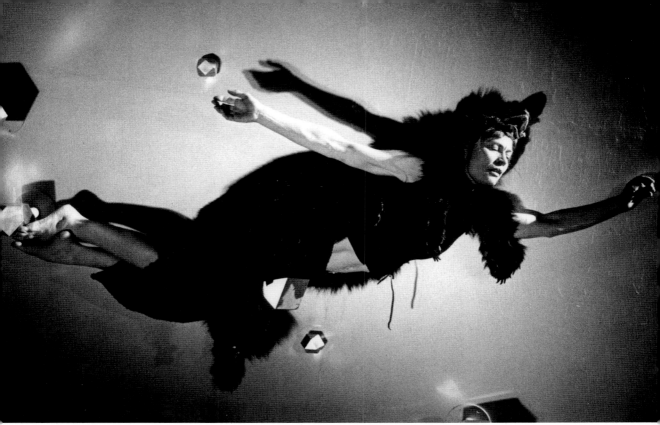

DON HALL

(or recreation) of myth. She engages the performing arts — dance, theatre, performance art, ritual, and popular entertainment. Her expression is unique and highly original. Her contact with other cultures, specifically First Nations and Japanese, have informed and shaped her practice and greatly expanded her repertoire by finding and incorporating non-Western perspectives and values. Her performances engage human activity in public ceremony particularly in the form of processionals (the most prominent of which is *Pelican Nocturne*), the art form that characterizes much of her later and most current work.

The themes of maternity and fertility have grounded many of Poitras' most important works. Those aspects of female identity that might appear to be apolitical but which in fact shape the political economies of women and their relationship to their social worlds, extend the scope of her emphasis on beauty and fertility. Her work combines reality with unreality on the same plane perhaps as a form of the surreal to make something plausible out of the strange. *Memex Ovum & An Installation in Black, Red, and White* is a work the artist describes as, "An ode to winter picnics. Dedicated to my mother Patricia Leigh Wiens, whose wonderful, magical winter picnics ignited my love of snow, fire, and fairytales. To the memories of our mothers' eggs living in our bodies." [3]

ROBIN POITRAS *honey works*, performance, Québec City, 2000

ROBIN POITRAS *ursa major*, MacKenzie Art Gallery, Regina, 2001. Installation — The Big Bear by John Noestheden

ROBIN POITRAS *ursa major/reclining*, MacKenzie Art Gallery, Regina, 2001. Installation — The Big Bear by John Noestheden

ROBIN POITRAS *CALLISTO*, Regina, 2002. Installation — The Big Bear by John Noestheden

Memex Ovum was inspired by stories and experiences of the Prairie winter and source ideas that included frozen embryos, the moon, Snow White, cryogenics, and the visual work of Roy Kiyooka, Michael Snow, and Ron Bloore — artists that inspired Poitras' improvisational works with the colour white. In this work, the life cycle of female reproduction is referenced as a database or biological archive, each ovum representing a potential birth or life. Poitras begins on stage in a sinuous dance, surrounded by wooden box forms that she rolls over and moves on. She pins her skirt up with clothespins which cluster around her hips and belly, moves through the environment, and finally smashes the ceramic dwarves with a hammer. To transform abstract and literary notions into physical actions, Poitras makes use of our familiarity with enchantment and beauty, often through invoking folklore, fable, and popular culture.

Poitras restructures the fairytale *Snow White and the Seven Dwarfs* and uses it as a template for the work. The metamorphosis in the fairytale takes place through the action of birth, the child signifying a new life and a new character. Poitras excavates the roots of consciousness found in fairytales and myths related to the transmission of information, symbolic or allegorical, from mother to child, mother to daughter, and sister to sister, and as a dialectical argument about history and nature, male and female, beauty and horror. These darker themes and vicissitudes appear in conjunction with her desire to transgress the boundaries between art, culture, and nature. In her work, art reveals its pagan roots and its terrors.

The limitations of the human body are made obvious in her works by the appearance of prostheses or exaggerated body parts suggesting a need that may have existed at one time: talons, wings, and a heightened sensory apparatus that humans may have lost in the evolutionary process, or functions that have been deselected in response to geographic conditions. At times, the prosthesis performs a metonymic function, substituting a part for the whole. In *Pelican Nocturne* the pelican beaks transport the artists into an animistic condition where their senses are enhanced, replacing the inefficient olfactory with a more highly tuned instrument. In works like Susan MacKenzie's *Proverb*, Poitras dances in yards of flowing silk that are attached to the dancers through a harness, providing an extension of their bodies, and creating a monumental architecture and landscape, hypothesizing the sensation of the body in flight.

One of Poitras' most memorable and early works was the *The Two Fridas*, a piece which introduced the idea of female suffering through the two invasive mechanisms of fertility and surgery. Kahlo's paintings broach the subject of pain and abandonment as brought about through the agency of male infidelity and the fragility of the male ego as represented by her love interest, Diego Rivera. Aspects of Poitras' work have parallels to Kahlo that would have been undocumented in 1988 when *The Two Fridas* was created.

Like *The Two Fridas*, much of her work is autobiographical, referencing a desire for children, her own remedial surgeries, and her will to create. The notion of the everyday appears in Poitras' work as part of a human, collective ritual that guides and informs the habits of our being. Her work speaks to the level of our collective unconsciousness revealed.

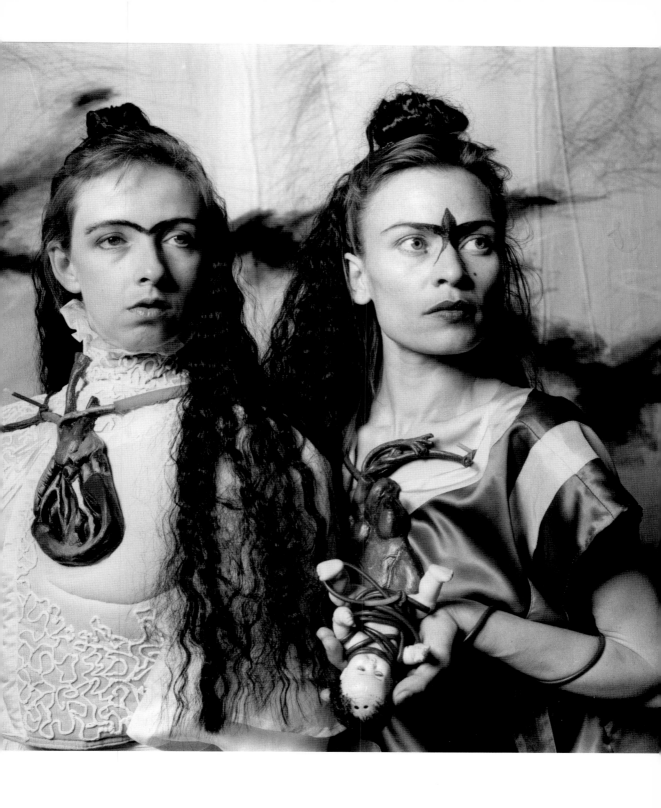

Scott Watson

Judy Radul

BODY ART FOR THE DISEMBODIED (1991)

Performance art isn't taken very seriously in Canada. I hear this all the time. Given that art is not taken very seriously in Canada, it can seem a minor complaint. But I suspect that behind all the "explanations" or "excuses" — it is difficult to reflect upon an ephemeral medium, the art world is still focused on gallery exhibitions, etc. — there lies a deeper resistance to the form. Intimacy is disturbing, bodies unmanageable, the speaking voice uncontrollable, and the product is uncommodified. It isn't just that people are indifferent, they actively don't want to know. The kinds of knowledge performance art produces and the kinds of questions it poses are, in large part, embarrassing and unreassuring. We resist interrogations that might destabilize our sense of ourselves as subjects or the suggestion that subjectivity itself can be politicized. The potential for a polemical figurative art is performance art's most radical aspect. Performance brings questions of expression and the limits of subjectivity to the foreground in a manner which no other medium can reveal.

Writing about performance does present special difficulties. In the case of Judy Radul, because she has worked in Vancouver and Holland, no one has seen all her performances. But more critical than the problem of access is the problem of discourse. Something essential is lost when the unruliness of

performance is subjected to a critique. The form of a catalogue essay, a more or less structured argument for the concerns of the artist and their context and consequence, is perhaps intrinsically unsuited to its subject. The writer's analytical voice participates in the very system of authority that the performance undermines. Yet, performance artists require legitimation in order to continue working and until there is more interpenetration between performance and critical writing, performance will always be in danger of falling off the margin it now tenuously occupies.

In writing about Judy Radul, there is another prefatory caution I would note. Radul is an artist and a writer who works in more than one discipline. She writes books and creates installations as well as mounts performance pieces and gives "straight" readings of her writing. For the occasion of the exhibition (*To Shine*, 1991) at the Western Front, I was asked to write about Radul's writing. While I do focus on her texts, it also made sense to consider the situation she places those texts in and her own thinking about the problems of the text; writing, reading, speaking, which are often central to her performance works.

As a performance artist, Radul is concerned with defining the discipline and recognizing its formal constraints. It is only by coming to such an understanding that the form can realize its historical potential, its relation to history, and its dialectical relation to society. The questions she puts to performance have largely to do with the authenticity of expression and the privileged place performance accords to a direct communication between the artist and the audience. The space of reception — the performance time itself and how the audience receives it — involves a fairly dense constellation of problems. Most of these hinge around belief and disbelief, the play between ironic distancing, and empathy for the performer's "truth." For Radul, these problems are best emphasized by questioning the status of the subject. The idea of the self as an isolated monad, the seat of "subjectivity," that exists in a condition of alienation from and contradiction to the totality of society, was given universal voice in the crises that gave birth to modernity as we know it. The problem, high on the agenda today, is that this "universal" voice and its claims are not universal at all but largely constructed out of a perspective that is male, white, straight, and middle class. For Radul, performance art offers the forms and means to question the regime of this subject.

Radul first began doing performance work in the mid-80s when she was a student at Simon Fraser University. She didn't want to make objects. The gallery experience was "too much like shopping."[1] But performance seemed political and distinct from a commodity fetish relation with a viewer. The body art of Vito Acconci and Chris Burden was one term of reference and the more textual and technologically implicated work of Laurie Anderson, Rose English, and Eric Bogosian another. If the generation of Acconci and Burden performed on the still heroic male body, using it as an icon of the alienated and universal individual, Anderson, English, and Bogosian's work involved a fragmented subject and multiple voices. They

1 Judy Radul, interview with Scott Watson (August, 1991).

reintroduced text into performance and opened up questions about language, gender, and the formation of the subject as an ideological and historical problem. Local punk music performance with its pulverization of the secure speaking monad and resulting liberating energization of the audience provided another example of the potential of performance.

Practically from the first, Radul focused on the voice as a material and symbolic element in the work; the voice as a utopian potential for the organization of new subjectivities that could break with the alienated monads of bourgeois self-consciousness. She experimented with the notion that the voice, voiced speech, occupies a social space that it can express and modify. It is not merely the outward manifestation of something inward and more authentic. She wished to challenge the authority that is invoked when someone says "I." The constructions that emerge in Radul's writings are a montage of autonomous and non-autonomous moments of selfhood. This was the strategy of early Dada performance and collage.

In collages by Hannah Hoch or Raoul Hausmann, for example, representations of heads, the site of the bourgeois monadic subject from which nature and the body are ruled, are often broken open, revealing not the central point of the man-centred humanist cosmos but jumbles of machine cogs and newspaper articles. The Dadaists, as anti-Freudians, proposed that modern subjectivity is not just a result of the hydraulic regulation of a libido centered on middle-class family life under the Father, but that consciousness is mediated by the world, especially the information industry, political struggle, and technological change. Alienation, then, cannot be "cured" by an adjustment of the individual to society but only by change in society as it is society that determines individuality.

Radul's performances utilize montage by emphasizing the dislocations between speech, bodily presence, and text. She often stages a send-up of the Freud-Lacan construction of identity, although she negotiates this theoretical terrain with some caution. It is, after all, the basis of important feminist critiques of representation. Radul's voice is sometimes infantile, sometimes hermaphrodite, sometimes critical, sometimes declarative. This multi-voiced aspect of her work, both in writing and performance, fragments the speaking "I." The "I" can still be voiced, but it is bi-valent; addressing, propositioning, resisting against, or acquiescing to the Symbolic Order and invoking, rebuking, denying, and desiring the imaginary.

In Lacan's terminology, the Imaginary is the stage of infantile identification with the mother. This stage is characterized by its seamlessness; there is no "I," no "other," and no unconscious. When the child enters the Symbolic Order, characterized by a sense of self separate and isolated from the continuum of existence, it enters language and the patriarchal regime of the phallus. Castration is the central metaphor for both Freud and Lacan's view of the driving force behind the situation of the self in the Symbolic Order. The symbolic phallus rules both men and women as an image of lack or disruption as it was the "phallus" which brought an end to the realm of the Imaginary. Castration anxiety represents this lack and determines our

SAMANTHA HAMERNES-COOMBAS

entry into language, history, society, and the forum of the genders.

Although the Freud-Lacan project has been the basis of a critique of the patriarchy and contains the critical tools to unmask patriarchy as ideology, it is primarily a discourse about the formation of the subject as a bourgeois monad. The Lacanian notion that the Symbolic Order and language are synonymous and that all subjects are determined by language is culturally specific. Only a European would reduce experience to language. We may observe the world through language but this does not mean that the world is language.

For Radul, the voice has an extra-linguistic character and potential (just as it has had for the avant-garde since the days of Futurist and Dada performance). She uses it as "material" that has the potential to exceed the language-based Symbolic Order. In Kaja Silverman's study, *The Acoustic Mirror: The Female Voice in Psychoanalysis and Cinema*, Silverman takes up Lacan's assertion that "language preexists and coerces speech," that "The moment a subject enters language, he or she undergoes a phenomenal 'fading' or 'aphansis.'" Speech, paradoxically, "produces absence, not presence." The loss of self in speech is due to the overpowering effect of language as a system of meaning and values. "The discoursing voice," that is the voice that

JUDY RADUL *A Dream of Naming*, directed by Penelope Buitenhuis, 1991

JUDY RADUL *Runaway*, a text performance with Deanna Ferguson. Perel Gallery, 1990

presumes to use language transparently, "is the agent of symbolic castration."[2] Yet there is another, nondiscursive voice which is an expression of the body.

According to Radul, who studied with Silverman at Simon Fraser in 1984, "The voice carries the sound of the body within it; the contours, the experience."[3] Taking her cue from Roland Barthes and Silverman, Radul suggests that we understand "speech" as "belonging to the tradition of masculine utterance and 'voice' as a new category which produces a feminine speaker whose authority [also] lies within the text..."[4] At least this would be a provisional understanding for the use of the voice as a medium and an understanding of its potential, especially in feminist projects. It would allow a text to take place while deferring the problem of the author as constituted by the patriarchy.

Radul's performance piece *Runaway* (1990), a "live sculptural situation," attempted to "produce a subjectivity not unified through the act of speech."[5] In *Runaway*, the voice is deferred. While one woman silently reads a text, a video monitor shows the text itself. As an "educational aid" set-up (in learning to read, to "scan") considerable pressure builds for articulation, for reading aloud, repetition by rote and some "instruction." But this never happens and the text is "voiced" not by the performer, but silently by the audience. The audience does not passively receive the text but becomes complicit in the construction of not only the text but the unity of speaker, text, and voice that Radul has dismembered. In a way, she transfers the authority of this unified subject from herself to her audience. In other performances, Radul does speak and use her voice to convey a text but always with a view to making the "author" a problem that contests the Symbolic Order.

The voice may exceed language, but the body can be positioned outside language altogether. Our bodies are in the world and even exceed society, which language does not. Yet our bodies, or the way we deal with them, are mutilated by society through its invasive institutions — the clinic, the court, the school, the workplace, etc. Our bodies are given gender, and with our genders our social roles in a patriarchal regime. "To have a body," Judy Radul wrote in her 1989 bookwork *Boner 9190 and the weak*, "is to be describable and therefore created rather than creator."[6] Not to have a body, of course, is not to be, but that does not mean that we don't also imagine being disembodied. Language and the voice, language and writing are forms of disembodiment. "But the voice also renders the body invisible, A GHOST."[7] The voice as the medium of language is the instrument for the subjugation of the body, but the body itself contains considerable powers of resistance. It also produces knowledge. The image that will stick with me from Radul's 1988 performance, *The Body of Knowledge*, is of Radul's naked backside, inscribed with the words "I know," presented to the audience. This piece which contains accounts of surgery and mutilation was about the socialization of the body and the kinds of knowledge the body acquires as it survives the violence of socialization.

2 Kaja Silverman, *The Acoustic Mirror: The Female Voice in Psychoanalysis and Cinema* (Bloomington: Indiana University Press, 1988), 39-40.

3 Judy Radul, *Rotating Bodies: Alexis Crystal and Blake* (Vancouver: Petarade Press, 1988), 8.

4 Judy Radul, "Speech as Presence, Silence as Death," unpublished mss. in "The Female Authorial Voice," in *The Acoustic Mirror*, 187-234. Silverman argues that Barthes constructs a female authorial voice in his famous essay, "The Death of the Author."

5 Judy Radul, description of *Runaway*, 1990.

6 Judy Radul, *Boner 9190 and the weak* (Nijmegen, The Netherlands: Knust Publishers & Judy Radul), 10.

7 Judy Radul, *Rotating Bodies*, 8.

BRAD POULSEN

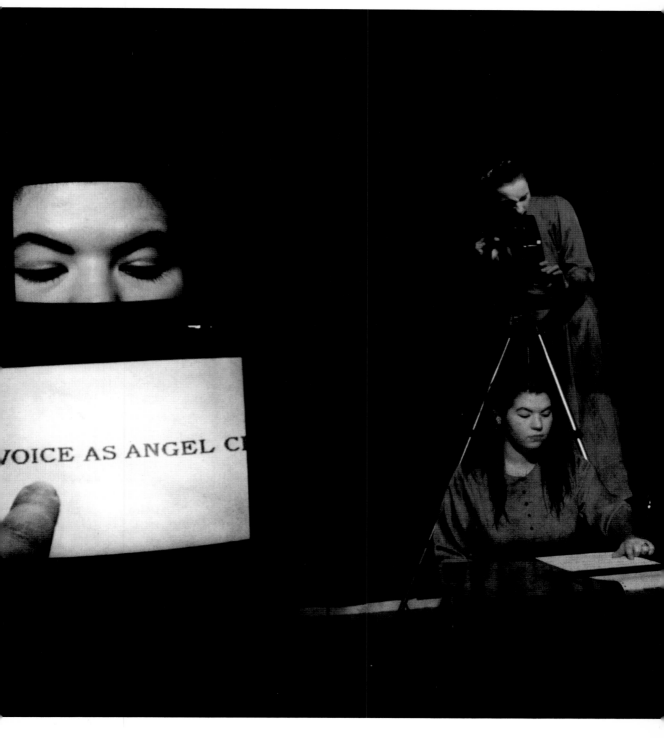

Gender is a crisis, both comic and macabre. In *Rotating Bodies* (1988), a hermaphrodite speaks: "I am a hermaphrodite, I have all the organs. This history which is not of me has implanted them, the dangling organ of this imposed culture hangs limp between my legs. Yes I am a hermaphrodite and I need MEDICAL attention."[8] The voice tries to regain the Imaginary through absorption of all the organs, but this sets off another crisis. The castration complex has become a medical emergency, the phallus a parasite. The Symbolic Order is in disarray.

The disarray personified in Radul's work in a series of grotesques and masks that she adopts as transgressive self-humiliations. Her adoption of the voice of the "weak" and her presentation of the body as grotesque wheedle away at the security of the bourgeois monad. The Imaginary speaks, saying, "Known as THE NATURAL, because I was on the scene when I arrived."[9] The most powerful of these grotesques are recent. The image of the feminine monster symbolically skewered on a spit in the installation, *To Shine* (1991), and the film loops of Radul as the same female grotesque (from the film by Penelope Buitenhuis) which she presents in her performance, *Melt*, is perhaps her most radical figuration of a subject. Her face is chalk-white with deep sunken eyes; it's a living death head. She's wearing something scaly and shiny as if she were half fish, half woman. She wears boxing gloves on her feet. She seems to have regressed to a more primitive form of life as if she's worn away at the bourgeois monad only to find the reptilian cortex.

Radul's grotesques have a relation to German expressionist cabaret. For her [1991] installation work at the Western Front, she included images which were partly inspired by the Berlin cabaret artist, Lotti Huber. Huber appeared in a Rosa von Praunheim film, *Anita: Dances of Vice* (1987), as an old woman who imagines herself to be the aged Anita Berber, a cabaret star of the 20s. In the film, Huber makes considerable use of her repertoire of *ausdrucks* (expressionist) studies. While the German tradition places emphasis on rage, infantilism, and pain, it is not without humour. There are, of course, Dada roots to what Huber does as she dismantles bourgeois self-composure. Radul adds to these the Lacanian inflections of contemporary feminist psychoanalytic theory, giving us the mirror stage as cabaret. It is as if Radul wants to turn Lacan into Dr. Caligari.

In *Melt*, identity is constructed across two bodies represented in the flesh and through film and video. A performer is introduced to the audience as "Miss Judy Radul." Her back is to the audience, the long raven hair and cabaret cape suggest that this might be Radul herself as the female grotesque. But the performer is a man, playing the female grotesque who we see in repeatedly projected film loops. In one vignette, she "vogues," in a third she flagellates herself. The male female grotesque imitates and parodies these routines throughout the performance. The other performer, at first hidden from the audience, is on a treadmill, her face hidden from us by a block of ice. Periodically, an image of a skull is projected on the ice. We get this part of *Melt* right away. The hot breath of the performer will sooner or

8 Ibid., 17.

9 Judy Radul, *Boner*, 4.

10 Ibid., 34.

11 Judy Radul, *Runaway*, unpublished mss. (1990).

later melt the ice and the face or the "subject" will be revealed. We soon realize that Radul is on the treadmill, we can see her face on video monitors. Her voice is amplified. We can hear that the text is prerecorded and that Radul is repeating it.

The performance includes slide documentation of previous performances and is a kind of destabilizing compilation montage. Radul's accounts include the things that went wrong or her evidence that she was drastically misunderstood. Someone sent her a love letter after a performance in Holland. A review emphasized her risky forays into self-humiliation: "Humiliation? I thought it was empowerment." At the conclusion of the performance, the man begins to flagellate himself furiously while Radul blasts through the ice with a blow torch, revealing not the figure we thought we'd been watching on the video monitor but Radul in drag with a moustache and beard. Radul and her partner sing an operatic love duet as she dissolves the terrors of castration: "No we won't die from genital mutilation / No not for us the stress and mess of castration / nah nah nah, etc." Mounting the treadmill again, Radul is pulled off stage by her companion.

The way gender is figured is obviously devious and subversive; we are led through a comedy of gender misidentification. The roles of the Symbolic Order can be disrupted. But we are so conditioned by a normalizing regime that the breakdown at first appears grotesque; the psychic world without its phallic axis seems askew and ridiculous. There are many layers in Radul's creation of the female grotesque. She is both a parody of essentialism and the constructed female Other. Her "star" qualities make her a phallic representation, while her close association with nature make her the archetypal Mother of the realm of the Imaginary.

Radul's use of the grotesque figure to launch a kind of assault on stereotypes of feminine attractiveness invokes, as she tells us in *Melt*, a dialectic of humiliation and empowerment. The reason they are in dialectical relation is that a position of humiliation invites rather than resists the threat of castration under the law of the Symbolic Order. It is paradoxically from this position that one might best challenge the law of the Symbolic Order, where one might begin an empowering resistance to that law.

But the empowering humiliation of the self-flagellating female grotesque should not be confused with the violence used to enforce gender in society. This violence also appears in Radul's texts. Often her voice is shocking, especially when it is that of the battered woman whose very identity is bound to her abuser. In *Boner*, a feminine voice declares, "the blow is my confirmation."[10] In *Runaway*, the text becomes a lie asserting a false authentic presence. Radul treats the text "like it was a woman so hard I'm hitting it trying to see through to what is really there she's lying bitch..."[11] These devices dwell on the search for an authentic subject and the futility of that search through images that rivet our attention to social gender-based violence and the violence of gender limits themselves. By adopting, as she periodically does, the voice of the "weak" — the voice that needs another to be complete, that needs confirmation of the kick or the blow — Radul takes

us in a descending spiral to the origins of subject formation as a brutal initiation. Into this situation, a situation that might be characterized as that of the castrated female voice — a construction Radul is at pains to deconstruct — Radul also brings a meditation on death as another means to ground her destabilized subject. For death can also be said to be a construction of the social, as a signifier it unites all others when it comes to questions of personhood or life's meaning.

While as subjects we are "discontinuous," death offers evidence and proof of the continuity of existence outside ourselves. This Bataillian argument, which also holds that the sexual drive is linked to death through its similar potential to disrupt the subject and restore a semblance of continuity, emerges like periodic blips in Radul's texts.[12] It's part of the grand guignol scenery; it's variously constructed and montaged to other images of loss and loss of "identity" in speaking.

The phrase "DRY DWELLERS OF ETERNITY" appears in *Rotating Bodies* as a heading for a text that includes this proposition: "To die is to be CANCELLED, to have your ratings drop, it is unpopular, an anti-social non-event, an unscene..." And elsewhere, "Death is beauty and the box, the worshiped space defined by demise, the stamp of authority too perfectly too late."[13] These are reference/citations from Walter Benjamin's "The Storyteller." Benjamin argues that as the general consciousness of death declines in modern society, the communicability of experience is diminished. Loss of awareness of death, loss of social space for death freezes and reifies the subject as something frozen, alienated, and neither quite alive nor dead. "Today people live in rooms that have never been touched by death, dry dwellers of eternity, and when their end approaches they are stowed away in sanitaria or hospitals by their heirs." For Benjamin, "Death is the sanction of everything that the storyteller can tell. [She] has borrowed [her] authority. In other words, it is natural history to which [her] stories refer back."[14] Yet, the "authority" whose loss Benjamin everywhere mourns, was in the first instance bestowed "too late." "And tonight my paper is on DEATH," Radul reports, "death is no longer a possibility, in your PRIVATE MOMENTS you can take away your life, TAKE YOUR LIFE away from the living, are they living your life?"[15]

In the context of Radul's work, the allegory being brought forward here has to do with belief in a natural order, that space we never really know, but belief in which underwrites our faith (or superstition) in gender, what we mean by biology. Her stories do refer back to natural history, but by means of disfigurement and address to the unnatural to which, one might add, a greater bond is felt.

Performance depends upon the possibility of such bonds or mutually reached understandings even if they are at best provisional, even if what is understood is the impossibility of communication. Radul is sensitive to notions of utopianism that are implicit in her practice. In performance, the notion of collectivity that Benjamin and others saw in a film audience is obviously not addressed. Because it is intimate and marginal, performance

12 As Michele H. Richman argues in *Reading Georges Bataille: Beyond the Gift* (Baltimore: The John Hopkins University Press, 1982), 81: "Bataille's work is distinguished by its explicit juxtaposition of death and eroticism. The latter is characterized as a disruptive force, antagonistic to homogeneity. It involves a total giving of oneself in an effort to restore a semblance of continuity through communication with the other. As part of the destructing process of the rational, Cartesian subject, it can lead to a fusion that defies physical boundaries. The subject transcends itself not to rejoining a lost union of oneness with the universe, but to participate in an experience that pushes Being to the limit during orgasm, the 'petite mort' simulating death."

13 Judy Radul, *Rotating Bodies*, 35 and 36.

14 Walter Benjamin, "The Storyteller: Reflections on the Work of Nikolai Leskov," in *Illuminations* (New York: Harcourt, Brace and World, Inc. 1968), 94.

15 Judy Radul, *Rotating Bodies*, 45.

Caught in the Act an anthology of performance art by Canadian women

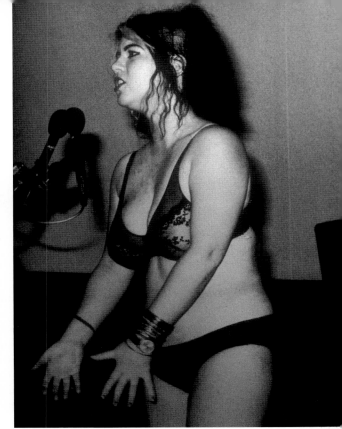

could be said to address a cell or specific community. This is not a community of good citizens but those who already doubt what she will call into question. This is why her disruptions are so elaborate and subtle, why an expectation must be anticipated so that it can be foiled, why Miss Judy Radul must appear as someone else. Gender roles are so deeply engraved that simple inversions must be inverted again to keep a critical destabilization in motion. Unless some sense of crisis and anxiety about gender roles is maintained, we will not be in a position to intervene in their violent narratives.

The question of Radul's feminism must arise in any discussion of her work, as must her attempt to imagine the heterosexual without being heterosexist. As far as the latter is concerned, she takes it as axiomatic that heterosexuality is a policing and surveying construction that grinds out mutilated bodies. Within this mutilated field, she experiments with androgynes and hermaphrodites, trying to find a sufficient economy of desire.

Julia Kristeva has identified three stages of feminism. She identifies the first stage as concerned with rights, equality, and power. As women attained positions of power in society, but society did not change in a fundamental way, a new generation questioned the nature of power itself. There began a definition and privileging of the feminine and an exploration of

JUDY RADUL *The Body of Knowledge*, Western Front, Vancouver, 1988

JUDY RADUL *Use It or Lose It*, Western Front, Vancouver, 1987

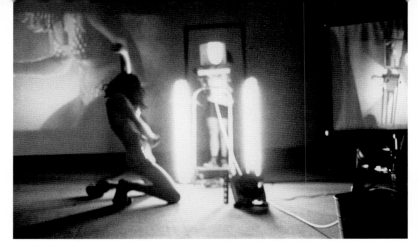

JUDY RADUL *Melt*, Western Front, 1991.
Performers: Andrew Wilson and
Judy Radul

essentialism. The third stage, with whom Kristeva identifies, questions the construction of gender itself. For Kristeva, "the very dichotomy man/woman as an opposition between two rival entities may be understood as belonging to metaphysics."[16] Kristeva does not see these stages as successive but three fronts working in the same historical era, our own. Kristeva's formulation is over a decade old and to it we may add another, fourth, stage to which artists and feminists like Radul belong.[17] For Radul, gender is only metaphysical in that the Symbolic Order is itself metaphysical. In an era of escalating violence against women and the politicization of this issue, gender isn't metaphysical. Theory can't make gender disappear, it can only demonstrate the absurdity of the Symbolic Order. It is perhaps too early to say just what the formulations and positions of Radul's generation will be. Her work rides a contradiction. She wishes the text to produce a subject, yet her theoretical ground is still one that defers the possibility of any such authentic subject. For Radul, this is a necessary contradiction of performance. That is, gender must be critiqued, but as long as systems of domination still rely on gender, we should not avert our attention from its narratives.

Imagining the subject involves recognizing that dominant discourses have already positioned the subject through means that restrict its material potential. While at the same time, it is from the contradictions in these same discourses that the possibility for emancipation arises. Radul's work operates to push at tensions that arise between social subjects and their imagination through the "natural" of what has been denied them, all the while recognizing that utopianism ought to be under investigation as it may also be part of the fix.

16 Julia Kristeva, "Woman's Time," in *Signs* (autumn, 1981), 33.

17 Radul interview with Watson.

★ ★ ★

This article was first published by the Western Front in a catalogue for the Judy Radul exhibition, *To Shine*, in 1991.

Karen Stanworth

RE-PLACING PERFORMANCE

The Inter-Media Practice
of Françoise Sullivan (1994)

Performance art exists ambiguously in the space between "high art" and
those apparently more populist forms of public expression such as dance,
theatre and music. A process with no product, a practice with no remaining
evidence, it often proves difficult to retrace the historiographic significance
of a specific performance in the development of an artist's body of work.
Furthermore, when an artist, such as Françoise Sullivan, produces work
within and across both the popular and so-called "high art" forms, it
becomes difficult to resolve the perceived contradiction between craft and
art, or, between performance and dance. As a consequence, Sullivan's per-
formance pieces of the 1970s have been critically subsumed into her prior
art practice. Despite the evidence of site-specific work, of pieces which
articulate a particular history, and of shifting realms of concern, critics have
continued to view Sullivan's performance pieces of the 1970s and her paint-
ings of the 1980s through the lens of Automatism, virtually precluding any
other interpretations of Sullivan's work. This essay attempts to address this
critical lacuna by retrieving the specificity of her work after 1970, and by
examining whether that practice is continuous with the Automatiste stance
of the 1940s as evidenced in her writing and in her dance productions.
On August 9, 1948 in Montréal, Paul-Emil Borduas and fifteen Québécois

artists, dancers, and poets signed and published a manifesto, *Le Refus global*, which profoundly rocked the socio-cultural foundations of Québec. The artists involved became known as the Automatistes due to their emphasis on the necessity for "automatic" or spontaneous expression to be manifested in their art. The spontaneous, whether literary or visual, was proposed as a means of counter-acting the rules of production implicit in art and society. The Automatiste manifesto articulated a refusal to accept any personal, social, or aesthetic confinement. The lead article declaimed all forms of "intention, the two-edged, perilous sword of reason" and proclaimed the necessity of magic and "objective mysteries." [1]

The manifesto has been both damned and praised for single-handedly undermining the status quo in Québec. The motivations for its production in the summer of 1948 were tied to various personal and professional quarrels, post-war dissatisfaction, local politics, etc. While it has been generally acknowledged that the manifesto was the product of its time and place, and therefore served as a prelude to the Quiet Revolution in Québec in the 1960s, it has ironically been preserved primarily as an aesthetic and philosophical movement by Canadian art historians. In particular, Françoise Sullivan's contribution to the manifesto, "La Danse et l'espoir," [Dance and Hope] has been interpreted as being somehow autonomous from the socio-political aims of the Automatistes. Disconnected from history, the artist becomes the aesthetic pawn of her own writing. Critics seek the writer and dancer of 1948 in all her subsequent production, disregarding the relations between choice of medium, subject/object meanings, socio-cultural context, and personal history.

The desire on the part of the Automatistes to overthrow the entrenched relations of power, whether artistic or political, secular or religious, was seemingly informed by a Jungian rhetoric. Borduas' lead text incorporated references to the collective unconscious and psychic energies of the Québécois — references which had appeared previously in Sullivan's public reading of "La Danse et l'espoir" [Dance and Hope] six months prior to the publication of the manifesto. [2] She, in turn, likely developed her notions of how the collective unconscious might be expressed in visual form by drawing on the anthropologically-informed dance theory of Franciska Boas in New York and on discussions with her childhood friend and co-signatory of the *Refus global*, the poet and psychologist-in-training, Bruno Cormier. [3]

Sullivan proposed that the modern dancer was capable of discovering a common culture which had been shared by everyone at some undefined point in the past. The body was seen as the storehouse of cosmic energy, which was released through Automatiste dance. The dancer could go "beyond the individual towards the universal." [4] This "universal" or the collective unconscious is articulated through symbolic themes believed to underlie the automatic dance performance. For the Jungian, the symbol expresses the essence of human psychic energy. Some such symbols may be archetypal, that is, they may be derived from mythic themes whose symbolism illustrates universal human history, or, the symbols may have personal significance, and

1 Ray Ellenwood, *Refus global* (1948), authorized translation in *Total Refusal* (Toronto: 1985), 37.

2 Claude Gosselin, "Sur Françoise Sullivan" in *Françoise Sullivan — Retrospective* (Québec: Ministère des affaires culturelles,1981), 21. "La Danse et l'espoir" was read at an Automatiste evening at the Gauvreau apartment on February 16, 1948.

3 Cormier's article "L'oeuvre picturale est une expérience" was probably in progress before Sullivan's paper was read. It is evident that there was not only one source for the expression of collective unconscious in this forum. While Cormier cited Freud in his essay, he referred to ideas which also reveal a Jungian conception of expressive energy of the unconscious, of the cosmos and of archetypes. See Ellenwood, 12, 93-100.

4 F. Sullivan, "La Danse et l'espoir" in Ellenwood, 106.

5 See M. Bousquet-Mongeau, C. Gosselin and D. Moore, *Françoise Sullivan — Retrospective* for the most extended discussion of Sullivan's oeuvre prior to 1981.

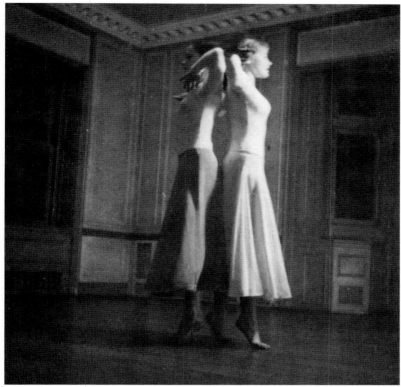

reveal the individual unconscious. In the performances in which Sullivan danced alone, as in *Danse dans la neige* (1948), she attempted to release her individual psychic energy through movement — movement, which she proposed would symbolize the universal or collective psyche.[5] She also sought to recreate archetypal symbols, as is exemplified by her reference to the "Shadow," defined by Jung as "our other self." The archetypal symbol of the Shadow underlies her performance of *Dualité* where two dancers, Sullivan and Jeanne Renaud, one in black, one in white, enacted themes of opposition and attraction.

While Sullivan's dance and choreography of the 1940s was undoubtedly Jungian in its Automatiste enactment of symbolic, "universal" elements, I question the authority of this interpretation in her subsequent production. In particular, Sullivan's return to the "high art" medium of painting in the 1980s, has reinforced the tendency to read the predominantly performance and site-specific work of the 1970s as part of an aesthetic, ahistorical progression from Automatiste dance to contemporary painting. This framing of Sullivan's performance pieces by "high art" reduces them to contributory elements (as part of a progressive history) rather than acknowledging their disruptive challenge to the aesthetic centre.

FRANÇOISE SULLIVAN *Dualité*, 1948. Performers: Jeanne Renaud and Françoise Sullivan

The critical placement of the artist's contemporary work within the bounds of her Automatiste stance is exemplified by a recent analysis of Sullivan's painting, in which the critic characterized *Beware! Beware! His flashing eyes, his floating hair* (1983) as exemplary of Sullivan's "desire for tangency with the universe."[6] The painting depicts a figure with arms outstretched and legs apart with most of the body weight balanced on one leg (not quite the model of balance represented by Leonardo Da Vinci's *Vetruvian Man*). The figure appears to be female. She is framed by a rectangle which is inscribed in a circle, but the rectangle breaks through the confines of the circle at the base. This image is described as "a metaphor of the universe and of pictorial representation, since the artist has made a summary of her own body by placing herself on the canvas… [This depiction] evokes the excessiveness of the body that merges with the universe."[7] The implication is that the artist returns once more to that notion of the unconscious, now evinced as bodily excess, which is realized within the collective experience of the universe. However, I would suggest that the represented body contains the potential of self-contradiction in its symbolic and allegorical dimensions. Symbolic of the artist (extending da Vinci's *Vitruvian Man*), the body also functions allegorically as gender displacement serves to destabilize the image of man at the centre of a harmonious universe. Breaking through the geometric framing of the body (the rectangle not entirely contained within the circle), the body's transgression is echoed in the emblems of the scorpion and the paint brush which do not belong in the ideal universe proposed by Leonardo. Here, the scorpion, as a sign of astrological identification, is understood as emblematic of the year end, the end of a cycle. Similarly, the paint brush in the extended hand of the artist implies the desire to control or to author her own fate. The face of the artist is darkened by a shadow cast across her visage. Is the masked face a further rebuttal of cosmic harmony? Or does it reinforce a negative interpretation of the presented cosmology? When formal considerations are added to the whole set of represented relations, such as the ephemeral drawing of the body compared to the vehemence of the swirls of paint in her immediate space, then the reading of the image is far more complicated than is implied by the idea that "the excessiveness of this body merges with the universe." Rather than merging, it would seem that displacement or uncertainty of position is the artist's concern in *Beware! Beware!* … The irony is further underlined by Sullivan's use of Coleridge's poem as a source for her title since Coleridge's concept of the unity of the symbol to its referent is so obviously being queried by the artist.

Sullivan's post-1970 production, whether performance or painting, seems to be undermining the Surrealist paradigm "to explore the subconscious and to expand the boundaries of memory as knowledge." Rather, she appears to be questioning the very rationale of such an inwardly directed approach.[8] It may be that such a challenge would be the inevitable result of her optimistic desire to "unite objective space and dream space" while at the same time insisting that "art can only flourish if it grows from problems

6 Marcel Saint-Pierre, "Françoise Sullivan — La Rhétorique du rêve, The Rhetoric of Dreams" in *Vanguard* (summer 1986), 38.

7 Ibid.

8 Ibid., 37.

9 Sullivan in Ellenwood, 115.

10 Claire Gravel "Françoise Sullivan — La Parole retrouvée" in *Vie des arts*, vol. 32, no.130 (March 1988), 44-47. Gravel refers to Sullivan's comment on the impact of Joseph Kosuth on her thinking about her own art production.

11 Françoise Sullivan interview with Gilles Toupin, "La nostalgie de l'art" in *La Presse* (January 13, 1973), D-14.

12 Ibid.

which concern the age."[9] How can the transcendent transcend the temporal, if it must be sited in it? Sullivan's Automatiste desire for cosmic consciousness appears to have been reassessed in the light of temporal realities. In part, this shift from modernist to anti-modernist concerns, or from symbolic unity to rhetorical stance, is located in her response to Joseph Kosuth's determination of the death of art.

After reading Joseph Kosuth's *The Philosophy of Art* (1969) in which he announced that the world was overstocked with art which was no longer necessary or valid, Sullivan was prompted to face her growing discontent with abstraction which had dominated art in North America for two decades.[10] Working within an abstract paradigm, Sullivan had been producing minimalist sculptures such as *Aeris Ludus* (1967) which strives to attain a harmonious whole executed with a few basic shapes unified in orange paint. During an interview in 1973, in which she was defending her abandonment of abstraction, Sullivan declared:

Like many other artists, I was distraught. I had a great love, at the depths of my soul, for art, but I was uneasy to even pronounce the word. The artist consecrates her life to do a job which is nearly no longer plausible. Our world is saturated with art objects. So what do we do now? I do not think today that artists are happy because of this gap between what the artist is doing [minimal art] and what the artist wants to do ... [11]

In addition to the aesthetic and philosophical impact of Kosuth, it is likely that Sullivan's personal life further pressured her into some form of reassessment. Her biographies, whether copious or brief, all mention her marriage to Paterson Ewen and the birth of her four sons through the 1950s. This personal data is relevant since this period of alienation from art during the years of 1968-70 paralleled her estrangement as she was in the process of separation from Ewen. This was also a period of extreme political and social upheaval in Québec. The student riots in the colleges and six universities, the dramatic intervention in the religious control of education and the foundation of the The Parti Québécois marked an intense era of cultural change. By 1970, the FLQ crisis with the kidnapping of Cross and Laporte and the enactment of the War Measures Act exemplified the frustration of many Québécois with the status quo. It is no surprise that this was the background for questioning the pursuit of the unifying potential of art. Sullivan's historic association with the Automatistes arguably set a personal precedent for her in that she was not afraid to challenge established conventions. By 1970, the hegemonic presence of formalism was deemed no longer convincing.

In an interview regarding an installation piece done in 1973, Sullivan declared that she and her contemporaries "are no longer interested in problems of form and colour any more. We are working at another level."[12] The need for authenticity in representation was pressing. All of Sullivan's subsequent work questions the nature of representation, and particularly that of the human subject. Her practice of the 1970s and 1980s is characterized by a shift from a search for symbolic unity to a fractured discourse of the other realized within a rhetorical stance which appropriates symbolism and allegory

in order to challenge representational norms.

The paradigmatic shift which I perceive as having occurred at the inception of Sullivan's self-conscious, anti-modernist practice is actualized by a change from notions of internal coherence in art to explorations of external reference. The breakdown of the modernist conception of art as a "hard-won unity" of surface and spatial tensions resulted in a reconstruction of referentiality in Sullivan's performance pieces, paintings, and choreographic work.

Ambiguous and always contextualized physically and theoretically, her post-1970 work implicates one aesthetic practice into another. Her performance pieces such as the promenade, *Rencontre avec un Apollon archaïque* (1974), are informed by her previous dance experience, and in turn impact upon her later choreography. The dancer who wrote "La Danse et l'espoir" abandons a vision of harmony in order to begin a re-assessment of what art means to her. Her "encounter with Apollo" is explicitly referential. It does not exist except as a photographic record. She takes her "encounter" out of doors. The artist/dancer moves in a choreographed path through Montreal's East End refineries searching through the detritus of the industrial age for a sign of classical art. What does the Apollo signify? Or should the question be how much does it signify? The possibilities range from a personal search for traditional values in artistic practice, to a post-modern questioning of the value of representation itself (signified by Apollo) in a world so cluttered that Apollo can be reduced to a simulacrum posted randomly amongst the refineries.

Once again, the response to Sullivan's production was to review it as consistent with Automatism. In the catalogue from the retrospective exhibition of Sullivan's oeuvre, it was stated that the motive for her "submission" to antiquity in her Rencontre d'un Apollon becomes "clear and coherent" when one recalls that she believed in the "rediscovery of the truths already familiar to the ancient primitives ..."[13] However, I would suggest that the parallelism between the use of Apollo and the search for ancient truths is not so apparent because, as a sign, the Apollo elicits numerous readings and it cannot be assumed to signify a universal archetype.[14] This questioning of the authenticity of the symbol, its reception, and the consequent validity of representation appears to inform all the post-1970 work. It is essential to consider Sullivan's performance pieces in light of her conscious choreography of space and time relations in the promenades. It is not coincidental that her performance pieces are awkward to categorize as dance or installation.

As a text, *Hiérophanie*, a performance/installation/dance piece of 1979, partially assists in the examination of the shift in Sullivan's position relative to aesthetic ideologies. *Hiérophanie* was Sullivan's first major choreography since the 1950s. It was characterized by the "derviches-tourneurs" often present in her earlier pieces (notably in the pieces in which she danced herself). Breaking the self-reflexive harmony of her early dance pieces, Sullivan inserted abrupt breaks in the music and in the use of materials (here a long piece of brown paper) which literally cut the movement of the dancers.

13 David Moore, "Françoise et l'espoir" in *Françoise Sullivan — Retrospective* (Québec: Ministère des affaires culturelles,1981), 84.

14 Indeed, the Apollo image chosen was that of the Belvedere Apollo which was widely admired as the epitome of Classical art in the late-eighteenth and nineteenth centuries. When it was realized that this Apollo was a late Roman copy of a Greek original, the object lost its élite status.

15 Angèle Dagenais, "Françoise Sullivan: un retour à la chorégraphie" in *Le Devoir* (April 3, 1979), D-7.

Caught in the Act an anthology of performance art by Canadian women

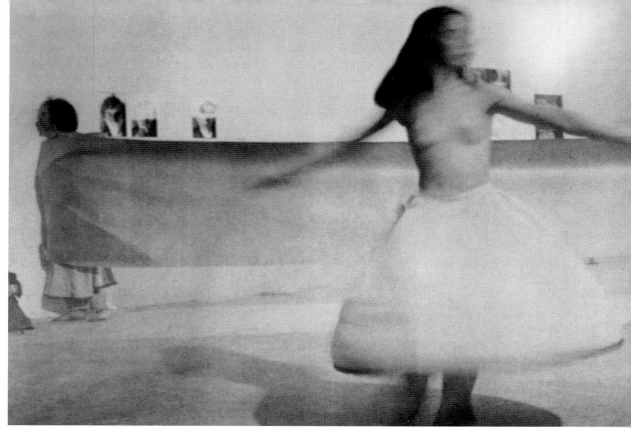

DAVID MOORE

Rather than the trance-like, automatic dance of the 50s, *Hiérophanie* was constructed to be deconstructed. An observer wrote that the impact of the dance "was troubling and fascinating ..." — hardly the reaction of an Automatiste viewer anticipating a recovery of deep emotional resonance achieved through cosmic harmony.[15] Sullivan was tearing away at the idea of myth, and forcing myth to unveil, to deconstruct its own tautological authority.

Similarly, another product of Sullivan's late 1970s practice centred on constructive/deconstructive activity — the blocking and unblocking of doorways and windows. Once more, the record of these activities is photographic. It is the recording of the act which becomes the artifact. The moment of creative production is further distanced by having the performance and its record occur in Crete (home to many fundamental Western myths), while its reproduction through display was in a North American gallery. The photographs of the *Fenêtres abandonnées, bloquées et debloquées* (1978) were arranged in the gallery in such a way that the observer was forced to experience the event in one of two ways; either reconstructing the blocking by approaching from the end of the photo series which started with a photograph of the empty window, or by deconstructing the blockage by approaching from the opposite side of the gallery where the series of

FRANÇOISE SULLIVAN *Hiérophanie*, 1979

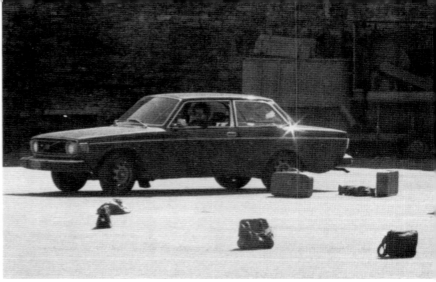

photographs commenced with the image of a blocked window. In other words, the observer was choreographed through the exhibition. To what end? This presentation of photographs of the artist's personal experience becomes another event in its representation. The use of the secondary medium forces the viewer to question what is being represented and to what degree the viewer is constructing the meaning(s) available.

This layering of activity and meaning is also present in a later choreography, *Et la nuit à la nuit* (1981). Here again the critical response describes the enactment as a symbolic fertility rite, cites "La Danse et l'espoir," of 1948, and comments that "the archetypal elements which she has used before are found in a moving synthesis, profoundly human." [16] Certainly the use of symbolic motifs underscores every move in this production. The use of the nude, pregnant dancer is explicitly referential as she appears at the end of the performance sedately carrying a basket from which she removes half a dozen young rabbits. While Iro Tembeck has observed that "the dance finishes with this double symbol of fertility," it should not be inferred that the literal symbolism is meant to encompass all potential meaning. [17]

Ironically, Sullivan herself states that *Et la nuit à la nuit* was conceived in a state of semi-consciousness and built around several key images. [18] While the choreographer may or may not have conceived the piece in such a state, the dance itself is performed according to prescribed choreographic directions. It is a predetermined enactment which regardless of the inspiration fulfills a specific intention. As such the "automatisme" of its dancers is constrained if indeed it is possible. It is imperative to separate the stated "automatic impulse" of the author/choreographer from the directed movements of the dancers. In fact, Sullivan's choice of symbols and structuring of interactions would not support an unconscious expression but rather a self-aware examination of her world and the power relations of men and women. Nor it is possible to claim that this dance portrays the "hope" of "La

16 Moore, 90.

17 Iro Tembeck, "Danse à Québec," in *Re-flex* 2 (1982), 18.

18 Françoise Sullivan in publicity statements for *Et la nuit à la nuit*, Le Tritorium, CEGEP de Vieux Montréal (March 27-April 1, 1981).

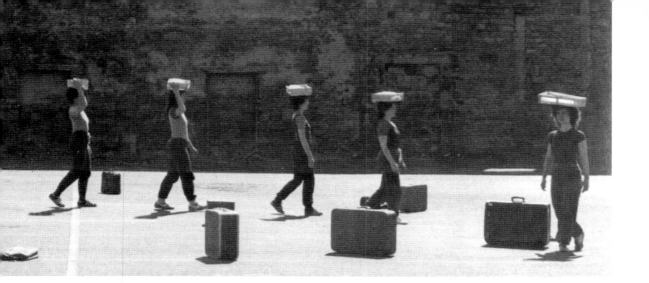

Danse et l'espoir." If anything, the dance explicitly challenges the reification implied in the potentiality of the feminine archetype, *Le Grand plein*, (the reproductive mother).

The three dance segments act out the symbolic relations between Man, symbolized as the River, and Woman, symbolized as the Mountain. The "natural" progression of life is represented in vignettes describing the birth of man by woman, their consequent union, the eventual destruction of both, and the closing scene featuring the pregnant dancer. The dance appears to literally confirm the cycle of life. If, however, the dance is not interpreted in light of the "hope" but in recognition of the shift in Sullivan's art practice (as exemplified above), then the dance could be understood as an allegory of desire. The use of multiple symbols is not necessarily only literal, and the literal and allegorical do not necessarily have to confirm each other. The rhetorical stance implicit in the anti-modern positions evidenced in Sullivan's work since 1970 can again be found in *Et la nuit à la nuit*. There is no hope of breaking the cycle, doomed to repeat itself through birth, union and destruction; continuity may be ironic, satiric, or pathetic, and confounds hopefulness. The use of the nude woman reinforces her role as the vulnerable element in the equation. Her pride and self-confidence is misplaced in her destructive fertility. Certainly, it is possible to read this piece as an anti-modern investigation of the human condition and the gender difference which sustains it.

The use of symbols to construct a metaphor which is, in turn, deconstructed by the rhetorical stance of artist and viewer, is evident in Sullivan's recent work. This brings us back to the question posed at the beginning of this essay — whether Sullivan's current art products, paintings, or choreographic productions can be judged as continuous with her Automatiste stance of the 1940s.

The nearly pervasive tendency to interpret Sullivan's post-1970 work as somehow relating to her Automatiste writing "La Danse et l'espoir" and to her

FRANÇOISE SULLIVAN *Accumulations VI*, 1980, performed in a parking lot in Old Montréal

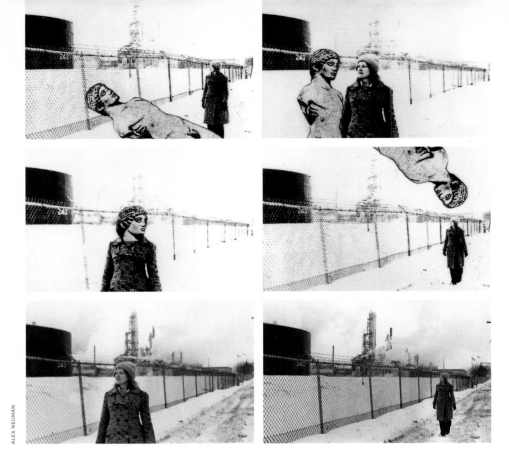

ALEX NEUMAN

FRANÇOISE SULLIVAN *Rencontre avec un apollon*, 1974

Danse dans la neige has created a methodological quagmire for the critics. On the one hand, they admire the consistency of notions of hope, on the other they try to fit the artwork itself into that interpretation. Once performance is re-placed into Sullivan's oeuvre as another expression, and not as a replication of prior concerns dressed in a new mode, then it must be acknowledged that the fragmented nature of the work presents anything but a harmonious whole. Whether it is discontinuous dance or torn, unprimed, unmounted canvas which is the material, it appears that Sullivan can no longer be subsumed under the aesthetic conceptualization of Automatisme. The artist who refused to accept convention, whether aesthetic, social or political in the *Refus global*, is still refusing the established categories. I argue that in replacing her performance art into her total oeuvre, we can realize a larger appreciation of her contribution to a dynamic cultural expression in Canada, whether achieved through dance, performance, or autonomous art objects.

* * *

This is a revised version of the essay "Re-placing Performance in "Art": The Case of Françoise Sullivan," first published in *Tessera* 11 (winter 1991), 99-108. This version was first published in *Canadian Dance Studies* 1 (1994), 107-116. Reprinted with permission of the author.

Elizabeth Chitty

Sylvie Tourangeau

PERSONAL PLURALITY

Sylvie Tourangeau is concerned with the nature and process of performance and the notion of presence in the performer and objects. She refers to performance as direct communication yet she embraces ambiguity. She does this through actions and the use of objects unlikely to signal shared understanding to an audience. "Performance is DIRECT in its communication and peripheral in its formulations of meaning."[1] The tension between a desire to communicate and intense ambiguity preoccupies her.

Her comments in 1989 as co-curator and writer for a performance series, exhibition and catalogue, *Performances + artefacts*, apply to her own work:

MANY artists turned away from the practice of performance, thus offering, in response, their ABSENCE as a generative force.
SEVERAL others became more and more redundant (an inexhaustible formula)
SOME, finally, as France Gascon has written, were confronted with the obligation of taking performance as a specific problematic.[2]

Sylvie Tourangeau was amongst the latter group of artists.

Tourangeau came to the practice of performance art from theatre. From fourteen to eighteen years old, she performed with a semi-professional theatre company in a repertoire ranging from classical to collective creation. She earned her BA in dramatic arts from the Université du Québec à Montréal in

1 Denis Lessard and Sylvie Tourangeau, *Performance + artefact* (Longueuil: Galerie d'art du Collège Edouard-Montpetit, 1989), 14.

2 Ibid., 15.

1981, but very early in her studies, with a boost from reading Antonin Artaud, she realized that a theatre education was not what she wanted. She was not interested in becoming a better actor and learning to interpret; her interest was to learn about creativity, and from 1978 onwards her focus was to differentiate herself from theatre. While a student, she began working as a performance artist in collaboration with her brother, Jean Tourangeau, and others, using Jean's poetry in the work. This shift from theatre to working with poetry is a transition but one that remains text-based, the first performance being "une soirée de poésie"[3] However, her work soon became multidisciplinary, employing, "textes poétiques, danse, théâtre, chanson, Super 8, souliers à claquette."[4]

A central concern for Tourangeau was to work against the representation of character. It was the deconstruction of representation in conventional, theatrical terms that led her to a consideration of objects that she differentiated from the use of theatrical props. Consideration of objects is a key concern that has continued in her work. The ideas she has discussed regarding her use of objects include exploring the relationship between herself and the object and using her live presence to change the object, becoming a bridge between the everyday meaning of the object and a new personalized meaning. An early text about performance is subtitled "Corporiser en objet fugitif," *corporiser* being a created verb meaning "to put in the body."[5] In her 1998 exhibition at the Musée d'art de Joliette, Tourangeau created installations with objects previously used in her performances. In the catalogue and artist book accompanying the exhibition, *objet(s) de présence*, she speaks of the following:

> [the] narrow relationship between two components of the artistic practice of performance: one, that of the object, material, inanimate, visible, and the other, that of the living, human presence, as capable of being tangible as of being evanescent ... [The objects are] living, *dynamic artefacts*, from which still emanates the experience of the performative moment shared by a spectator and an artist.[6]

The notion of "presence" is interesting to consider when reflecting on the differentiation between performance art and performing arts disciplines. In performance art circles, presence appears as a subject worthy of investigation by virtue of its intangibility and ambiguity and is influenced by philosophical investigations of presence in visual art discourse that analyse perception. In performing arts disciplines, presence is more likely to be considered a rudimentary prerequisite for performing, akin to raw talent and so fundamental as to not merit much examination. Or, conversely, it is seen as the product of virtuosic, acquired, body-based skills. In the latter case, it is not the least ambiguous or intangible and is acquired through effort.

Perhaps this points to a possible differentiation between performance and performing arts sensibilities; a focus on microcosm vs. macrocosm, detail vs. the effect of detail within a larger picture. Perhaps the interest in the small (if that can be extrapolated from microcosm and detail) is a legacy of the minimalist 70s. Perhaps it reveals the differences between emphasis

3 Alain-Martin Richard and Clive Robertson, eds. *Performance Art in Canada, 1970-990* (Québec: Les Éditions Intervention, and Toronto: Coach House Press, 1991), 149.

4 Ibid., 171.

5 *Bulletin de la Chambre Blanche*, no. 7 (February 1981), 5. Translation from correspondence with the artist.

6 Louise Paillé and Sylvie Tourangeau, *objet(s) de présence* (Joliette: Musée d'art de Joliette, 1998), 44.

7 Salim Kemal and Ivan Gaskell, eds., *The Language of Art History* (Cambridge: Cambridge University Press, 1991), 7.

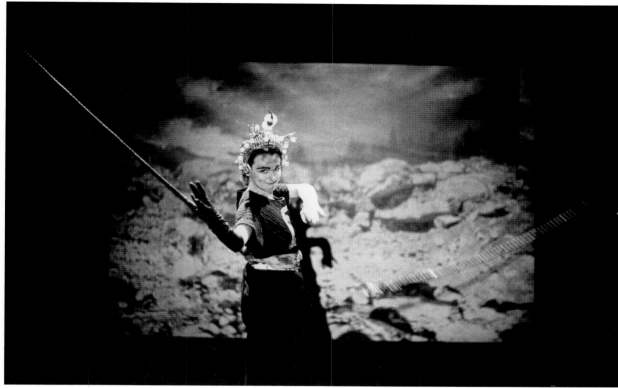

MARTIN LABBÉ

on theory and experience. Another view of the interest in presence is that it reflects the valuing of ambiguity as a central strategy of destabilizing subject, of the tearing away of notions of concrete truth and fact that has characterized much philosophical discourse and popular experience since the 1960s.

A preoccupation with objects is interesting to view from the perspective of transit amongst artistic disciplines. Performance art, framed by a visual art base, is usually historically seen as rooted in turning away from the object:

Another concern of contemporary art practice is the development of means of evading the production of art objects as such. Here, again, the examination of the relationship between language and art is crucial. Most obvious among the strategies followed by artists has been the growth of performance art. A performance cannot be treated in the same terms of display and commerce as an art object.[7]

Tourangeau's disciplinary transit was from text-based conventional theatre, to poetry-based performance, to objects in performance which are approached at least in part from a perspective informed by theoretical approaches in visual art (about representation, perception, and presence).

SYLVIE TOURANGEAU *Via Memoria (Mlle Chang)*, Espace Go, Montréal, 1987

EC Can you define the goal of this practice? Is it essentially a transformative experience? Is your interest in taking the meaning of objects outside of their habitual meaning for transformative reasons?

ST *Oui, le performance transforme l'objet, l'object transforme le performance.*

ST/LD There's transmission both ways, the performance will transform the object and how we see it and relate to it, but also the object itself transforms the performance. What's going on in the present moment between herself and the object, what's circulating between the two — that's what interests her.

EC What part does the audience play; is the presence of an audience important to these transformative experiences? Is the essence of this use of objects about presenting a transformative experience for audience?

ST/LD That's her way of attaining that. The audience is following her and with her with what's going on.

EC So it's an offering.

ST/LD The object becomes an intermediary between her and the audience and vice versa so it is her ultimate goal for the audience to also go through the transformation. So transformation is really an important point because that is what brought her from theatre to performance. She says, "If there's no transformation in the audience, then I'd rather stay home."[8]

To me, these words reveal an artist firmly based in a desire to communicate and affect and an artist committed to means that are rooted in personalized, possibly obscure experimentation. From this perspective, Tourangeau's work concurs with this definition of performance art:

Performance art has typically been defined as motivated by a "redemptive belief in the capacity of art to transform human life" as a vehicle for social change, and as a radical merging of life and art.[9]

Early in her work, Tourangeau focused her interest in process, personalization, and the nature of performance onto the subject of female identity. Her collaborations with her brother Jean addressed male and female stereotypes and ideas about seduction and coupling, for example. *En déroute ... je vole toujours ...*[10] was a one-hour solo performance first performed during the Art et féminisme event at the Musée d'art contemporain, Montréal in 1982. In *En déroute ... je vole toujours ...*, Tourangeau carried out routine actions such as brushing her hair while her recorded voice reflected on the choices she had made in her life: how her identity was different to what was expected of her, internal monologues about the choices she was making in that moment, choices of daily activities, and feminine stereotypes. A film of Tourangeau and others building a pyramid at the top of Mont-Royal was projected onto a screen that hung on the wall. At the foot of the screen was an upside down table representing a cloud. Two circles and a triangle made of silver plastic were on the floor and became the sites of specific activities. The actions of daily routine took place in one of the circles. In the second circle was a gun, which, early in the performance, she pointed at the audience. The gun was used as a tool of social language, to "get what she wanted."

SYLVIE TOURANGEAU *Via Memoria* (*L'Hybridité vivante*), **Espace Go, Montréal, 1987**

8 Sylvie Tourangeau, interview with Elizabeth Chitty, simultaneous translation by Louise Dubreuil (Montréal, July 25, 2001).

9 Amelia Jones, *Body Art/Performing the Subject* (Minneapolis: University of Minnesota Press, 1998), 13. The quote within is from Robyn Brentano. I should point out that Jones' book presents this definition in order to contrast the art she investigates.

10 The title of this 1981 version of the performance has been printed in three versions: with repeating periods following "déroute" and "toujours"; following "déroute" only and "toujours" only. I have followed what is printed in the *Art et féminisme* publication.

MARTIN LABBÉ

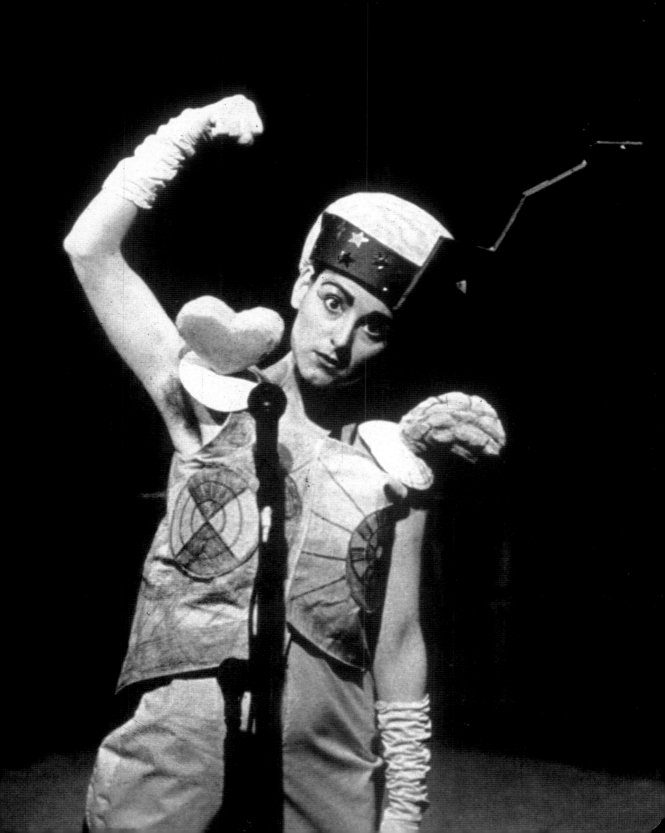

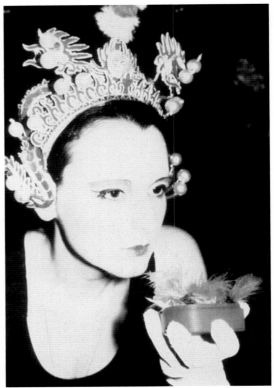

RAYMONDE APRIL

MARTIN LABBÉ

11 Tourangeau, interview with Chitty. This description is based on Tourangeau's recollection of the performance.

12 Rose Marie Arbour, Suzanne Lamy, Diane Guay, [et al], *Art et féminisme* (Montréal: Musée d'art contemporain de Montréal, 1982), 138.

13 Ibid.

14 Tourangeau, interview with Chitty.

Following this aggressive act, she travelled between circles with a movement style that was influenced by Tai Chi, which has a soft, fluid body use. Her interest in Tai Chi was based in the representation of balance between yin-yang, female and male.[11]

The catalogue of *Art et féminisme* includes a text written by Tourangeau prior to creating the performance. (The text was not part of the performance. She describes it as the inspiration for the subsequent performance.) In it, she speaks of tracing in feminine and feminist terms the codes of her behaviour, that the distance she takes when she chooses the signs she gives to others brings her to transformation and engagement and that this distancing game allows her to fool learned perceptual mechanisms. The last sentence is, "Ici ... j'y vois ma participation."[12] She recognizes her participation in this social construction. The entire short, poetic text includes three repetitions of the single line: "biannuelle-sauvage-cultivée-exotique,"[13] the words repeated to fill the page horizontally. This choice of words, rich with reference to plants, resonates with issues of biological determinism which were part of feminist discourse in the 1970s.

As a theatre student, Tourangeau's desire was to replace the theatrical construct of characters with something more personal. In the 70s, this

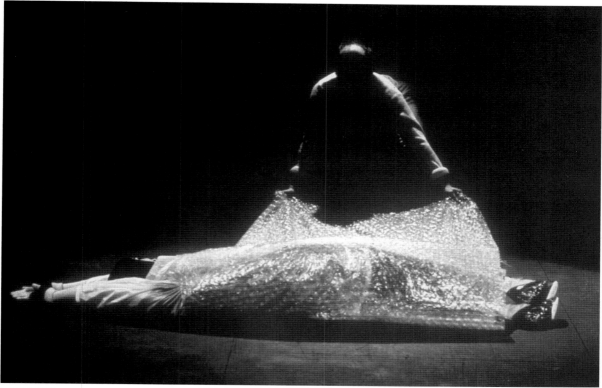

GINETTE CLÉMENT

impulse was shared by many performance artists who came from perform-
ing arts disciplines. (For me, the desire was identified as being more
"honest.") The use of personal acts and reflections is a common strategy
resonant with the feminist credo that "the personal is the political."

Costume is very evident in Tourangeau's work of the 80s. In *Via Memoria*,
part of *L'Hybridité vivante* (1987), she is dressed in a cartoonish, sci-fi costume
with a long black zigzag shape extending from a headband over a headdress
resembling a brain, with a red heart on her right shoulder and a brain on her
left. In another work, she wore on the outside of her clothing a halter top
reproduced from a Sonia Delaunay painting and she often wore a transpar-
ent raincoat. According to Tourangeau, costumes played a key role in her
"trying to re-invent female heroines."[14] This aspect of her work and the car-
toonish sensibility links her aesthetically as well as politically with other
performance artists such as The Clichettes and Shawna Dempsey.

In *Via Memoria*, she also sings and dances in a pop style; however, the
lyrics are not standard pop material:

SYLVIE TOURANGEAU *Les meilleurs
mots sont de lui*, La Chambre Blanche,
Québec, 1979

SYLVIE TOURANGEAU *La vie est un bip*,
Bar Mexicana, Montréal, 1990

SYLVIE TOURANGEAU *Via Memoria part 1
(La performeuse chercheuse)*, Espace Go,
Montréal, 1987

At the heart of the desert of autonomy

an eternal fresco
the living hybridity
a great unknown

shape the moment.

Why become engulfed by this hell of a modernity fashion?[15]

Tourangeau did not formally study dance but as a theatre artist brought some body awareness to performance and took some movement courses (in butoh, for example). Her movements in work such as *Via Memoria* are confined to the realm of the pop and vernacular. This pop style of movement was quite popular with some artists at the end of the 70s and early 80s; the work of David Buchan is one example, and was framed by some artists as embracing "amateurism." [16] Ironically, despite its derogatory associations to dilettantism and ineptitude, the word *amateurism* has its roots in the Latin word, *amare*, to love. Multidisciplinary performance artists of the 70s and 80s often used theatrical and entertainment devices in which they had no technical skill. This was sometimes about "being serious about our silliness" (à la artists from the Western Front),[17] sometimes a strategy to avoid and critique the paralysis found in traditional performing arts over technique, sometimes a comic means of poking fun at earlier decades out of sheer delight in their visual extremes or feminine roles. I have already mentioned Tourangeau's use of Tai Chi-influenced movement in her earlier work to represent a concept of yin-yang. In *Via Memoria*, her movement choices represented historical eras. Both examples illustrate a descriptive and representational approach to movement language that is limited from a dance perspective. Tourangeau also speaks of movement as a tool to help the audience experience the transformation she seeks:

What's really essential about movement and the way to use it is to find where your movement starts from and try and give [that] to the audience ... so the movement is to allow the consciousness to move, to travel.[18]

The concept of where movement starts is a very dancerly concern; it is at work in technical pedagogy and execution as well as notions of interpretation and expressivity. By the mid-80s, Tourangeau decided to develop an approach to working with the body that met her own needs, a decision that arose "after she started doing performance and started to feel a lack, really, that she was wanting a certain presence." [19] Her theatre background, or more specifically what she rejected in it, provided a starting point for her by reacting against an emphasis on projection. Instead, she attempted to amplify from within. She expanded her peripheral vision to become more aware of the audience and used that response as a tool to become spontaneous. She developed exercises, "to slow down when she feels the impulse of a movement, of an action, and then carrying it out to stretch that space in between." [20]

15 Sylvie Tourangeau (unknown translator), unpublished.

16 AA Bronson and Peggy Gale, ed., *Performance by Artists* (Toronto: Art Metropole, 1979), 281 and 283. See Hank Bull's comments about "militant unprofessionalism" and professionalism in *Performance Notes From the Western Front*.

17 This reference is from recollections of conversations with Kate Craig.

18 Tourangeau, interview with Chitty.

19 Ibid.

20 Ibid. These ideas are very similar to those found in some dance and theatre training systems. In my experience, performance artists have usually shunned performance training as somehow tainted with conventional disciplines and regressive but hopefully that is becoming an outmoded behaviour.

21 Ibid.

22 Richard and Robertson, 152.

23 Ibid.

This is a process of embodiment. Tourangeau began to give workshops in performance in 1983 and this work informed her workshops by 1990.

Sylvie Tourangeau's work is interdisciplinary in the sense that it has no base in a single discipline. Her motivations and influences have come from varied artistic disciplines and have been applied to what interests her at the moment:

Even in performance, she's always felt a bit of an outsider because she's not coming from visual art … from one to the next performance, she chooses really what disciplines, objects that work for what she wants to say … so it's more important for her in her whole process of doing performance over the years to learn how to do new things, that's really what's the most challenging and important so she's always felt a little outside of the frames that are there. So what brings all the work together is really the work around being present, in real time, as she's doing performance by any means necessary.[21]

In this article, I have attempted to draw attention to Sylvie Tourangeau's disciplinary sources, strategies, and differences because I believe performance art is based in plurality and I resist framing it only from a visual art perspective. Tourangeau's work exemplifies this perspective. She has said:

I perform cross-references and cross-influences. My preference is for natural gestures, simple interaction and the "uncertain" in fiction and reality. I explore the limitations of different disciplines. I believe in the power of evocation.[22]

Performance art is often viewed in hierarchical comparison to other art forms, two common comparisons being that it is more radical in nature than the performing arts, or, that it is only technically unskilled performing. A pluralistic view that does not impose such hierarchies is preferable for those practitioners and audience members seeking an artistic climate of exploration and discovery. As Sylvie Tourangeau has stated, "Performance art upholds no hierarchy and consolidates no experience."[23]

Barbara Fischer

Colette Urban

OF CHILDREN'S RHYMES, SPIDERS, AND OTHER ENTRAPMENTS ... (1993)

I. In Performance

Performance has always been one of the primary sites of a re-negotiation of identity in the body politic. In fact, that renegotiation is what distinguishes Performance as a genre within the visual arts from 1960s Body Art. If Body Art took its cue from minimalist and conceptual concerns with a sense of purity of presence, Performance introduced masquerade, theatricality, and a questioning, a crisis of identity.[1]

The role of women artists, and more significantly the introduction of problems of gender identity, was pivotal in this development. In fact, the very appearance of women in the field of vision — the emerging presence of women artists — seemed enough to throw the "psychic territorial power lines"[2] of gender identity into disarray (effecting a crisis of identity for both male and female viewers alike, though differently for each). It might even be argued that it was precisely the uncertainty brought on by breaking expectations and rupturing existing codes of female conduct, language, and even subjectivity, as introduced by women artists into Body Art, that accounted for the change within the medium. Lucy Lippard once wrote:

When women began to use their own faces and bodies in photoworks, performance, film, and video, rather than being used as props in pieces by

men, it was inevitable that Body Art would acquire a different tone.[3]

Or, as Moira Roth put it in her survey of 1970s performance entitled *The Amazing Decade: Women and Performance Art in America*:

By 1970 women artists had discovered that performance art [...] could be a particularly suitable form in which to explore their reassessments of themselves and other women. Thus increasingly over the decade, more and more women artists channeled their creative energies into this new medium and in the process transformed its content and its form.[4]

If, in the context of contemporary art, performance no longer occupies the centre of activity in the way it did in the 1970s, it continues to be an important medium for artists, and especially women artists, who seek to take a critical account of conditions of subjectivity and of individuality, as articulated or registered through the activity of the body in the Social.

II. Allegories of the Social

Colette Urban's performances, which in a sense begin with the opening of a secondhand junk store on Queen Street West in the 1970s in Toronto,[5] have always been concerned with the (re)negotiations of identity, in particular as it concerns female subjectivity, or the identity of femininity. The junk store's collection of discarded things (hats, clothing, props, trinkets, furniture) functioned as catalyst in the trading or interchange of identities, here between objects and customers. It is in her later performance works, however, that the use of the found and secondhand — whether of material or immaterial nature — is articulated with regard to identity. With a keen sense for seemingly insignificant or odd manifestation of social ritual — found in marginal materials such as outdated girls' education books or odd costumes and props — Urban's performances throw into relief the theatricality of the enactment of identity including notions of proper conduct and etiquette. Her sculptural and time-based allegorical works represent "performance" itself with subtle irony, playful wit, and poignantly staged images — as that within which identity takes shape.

In *Orchestrina* (1989), for instance, Colette Urban utilizes records of children's songs and draws out their role in upholding social codes, in molding identity.[6] In this work, Urban assumes the role of conductor but one who leads a very odd orchestra. Wearing a dark evening suit appropriate for the formality of the occasion, her work begins with an invitation for volunteers to partake in a concert which is performed on record players operated like wheelbarrows. (Each record player includes a battery-operated speaker attached to a frame with a wheel and handlebars; once it is pushed, the turntable begins to turn and thereby produces the sound of a particular record). As the volunteers are called up, one by one, each is asked to "tune" their instrument; that is, to walk at a pace that makes the record spin at 33 rpm — which, it turns out, is not an easy task. In fact, throughout the walk of the performers, the sound goes in and out of the right pitch, wavering between an all too high, manic version and a slowed down, very low warble.

The nature of the tuning of the instrument can easily be seen as an allegory

1 Philip Monk, "Coming to Speech: the Role of the Viewer in Performance," in *Performance, Text(e)s & Documents* (Montréal: Les Éditions Parachute, 1981), 146-7. Unlike Body Art with its "stubborn insistence on presence," as Philip Monk once put it, performance opens a discursive space between two "marks" on the body of the viewer: "what the viewer brings to the performance as knowledge, desire, and history (ideology) and how the viewer is acted upon by the analytical effects of the performance."

2. Carolee Schneemann, *More Than Meat Joy: Complete Performance Works* (New York: Documentext, 1979), 52.

3 Lucy Lippard, "The Pains and Pleasures of Rebirth: European and American Women's Body Art," in *From the Center: Feminist Essays on Women's Art* (New York: E.P. Dutton, 1976), 121.

4 Moira Roth, ed., *The Amazing Decade, Women and Performance Art in America, 1970-1980* (Los Angeles: Astro Artz, 1983), 8.

5 The junk store lasted until Colette Urban was evicted in 1977.

6 The performance was most recently staged at the Arts and Letters Club in Toronto, February 21, 1993.

of the individual's place within the social. *Orchestrina*'s demands are to tune in, to synchronize one's walk to what one knows the sound to be, and, in effect, to march to the tune. All this is underlined by the songs themselves which, as children's entertainment and playschool ritual, implicate the process of education, language, and social skill's development, through "Donald Duck and his Friends," "Cinderella," and "The Adventures of Raindrop," and such simple singalongs as "Row, Row, Row Your Boat."

Yet, the work gives musical expression not only to the individual's, but to a collective effort. After "tuning" his or her instrument individually, each performer is called up, one after the other, to join into the loosely orchestrated walk around the room, encircling the audience in the centre of the space. Together, their instruments add up to a growing, warbling, manic symphony, with the entire room resonating in a dense sound of mismatched speed, volume, pitch, and timbre. *Orchestrina* thus brings the individual, and the tension inherent in the individual's striving (of achieving synchronicity with a given tune) into a general dissonance, where each motor adds to a fantastic disharmony and cacophony rather than to a harmonious social whole.

III. Children's Rhymes, Household Tips, and Other Entrapments

In Colette Urban's performances, a wide variety of materials come to represent the props, the objective conditions, or social structures of individual subjectivity. Their use suggests — allegorically — the enactment of a role and, as such, a process fraught with tensions, flaws, and fissures. If, in *Orchestrina*, the performance of a song makes very definite, also unsustainable demands on the individual operating the instruments, other works will employ more demanding devices, things that control the performer or make her move in an awkward manner. *Spilt Milk* (1988), for instance, features an audiotape of a group hypnosis session which begins at normal playback speed but then slows down increasingly into an hypnotic pace. The performance involves Colette Urban, who acts as though put under hypnosis herself. Strapped into a diver's suit which has a ten-foot ladder attached to its back, she walks and finally runs in a circle with a full bucket of milk. If her movements appear the result of hypnotic suggestion, it also seems that she is under the spell of desire or ambition (suggested by the ladder as an emblem of personal or social ascent, i.e. the ladder of success); or, conversely, that she carries the ladder for others to climb. The unwieldy weight of both the ladder and bucket forces a strange excess of expenditure, a literal wasting or spilling of energy on the performer's part, like the milk that keeps sloshing over the rim of the bucket.

Gender is a more explicit issue in *a song to sing, a tale to tell, a point to make* (1989) and *Blind Spot* (1987). The former begins with a male voice reading a rather discouraging text on how a girl might (or might not) succeed at writing a story.[7] Dressed in a girl-child's dress, with impossibly long, stick-like extensions attached to her arms, Colette Urban rolls a gravel-filled world globe about while a record plays, in ironic contrast to her awkward and restrained movement, a "Wonder Woman" story. If the image itself disturbs it, the ideal of "Wonder Woman" is derailed at the end of the performance

7 The story was published in *Hundreds of Things a Girl Can Make*, 1945, a book which concerns "appropriate" subjects of learning for girls.

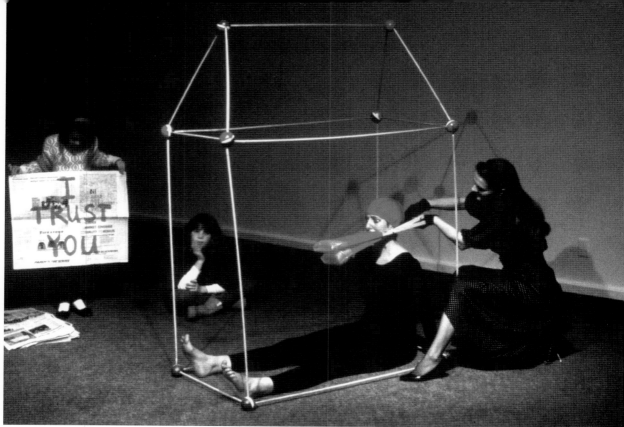

DAVID MORRISH

with the song "Somewhere, over the rainbow…" Identity in this performance is a position wrested from somewhere between a disastrous inability and an impossible perfection; Colette Urban is strangely empowered, or enacts power obliquely, as she turns and rattles the world globe.

COLETTE URBAN *Landing Here,*
Sir Wilfred Grenfell College Art Gallery,
Corner Brook, Newfoundland, 1992

IV. The Ventriloquist: I, You, or Who Speaks Me?

If Urban's performances function as allegories of an individual's struggles with identity (as represented by songs, images, or socially defined and gendered tasks), most often the inscribed failure is gently ironic, funny, or eclipsed as absurd. In *Landing Here* (1992), however, the scenario becomes sinister, oppressive, and nothing less than harrowing. More than any of her other works, *Landing Here* addresses the traditional role of the woman within the domestic sphere. The subject is immediately apparent when the audience finds Colette Urban sitting in, and framed by, a makeshift, precariously small, stick-like house. The house as an image of confinement, even a cage, becomes more oppressive as an assistant sitting next to the performer begins to move a beak-like protrusion attached to the performer's head. The protrusion moves like scissors, open and shut, and a voice is heard which iterates an intense soliloquy, "between you and I," a story about "me" addressed

to someone, such as perhaps "you" in the audience:

I am temporarily in your presence; I feel your gaze; I want your approval; my eyes are open; I see you; I trust you; My heart is racing; I've changed; I feel you; I speak silence; My lips move as you watch ...

At first, the words seem to be her own, but then it becomes clear they come from the immobile lips of the assistant who is putting words in her mouth: the assistant gives her speech. In this strange play of enunciation, the identity of "I," "you," and "me" begins to waver and slips up. Who speaks "I" or "you?" Who is "me?" As an allegory for a female self trapped and spoken for within the domestic sphere, the expressed search for contact and communication, and the performance itself, do not answer these questions but devolve into absurdity as a recorded voice offers helpful household hints. Beginning in a rational, instructive manner (with useful, illuminating collectibles specifically addressed to women such as "save your back by using an ordinary car jack to hoist heavy furniture when trying to slide a rug under the large pieces") the sentences end in a jumble of fragments mixed at random and mounted together to no longer make any sense:

On rainy days picturing the location of the items to hoist heavy furniture will let you know by the feel ... save steps in the supermarket when trying to slide a rug under the large pieces that you have reached the bottom ... save your back the last step of a dark staircase spilled on a book page, etc.

The haunting dissolution of order, of identity and communication, which this performance shares with *Orchestrina*, is ambiguous. One might see in it an expression of increasing separation between the individual and the social, as the performer appears driven into utter isolation and entanglement within the domestic sphere. Conversely, it may represent the dissolution of all boundaries between individual self and the world, as the self that appears to speak is, in fact, spoken through the incessant stream of messages, the all-present reminder of better techniques, more efficiency, and greater utilization of the body in domestic labour — until it breaks into hysterical dysfunction ...

don't is gentle for being erased ... to conserve energy with children's shoes ... airholes brush your screens ... windows have been on the stove ... remove five minutes ...

V. Animal Spirits

The structure of Colette Urban's work often brings out a sense of entrapment, often through the evocation of animals. They tend to stand in for a self — whether as victim or perpetrator. In *I Feel Faint* (1985), for instance, Urban is seen in a very peculiar armor which consists of motorcycle tires cut in half and strapped to her feet like two giant, curved shoes and a large beak-like sheet-metal hat in which a lightbulb is mounted so as to dangle in front of her face — like a flashlight under the bedcover. In the darkened room, illuminated only by this single source of light, Urban begins to read a breathless story spelled out in a spiral on the floor, a story about an animal mother being cornered by a hunter.[8] The children's story would be enough to whip up fear if one was young, but even now, though the story is sentimental

COLETTE URBAN *Pretend Not to See Me*, duratrans light box, 65.5 x 28 x 21 cm, 1999. Collection University of Lethbridge Art Gallery

8 The story is a rewritten extraction from *The Vanishing Prairie*, a book produced by Disney Studios in 1953.

ELISABETH FERYN

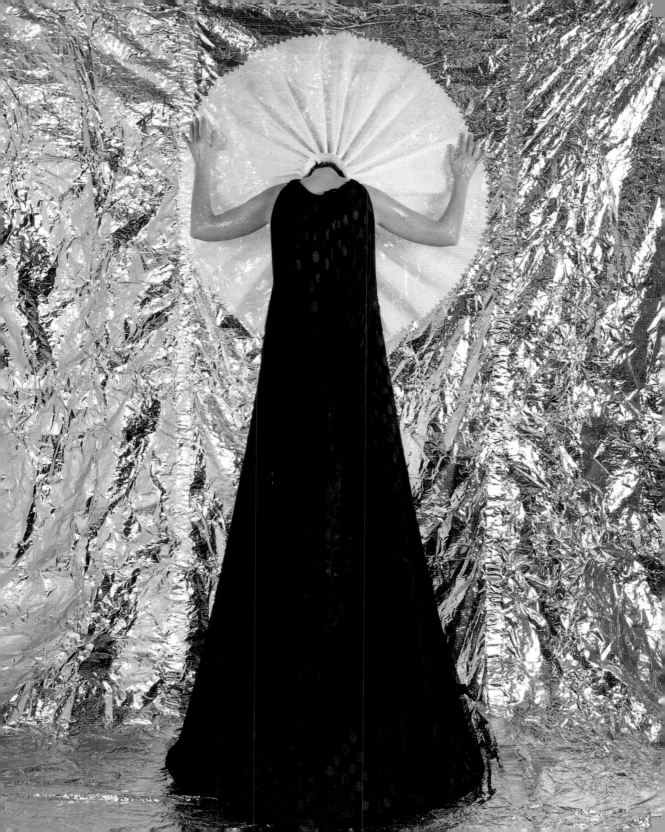

in its anthropomorphism, the narrative has its own compelling force, driving from the flash of danger and threat of mortal capture to relief in the end, with the animal's escape into safety.

As the title already suggests, the story of hunting and being trapped is transferable from the figure of the animal to the subject of the performance, the "I" of *I Feel Faint*. Urban's quickening movement seems propelled by (or hooked on) the narrative to the point of fainting, the point where all strength leaves the body under siege. The hunter, in this case, seems to be the story itself: an instructive children's story it h(a)unts the "I" to spiral in on itself, into the centre, where the only escape available seems to be to take flight, that is, to faint.

VI. Spider Woman

It is not always as a victim, however, that the animal-self appears. In *Blind Spot*, Colette Urban represents herself within the ambiguities of an active and passive being, and poses the question of performance as both a mode of adopted or complying behaviour and as an active assertion of her own difference from an existing norm. This work begins with an introduction to good dancing, striking up the demarcation between an active male leading role and a good passive female following in dance.[9] Dressed in a late nineteenth century mourning dress and a black sleeping mask (a veritable widow in black or black widow), Urban attaches bungee cords, which are mounted to a wall, to her ankles and wrists and thus suspends herself (visually) like a spider in a corner of the room. This suspension allows Urban to sway in her web, with her movement suggestive of both a spider crawling gently on top of the web and/or of a woman caught within the traps of convention.

If the image alone is a poignant metaphor for the woman artist suggestive of the problems of female identity as caught in or on the tightrope between an active and passive role, between leading and following the dance (or in the context of performance as such), Urban's epilogue develops the theme of the black widow spider in greater depth. Spinning a narrative web from the threads of autobiography, superstition, science, and myth, she leaves it up to the audience to disentangle the net within which female subjectivity is suspended. A spider may be a sign of good luck when found on a wedding dress, but a black widow threatens mortal danger when under the toilet seat in the outhouse. For Colette Urban, the black widow spider also signifies a black widow — a woman in mourning. The black dress Urban wears for the performance makes reference to her great-grandmother's black silk mourning dress, which in the nineteenth century could also be worn to weddings, and which Colette herself wore when she was twelve and performed for her aunts and uncles in the parlor. The black widow in the performance also stands for the spinster, an unmarried woman, and spinning was a widow's or spinster's occupation in the seventeenth century. Spider's silk might be woven into a web to trap flies, but it also signifies material which is liquid at first and hardens in the air like the ink in writing — a metaphor perhaps, for the work of the artist.

9 The instructions are read by two children, and they range, in their own gender-specific way, from "Hold your partner firmly to give her confidence, but not so tightly as to restrict her movements" (addressed to the male leader) to "Develop perfect balance and learn to glide smoothly in response to your partner's lead," and "Do not criticize or attempt to teach or lead your partner. Follow his lead even if you are convinced he is wrong" (addressed to the female follower).

BARRIE JONES

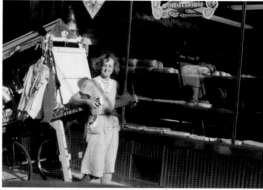

JULIE URBAN

VII. Dissonance and Subjectivity

Colette Urban's work rarely leads to a solution, least of all into a liberation, the articulation of individuality or subjectivity as innately free from social convention. Always, subjectivity appears as an effect of being inside a game (the rules of which are not one's own), of being bound to something that one is at odds with (like being in the wrong dress at the wrong time), or of being wrongfully a part of the right thing (whether by default, or necessity, mischievously, for pleasure, or at will). And it is the tension — the disharmonious timbre — between adhering to a task or diverging from it, that is, of enacting a code or disturbing it; of immersing seamlessly into a set role or assignment, and of struggling with it; of being in sync or at odds — that defines, for Colette Urban, not only the question of performance, ... but, the very problem of identity. The onus in her performances is on the dysfunctional, the structure and breakdown of codes, or the detrimental pursuit of an approximation of their rules. It is about identity as a process within which the self approximates and breaks from the rules and instructions of performance in the social world.

COLETTE URBAN *Round Peg in Square Hole*, photograph of performance, 1999

COLETTE URBAN pulling her cart in Kensington Market, Toronto, 1976

★ ★ ★

Reprinted with permission with some stylistic revisions, from *Colette Urban*, Sir Wilfred Grenville College Art Gallery, Memorial University of Newfoundland (1993).

Bibliography

A General Bibliography

"Tele-Performance" issue, *Centerfold* (December, 1978).

AA Bronson and Peggy Gale, editors, *Performance by Artists* (Toronto: Art Metropole, 1979).

Tanya Rosenberg, editor, *Spaces by Artists, Retrospective Parallelogramme 3, 1978-79* (Toronto: ANNPAC, 1979).

Alvin Balkind and R. Gledhill, editors, *Living Art Vancouver*, catalogue, Vancouver: Western Front, Pumps, Video Inn, 1980.

Susan Britton et al., "The 11th Paris Biennale: The Canadians (11ᵉ Biennale de Paris: Les Candiens)," *Parachute* 20 (fall 1980).

"Ritual Actions" issue, *artscanada*, no. 240/241 (March/April 1981).

Jennifer Oille, "A Question of Place 2," *Vanguard*, vol. 10, no. 9 (fall 1981).

Retrospective 4, Documents of Artist-Run Centres in Canada, 1979-80 (Toronto: ANNPAC, 1981).

Chantal Pontbriand, editor, *Performance Text(e)s and Documents: Proceedings of the Conference, Multidisciplinary Aspects of Performance and Postmodernism*, Montréal: Éditions Parachute, 1981.

Lorne Falk, editor, *Agit Prop: Performance in Banff*, Banff Press, 1982.

Goldie Rans, "The Paradigmatic Phrase: Performance Art," *Vanguard*, vol. 15, no. 8 (October 1985).

AA Bronson, editor, *From Sea to Shining Sea: Artist Initiated Activity in Canada 1939-1987*, Toronto: The Power Plant, 1987.

Alain-Martin Richard and Clive Robertson, editors, *Performance au/in Canada 1970-1990*, Québec: Éditions Interventions and Toronto: Coach House Press, 1991.

Keith Wallace, editor, *Whispered Art History: Twenty Years at the Western Front*, Vancouver: Arsenal Pulp Press, 1993.

Johanna Householder, editor, "Performance Tirades" issue, *Canadian Theatre Review*, no. 86 (spring 1996).

Richard Martel, editor, *L'Art en actes: le Lieu, centre en art actuel: performance, installation, arts média, manœuvre*, Québec: Éditions Interventions, 1998.

Philip Monk, *Picturing the Toronto Art Community: The Queen Street Years*, Toronto: The Power Plant, and C International Contemporary Art, 1998.

Private Investigators: Undercover in Public Spaces, catalogue, Banff: Walter Phillips Gallery and The Banff Centre Press, 1999.

Brice Canyon, editor, *Live at the End of the Century: Aspects of Performance Art in Vancouver*, Vancouver: Visible Arts Society and grunt gallery, 2000.

Elizabeth Chitty, "The 70s Dance Artists," *Dance Collection Danse*, part 1, no. 50 (fall 2000); part 2, no. 51 (spring 2001).

Richard Martel, editor, *Art Action, 1958-1998*, Québec: Éditions Interventions, 2001.

Guy Laramée, editor, *Espace traversé : réflexions sur les pratiques interdisciplinaires en art*, Trois-Rivières: Éditions d'Art Le Sabord, 2002.

Jennifer Fisher & Jim Drobnick, *CounterPoses*, Montréal: Oboro, 2002.

Luis Jacob, "Golden streams: artists' collaboration and exchange in the 1970s," *C: International Contemporary Art* 80 (winter 2004).

Shawna Dempsey & Althea Lahofer, *Live in the Centre: An Incomplete and Anecdotal History of Winnipeg Performance Art*, Winnepeg: The Winnepeg Art Gallery, 2004.

Lillian Allen

Lillian Allen, *Rhythm An' Hardtimes*, Toronto: Front Line Publications, 1983.

Clive Robertson, "Rhythm and Resistance: maintaining the social connection: interview with Lillian Allen, Devon Haughton and Clifton Joseph," *Fuse*, vol. 7, no. 1/2 (summer 1983).

Tom Harrison, "Women should stir up dirt," *The Province*, Vancouver: (May 14, 1987).

Susan Sturman, "Women Centre Stage," *Fuse*, no. 50 (July 1988).

Lillian Allen, *Nothing But A Hero*, Toronto: Well Versed Publishing, 1990.

Lillian Allen, *Why Me?* Toronto: Well Versed Publishing, 1992.

Lillian Allen, *Women Do This Everyday*, Toronto: Women's Press, 1994.

Sheila Nopper, "Vocal Resistors" *Herizons*, vol. 11, no. 3 (summer 1997).

Brenda Carr, "Come Mek Wi Work Together: Community witness and social agency in Lillian Allen's Dub Poetry," *Ariel: A Review of International English Literature*, 1998.

Lillian Allen, *Psychic Unrest*, Toronto: Insomniac Press, 1999.

SELECTED RECORDINGS

Freedom and Dance, CD, Verse to Vinyl, 1998.

Conditions Critical, Redwood, USA, 1988/Verse to Vinyl, 1986.

De Dub Poets, EP, Voicepondence, 1984.

Anna Banana

"The Transformation of Anne Long," *Maclean's*, vol. 85 no. 3 (March 1972).

Vic d'Or, "The Summer of '72/The Springing of 1984," *artscanada*, vol. XXIX, no. 174/175 (December 1972/January 1973).

David Zack, "An Authentik and Historikal Discourse on the Phenomenon of Mail Art," *Art in America*, vol. 61, no. 1 (January/February 1973).

Anna Banana, editor and co-editor, *VILE Magazine*, nos. 1-7 (Vancouver and San Francisco: Anna Banana, 1974-1980).

Hervé Fischer, *Art et communication marginale*, Paris: Balland, 1974.

"Why Banana?" *Art Contemporain*, no. 6/7 (winter 1983/84).

20 Years of Fooling Around with A. Banana, catalogue and edition of stamps, Vancouver: grunt gallery, 1990.

Ingrid G. Daemmrich, "The Banana in Contemporary Germany: Art Parodies Science," *The Changing Seasons of Humor in Literature*, Dubuque: Kandall Hunt Publishing Co., 1995.

Rebecca Belmore

Rebecca Belmore, "Autonomous Aboriginal High-Tech Teepee Trauma Mama," *Canadian Theatre Review*, no. 58 (fall 1991).

Charlotte Townsend-Gault, "Having Voices and Using Them," *Arts Magazine*, vol. 65, no. 6 (February 1991).

... Rebecca Belmore

Robert Houle, Diana Nemiroff, and Charlotte Townsend-Gault, *Land, Spirit, Power: First Nations at the National Gallery of Canada*, Ottawa: National Gallery of Canada, 1992.

Scott Watson, "Whose Nation?" *Canadian Art*, vol. 10, no. 1 (spring 1993).

Allan J. Ryan, *The Trickster Shift: Humour and Irony in Contemporary Native Art*, Vancouver: University of British Columbia Press, 1999.

Marilyn Burgess, "The Imagined Geographies of Rebecca Belmore," *Parachute 93*, (January/February/ March, 1999).

Barbara Fischer, editor, *33 pieces*, Mississauga: Blackwood Gallery, 2001.

James Luna and Charlotte Townsend-Gault, *Rebecca Belmore: The Named and The Unnamed*, Vancouver: Morris and Helen Belkin Art Gallery, 2002.

Robin Laurence, "Racing Against History: The Art of Rebecca Belmore," *Border Crossings*, no. 83 (2002).

Berenicci

Judith Doyle, "222 Warehouse," *Parachute 20* (fall 1980).

Randy & Berenicci. "Singapore Postcards," *Impulse*, vol. 8, no. 3 (summer 1980).

Clive Robertson, "Video/Video," *Fuse*, vol. v, no. 8/9 (November/ December 1981).

Randy & Berenicci, "First you learn the language," *C Magazine*, no. 11 (1986).

Andrew J. Paterson, "Randy & Berenicci," *Lola 14* (winter 2002-03).

May Chan

Art and Community, catalogue, Toronto: The Community Arts Group and A Space, 1987.

The Diary Exhibition/Journaux Intimes, catalogue, St John's: Art Gallery of Memorial University, 1987.

May Chan, *The Fifth Girl*, Toronto: Pedlar Press, 2002.

Ian Hodkinson, Robert Mulder and Bill Roff, editors, *Art for Earth's Sake: The Millennium Project*, Kingston: Kingston Artists' Association Inc., 2003.

Christine Conley, "Touching Home: An Interview with May Chan," *n. paradoxa*, vol. 13 (2004).

Elizabeth Chitty

Elizabeth Chitty, "Lap Documents," *Dance in Canada*, no. 11 (winter 1977).

Peggy Gale, "Elizabeth Chitty: Demo Model," *Centerfold* (December 1978).

René Blouin, "Recent Pasts," an interview with Elizabeth Chitty, *Parachute 16* (fall 1979).

Philip Monk, "Common Carrier," *Modern Drama*, vol. XXV, no. 1 (1982).

Nancy Tousley, "Notes on Agit Prop/ Performance in Banff," *artscanada*, no. 248-249 (November 1982).

Chantal Pontbriand, *Three in Performance*, Saskatoon: Mendel Art Gallery, 1983.

Reg Skene,"Dance show stunning, powerful," *Winnipeg Free Press* (September 22, 1986).

Elizabeth Chitty, "Heart, Soul and Thighs," *This Passion: for the love of dance*, Toronto: Dance Collection Danse Press/es, 1998.

The Clichettes

"The Day The Clichettes Said: I Do! I Do! I Do!" artists project, *File*, vol. 4, no. 2 (fall 1979).

Carole Corbeil, "It's exhausting to be a girl," *The Globe and Mail* (July 2, 1980.)

Mira Friedlander, "Feminist Performance: On The Cutting Edge," *Canadian Theatre Review*, no. 43 (summer 1985).

Clive Robertson, "The Compleat Clichettes," *Fuse*, vol. 9 no. 4 (1985).

Susan Swan, "The Triumph of Girl Art," *Toronto Life*, vol. 20, no. 6 (June 1986).

Jon Kaplan, "Lip-synching clichettes set to explode with rage," *Now*, June 14-20, 1990.

Louise Garfield, Janice Hladki and Johanna Householder, "Out for Blood" (script), *Canadian Theatre Review*, no. 86 (spring 1996).

Kate Craig

Peggy Gale and René Blouin, *Western Front Video*, Montréal: Ministère des affaires culturelles du Québec in association with Vancouver: Western Front Society, 1984.

Sara Diamond, "On off TV," *C Magazine*, no. 10 (summer 1986).

Shonagh Adelman, "Redefining the Female Subject: five feminist videotapes," *C Magazine*, no. 28 (winter 1991).

Nell Tenhaaf, "Of monitors and men and other unsolved feminist mysteries: video technology and the feminine," *Parallelogramme*, vol. 18, no. 3 (winter 1992/1993).

Dot Tuer, "Perspective of the Body in Canadian Video Art," *C Magazine*, no. 36 (winter 1993).

Christine Ross, *Images de surface: l'art vidéo reconsidéré (Images of surface: video art reconsidered)*, Montréal: Éditions Artextes, 1996.

Grant Arnold, Nicole Gingras and Brice Canyon, *Kate Craig: Skin*, Vancouver: Vancouver Art Gallery, 1998.

Nicole Gingras, "Kate Craig: le mouvement des choses," *Parachute 90* (April/June 1998).

Scott Watson, "Kate Craig," *Art/Text* (Australia), no. 61 (May/June/July 1998).

Jenny Lion et al., *Magnetic North*, Minneapolis: University of Minnesota Press and Walker Art Center, and Winnipeg: Video Pool Inc., 2000.

Rae Davis

Robert Racine, "Festival de performances du MBAM" *Parachute 13* (winter 1978).

Goldie Rans, "Electric Blanket 2: for Stella Taylor," *Parachute 25* (winter 1981).

Peter Rist, "Rae Davis," *Vanguard*, vol. 15, no. 6 (December 1986/January 1987).

Robert McKaskell, "Rae Davis — Vanishing Acts: A view from the inside," *The Act* (New York), vol. 1, no. 2 (spring 1987).

Jean Tourangeau, "Performance + Artefacts ou le pouvoir de la mémoire," *Vie des Arts*, vol. 34, no. 136 (1989).

Barbara Sternberg, and Penelope Stewart, "Rae Davis: Breaking Out of the Play," *Matriart*, vol. 2 no. 4 (summer 1992).

Sandra Gregson, "Rae Davis and Barbara Sternberg," *Lola 8* (winter 2000).

Francine Dagenais, "Rae Davis," *Parachute 106* (April 2002).

Patrick Mahon, "Rae Davis," *Border Crossings*, no. 82 (May 2002).

Shawna Dempsey & Lorri Millan

Lisa G. Mark, "Hijacking Cabaret," *Border Crossings*, vol. 15, no. 1 (winter 1995).

Renée Baert, "Three Dresses, Tailored to the Times," *Material Matters: The Art and Culture of Contemporary Textiles*, edited by Ingrid Bachman and Ruth Schering, Toronto: YYZ Books, 1998.

Robert Enright, "Brave New Girls: Moments of Beauty and Rage. The Art of Shawna Dempsey and Lorri Millan," *Border Crossings*, vol. 17, no. 2 (May 1998).

Jan Allen, "The Female Imaginary," *Matriart: A Canadian Feminist Art Journal*, vol. 5, no. 4 (1995).

Susan Heald, "Sex and Pleasure, Art and Politics, and Trying to Get Some Rest: An Interview with Shawna Dempsey and Lorri Millan, Performance Artists," *Atlantis*, vol. 23 no. 1 (fall 1998).

Lizbeth Goodman, editor, *Mythic Women/Real Women: Plays and Performance Pieces by Women*, London: Faber and Faber Ltd, 2000.

Louise W. May, editor, *The Feminist Reconstruction of Space*, St. Norbert: St. Norbert Arts Centre, 2000.

B.J. Wray, "Structure, Size and Play: The Case of the Talking Vulva," *Decomposition: Post-Disciplinary Performance*, edited by Sue-Ellen Case, Phillip Brett and Susan Leigh Foster, Bloomington, Indiana: Indiana University Press, 2000.

Nathalie Derome

Aline Gélinas, "Derome-Laliberté," *Ré-flex*, vol. 4, no. 2 (juin/juillet/août 1984).

Nathalie Derome, "Spécial Pitoune," *La Revue des Animaux # 9: Spécial Pitounes!* edited by Benoît Chaput, Montréal: L'Oie de Cravan, 1998.

Victoria Stanton and Vincent Tinguely, *Impure: Reinventing the Word: The theory, practice and oral history of 'spoken word' in Montreal*, translated by Susanne de Lotbinière-Harwood, Montréal: Conundrum Press, 2001.

Nathalie Derome, "Une Histoire de Salami," *Des Racines d'Identidad*, Montréal: Solidarte, 2002.

Margaret Dragu

Adele Freedman, "Honky Tonk Philosopher Queen," *The Globe and Mail* (June 14, 1978).

Linda Howe-Beck, "Dragu Lets Reality In," *The Montreal Gazette* (May 24, 1980).

... Margaret Dragu

Max Wyman, "Swan Song for Babes in Paradise," *The Province* (September 23, 1981).

Stephen Godfrey, "Tracking an Eclectic Eccentric," *The Globe and Mail* (June 9, 1982).

Margaret Dragu and A.S.A. Harrison, *Revelations: Essays on Striptease and Sexuality*, London: Nightwood Editions, 1989.

Margaret Dragu, Susan Swan and Sarah Sheard, *Mothers Talk Back: Momz' Radio*, Toronto: Coach House Press, 1991.

Brenda-Lea Brown, editor, *Bringing it Home: Women Talk about Feminism in their Lives*, Vancouver: Arsenal Pulp Press, 1996.

Carol Anderson, editor, *This Passion: For the Love of Dance*, Toronto: Dance Collection Danses Press/es, 1998.

Paul Couillard, editor, *La Dragu: The Living Art of Margaret Dragu*, Toronto: Fado Performance Inc., 2002.

"Ethel Tibbets Awards: Woman of the Year for Arts: Margaret Dragu," *Richmond Review* (March 6, 2003).

Lily Eng

"Eng: distinctive and open," *Ottawa Revue* (November 27-December 3, 1980).

Philip Monk, *Language and Representation: Brian Boigon, Andy Patton, Kim Tomczak, John Scott, Judith Doyle, Missing Associates*, Toronto: A Space, 1982.

Dot Tuer, "The CEAC Was Banned in Canada," *C Magazine*, no. 11 (1986).

Paula Citron, "Eng comes out of cold into Sun and its parts," *The Toronto Star* (May 11, 1992).

Jennifer Rudder, "[ENG]land," *Lola 2* (summer 1998).

Gathie Falk

Lloyd Dykk, "Wildly Indulgent Pieces of Theatre," *The Vancouver Sun* (February 4, 1971).

Mayo Graham, *Some Canadian Women Artists*, catalogue, Ottawa: The National Gallery of Canada, 1975.

Tom Graff, "Gathie Falk at Artcore," *YVR*, no. 5 (December 1978/January 1979).

Gathie Falk, "A Short History of Performance As It Influenced or Failed to Influence My Work," *artscanada*, vol. 38, no. 1 (March/April, 1981).

Ann Rosenberg, "Gathie Falk Works," *The Capilano Review*, nos. 24/25 (1982).

Gathie Falk Retrospective, catalogue, Vancouver: Vancouver Art Gallery, 1985.

Vera Frenkel

Henry Lehmann, "...And Connecting with Strangers: Vera Frenkel at Espace 5," *The Montreal Star* (November 9, 1974).

John Noel Chandler, "Vera Frenkel: A Room with a View," *artscanada*, vol. 36, no. 2 (September 1979).

Gary Michael Dault and Vera Frenkel, *Lies & Truths: Mixed-format Installations*, Vancouver: Vancouver Art Gallery, 1979.

Vera Frenkel, "Discontinuous notes on and after a meeting of critics by one of the artists present," *artscanada*, vol. 38, no. 240/241 (March-April 1981).

"The Cornelia Lumsden Archive: Can Truth Prevail?" by R. Austen-Marshall, as presented by Vera Frenkel, *Museums by Artists*, edited by AA Bronson and Peggy Gale, Toronto: Art Metropole, 1983.

Nik Houghton, "Sex, fleas and Or-phelia: Vera Frenkel and Ulrike Rosenbach at AIR," *Independent Media*, London (November 1988).

John Bentley Mays, "Sex was just the preamble," *The Globe and Mail* (September 8, 1989).

Lydia Haustein, "Displacement: Vera Frenkel, Ilya Kabakov, Michelangelo Pistoletto und Royden Rabinowitch auf der documenta IX," *Kunst und Unterricht*, Heft 164 (1992).

"Dysfunction, Gaps in the Chain of Evidence, and Other Teaching Stories," text of performance/lecture, *Akademie zwischen Kunst und Lehre: Künstlerische Praxis und Ausbildung — eine kritische untersuchung*, Vienna: Institut für Gegenwartskunst, Akademie der Bildenden Künste, 1992.

Dot Tuer, "Worlds Between: An Examination of the Thematics of Exile and Memory in the Work of Vera Frenkel," *Matriart 4*, no. 3 (1994).

Colleen Gray

Anna-Marie Larsen, *Place Settings*, catalogue, Calgary: Second Story Gallery (now Truck Gallery), 1987.

Donna McAlear, *Elemental Instincts, a matter of course*, catalogue, Calgary: The Nickel Arts Museum, 1988.

Sandra Tivy, *Media Blitz*, catalogue, Calgary: The New Gallery, 1988.

M.V. Stirnemann, *It's Now or Never: over*, catalogue, Calgary: The New Gallery, 1990.

Johanna Householder

Peter Goddard, "XXX Testimonial: A star is porn," *The Toronto Star* (February 3, 2002).

Robin Pacific, "The Neutron Hazer and the Mystic Gulf: Remembering Remembrance Day," *Fuse*, vol. 25, no. 1 (2002).

Johanna Householder, "10 Meditations on a Song by Olivia Newton John," *Touch/Touché*, catalogue, Toronto: InterAccess, 1999.

Steve Rife, "Interview: Johanna Householder: Time Indefinite," *100* (OCAD), no. 1 (winter 1999).

Randi Spires, "Feminism and Art in Toronto: A Five Year Overview," *ArtViews* (spring 1987).

Johanna Householder, editor, "6 of 1001 Nights of Performance," activity book insert, *Parallelogramme*, vol. 12, no. 2 (1987).

Liz Nickson, "Three Toronto Dance Artists: Notes and Images," *Fireweed* 3/4 (summer 1979).

The Hummer Sisters

D. Ann Taylor, "From Maggie Muggins to Nympho Warrior," *Fireweed*, no. 8 (fall 1980).

Mira Friedlander, "Feminist Performance: On The Cutting Edge," *Canadian Theatre Review*, no. 43 (summer 1985).

Marni Jackson, "Mas' Appeal," *Canadian Art*, vol. 4, no. 2 (summer 1987).

Michèle White, "VideoCabaret and the Subversion of Scenography," *Canadian Theatre Review*, no. 70 (spring 1992).

Suzanne Joly

Sonia Pelletier, "Performances + Artefacts," *Inter*, no. 44 (été 1989).

Jean Tourangeau, "Performances + Artefacts ou le pouvoir de la mémoire," *Vie des arts*, vol. 34, no. 136 (1989).

Pascale Beaudet, "Voir ou regarder," *L'Artefact* (automne 1995).

"Dossier sur Lanaudière," page couverture et propos d'entrevue, *Esse arts + opinions*, no. 29 (été/automne 1996).

Sonia Pelletier, "Performances à Montréal," *Inter*, no. 74 (2000).

Suzanne Joly, "Quelle ville habitez-vous? Quelles ville vous habite?" *Esse arts + opinions*, no. 42 (printemps/été 2001).

Kiss & Tell

Lynda Nead, *The Female Nude: Art, Obscenity and Sexuality*, London: Routledge, 1992.

Joanna Frueh, Cassandra Langer, and Arlene Raven, editors, *New Feminist Criticism: Art, Identity, Action*, New York: Icon Editions, 1993.

Kiss & Tell, *Her Tongue On My Theory: images, essays and fantasies*, Vancouver: Press Gang Publishers, 1994.

Kiss & Tell, "Seizure Story," *Suggestive Poses: Artists and Critics Respond to Censorship*, edited by Lorraine Johnson, Toronto: TPW, and Riverbank Press, 1997.

Deborah Bright, "Mirrors and Window Shoppers: Lesbians, Photography, and the Politics of Visibility," *Over Exposed: Essays on Contemporary Photography*, edited by Carol Squiers, New York: The New Press, 1999.

Victoria Brownworth and Susan Raffo, editors, *Restricted Access, Lesbians and Disability*, Seattle: Seal Press, 1999.

Harmony Hammond, *Lesbian Art in America: A Contemporary History*, New York: Rizzoli, 2000.

Sylvie Laliberté

Sylvie Tourangeau, "Sylvie Laliberté : La Chambre Blanche," *Vanguard*, vol. 14, no. 7 (September 1985).

Sylvie Tourangeau, "La performance en mutation," *Vie des arts*, vol. 31, no. 123 (juin 1986).

René Payant, *Vedute : pièces détachées sur l'art : 1976-1987*, Laval Québec: Trois Rivières, 1987.

Sylvie Laliberté, "Manifeste," *Tessera*, vol. 11 (winter 1991).

Jennifer Couëlle, "Lectures frivoles/Frivolity and fake fire," *Art Press*, no. 231 (January 1998).

Paulette Gagnon and Sandra Grand Marchand, *Culbutes : œuvre d'impertinence*, catalogue, Montréal : Musée d'art contemporain de Montréal, 1999.

... Sylvie Laliberté

Nicole Gingras and Louise Déry, *Espaces intérieurs : le corps, la langue, les mots, la peau*, Montréal: Musée d'art contemporain Montréal, 1999.

Marie-Josée Jean, *The knowing image*, Montréal : VOX, centre de diffusion de la photographie, 2000.

Jean-Pierre Latour, "Qui veut faire l'ange n'a qu'à faire la fête," *ETC Montréal*, no. 49 (mars/avril/mai 2000).

Gilles Godmer, *Sylvie Laliberté : œuvre de politesse*, catalogue, Montréal : Musée d'art contemporain de Montréal, 2001.

Frances Leeming

J. Humbert, "Something Called Maple Sugar," *Musicworks*, no. 6 (winter 1979).

Clive Robertson, "Performance Art Re-visited," *Fuse*, vol.9 no. 6 (May/June,1986).

Petra Rigby Watson "Andrew J. Paterson, Frances Leeming" *C Magazine* (1987).

Kim Sawchuk, "Playing with Monsters," in France Choinière, ed., *Deviant Practices*, Montréal: Dazibao les essais (1999).

Frances Leeming, "When the Hand is Not Always Quicker than the Eye," in Susan Lord and Gary Kibbins, eds., *Public 25* (2003).

Cheryl L'Hirondelle Waynohtêw

http://ndnnrkey.net

Ahasiw Maskêgon-Iskwêw, "Talk Indian to me (5)," *Mix Magazine*, vol. 22, no. 3 (winter 1996).

Carol Adams, "Women's voices growing in strength (Native singer Sadie Buck inspiration to Aboriginal women)," *Wind Speaker*, vol. 16, no. 8 (December 1998).

Candice Hopkins, *Interventions In Traditional Territories*, http://ndnnrkey.net/writing/intervention.txt, 2001.

Waynohtêw, *Copyleft vs Copyright*, speaking notes presented at an Aboriginal intellectual property symposium in Saskatoon coordinated by Greg Young-Ing, unpublished, 2002.

Mike Patterson, *First Nations in Cyberspace: Two Worlds and Tricksters Where the Forest Meets the Highway*, Ph.D. Dissertation for the Department of Sociology/Anthropology, Ottawa: Carleton University, 2003. www.carleton.ca/~mpatters/soc.html.

Toby MacLennan

Barbara Frum interview with Toby MacLennan [*Singing the Stars* at the H. R. MacMillan Planetarium, Vancouver, BC.] CBC Radio: *As It Happens* (1977).

Jack Burnham, "The 10th International Sculpture Conference," *The New Art Examiner* (July,1978).

Sally Banes, "In Search of Illumination," *The Village Voice*, NYC (May 11, 1982).

Toby MacLennan, *Singing the Stars*, Toronto: Coach House Press, 1983.

Avis Lang Rosenberg, "Toby Chapman MacLennan: 10 May," *Vanguard*, vol. 5, no. 6 (August 1976).

Jennifer Dunning, "The Stage: 3 pieces by Toby MacLennan," *The New York Times* (August 21, 1986).

Tanya Mars

François Cliché, "Hot Wet Milk," *Inter*, no. 74 (1999).

Kim Sawchuk, "Playing With Monsters," *Deviant Practices*, France Choinière, ed., Montréal: Dazibao, 1999.

Paulina B. Abarca and Aurele Parisien, "Quebec's Risky Business," *Stage* (fall 1995).

Robert Stacey, editor, *Pure Hell*, catalogue, Toronto: Power Plant, 1990.

Paul Couillard, "Tanya Mars, Pure Hell", *High Performance* (summer 1991).

Elke Town, "Three Sisters," *Canadian Art*, vol. 6, no. 2 (summer 1989).

Dot Tuer, "Video in Drag: Trans-sexing the Feminine," *Parallelogramme*, vol. 12, no. 3 (February/March 1987).

Jennifer Oille, "Picnic in the Drift", *Vanguard*, vol. 11 (February 1982).

Tanya Rosenberg, "Codpieces: Phallic Paraphernalia," *Branching Out*, vol. III, no. 1 (February/March, 1976).

Henry Lehmann and Georges Bogardi, "Artist's codpieces match wearer's personality," *The Montreal Star* (October 23, 1974).

marshalore

Nancy Nicol, "Marshalore: Another State of Marshalore: an interview by Nancy Nicol," *Centerfold* (December 1978).

Rose-Marie Arbour et al., *L'art et féminisme*, Montréal: Musée des beaux-arts de Montréal, 1982.

Chantal Pontbriand, *Three in Performance*, catalogue, Saskatoon: Mendel Art Gallery, 1983.

Marshalore, "A Postcard Home: an allegory for flora and fauna with texts, sound and actions," *Parachute 30* (1983).

Karen Asher, "Tom Dean's 1974 Performance," *That 70s Show*, catalogue, Winnipeg: Gallery One One One (University of Manitoba), www.umanitoba.ca/schools/art/content/galleryoneoneone, 2003.

Marie-Michèle Cron, "La vidéo combative des années 70," *Esse arts + opinions*, no. 46 (automne 2002).

Rita McKeough

Paula Levine, "The Resilient Center: Speaking from the Mouth of the Wolf," *Arts Atlantic 41*, vol. 11, no.1 (fall 1991).

Leslie Dawn, "Hold Tight/Bye Bye," *Vanguard*, vol. 18, no.1 (February/March 1989).

Helen Marzolf, *Tremor: an installation by Rita McKeough*, catalogue, Regina: The Dunlop Art Gallery, 1989.

Joan Borsa, "Rita McKeough: Some Voices Have Hearts," *Vanguard*, vol. 15, no. 3 (summer 1986).

Linda Milrod, *Afterland Plaza, An Installation at the Mendel Art Gallery*, catalogue, Saskatoon: Mendel Art Gallery, 1985.

Pam Patterson

Pam Patterson, "Kiss & Tell: Representing Lesbian Sexuality," *Matriart*, vol.1, no.2 (summer/fall 1990).

Pam Patterson, "Jamelie Hassan: A Commitment to Moral Art," *Matriart*, vol.1, no.1 (spring 1990).

Pam Patterson, "Mothers Making Art," *Matriart*, vo.1, no.4 (1991).

Pam Patterson and Margaret Rodgers, *Mapping the (Un)Familiar*, Bowmanville: The Visual Arts Centre of Clarington, 1994.

Pam Patterson, *The Self that enacts learning: Research on learning strategies and practices in a Canadian women's art collective*, BAAWA, (PhD Thesis), Toronto: OISE/University of Toronto, 2000.

Paulette Phillips

Elke Town, "Paulette Phillips: Find the Performer," *C Magazine*, no. 1 (winter 1983/84).

Andrew Patterson, "Paulette Phillips and Geoffrey Shea," *Vanguard*, vol. 17, no. 1 (February/March 1988).

Paulette Phillips, New City Fiction issue, *Impulse Magazine*, vol. 14, no. 2-3 (1988).

Nelson Henricks and Steve Reinke, editors, *By the Skin of their Tongues*, "Lockjaw" (video script), Toronto: YYZ Books, 1997.

Nell Tenhaaf, "Paulette Phillips," *Parachute 63*, (July/August/September 1991).

Kathleen Pirrie Adams and Gordon Hatt, *Paulette Phillips, The Secret Life of Criminals, Clues and Curiosities*, catalogue, Cambridge: Cambridge Galleries and Oakville: Oakville Galleries, 2004.

Robin Poitras

Jacqueline Bouchard, "L'art réfléchit, l'eau réfracte (Art reflects, water refracts)," *Esse*, no. 26 (printemps/été 1995).

Júlia Klaniczay et al., *Video-expedition in the performance-world*, Budapest: ARTpool Müvészetkutató Központ, 1995.

Marie Mendenhall, "New Dance Horizons: a look back and forth," *Performing Arts and Entertainment in Canada*, vol. 31, no. 3 (winter 1998).

Victor Dwyer, "Of winners, cold winds and Winnipeg: with our first annual Readers' Choice Travel Awards, you let us know all of your favourites. Here, too, is one of mine," *The Globe and Mail* (October 30, 1999).

Jackie Caton, "Dancing Towards the North Star," *Performing Arts and Entertainment in Canada*, vol. 33, no. 2 (fall 2000).

Richard Martel et al., "Rencontre Internationale d'Art Performance 2000," *Inter*, no. 80 (hiver 2001/2002).

Judy Radul

25 Young Artists, catalogue, Vancouver: Or Gallery Society, 1986.

Peter Cully, "Window Dressing," *Vanguard*, vol. 17, no. 2 (April/May 1988).

To Shine, catalogue, essays by Scott Watson and Susan Lord, Vancouver: Front Gallery, 1992.

Personal Size, monograph, Montréal: La Centrale, 1994.

Topographies: aspects of recent BC art, catalogue, essays by Grant Arnold, Monika Gagnon and Doreen Jensen, Vancouver: Douglas and McIntyre and The Vancouver Art Gallery, 1996.

... Judy Radul

Robin Laurence, "Performance-Art Documents Capture the Ephemeral," *The Georgia Straight* (June 18-25, 1998).

Marina Roy, "How to do things with art: 'performative utterances' in photography," *Prefix Photo*, vol. 5, no. 1 (2004).

Adam Budak, "Performative Poetics of (Video) Dreaming," *Videodreams, Between the Cinematic and the Theatrical*, edited by Peter Pakesch, Cologne: Verlag der Buchhandlung and Walther König, 2004.

Leena Raudvee

Leena Raudvee, "Feminism and Art: Ideology and Image," *Broadside*, Toronto, 1995.

Mary Hartling, "Beyond the Framework," *The Intelligencer* (August, 2001).

Jon Kaplan, "Top Loading Performance Art," *Now* (June 1984).

Françoise Sullivan

Françoise Sullivan, "La danse et l'espoir," *Refus Global*, Saint-Hilaire: Éditions Myrtha Mythe, 1948.

Françoise Sullivan, "Je précise," *Danse dans la neige*, Montréal: Image Ouareau, 1978.

Martine Bousquet-Mongeau, Claude Gosselin, and David Moore, *Françoise Sullivan: Rétrospective*, Montréal: Musée d'art contemporain de Montréal, 1981.

Ray Ellenwood, *Egregore: A History of the Montreal Automatist Movement*, Toronto: Exile Editions, 1992.

Louise Déry, Jean Dumont, and Michel V. Cheff, *Rétrospective Françoise Sullivan*, Québec: Musée du Québec, 1993.

Janice Andreae, "Launching the Body: Françoise Sullivan & Refus global," *Matriart*, vol. 7, no. 8 (1999).

Jérôme Delgado, "Des performances photographiques et uniques de Sullivan," *La Presse* (7 septembre , 2000).

Sylvie Tourangeau

Elizabeth Wood, Gilles Daigneault, and Mona Hakim, *Incursion latérale (Lateral incursion)*, Joliette: Conseil de la Culture de Lanaudière, 1994.

Sylvie Cotton et al., *L'installation: pistes et territoires — l'installation au Québec, 1975-1995: vingt ans de pratique et de discours (Installation: tracks and territories — installation in Québec, 1975-95: 20 years of practice and debate)*, Montréal: Galerie Skol, 1997.

Denis Lessard, "Joliette: Ecrire sa propre histoire: Sylvie Tourangeau, Objet(s) de presence, Musee d'art de Joliette, du 3 mai au 16 aout 1998 (exposition)," *ETC Montréal*, no. 44 (December 1998).

Réjean-Bernard Cormier, "Sylvie Tourangeau: la performatif ou l'anatomie d'une pratique," *Espace*, no. 47 (printemps 1999).

Germain Lafleur et al., *H2O ma terre: Symposium international de création in sity*, Carleton: Centre d'artistes Vastes et Vague, 2002.

Marie-France Beaudoin, "Au-delà de la performance," *ETC Montréal*, no. 64 (décembre 2003).

Sylvie Tourangeau and Stéfane Cloutier, *Sylvie Tourangeau: Appel(s) à l'aigle*, Montréal: [Sylvie Tourangeau], 2003.

Colette Urban

Ron Shuebrook, "Empathetic Witness," *Vanguard*, vol. 10, no. 1 (February 1981).

Martha Fleming, "Six from the Styx," *Arts Atlantic*, no. 10 (spring 1981).

Jean Tourangeau, "Performance et artefacts ou le pouvoir de la mémoire," *Vie des Arts*, no. 136 (automne 1989).

Dan Ring, *Colette Urban*, Saskatoon: Mendel Art Gallery, 1990.

Laura U. Marks, "Colette Urban," *Fuse*, vol. 10, no. 1 (May/June 1993).

Helga Pakasaar, *The Performance Sites of Colette Urban*, Windsor: Art Gallery of Windsor, 2001.

REBECCA BELMORE *For Dudley*, performed at the 7a*11d International Festival of Performance Art, Symptom Hall, Toronto, 1997

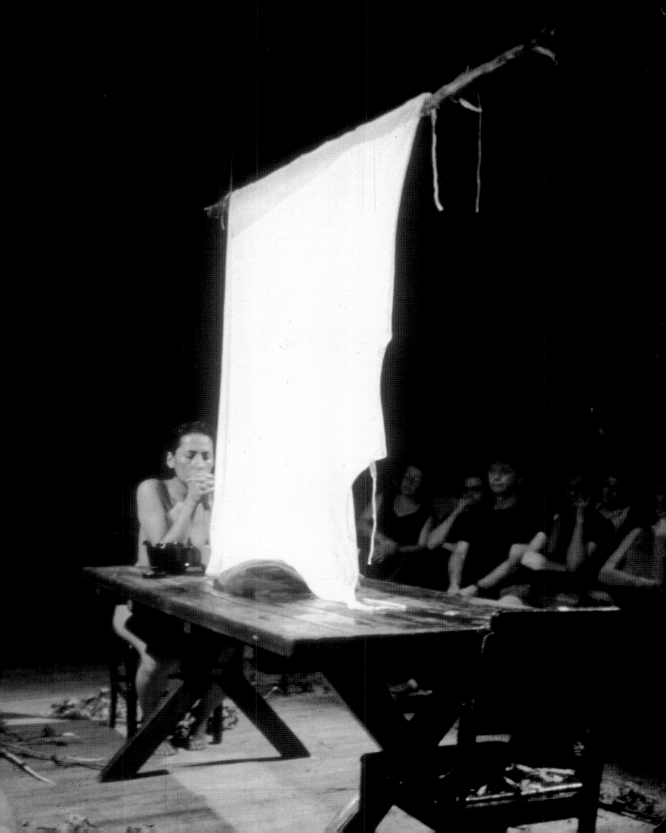

Contributors

Glenn Alteen is a Vancouver-based curator and writer and director of the grunt, an artist-run space known for its cutting edge programming. He has worked extensively in performance art and is a co-founder of LIVE: the Vancouver Performance Biennial (1999, 2001, 2003). His writing on performance was recently published in *La Dragu* (Fado: Toronto, 2002), *LIVE at the End of the Century* (grunt: Vancouver, 2000), and *Locus Solus* (Black Dog: London, 1999). He has curated exhibitions nationally and internationally, most recently *Vancouver Video*, which was shown in Italy and Britain (2002, 2003).

Jessica Bradley began her career at the National Gallery of Canada and then joined The Canada Council for the Arts where she was responsible for the dissemination and display of the Art Bank's collection of contemporary Canadian art. From 1979 to 1987, she was associate curator of contemporary art at the National Gallery. She was a curator, critic, and consultant in Montréal from 1988 until 1995 when she was appointed curator of contemporary art at the Art Gallery of Ontario. Since 2003, she has been an independent curator and critic. She is an adjunct professor in the Faculty of Fine Arts at York University, Toronto, and was commissioner for Canada's representation at the Venice Biennale in 1982, 1984, and 1999.

Ian Carr-Harris is a Toronto-based artist whose work has been exhibited nationally and internationally since 1971, including the Venice Biennale (1984), documenta, Kassel, Germany (1987), the Sydney Biennale, Sydney, Australia (1990), and The Power Plant (2002). He is represented by the Susan Hobbs Gallery in Toronto, and teaches at the Ontario College of Art and Design. His publication history of reviews, articles, and catalogue essays is extensive, and he is currently Toronto correspondent for the London (UK) magazine *Contemporary*. He was a founding board member of A Space and of The Power Plant, and has served on the board of the Art Gallery of Ontario. He is currently on the board of the web-based Centre for Canadian Contemporary Art.

Elizabeth Chitty is an interdisciplinary artist. Since 1975, she has created performance, video, and installation works. Her performance work has had four phases: works influenced by conceptual art and the multidisciplinary climate of the 70s in Canadian artist-run centres (1975-82); epic spectacles with multiple slide projections (1983-90);

landscape-based, in which the audiences followed walks and trails (1992-97); and the current phase of voice and movement, digital visuals, and spatialized sound expressing social issues. She lives in the Niagara region.

As Neutral Ground's director, **Brenda Cleniuk** co-founded the Soil Digital Media Suite in 1997 as a lab for new media creation which she currently programs and directs. She has curated or produced projects with artists from Canada, Mexico, the US, Germany, France, and the UK and initiated a program of performance mini-festivals around themes of diversity, mark making, existential philosophy, art and utility, and archaeology. Cleniuk received Bachelor's degrees in English literature, psychology, and art history. Her most recent art projects were created for soilmedia.org and include a digital cinema piece about erotic stress.

Christine Conley is an independent curator and art historian with a long-term interest in the performative and issues of subjectivity. She has witnessed May Chan's performances since 1987, curated one of her performance/installations in 1990, and published an interview with the artist in *n.paradoxa* vol. 13 (January, 2004). Her present project is a national touring exhibition of photo-conceptual artist Theodore Wan for the Dalhousie Art Gallery in Halifax. Dr. Conley is based in Ottawa where she teaches art history and theory at the University of Ottawa and holds a postdoctoral fellowship in cultural mediations at Carleton University.

Paul Couillard is a performance artist, organizer, and writer. For the past five years, he has worked as the performance art curator for Fado Performance Inc., and he is a founding member of the 7a*11d International Festival of Performance Art. He is also the editor of Canadian Performance Art Legends, a series of books on senior Canadian performance artists. The first publication in the series, *La Dragu: the Living Art of Margaret Dragu*, was released in 2002.

Margaret Dragu is celebrating her third decade as a performance artist. She has presented her work in galleries, museums, theatres, nightclubs, libraries, universities, and site-specific venues including parks, botanical gardens, and public parade routes across Canada, the west and east coast of the United States, and in western Europe. Margaret is a film and video artist, writer, choreographer, actor, and radio broadcaster. She is also a fitness instructor and personal trainer at community centres and hospitals in the city of Richmond, BC. One of Margaret's recent works is *Conscious Corpus*, a series that investigates the body by drawing upon a holistic lexicon from both her fine arts and body arts practices.

Tagny Duff is an interdisciplinary artist and independent curator. She has exhibited extensively, and published numerous articles, essays, and reviews for Canadian journals and catalogues. Duff lives in Montréal where she is currently completing a masters of Fine Art at Concordia University.

Barbara Fischer produces exhibitions and writings on contemporary art in Canada and internationally. She has worked independently and has held curatorial positions at the Walter Phillips Gallery (Banff), the Art Gallery of Ontario (Toronto), and at The Power Plant (Toronto). She is currently the director/curator of the Blackwood Gallery, University of Toronto at Mississauga.

Jennifer Fisher is a Montréal-based curator, writer, and teacher. She is a founding member of the curatorial collaborative DisplayCult which produced *CounterPoses* (1998), *The Servant Problem* (2000), *Vital Signs* (2000), *Museopathy* (2001), and *Linda Montano: 14 Years of Living Art* (2003). Her writings focus on performance in art practice and exhibitions, cultural studies approaches to contemporary art, and the aesthetics of the non-visual senses. She teaches in the art history department at York University.

Kirsten Forkert is a Vancouver-based artist working in installation, performance, and text. She has presented her work across Canada. Kirsten's practice is inspired by the possibility of alternative ideas of community, outside definitions offered by the rhetoric of official culture or the market. Her recent work has involved audience interaction as a way of creating social spaces: a series of walks in which decisions are made collectively as to where to go, and which actions to perform, and activities performed together with individuals and small groups, that draw attention to the experience of time and place and how these are affected by larger social and economic structures.

Tom Graff is a Vancouver performance artist, writer, and curator who has long supported Canadian women visual artists. His collaboration with Gathie Falk led to his curating of their 1971-72 cross-country performance art tour. With fifty-two art gallery and university presentations, involving a cast of seven, from British Columbia to Prince Edward Island, the tour was a first in Canada. Graff's subsequent solo tours and his 1983 precedent-setting

appearance at the National Gallery brought more curatorial awareness to the performance art discipline in Canada. His own performance work has toured Europe and the Asia Pacific. Currently, when he is not consulting on visual and performing arts projects, he is working on his own book works, performance CDs, and a world paper arts centre, Papyrus.

Nelson Henricks is a graduate of the Alberta College of Art (1986). He moved to Montréal in 1991, where he received a BFA from Concordia University (1994). Henricks has taught at Concordia University (1995-2004), McGill University (2001-2003), and UQAM (1999, 2003). A musician, writer, curator, and artist, Henricks is best known for his videotapes, which have been exhibited worldwide. A focus on his video work was presented at the Museum of Modern Art in New York (2000). Henricks was also a recipient of the Bell Canada Award in Video Art (2002). www.nelsonhenricks.com

Karen Henry was director of the Western Front from 1987-91, director/curator of the Burnaby Art Gallery 1991-97, and adjunct curator at Presentation House Gallery from 1997-2002. In 2001, she received a Curatorial Fellowship from the Walter Phillips Gallery at the Banff Centre and in 2003, a fellowship at the National Gallery of Canada for research on Canadian curator Doris Shadbolt. In 2002, she wrote and produced a video on Shadbolt's life and work. She has published numerous catalogues and essays in Canadian and international magazines. Recent publications include *Allyson Clay: Imaginary Standard Distance* (2002) and a text on two works by David Rokeby co-published by the Art Gallery of Hamilton and Presentation House Gallery (2004).

Rochelle Holt studied women and the fine arts at Concordia University and later completed an Honours BA in art history at the University of Toronto. Her interest in curating women in performance art began with her participation at A Space Gallery. This history began with Helena Goldwater's *Wet* and was followed by "The Message is the Medium: Girls Strut Their Stuff," a series that presented nine artists. Her interest in performance art and installation has resulted in a three-part series "Time/Space/Presence," and a solo exhibition and performance by Japanese artist Tari Ito, founder of WAN (Women's Art Network). Holt is a member of the 7a*11d Festival collective. Her practice includes a focus on feminist issues and other political and social concerns.

Johanna Householder has been making performances in Canada since 1976. She, Louise Garfield, and Janice Hladki were The Clichettes for a dozen years. Her most recent works include a series of video "Approximations" done in collaboration with b.h. Yael and the performance/installation *Remembrance Day* (2001), the fourth in a series of collaborations with her daughter, Carmen Householder-Pedari. She has performed across Canada and in the US under variable circumstances. She began teaching performance at the Ontario College of Art and Design in 1987, where she was chair of the new media/integrated media program from 1990-96. She is a founding member of the 7a*11d International Festival of Performance Art which held its 5th biennale in Toronto in 2004, and has curated many international artists for the festival.

Marni Jackson's performing career began when she played Anne Frank, as a roundish blonde WASP, in an excellent high school production. She then went into retirement. In her comeback, she played Monica The Voiceover, in *Half-Human, Half-Heartache*, which she co-wrote with The Clichettes. She also co-wrote *She-Devils of Niagara* with The Clichettes. She has toiled in film, theatre, radio, and TV. Marni Jackson is a multiple National Magazine Award winner, and the author of *Pain: The Science and Culture of Why We Hurt* (2003) as well as the Canadian bestseller *The Mother Zone* (1992).

Avis Lang is a senior editor at *Natural History*, a century-old magazine of the sciences. Before moving to New York City in 1983, she lived for fifteen wonderful years in Vancouver, where, under the name Avis Lang Rosenberg, she taught art history, wrote essays on art, participated in performance works by Tom Graff and Toby MacLennan, and curated several exhibitions, including *Pork Roasts: 250 Feminist Cartoons* (1981), a Canada Council-funded project that included the work of more than a hundred artists from a dozen countries.

Donna Lypchuk is a humourist, columnist, critic, and screenwriter who resides in Toronto. She spent a decade living at the Cameron Public House and has acted as a fundraiser, office assistant, and video camera operator for The Hummer Sisters.

Ahasiw Maskegon-Iskwew is Cree/French Métis born in McLennan, Alberta. He graduated from Emily Carr College of Art & Design, and studied at Concordia and Simon Fraser University. After working in the artist-run community in Vancouver, he participated in the Equity Internship Program at The Canada Council for the Arts. He was assistant editor of the *Talking Stick: First Nations Arts Magazine*, and production manager for Soil Digital Media Suite at Neutral Ground in Regina. Maskegon-Iskwew worked as web editor for the Aboriginal Peoples Television Network from 2000-2004. His critical writing has been published in *Mix*, *Fuse*, and *The Multiple and Mutable Subject: Postmodern Subjectivity and the Internet*, edited by Vera Lamecha and Reva Stone. His work will appear in an anthology of Aboriginal media art edited by Dana Claxton and Melanie Townsend, and a anthology of Aboriginal performance art edited by Glenn Alteen and Florene Belmore.

Tanya Mars is a multidisciplinary performance artist who has been actively involved in the Canadian artist-run movement since the mid-70s. She was a founding member and past director of Canada's first women's art gallery, Powerhouse Gallery/La Centrale in Montréal. During the 70s and 80s she was a member and secretary of the Association of National Non-Profit Artist-Run Centres (1976-1989), a national lobby group for artist-run centres. She was the editor of their publication, *Parallelogramme* for thirteen years. She is a member of the 7a*11d Festival collective, and she is a past president and member of Fado, a centre for the promotion and presentation of performance artists. She received a Chalmers Fellowship for her performance, *The Tyranny of Bliss*, presented by Fado in Toronto and at the Art Gallery of Hamilton in June, 2004. She teaches at the University of Toronto at Scarborough.

Jenifer Papararo is a curator at the Contemporary Art Gallery in Vancouver. She is a member of the artist collective Instant Coffee (www.instantcoffee.org) and past program director of Mercer Union, Toronto. Recent curatorial projects include *Together Forever*, a group exhibition featuring the work of assume vivid astro focus, Massimo Guerrera and Revolutions on Request (Contemporary Art Gallery, Vancouver); *SoundSystem* by Mark Leckey, and *Playtime* by Tony Romano (Mercer Union); and *The Jennifer Show* (Oakville Galleries, Oakville, Ontario). She often writes for *C Magazine*, Toronto, and has recently contributed "Writing Out Failure" on the work of James Carl, to the anthology *Retail by Artists*, Art Metropole, Toronto.

Pam Patterson (Ph.D.) has for thirty years been active in various arts communities. Her research is energized by her personal politics and focused on embodiment in art practice, with, for example, publications: *Studies in Art Education*, *Resources for Feminist Research*, *Fuse*, *Parachute*, and conferences: the Feminism and Art Conference (WARC, Toronto), History of Art Education Symposium (Penn State), and Committing Voice (Goddard); and curatorial projects. She currently teaches at the Art Gallery of Ontario (Anne Tanenbaum Gallery School) and Toronto School of Art. As a performance and visual artist, she has exhibited and performed solo, and with Leena Raudvee in ARTIFACTS.

Christine Redfern is a multidisciplinary artist working in Montréal, Québec. Her interdisciplinary and multilingual collaborative projects often hijack other dissemination networks and non-traditional mediums in order to circulate creative visual work to audiences outside the contemporary arts milieu. Her musings on the arts can be read weekly in the *Montréal Mirror*. She received a BFA in Studio Arts from Concordia University, Montréal (1989) and a B.Sc in biomedical communications from the Faculty of Medicine, University of Toronto (1994). Visit www.re-dress.net.

Clive Robertson is an artist and cultural critic teaching contemporary art history and policy studies, performance, and video production at Queen's University, Kingston. He is currently producing an artist's book of his published and unpublished letters to *The Globe and Mail* and an essay collection of his writings on arts policy and self-governance. He is working with Modern Fuel on *Then, and Then Again (1970-2004)* a historical document exhibition of his performances, media arts, curatorial, and publishing collaborations which will tour in 2006.

An associate professor in the department of Communication Studies, Montréal, **Kim Sawchuk** has been writing on corporeality, feminist performance practices, new media art, and technological culture since the early 1990s. Her co-edited anthology with Bill Burns and Cathy Busby, *When Pain Strikes* (1999), includes contributions from academics, artists, and front line activists addressing the subject of pain. She co-edited *Wild Science: Reading Feminism, Medicine and the Media* (2000) with Janine Marchessault. She is a co-founder of Studio XX in Montréal, a digital arts centre for women that acts as a forum for artists and activists to debate the advent and effect of the new media technologies from a feminist perspective.

Karen Spencer practices performative-like interventions in public space. She attempts to quietly disrupt the assimilation of unacknowledged value systems based on power relations. She currently lives in Montréal.

Karen Stanworth is an associate professor in visual arts and education at York University. Her research focuses on visuality and the representation of identity. She has worked on a range of objects, from 19th century spectacle to 20th century dance, group portraiture to educational museums, but her subject remains centred on the paradoxical desire to belong and yet be apart — and the ways in which this desire is visually enacted.

Barbara Sternberg has been making experimental films since the mid-70s. Her films have been screened widely and are in the collections of the Art Gallery of Ontario and the National Gallery of Canada. Sternberg has also participated in gallery exhibitions with mixed media installations and performance art. She was co-founder of Struts Gallery in Sackville, NB and was a founding member of Pleasure Dome: Artists Film Exhibition Group, Toronto. Sternberg has made two collaborative works with Rae Davis, *Surge* (1998) and *Glacial Slip* (2003).

Dot Tuer is a writer, cultural theorist, and historian whose writing on contemporary art explores the intersections of history, memory, and technology. She has published numerous articles and catalogue essays on new media, performance and photography and a collection of her essays is forthcoming from YYZ Books. Tuer has presented public lectures for the National Gallery of Canada, the DIA Centre for the Arts, the Chicago Institute of the Arts, the Sydney Biennale, and the National

Museum of Fine Arts in Argentina, among others. She is the recipient of Canada Council and Ontario Arts Council awards for her critical writing and fiction.

Born in 1955 in Brussels, where she studied literature and art history, **Marine Van Hoof** now lives and works in Montréal, Québec. She approaches both art criticism and teaching in an interdisciplinary and cross-cultural manner. Her research focuses on the image of the human body in popular culture and contemporary art forms, including performance art, new technology, cyber-art, science fiction, video games and the feminist movement. A regular contributor to *Vie des Arts*, she has been published in renowned publications such as *Archée* as well as the *Journal des Arts*, *Parachute* and *Artpress*. Her current research focuses mainly on the representations of sexuality in contemporary art by female artists.

Jayne Wark is associate professor of art history at the Nova Scotia College of Art and Design in Halifax. Her areas of teaching and research include Canadian and American performance, video, and conceptual art from the 1960s to the present. Her book, *Radical Gestures: Feminism and Performance Art in North America, 1970s to 2000*, is forthcoming from McGill-Queen's University Press. She has received a National Gallery of Canada Research Fellowship to pursue work on a book on conceptual art in Canada.

Scott Watson is a professor in the department of art history, visual art and theory at the University of British Columbia where he is also the director of the Morris and Helen Belkin Art Gallery. He has written extensively on contemporary Canadian art.

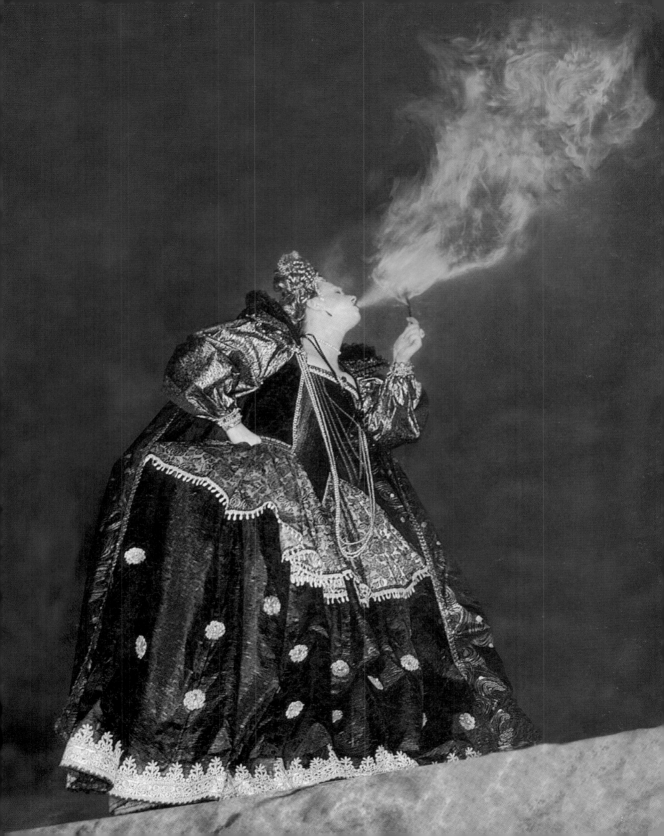

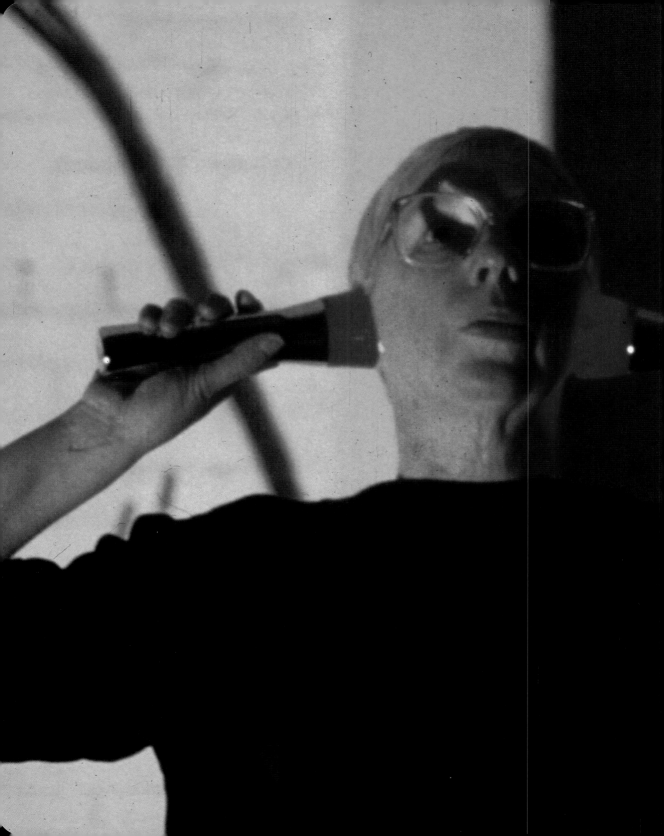

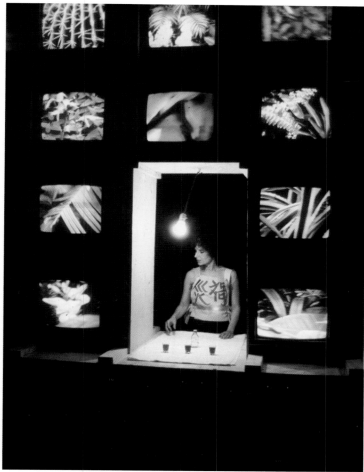

DAVID HLYNSKY

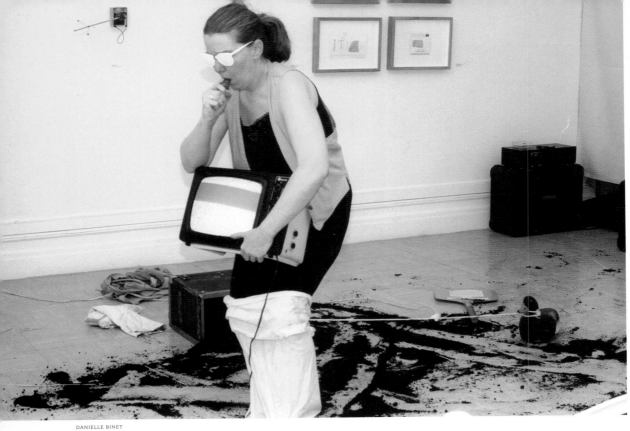

DANIELLE BINET

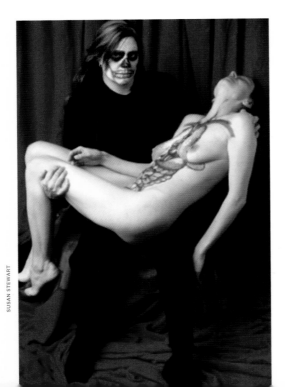

SUSAN STEWART

SUZANNE JOLY *Je n'ai plus toute ma terre*, performance, Galerie Sans Nom, Moncton, 1997

KISS & TELL *Corpus Fugit*, Festival House, Vancouver, 2002. Pictured: Persimmon Blackbridge, Lizard Jones

SHAWNA DEMPSEY & LORRI MILLAN *Arborite Housedress*, performed by Shawna Dempsey. Studio photo taken at the Winnipeg Art Gallery, 1995. First performed at Walter Phillips Gallery, Banff Centre, 1994

SHEILA SPENCE

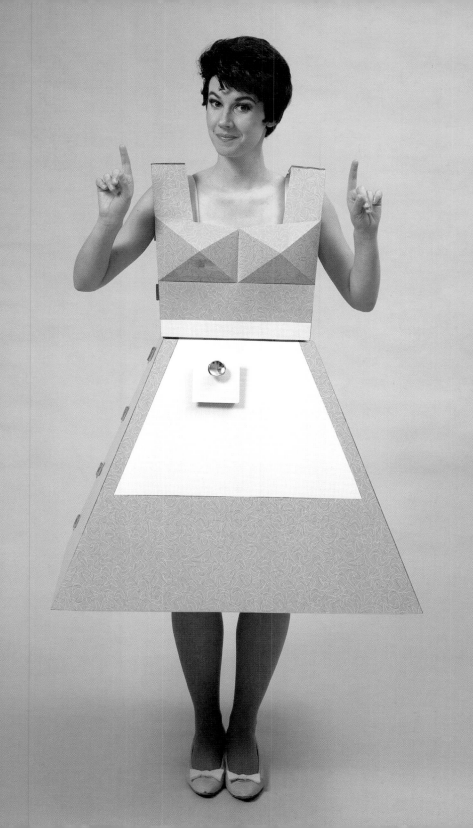

REBECCA BELMORE *Ayum ee-aawach Oomama-mowan (Speaking to their Mother),* Fort Qu'Appelle Valley, 1992

MAY CHAN *Chinese Calligraphy* (part of Anti-Racism project), Niagara Artists' Centre, St. Catharines, 1994

MICHAEL BEYNON

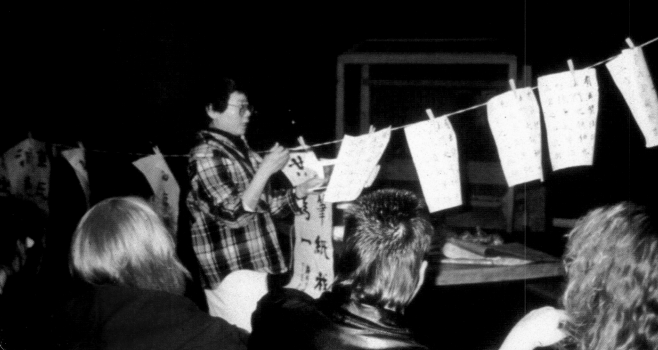

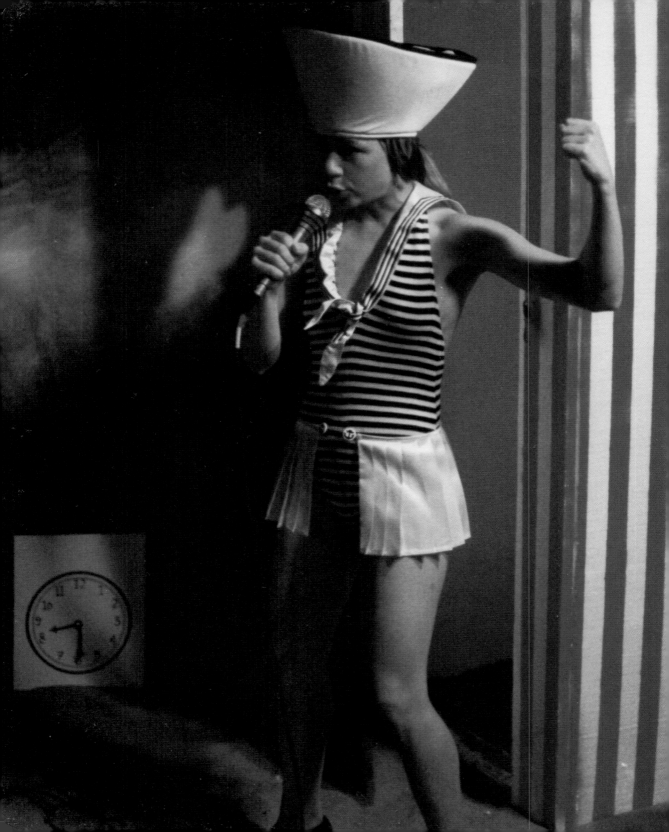

SYLVIE LALIBERTÉ *Ma cabane érotique au Canada*, Festival de Théâtre des Amériques, Montréal, 1987

COLLEEN GRAY *Tableaux Vivants: Vancouver*, Video In, Vancouver, 1998

FRANCES LEEMING *Finding Faults in the Firmament*, performance still, DanceWorks 38, Harbourfront, Toronto, 1985

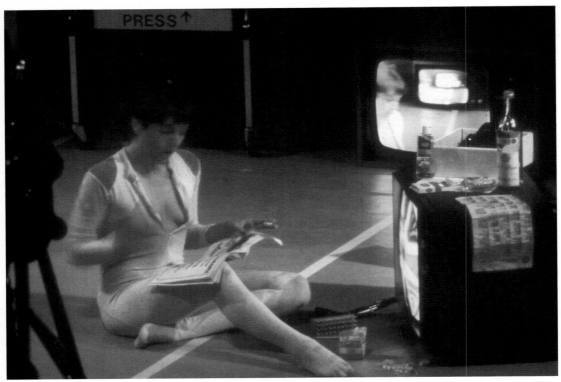

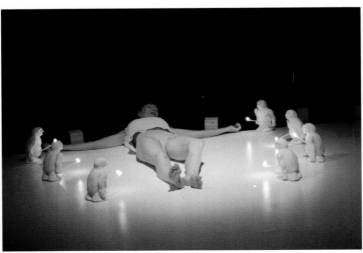

MARGARET DRAGU *TV Hertz*, collaboration with Enrico Campana, Art Gallery of Ontario, Toronto, 1979

ROBIN POITRAS *memex ovum*, 2001. Original dwarf by Edward Poitras

RITA MCKEOUGH *Shudder*, Ace Art, Winnipeg, 2000. Performance for 7 performers, video projection, audiotape on moving speakers. Rita (kneeling) with vocalist Kathleen Yearwood

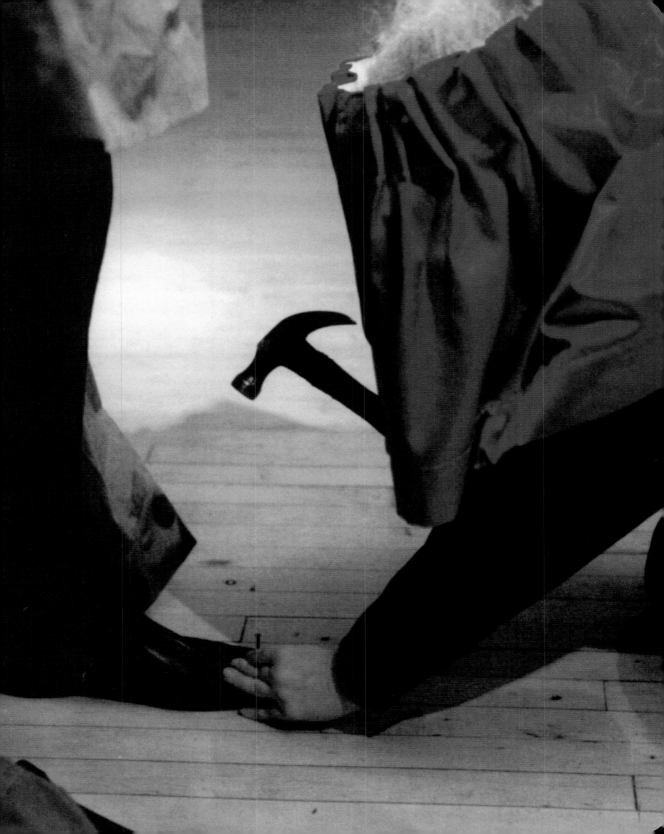

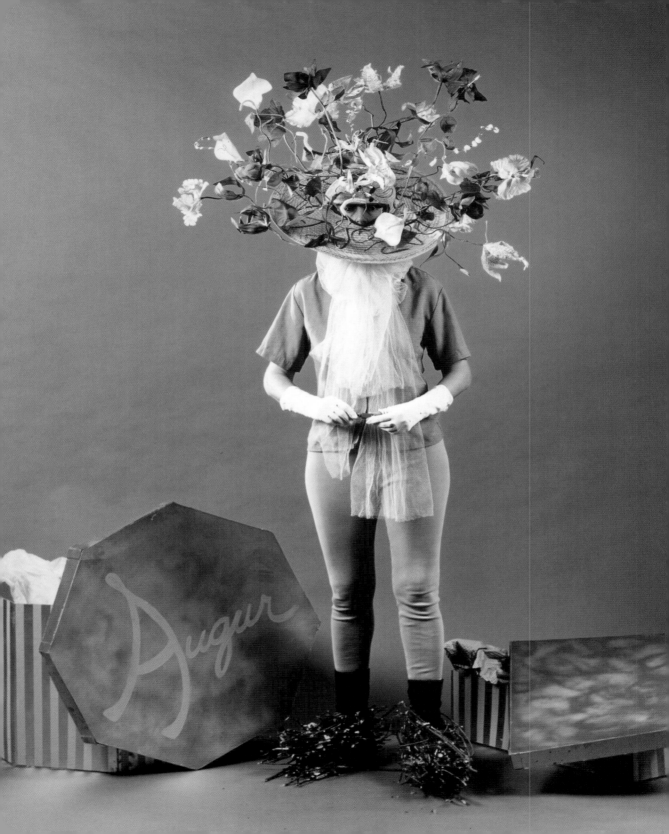

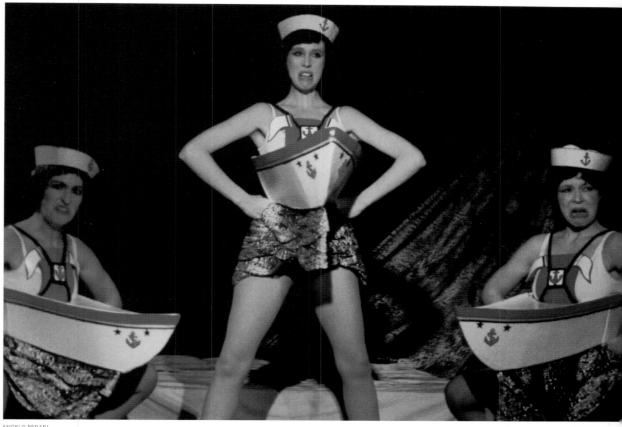

ANGELO PEDARI

COLETTE URBAN *Augur*, performance props and costume, 132.5 x 115 cm chromogenic print, 1999. Collection of the Art Gallery of Windsor

THE CLICHETTES *Seaman*, in *Send These Lips to Houston*, at the Rivoli, Toronto, 1984

ELISABETH FERYN

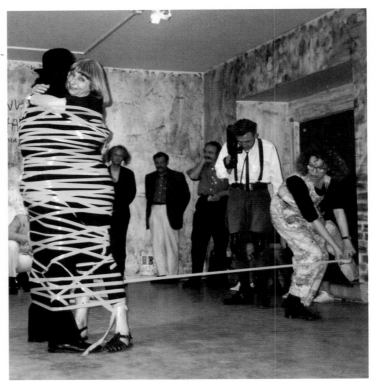

REID WOOD

ANNA BANANA with John Held, *Wrap*,
Le Lieu, Québec, 1994

JUDY RADUL *Power Circus*, rehearsal
still, 1991

FOLLOWING PAGE
JOHANNA HOUSEHOLDER *Bad Seed TV*,
in *Performance Bytes*, Toronto, 1997
PHOTO: ANGELO PEDARI

ANN MARIE FLEMING

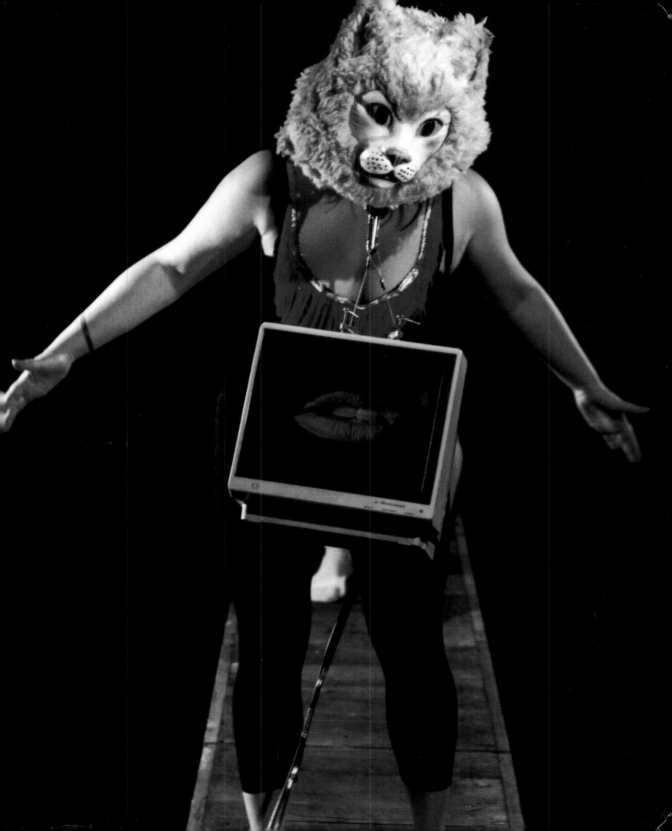

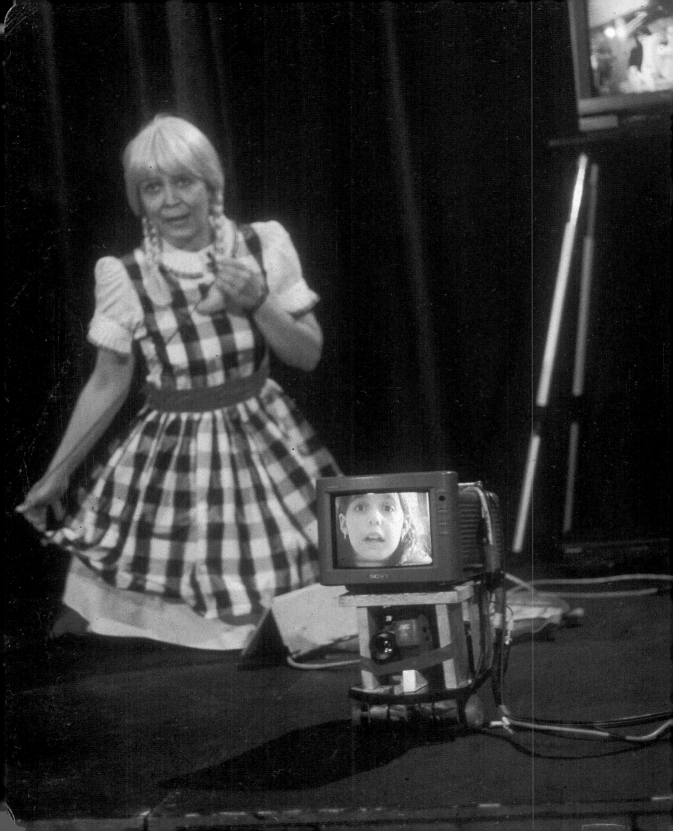